Diagramming Modernity

Books and Graphic Design

in Latin America, 1920-1940

Diagramming Modernity

Books and Graphic Design

in Latin America, 1920-1940

Rodrigo Gutiérrez Viñuales | Riccardo Boglione

Archivo Lafuente | Heras, Cantabria, Spain | MMXXIII

Contents

- **7** Introduction
 Rodrigo Gutiérrez Viñuales | Riccardo Boglione
- **19** Latin American Illustrated Books: A Transatlantic Journey
 Juan Manuel Bonet
- **85** Argentina
 Rodrigo Gutiérrez Viñuales
- **161** Bolivia
 Rodrigo Gutiérrez Viñuales
- **189** Brazil
 Rodrigo Gutiérrez Viñuales
- **249** The Caribbean and Central America
 Riccardo Boglione
- **279** Chile
 Rodrigo Gutiérrez Viñuales
- **341** Colombia
 Riccardo Boglione
- **367** Cuba
 Riccardo Boglione
- **399** Ecuador
 Rodrigo Gutiérrez Viñuales
- **437** Mexico
 Marina Garone Gravier
- **511** Peru
 Rodrigo Gutiérrez Viñuales
- **557** Uruguay
 Riccardo Boglione
- **613** Venezuela
 Riccardo Boglione
- **633** Word-Image
 Riccardo Boglione
- **689** Verbovisualidad: Visual Representations of Language
 Riccardo Boglione
- **733** Pre-Columbian and Ancestral Traits
 Rodrigo Gutiérrez Viñuales
- **767** Political and Social Graphic Design
 Dafne Cruz Porchini
- **791** Bibliography
- **805** Index of names in catalogued works

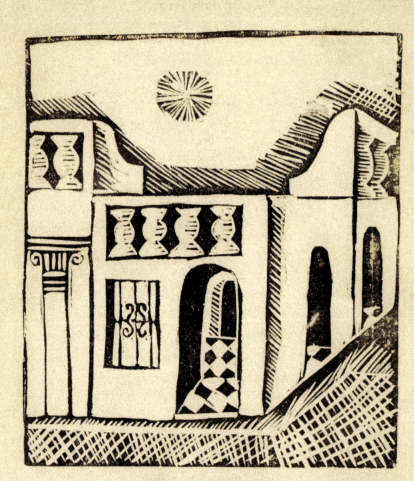

Cover by Norah Borges for Jorge Luis Borges, *Fervor de Buenos Aires*. Buenos Aires, Imprenta Serrantes, 1923. 19.2 x 14.4 cm. Archivo Lafuente

Introduction

Rodrigo Gutiérrez Viñuales | Riccardo Boglione

Over the past decade, and to a certain extent in the wake of what was taking place in other parts of the world, the key role played by graphic design—understood as illustration and typographical inventiveness—in regional and national histories of art has been revised and established.

A number of exhibitions and books confirm the process: *O design brasileiro antes do design* (2005), coordinated by Rafael Cardoso; *México ilustrado, 1920-1950*, curated by Salvador Albiñana (2010), *Poesía e ilustración uruguaya 1920-1940* and *Vibración gráfica. Tipografía de vanguardia en Uruguay, 1923-1936*, curated, respectively, by Pablo Thiago Rocca and Riccardo Boglione in 2013; *Antología visual del libro ilustrado en Chile*, by Claudio Aguilera Álvarez (2014), *Libros argentinos. Ilustración y modernidad (1910-1936)*, by Rodrigo Gutiérrez Viñuales (2014), and *A capa de livro brasileiro, 1820-1950*, by Ubiratan Machado (2017), are but a few examples. Furthermore, the presence of illustrated Latin American books in shows and publications produced in other continents, such as *La vanguardia aplicada (1890-1950)*, staged at Fundación Juan March in Madrid in 2012, or more specific books like *Impresos de vanguardia en España (1912-1936)*, by Juan Manuel Bonet (Valencia, 2009), and *Futurismi nel mondo*, by Claudia Salaris (Pistoia, 2015), do not only signal an increasing interest but have also become cornerstones for the establishment and growth of public and private collections of such material worldwide.

Later on, the numerous facsimile editions of these works, made in different countries preserving their original graphic features, reveal their true importance. To mention but a few cases, the various editions of *5 metros de poemas*, by Carlos Oquendo de Amat, published in Peru; the double edition of the two Parisian books by Vicente de Rego Monteiro, *Légendes, croyances et talismans des indiens de l'Amazone* and *Quelques*

visages de Paris, two other books by Oswald de Andrade, *Pau Brasil* and *Primeiro caderno do alumno de poesia Oswald de Andrade*, *Feuilles de route. I. Le Formose*, by Blaise Cendrars, illustrated by Tarsila do Amaral, and *Jogos pueris*, by Ronald de Carvalho, with illustrations by Nicola de Garo, all six published in Brazil. This editorial activity was complemented by the re-edition of complete magazine collections: *Amauta* and *Boletín Titikaka* in Peru; *Irradiador* and the numerous publications made by Fondo de Cultura Económica in Mexico (including the art review *Forma* and *Horizontes*); *Válvula* in Venezuela; *Klaxon*, *Estética*, *A Revista*, *Terra Roxa*, *Verde*, *Revista de Antropofagia* (that were included in the box titled *Revistas do Modernismo 1922-1929*, published in 2014) and *Madrugada* in Brazil; *Martín Fierro* and *Proa* in Argentina; *Vanguardia* in Uruguay, among others.

Passionately seeking out such works, we decided to complete the task of compiling and analyzing Latin American books, mostly in the fields of art and literature, we had initiated a few years ago. These books were distinguished by the accordance of their illustrations and cover designs with the change in the paradigms of design that took place worldwide in the second decade of the 20th century, summed up here in the word modernity. Our intention was to establish a referential corpus that would assemble and compare meaningful editions, works scattered around libraries and private collections and were only vaguely known, or else had been displayed or reproduced in locally rather than as parts of a group that oversteps borders.

Over the past few years, we had each (a European author living in Latin America and a Latin American living in Europe) taken advantage of what we had learned in our readings, in interviews with colleagues, visits to collections, second-hand bookstores, street markets and Internet searches, acquiring material with a view to embark upon such a task. Our intention was to add our own respective collections to those of other European and American collectors, libraries, and other organizations capable of enhancing this first all-encompassing gaze that we hoped to extend throughout the continent. We took the years 1920 to 1940 as our reference, a period in which Latin America witnessed a marked transformation of forms of artistic production and, more specifically, of graphic design.

Having got thus far, we decided to get in touch with José María Lafuente, with whom we had already had a few earlier meetings to discuss these affairs. Our conversations, and the chance to study his Latin American material displayed in *La vanguardia aplicada* exhibition in Madrid, had provided us with an accurate understanding of the value and potential of such collections. By then, it was a central part of the recently founded Archivo Lafuente. When we suggested systematically undertaking the publication and perhaps exhibition of the works, Lafuente immediately agreed, and our joint research project began to take shape. In addition, given the existence of the Archivo, from then on, we would focus on deliberately increasing its Latin American heritage, following specific guidelines.

Although in some cases we were starting from incipient collections of national repertories that supposedly reflected certain central discourses, both in visual and in textual terms (to which we shall refer later), we were particularly interested in exploring the international associations that would prove Latin America was a territory of connections, in spite of its undeniable limitations. The task of studying the entire continent favored the convergence of knowledge that led to the prospect of discovering, among other

aspects, the presence of numerous illustrators in countries other than those of their birth. The list is long, but we could mention here a few macroscopic cases: the Argentine Alfredo Guido, whose works we also come across in Bolivia and Brazil; Chilean artist Germán Bartra, equally active in Peru, where we also discover Mexican artist Gabriel Fernández Ledesma (not only in the field of books but also in Peruvian, Uruguayan and Argentine magazines); Argentine artists Norah Borges and María Clemencia López Pombo, present in Uruguay, Chile, Peru and Brazil; and the Paraguayan Andrés Guevara, working in Brazil and Argentina.

Similarly, the continental research was favored by the fact that in those days copies of books and magazines from one country to the next, to a fair extent thanks to having been sent by their authors to colleagues or literary reviews to promote their circulation, forming a mesh of transnational exchanges. Most of these copies were dedicated, which also enabled us to increase our knowledge of some of the connections established at the time. Having been produced elsewhere, these books aren't usually of interest to researchers or collectors in their final destinations, so they can be given a new dimension.

One last note regarding the dedications they contain: besides what we have said in the last paragraph, the inscriptions were the result of the limited commercialization of many of the editions—most of which had short print runs— and therefore of a more "domestic" distribution made by authors and artists who, instead of selling copies, gave them away as presents, just as they themselves received copies from friends and colleagues. This is also telling of how difficult it sometimes was to assemble these books, and of how fortunate it is that they have survived so many decades. Indeed, one unfavorable circumstance that had to be remedied in the collecting process is linked to the conservation of many of these books, especially those from the Caribbean, Cuba in particular. The original use of poor-quality paper, added to excess humidity and heat, produced the tangible deterioration of many copies, so that it is sometimes a wonder that they have survived to our days. Furthermore, bad preservation conditions (a constant characteristic, although not limited to Cuba), has led to the irreparable loss of most of the few copies in print.

The tasks of consolidation and restoration of volumes carried out at Archivo Lafuente were a necessary part of the process. Along these lines, and for this project specifically, regardless of the collection to which they belonged we decided to display the books in their present condition, without performing any "digital" restoration, save for a few cases in which this was absolutely necessary in order to appreciate them fully.

Besides the recovery of lost copies, we faced the task of having to unbind some editions, having only managed to purchase them printed on quarto sheets, although the original covers were found in their interiors. Such bindings had been used to "dignify" the books, divesting them of presentations considered strictly for advertising purposes. More than in other countries, this was often the case in Brazil, where one of the key illustrators was Tomás Santa Rosa who judged certain bindings superfluous, the result of "excessive veneration."

* * * * *

One of the main purposes of this survey was to try and transmit the importance of the visual construction of modernity through

books, suggesting one possible interpretation among many, and convinced of the capital importance of printed matter, especially covers of books and magazines, in introducing, adapting and disseminating new plastic—and hence ideological—values in any narrative on the history of art. These areas often became spaces for formal experimentation in the case of artists who were more used to working on canvas. This is explained, to a certain extent at least, because many artists tried their hand at graphic design in the initial stages of the modern development of illustrated covers, when many of the publishing rules concerning book jackets that would subsequently be enforced were still flexible, and in some cases were even non-existent. As a result, artists enjoyed a fair degree of freedom, further encouraged by their incipient interest in using striking designs to catch viewers' attention in store windows. Very often, the illustrations in the inner pages of the books in question reflected the same freedom: sometimes they were "continuations" of the outer designs, while on other occasions they were completely independent of their respective covers; in almost all cases, however, they displayed their makers' most "innovative" designs. In short, a book cover was a membrane that separated a text from the outside world and at once associated the two. An image, as recently described, that revealed the connection "between the individual vision of an artist and the social, cultural, and historical circumstances of the times (or of the different times, given that the texts were given new covers on occasion of each new edition)" (Mendelsund and Alworth, 2020: 55).

Accordingly, the images in these books and in other outstanding samples of graphic design offer us the possibility of going through a wall—of constructing a narrative, a different narrative, signed by names that don't usually appear in official art histories. In spite of their anonymity, they laid the foundations of a genre, while often remaining illustrious outsiders. Contrary to the case of literature, where databases enable us to construct more precise itineraries, the works of these creators present added difficulties when it comes to following trails. Information is usually quite scattered, especially bearing in mind that as art historians we have avoided this sort of material as the central object of study.

The choice of a title for the book was a theme of debate, or rather a decision that stemmed from a necessary phase of maturation. After studying several possibilities, we decided to use the term "modernity" in the title instead of the more tempting term "avant-garde," as the latter, more specific, was much more restrictive. With continental exceptions such as Neo-Pre-Columbianism, in the field of graphic art the aspects featured by the avant-garde were almost exclusively reflections of European creations. This would have obliged us to adopt a biased, subordinate look at Latin America that would have been incomplete and misleading. Save a few extraordinary exceptions (Mexican Stridentism and muralism, Brazilian Modernism and, to a lesser extent, Chilean Runrunism), in Latin America there were no organized, precise, collective programs designed to subvert the system of production and circulation of images that characterized, albeit briefly, some of the historical isms. The sphere of graphic art prioritized a synchronization (not, as has been scornfully suggested, an "updating") with the formal renewal of visual iconic language on a global scale.

So, to sum up, broadly speaking the term "modernity" describes certain attitudes and practices common to such productions, always,

however, extremely varied and presented either in combined groups or independently: the exploitation of new printing techniques; allusions to advertising models tending to impress; the conceptualization of illustration as a part of the work and not only as a support of a text; the re-signification of popular graphic art; the move from conventional decoration to bolder forms of expression; the abandonment of pure ornamentation; the re-elaboration of Cubist and Futurist elements; the tendency toward synthesis; the exploitation of asymmetry and the exacerbation of symmetry; dynamic relationships but also strict dependence between letters and images; the broadening of palettes and strident color combinations; stylistic hybridizations.

That said, we must insist on the fact that the concepts of "modernity" and "avant-garde" are erratic: rather than fixed categories they are open and fickle. Similarly, they are universes that bring together numerous agents, ideas, attitudes, esthetics, etc., and even artists who are, in principle, reluctant to accept the "new ideas," make certain forays into them.

Thus, we prefer to adopt a loose and flexible definition of "modernity" and a broad survey capable of presenting wide ranges of creations from different countries, with their varied dynamics and degrees of modernity, understood from the point of view of their own means, situations, and possibilities, although always with the intention of breaking the logics of nineteenth-century designs. In short, an art of its place and its time, with logical intersections and transmissions of information with other latitudes. Hence, too, our decision to include the productions by Latin American artists in the European and American contexts as an extension of their work and their inclusion in different spheres.

Having made this decision, therefore, we couldn't simply apply formulas of the European isms to those realities, as this would have entailed the risk of limiting ourselves to an confined universe that would have distorted the reality of our countries, or the risk of falling into one of the obsessions of attributing European precedents to everything. The challenge, in part, was to strike a middle point, a balance, that would enable us to understand the imported forms and their development in those fields, though measured in local time, as described by Joaquín Torres-García when speaking of converting "the foreign into our own substance."

This is further emphasized by the lucid analysis made by Ticio Escobar: "Indifferent or fascinated, Latin America culture has witnessed the arrival of successive groups of the most diverse of modernist forces. Sometimes, it would dispute them or else avoid contact with them. At other times, it would escort them, or even lead a foray that opened up new though narrow paths. But it never took part in great plunders or conquered many new domains, and only partially believed in the former European logos. It never fully accepted the reasons for such an unconvincing reason, verified the advances of a progress that was always delayed, or took advantage of the shelter of imposing foreign totalities." (Escobar, 1994, 51).

* * * * *

The configuration of the visual discourses included in this book can be described as a journey, as can each one of them specifically, and many would be undertaken as an adventure for which we had no previous guidelines. Our pre-selection and selection processes before establishing the final contents were governed by several criteria.

Bearing in mind the huge volume of material with which we were working, the first important decision entailed focusing on books alone, leaving to one side both magazines and artists' editions of prints, illustrations, and other printed matter (musical scores, invitations, etc.). Such editions were very common in those days, as they enabled artists to widely disseminate their work—portfolios of caricatures, illustrations, or prints such as those by the Mexican Roberto Montenegro, or the Argentine Gregorio López Naguil and, in the 1930s, socially themed works like those by Brazilian artist Emiliano Di Cavalcanti, the Uruguayan Argentine Guillermo Facio Hebecquer, the Ecuadorian Eduardo Kingman, the Chilean Carlos Hermosilla, or the Mexican David Alfaro Siquieros, among many others. Particularly in the case of reviews, which were absolutely central to the circulation of ideas—and hence of graphic ideas—on the continent, we have included unusual and meaningful samples of such works as illustrations of texts, in an attempt to provide a succinct outline of innovative designs that paralleled those being made for books, which they mirrored.

Once this canon—the choice of books alone—had been established, the compiled material that remained outside the final version is almost three times greater than the material included, which was characterized, of course, by the graphic quality of the material chosen after having examined an immense number of volumes. The texts quote many books that we have been unable to reproduce here due to restrictions of space and design, which explains why we have set up a specific website, inside the Archivo Lafuente, that will feature the research more completely and include all these books. Our project, therefore, is open-ended and in continuous progress, enabling us and others to add future issues as is usually the case with such compendiums.

Notwithstanding what we have pointed out, and well aware that in other circumstances they could have been excluded from our list, in some instances we chose to keep books that for reasons other than a high plastic quality—either because of the importance of the author, of our interest in shedding light on other artists or styles to which work is related; in the case of designs by renowned painters or sculptors who are scarcely known or even totally unknown as illustrators; in order to enhance our specific understanding of a particular illustrator; because their inclusion is useful for our historical survey (micro-histories of art, particularly on a "national" scale, emphasizing chapters that reveal forgotten paths); because they enable us to create "small societies" within our visual or textual journey in connection with other listed books; because they are unknown books, and hence help transform visual narratives (especially true in the cases of Argentina, Brazil, and Mexico, chapters in which we have included material absent from the numerous preceding studies); or because they allow us to substantiate the visual survey of those countries that have scant material (only once we have eliminated works that are too mediocre to deserve a mention, of course, whatever their country of origin).

Another of the criteria that prevailed was that of prioritizing the country of publication over and above the nationality of the author or artist, save for very specific cases based on the impact and dissemination of books in countries other than those of their publication. In this sense, we have turned to Latin American designers and illustrators who worked abroad, and to others from Europe and America who produced works in Latin America. This explains why the chapter

entitled "Latin American Illustrated Books: A Transatlantic Journey" doesn't include books written by Latin American authors designed or illustrated by foreigners. In this case, therefore, the criterion of the Latin American illustrator/designer prevails, even when the books illustrated are by European or American authors.

We organized our lists following a certain chronological sequence, although on several occasions we changed this internal order according to the discourse, grouping works together by themes, authors, or other principles we established when drawing up our essays. As regards our time frame, the phenomenon of modernity and the esthetic avant-garde obviously extended beyond our confines, so in very concrete cases we have included books produced in the 1940s.

Similarly, when it came to defining a starting point, in most of the countries surveyed we began by presenting a series of illustrated books of Symbolist style, some of which were made before 1920, that inaugurated modernity although they did not yet feature the intensity of the avant-garde trends. Here, our intention is to create a context that will further understanding of the various spheres in which successive "modernisms" were established. In other words, to show processes of continuity, not of interruption such as those authors usually prefer to highlight. Hence the avant-garde names Gregorio López Naguil, Alfredo Guido, Juan Antonio Ballester Peña or Lucio Fontana in Argentina; Emiliano Di Cavalcanti in Brazil, Jorge Délano, Luis Meléndez or Alfredo Molina La Hitte in Chile; Diego Rivera, David Alfaro Siqueiros or Roberto Montenegro in Mexico; Carlos Quízpez Asín, José Sabogal or Alejandro González Trujillo in Peru; or Uruguayans like Joaquín Torres-García or Rafael Barradas, who before creating their most advanced works had gained experience as illustrators in Modernism and Symbolism.

Although the graphic avant-garde produced its own revolutions, in the case of Latin America this did not entail disdain toward preceding trends or the intense imposition of novelty. Avant-garde trends arrived and were disseminated in contexts that had already begun to experiment with new artistic languages, and "modern" graphic design had already been consolidated in the field of book and magazine illustration based on technical innovations, the ongoing improvement of printing presses, editorial policies, and the formerly unprecedented dedication of many artists to such work.

The result of this process of pre-selection and selection is a broad collection of samples that is not complete, although it can provide a basis for subsequent, more comprehensive, studies of the countries and themes addressed. From the amount of material we have ruled out it could seem as if we had tried to be exhaustive, which is not the case and is, in fact, impossible. After a number of years devoted to seeking and finding such material, we have learned that the undertaking is endless and new references susceptible of being incorporated into these discourses will always surface. This is part of the risk entailed by such research, but we are happy to leave our project open-ended. Starting from these premises, besides presenting a selection of what we consider to be the best editions among those surveyed, our intention has been to endorse a way of classifying and analyzing these materials.

* * * * *

The texts that precede our visual journey, whether they discuss countries or transversal themes, are indissolubly connected to these

and interact with them continuously; the ones without the others would be sterile. Posed as a sort of "road map" for the sequence of images included after them, they include references to other sections so that the book actually consists of separate chapters that are nonetheless interrelated with the volume as a whole. Thus, the books reproduced loosely follow the essays and yet do not strictly obey the order in which they are cited. That is, parallel to the historical and critical itineraries traced in words, they trace other iconic and sensory itineraries. As editor of the book, José María Lafuente decided the order of appearance of the images to enhance their intrinsic charm through the connections between covers and inner pages.

To return to the essays, rather than produce definitive narratives, which is virtually impossible due to the limitations of space, our idea was to present a series of synthetic comments to help readers visually categorize the subject. We are well aware of the fact that some of the texts may seem rudimentary to experts from the different countries examined. However, we should not forget that these texts are also addressed at potential readers from other latitudes who have no previous knowledge of the subject.

A certain discrepancy may be observed between the way in which we have approached our respective texts. This is due to the fact of having chosen different starting points: the history of art, on one hand, and the literary field, on the other. Nevertheless, we both read and comment on each other's writing, and are therefore mutually encouraged by our partner's thoughts and opinions.

We did, however, decide to use a few unifying elements, such as a succinct "historiographic" analysis at the beginning of each chapter that would describe existing contributions to—and appraisals—of our material, both in the form of books and of exhibition catalogs.

The result is, of course, a series of partial narratives, appendices we have separated from broader artistic fields in order to throw them into relief. This deliberate connection of separate themes has shed new light on the events, that were probably not seen in the same light when they were actually taking place.

* * * * *

The book is structured into two parts: national stories and transversal narratives. In the latter, unifying texts, we have insisted on building bridges between the creations in different countries.

While the two of us have written most of the chapters, we have also invited three experts to present three specific chapters. Juan Manuel Bonet has contributed an analysis of the images we have grouped under the title "Latin American Illustrated Books: A Transatlantic Journey," and Marina Garone Gravier has composed a similar text in the section devoted to Mexico. Likewise, we thought it would be interesting to include a text that would furnish a global assessment of graphic design dedicated to social themes during the period studied, a key motif in Latin American illustrated works. Complemented by a cross section of images from different countries, the text in question is by Dafne Cruz Porchini—a Mexican specialist well-versed in the matter—and provides an impressive end to the story. The inclusion of these three essays notably enhances our book, all the more since we asked them not only to comply with certain requirements of the book as a whole, but also to adapt their texts as far as possible to their respective areas of expertise.

Among the difficulties we encountered during our research we must mention the scarce number of copies located in some of the countries, which meant, among other things, that the countries in question could not be assigned a relevant section of their own. This was the case in each of the Central American countries and the Caribbean islands (with the exception of Cuba), and in Paraguay. All we discovered in these countries were scattered originals, insufficient to draft a homogeneous discourse. As a result, in the case of Central America we resolved to group the publications together and tell some of the stories about them. We even decided to include references that aren't as "modern" as we would have liked, but reveal a certain desire to take part in the discourse of renewal of the times. Thus, faced with the problem of locating material from that region and with the dilemma of how to proceed, we preferred to complement the few specimens that definitely fall into the Modernist category with several printed drafts to increase the representation of countries that would have inevitably been marginalized had we strictly applied the filter of modernity or the avant-garde. We believe it is meaningful to present an overview of what they were creating during those convulsive years.

With regard to Paraguay, the few books we have found appear in cross sections. The relative proximity between this land, one of the *Mediterranean* countries in South America, and Buenos Aires, made the metropolis a paradigm for Paraguayan creators, and both poets (including Elvio Romero) and artists (chiefly Andrés Guevara) worked and published in the Argentine capital. Moreover, the country was very slow to adopt Modernism, which is easy to understand if we bear in mind that Paraguayan historians usually signal a show held in 1952 as the first avant-garde exhibition staged in the country.

We soon realized that Modernism and avant-garde movements didn't only develop in capital cities, but also in several inland towns and villages, which became points of reference that signaled the heterogeneous and decentralized artistic scenes of their countries, as exemplified by Rosario, La Plata, or San Rafael in Argentina, Cuzco, Puno, or Arequipa in Peru, Quillota in Chile, Jalapa (*Estrindentópolis*) in Mexico, Medellín in Colombia, or Cataguazes and Porto Alegre in Brazil.

Although national discourses were drawn up independently, a joint reading of these reveals numerous constant features that enable us to establish unifying readings. Logically, reasons of space prevent us here from mentioning all the possible correlations but we can speak of a few, including the contact between commercial and avant-garde graphic art, the influence of magazine and poster design (to a fair extent from the United States), the importance of Art Deco as a sign of modernity, the dissemination of the ideas and techniques of Cubism, or the importance of particular artists who, after working in a specific milieu, adopt Modernism and avant-gardism, revealing how some crystallizations aren't produced by "environmental issues" but derive from the independent action of certain individuals.

As is obvious, many of these themes could become Latin American research projects in themselves. Indeed, other subjects too could be jointly examined, such as the importance attained by arts and crafts schools in the wake of those established by William Morris, those of the German Bauhaus or the Russian Vkhutemas. Another interesting topic is that of the popular editions of the 1930s, with mass

print runs and attractive cover illustrations, often characterized by the use of glossy paper. Not quite "avant-garde" (although we could speak of a domesticated avant-garde), they did, however, have a clearly modern pulse: Botas in Mexico, Ercilla and Zig-Zag in Chile, Tor in Argentina (or even Spain, with publishing houses like Ulises, Zeus or Cénit, whose works were no doubt distributed in Spanish-speaking Latin America). Their dissemination on a huge scale enabled an all-inclusive socialization of the languages of modernity, a fact we have also striven to reflect.

* * * * *

The last part of the book is dedicated to the "cross sections", where creations from the different countries coexist and strike up a dialog focused on topics particularly relevant to the formal and ideological development of modernity.

The first section is devoted to what Italian art historian Maurizio Scudiero has defined as the "Word-Image." For the definitive version of this section we have had to make a number of cuts to ensure the quality of the material finally included. The first two parts of this section focus on covers that are filled with letters, of capital importance in the avant-garde politics that developed greatly throughout Latin America in lettering and typography, while a third section and a brief subsection examine the use of numbers in titles, another very common feature at the time.

A second "cross-sectional" chapter brings together examples of works from several countries on the continent, and explores how their authors implemented the great verbo-visual revolution begun in Europe in the 1910s, and whose growth would be central to the experimental literature of the twentieth century.

The third chapter, with a strong identity component, is devoted to "Pre-Columbian and Ancestral Traits," and reveals the continent's search for an autochthonous avant-garde, based on the contemporary recuperation and reinterpretation of Amerindian designs. To a certain extent, this could be considered a splintering or consequence of the "applied avant-garde" (to use the title of the emblematic exhibition 2012 held at Fundación March in Madrid, half of which was dedicated to the Archivo Lafuente), a Latin Americanization of the graphic revolution that was taking place in Europe. We felt that bringing these works into contact with one another, from Argentina to Mexico, was key to presenting a wide survey of the development of design in the continent.

Last but not least, the crucial lucid text by Dafne Cruz Porchini dedicated to "Political and Social Graphic Design," a true reflection of one of the fundamental aspects of Latin American illustration in those days, derived for the most part from the impact of Mexican Muralism and its upshot, the circulation of anarchist and socialist ideologies, the expansion of popular xylography, and the side effects of the economic crisis of the 1930s, characterized by "engaged art."

Featuring national books in cross-sectional areas was complex and challenging, an exercise that we undertook trying to preserve a certain balance. Indeed, the section "Word-Image," besides being by far the longest in terms of examples, is visually strongest from a forward-looking perspective too, so in order to denote it as such, it had to welcome significant material from each country. To some degree, the (necessary) existence of these sections tended to "de-modernize" the national chapters as much of their avant-garde material was transferred. This was a risk we had to run. Nonetheless, the fact

that certain books do not appear in their national sections doesn't mean that we don't consider them in their original context; actually, many of them are mentioned in the national essays, where readers are referred to their reproductions in the transversal sections. Another of the measures taken to mitigate these possible disadvantages was to keep some word-image examples or pre-Columbian and ancestral traits within the national chapters in order to visualize them in their original contexts and link them to the cross sections.

* * * * *

After this long-drawn-out introduction, it is time to move on to the body of the book. However, we would first like to underpin some of the intentions expressed in this preface. One of these, which we consider crucial, is our desire to establish a series of partial art histories for each of the countries in a book of continental scope, considering the limitations entailed by such a broad perspective. Most of these partial histories are original (less so perhaps in those cases that had previously been the object of thorough study, like Argentina, Uruguay, Brazil or Mexico). As researchers, the chance to refer for the very first time, and in a volume encompassing Latin America as a whole, to a great number of artists who had never before been mentioned in the art histories of their own countries, is not only immensely satisfying but is also a starting point for future researchers.

A second intention is to highlight the importance of Latin American contributions to global debates. We are, of course, aware that in order to reconstruct history precisely (particularly the history of those years), we Latin Americans must examine our circumstances and times, bear in mind our progress and slowness, without forgetting our network of connections with Europe and the United States. In this sense, thanks to our selection of works, we also believe we have made a substantial contribution to current studies.

Finally, we hope this book will be useful to both lovers and researchers of the history of art and literature, and to private and public organizations interested in enhancing their own collections. In short, we aspire to reveal the esthetic transcendence of these artistic proposals and editorial designs, most of which had been shelved or forgotten, and the historical-patrimonial value of the material. *Diagramming Modernity* should, above all, trigger similar projects of recovery, inspire future uncharted lines of inquiry, and open up new paths in collecting.

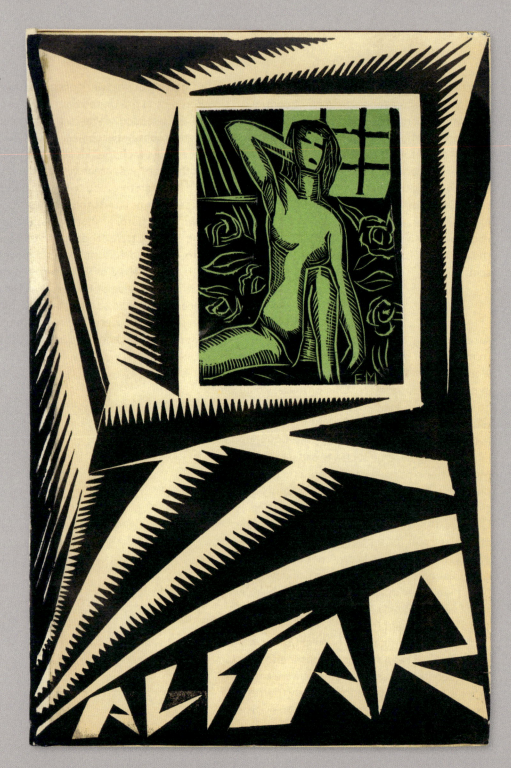

Cover by Francisco Miguel [Fernández Díaz] for *Alfar. Revista de Casa América-Galicia*, no. 33, October 1923. Editor: Julio J. Casal, Corunna. Talleres Gráficos El Noroeste, 31.9 × 21.3 cm. Archivo Lafuente

→

Vincent Huidobro. *Moulin*, Paris, not bound, 1921. 27.5 × 21.5 cm. Archivo Lafuente

Latin American Illustrated Books: A Transatlantic Journey

Juan Manuel Bonet

If we are going to look for a foundational work on the story we are trying to tell here, we must mention a book by Ilya Ehrenburg that appeared in Paris—the city in which he was then based—and whose Russian title was translated into Spanish as *Historia de la vida de una tal Nadienka y de las revelaciones que ha tenido* (1916). The work was illustrated with Cubist lithographs by his friend Diego Rivera. The following year the two would work together on another project, the publication *Sobre el chaleco de Semen Drozd*. The bittersweet portrait of the Russian by Ramón Gómez de la Serna in *Retratos contemporáneos* (1961) testifies to their Parisian friendship.

That was the last important book to be illustrated by Diego Rivera in Europe, although we should not forget his graphic collaboration on the book *Mexico* (1925) by Alfons Goldschmidt, published in Berlin. Nor should we overlook the fact that in 1929 the Dutch magazine *Wendingen* dedicated an entire issue to his murals, the extraordinary Neoplasticist cover of which was designed by Vilmos Huszar, or that in 1931 his great Cubist portrait of Gómez de la Serna, painted in Madrid in 1915, was used by the sitter as the cover of his highly personal encyclopedia *Ismos*, published by Biblioteca Nueva, one of whose chapters was titled "Riverism." On the other hand, the *Paris 1918* album—a lithographed manuscript text by the Madrid author which would have been accompanied by lithographs by Angelina Beloff, Juan Gris, Lipchitz, Marevna, Picasso, Rivera and fellow Mexican Ángel Zárraga—did not get to see the light of day. Zárraga, who was very close at the time to Rivera, produced the linear illustrations of *Profond aujourd'hui* by Blaise Cendrars (1917), a great work by the poet-cum-typographist François Bernouard. Another Mexican album, *Caricatures de Georges de Zayas : Huit peintres / Deux sculpteurs / Et un musicien très modernes* (1919), was published that same year in Paris,

prefaced by well-known Curnonsky, "le prince de gastronomes…". The painters, in alphabetic order, were Marcel Duchamp, no doubt the most iconic figure in the group, depicted as a ghostly, Laforguist figure committed to his passion for chess; Albert Gleizes; Marie Laurencin, Apollinaire's muse and the mirror into which many other female painters of the time, including Norah Borges, would look; Matisse; Metzinger; Picasso; Georges Ribemont-Dessaignes, who was in fact an interesting painter in his own right, at first under the influence of Symbolism and later clearly under that of Picabia. The sculptors were Archipenko and Brancusi. "Et un musicien": Erik Satie, a friend of Curnonsky's from the Chat Noir days.

Rivera, Zárraga and, to a lesser extent, Georges de Zayas (whose brother Marius, much more important, shall be discussed later, although we shouldn't forget that in 1914 Apollinaire's journal *Les Soirées de Paris* published some of his caricatures) participated throughout that decade in the new aesthetics, but they weren't the only Latin Americans to join the Cubist revolution under way in Paris at the time. A journey through the publications by avant-garde Latin American poets outside Spanish-and-Portuguese-speaking American lands must necessarily begin in 1917 with Chilean author Vicente Huidobro and his *Horizon carré*, cornerstone of Hispanic avant-garde poetry. This volume is extraterritorial, on the one hand because it was published in the Paris (by printer Paul Birault, remembered for this exquisite work and for others by Max Jacob and Pierre Reverdy), and on the other owing to the fact that instead of being written in the language of Cervantes it was composed in French, lingua franca of the avant-garde. The "de tête" copies were illustrated with a plate that reproduced a drawing by Juan Gris, one of the poet's guides in the French capital who revised his still hesitant French for the publication. The following year, *Tour Eiffel*, one of the four titles published by Huidobro during the four months he spent in Madrid, is worthy of note. Also composed in the tongue of Racine, this long poem was printed on sheets of different colors. It included a photographic reproduction of one of the visions of the Tower created by Robert Delaunay, who designed its spectacular pochoir cover as well.

The other three books by Huidobro that appeared in Madrid in 1918, *Hallalli*, *Poemas árticos*, and *Ecuatorial*, are characterized by an austere, almost pre-Minimalist typography (especially their covers), a genuine adaptation of Paul Birault's model, and are devoid of illustrations. Over the next few years, other works by Huidobro would appear in Spain, among which the graphic design of *Mío Cid Campeador* (1928), illustrated by Santiago Ontañón, is worthy of mention.

What remained as an unfinished project was the group of large-format "painted poems" *Salle XIV*. The originals were exhibited by Huidobro in the Parisian Édouard VII theater in 1922. The catalog, prefaced by the omnipresent Waldemar George, features Picasso's linear Ingresque portrait of the poet (made in 1921, year in which it was reproduced on the frontispiece of *Saisons choisies*), and a loose sheet in its interior presents the poem "Moulin," on one side in its calligrammatic and calligraphic rendering, and on the other, in its typographic version. On occasion of the *Salle XIV: Vicente Huidobro y las artes plásticas* exhibition held at Madrid's Museo Nacional Centro de Arte Reina Sofía (MNCARS) in 2001, the curator of the show, Carlos Pérez, fondly remembered museographist, managed to achieve the poet's dream by replacing the pochoir technique with that of silk-screen printing.

Creación, Huidobro's Madrid journal, was a nomadic international review subsequently renamed *Création* and published in Paris. A melting pot of languages, genres and styles (Post-Modernism, Cubism, Ultraism, Creationism,

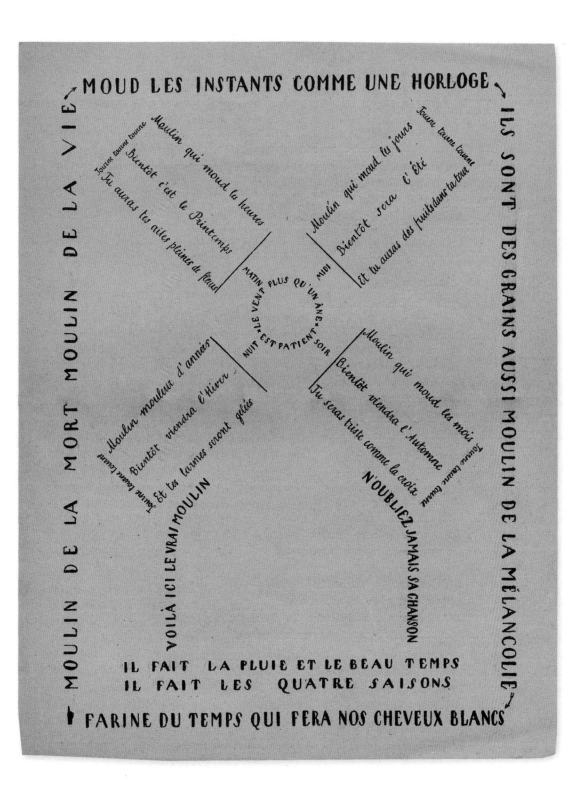

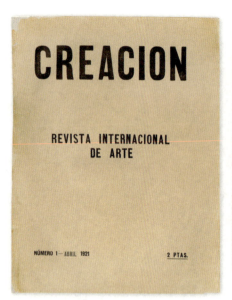 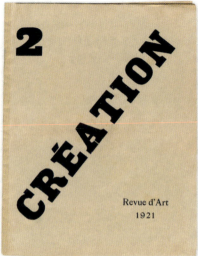 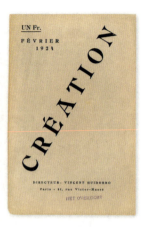

Dadaism), between the years 1921 and 1924 three issues saw the light of day.

If Huidobro had a Symbolist past during which, still in Santiago de Chile, he was tempted to compose poems in the form of pagodas or other shapes, i.e. what were not yet known as caligrammes, then so did his future Uruguayan friend Joaquín Torres-García, who in the *fin-de-siècle* Barcelona circles of Els Quatre Gats had experimented with Symbolism and would go on to become one of the leading figures of Eugenio d'Ors's Noucentisme. This is the context in which he published his first theoretical book, *Notes sobre art* (1913), printed in Girona by Masó. The book is beautifully illustrated with woodcuts by Torres-García himself, and one made by his wife Manolita Piña. He would subsequently break with Classicism, work side by side with his fellow countryman Rafael Barradas, and become friends with Catalan poet Joan Salvat-Papasseit as hinted at in the cover of the 1917 second edition of *El descubrimiento de sí mismo: Cartas a Julio que tratan de cosas muy importantes para los artistas*, also printed by Masó. The sober interior has neither illustrations nor any typographical interest; the cover, on the other hand, depicting a clock and a city, can be associated with the work *Hoy* (1918) in the permanent collection of the Institut Valencià d'Art Modern (IVAM) showing a support for a calendar pad, reveals the artist's belonging to the avant-garde.

Poemes en ondes hertzianes (1919) is a prodigious work, the highest expression of the dialog between Salvat-Papasseit, the most significant Catalan avant-garde poet, Torres-García, and his colleague and fellow Uruguayan Rafael Barradas, also based in Barcelona at the time. While in this seminal volume Barradas is only represented by a reproduction of his portrait of the poet, Torres is the author of an urban, Vibrationist cover and illustrations of the port, the railway station with trains entering and leaving, the railway maps of Switzerland and northern Italy, and the telegraph posts that are also evocative of Europe, all encompassed in an atmosphere that recalls that of Huidobro's *Hallali*.

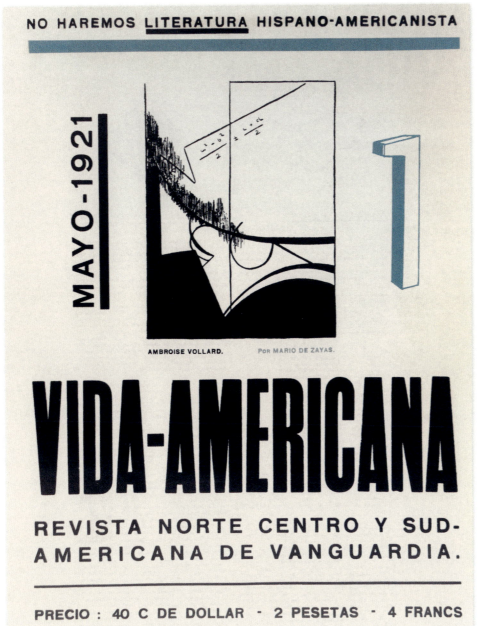

Illustration by Marius de Zayas for *Vida americana. Revista Norte Centro y Sud-Americana de Vanguardia*, no. 1, May 1921. Art director: David Alfaro Siquieros, Barcelona. J. Horta, 28.5 x 22.3 cm. Institut Valencià d'Art Modern, Valencia

←

Creación. Revista internacional de arte, no. 1, April 1921. Editor: Vicente Huidobro, Madrid. Jesús López. 35.5 x 27.7 cm. Archivo Lafuente

Création. Revue d'Art, no. 2, November 1921. Editor: Vincent Huidobro, Paris. Union, 31.8 x 24.5 cm. Archivo Lafuente

Création, not numbered [no. 3?], February 1924. Editor: Vincent Huidobro, Paris. Union, 24.5 x 16 cm. Archivo Lafuente

Rafael Barradas and Norah Borges for Guillermo de Torre: *Manifiesto Ultraísta Vertical*, Madrid. G. Hernández y Galo Sáez, 1920. 44.8 x 28 cm. MJM Collection, Madrid

MANIFIESTO ULTRAISTA
POR GUILLERMO DE TORRE

VERTICAL

PERSPECTIVA MERIDIANA

Un Sol tentacular irradia luminosos reóforos vibrátiles a través del multiedrismo cósmico.

Dardeantes rayos térmicos que rasgan el Orto Novidimensional Estético, vivifican las fibras sensoriales e intelectivas de los Lucíferos Ultraístas.

¡Y una polarización triunfal de impulsos dinámicos hipervitalistas, acelera la hélice de nuestras inquietudes pugnaces!

ÍNDICE DE SENSACIONES, VISIONES Y CEREBRACIONES :: ::

VERTICAL: De Cenit a Nadir: Un luminoso rayo perpendicular incide las novísimas regiones estéticas: Y la rosa polipétala aflorada en la más alta cima tórrida se destríe en llamaradas sintéticas:

Dirección lírica — *Curvatura crítica*

¡Palabras incendiarias!
¡Muecas burlescas!
¡Intenciones nihilistas!
¡Gestos rebeliosos!
¡ ESPASMOS HIPERESPACIALES !
Trayectorias espiralizantes en los agros zodiacales.
Introspecciones mayéuticas.
Raras cerebraciones hiperconscientes.
¡Mis miradas perforan la región del cuarto espacio!
Iluminación roentgénica de los cerebros porveniristas.
Sístoles superátricos.
Circunvoluciones arácnidas.
Acrobacias líricas.
Descoyuntación tipográfica: Las linotipias sufren un ataque de histeria: rrzjlmdlkaaaboccctttpzzevssasfff.
Vertebración atlántica de las figuras y los paisajes fundidos en una compenetración espacial de los volúmenes flotantes.
Ritmizaciones geométricas.
El séptuplo corazón de la hélice vibra al ritmo ortal.
¡Impetus ascensionales do Psiquis velivolante!
Y un arco-iris heptacorde musicaliza la armonía enespacial.
Los ríos sangran fuego.
En el paisaje contorsionado fluye la hemorragia solar.
Dehiscencia del vertículo heptacromista.
Meridio plenisolar.
Y, ante los ojos resurrectos, un fragante PANORAMA ULTRAESPACIAL.

:: SÍNTESIS PANORÁMICA

APOTEOSIS DE HOY: Vibración concéntrica del momento poliédrico, al ritmo de las hélices cosmogónicas.

En el vórtice de nuestro instante ultráico, se plasma una hipervitalista apoteosis antiliteraria de las cerebraciones maquinísticas, los orgasmos aviónicos y los paroxismos líricamente centrífugos...

¿Cómo vislumbramos la síntesis afranjada de esta hora multiédrica, polirrítmica y multánime? Yuxtaposición policromática de las perspectivas intermundiales. Escuchad la polifonía intraocénica en los auriculares telefónicos. El Hombre Vertical se despliega alado abrazando los continentes. Los vocablos truncados, se abaten velivolantes sobre las antenas radiotelegráficas. Albatros e hidroaviones logarítmizan la pizarra marina, y planean sobre los faros del oleaje astral. Los corazones aterrizan en un periscopio emergente.

Panorama multitudinario de las ciudades contorsionadas en su mecanicismo eufóricamente veloz. ¡Oh, los gestos luminosos de los carteles formados por bujías astrales en el horizonte nocturno! Y en el aire, el grito virgen de los trolleys—que dice un cantor fraterno de la profundidad sinfrónica.

Circuitos perihélicos: Viajes en la planitud pura del espacio isótropo: Anhelos antropocéntricos: Vibracionismo de los colores impolutos y de las palabras abstractas: Hay un ciclón sensual en el cráter erótico: Exaltaciones pláticas: Los sexos subvertidos deambulan insurrectos: Y las visiones leticias se transforman tras las introyecciones metafóricas.

Un friso de núbilos coritas se sumerge en el lago de su espejo lés-

SIMULTANEISMO NUNISTA

bico. Feminas cygneas, en la ribera nostálgica, punzan su endocardio, abluciónandose en sangre sentimental. En el museo hay un cuadro anacrónico: campesinos de égloga exprimen la ubre de un sol que transmonta vesperal. En el estadio: adolescentes púgiles cultivan su musculatura mental al pasear a través de un laberinto ideológico y yerbalizar abstractamente.

Los expectadores son arrollados por las calles que desfilan cinemáticas. Sinfonía motorística de las sirenas y klaxons en las avenidas arteriales. Itinerario noviespacial del paisaje al volante de un 60 HP. Hay billetes de circunvalación lunaria, tarifa especial, para los poetas delicuescentes. Anuncio: «Se ofrece un gran stock de figuras orientalistas decorativas—Schahrazadas, Salomés, Judiths—como señoritas de compañía en los paseos lésbicos de morfinómanas irredimibles.»

Pesquisas nouménicas en los laboratorios de radioactividad. Y en contraste, precipitados alquímicos en las páginas de libros noviestructurales: Ved aquí un puzzle de las arduas y dinámicas alegorías occidentalistas: Kaleidoscopio imaginativo del complexo noviespacial: Mi manifiesto traza cabriolas caprichosas en el éter abstracto, rehuyendo las citas matemáticas, y dibuja una espiral de alucinaciones sugerentes. Ritmos plurales acompasan los instintos nómadas. Y la urgencia innovadora justifica la erección vertical.

:: :: ACTITUD VERTICALISTA

Tras la bélica convulsión europea, en el panorama ideológico, artístico y literario del Occidente resurrecto, se ha iniciado una transmutación vertebral: El gran error, tendido como una noche opaca—preñada de sangre—entre los años 1914-18—, ha abortado una generación juvenil e innovadora que polariza sus nihilismos burlescos paradójicamente simultáneos a sus esfuerzos reconstructores o renascentistas. Y, en el orden ético y estético, destruye las viejas y topificadas «ideas-madres», los crasos «conceptos fundamentales», generadores de falsedades y aberraciones mortíferas —cuyo reciente ejemplo sangra aún. Allende las fronteras capturadas, al derrocar burlescamente las normas vigentes, y sentirse recién nacida ideológicamente, e ingrávida en el espacio, la nueva generación ultraísta ha ascendido a un medio día luminoso, pluralmente henchido de inéditas y sugerentes perspectivas mentales.

En la nueva planimetría estética, de un área ultradimensional y de una altitud hiperbórea, fruitece un meridio plenisolar verticalmente simbólico. Los electrodos—aniones y cationes—del voltaico globo solar suscitan un luminoso circuito porvenirista, rompiendo el brumario caótico. Electrolisis lírica. En los búcaros aéreos, que contienen los nepenthes atmosféricos, fluye una potente endósmosis que galvaniza la caquexia petálea de las rosas astrales. Y vigoriza la musculatura de los pugilistas polémicos.

En la plenamar celeste del intenso azul cedrújulo, un apolíneo sol de Occidente irisa y refracta el aleteo tornátil de los espíritus aviónicos. Bajo la bautismal aspersión multánime nuestros ojos-antorchas de lucíferos ultraístas perforan e iluminan las inéditas perspectivas verticales. Fluye un «simoun» que vaporiza atmosféricamente las bellezas ortalas. (Todo, protagonistas y ambiente, recíprocamente interpenetrados, vibran erectos en un escorzo avanzativo) En el laboratorio cerebral ultraísta, se efectúa un precipitado barroco de emociones y sensaciones vorticistas. Nuestros músculos discobólicos adquieren una tensión eléctrica de infinitos watios. Y se extienden, en un ademán pugnaz, hacia los horizontes dinámicos de un área enespacial.

IDEARIO ESTÉTICO

Mis concepciones estéticas ultraístas están situadas, y logran su más perfecta proyección, en la planimetría noviespacial, en la región del Espacio Absoluto: En cuyos dinteles resalta sugeridoramente el enorme geométrico de la cuarta dimensión: Y se abren las perspectivas ilimitadas del Hiperespacio, donde se desarrolla la introspección espiritual y la mayéutica crítica de las novísimas direcciones estéticas.

Los apotegmas cubistas—en el sector literario—de la pura sensa-

ción integral, más allá de su realidad objetiva, auguran un Arte de creación abstracta. Y ya las primeras poematizaciones creacionistas han plasmado el ansia de retorno sensorial hacia un primitivismo recreador que descubre emociones impolutas y paisajes noviespaciales.

Y he aquí la actitud hiperconsciente, sinfrónica y vertical del nuevo lírico: Desde su atalaya anténica, el Poeta oye rimar sus diástoles líricas con las vibrátiles hélices cosmogónicas. Al desgajarse totalmente de las sombras pretéritas, en un viril impulso superador, se ha desprendido de toda secuencia anacrónica y toda superstición ritualista, deviniendo libre, incontaminado y ortal. Su manumisión y desnudez le coloca en un estado de amnésico candor mental y de purificación óptica ingenuista, que le hace afrontar todos los panoramas con una sensibilidad dehiscente, extrayendo de su dintorno nuevos módulos de belleza intraobjetiva. Pues hastiado del eterno espectáculo, que al reflejarse en los lisos espejos literarios, ofrece el orbe marchito, el nuevo lírico perfora vías aferentes de insólitas perspectivas enespaciales. Y este anhelo es simultáneamente unánime. Así, en todos los poetas contemporáneos de vanguardia, sinfrónicamente enlazados por idearios consanguíneos, surge, como el vértice más cardinalmente buído de sus cerebraciones superatrices el anhelo divino o demiúrgico de crear líricamente un orbe de imágenes o representaciones impolutas. O sea, vivificar, re-crear intraobjetivamente — al fundirse en el crisol lírico sus emotivos subjetivismos abstractos con las concreciones externas—los elementos nucleales del Kosmos, para componer una nueva totalidad frutal estética.

De ahí la actitud ingenuista ante la anhelada revivicencia de la poma cósmica, que adoptan los novísimos poetas, deseando captar módulos primigenios. Y en el espasmo augural, el lírico abre los ojos extasiado ante la naturaleza taumatúrgicamente transmutada, y ante la vida henchida de matices, ritmos y sugerencias insólitas a través de sus imágenes polipétalas. Tras los arcos-iris augurales surgen las perspectivas inmaculadas, frescas del rocío sensorial. Todo adquiere, ante sus miradas noviespaciales, un ritmo dehiscente, un miraje ortal y una gracia alboreante. ¡Lírica hora creatriz y demiúrgica!

En sus minutos, el poeta ultraísta lanza su evohé augural con palabras fragantes, y poseso del espasmo nunista, imbibido de la nueva belleza en torno, va dibujando inconexamente, en rasgos expresionistas, sus rápidas percepciones, con un lenguaje límpido y barnizado de metáforas audaces e imágenes noviestructurales: En cuadros esquemáticos que vibran simultáneamente, por la superposición de planos visuales y múltiples sensaciones centrípetas. La imagen — protoplasma primordial del nuevo substratum lírico - se desdobla y se amplía hasta el infinito en los poemas creados de la modalidad ultráica. El poeta aspira a construir un orbe distinto en cada poema, sintetizando en él la esencia depurada del lirismo enespacial.

:: INNOVACIONES Y SUBVERSIONES :

En nuestro plano ultraísta, ya han surgido inicialmente los síndromes frutales de estas teorizaciones innovadoras, con sus secolios subversivos. Los aristos críticos de vanguardia afirman su intención de rectificar, previamente, los errores sensoriales e intelectivos, para modificar las estructuras pictóricas y líricas, y construir nuevos módulos auténticos de Belleza si espacial.

Todas las pugnaces corrientes estéticas de vanguardia abocan hoy al mismo lema unificador: Creación. El Arte Nuevo apellídase *ultraísta, creacionista, cubista, futurista, expresionista*, comienza allí donde acaba la copia o traducción de la realidad aparente: allí, en aquel plano ultraespacial donde el poeta forja obras inauditas y creadas que no admiten confrontación exterior objetiva.

Bajo la influencia cósmica del subversivo nihilismo mental, las raigambres primievas y las frondas milenarias, han estremecido en un volcánico paroxismo de estratos removidos. Todo se desarticula y aparece inconexo, como en la apoteosis deslumbrante de un Caos o de una nueva Creación. Han girado los conmutadores lumínicos de la vetustofobia nihilista y del filoneísmo ultráico. Los alaridos antiliterarios del anthropopiteco resurrecto —encarnado en cualquier poeta dadaísta— desvastan los recintos musoleales y truncan los iconos dormidos. Y una gavilla de relámpagos verbales ilumina las rutas exaéricas, donde los púgiles poetas adámicos viven la vitalidad de cada instante cultivando la antifilosofía de sus acrobacias espontáneas.

:: ULTRAÍSMO ABSTRACTO ::

¡Barroquismo!, ¡Verticalismo!, ¡Vorticismo! Ultra: Vértice de fusión e irradiación donde convergen y se ramifican todas las intenciones superatrices que propulsan los aristos vanguardistas.

Ved la perspectiva sintética de una trayectoria rebasadora: Los poetas ultraístas, tremantes en el espasmo nunista y poseídos de la emoción intelectual sinfrónica, propendemos a la integración literaria del hoy y a la descomposición electrolítica de sus nuevos elementos peculiarizantes: A la ritmización multánime del latido renacentista: De las sístoles maquinísticas: De las velocidades vitales: De las ascensiones eróticas: Del vibracionismo cinemático: Del hambre hiperespacial: De las proyecciones ultravioletas: Y del aviónico vértigo intelectual.

Hoy el Hombre se siente elevado —sin perder su categoría humana, y venciendo el espejismo hipnótico de Zarathustra —a su enésima potencialidad energética. Nuestras vidas polifacéticas aceleran la vibración polirrítmica del ideario ultraico. Y ebrios por el vapor del dinamismo accional, fundimos en nuestro cerebro los elementos exteriores con las más íntimas inquietudes espirituales. ¡Nueva yuxtaposición de sensaciones disímiles que suscita el dualismo intelectivo-sensacional! De ahí nuestro apasionamiento por la literatura tentacular, que refleja o crea los henchidos panoramas dinámicos, prolongando el circuito hiper vitalista de las horas palpitantes.

:: PIROTECNIA TEÓRICA ::

Nunismo: ¡Exaltemos triunfalmente la vibración simultaneísta del momento! ¡Gocemos los elementos genuinamente de hoy! ¡La esencia del minuto fugitivo es mía, no ha sido de mis antepasados ni será de mis descendientes, y por su sincera calidad atmosférica perdurará, aun en la mutabilidad deveniente, un valor de perennidad!

Los luciferos ultraístas, los «pionniers» de avanzada, perforamos las inéditas perspectivas devanando itinerarios abstractos. En nuestro vértice equidistante desembocan las angulares corrientes estéticas de vanguardia. Comulgamos básicamente con el ideario futurista, que asimilamos al nuestro como elemento primordial de toda modernidad consciente, innovadora e iconoclasta. Usamos de la imaginación sin hilos y de las palabras en libertad. Participamos de las normas cubistas al iluminar sus perspectivas exaédricas, y situar la imagen en el espacio según la yuxtaposición y compenetración de planos. Y junto al *film* cinematográfico norteamericano, gran inyección vivificante, por el frenesí de sus hazañas musculares y mentales, amamos la intención de retorno hacia las primitivas estructuras y el orgasmo barroco, que implica toda esa estatuaria subconsciente, acerba e impar del Arte negro. De las derivaciones del cubismo literario hemos extraído la imagen creacionista, como célula primordial del novísimo organismo lírico. Nuestra irreverencia burlesca ante los «valores prestigiosos» y nuestra incredulidad heresiarca, mas el ímpetu disolvente y arrollador del *Ultra*, nos identifica parcialmente con la gesta Dadá. No obstante, resalta nuestra disimilitud al popularse una superación literaria jocundamente afirmativa. Pues los ultraístas debemos exaltar jubilosamente las calidades pragmáticas del mundo occidental. En nuestro anhelo de un arte abstracto, exultante, dinámico, potencial e inmáculo, hemos borrado el último coeficiente de melancolía romántica que disminuía el valor de nuestra ecuación vital, deviniendo estatuariamente apolíneos y dionysíacamente optimistas. Así, hoy nuestra actitud vertical se acompasa con las orquestas negras y las polifonías motorísticas.

Hay una metamorfosis de símbolos. Psiquis, mariposa, deviene aviadora. Laoconte se desenlaza las sierpes de sus barrocas ideaciones. Y Ariadna marca con un hilo la brújula del laberinto ultraespacial.

VERTICAL: He ahí mi actitud literaria peculiarmente ultraísta:

V E R T I C A L

VERTICAL. He ahí el erecto símbolo y la antena radiotelegráfica que irradia verbalismos sintéticos y conmociones de última hora: VERTICAL. He ahí la línea del meridiano estético que regula el horario de los intelectuales avanzados.

Jóvenes poetas: camaradas: erguíos verticalmente, fírmemente erectos como antenas señeras a bordo del trasatlántico juvenil en el océano ultraico. ¿No percibís ya una metarrytmización lírica y cómo nuestro proyector irradia hasta la región hiperespacial henchida de gases innovadores a una presión sideral?

VERTICAL: Actitud ultraísta: Antena polar: Poma astral: Y velivolantes, en torno a la abstracción polifacética, una escuadrilla aviónica de espíritus porveniristas que exultan impávidos en su tangencialidad solar.

GUILLERMO DE TORRE.

Madrid, noviembre, 1920.

Efigie del autor, por Barradas, y «bois» ornamentales de Norah Borges.

Para el envío particular de VERTICAL: Paseo de San Vicente, 22, 1.°
Depósito y venta: **Librería Yagües, Caballero de Gracia, 28. — MADRID**

Cover by Rafael Barradas for *Ultra: poesía, crítica, arte*, year 1, no. 19, December 1921. Madrid. Establecimiento Tipográfico La Mañana, 33.2 x 25.5 cm. Library of the Gerardo Diego Foundation. Santander

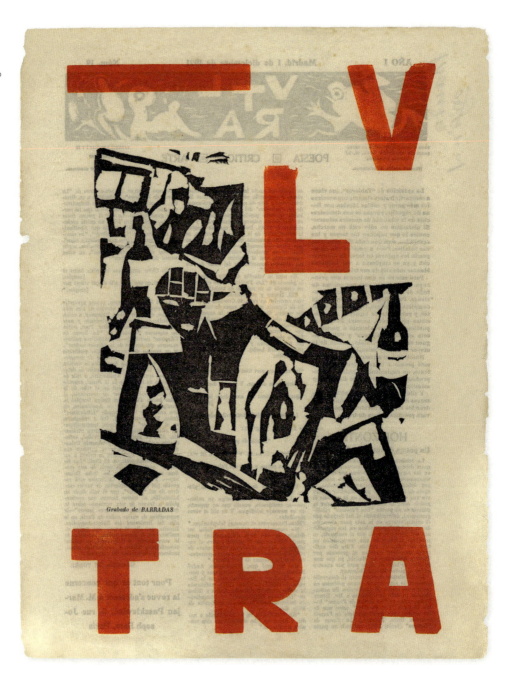

We are obliged to associate this book by Salvat-Papasseit and his journals (*Un Enemic del Poble*, *Arc Voltaic*, and *Proa*) with the only published issue of Barcelona's *Vida-Americana* (1921), "north, central and south American avant-garde review" edited by Mexican David Alfaro Siqueiros, then Mexican consul in the Catalan capital. Reproduced on its cover is Marius de Zayas's abstract caricature of Ambroise Vollard, and inside we discover those of Apollinaire and Picabia, all taken from *Les Soirées de Paris*. Other authors included in the publication are Barradas, Salvat-Papasseit himself, Torres-García, and Tomás Garcés, and the texts reproduced are by Darius Milhaud, Ozenfant, and Alan Seeger, among other authors. The journal is remembered above all for having published the Latin American manifestos drawn up by its editor, yet we should not forget that its context is mainly that of Europe and Barcelona, under the sign of the Barradas, Salvat-Papasseit, and Torres-García triad, a fact long overlooked.

Established in Madrid in 1918, Barradas was one of the chief graphic collaborators of comedy writer and theatrical impresario Gregorio Martínez Sierra. Of all the books he produced for the latter, *La feria de Neuilly* is held to be the best, a 1920 re-edition of a volume by Martínez Sierra himself, first published in 1910 by Garnier in Paris and delicately illustrated by Xavier Gosé. The cover of the 1920 volume, presumably by Manuel Fontanals, is flowery and not too inspired. The illustrations, on the other hand, combining black, green, and orange, are lively, Vibrationist, and evoke the city of light.

When all is said and done, Barradas's presence in Ultraist journals was much more important. *Grecia*, *Perseo*, *Reflector*, *Tableros* and *Ultra* were among those that turned to him for illustrations, and in some cases for cover designs. In *Grecia*, Barradas and Norah Borges contributed to the illustration of the *Manifiesto Vertical* (1920) by Guillermo de Torre, that appeared as a supplement (in actual fact as a sort of poster, characterized by being printed on both sides) to issue number 50, the last to be published. In other respects, up until his untimely death, Barradas was artistic director of *Alfar* in Corunna, the literary editor of which was Julio J. Casal, the Uruguayan poet whose work spanned from Modernism to a very moderate avant-garde and who would subsequently transfer his publication to Montevideo. At the Gran Café Social y de Oriente on Madrid's Calle de Atocha, practically on the corner with the square, Barradas was the center of the literary gatherings known as that of "the Alfareros," after the name of the journal. His graphic contributions to *Alfar* and the Ultraist reviews would be followed by others in Spanish publications such as *La Gaceta Literaria*, *Hèlix* in Vilafranca del Penedès, *Papel de Aleluyas* in Huelva, and *Ronsel* in Lugo.

Indeed, *Ronsel* and *Alfar* published literary works by Argentine poet Francisco Luis Bernárdez, of Galician descent, who in the early 1920s was living in Vigo. Bernárdez's first book, *Orto* (1922), was halfway between late-Modernism and Portuguese Saudosismo. Its cover design was by Pontevedra artist Manuel Méndez, and its frontispiece bore a poor reproduction of one of Barradas's classical linear portraits. The convergence of the Uruguayan artist and Méndez, and Xavier Bóveda and Eugenio Montes, to whom the book was dedicated, reveal its connections with Ultraism. The second book, *Bazar* (1922), is worth a mention because of its fine content (much more modern than his first book), its preface by Ramón Gómez de la Serna, and its lively illustrations and spectacular cover with a two-colored plate attached (that is often missing, as in the case of the copy in the National Library of Spain) by Barradas, who revisits motifs from his painting of the period, filled with bazaars, cardboard gee-gees, and price signs like the "65" on the cover (which in other cases is complete, "0.65"). As regards his third and last

book of poems, *Kindergarten* (1923), its emphatic three-colored cover (three primary colors) and amusing illustrations are by Cándido Fernández Mazas, a painter and poet from Ourense who is also the author of the caricature of the poet printed at the time on his stationery.

Apropos bazaars, we should recall that as a member of the Pombian literary gatherings, Barradas collaborated with Gómez de la Serna illustrating three of his children's stories, one of which was titled *En el bazar más suntuoso del mundo* (1924). Four years later, Ramonian, i.e. avant-garde, cartoonist and future Falangist Samuel Ros sketched yet another *Bazar*, with a wonderful cover by Tono.

While in *La sombrilla japonesa* (1924) Barradas merely made a linear portrait of its author, Isaac del Vando Villar, editor of *Grecia*, his cover for *Hélices* (1923), the only book of poems by Guillermo de Torre, was a great contribution to a volume that featured illustrations by two other painters—Daniel Vázquez Díaz rendered his portrait and Norah Borges his ex libris.

Carlos María de Vallejo, a wandering Uruguayan poet with a previous body of work of another kind (quite dispensable), produced quite a fine avant-garde book, *Disco de señales* (1929) that was published in Cadiz where he was the Uruguayan consul and where he launched *Renovación*. The book's cover has a drawing by Barradas, although we have recently learned of the existence of another version by one Hidalgo we are unable to situate. His next book of poems, *Los maderos de San Juan* (1932), also produced in Cádiz by the publishing house associated with the journal *Isla*, featured a cover and illustrations by Melchor Méndez Magariños, a Galician painter who had made a name for himself in the Uruguayan art scene, and musical illustrations by Uruguayan composer Luis Cluzeau Moreau. The book was republished two years later in Valencia, with the same foot as *Isla* and a few changes, such as a different cover by the same artist and the inclusion of a recent oil portrait of him by Valencian painter Genaro Lahuerta.

To return to Paris, that was where the first Argentine avant-garde book appeared, *Veinte poemas para ser leídos en el tranvía* (1922) by Oliverio Girondo. A large-format volume with a wide typography, the book was illustrated by the author himself with dazzling pochoirs, such as the outstanding image of a Parisian lamp post, that of sailors from Brittany, and a postcard from Rio de Janeiro. Valery Larbaud, who was so attentive to the new Hispanic values, was thrilled by this book and couldn't avoid recognizing in his new (and rich) Argentine friend a spiritual brother of Barnabooth's, as observed by the Argentine author in the copy he dedicated to him and is preserved in his superb library that now forms a part of the local multimedia library named after him, "To Valery Larbaud, good friend of A. O. Barnabooth's." Girondo's second collection of poems, *Calcomanías* (1925), published in Madrid, featured only two illustrations—a train coach on the front cover and a Flamenco tavern on the back cover. In Paris, the Argentine also visited Jules Supervielle and the Uruguayan painter and writer Pedro Figari, among others. In Madrid, his best friend was Gómez de la Serna.

The eccentric Argentine author whose pen-name was Viscount Lascano Tegui (another of his disguises was "Rubén Darío, son") and frequented Montparnasse, Alfonso Reyes and Gómez de la Serna, is renown, above all, for a book of erotically-charged dense prose, in the style of Paul Léautaud, *De la elegancia mientras se duerme* (1925), illustrated by his fellow countryman Raúl Monsegur, another friend of Girondo's and Figari's. This book, halfway between Symbolism and the avant-garde, like its illustrations, was translated into French by Francis de Miomandre in 1930.

The painter and poet Vicente do Rego Monteiro, from north-east Brazil, one of the most prominent figures in that country's great

generation of Modernist artists, also spent part of the 1920s in Paris. His first graphic design there was the illustration of *Légendes, croyances et talismans des indiens de l'Amazone* (1923), a volume compiled by P. L. Duchartre that can be described as an exaltation of Amazonia and published by the great Alfred Tolmer. Even more superb is *Quelques visages de Paris* (1925), a presumed literary and graphic testimony of the journey made by an Amazonian Indian to the French capital. The book was printed by Juan Durà, a Spanish anarchist who published the anti-Primo de Rivera works by Vicente Blasco Ibáñez, Eduardo Ortega y Gasset, and Unamuno. Mention must be made, too, of the red and black cover and linear illustrations the Brazilian artist made for a frivolous book, *Montmartre en 1925* (1925), by Jean Gravigny. In the postwar period, Rego Monteiro would return to Paris, where he would devote himself to his poetic publishing house, La Presse à Bras.

Feuilles de route: I. Le Formose (1924) was the first volume of an announced five-volume project by Blaise Cendrars on his discovery of Brazil, that would prove so decisive for the

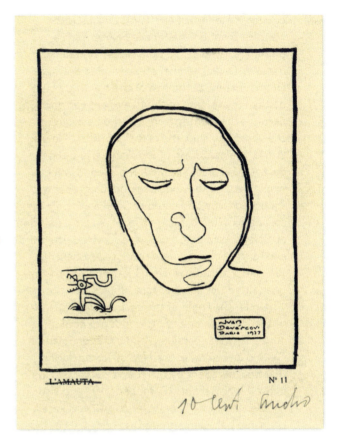

Inner page by Juan Devéscovi for *Juan Devéscovi, Xavier Abril de Vivero* (exh. cat.), Paris. Association Paris – Amérique Latine, 1927. 15.5 x 12 cm. José Carlos Mariátegui Archive, Lima

country's Modernist artists. As an illustrator, we must mention the female painter Tarsila do Amaral (who at the time simply signed her name as Tarsila) and her stenographic drawings. Unfortunately, at the end of the day this would be the only volume of the five to appear, and narrates the journey from Paris to Le Havre, the voyage by ship, the first signs of the New World, the confusion of Rio, Santos, and the Santos – São Paulo railway. The second volume would certainly have been astounding, as it was supposed to be dedicated to São Paulo; only the six poems in the catalog of Tarsila's solo exhibition at Galerie Percier in 1926 have survived. The third and fourth volumes were supposed to describe Rio, and *a fazenda*, while the last one was to have been titled *Des hommes sont venus*.

Under the angle of the cosmopolitanism of the 1920s, in one of his wonderful books Jorge Schwartz parallelly studied Girondo and Oswald de Andrade, husband of Tarsila during that decade, spent by the couple in Paris. Oswald himself is also slightly Barnaboothian, and also had dealings with "Don Valerio." Au Sans Pareil, the same publishing house that released *Feuilles de route* would publish Oswald de Andrade's *Pau Brasil* the following year, and in the same format as *Feuilles de route*. *Pau Brasil* was the Brazilian author's first book of poems and also included Tarsilian stenographic drawings in a new and masterly combination of verse and line.

One genre we must needs mention in this survey is that of caricaturists' albums. I have already cited the one by Georges de Zayas, and would now like to draw attention to three Latin American cartoonists who during the 1920s lived and published in Paris: Chilean Oscar Fabrès, Cuban Armando Maribona, and Salvadoran Toño Salazar.

Oscar Fabrès (he always used this accent, a Parisian legacy) has been largely forgotten and yet his career in Santiago de Chile, Paris and then in Amsterdam and New York and, above all, the quality of his work, seem to call for us to rediscover him. In his homeland he is remembered as the most regular illustrators of the page titled "La Nación en París" [The Nation in Paris] edited by Juan Emar in the Santiago newspaper *La Nación*. Here is a tentative list of the books he illustrated, usually in the pochoir technique, in the Paris of the happy twenties: *Fumets et fumées* (1925), by Francis de Miomandre; *À Travers Paris* (1925), by *fantaisiste* poet Tristan Derème; *Quartier reservé* (1926), by Eugène Marsan; *Devoirs de vacances* (1927), by Jehanne Tamin, prefaced by abovementioned Derème; *Longchamp* (1928), with a preface by Foujita; and *Montparnasse : Bars, cafés, dancings* (1929), by André Salmon. We have no publishing details about the album concerning Longchamp and its horse-racing, but we do know that *Montparnasse* was published by Éditions Bonamour. The other titles were released by the publishing house associated with *Le Divan*, journal on which the author worked as an illustrator. We should also mention his 1924 exhibition at Galerie du Mont-Thabor, *Les fiacres*, a title that reminds us of Constantin Guys. One album that was never published, although its original sketch has survived to our days is *La vie fantaisiste d'un barman de Montparnasse en six dessins et un poker dice* (1930). There are coincidences between Fabrès's work, characterized by its delicacy and clear lines, and those of Chas-Laborde (born in Buenos Aires, by the way), Daragnès, Dignimont, Pierre Falké and other French artists of the period.

I digress here to mention Chilean painter Luis Vargas Rosas, another contributor to the Parisian pages in *La Nación* newspaper. Lucho Vargas, as he was familiarly known, illustrated two books by Agustín Edwards published in London, *Peoples of Old* (1929) and *The Dawn: Being the History of the Birth and the Consolidation of the Republic of Chile* (1931) in Symbolist fashion. Later on, as a partner in *Abstraction-Création*, he explored organic

geometry and would work with Stanley William Hayter at Atelier 17, where *Fraternity* (1937) was printed, a chalcographic album produced in solidarity with the Spanish Republic at war and which included one of his copper engravings (besides others by Hayter himself, Joseph Hecht, Gladys Dalla Husband, Kandinsky, Roderick F. Mead, Miró, Dolf Rieser, etc.). That same year, he collaborated on the installation of the Spanish pavilion at the Parisian International Exhibition.

To return to cartoonists, we must refer to the small masterpiece by Armando Maribona *Decapitados* (1926), both its title and its laconic cover—a guillotine silhouetted in red—that combines the caricatures announced in its subtitle and their glosses by a series of Latin American writers based in Paris, including Miguel Ángel Asturias, Ventura García Calderón, José Mª González de Mendoza (alias "el Abate Mendoza"), and Tomás Hernández Franco, Lascano-Tegui, León Pacheco, Alfonso Reyes, César Vallejo and Gonzalo Zaldumbide. With the exception of Hernández Franco, they were all among the *decapitados* [the beheaded], besides Cardoza y Aragón, Enrique Gómez Carrillo, Alfonso Hernández Catá, Francis de Miomandre, Toño Salazar, and many more, including the Italian Pirandello and Spaniards like Baroja, Blasco Ibáñez, José Francés, Unamuno and Valle-Inclán, etc.

Of the three Latin American cartoonists in Paris, Toño Salazar was the most modern, as previously revealed by his striking multicolored cover for *Luna Park* (1924) by Guatemalan Luis Cardoza y Aragón. The cover of the album titled *Caricatures* (1930), prefaced by Kees van Dongen, on the other hand, was extremely conventional, not at all up to the standards of its contents: portrayals of Bourdelle, Cendrars, Claudel, Colette, Fargue, Gide, Joyce, Kiki de Montparnasse, Moïse Kisling, Larbaud, Marie Laurencin, Pierre Mac Orlan, Maeterlinck, Henri Matisse, André Maurois, Miomandre, Picasso, Paul Poiret, Henri de Régnier, Salmon, Stravinsky, Van Dongen himself, and José Vasconcelos, among others. Only one of those portrayed appeared in Maribona's work—the figure of Miomandre. After his period in Paris would come his years in New York, Buenos Aires and Montevideo, followed by his return to home.

Toño Salazar is the author of the shrewd portrait of Costa Rican Max Jiménez that appears in the frontispiece of the latter's first book of poems, *Gleba* (1929), whereas the frontispiece portrait of his second book, *Sonaja*, published in Madrid in 1930, was by Maribona. The covers of both volumes are decorated with calligraphy, presumably by the Costa Rican poet, sculptor, painter and engraver who led a nomadic, turbulent life.

Dominican artist Jaime Colson also deserves more international recognition than he has so far received. In the context we are examining today, we must call attention to his forceful cover and illustrations for the book of texts in prose by his fellow countryman Tomás Hernández Franco, *El hombre que había perdido su eje* (1926). That same year he took part in a group show of works by Latin American artists held at Cabinet Maldoror in Brussels, alongside the Mexicanized Spaniard Santos Balmori, Chilean Isaías Cabezón, and Peruvian César Moro, and the following year his work was included in a show along with Moro the Association Paris-Amérique Latine in Paris. Moreover, he was close to Torres-García and Germán Cueto, whom he would see again in Mexico in the 1930s, where he frequented other Stridentists and joined the League of Revolutionary Writers and Artists (LEAR, for its initials in Spanish). Having returned briefly to Paris, in 1939 he was invited to take part in a group show with Cuban artist Mario Carreño and Max Jiménez at the Bernheim-Jeune gallery.

In 1927, Peruvians Xavier Abril and Juan Devéscovi, both of whom contributed to *Amauta*, exhibited together at the same Paris-Amérique

Cover by Marius de Zayas for *291*, no. 1, March 1915.
Editors: Alfred Stieglitz, Marius de Zayas, Paul B. Haviland, Agnes Ernst Meyer, New York, 291.
44 x 26 cm.
Archivo Lafuente

Latine society: the former presented his poems, and the latter his drawings. My first chance to see the small yet rigorous catalog of this show presented itself only recently, when it was included in one of the display cabinets in the exhibition dedicated to *Amauta* and curated by Beverly Adams and Natalia Majluf at Madrid's Reina Sofía museum in 2019.

Viñetas (1927) is the title of a book that is not very well known and that we discovered on occasion of the aforementioned Huidobro show also at the Reina Sofía. Signed "Juan de Armaza," the book is actually by Chilean writer and diplomat Alfonso Bulnes, and its angular and Post-Cubist woodcut illustrations are by his wife, painter and sculptress Marta Villanueva who, years later, under the guise of "Luz de Viana," set out on a literary career as a storyteller. *Viñetas* would be republished, this time without resorting to a pseudonym, in 1942 by La Cruz del Sur, the publishing house run by exiled Spaniard Arturio Soria based in Santiago de Chile, with typography by Mauricio Amster, a Polish Communist graphic designer who worked in Spain under the Second Republic and the Civil War and arrived as a Spanish exile in Chile, his final homeland of choice, aboard the *Winnipeg*.

Argentine painter Héctor Basaldúa is included here for his work on *Los consejos del viejo Vizcacha y de Martín Fierro* (1928), an extract from *Martín Fierro* by José Hernández, with delicate burins illustrated with pochoirs. This beautiful volume, published by the Association of Friends of Art Books (ALA, for its Spanish initials), was prefaced by Eugenio d'Ors, co-founder of the association together with Argentine Adelia de Acevedo. Basaldúa, who would eventually be widely acclaimed as a set designer at the Colón Theater in Buenos Aires, was living at the time in Paris. The impressive book *Ollantay* (1931), a Quechuan drama prefaced by Ventura García Calderón, was also published by ALA and featured colored boxwood prints by Argentine sculptor also resident in Paris, Pablo Curatella Manes. Another important album is *Images du Guatemala* (1927) by Carlos Mérida, with a preface by André Salmon, published by Galerie des Quatre Chemins.

Cuban author Alejo Carpentier led an intense life in Paris during those years, where he published *Poèmes des Antilles* (1929), for which Pierre Thiriot designed a spectacular cover, and which were set to music by Marius-François Gaillard. His first book, *¡Ecue-Yamba-ó!: Historia afro-cubana*, was published in Madrid in 1933 by Juan Negrín's publishing house España, with a cover by two of his fellow countrymen also based in Paris at the time, Federico Tomás Franco (author of the Afro-Cuban vignette, disguised under the initials F. T.), and Marcelo Pogolotti (author of the modern layout, signed with his own initials: M. P.). While we have quite a lot of information about the latter, who wrote a splendid book of memoirs, the documentation on the former is very scarce. Carpentier himself left an important clue as to his activity in one of his columns, *Carteles* of 23 September 1934, where he discusses the posters, score covers, and even cabaret decorations by Franco, which proved decisive for the dissemination of Cuban musical modernity in the French capital, that he himself championed (see p. 372). The Madrid album *15 grabados en madera* (1929) by Mexican Gabriel Fernández Ledesma is impressive. Other Latin American books published in the Spanish capital that deserve a mention for their graphic design are *Leyendas de Guatemala* (1930) by Miguel Ángel Asturias, with a cover and illustrations by Ramón Puyol inspired by Mayan motifs; the monograph by Luis Cardoza y Aragón on his fellow countryman Carlos Mérida that appeared in 1927 published by *La Gaceta Literaria*; *Hélices de huracán y de sol* (1933), a book of poems by Ecuadorian author Gonzalo Escudero, for which Mauricio Amster designed a powerful two-colored cover (see p. 435); and *Viaje a Rusia* and *El tungsteno*, both of 1931, by César Vallejo, the

former with another wonderful cover by Mauricio Amster, and the latter with a cover by Ramón Puyol. This list could, in fact, be much longer, as we could also mention two of the five volumes of stories by Basile translated by Rafael Sánchez Mazas for Ediciones del Árbol publishers run by José Bergamín, *Los tres reyes animales* and *La fábula del ogro*, both illustrated by Chilean Isaías Cabezón ("Isaías C."). Two others were illustrated by José Moreno Villa, and another by Maruja Mallo (under the transparent pseudonym "Mary Mall"). The series was printed by Manuel Altolaguirre. Norah Borges, mentioned earlier when enumerating the Ultraist journals and their graphic designers, spent the years of the Spanish Republic in Madrid. Besides contributing to certain periodical publications and to the *Almanaque literario 1935*—designed by Mauricio Amster, incidentally— in the Spanish capital she illustrated *Júbilo* (1934) by Carmen Conde with linear drawings. *Júbilo* was published in the same Murcian collection titled Sureste, that also released *Perito en lunas* by Miguel Hernández.

* * * * *

American Coda

Like Rivera in Europe, in America the unquestionable forerunner is another Mexican, caricaturist Marius de Zayas. Trained as a Symbolist like many of the early prominent figures in the New York avant-garde, his career has close ties with that of one of its members— the great photographer and dealer Alfred Stieglitz, founder of the Photo Secession movement, the Little Gallery, and two successive reviews, *Camera Work* and *291*. In the former, Zayas published some of his abstract cartoons; in the latter, he displayed his considerable graphic talent creating genuine masterpieces and, at the end of the day, forming an indestructible unity.

A friend from Zayas's childhood and youth, José Juan Tablada, who also trained as a Symbolist, lived in Japan, Paris, Bogotá, and Caracas, where he published his two key books, *Un día* (1919) (see. p. 623) and *Li-Po y otros poemas* (1920) (see pp. 704-705). He spent his mature years in New York, where he ran a bookstore, frequented Zayas (who sketched his portrait for the frontispiece of *Li-Po y otros poemas*). Thanks to Stieglitz (who displayed works by Torres Palomar, another Mexican who lived in New York and was a friend of the poet's and inventor of kalograms), Tablada wrote extraordinary fragmentarist poems on the city, grouped under the title *Intersecciones*, that never appeared in one volume although a project by Miguel Covarrubias to publish *La Babilonia de hierro*, a Manhattan book written by both authors has survived. Tablada was one of the poets (the other was Huidobro) whose work was set to music by Edgar Varèse in *Offrandes* (1927), the cover of which was designed by the Precisionist Niles Spencer. Tablada's only New York publication was *La feria: Poemas mexicanos* (1928), with a delightful pink cover in which Covarrubias imitates traditional perforated paper of the sweet land, inside, we find woodcut vignettes by Mexican artist Matías Santoyo and a drawing by American draftsman George Overbury "Pop" Hart.

In his adoptive country, Miguel Covarrubias, who rubbed shoulders with everyone, from Stieglitz to Hollywood stars, met with stunning success as an illustrator of magazines such as *Vogue*, *Harper's Bazaar*, and *Vanity Fair*. His first two books, *The Prince of Wales and Other Famous Americans* (1925), with a preface by Carl Van Vechten, one of those portrayed in a caricature, and *Negro Drawings* (1927), with texts by fellow cartoonist Ralph Barton and Frank Crowninshield, funnily enough the editor of *Vanity Fair*, are spellbinding, as are *Island of Bali* (1937), with photographs by his wife Rosa Rolando. The Mexican author was also outstanding as an illustrator for a number of books by other writers.

Cover by Diego Rivera for *Fortune*, vol. 5, no. 3, March 1932. Editor: Henry R. Luce, Time Inc. New York. 35.5 x 28.5 cm. Archivo Lafuente

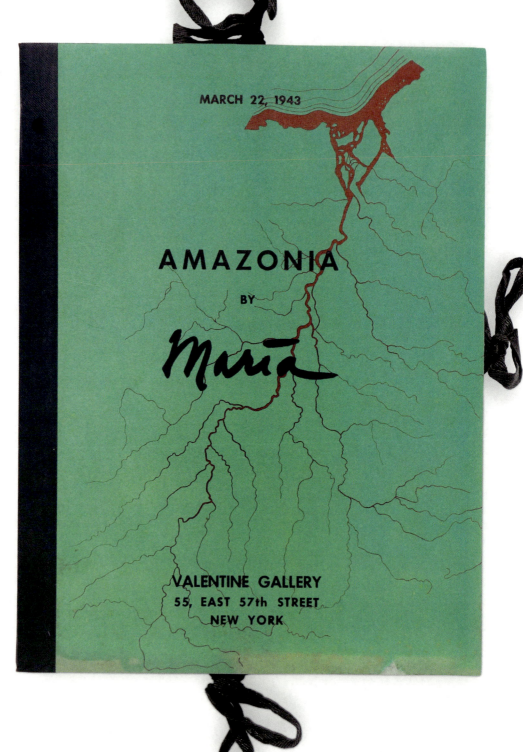

Cover by Maria Martins (author) for *Amazonia*, New York. Valentine Gallery, 1943. 29 × 22.5 cm. Private collection, Granada

Still in the United States, *Urbe* (1924), the "Bolshevist super poem in 5 cantos" by Stridentist Manuel Maples Arce metamorphosed into *Metropolis* (1929), translated into English by John Dos Passos and published with the additament of a very "Stridentopolis" black and white plate colored in some copies by Fernando Leal, a Mexican painter, muralist and engraver who collaborated with the Stridentists and subsequently joined the ¡30-30! group. Another former collaborator of the movement founded by Maples, Mexicanized Frenchman Jean Charlot, would be very active in the American book world.

The vogue for Mexican muralists north of the border was translated into a series of frankly interesting bibliographic works, among which we should mention the translation of *Los de abajo*, by Mariano Azuela: *The Underdogs* (1929), illustrated by José Clemente Orozco, who in 1931 would also illustrate *The Glories of Venues: A Novel of Modern Mexico*, by Susan Smith (who in 1930 published *Made in Mexico*, illustrated by Julio Castellanos), and in 1947 *The Pearl* by John Steinbeck. Yet, who obviously takes the cake is Diego Rivera, leader of the movement. I shan't cite his catalogs or monographs, although I will mention his authorized biography, published by Bertram D. Wolfe in 1939, to highlight the extent of "Riveramania" in the United States. From then on, the books illustrated by the Mexican would appear in rapid succession: *Mexican Maze* (1931,) by Carleton Beals; *Mexico: A Study of Two Americas* (1931), by Stuart Chase; *El indio* (1937; although the book had been translated into English by Anita Brenner, who worked so hard for Mexico, its title was Spanish), by Gregorio López y Fuentes; and *Portrait of Mexico* (1937), by aforementioned Wolfe. To this list we should add his illustration of the English translation of *La tierra del faisán y del venado* by Antonio Mediz Bolio in 1922, clearly destined to be exported to the other side of Río Grande, under the title *The Land of the Pheasant and the Deer: Folksong of the Maya* (1935), with a preface by Ermilo Abreu Gómez.

The work by Guatemalan artist Carlos Mérida on the illustrations of *Banana Gold* (1932), the Central American book by Carleton Beals, is splendid. Besides its dust jacket and illustrations, it is striking for its yellow spine (the color of the cover) with six superimposed tropical pineapples. The biography of Porfirio Díaz, by Beals himself, was also published in 1932 and subtitled "Dictator of Mexico." It has a superb cover of great symbolic intensity (the country, in the palm of a hand, presumably Díaz's own hand), and illustrations by Mérida. Beals's Peruvian book *Fire on the Andes* (1934), illustrated by José Sabogal, is another fine example of a fruitful dialog between text and image, and a wonderful work by the greatest representative of Peruvian painting and engraving of the *Amauta* period. Lippincott, who published all the mentioned volumes by Beals in Philadelphia, also published what is perhaps the most memorable of those by the indefatigable traveler, *The Crime of Cuba* (1933), with canonical photographs by Walker Evans. We must also mention *Tsantsa*, a story about the Ecuadorian jungle by Russian author Isadore Lhevinne (1933), illustrated by Camilo Egas, a painter from Quito who had also been in Paris and spent a number of years living in New York.

Given that in the European section of this essay I have mentioned three important Brazilian artists, Tarsila do Amaral, Oswald de Andrade, and Vicente do Rego Monteiro, American production would not be complete without a reference to the masterpiece *Amazonia* (1943), a portfolio published by Valentine Gallery in New York and designed by Maria Martins, the great figure of Brazilian Surrealism who both in New York and Paris was acclaimed by André Breton and fellow Surrealists.

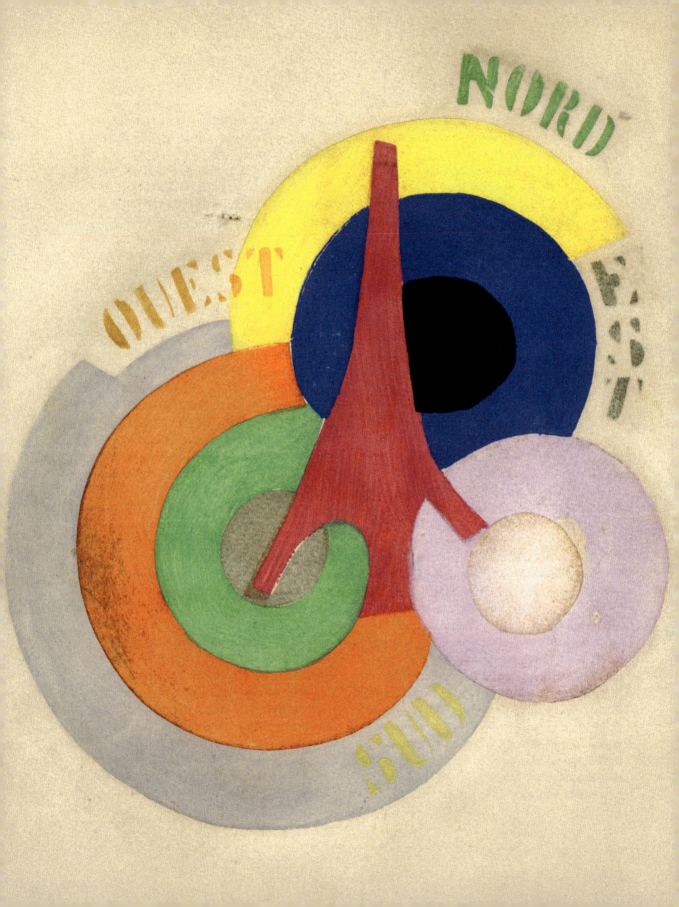

Latin American Illustrated Books: A Transatlantic Journey

Inner pages by Diego Rivera for Ilya Grigoryevich Ehrenburg, *Relato de la vida de una tal Esperancita (Nadienka) y de ciertas revelaciones que ha tenido*, Paris, not bound, 1916. 19 x 14 cm. Collection of the Dolores Olmedo Patiño Museum, Mexico City

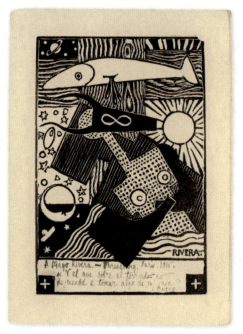

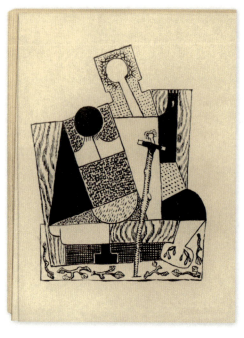
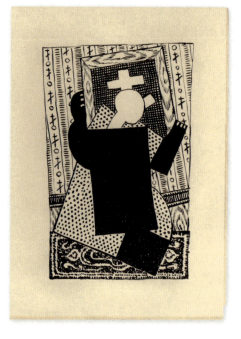

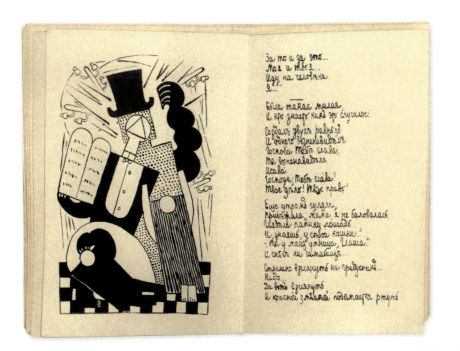

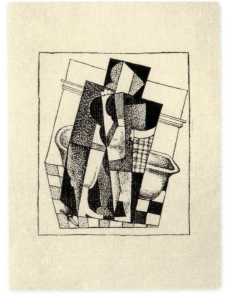

Inner pages by Diego Rivera for Ilya Grigoryevich Ehrenburg, *O zhilete Semena Drozda. Molitva,* Paris. Rirachovsky, 1917. 16 x 12 cm. Collection of the Dolores Olmedo Patiño Museum, Mexico City

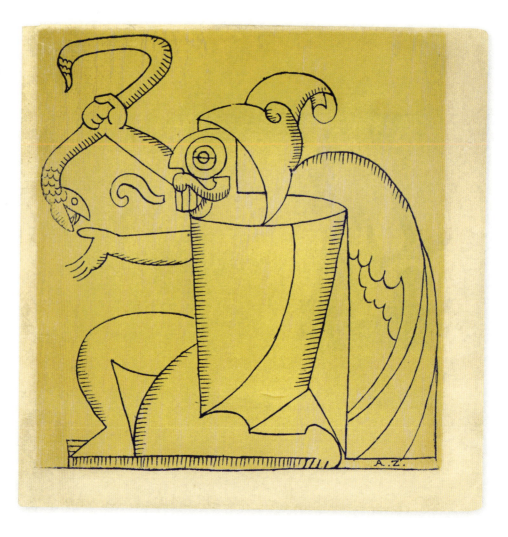

Cover and inner pages by Ángel Zárraga for Blaise Cendrars, *Profond Aujourd'hui*, Paris. François Bernouard, 1917. 18 x 18 cm. Archivo Lafuente

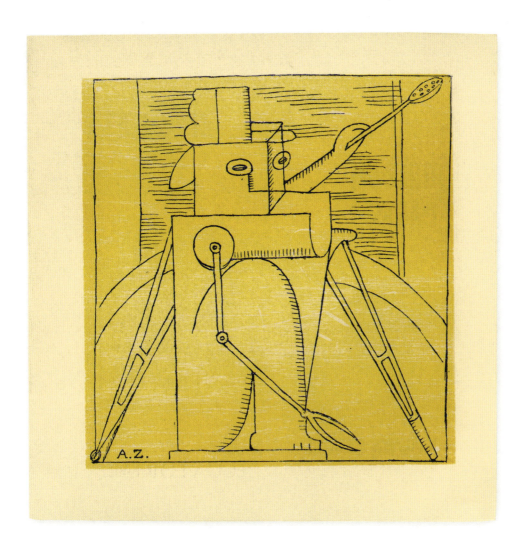

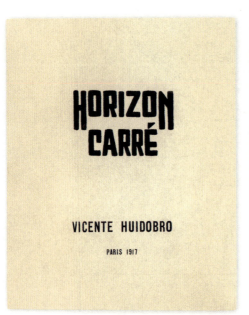
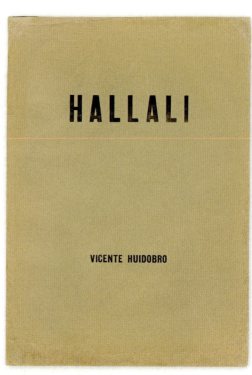

Vicente Huidobro, *Horizon Carré*, Paris. Paul Birault, 1917. 22.7 x 18.3 cm.
Archivo Lafuente

Vicente Huidobro, *Hallali: poème de guerre*, Madrid. Jesús López, 1918.
34 x 24.3 cm.
Archivo Lafuente

Vicente Huidobro, *Poemas Árticos*, Madrid. Pueyo, 1918.
20 x 14 cm.
Archivo Lafuente

Vicente Huidobro, *Ecuatorial*, Madrid. Pueyo, 1918. 25 x 19 cm.
Archivo Lafuente

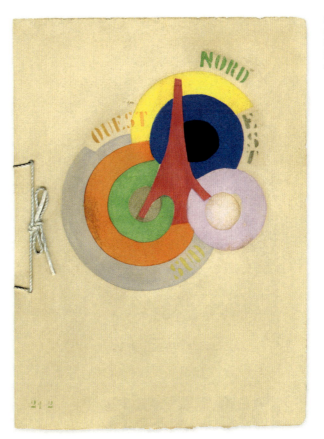

Cover by Robert Delaunay for Vicente Huidobro, *Tour Eiffel*, Madrid. Pueyo, 1918. 35.2 × 25.8 cm.
Archivo Lafuente

Joaquín Torres-García,
Notes sobre art, Girona.
Tallers Rafel Masó, bound
by Eduard Domènech, 1913.
15.7 x 12 cm.
Archivo Lafuente

Joaquín Torres-García,
La regeneració de sí mateix,
Barcelona. Salvat-Papasseit,
1919. 16.1 x 11.1 cm.
Archivo Lafuente

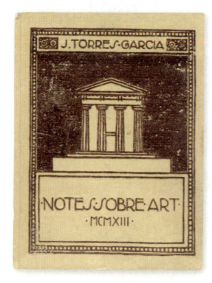

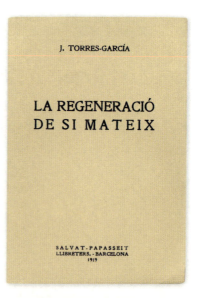

Joaquín Torres-García,
Diàlegs, Terrassa. Mulleras
& Co., 1915. 15.8 x 12.1 cm.
Archivo Lafuente

Joaquín Torres-García,
*Un ensayo de clasicismo:
la orientación conveniente
al arte de los países del
mediodía*, Terrassa. Mulleras
& Co., 1916. 21.8 x 16 cm.
Archivo Lafuente

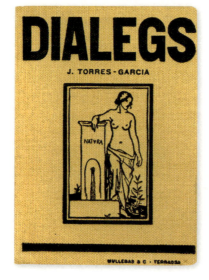

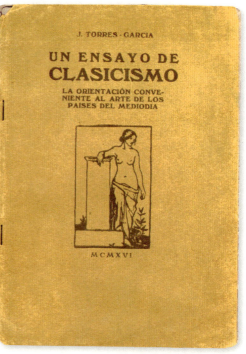

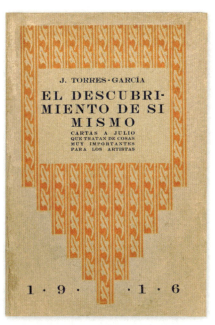
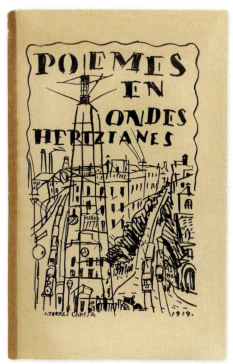
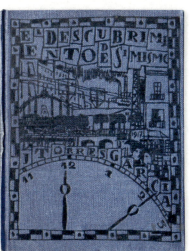

Joaquín Torres-García, *L'art en relació amb l'home etern i l'home que passa,* s.l. (Barcelona?). Edició dels amics de Sitges, 1919. 17 x 12.1 cm. Archivo Lafuente

Joaquín Torres-García, *El descubrimiento de sí mismo: cartas a Julio que tratan de cosas muy importantes para los artistas,* Terrassa. Establecimiento Tipográfico La Industria, Morral & Co., 1916. 19.4 x 13.3 cm. Archivo Lafuente

Cover by Joaquín Torres-García for Joan Salvat-Papasseit, *Poemes en ondes hertzianes,* Barcelona. Mar Vella, 1919. 22.2 x 14.3 cm. Archivo Lafuente

Joaquín Torres-García, *El descubrimiento de sí mismo: cartas a Julio que tratan de cosas muy importantes para los artistas,* Girona. Tipografia de Masó, 1917. 15.1 x 11.8 cm. Archivo Lafuente

Cover by Manuel Fontanals [?] and inner pages by Rafael Barradas for Gregorio Martínez Sierra, *La feria de Neuilly*, Madrid. Saturnino Calleja, 1920. 19.5 x 13 cm. Private collection, Granada

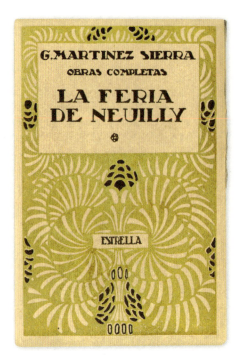

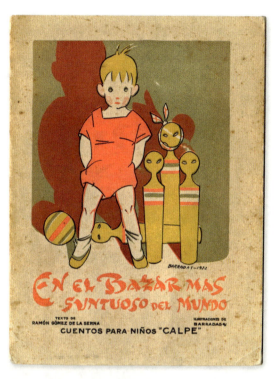

Cover and inner pages by Rafael Barradas for Ramón Gómez de la Serna, *En el bazar más suntuoso del mundo,* Madrid. Calpe, 1924. 23 x 17 cm.
Archivo Lafuente

Cover by Rafael Barradas for Francisco Luis Bernárdez, *Bazar*, Madrid. Rivadeneyra, 1922. 24.5 x 17 cm.
Archivo Lafuente

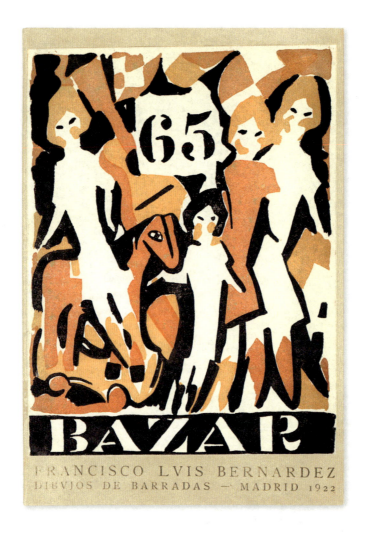

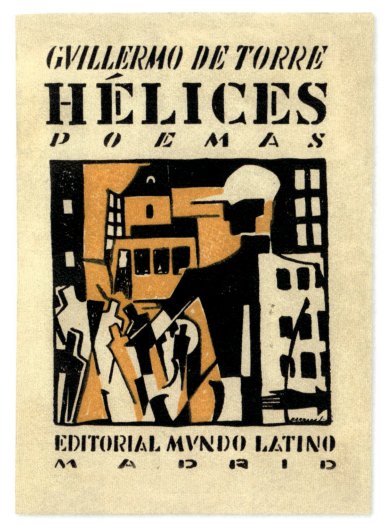

Cover by Rafael Barradas for Guillermo de Torre, *Hélice: poemas (1918-1922)*, Madrid. Mundo Latino, 1923. 25.4 x 18.7 cm.
Archivo Lafuente

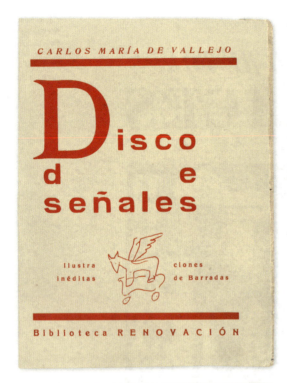

Barradas. "Supervivencia"

Barradas. "Taberna de puerto"

Barradas. "Toneleros bailadores"

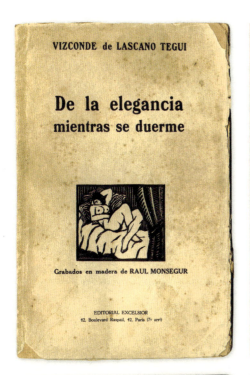

Cover and inner pages by Raúl Monsegur for Vizconde de Lascano Tegui, *De la elegancia mientras se duerme*, Paris. Excelsior, 1925.
22 x 14.2 cm.
Private collection, Granada / Archivo Lafuente

⟵
Cover and inner pages by Rafael Barradas for Carlos María de Vallejo, *Disco de señales*, Cádiz. Salvador Repeto, 1929.
22.5 x 18 cm. National Library of Spain, Madrid

OLIVERIO GIRONDO

VEINTE POEMAS

PARA SER LEIDOS
EN EL TRANVIA

ILUSTRACIONES DEL AUTOR

RÍO DE JANEIRO

La ciudad imita en cartón, una ciudad de pórfido.

Caravanas de montañas acampan en los alrededores.

PEDESTRE

En el fondo de la calle,
un edificio público aspira el mal olor de la ciudad.

Las sombras se quiebran el espinazo en los umbrales, se acuestan para fornicar en la vereda.

Con un brazo prendido a la pared, un farol apagado tiene la visión convexa de la gente que pasa en automóvil.

PAISAJE BRETÓN

Douarnenez,
en un golpe de cubilete,
empantana
entre sus casas como dados,
un pedazo de mar,
con un olor a sexo que desmaya.

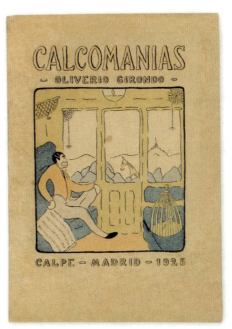

Cover by Oliverio Girondo (author) for *Calcomanías*, Madrid. Calpe, 1925.
26.5 x 19 cm.
Archivo Lafuente

«⸺
Inner pages by Oliverio Girondo (author) for *Veinte poemas para ser leídos en el tranvía*, Argenteuil. Coulouma, 1922.
31.8 x 25.4 cm.
Archivo Lafuente

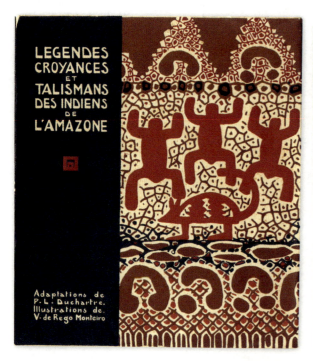

Cover and inner pages by Vicente do Rego Monteiro for P. L. Duchartre, *Légendes, croyances et talismand des indiens de l'Amazone*, Paris. Tolmer, 1923. 25.2 x 22.2 cm. Private collection, Granada

Covers by Vicente do Rego Monteiro for Jean Gravigny, *Montmartre en 1925*, Paris. Montaigne, 1925. 19.1 x 14.4 cm. Archivo Lafuente

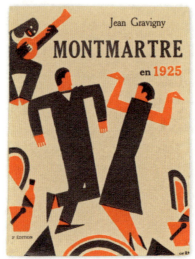
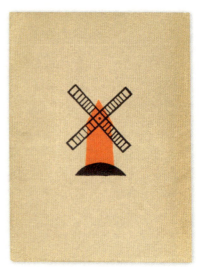

→

Cover and inner pages by Vicente do Rego Monteiro (author) for *Quelques visages de Paris*, Paris. Printers: Juan Durá, 1925. 24.1 x 19.7 cm. Private collection, Granada

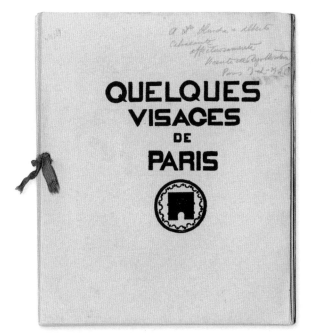

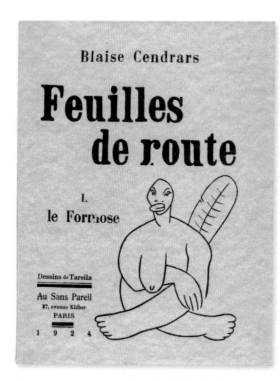

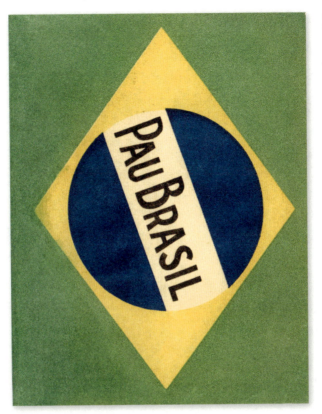

Cover by Tarsila do Amaral for Oswald de Andrade, *Pau Brasil*, Paris. Sans Pareil, 1925. 16.5 x 12.8 cm. Archivo Lafuente

⬅
Cover and inner pages by Tarsila do Amaral for Blaise Cendrars, *Feuilles de route: I. Le Formose*, Paris. Au Sans Pareil, 1924. 16.9 x 13 cm. Archivo Lafuente

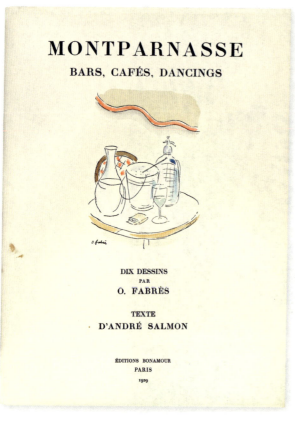
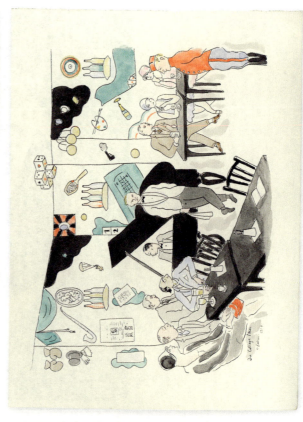

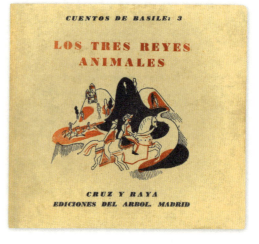

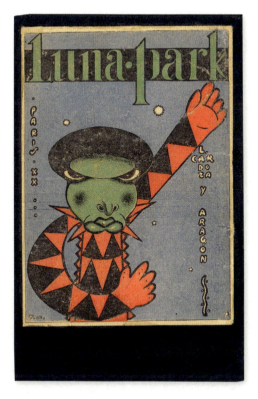

Cover by Toño Salazar for Luis Cardoza y Aragón, *Luna Park*, Bruges. Sainte Catherine, 1924.
18.4 × 11.8 cm.
Archivo Lafuente

←
Cover and inner pages by Oscar Fabrès for André Salmon, *Montparnasse. Bars, Cafés, Dancings*, Paris. Bonamour, 1929.
38 × 27 cm. Chancellery of the Universities of Paris, Jacques Doucet Library, Paris

Cover by Isaías Cabezón for Giambattista Basile, *La fábula del ogro*, Madrid. Cruz y Raya, Ediciones del Árbol, 1936. 19.8 × 18.3 cm.
MJM Collection, Madrid

Cover by Isaías Cabezón for Giambattista Basile, *Los tres reyes animales*, Madrid. Cruz y Raya, Ediciones del Árbol, 1936.
19.8 × 18.3 cm.
MJM Collecion, Madrid

Cover by Pedro Figari (author) for *Historia Kiria*, Paris. Le Livre Libre, 1930.
23 x 14.3 cm.
Archivo Lafuente

Cover by Armando Maribona (author) for *Decapitados: caricaturas*, Paris. Excelsior, 1926.
25.4 x 18.4 cm.
Private collection, Granada

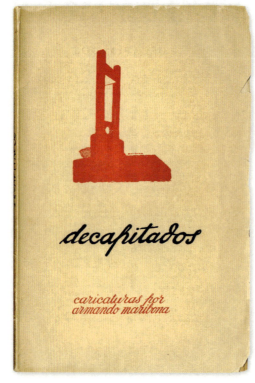

→
Inner pages by Marta Villanueva for Juan de Armaza (pen-name of Alfonso Bulnes), *Viñetas*, Paris. París-América, 1927.
23.8 x 18.8 cm.
Archivo Lafuente

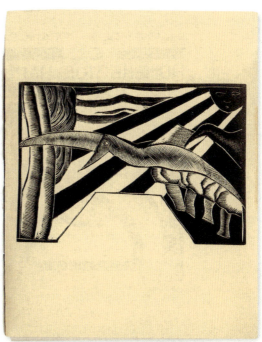
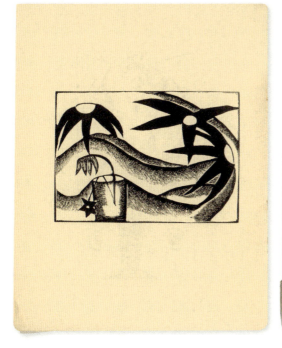
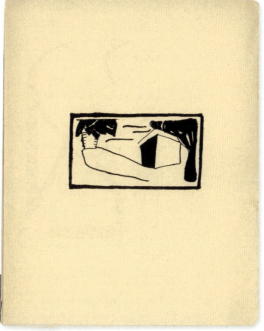

Cover and inner pages by Jaime A. Colson for Tomás Hernández Franco, *El hombre que había perdido su eje*, Paris. Agencia Mundial de Librería, 1926. 20.4 × 13.7 cm. Archivo Lafuente

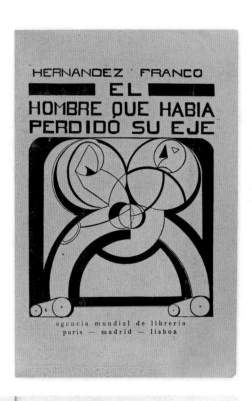

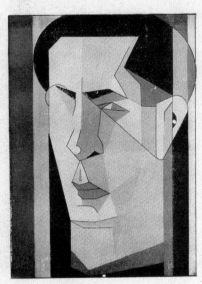

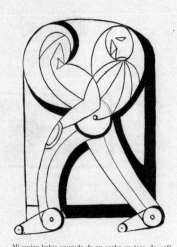

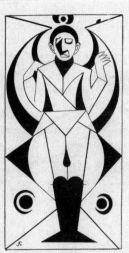

Aquel hombre no había logrado nunca un momento de soledad. La madre, la nodriza, el aya, los confidentes, las queridas, se lo habían repartido desde siempre.

Para cada mujer hay en el mundo un amante : un verdadero amante que podría amarla con toda su boca, con todo su pensamiento, con todo su sexo... y miles

El alma de los inventores se consume, en un fuego de inquietud, ante los altares de Onán, — semi-dios. —

Me quito el abrigo sin la ayuda del hombre de la guardarropía.

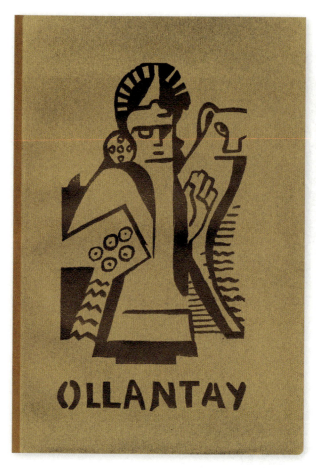 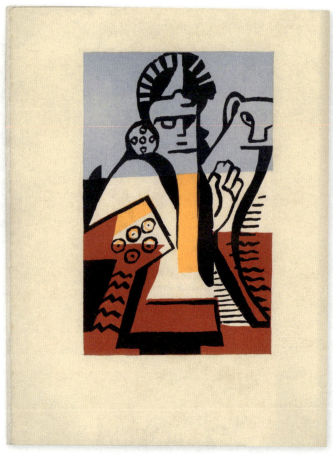

Cover and inner page by Pablo Curatella Manes (author) for *Ollantay: drama Kjechua*, Miguel A. Mossi (transl.), Madrid / Paris / Buenos Aires. Agrupación de Amigos del Libro de Arte, 1931. 32.5 x 22.5 cm. Archivo Lafuente

Cover and inner page by Dr. Atl (pen-name of Gerardo Murillo, author) for *Le sinfonie del Popocatepetl*, G. V. Callegari (transl.), Milan. Cristofari, 1930.
23 x 16.5 cm.
Private collection, Granada

Cover and inner page by Luis Vargas Rosas for Agustín Edwards, *The Dawn: Being and History of the Birth and the Consolidation of the Republic of Chile*, London. Ernest Benn Ltd., 1931.
24.5 x 16 cm.
Archivo Lafuente

Covers by Héctor Basaldúa for José Hernández, *Los consejos del viejo Vizcacha y de Martín Fierro a sus hijos*, Madrid / Paris / Buenos Aires. Agrupación Amigos del Libro de Arte, 1928. 16.5 × 16.6 cm. Private collection, Granada

Cover by Camilo Egas for Isadore Lhevinne, *Tsantsa*, Toronto / Melbourne / Sydney. Cassell and Co. Ltd., 1933. 19.5 × 13.3 cm. Private collection, Granada

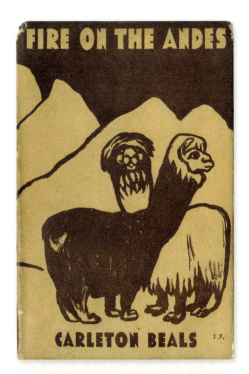
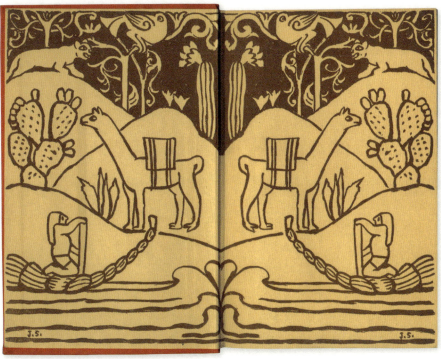

Cover and flyleaves by José Sabogal for Carleton Beals, *Fire on the Andes,* Philadelphia / London. J. B. Lippincott Co., 1934.
21.7 x 14.5 cm.
Private collection, Granada

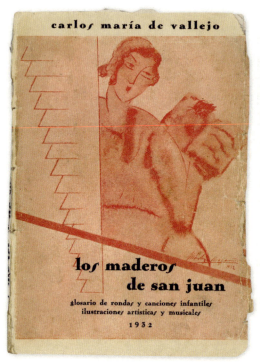

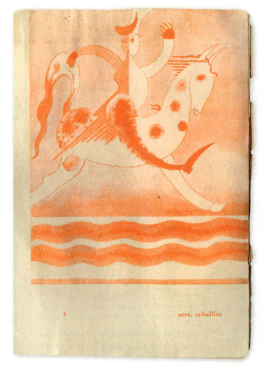
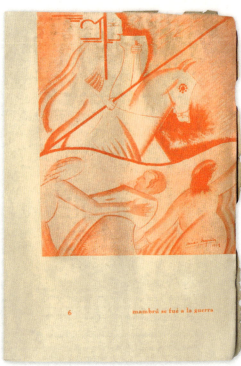

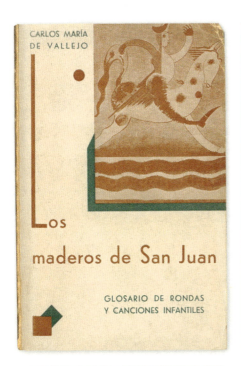
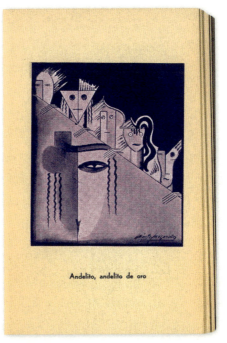

Andelito, andelito de oro

Cover and inner pages by Melchor Méndez Magariños for Carlos María de Vallejo, *Los maderos de San Juan. Glosario de rondas y canciones infantiles*, Valencia. Colección Isla, 1934. 19 x 12.3 cm. Private collection, Granada

Al pasar la barca

Una tarde de verano

← **Cover and inner pages by Melchor Méndez Magariños for Carlos María de Vallejo,** *Los maderos de San Juan. Glosario de rondas y canciones infantiles*, Cádiz. Salvador Repeto, 1932. 20.6 x 14.6 cm. Archivo Lafuente

Inner pages by Norah Borges for Carmen Conde, *Júbilos. Poemas de niños, rosas, animales, máquinas y vientos,* Murcia. Sudeste, 1934. 25 x 17 cm.
MJM Collection, Madrid

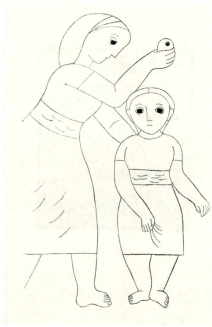

→»
Cover and inner pages by Miguel Covarrubias (author) for *Negro Drawings,* New York. Alfred A. Knopf, 1927. 26 x 19.5 cm.
Archivo Lafuente

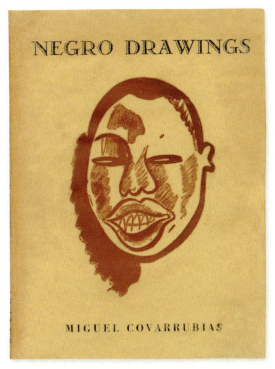
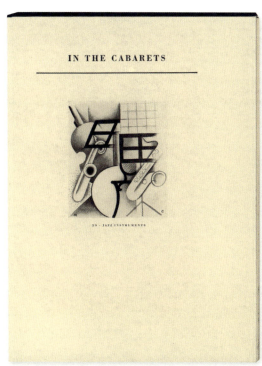
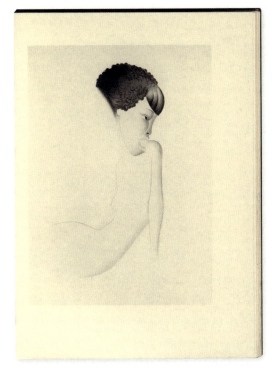
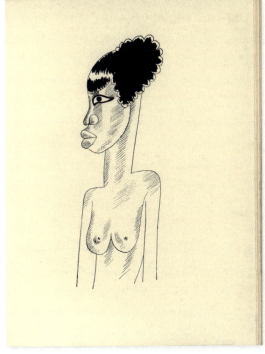

Cover by Miguel Covarrubias for José Juan Tablada, *La Feria (poemas mexicanos)*, New York. F. Mayans, 1928. 20.6 x 13.5 cm. Archivo Lafuente

→»
Inner pages by Miguel Covarrubias (author) for *The Prince of Wales and Other Famous Americans*, New York. Alfred A. Knopf, 1925. 20.6 x 13.5 cm. Private collection, Granada

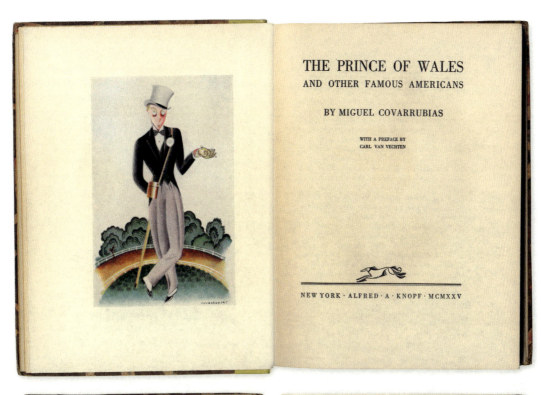
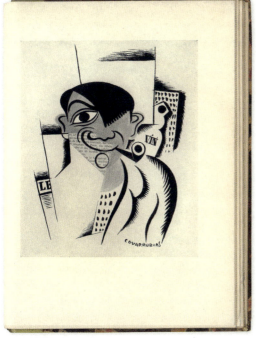
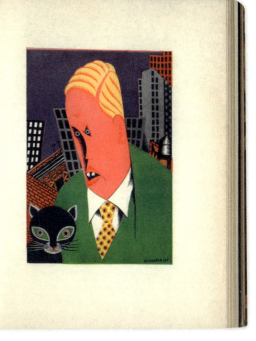

Manuel Maples Arce,
Metropolis, John Dos Passos (translator), New York. T. S. Book Company, 1929.
32.7 x 24.6 cm.
Galería López Quiroga / Private collections

→
Inner pages by Fernando Leal for Manuel Maples Arce, *Metropolis*, John Dos Passos (transl.), New York. T. S. Book Company, 1929.
32.7 x 24.6 cm.
Galería López Quiroga / Private collections

LATIN AMERICAN ILLUSTRATED BOOKS: A TRANSATLANTIC JOURNEY 77

Cover by De la Fuente for Luis C. Sepúlveda, *Instantáneas neoyorquinas*, New York. Palas, 1930. 19.5 x 13.3 cm. Private collection, Granada

→»
Cover and inner pages by José Clemente Orozco for Mariano Azuela, *The Under Dogs*, New York. Brentano's, 1929. 19.3 x 13 cm. Archivo Lafuente

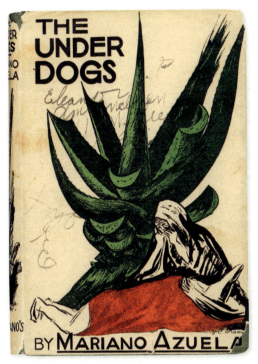
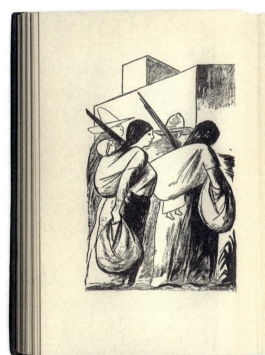
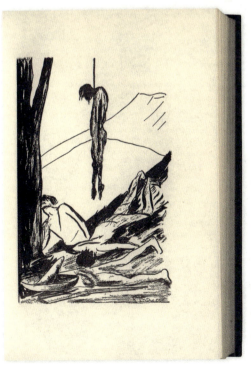
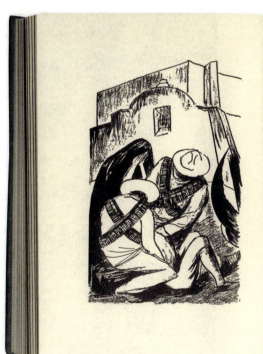

Cover and flyleaves by Carlos Mérida for Carleton Beals, *Porfirio Díaz: Dictator of Mexico*, Philadelphia / London. J. B. Lippincott Co., 1932. 24.3 x 16.5 cm. Archivo Lafuente

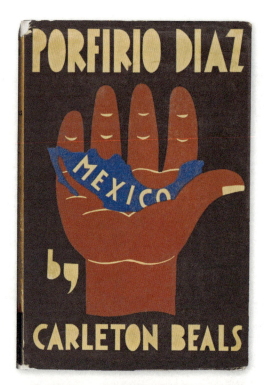

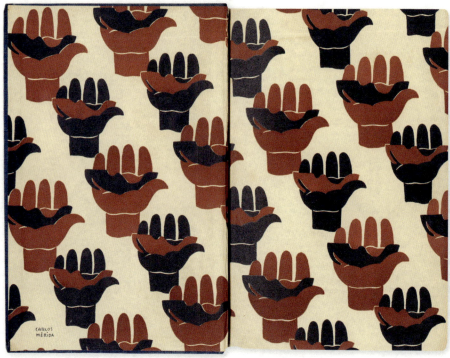

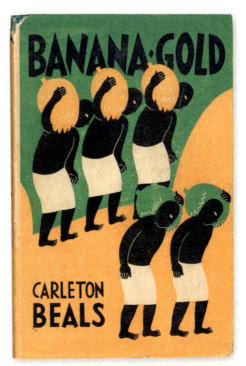

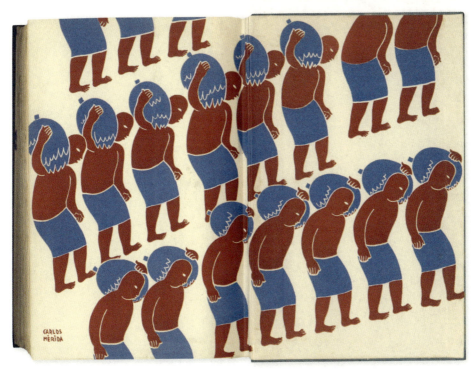

Cover and flyleaves by Carlos Mérida for Carleton Beals, *Banana Gold*, Philadelphia / London. J. B. Lippincott Co., 1932. 22.5 x 15 cm. Archivo Lafuente

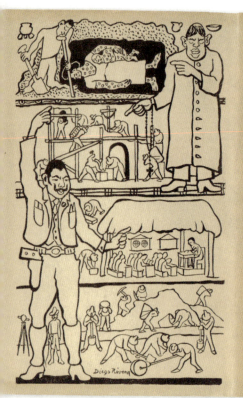

Covers by Diego Rivera for Gregorio López y Fuentes,
El indio, Indianapolis / New York. The Bobbs-Merrill Company, 1937.
21.5 x 14 cm.
Archivo Lafuente

Covers by Diego Rivera for Antonio Mediz Bolio, *The Land of the Pheasant and the Deer. Folksong of the Maya*, Enid E. Perkins (transl.), Mexico City. Editorial Cultura, 1935. 23.3 x 17 cm. Archivo Lafuente

PRISMA

Revista Mural

Dirección: Viamonte 1367

PROCLAMA

Naipes Barajando un mazo de cartas se puede conseguir que vayan saliendo en un enfilamiento mas o menos simétrico. **Filosofía** Claro que las combinaciones así hacederas son limitadas i de humilde interés. Pero si en vez de manipular naipes, se manipulan palabras, palabras imponentes estupendas, palabras con antorchados i aureolas entonces ya cambia diametralmente el asunto.

En su forma mas enrevesada i difícil, se intenta hasta explicar la vida mediante esos dibujos, i al barajador lo rotulamos *filósofo*. Para que merezca tal nombre, la tradición le fuerza a escamotear todas las facetas de la existencia menos una, sobre la cual alienta las demás, i a decir que lo único verdadero son los átomos o la energía o cualquier otra cosa.

¡Como si la realidad que nos estruja entrañalmente, hubiera menester muletas o explicaciones!

Sentimiento Yo os llevo mi evidente i palmaria, el jorgial enrevezar palabras: campea *Desprecio* de una celebridad medrada no ni la literatura actual. Las poetas roto se acopan de hombrear la acha ley cantizador enmaranada que los rubenianos herederos de Darío y los otros — les recao. las jocas, los áureo grupos, las paisajes enrobinos y enverdecidos, i esgazar rotilantemente los fajos adjetivos estáfete, divino, azul, misterioso... Cuanta sacaramundia i cuanta neplica en ese monstruar de imprecares i descargarse palabras, cuanto enseñe abuerte de afirmaciones ventiladorantes en las mentes, cuenta *insipiencia* en sus vanaglorias de sembladoras agoreras! Mientras tanto los demás lineces podo lo que es evidentar el laurato Azul-Emboncanismo, ejemplos sin amoroblo ofrecido humedina pasmes modistas que laemilitaba de vieje plantea agorejantes tendíamos después con un gesto de acontentada sanación y de aspecialziación parvida.

Impiedoso y cos como siendo la cullera obra podeína es lo útil, conde suseitos en lleve en ab dios un cristal pura-puer más vil o la literatura allá. Los poetas rotos acopan de hombrear la acabo leyes canticulares marinados que los rubenianos he-rodero* Un otaba. Esto crea le en la salchigrafía, tres copas en propletor que aproximadamente en precede era gaudí pero en el noto que asume esperan no puedan a pronumentes no agrada. Pero sin embargo, i a pesar de que todos nuestros estilista hace conjunte adornado, y cosecha quilombo de miel los textos quiero la verda ditulado azur emberadista, cero que *lera* de diga unhela. A sol aquel tendremos en poesía la subversión de los aplimos actuales lingüísticos cultibarados.

Ultra Nosotros los sinícanos en esta vegua de montarabistas con epiletas ortodos, dueñones i platas, el estuvo en carambolar en miraje preciente desperdicilda en ella. Como i hindrismo ultra se intolera en todas cuanto oberas clasicimpedines sin mando se entra a la fillosia: al blanco Oposatia son ya el pordonto, viaja fuera del toesmuestras. Puesta, para que quiero capaz que han requerido el carrige i decemiten fuera de una paro preguntado su pausa y pura preque llegado i mos ente se contengasam, con vulcanos ineras estraer lalgoristas con esbantos gaverete. Pero como más se acerca al toto que pueden considerano, los sinícanos gemamos pura que prosperoramento ponen os fesciencia los exsantarazados al las ay queremos el apego y su prefería presa lo que una ipora serpasa lo que uno sirsita repoversió i, una ipora serpasa lo que es apora nupaiano con aixido en frente aqueja que necesita por un en el para el por el ra-rumba, de ultrainstrucas, mas fosrmula el sustrativocu, anciana los que un tocaria cuarquier a los vegana en los o a bre que coreativa gracia de la reproducciones...

Latiguillo Más adecuada PRISMA, por contigo sobre, pabra... la voría a pronto la al siglo lo ardienta de venas en la relato lo real de vira, la recorre de lata voz in tola... el hemo ahí enlinrto olgorsa i enasorbar ne sus i va sua puesta.

Guillermo de Torre — Eduardo González Lanuza
Guillermo Juan — Jorge Luis Borges

CAMINOS

Mis brazos polvorientos como leguas
y el camino perdido igual que un beso
Déjame rezar los árboles despacio
Rosarios de colores somnolientos
Su risa como un globo de distancia
Se ha roto sobre mi pecho
y mis pasos se alejaron en las canciones
Ya no puedo contar las rosas de mis dedos
Mira amigo
 mi voz pasa
en aquel cotorro

J. Rivas Panedas

NAUFRAGIO

Siglo
 minuto
 instante
Cuantos barcos y lunas cruzaron lo distante
del mar
 Mar
 Mar de palabras claro
 Mar de mirada gracia
 que el viento das la cara
 y el hombre blanco al aire
Siglo
 minuto
 instante
Yo, y yo
 los dos mudos
 a dos interrogantes

Adriano del Valle

RISA

Para tu risa pájaro mi casa es una jaula
mi casa abierta y soleada
como una naranja

EXTASIS

Mi frente está apagada
pero los sueños arden en tu lámpara

PEDRO GARFIAS

SOL

Te he visto una mañana despierto
bañero de poetas y de mendigos
descifrador del vitral de la catedral
arpa dorada, tibia y matinal

Isaac del Vando-Villar

ALDEA

El poniente de pie como un Arcángel
tiraniza el sendero.
La soledad repleta como un sueño
se ha remansado al derredor del pueblo
Las esquilas navegan la brisa
dispersa de las tardes
 La luna nueva
es una vocecita baja el cielo
Según va anocheciendo
vuelve a ser campo el pueblo

Jorge-Luis Borges

EL TREN

El tren de carga
es un pedazo de suburbio
patinando sobre la llanura

La chimenea eterna
como un dedo
imponiendo silencio a la miseria

El silbido rígido
cual látigo de acero
taladrando las nubes

Los vagones como casas sonámbulas
corriendo de la mano
sueñan con dar la vuelta al horizonte

E. González Lanuza

PUERTO

La cruz del palo mayor
pasa bendiciendo las aguas
En la mano del mástil
el gallardete es un pañuelo
 que va diciendo adiós al barrizale
Yo camino perdido como un ciego
por las dos calles de tus ojos

GUILLERMO JUAN

ANGUSTIA

El incensario de la nada
consumía un gran holocausto
sin ídolo y sin rito
Me dejaron tan solo
y con todas las horas en las manos
como juguetes rotos
Sin encontrar un nido
mis gritos retornaron ateridos
y fuí tras el silencio

JACOBO SUREDA

PRISMA

REVISTA MURAL — Buenos Aires
BULNES 2216

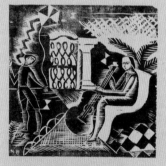

2

Por segunda vez, ante la numerosa indiferencia de los muchos, la voluntaria incomprensión de los pocos i el gozo espiritual de los únicos, alegramos con versos las paredes.

Volvemos a crucificar nuestros poemas sobre el acaso de las miradas.

Esta manera de manifestar nuestra labor ha sorprendido; pero la verdad es que ello - quijotada, burla contra los vendedores del arte, atajo hacia el renombre, lo que queráis - es aquí lo de menos. Nuestros versos son lo importante.

Aquí los dejamos sangrantes de la emoción nuestra, bajo los hachazos del sol porque ellos no han menester las complicidades del claroscuro.

Ningún falso color vá a desteñirse, ningún revoque vá a desprenderse.

Los rincones i los museos para el arte viejo i tradicional, pintarrajeado de colorines i embarazado de postizos, harapiento de imágenes i mendicante o ladrón de motivos.

Para nosotros la vida entusiasmada i simultánea de las calles, la gloria de las mañanitas ingenuas i la miel de las tardes maduras, el apretón de los otros carteles i el dolor de las desgarraduras de los pilluelos; para nosotros la tragedia de los domingos y de los días grises.

Hastiados de los que, no contentos con vender, han llegado a alquilar su emoción i su arte, prestamistas de la belleza, de los que estrujan la mísera idea cazada por casualidad, talvez arrebatada, nosotros, millonarios de vida y de ideas, salimos a regalarlas en las esquinas, a despilfarrar las abundancias de nuestra juventud, desoyendo las voces de los avaros de su miseria.

Mirad lo que os damos sin fijaros en cómo.

POEMA PASTORAL

ADRIANO DEL VALLE

NOCTURNO

Eduardo GONZÁLEZ LANUZA

TORMENTA

EL OSO

BAHIA

L. CONDE ALMANSA

AURICULARES

SALVADOR Reyes

IGLESIA

ATARDECER

POEMA

PLAYA

Guillermo JUAN

Guillermo DE TORRE

Jorge-Luis BORGES

Jacobo SUREDA

Argentina

Rodrigo Gutiérrez Viñuales

In the context of Latin America, Argentina is another of the countries, along with Brazil and Mexico, that generated a greater number of publications during the period we are studying. This is due, above all, to the consolidation and transformation of publishing houses founded in the nineteenth century, and to the appearance of new publishers in the second half of the 20th century that aspired to introduce modern practices—in our case, to favor book illustration. Among the most noteworthy new companies are Claridad, Proa, Martín Fierro, Campana de Palo, Gleizer, Samet, L. J. Rosso, Babel, El Inca, and Nuestra América, although there are many more of course. As regards illustrated books specifically, when we were working on *Libros argentinos. Ilustración y modernidad (1910-1936)*, published in 2004, we realized the great volume of material available and the tangible possibility of composing an alternative "history of Argentine art," based almost exclusively on the graphic design of books.

Given the scope of that study, which furthermore included approximately 2700 reproductions, we have decided to create a new, more synthetic narrative in this project, based on a more fitting selection of what we consider to be the most striking examples of such a vast collection. We also feel that time is now ripe—and are therefore acting accordingly—for introducing a series of meaningful books into this visual discourse, books of whose existence we only learned after having completed that publication. We had already acknowledged that such works, structured by bringing together parts found in different places, necessarily coexist with a sort of Murphy's law: once they see the light, and even when their research has been carried out conscientiously, in all likelihood they will appear as unknown copies important enough to merit their inclusion. Therefore, along these lines, we insist that this is now a wonderful opportunity to present certain works we have managed to collect over recent years.

As in the case of other countries on the continent, the graphic modernism of Argentine books was first described by several artists who in the 1910s frequented Symbolist circles. In Argentina the group was as solid as it was varied, enhanced by the fact that several of its members had settled for some time in Europe, especially in Paris. This was the case of Rodolfo Franco and also that of Gregorio López Naguil, the latter a disciple of Hermenegildo Anglada Camarasa's in the "city of light" and in Pollença (Majorca), to where the master retired shortly before the outbreak of the First World War. López Naguil, esthetically linked to Mexican artist Roberto Montenegro, another seminal figure in Latin American graphic Symbolism, with whom he shared a friendship and artistic projects in Anglada's circles in the two aforementioned cities, was back in Buenos Aires between 1916 and 1919, a short though fruitful period in which he was recognized as one of the most advanced artists in Argentina.

In those days, López Naguil produced several book illustrations that were highly considered by literati and book lovers alike. From his great collection we have chosen two outstanding examples for our visual sequence: the cover of *Vita abscondita* (1916), a collection of poems by his friend Fernán Félix de Amador, art critic and promoter of Modernist literature in the country; and the cover of *Inquietudes sentimentales* (1917), by Chilean author Thérèse Wilms Montt who had only recently arrived in Buenos Aires, thanks to the help of Vicente Huidobro, after having escaped from a convent where she had been sent against her will. The works by López Naguil are a comprehensive cross-section of his European learnings and, like those by Montenegro in Mexico, reveal the distinct influence of British artist Aubrey Beardsley, the most famous illustrator of the works by Oscar Wilde.

So, in the period comprised between the mid-1910s and the mid-1920s the most innovative

←
Illustration by Norah Borges for *Prisma. Revista mural*, no. 1, n.d. [1921?]. Editors: Jorge Luis Borges and Eduardo González Lanuza. Buenos Aires. n.p. 61 x 83.5 cm.
Archivo Lafuente
Photo: Belén Pereda

Illustration by Norah Borges for *Prisma. Revista mural*, no. 2, n.d. [1927?]. Editors: Jorge Luis Borges and Eduardo González Lanuza. Buenos Aires. n.p. 57.5 x 80 cm.
Archivo Lafuente
Photo: Belén Pereda

Cover by Roberto Montenegro for *Los Raros: revista de orientación futurista*, no. 1, 1 January 1920. Editor: Bartolomé Galíndez. Buenos Aires. n.p. 19.5 x 14.5 cm.
Archivo Lafuente

→
Cover by Nicolás Antonio Russo for *Inicial: revista de la nueva generación*, year I, no. 1, October 1923. Writers: Roberto A. Ortelli, Alfredo Brandán Caraffa, Roberto Smith, Homero M. Guglielmini. Buenos Aires. n.p. 22.2 x 16.5 cm.
Archivo Lafuente

illustrated works in Argentina were Modernist and Symbolist. Besides the previously mentioned artists, mention should be made of Juan Antonio Ballester Peña (Ret Sellawaj), whose works we shall discuss further on in depth; Nicolás Antonio Russo, author of the wonderful cover of *Poemas egotistas* (1923) by the Spanish poet Pedro Herreros, of late admired anew; Alfredo Guido, one of the chief representatives of Argentine Modernism born in Rosario who stands out for his versatility, not only as an illustrator but also as a ceramicist, a muralist, a maker of indigenous furniture and of stained-glass windows, a distinguished etcher who also tried his hand at many other printing techniques; and finally, the Asturian artist Alejandro Sirio, one of the two most prolific producers of illustrated book covers in the first half of the century, along with the Catalan Luis Macaya, before the arrival of the Galician Luis Seoane in 1936.

In the 1920s Rosario, Alfredo Guido's city, was home to numerous modern artists, among whom we can speak of Lucio Fontana and Julio Vanzo. In those days, Fontana, who decades later would achieve international recognition thanks to Spatialism, was a young artist chiefly active in the field of sculpture (his father's craft) and only made a few graphic works. His cover for *Del verbo lírico* (1926) by Manuel Núñez Regueiro betrayed his taste for Symbolism, as does the cover designed by Félix Pascual for *¡Más allá…! La victoria está al final* (1923) by José Oliva Nogueira.

Caricature is probably one of the most direct expressions of the synthetic avant-garde, an aspect that hasn't yet been sufficiently examined in historiographic texts, although it is clear to see in various images of the years in question. The expertise of European masters such as the Norwegian Olaf Gulbransson, the French artist Sem, and above all, the Spaniard Luis Bagaría, all of whom were known in Argentina thanks to the circulation of the reviews and newspapers that published their works, planted a seed that

would come to fruition in designs by artists like Antonio Bermúdez Franco. Bermúdez is one of the most brilliant modern graphic designers in Argentina, particularly bearing in mind that when he published his remarkable *Álbum de caricaturas* (1919) he was barely thirteen. The caricatures included in the album, such as the one of King Alfonso XIII, verge on abstraction and reflect the high standard of his work. The same can be said of the illustrated covers he produced during those years, like those of *El sendero inmaculado* (1919), for his brother Fernando Bermúdez Franco; the one for the curious book *Prismas* (1920), by Sagunto Torres; and later on, the one for *La garganta del sapo* (1925), by his friend José Sebastián Tallon.

Despite not always being specifically mentioned, Bermúdez Franco appears in many of the traditional group photographs taken at the banquets organized on occasion of book launching ceremonies in Florida, and in those of reception or farewell parties, all of which were often reproduced in the pages of the avant-garde review *Martín Fierro*. He was also portrayed in the group photos of colleagues who maintained close esthetic ties with the Boedo group. This was actually quite normal, in spite of the dialectics and seeming rivalry between the two cliques, which was more a myth concocted by historians than a real-life situation, as Borges occasionally recalled.

The Florida area, where other prominent reviews such as *Proa* (in its different periods) and *Inicial* coexisted with *Martín Fierro*, was also home to several artists devoted to book illustration, including a few writers who turned their hand to the practice. The most outstanding example is that of Oliverio Girondo, who illustrated his own literary works, like *Veinte poemas para ser leídos en el tranvía* (1922) and *Calcomanías* (1925), published respectively in Argenteuil and Madrid (see pp. 54-55). In 1926, on occasion of the first visit made by Filippo Tommaso Marinetti to Argentina, Girondo, Guillermo Korn and the group congregated around *Valoraciones* journal organized the First Writers' Salon in La Plata, where a number of works made by Girondo and Korn, besides other artists such as González Carbalho, Borges, Güiraldes and Marinetti himself, were made known. On that occasion, Korn presented a *Falso grabado de Norah Borges* [False Portrait of Norah Borges] he had made as a tribute to a figure who had already attained certain recognition in the field.

Indeed, Norah Borges—whose Expressionist prints were described by her husband, the

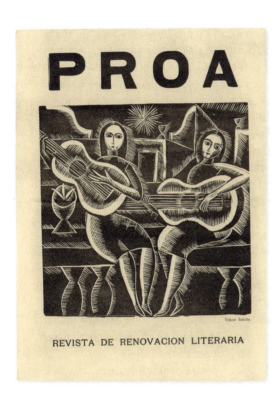

Covers by Norah Borges for
Proa: revista de literatura,
year I, nos. 1-3, August 1922
– July 1923. Buenos Aires.
n.p. 33.3 x 24.5 cm.
Archivo Lafuente

Spanish author Guillermo de Torre, as having "a candid, tortured air"—had previously designed the covers of two books written by her brother Jorge Luis Borges: the woodcut for *Fervor de Buenos Aires* (1923) and the vignettes for *Luna de enfrente* (1925). By the time she produced the latter she had begun to favor lyrical, Indian ink linear drawing over and above xylography, as proven by her illustrations in *El pescador de estrellas* (1926), by Chilean authors Alejandro Gutiérrez and Luis Enrique Délano (see p. 308), in which delicate lines and expressiveness aren't at odds with a truly avant-garde approach. The inner illustrations made by Santiago-born Bernardo Canal Feijóo for his first collection of poems, the admired *Penúltimo Poema del Fút-bol* (1924), are a high point of such synthetic linear drawing with their dynamic and occasionally geometrized figures of footballers in action, on backgrounds of diagrammatic shoots of grass, occasionally accompanied by goalposts.

After years of European experience in which he dabbled in Italian Futurism and Cubism practiced by the second generation of painters to adopt the style, Emilio Pettoruti returned to Buenos Aires where he held a fine exhibition at the Witccomb Gallery late in 1924. That year he had made the abstract composition for the book *Contraluz* by the poet Pedro V. Blake, also from La Plata. Pettoruti designed other memorable works, a few of which are reproduced here, such as the cover for the curious book *El último de los profetas* (1928), by Bernardo Graiver, and some of the cartoons included in *Carlos M. Noel: atentado* (c. 1930), made in collaboration with the journalist Enrique E. García. With its steel screws, this book was clearly indebted to the well-known volume *Depero futurista, 1913-1927* (1927), a self-advertising publication by the Italian Fortunato Depero. In *Atentado*, intended as a tribute to Noel, mayor of Buenos Aires between 1922 and 1927, a period during most of which Marcelo T. de Alvear was president of Argentina, Pettoruti

illustrated each of the poems with Cubo-Futurist drawings (Artundo, 2018), and one of these designs would be reused by the artist himself to decorate the cover of *Córdoba, la "Docta" como yo la vi...* (1930), by Oscar Fernández Silva. While the colophon of *Atentado* mentions that the print run was of one hundred copies, we believe that, in view of the object's complexity and of the scarce number of copies known, the actual edition must have been much smaller.

By the same token, Pettoruti designed covers like *Día de canciones* (1930), by González Carbalho, that included a Cubist vignette, and that of *Sol alto* (1932), by aforementioned Carlos Feijóo, founder in Santiago del Estero of the La Brasa group which Pettoruti would join during those years. 1932, year of the fiftieth anniversary of the foundation of the city of La Plata, is also the date of one of the most outstanding works by a distinguished local artist, Adolfo Travascio: the cover and the geometrized inner compositions of *Poemas para el sueño de Blanca*, by Emilia A. de Pereyra. This design can also be considered Post-Cubist, an extension of the style the artist had masterly displayed in one of the most paradigmatic works of the Argentine artistic avant-garde—*Antena: 22 poemas contemporáneos* (1929), by Marcos Fingerit, considered by May Lorenzo Alcalá (2009, 155) as probably "the most Futurist book of [Río de La Plata] poems of the 1920s, not only on account of its content, but also because its cover strictly obeys the movement's esthetics."

Similar geometric features to those characterizing Pettoruti's production of those years can also be traced in that of other artists, some of whom are more than well-known and historically recognized, while others, equally worthy of note (at least as regards their known designs) have been almost completely ignored. Such is the case of Carlos Pérez Ruiz, an artist associated with avant-garde reviews like *Proa* and El Inca publishers, among others. In these artistic circles he produced his most famous work, the cover of *Índice de la nueva poesía americana* (1926), an anthology prefaced by the Peruvian author Alberto Hidalgo, the Chilean Vicente Huidobro, and the Argentine Jorge Luis Borges. That year, the same publisher produced *Terremotos líricos y otros temblores* by José Soler Darás, with a wonderful and dynamic cover designed by the author himself, which is considered one of the high points of experimental graphic art in Argentina, another excellent example of a man of letters venturing into the field of illustration. In 1928, El Inca published *Descripción del cielo: poemas de varios lados*, by Alberto Hidalgo, that includes twelve large foldable pages, with the same number of poems featured as posters. In this edition the pages are folded and bound, therefore readers are required to play a more active part, spreading them out in order to read them.

Besides Norah Borges, Pettoruti, Travascio and Pérez Ruiz, other gifted artists in the Argentine graphic avant-garde were Julio Vanzo, from Rosario, and Manuel Mascarenhas. In the mid-1920s, Vanzo, one of the pioneers of Cubism in the country (before Pettoruti's return), shared a studio with Lucio Fontana. At this time, he made two of his masterpieces, the illustrations for the book *Hacia afuera* (1926), by Hernández de Rosario, and those for the collection of poems titled *Oiler* (1928), published in Córdoba by Roberto Smith. Both works reveal Vanzo's fascination with Cubism and Futurism, his use of diagonal lines to create lively images, the presence of automobiles, sporting scenes, the hustle and bustle of port activity, and cityscapes depicting skyscrapers. In cases such as *Hacia afuera*, he promoted this avant-garde manual through the use of black and red, one of the most common color combinations in modern graphic art, well established in those days.

As regards Mascarenhas, his production is much more elusive; as we said in the case of

Oliverio Girondo, *Manifiesto de Martín Fierro*, Buenos Aires. Martín Fierro, n.d. [1924?]. 42.4 x 24.2 cm. Archivo Lafuente

→
Illustration by Ret Sellawaj (brush name of Juan Antonio Ballester Peña) for *La campana de palo*, no. 13, March 1927. Editors: Alfredo Chiabra Acosta and Carlos Giambiagi. Buenos Aires. La campana de palo. 36.2 x 27.5 cm. Archivo Lafuente

LA CAMPANA DE PALO

Periódico Mensual de Bellas Artes y Polémica

Casilla de Correo 218

N.º 13 BUENOS AIRES, MARZO DE 1927 10 Cts.

Un nuevo prosista: FLORENCIO ESCARDÓ

SILUETAS DESCOLORIDAS

En la sala.—Las camas tienden a uno y otro lado sus quietudes paralelas.—Las colchas son blancas, las intranquilidades negras.—La claridad se ensancha en los tonos limpios.—Con menos luz la bondad pudiera hacerse cómplice de la penumbra.—Así, es imposible no ver detalles ásperos.—Bajo las almohadas está escondida la esperanza; cocina las cabezas pesadas de silencios.—La hermana pasa meciendo suavemente las alas almidonadas de la cofia.—Con las alas diminutas de las manos es una hada azul dos veces alhajada.—Las figuras aparecen difuminadas en la evocación y se borran en seguida.—La costumbre hace de director de escena.

I

ANUNCIACION, la enfermera. La voz, el gesto y la torpeza son rápidos. Mania por derechos de nacionalidad. Es la dueña omnimpertinente de las llaves y las propinas. Usa delantal y cofia. Con ellos se blanquea la sirvienta y se oscurece la enfermera.

El 9 es un buen enfermo. Nunca pide nada. Dicen que morirá esta semana. Sería una pena. El que venga puede ser incómodo. También uno de los practicantes es bueno. Sólo hay que cambiarle la túnica una vez por mes. La vez que viene. Será un buen médico. El doctor es muy bueno también. Jamás observa la falta de las drogas de la sala. Es un verdadero doctor.

Alguien reclama una jeringa. La inyección urge. Anunciación sospechó que debía ir a buscarla. Se sumerge en el vano de la puerta.

El silencio se mella con la respiración entrecortada del 9.

II

PRINCIPE, el practicante. Está contento. Estudia ahora 170 páginas por día. No lee la letra chica. Cuenta 24 años, 9 sobresalientes y 2 ideas. Piensa de 6 a 7. Vive en concubinato con el texto. Le es fiel. Tiene un porvenir seguro. Publicará una observación sobre el cuadro febril de la memoria documentada en 10.000 casos. Tendrá consultorio con 60 tarjetas por día. No más. Su ciencia será enorme. Su automóvil también. Morirá de una enfermedad perfectamente estudiada.

Lee el reloj. Son las 11. La jeringa tarda. Se va. Mañana preguntará la hora justa en que murió el 9.

III

BONIFACIO, médico interno, es por compensación hombre externo. Ha descubierto el secreto de que los tacos de los botines no se gasten nunca. Su peinado es liso y pretencioso. Su inteligencia también. Mira las paredes y encuentra todo en orden. Las cosas no cambian en su ausencia. En su presencia tampoco. Las enfermeras lo quieren mucho. El les corresponde. Bien entendido, el amor al enfermo, puede empezar por el amor a la enfermera.

El 9 está grave.
—Bueno. Hay que proceder. Llamen al practicante... ¡Ah! Y que le avisen cuando la cama se desocupe. La necesita para un recomendado. Los enfermos al revés que los específicos no se recomiendan por sí solos.

IV

JULIO, el practicante, está en la sala desde el principio. Ahora lo descubrimos por la sonoridad de su silencio. Se inclina sobre un enfermo: el viejito de la cama 16, que ayer le besó las manos. Cosas de enfermos.

La enfermera, en cambio, lo detesta. Ensucia muchas túnicas. Viene temprano, se va tarde. Es un desordenado. Es medio tonto. Toma las guardias y el trabajo de todos. Además en las paredes de su cuarto no hay recortes de «La Vie Parisienne». No parece estudiante.

V

EMPIEZA a entrar gente. Son diez, quince, veinte túnicas blancas. Se agrupan alrededor de una cama. Suena un timbre. La espera se estira como un gato perezoso. El silencio bosteza. La paciencia también. Entra el Maestro. Tiene la cabeza baja. Está pensando. La ciencia no sabe qué hacer; a veces, se mete en los frascos de las mesas de luz. El maestro hace un gesto. La sabiduría vergue el fuelle. El jefe lee en voz alta una historia. Es la historia clínica. Termina. Se oye pensar al maestro. Y se ve. Empieza a explicar: el tono es gangoso y adormilado. El sentido también.

Todas las caras asisten atentamente a la explicación. El sonido gangoso va haciendo cortes seriados del silencio. Afuera recortada a la admiración por el hueco de la ventana una rama florecida se dibuja sobre el cielo lejano de pureza. La clase ha sido muy interesante.

El doctor Recio, después de leer la historia clínica va a felicitar al maestro. Otros también...

UNA ACCION
LA CAMPANA DE PALO

Pérez Ruiz, he is almost completely absent from the history of Argentine art. The few works that he is known to have made leave no one indifferent, as proven by two outstanding covers, that of *Prontuario de lo grotesco* (1928), by Manuel Kirs, in which the calligraphy of the title in green ink heightens the work's Expressionistic air, and the subsequent design for *Cuentistas argentinos de hoy* (1929), a book by Miranda Klix released by Claridad publishers, affiliated with the Boedo group, another Expressionistic composition by Mascarenhas more in keeping with the avant-gardism of Florida.

The notable development of print design applied to books we see in several Latin American countries throughout these decades (quite obviously in Chile, Uruguay, Peru, Ecuador and Mexico) can also be traced in Argentina. More specifically, mention must be made of woodcuts and linocuts; indeed, we could even speak of an "esthetic of xylography" that led artists to imitate in drawing the impressions of woodcuts. In this field, as in that of social graphic art, we cannot avoid referring to the publication of *Historia de Arrabal* (1922), by Manuel Gálvez, that included over seventy prints by Adolfo Bellocq. This edition, and others like *Los pobres* (1925), written by Leónidas Barletta and illustrated by José Arato, both of whom belonged to the Artistas del Pueblo group, prove how certain international imaginaries and ways of working wood were adapted in the country. There is, in this sense, a clear influence of German Expressionism and its medieval roots as its practitioners favored incisions following the grain of the wood, which gave the images greater expressive force, emphasizing outlines and dominant features. The dissemination of the work of Frans Masereel, primarily, besides that of several French books of the period. had encouraged the practice of these techniques. Such esthetic "appropriations" by Argentine artists were complemented by autochthonous features, depictions of actions carried out in outlying neighborhoods with popular architecture and, in the case of *Historia de arrabal*, set in the port suburbs of Buenos Aires, adding all sorts of typical characters, including laborers, whores, sailors, hustlers, and preachers.

As regards prints published in books, another work worthy of mention is *Las tres respuestas* (1925), by Arturo Lahorio. Today the volume is much sought-after by collectors and bibliophiles for its modern woodcuts by Valentín Thibon de Libian, recognized at the time as a painter in the salons of Buenos Aires and who made a few forays into the field of artistic illustration, as in the case of this book by Lagorio and a few covers designed for the brothers Raúl and Enrique González Tuñón.

The Catalan artist Pompeyo Audivert was also a renowned engraver with a long trajectory in the discipline (that included an interesting Surrealist period in Mexico in the late 1940s and early 1950s). Audivert and fellow Catalan José Planas Casas designed wonderful linocuts that were reproduced in another much-admired Argentine avant-garde book, *Molino rojo* (1926), by Jacobo Fijman. Its cover was by Audivert, as was that of Fijman's next book, *Hecho de estampas* (1929), whose interior also included several of his cartoons. In those days, Audivert focused on social themes (some of which featured in *Molino rojo*) and cityscapes, although he also produced an innovative series of Stations of the Cross in 1929; his modern treatment of religious subject matter would also be explored by several avant-garde artists in Argentina in those years, where the Catholic review *Criterio* had brought together a fair number of the prominent figures around *Martín Fierro* review, that had just closed.

We could almost speak of a fascination with Catholicism in the avant-garde circles of Buenos Aires in the late 1920s, exemplified by cases as emblematic as that of Jacobo Fijmann himself, a Jew who converted to the Catholic

faith and even considered the possibility of becoming a Benedictine monk. In the ranks of the plastic artists, besides similar esthetic and thematic inclinations such as those shown by Norah Borges, we must mention another "conversion", that of Juan Antonio Ballester Peña, who as an illustrator was better known by the anagrammatical brush name of Ret Sellawaj. Ballester Peña, well-known for his linocuts and woodcuts, was one of the maximum representatives (along with Norah Borges and Adolfo Bellocq) of graphic Expressionism. Often under the influence of Frans Masereel, Ballester Peña produced numerous designs for books of Socialist ideology, in connection with publishing houses such as La Protesta or Campana de Palo, before changing direction radically around 1928, when he began to explore lyrical, linear drawing for religious content.

The quality of Ret Sellawaj's work is exemplified in several of his works, that range from the ancestral character of the illustrations in *Leyendas guaraníes* (1925 and 1929), by Ernesto Morales, and the symmetric Post-Cubism featured in the cover of *El humanisferio* (1927), an anarchistic utopia written by Joseph Déjacque, to the quasi-abstraction of *La campaña del General Bulele* (1928), by Luis Reissig, not to mention emblematic designs such as his illustrations for *Zancadillas*, by Álvaro Yunque, or *Un poeta en la ciudad*, by Gustavo Riccio, both of 1926. Ret Sellawaj also produced other avant-garde illustrations for Yunque, in the field of children's literature, that also deserve to be mentioned in this survey: those of *Barcos de papel* (1926) and those of *Jauja: otros barcos de papel* (1929).

No doubt Sellawaj is another of the key figures of the Argentine avant-garde who is only recently being recognized. The same can be said of two other artists, both of whom were born in Italy but grew up in Argentina following their parents' move to Latin America: José Bonomi and Bartolomé Mirabelli. Thanks to their talent and sense of modernity, both succeeded in securing privileged positions as illustrators in publishing houses and magazines, and would be called on by the writers from Florida and Boedo to design their book covers.

As in the case of Ret Sellawaj, both are prolific designers, so we have chosen a handful of their most meaningful works. Among those by Bonomi, we must refer to the abstract, faceted and colorful ground conceived for *La mujer de Shanghai* (1926), by José de España; the use of vibrant diagonal lines and the typical café scene on the cover of *El alma de las cosas inanimadas* (1927), by Enrique González Tuñón; and finally, the cover that we consider the most outstanding of those he made in the 1920s, that of *Aventura* (1927), by Horacio Schiavo, a Symbolist nautical scene characterized by unmatched dynamism. An impressive design made the following decade is the emblematic cover of *Espantapájaros* (1932), by Oliverio Girondo, the draft, printer's proof, and printer's original illustration of which are kept in the Archivo Lafuente.

Mirabelli, whose career as an illustrator, poster and advertising designer was as admirable as it was silenced, was one of the artists most well-connected to European trends in the field, particularly in his native Italy, as proven by the influence of paradigmatic artists Fortunato Depero and Erberto Carboni on his work. Two covers designed by Mirabelli for Raúl González Tuñón are especially noteworthy: *Miércoles de ceniza* (1928), and the collection of poems titled *La calle del agujero en la media* (1930). Both compositions are characterized by their dynamism, achieved thanks to the use of diagonal lines that often intersect, by the precision of Expressionist settings, and by a tendency to vary the calligraphy of the titles. These designs by Mirabelli are included among a large group of books whose literary or artistic themes were distinctly urban in nature. Such iconic works

would do much to promote the transformation of Buenos Aires into a modern metropolis.

An unavoidable reference in this survey of avant-garde Argentine illustrators is the Paraguayan artist Andrés Guevara, a key figure in the artistic circles of Rio de Janeiro until the Revolution of 1930 forced him into exile and he settled in Buenos Aires. One of the authors for whom he would illustrate more books was Omar Viñole, and even though we have no clear evidence of the fact, we believe that he designed the spectacular cover of the exceptional first edition of *Cabalgando en un silbido* (1932), the jewel in Argentine book illustration. Besides being one of the main contributors to the multicolored review *Crítica*, in the 1930s Viñole illustrated outstanding covers for volumes like *Historias de niños* (1931) and *Cantados* (1933), by González Carbalho; *Dan tres vueltas y luego se van* (1934), by Raúl González Tuñón and Nicolás Olivari; *Sabadomingo* (1938), by César Tiempo; along with other masterpieces such as the cover of *Bajo el paraguas* (1935), by Manuel Alcobre, with Post-Cubist features, and that of *Trapecio* (1936), by Demetrio Zadán.

Despite not achieving the popularity of artists like Ballester Peña, Bonomi, Mirabelli or Guevara, many other prominent illustrators also actively promoted Argentine graphic modernism. Some were only sporadically "modern," in a specific area of their work (such as Sirio or Macaya, for instance); others were decidedly advanced and yet their production was noticeably small or dispersed (of these, we shall only cite Pérez Ruiz and Mascarenhas). Of course, due to limitations of space we can only refer a group of these artists here, graphically represented by examples of their work that fit neatly in our narrative. This, for instance, is the case of caricaturist Pedro Ángel Zavalla (Pelele) and his faceted, geometric composition for the unusual leaflet *Lo que nadie sabe de Franco*, published around the year 1926, a design that could be described as halfway

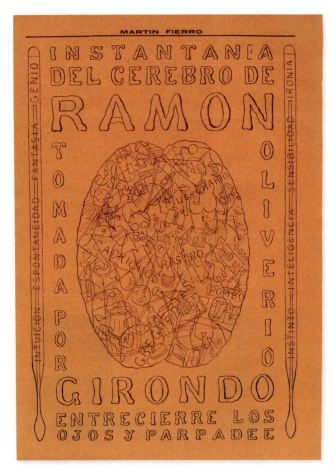

between neo-popular and Futurist, derived, perhaps, from the influence of Marinetti who had sojourned in Buenos Aires that same year. Another geometric design worthy to be listed in this group is the illustration made by the architect Ángel Guido for his own book *La machinolatrie de Le Corbusier* (1930). Guido only worked intermittently in the field of editorial illustration, probably encouraged by his brother Alfredo, whom we mentioned as one of the most versatile artists in the Argentine avant-garde.

Broadly speaking, the main esthetic resources we have been mentioning in this study can be considered the founding principles of Argentine graphic modernism in the 1920s and 1930s:

calligraphy, diagonal lines, zigzags, circles, and other symbols of dynamism and movement, silhouettes and negative images, Post-Cubist and other geometric features, faceting of planes, Art Deco syntheses, Expressionism in the treatment of figures, and the presence of certain modalities of lyrical drawing. The survival and transformation of the avant-garde trends can be observed in compositions such as those made by Ramón Caballé for *Y van dos...* (1931), by Marcelo Menasché, or by Miguel Ángel Ramponi for the second book by his brother Jorge Enrique, the collection of poems titled *Colores del júbilo*, published in Mendoza in 1933. Both covers represent high points of Argentine graphic art of that decade; depicted in a limited range of colors, they have calligraphic orthogonal and diagonal titles characterized by vibrant elements such as arrows and a whipping top, all set against a backdrop in which the circle emerges as the ultimate and most effective feature. In the case of Menasché's book, the white ground on which the two targets are placed is formed by concentric circles.

In the previous paragraph we mentioned "certain modalities of lyrical drawing," a range in which artists such as Norah Borges, Jorge Larco or post-Socialist Ret Sellawaj were authorities, just as Raúl Soldi would be in the 1930s. This is confirmed by his cover and drawings for *Interregno* (1933), by Pedro V. Blake, although his most famous works in the genre are his handmade designs for *Contrapelo*, by Francisco Di Giglio, produced that same year, a book prefaced by Ramón Gómez de la Serna. The covers of the estimated ninety copies of the print run—although we believe the actual number was lower—are unique works of art that present a combination of stencil-printed titles with different collages, either on cardboard or on wood. The copies we are familiar with include a drawing by Soldi printed in mimeograph and hand-colored, along with press cut-outs, some

«—
Inner page by Oliverio Girondo for *Martín Fierro: periódico quincenal de arte y crítica libre*, second period, year II, no. 19, 18 July 1925. Editor: Oliverio Girondo, Buenos Aires. Martín Fierro. 40.3 x 29 cm.
Archivo Lafuente

Covers by Ernesto Scotti for *Nafta, el combustible del siglo. Publicidad de Yacimientos Petrolíferos Fiscales (YPF)*, Buenos Aires. Yacimientos Petrolíferos Fiscales, 1931. 22.9 x 12 cm. Private collection, Granada

of which contain photographs. The covers and interior pages are joined by two metal rings, a truly innovative feature for the country and for the period. The book was printed by mimeograph and comprised seventeen illustrations, hand-colored one by one by Soldi. Their themes and concepts were varied, and complemented the compositions by Di Giglio. Several were of female figures, others depicted popular neighborhood scenes, fairs and bullfighting events, while others were interior views, serene or festive; there was a funeral carriage, harlequins and sailors, and even an abstract image, in essence the most simple of the illustrations, consisting of a continuous red line with occasional curves and clefts that evoke compositions by Hans Arp.

Like Gómez de la Serna, another famous Spanish author also traveled to Buenos Aires in those years: Federico García Lorca. The poet from Granada would spend several months of the years 1933 and 1934 in Argentina and Uruguay. In Buenos Aires he illustrated three limited editions, including the plaquette *El tabernáculo* (1934), by Ricardo E. Molinari, promoter of the publications. Along with the printer Francisco A. Colombo, Molinari was notable for his production of his own editions as well as those by others, in limited print runs and on different types of paper, usually featuring illustrations. Up until the mid-1930s, many of the designs were by Norah Borges; included here as examples are *El pez y la manzana* (1929) and *Cancionero de Príncipe de Vergara* (1933), both for Molinari. Several others were by Alberto Morera, an artist from the Argentine school in Paris who was active around the end of that decade and the early years of the 1940s. These delicate, painstaking, and now rare copies were chiefly distributed by the authors themselves or their publishers among their circles of friends, and very few, if any, were actually sold.

Music, drama, and other artistic expressions usually associated with entertainment featured prominently in the graphic art of the period.

Ernesto Pettoruti, *Tribute to Norah Lange by Grupo Signo*, 1932.
Indian ink and watercolor on paper, 48 x 33.3 cm.
Archivo Lafuente
Photo: Belén Pereda

This is exemplified by the cover of the book *Los motivos del grafófono* (1928), by Enrique Almonacid, designed by Octavio Fioravanti, and three other works related to the theater: the Cubist cover sketched by Emilio Pettoruti for *El nuevo teatro argentino* (1930), by Italian author Anton Giulio Bragaglia; that of *Teatro Popular* (1931), by Antonio F. Marcellino, designed by José Villanueva which, like the one made by Gregorio López Neguil for *Pasa el circo* (1939), written by Gloria Ferrándiz, recreates the spectacularity and movement characterizing the stage during a performance; and finally, that of *Mêkhãno: ballet en cuatro cuadros* (1937), by Fifa Cruz de Caprile, where the set designs and stage costumes were created by Héctor Basaldúa, while the refined edition produced by Artes Gráficas Futura (run by Ghino Fogli) included a silver cover with a "robotic" drawing by Horacio Cruz. Other books with "metallic" covers appeared during these years in Argentina, such as the one designed by Manuel Fortuny for *M. A. 1. Radio Corazón (transmisora argentina). Poemas y canciones* (1935), written by Miguel de Arzubiaga.

Means of transportation played a key role in consolidating an imaginary capable of reflecting the dynamism of the age and the speed of contemporary cities, as reflected in modern graphic works. Although the illustrator from Asturias Alejandro Sirio is one of the most prolific designers working in Argentina in the first third of the twentieth century, his forays into avant-garde trends were few and far between; nevertheless, some of his covers are worthy of mention, such as the one he made for *Velocidad* (1931), by the journalist Chita de Leonard, a composition that evoked those of advertisements in which the entire foreground accommodates the drawing. Airplanes feature in covers like the one conceived by Juan Bautista Dell'Acqua for *Más allá* (1933), by Pedro Jorge Garbi, depicting a scene dominated by a paper plane whose vertical stabilizer is a heart; to the left, a smoking chimney containing the illustrator's signature is cut out against a blue sky. In his turn, Luis Macaya is the artist who designed the cover of *Aterrizaje* (1931), by Desseim Merlo, a book characterized by great calligraphic liveliness, the axis of which is a geometric nosediving plane.

Macaya also illustrated the covers of *Jazz y Golf* (1930), by Ferrari Amores, and *Cocktail (para el atardecer de un sábado inglés)* (1932), by Silvia Guerrico. Thematically dedicated to "leisure and entertainment," these vigorous and colorful Deco designs are characterized by the multiplication of diagonal lines in handmade drawings and letters expressing a wide range of features from modern life: a jazz band, black dancers and boxer, a mulatta dancer, golf and tennis players, a transatlantic, an automobile, and skyscrapers.

In those days, football provided an alternative form of entertainment, in this case more popular and widespread throughout the River Plate region—for Argentina and Uruguay, it would gradually become a part of national identity. In 1930 the two countries played each other in the first world championship final, won by the latter which was the host country; the well-known illustrator from Buenos Aires Lino Palacio made the cover of the "Argentine-Uruguayan novel" *4 á 2* (1932), by Carlos B. Quiroga, a title that recalled the result of the final. In his turn, another Argentine artist, Luzuriaga, designed the cover of *Shot al arco* (1933), by *monsieur* Perichon. The two compositions, clearly modern, reproduced similar scenes: the shot at the goal and the imminent goal, no doubt the most exhilarating moment of the match.

Another plausible setting for illustrated books in those presumably dispersed years was the city, represented from architectural and town-planning angles. The seduction of skylines and other urban vistas, featuring skyscrapers (that almost always seemed to be tottering), spotlights and dramatic light beams, caught the attention of numerous artists and made its way into works

of very high quality. Such is the case of the wonderful cover of the "Buenos Aires novel" *El hijo de la ciudad* (1931), by Sara de Etcheverts, designed by J. E. H., initials whose meaning unfortunately still eludes us. In this large-format book, besides skyscrapers and beams of light, we see a Cubistic face that evokes those of some of the portraits made in Rosario by Julio Vanzo around 1920, not to mention the *archicaricatures*, a term used to define the works by the Uruguayan artist Dardo Salguero de la Hanty—some of which were published in issues of *Proa* review in the first luster of the 1920s—and the architect Francisco Salamone, who had set out on his career around 1930 in Córdoba.

Vanzo precisely is the author of two outstanding panoramic covers that can be classified in this urban an "verticalistic" trend: those of *La inquietud del piso al infinito: Relatos fantásticos* (1931), by Alberto Pinetta, and *La ciudad cambió la voz* (1938), by Mateo Booz. The esthetics of poster design is patent in the former, as well as a perceptible theatrical slant. The latter is a monumental panegyric to skyscrapers that includes several Ks, an advertisement for a brand of cement with which, "it is now possible to build a one-hundred story house," as we read inside the book. In the cover for Booz's book, Vanzo revisits, in iconographic terms, a setting he particularly liked, that of the port, as we saw earlier in his illustrations for *Oiler*, by Roberto Smith. The back cover—actually the beginning of the image—shows the ravine, the river and a few scattered houses that represent the city before it "its voice changed."

Other covers can also be ascribed to this avant-garde spirit. Among them, the one that Abraham Vigo made for the book titled *Yo vi...! ...en Rusia* (1932), by Elías Castelnuovo, characterized by a disorganized chaotic group of large buildings, a concrete jungle that fills the entire space in which the artist has inserted the titles in red, adding great dynamism to the composition thanks to the diagonal layout of part of the title. Wiedner gives the frontispiece of the school-reading book *Renovación* (1933), by Ricardo Ryan, a certain paleo-Futuristic air, presenting several airplanes plowing the sky beneath the huge skyscrapers while beams of light emerging from behind the buildings illuminate the firmament, as in the aforementioned book by Etcheverts.

Photography, more specifically photomontage, would be called to play a key role in these urban vistas. One of the first examples of the presence of the technique in the field of book design is found in Luis Macaya's illustration for *Concéntricas* (1932), by Sixto Martelli. His composition is based on photographic cut-outs, mostly of European origin, forming a frieze on the front and back covers. However, the high point of this form of illustration is the publication of the emblematic photo-book *Buenos Aires 1936* by Horacio Coppola, a municipal commission made on occasion of the fourth centenary of the foundation of the capital. Some of the nocturnal photos taken for the project would be used by Attilio Rossi to compose the cover of *La ciudad junto al río inmóvil*, by Eduardo Mallea, released that same year by the publishers of *Sur* review. The circle connected to the publishing house favored the meeting between Rossi, and Horacio Coppola and his wife Grete Stern, an encounter that marked the beginning of their collaborative projects which would also involve the Argentine-Galician artist Luis Seoane.

During these years photography and photomontage would be used abundantly in book-cover designs. Besides those already cited in our visual narrative, we must mention odd specimens such as the "Siamese" book by Braulio Mate that includes two works in one: *Una novela de actualidad* and *Humanización del hombre* (1934). Even though the two covers, both by Mate, are of extremely high compositional quality, the former stands out especially, as

illustration and photomontage complement horizontal and vertical calligraphic games to define one of the most genuine works in Argentine book design of the period. The cover of *Nuevo arte* (1934), by Peruvian author Felipe Cossío del Pomar, again designed by Julio Vanzo, is another perfect example of the coexistence of illustration-photography-calligraphy. In this case, the artist's palette is restricted to white, black, red, and gray, shades that prevailed in Vanzo's graphic works of these years. In his turn, Eliseo Montaine is responsible for designing the splendid double cover of *El hombre de la baraja y la puñalada: estampas cinematográficas* (1933), by Nicolás Olivari, that includes photomontage with portraits of actors and actresses.

In contrast, to a certain extent, with the optimistic idolatrous worshipping of modernism revealed in these urban visions, and more in keeping with the gloominess of the political reality and economic collapse of the 1930s, the circulation of literary and graphic works of a social nature grew. Debates among artists and intellectuals took on a new dimension, focusing on their own engagement, the social role of art, and its legitimacy as a revolutionary medium. Concerns with issues such as the advance of European totalitarianisms were not foreign to artists or men of letters, who carried out rebellious acts and gave free rein to associationism. This is exemplified by the foundation of the Group of Intellectuals, Artists, Journalists, and Writers (A. I. A. P. E. for its initials in Spanish), that would publish the magazine titled *Unidad por la Defensa de la Cultura*, whose first issue circulated in Buenos Aires in January 1936.

In the field of books, the translations of numerous foreign social novels, particularly from Russia, Germany, North America and Italy, began to be valued. Editorial Claridad was the most active publishers of such versions, although many were also produced by Tor, Anaconda, Imán, Nervio, and other firms. Social subject matter was consolidated as the main realm of avant-garde graphic work. As for books, cover designs redoubled their mission of informing of their contents and catching the attention of possible consumers. As declared by the Mexican author Gabriel Fernández Ledesma, a stunning design doesn't wait to be visited: it goes out and calls to passers-by on the street. This was quickly grasped by the above-mentioned publishing houses, whose editions saw the quality of their paper and presentation decrease, while the presence of illustrations was reduced almost exclusively to covers, often under the influence of modern propaganda poster design or of political photomontage, with striking typography and compositionally integrated titles, freely placed in space, either in straight lines, diagonally or in the form of arcs. The repeated use of close-ups in illustration is explained by the impact of film and photography. As regards the influence of posters, to a certain degree they transformed book covers into small bills, in which forms were refined and simplified, decorativeness and perspectives were marginalized, and flat, suggestive colors made an appearance.

Another of the techniques previously described that began to appear regularly in the genre of Social Realism was photomontage, considered as it was a direct and efficient way of transmitting messages, well suited to agitprop and large-scale advertising. It was an art of fragmentation, defined in compositions created out of independent photographs that lost their original function and context. Hence, significant details were removed from them in order to highlight others (Rowell, 2002, 55-57), joining up pieces of the real world in collages, just as the Cubists had done (Hollis, 2012, 33), and, in short, producing undeniably chaotic structures that sought to generate new meanings starting from the casual wanderings of the gaze (Scudiero, 2012, 190).

Among the devotees of sociopolitical montage in the mid-1930s we must mention Julio Vanzo and the artist of Catalan descent José Planas Casas. The former stands out for his cover of *Líneas y trayectoria de la Reforma Universitaria* (1935), by Juan Lasarte, a symbolic composition based on a photograph of an anti-establishment demonstration, surrounded by flames, while set against the background is the black silhouette of the university as a fossilized temple, from where three bats escape the fire. In his turn, Planas made two covers for Imán publishing house, a firm inclined to encourage photographic experimentation on its book covers. Both *Mundo nuevo*, by Pierre Besnard, and *Mortalidad infantil y natalidad*, by Jorge F. Nicolai, of 1935, are made from remarkable photomontages that include drawings: fists clenched and breaking chains as a symbolic lure in the former, and the shadow of death creeping up to embrace a naked infant depicted above two weeping children, one of them heartbroken, in the latter.

The reaction against the negative news that came from abroad proved to be one of the most fertile fields in Argentine literature and graphic art, where all that was related to totalitarian regimes, particularly to Nazism, was warmly welcomed in attempts to inform and reflect on the state of the world. Indeed, one of the most interesting books published in Buenos Aires in the first luster of the 1930s was *El plan de Hitler*, by Ernst Henri (1934). The photomontage included a diagonal composition in which images of the army and air force appear separately, and superimposed on both are the photographic portraits of three characters, one of them Hitler himself. The drawn cover of a subsequent edition published the following year, much more brutal in content, featured the figure of the Führer in the foreground, pierced by an axe and surrounded by flames, bombings, tortures, swastikas and three soldiers marching (two of them wearing gas masks and the other converted into a skull). Another of the covers that depicted the animosity toward Hitler and his methods is the anonymous design of *Alemania atrasa el reloj* (1933), by E. A. Mowrer, a geometrized, synthetic composition which combines the use of Deco typography and the figure of a hanged man, set against a swastika, the rope suspended from the minute hand of the clock.

Political drawings connected to the art of books reflect a number of metaphors alluding to social productivity and utopia, where there is room for reinventions and recycled pre-existing iconographic forms, many of which derived from Christian symbolism in a clear instance of visual democratization. Dafne Cruz Porchini provides us with one of the most lucid and complete recent studies of the social themes that flooded the imaginary of the 1930s in Mexico, valid too for other areas. A prevalent motif was the representation of masses, usually associated with the utopia of the future, educational iconography that reflected the shared experiences of teachers and pupils, desks, blackboards and open books as chief attractions, and, in short, all the symbols of productivity: schools, electricity towers, factories with high cement chimneys, plows, sown lands, tractors, all of which contrasted with "the depictions of a corrupt clergy, the incarnation of the bourgeoisie as the great whore, the symbolic gesture of the laborer removing his blindfold, and the utopian vision of a field full of idyllic dawns and the force of labor." (Cruz Porchini, 2010, 43).

While these references are stressed in the 1930s, we would like to mention a few precedents, such as the cover that Rafael de Lamo designed for *Los charcos rojos* (1927), by Bernardo González Arrili, dominated by a foreground with a huge iron structure placed in a great industrial complex beneath which a mass of workers appears to move. Also, that of the rare edition of *Los 7 locos* (1929), by Roberto Arlt, the author of which is unknown, featuring five clenched fists emerging from inside a prison cell.

Inner page by Horacio Coppola (author) for *Buenos Aires 1936*, Buenos Aires. Municipalidad de Buenos Aires, 1936.
33 x 24 cm.
Archivo Lafuente

Cover by Horacio Coppola (author) for *Buenos Aires 1936*, Buenos Aires. Municipalidad de Buenos Aires, 1937. 31.5 x 22.5 cm.
Ramón Reverte Collection, Mexico

→
Flyleaves by Attilio Rossi for *Cómo se imprime un libro*, Buenos Aires. Imprenta López, 1942.
28 x 23 cm.
Archivo Lafuente

The age-old recourse of the clenched fist was one of the most repeated motifs used to represent rebellion or the triumphalism of the oppressed (laborers, prisoners, etc.); at the end of the day, agitprop.

There are abundant examples of all these meanings, and several of the clichés can be traced in the production of Abraham Vigo, a member of the Artistas del Pueblo group. The commitment of leaders with the working masses appears on covers such as that of *El arte y las masas* (1935), by Elías Castelnuovo, the foreground of which portrays a clenched fist holding a rifle that pierces the eye of a painter's palette and is, at once, the pole of a red flag. Vigo was also responsible for the frontispiece of *Cristo el anarquista* (1936), by the Brazilian writer Aníbal Vaz de Mello, a book published by Claridad. Vigo's design shows a close-up of Christ about to launch a bomb on an impressive, almost metaphysical, city of skyscrapers.

Another striking cover is the one made by Ascanio Marzocchi Paz for *Reconstrucción social* (1933), by Diego Abad de Santillán and Juan Lasarte, where a symbolic male figure, naked, moves forward between scaffolding. Depictions of bodies also abound, especially those of athletic men, portrayed in a monumental style partly derived from the geometrizations of Art Deco, that also characterizes certain public sculpture of the period, poster design and Mexican muralism. This was one of the identifying traits of the work by artists like Pompeyo Audivert, Clément Moreau (pen-name of German author Carl Meffert in exile) and Demetrio Urruchúa, all of whom played decisive roles, as did Planas Casas, in shaping the left-wing imaginary of Imán publishing house. Audivert's woodcut composition for *Camisas negras* (1934), by Italian anarchist authoress Luce Fabbri, published by Nervio, is also worthy of mention. The cover of *El tráfico sangriento* (1935), by Fenner Brockway, was designed by Moreau and can be described

as a political caricature that recalls the work of his admired Georg Grosz, anticipating the esthetic of the anti-Nazi compositions he would subsequently make for reviews such as *Argentina Libre* (that from 1945 onward would be called *...Antinazi*, with suspension points due to the prohibition of using the word "Argentina").

The cover of *Socialismo constructivo* (1934), by Rudolf Rocker, has been attributed to Urruchúa. In 1937 Urruchúa illustrated that of *Una juventud en Alemania*, by Ernst Toller, a work published four years after Toller's books had been burned in a public act in Germany; to the image that covers most of the surface, Urruchúa adds a geometric typography on a brown ground. But no doubt the most important of his works is the set of illustrations—whose almost "sculptural"

monumentalism anticipates styles that would be developed by Ricardo Carpani in the 1960s—included in one of the most controversial books of the period, *Tumulto* (1935), by José Portogalo. Both this book and *El derecho de matar* (1933), by Raúl Barón Biza, shared the sad precedent of the seizure of the edition and the persecution of the author. The cover of the latter shows the jacket of genuine silver lacquer on which we make out a scythe and a skull, designed by an unknown Teodoro Piotti.

Around the mid-1930s, military themes would be increasingly frequent. In this context, at the beginning of the decade the publication of *Julio, 1914*, by Emil Ludwig, dedicated to the First World War, with "the great cannon of war books" presiding over its anonymous cover, appeared as a fateful omen. 1935 was the year when a young Leónidas Gambartes from Rosario designed the cover for *Guerra*, by Leopoldo Sofer, in which he introduced the silhouette of a soldier blown to smithereens.

The Spanish Civil War was, of course, a central theme given that numerous artists, writers, and intellectuals would be directly or indirectly involved in the armed conflict. We shall only refer here to a handful of illustrated books from among those we consider most meaningful. Julio Vanzo designed the cover of *España levanta el puño* (1936), by the journalist Pablo Suero from Gijón, in which he turned to the hackneyed motif of the raised fist. Juan Carlos Castagnino designed the cover for *La rosa blindada* (1936), by Raúl González Tuñón, a book of poems dedicated to the thwarted uprising of Asturian miners. *Pax: poemas para la angustia del mundo* (1936), by Miguel Alfredo D'Elia, featured notable avant-garde illustrations by Ernesto Scotti that anticipated the European tragedy. Víctor Poggi, who in those years would illustrate the covers of the various installments of *Juan Cristóbal*, by Romain Rolland, published by the Montevidean publishing house Mañana in Buenos Aires, designed the cover of *La guerra en España* (1937), by Luis Fischer, published by La Nueva España.

The course of the Spanish Civil War between 1936 and 1939, and the resulting exile of intellectuals and artists, would establish the pre-eminence of the Argentine publishing market for Spanish books on a worldwide scale, taking the place occupied until then by Spain. The founding of publishing companies such as Losada, Poseidón, Emecé, Botella al Mar, and so many others strengthened Argentina's role during the 1940s, giving birth to a period usually recognized as a "golden age" of Argentine books but that, in our case, corresponds to a later stage.

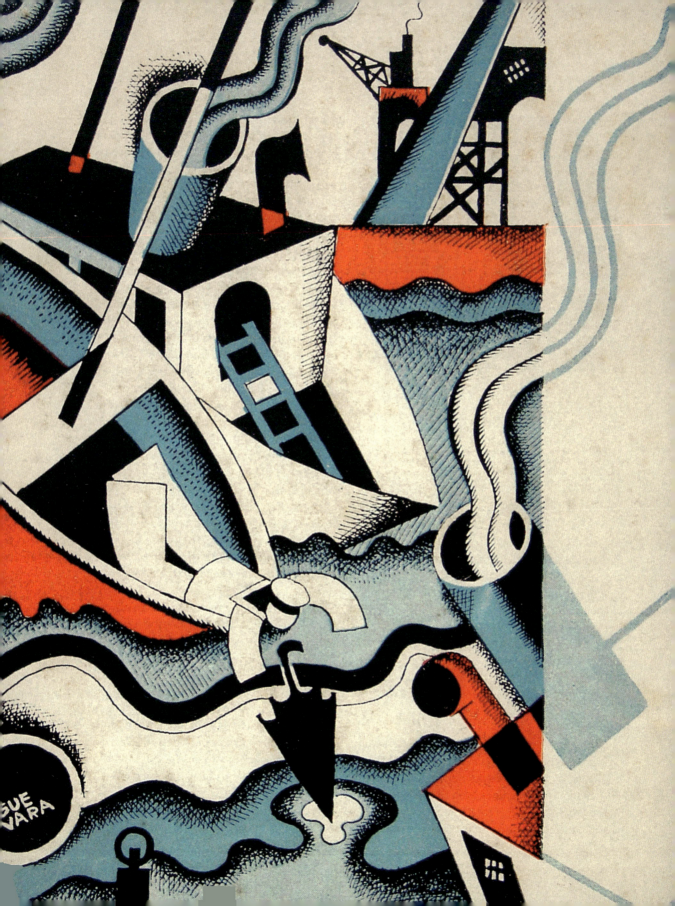

Argentina

Cover by Gregorio López Naguil for Fernán Félix de Amador, *Vita absondita: poemas,* Buenos Aires. Busnelli y Caldelas, 1916. 21.3 x 16.5 cm. Private collection, Granada

Cover by Antonio Bermúdez Franco for Sagunto Torres, *Prismas: poesías,* Buenos Aires. Imprenta Mercatali, 1920. 18.8 x 12.9 cm. Private collection, Granada

Cover by Gregorio López Naguil for Thérèse Wilms, *Inquietudes sentimentales,* Buenos Aires. Imprenta Mercatali, 1917. 20 x 16.5 cm. Private collection, Granada

Cover by Antonio Bermúdez Franco for Fernando Bermúdez Franco, *El sendero inmaculado,* Buenos Aires. Imprenta Mercatali, 1919. 18.5 x 12.8 cm. Private collection, Granada

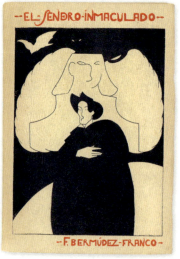

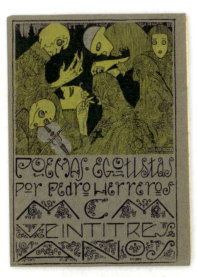
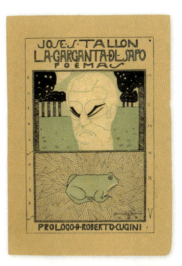
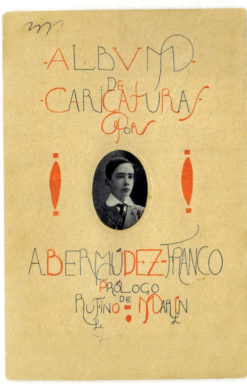

Cover by Nicolás Antonio Russo for Pedro Herreros, *Poemas egotistas: consideraciones,* Buenos Aires. Talleres Damiano, 1923. 18.8 x 13.8 cm. Archivo Lafuente

Cover by Antonio Bermúdez Franco for José S. Tallon, *La garganta del sapo: poemas,* Buenos Aires. J. Samet, 1925. 18.5 x 13 cm. Archivo Lafuente

Cover and inner page by Antonio Bermúdez Franco (author) for *Álbum de caricaturas,* Buenos Aires. Talleres Peuser, 1919. 27.4 x 18.6 cm. Private collection, Granada

Cover by Félix Pascual for
José Oliva Nogueira,
*¡Más allá...! La victoria
está al final*, Rosario.
Talleres Gráficos Romanos
Hermanos, 1923.
17.3 x 13.1 cm.
Private collection, Granada

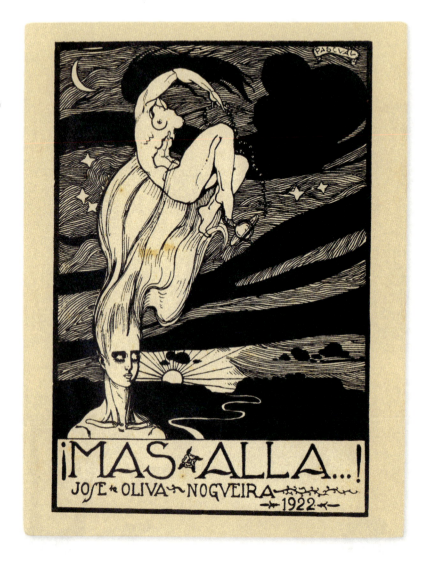

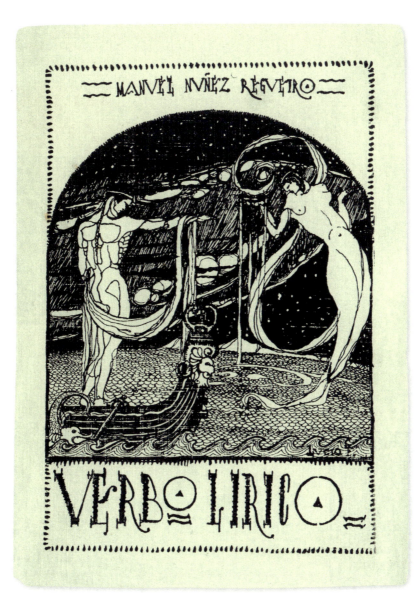

Cover by Lucio Fontana for Manuel Núñez Regueiro, *Del verbo lírico (versos),* Buenos Aires. Agencia General de Librerías, 1926. 19 x 13.5 cm. Private collection, Granada

Cover by José Arato for Leónidas Barletta, *Los pobres*, Buenos Aires. Claridad, Los Nuevos, 1925. 18.6 x 13.9 cm. Archivo Lafuente

Cover and inner pages by Adolfo Bellocq for Manuel Gálvez, *Historia de Arrabal*, Buenos Aires. Agencia General de Librería y Publicaciones, 1922. 18.6 x 13.2 cm. Archivo Lafuente

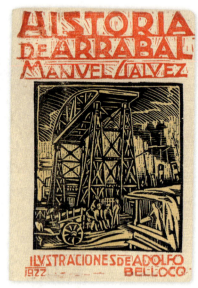

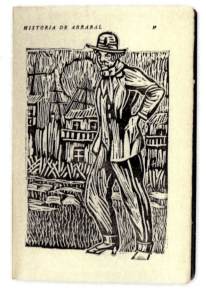

→»
Cover and inner pages by Valentín Thibon de Libian for Arturo Lagorio, *Las tres respuestas*, Buenos Aires. M. Gleizer, 1925. 21.8 x 21.8 cm. Archivo Lafuente

Inner pages by Bernardo Canal Feijóo (author) for *Penúltimo Poema del Fút-bol*, Santiago del Estero. R. Ribas, 1924. 27.6 x 18.5 cm. Archivo Lafuente

Cover by Norah Borges for Jorge Luis Borges, *Fervor de Buenos Aires*, Buenos Aires. Serantes, 1923. 19.2 x 14.4 cm.
Archivo Lafuente

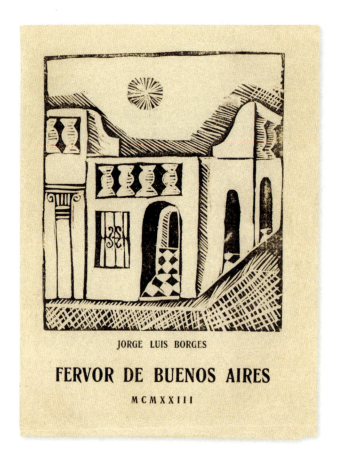

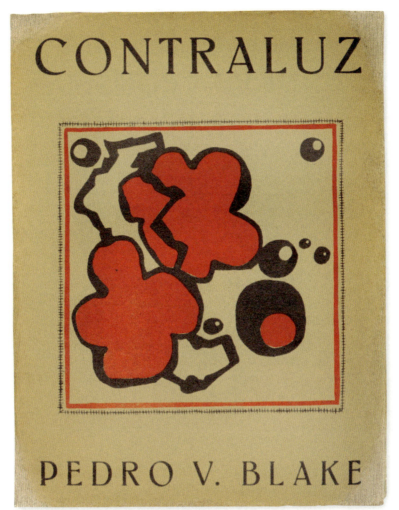

Cover by Emilio Pettoruti for Pedro V. Blake, *Contraluz*, Buenos Aires. Talleres Gráficos G. Ricordi y Cía., 1924. 26.5 x 20.5 cm. Archivo Lafuente

Cover by Carlos Pérez Ruiz for Alberto Hidalgo, Vicente Huidobro and Jorge Luis Borges (preface), *Índice de la nueva poesía americana*, Buenos Aires. Talleres Gráficos El Inca, 1926. 18.6 x 14 cm. Archivo Lafuente

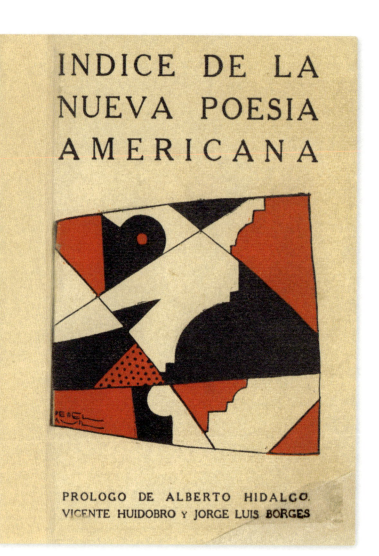

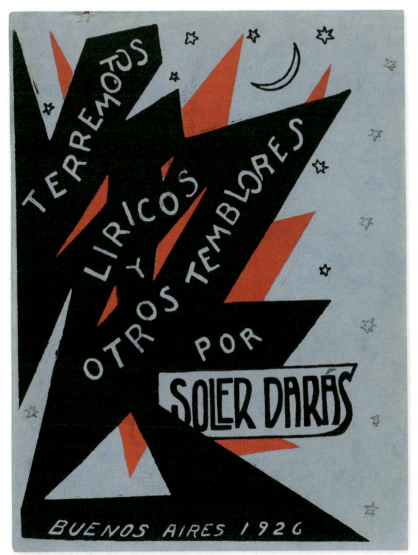

Cover by José Soler Darás (author) for *Terremotos líricos y otros temblores*, Buenos Aires. Talleres Gráficos El Inca, 1926. 19.2 x 14.2 cm. Archivo Lafuente

Cover and inner pages by Julio Vanzo for Fausto Hernández de Rosario, *Hacia afuera*, Buenos Aires. J. Samet, 1926. 23.9 x 16.6 cm. Private collection, Granada

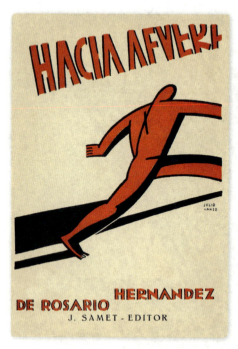
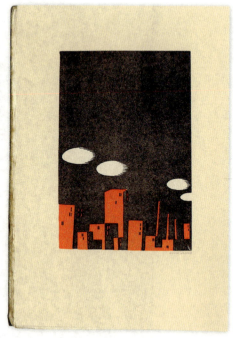
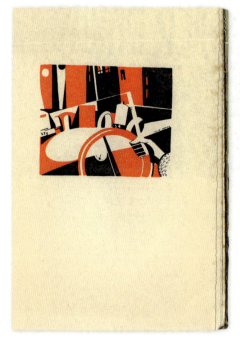
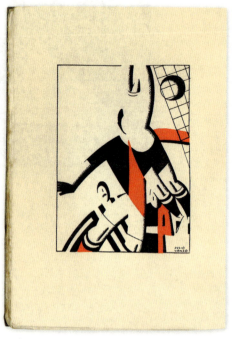

→
Cover and inner pages by Julio Vanzo for Roberto Smith, *Oiler: poemas*, Córdoba. Publishers of El País, 1928. 23 x 19 cm. Private collection, Granada

24

A la llegada de los barcos iba por los muelles, atrapadora ingenua de los hombres, pintados apenas los labios, demasiado rojos, en su cara morena.

Iba por los muelles a la hora del amarre, hora en que ya están libres los carboneros, los oilers y los fogoneros. Maravillosa pasión de dos o tres días, de horas a veces, lo que el barco anclara en aquel puerto tropical.

27

Escalerilla leve de la máquina, en tus últimos peldaños durmió la esperanza muchas veces. Pero solo durmió.

Puerto que dejamos y puerto que llegamos, la maravillosa ilusión seguía durmiendo en tus últimos peldaños. Era peor despertarla, pero yo no lo sabía. Las tabernas de

43

Treinta oilers anduvieron por sus máquinas: treinta oilers lo hicieron caminar.

Pobre barco mío del lejano Seatle, perdido en otro mar.

Treinta oilers anduvieron por sus máquinas: treinta oilers lo hicieron caminar. De los treinta sólo yo cuento su historia. Y la cuento... así nomás.

Cover and inner pages by Adolfo Travascio for Marcos Fingerit, *Antena: 22 poemas contemporáneos*, Buenos Aires. Tor, 1929.
18.8 x 12.1 cm.
Archivo Lafuente

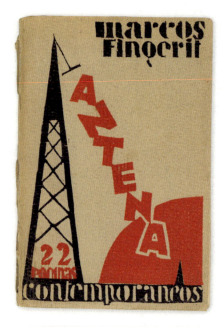

ARGENTINA 123

Cover and inner pages by Adolfo Travascio for Emilia A. de Pereyra, *Poemas para el sueño de Blanca*, Buenos Aires. Talleres Gráficos Porter, 1932. 25.6 x 18.3 cm. Private collection, Granada

Cover by Pompeyo Audivert for Jacobo Fijman, *Hecho de estampas*, Buenos Aires. M. Gleizer, 1929. 23.4 x 18.8 cm. Archivo Lafuente

→»
Cover and inner pages by Pompeyo Audivert for Jacobo Fijman, *Molino Rojo*, Buenos Aires. Talleres Gráficos El Inca, 1926. 19.5 x 14 cm. Archivo Lafuente

Cover by Ret Sellawaj (brush name of Juan Antonio Ballester Peña) for Álvaro Yunque, *Zancadillas (cuentos)*, Buenos Aires. La Campana de Palo, 1926.
16.5 x 12.2 cm.
Archivo Lafuente

Cover by Ret Sellawaj (brush name of Juan Antonio Ballester Peña) for J. Déjacque, *El humanisferio*, Buenos Aires. La Protesta, 1927. Los Utopistas Collection, no. 1
18.3 x 13.3 cm.
Private collection, Granada

Cover by Ret Sellawaj (brush name of Juan Antonio Ballester Peña) for Ernesto Morales, *Leyendas Guaraníes*, Buenos Aires. Pedro García, 1925.
16.4 x 12 cm.
Private collection, Granada

Cover by Ret Sellawaj (brush name of Juan Antonio Ballester Peña) for Gustavo Riccio, *Un poeta en la ciudad*, Buenos Aires. La Campana de Palo, 1926.
16.6 x 12.3 cm.
Archivo Lafuente

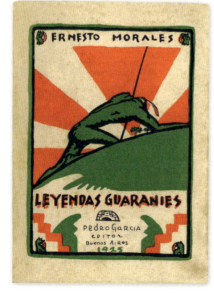
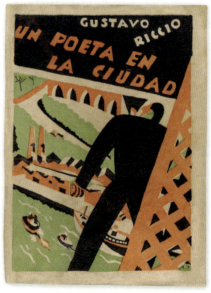

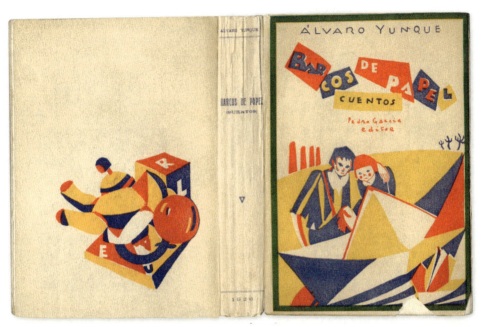
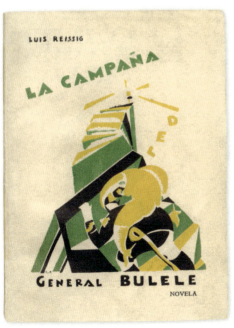
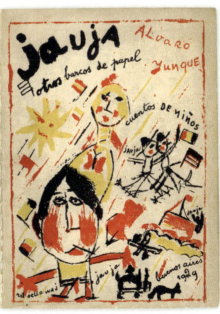

Cover by Ret Sellawaj (brush name of Juan Antonio Ballester Peña) for Álvaro Yunque, *Barcos de papel*, Buenos Aires. Pedro García, 1926. 18.4 × 13 cm. Private collection, Granada

Cover by Ret Sellawaj (brush name of Juan Antonio Ballester Peña) for Luis Reissig, *La campana del General Bulele: novela*, Buenos Aires. Talleres Gráficos Radio Revista, 1928. 18.8 × 14 cm. Archivo Lafuente

Cover by Ret Sellawaj (brush name of Juan Antonio Ballester Peña) for Álvaro Yunque, *Jauja: Otros barcos de papel (cuentos de niños)*, Buenos Aires. Librería Hispano-Argentina, 1929. 18.5 × 14 cm. Archivo Lafuente

Cover by José Bonomi for Oliverio Girondo, *Espantapájaros (al alcance de todos)*, Buenos Aires. Proa, 1932. 25.3 x 19.3 cm. Archivo Lafuente

Cover by José Bonomi for Horacio A. Schiavo, *Aventura: poema*, Buenos Aires. "La Facultad," Juan Roldán y Cía., 1927. 18.8 x 13.4 cm. Archivo Lafuente

Cover by José Bonomi for Enrique González Tuñón, *El alma de las cosas inanimadas*, Buenos Aires. Manuel Gleizer, 1927. 18.8 x 13.9 cm. Archivo Lafuente

Cover by José Bonomi for José de España, *La mujer de Shanghai*, Buenos Aires. Manuel Gleizer, 1926. 18.5 x 13.7 cm. Archivo Lafuente

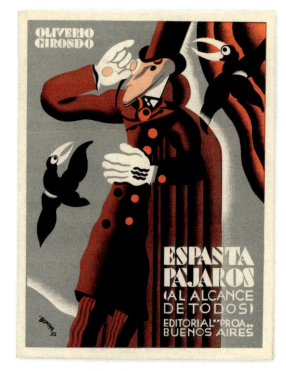
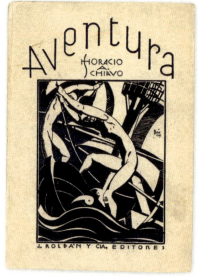
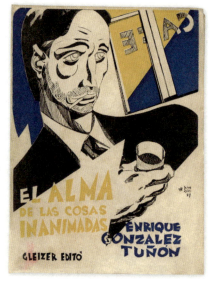
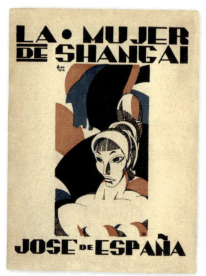

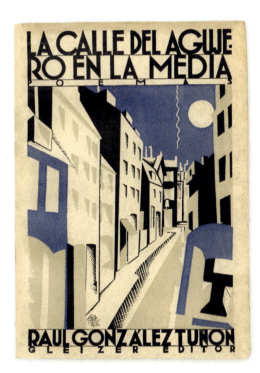
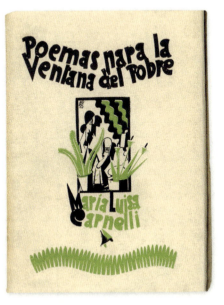
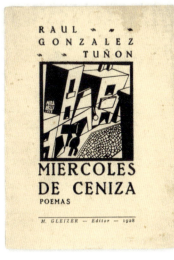

Cover by Bartolomé Mirabelli for Raúl González Tuñón, *La calle del agujero en la media*, Buenos Aires. Manuel Gleizer, 1930. 23.8 x 17 cm. Archivo Lafuente

Cover by Bartolomé Mirabelli for María Luisa Carnelli, *Poemas para la ventana del pobre*, Buenos Aires. Sociedad de Publicaciones El Inca, 1928. 19.4 x 14.5 cm. Archivo Lafuente

Cover by Bartolomé Mirabelli for Raúl González Tuñón, *Miércoles de ceniza: poemas*, Buenos Aires. Manuel Gleizer, 1928. 16.4 x 12 cm. Archivo Lafuente

Cover by Bartolomé Mirabelli for Juan Óscar Ponferrada, *Calesitas: versos*, Buenos Aires. La Peña, 1930. 21 x 15 cm. Archivo Lafuente

Covers by unknown artist for Filippo Tommaso Marinetti, *El Futurismo*, Buenos Aires. n.p. [Tor?], n.d. [c. 1930?]. 18.8 x 12.5 cm. Archivo Lafuente

Cover by unknown artist for Juan Filloy, *Periplo*, Buenos Aires. Imprenta Ferrari Hermanos, 1931.
18.5 x 14 cm.
Archivo Lafuente

Alberto Hidalgo,
Descripción del cielo:
poemas de varios lados,
Buenos Aires. Editorial
El Inca, 1928.
22 x 18 cm.
Archivo Lafuente

DESCRIPCION DEL CIELO

poemas de varios lados, construidos por

ALBERTO HIDALGO

buenos aires

Sociedad de Publicaciones El Inca

OBRA DEL ARTISTA

CICLO DE LA JUVENTUD
Panoplia Lírica
Las Voces de Colores
química del espíritu

CICLO DE LA MADUREZ
Tu Libro
Simplismo

CICLO DE LA DEPURACION
Descripción del Cielo

NOTA. — Los demás libros son accesorios

Descripción del Cielo

ALBERTO HIDALGO

DESCRIPCION
DEL CIELO
poemas de varios lados

BUENOS AIRES

OCIEDAD DE PUBLICACIONES EL INCA
EDICIONES ESPECIALES
9 2 8

Traducción, reproducción y plag[io]
La obra de arte es bien común.

A Roberto Lede-
ma, con amistad de
Hidalgo

TESTAMENTO

...después de un viaje de treinta años he llegado a este ... dé que podría ser el final. Sé que me otorga el derecho ...ar, aunque no es probable que ya lo ejercite. Sé más: ... después de haberlo publicado, la muerte ya no sería ...oloroso para mí. Esto es decir que he adquirido la con... de mi verdad y que estoy cierto de haber logrado ...arla.

... alcanzo a sospechar el juicio que esta obra haya de ... a mis contemporáneos. De las anteriores, conocí ... de antemano su dictamen. Supe a quienes habían ...tar y lo callarían o dirían lo inverso; a quienes real... desagradarían, y por fin a quienes parecerían buenas ...llar reparo en manifestarlo. Así fué, sin equívoco. Da ...esente nada sé. Hay una docena de hombres, cuya ... es la única que me interesa y para los cuales lo es... todo exclusivamente, y esa docena de hombres, que son ... de mi corazón, acaso queden perplejos con esto, qui... sus manos reste dormido el aplauso. Pero volverán a ... una y diez veces y acabarán comprendiéndome. Cier... ficultad proveniente de la densidad poética de estos ..., será, luego de haberla desentrañado, lo que más los ... a ser felices. Así es la poesía. Es inferirle agravio su... que cualquiera, por el solo hecho de ser alfabeto, ... entenderla. La verdadera poesía no se entrega de pri... intención. Hay que forzarla. Podrá apreciarse la belle... las metáforas y demás aderezos retóricos, que son lo ...al, pero no su sentido oculto, su mensaje interior. La

poesía da un goce semejante al que siente aquel que
de muchos esfuerzos descubre el secreto de una cla
siento cada día con más apremio la necesidad de esc
lenguaje cifrado.

Urge que no se vea en tres de los poemas se
puestos ningún contenido social, ni que remotamente
rezca. Nada más lejano del arte que esos asuntos. M
cación de Lenin" — lo mismo que "Envergadura de
quista" — es un poema de exaltación, de pura lírica
doctrina. Lenin ha sido un pretexto para crear, com
serio una montaña, un río o una máquina. La "Biogr
la palabra revolución" es un elogio de la revolució
de la revolución en sí, cualquiera que sea la causa
dicte. No puedo ser culpable de que no se me entiend

Esto no es precisamente un prólogo. Pensé pone
este lugar, y hace meses empecé a escribirlo, mas a lo
días me di cuenta de que él podría constituir trabajo
tanto estaba creciendo. Compendiando todas mis idea
estética moderna, saldrá después con el nombre de CI
POETICA.

Ahora sólo quiero decir que la presentación tipo
de DESCRIPCION DEL CIELO no es cosa de capr
mero afán de llamar la atención. Por su emoción n
compacta, éste es el volumen más extenso de los que
escritos. Entre línea y línea he puesto quince minu
meditación. Así mismo, los poemas quedan estrechos
hojas. Habría deseado consagrar un tomo a cada un
cribiendo una palabra o una letra por página. Adem
querido hacer un libro para la pared. Mis amigos
adornar sus muros con mis imágenes. Ha llegado el
de reemplazar las fotografías y los cuadros por los p
para que en los interiores presidan la vida de los hom

A. H.

oesía

e escuchar

Programa de poesía

Inventario de lo que ha de venir y no se sabe

Envasamiento de las veces que no se acaba nunca de escuchar

Angustia de la lluvia paralela cuando besa la tierra con ternura de cielo

Palabras escapadas desde toda ventana como de un palomar

Virginidad con que la luz mira las cosas

Flamear de una protesta enarbolada en cualquier grito

Un eslabón de sol en cada verso

Un ansia de ala

Y un viento mi viento el viento empujándolo todo hacia cualquiera parte

Nuevo autorretrato

Mi biografía es una esquina

Soy el punto de choque de dos vientos

Mi gráfico se hace metiendo un ángulo en la nada

En las noches sin luna enciendo un verso

A veces cae una música desde el quinto piso

para dar a mi arritmo un ritmo atónico

El cielo se agazapa en mis ventanas

En el aire hay veredas para el viaje de mis ojos

Una desarmonía me armoniza con el todo

Y resultante de dos fuerzas camino más allá del horizonte

Soy una esquina en marcha

Ubicación de Lenin

a

un fardo de distancias sobre el hombro
a ido a más allá de la eternidad

abrá temblado el tiempo
ándolo pasar sobre el cadáver de tanto siglo

e una diagonal a través de la gloria

una fuerza de émbolo les puso el hombro a las palabras nuevas

o el pasado todo el presente todo el futuro
a desembocar en su memoria para tomar oxígeno

parador del infinito
a verlo en su íntegro tamaño
que empinarse sobre la inmensidad del verso

b

el corazón de los obreros su nombre se levanta antes que el sol

endicen los carretes de hilo
e lo alto de los mástiles
odas las máquinas de coser

nos de la época las máquinas de escribir tocan sonatas en su honor

l descanso automático
hace leve el andar del vendedor ambulante

perativa general de esperanzas

regón cae en la alcancía de los humildes
dando a pagar la casa a plazos

izonte hacia el que se abre la ventana del pobre

gado del badajo del sol
pea en los metales de la tarde
a que salgan a las 17 los trabajadores

c

pitos de las fábricas han aprendido "la internacional"

ra al paso del "Rolls Royce" se desternillan de risa los automóviles "Ford"

e una muchedumbre de azoteas
chimeneas arengan a los astros
sus manos de humo

brisa aspira a una participación en las utilidades del paisaje

se está llenando de él igual que un vaso

d

los aniversarios de su muerte

elga de alas caídas

disolución del pensamiento

asfixia de las ambiciones

Los sauces enarbolan sus pájaros
a medio canto en señal de duelo

Las montañas ya no pueden bajo el peso de su nombre
llevándolo sobre los hombros hacia la rosa de los vientos

Hay una confabulación de torres
para desmoronarse
y hacer de ellas la iglesia de San Lenin

Embanderamiento total del cielo

e

Estableció por sobre cada altura un amanecimiento de posibilidades

En su mano anidaron las auroras

Una milagrería de luz surgió de su pecho

Así hoy tenemos día y nos sobra mañana

Ni una mancha de tinta hubo en su pensamiento

Sus ideas dan la impresión de que las hubiera lavado con potasa y cepillo

Antes de hablar ponía sus discursos encima del tejado para que se oreasen

f

L letra con el impulso de la ola
e angustia del oído atento a todo
n blandura suavidad sosiego del mucho sufrimiento
i puñal enderezado hacia el alma de la injusticia
n última vibración de la campana
L e n i n
sinfonía revolucionaria
repercusión de música ostensible
canto de gallo que anuncia la madrugada de la conciencia

g

Yo no soy comunista y sin embargo lo llevo en la cartera ese balcón
desde donde se ve inequivocadamente a todos

h

Para transcribir con exactitud la intensidad de su ausencia
será preciso arrebañar las almas
hacia la más lejana latitud del silencio

Hagamos muerte de un instante profundizado de vida
y consagrémosle esa ofrenda de nuestra precaria inexistencia
para que crezca en su homenaje tal una flor sobre una tumba

Poema del saltador

a

El hombre sabía que ahí tras de la tarde estaba el cielo
El cielo al alcance de la mano o más bien de los puños
Su andar puso en el espacio una solvencia mágica de proa
Se amortiguaba la lejanía lento reloj que pierde cuerda
Pronto la ciudad se hizo ausente
Un estreno de verde realizó la delación del campo
El mar cerró los párpados al ver el arco de sus piernas
Y ya se halló de pié sobre la punta de la noche

b

Entró en el fuego negro con decisión de leer un poema
La oscuridad blanqueaba las temblorosas estrellas
La luna estaba viendo lo que recién iba a ocurrir
Mirándolo los astros se dirían ésto es un bólido opaco
Con un ruido de trapos fríos las tinieblas lo dejaron pasar
Y de repente en sus arterias sonó la hora del alba

c

La luz empezaba lo mismo que la primera palabra que se dice
Iba el de un punto al otro cual una idea cuando se transmite
En el silencio de la mañana cayeron sus saltos con tintineo de monedas en la ranura de una ruleta automática
La existencia empezó a funcionar

d

Luego de haber recorrido el día la noche y el mundo el saltador vió que estaba otra vez en su punto de partida
Era su frente el cielo
La tierra era su carne
En su pulso golpeaba frenética el agua de los ríos
No había nada más allá del hombre

La hora cero

Hora en que a los relojes les duele las doce de la noche

Apéndice del tiempo mejor para la huelga de lo real

Segundo infinitesimal interminable como muchas horas cosidas unas a otras

Punto seguido para que hinchen el pecho las distancias

Apice de movimiento imposible de fotografiarse porque con él fracasa hasta la cámara ultrarrápida

Terraplén de la nada en el que los minutos se paran a tomar aire ávidos ya de ruta

Momento adulto tan mayor que se sale de la cuenta único que hay de fugacidad permanente

Esquina por donde dobla el día hacia la posibilidad de otro sistema

Trampolín de la eternidad en el gimnasio de los orbes

Agujero hecho en las paredes de la noche

por donde saca la cabeza un pedacito de aurora para ver si es temprano todavía

Medida infinita con que descifrar la anchura del latido del mundo

Hora cero sólo es verso el nacido en los brazos abiertos de tu instante

Biografía de la palabra revolución

Palabra que nació en un vómito de sangre
Palabra que el primero que la dijo se ahogó en ella
Palabra siempre puesta en pié
Palabra siempre puesta en marcha
Palabra contumaz en la modernidad
Palabra que se pronuncia con los puños
Palabra grande hasta salirse por los bordes del diccionario
Palabra de cariño fácil como una curva
Palabra de cuatro flechas disparadas hacia los puntos cardinales

Aquí queda desenraizada del olvido toda su anécdota

Sobre uno de los vértices más remotos del tiempo
los dolores humanos hicieron campo de concentración
Para emprender la ruta ¿hacia qué cielo?
cada uno según su intensidad tomó diverso carácter alfabético
Y la palabra quedó escrita
R E V O L U C I O N
Luego el sol al pasar por tras ella para hundirse en la noche
encendió sus diez letras
R E V O L U C I O N
Y fué el primer aviso luminoso del mundo

Ahora está en el hombre igual que está el oxígeno en el agua
Campos ciudades mares cuentan con una población de sus ecos
Les ha sustraído espacio a los cuerpos que se dilatan
Tiene violencia y distinción de ola de viento
Entra en las almas con una sensualidad de arado
Cartel escrito en el claro de dos brazos erguidos
Alcémoslo con la vida

Régimen de la amargura

a

Entré en mí por los prismas de mis ojos

Mi garganta venía perfumada de brisa

Con orgullo de remo mis brazos llegaron mojados de viento

Ya nieve negra mis cabellos afirmaban su eficacia de altura

Miradas con holgura de perspectiva que se borra más allá de los ojos

Piernas de haber traspuesto lo inveterado

Entre pecho y espalda una distancia de un millón de abrazos

Estatura la renovada longitud de un río

b

Me hallé sentado sobre mi ociosidad dando vueltas a las hojas de los libros y de los pensamientos

Yéndome de la tierra me dejé en ella de testigo

Y de vuelta para pedirme cuentas me arranqué el corazón y lo volqué en la mesa igual que una alcancía

Balance mirada y sentimiento vida interior la guerra el comunismo el arte el bien el mal todonada

Yo me puse a llorar sobre mí mismo

Y yo lloré también

Y yo y yo continuamos llorando todavía

c

Afuera está la nada disfrazada de vida
Toda palabra es muda
La mentira ha pintado la cara de las cosas
El sol es un afiche no es el sol
El paisaje se mira pero no es
Amor dolor inventos de la mecánica verbal
Universo objeto de juguetería
La verdad una rueda con dos puntos que se persiguen

Por eso yo y yo lloramos todavía

Uno al lado del otro con nuestro llanto enorme estamos llenando un pozo estamos llenando el mundo para ahogarlo en él

d

Hay un olor de lágrimas en esto

Temática eterna

a

El verso se distiende según lo hace el trayecto de la bala

Parte de mi corazón y llega al tuyo mi lector

Tu corazón se ilumina faro que me recita señales

Las recojo en la cuna de la mano y ahora te las devuelvo

Periscopio te alzo a flor de piel para ver los latidos de los hombres

La menor vibración de nuestra edad la registra tu oído

Los límites de la inteligencia los hace retroceder tu desperezo

Tú lees mis poemas como si fueras encendiendo luces

Se hace bengala la emoción arte milagro de colores

Tu voz corre por mi igual al viento por los callejones

Entra y me barre y sale renacida de mis dos mil atmósferas

Todo lo escribo para tí que me lo dictas

Estoy colaborado de tu aliento mejor

b

Mi lector soy yo mismo

Dibujo de niño

Infancia pueblo de los recuerdos

Tomo el tranvía para irme a él

La evasión de las cosas se inicia con terquedad de aceite que se esparce

El suelo no está aquí

Pasa una nube y borra el cielo

Desaparecen aire y luz y esto queda vacío

Entonces sales de un brinco del fondo inabordable de mi olvido

Fué en el recodo de una tarde señalado de luz por tu silueta

Una emoción sin nombre tenía encadenadas nuestras manos

Tus miradas convocaban mi beso

Pero tu risa río entre los dos corría separándonos niña

Y yo desde mi orilla te postergué hasta el sueño

Ahora tengo treinta años menos de los que me entregaron para darte

Si tu has muerto yo guardo este paisaje de mi corazón pintado en tí

Ornamentación para el amigo

Echo mi voz al ruido como al mar

No importa si naufraga en el oleaje suelto de la ciudad

Desamoblado el pecho en él ya puede descansar el único

Se ahueca el día para darle paso

El silencio arroja su polvo sobre los objetos

Y entra en mí y se tiende a lo largo de mi historia

Yo me hago una iglesia de soledad para escucharle
porque él contiene todos los ruidos igual que el blanco todos los colores

Transita el orbe capta su idioma y me lo trae

Así te tengo cosmos que es mío a la fuerza

Silencio música en reposo poesía en mudez

Sé tu amistad con insistencia de dicha sólo apercibida

Tanto te aclamo que te escribo siempre al final de cada verso

Envergadura del anarquista

Soy apretón de manos a todo lo que vive

Poseo plena la vecindad del mundo

Mi alma llama viva lame las paredes de la humanidad y sin piedad chamusca todo dolor asomado a algún balcón

El arroyo usa un ritmo asilábico aprendido a mi acento

El futuro va enroscado a la inflexión madura de mi voz

Voy colocando postes cada parcela de años

Soy el Amundsen de mí mismo

Cuantos explorándose se acerquen al infinito comprobarán las dilatadas leguas de mi viaje

Habrá un cartel en cada incertidumbre

Hablo y a mis palabras no les falta ni una probable dimensión

Marcho y los caminos quedan habitados para siempre

Grito y de las campanas gotean sonidos porque mis iras apuñalean todas las torres

Donde siembro un odio crece una bandera para los hombres de presente imposible

Nada de sangre me corre un viento por las venas

Mi corazón es una veleta en lo más alto de mi vida

Partida de nacimiento

El fuego mete las manos en mi pecho y lo devora todo incluso tu memoria

Fuego de llamas claras como si ardiera el agua

Soy un incendio blanco

Sombra desdibujada con tiza dentro de la tiniebla

Eso aquéllo lo otro son ceniza

Las llamaradas abrasan las ideas últimas telarañas

Algún recuerdo hace señas en vano

Imposible la subsistencia de la emoción aprendida

Mi carne se recoce barro solo decorado de penas

Piernas vísceras brazos consume esta presencia

Mis pulmones respiran un ambiente una atmósfera de cuadro

Mis muros me contienen más grande a cada pulso

Desde hoy tengo un crecer de humareda constante

Nazco de nuevo en este quemarme posterior

Y sé que con dignidad de muerte llegaré a mi final

GUIA

1. - Programa de Poesía.
2. - Nuevo Autorretrato.
3. - Ubicación de Lenin.
4. - Poema del Saltador.
5. - La Hora Cero.
6. - Biografía de la Palabra Revolución.
7. - Régimen de la Amargura.
8. - Temática Eterna.
9. - Dibujo de niño.
10. - Ornamentación Para el Amigo.
11. - Envergadura del Anarquista.
12. - Partida de Nacimiento.

Cover and inner pages by Emilio Pettoruti for Enrique Eduardo García and Emilio Pettoruti, *Carlos M. Noel: atentado. Por Enrique E. García en complicidad con Emilio Pettoruti*, Buenos Aires. Talleres Gráficos López y Compañía, n.d. [c. 1930?]. 24.2 x 32 cm. Argentine Academy of Letters Collection. Library. Gift by Miguel Lermon

NOEL.

Cover by Emilio Pettoruti for Bernardo Canal Feijóo, *Sol alto (poemas)*, Buenos Aires. "La Facultad," de Juan Roldá y Cía., 1932. 19 x 13 cm. Archivo Lafuente

Cover by Emilio Pettoruti for José González Carbalho, *Día de canciones*, Buenos Aires. El Inca, 1930. 24.8 x 18.8 cm. Archivo Lafuente

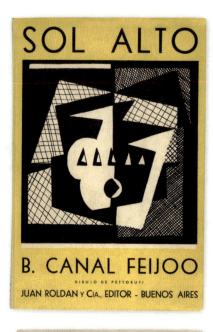

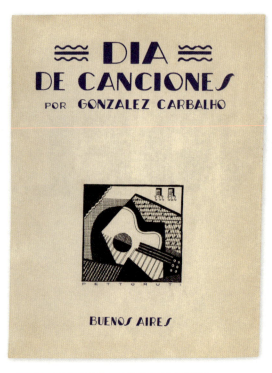

Cover by Emilio Pettoruti for Oscar Fernández Silva, *Córdoba, la "docta" como yo la vi…*, Córdoba. Pereyra, 1930. 17.5 x 12.8 cm. Archivo Lafuente

Cover by Emilio Pettoruti for Bernardo Graiver, *El último de los profetas*, Buenos Aires. Talleres Gráficos Argentinos L. J. Rosso, n.d. [1928?]. 19 x 13 cm. Archivo Lafuente

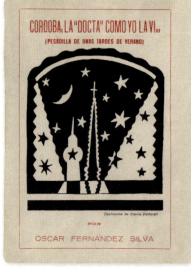

Cover by Ángel Guido (author) for *La machinolatrie de Le Corbusier*, Rosário. Author's edition, 1930. 22.4 × 15.5 cm. Archivo Lafuente

Cover by Manuel Mascarenhas for Manuel Kirs, *Prontuario de lo grotesco (Pantomimas)*, Buenos Aires. J. Samet, n.d. [1928?]. 19 × 13.8 cm. Archivo Lafuente

Covers by Manuel Mascarenhas for José Guillermo Miranda Klix, *Cuentistas argentinos de hoy: muestra de narradores jóvenes (1921-1928)*, Buenos Aires. Claridad, 1929. 18.5 × 13 cm. Private collection, Granada / Archivo Lafuente

Cover by Andrés Guevara for Manuel Alcobre, *Bajo el paraguas*, Buenos Aires. Tor, 1935. 19 x 13 cm. Mariano Moreno National Library, Buenos Aires

Cover by Andrés Guevara for Demetrio Zadán, *Trapecio*, Buenos Aires. Yo, 1936. 20.7 x 14.1 cm. Private collection, Granada

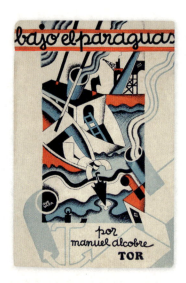

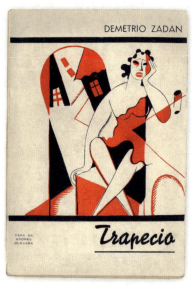

Cover attributed to Andrés Guevara for Omar Viñole, *Cabalgando en un silbido*, Córdoba. Marzano, 1932. 31 x 23 cm. Private collection, Granada

Cover by Andrés Guevara for Horacio Rega Molina, *La posada del león: misterio dramático en tres actos y en verso*, Buenos Aires. Tor, 1936. 19 x 12.7 cm. Archivo Lafuente

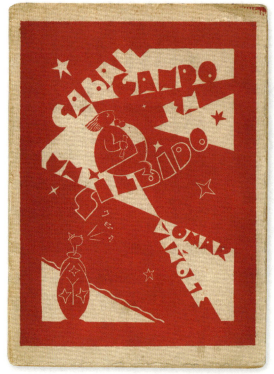

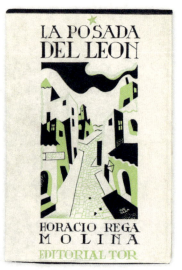

Cover by Andrés Guevara for José González Carbalho, *Cantados*, Buenos Aires. "La Facultad", 1933. 25.6 x 20 cm. Archivo Lafuente

Cover by Andrés Guevara for Raúl González Tuñón and Nicolás Olivari, *Dan tres vueltas y luego se van: espectáculo dramático en 3 actos; divididos en 1 prólogo y 7 cuadros*, Buenos Aires. Tor, 1934. 18.6 x 12.7 cm. Archivo Lafuente

Cover by Andrés Guevara for Ricardo M. Setaro, *El degollador de fantasmas (relatos)*, Buenos Aires. Tor, 1934. 18.9 x 12.7 cm. Archivo Lafuente

Cover by Andrés Guevara for José González Carbalho, *Historias de niños*, Buenos Aires. Anaconda, 1931. 23.7 x 19.2 cm. Private collection, Granada

Cover by unknown artist for Ricardo E. Molinari, *Delta*, Buenos Aires. Francisco A. Colombo, 1932. 24.6 x 16.3 cm. Archivo Lafuente

Cover by unknown artist for Ricardo E. Molinari, *Cuaderno de la madrugada*, Buenos Aires. Francisco A. Colombo, 1939. 17.6 x 11.5 cm. Archivo Lafuente

Cover and inner page by Federico García Lorca for Ricardo E. Molinari, *El tabernáculo*, Buenos Aires. Francisco A. Colombo, 1934. 24.6 x 16.5 cm. Archivo Lafuente

Cover and inner page by Norah Borges for Ricardo E. Molinari, *El pez y la manzana*, Buenos Aires. Proa, 1929. 24.7 x 19.4 cm. Archivo Lafuente

Cover by unknown artist for Ricardo E. Molinari, *Cancionero de príncipe de Vergara*, Buenos Aires. Asteria, 1933. 19.7 x 12.3 cm. Archivo Lafuente

Cover by unknown artist for Ricardo E. Molinari, *La corona: sonetos*, Buenos Aires. Francisco A. Colombo, 1939. 24.2 x 16.4 cm. Archivo Lafuente

Cover by Raúl Soldi for Pedro V. Blake, *Interregno: canciones*, Buenos Aires. Talleres Gráficos Cappellano Hermanos, 1933.
24.5 x 19.1 cm.
Archivo Lafuente

Cover by Raúl Soldi for Francisco di Giglio, *Contrapelo*, Ramón Gómez de la Serna (preface), Raúl Soldi (hand-colored drawings), Buenos Aires. n.p., n.d. [1933?].
24.8 x 19 cm.
Galería Zurbarán Collection, Buenos Aires / The Ryerson & Burnham Libraries, Art Institute of Chicago, Chicago / Private collection, Granada

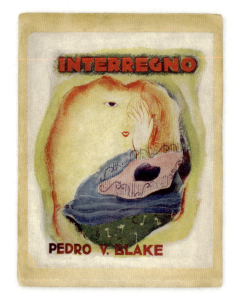
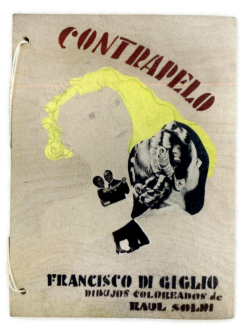
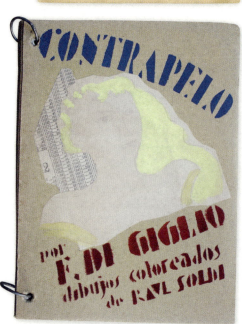
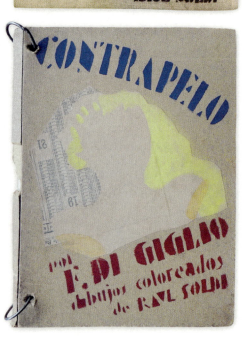

Inner pages by Raúl Soldi for Francisco di Giglio, *Contrapelo*, Ramón Gómez de la Serna (preface), Raúl Soldi (hand-colored drawings), Buenos Aires. n.p., n.d. [1933?]. 24.8 x 19 cm. Private collection, Granada

Cover by Luis Macaya for Justo G. Dessein Merlo, *Aterrizaje: canciones,* Buenos Aires. El Ateneo, 1931. 20.3 x 15 cm. Private collection, Granada

Cover by Ramón Caballé for Marcelo Menasché, *Y van dos...,* Buenos Aires. J. Samet, 1931. 19 x 14 cm. Archivo Lafuente

Cover by Miguel Ángel Ramponi for Jorge Enrique Ramponi, *Colores del júbilo: poemas,* Mendoza. Biblioteca "Almafuerte," 1933. 18 x 16.7 cm. Private collection, Granada / Archivo Lafuente

Cover by Juan Bautista Dell'Acqua for Pedro Jorge Garbi, *Más allá,* Lanús (Buenos Aires). Semáforo, 1933. 18.8 x 14 cm. Private collection, Granada

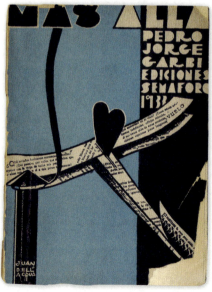

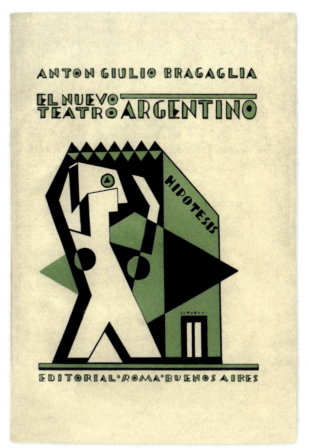

Cover by Emilio Pettoruti for Anton Giulio Bragaglia, *El nuevo teatro argentino: hipótesis*, Buenos Aires. Editorial Roma, 1930. 24 x 16.5 cm. Archivo Lafuente

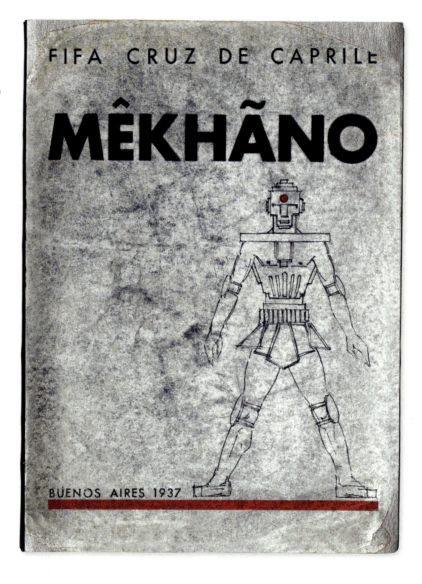

Cover by Horacio Cruz for Fifa Cruz de Caprile, *Mêkhãno: ballet en cuatro cuadros*, Buenos Aires. Gráficas Futura, 1937. 25 x 19 cm. Private collection, Granada

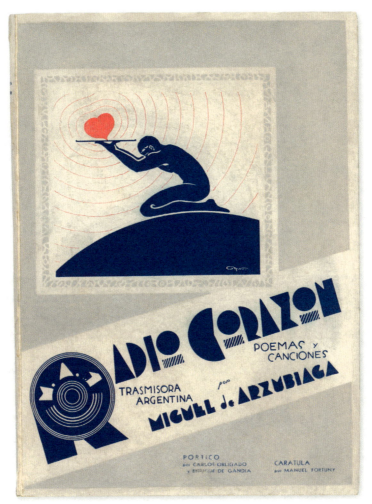

Cover by Manuel Fortuny for Miguel de Arzubiaga, *M. A. 1. Radio Corazón (transmisora argentina): poemas y canciones*, Buenos Aires. La Previsión, 1935. 23.2 x 17 cm.
Archivo Lafuente

Covers by Julio Vanzo for Mateo Booz, *La ciudad cambió la voz (novela)*, Santa Fe. Talleres Gráficos El Litoral, 1938.
19.3 x 13.5 cm.
Private collection, Granada

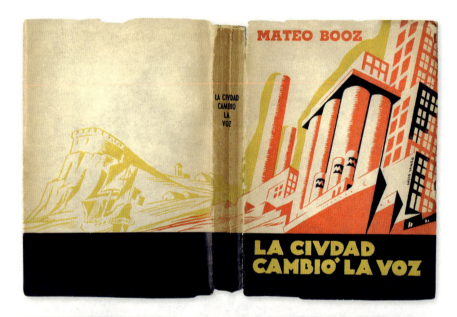

Covers by Julio Vanzo for Alberto Pinetta, *La inquietud del piso al infinito: relatos fantásticos*, Buenos Aires. Nuevo Plano, 1931.
20.1 x 14.1 cm.
Private collection, Granada / Archivo Lafuente

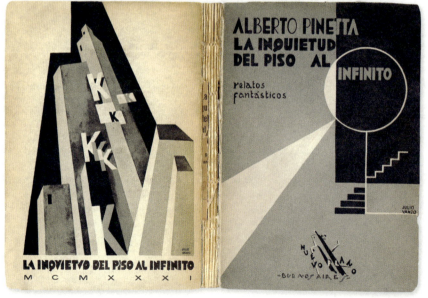

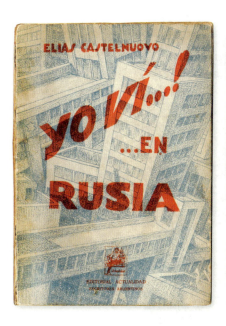
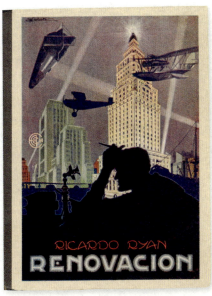
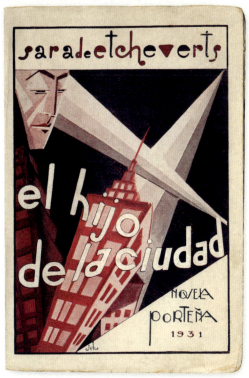

Cover by Abraham Regino Vigo for Elías Castelnuovo, *Yo ví...! ...en Rusia*, Buenos Aires. Actualidad, 1932.
20 x 14.3 cm.
Private collection, Granada

Cover by Carlos Wiedner for Ricardo Ryan, *Renovación: antología escolar*, Buenos Aires. Ángel Estrada y Cía., 1933.
20 x 15.8 cm.
Archivo Lafuente

Cover by J. E. H. for Sara de Etcheverts, *El hijo de la ciudad: novela porteña*, Buenos Aires. Talleres Gráficos Argentinos L. J. Rosso, 1931. 27.5 x 18.6 cm.
Archivo Lafuente

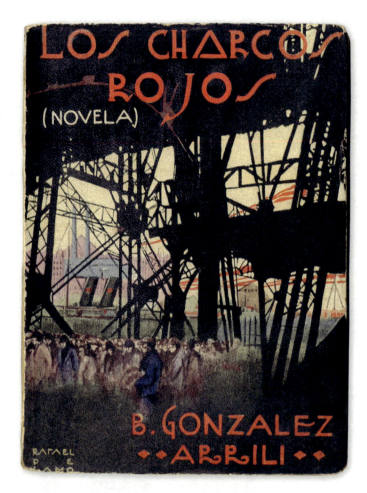

Cover by Rafael de Lamo with typography by Alejandro Sirio for Bernardo González Arrili, *Los charcos rojos (novela)*, Buenos Aires. Edén, Biblioteca Sol, 1927. 18.8 x 13.8 cm. Private collection, Granada

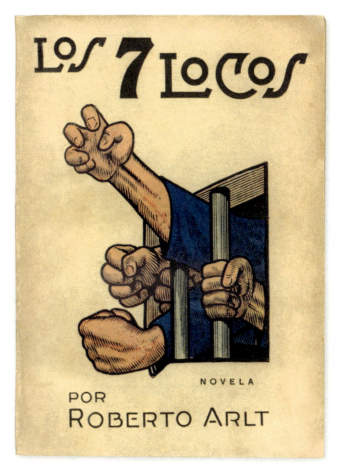

Cover by unknown artist for Roberto Arlt: *Los 7 locos*, Buenos Aires. Latina, 1929. 18.4 x 13.3 cm. Archivo Lafuente

Cover by Pompeyo Audivert for Luce Fabbri, *Camisas negras: estudio crítico histórico del origen y evolución del fascismo, sus hechos y sus ideas*, Buenos Aires. Nervio, 1934.
18.8 x 14.2 cm.
Private collection, Granada

Cover by unknown artist for Emil Ludwig, *Julio, 1914: el mes trágico*, Buenos Aires. Excelsior, n.d. [c. 1930?].
18 x 12.3 cm.
Private collection, Granada

Cover by Demetrio Urruchúa for Ernst Toller, *Una juventud en Alemania*, Buenos Aires. Imán, 1937.
19 x 13.2 cm.
Private collection, Granada

Cover by Lavín for J. Iván de León, *Un anarquista: novela*, Buenos Aires. Tor, 1930.
18.5 x 12.5 cm.
Archivo Lafuente

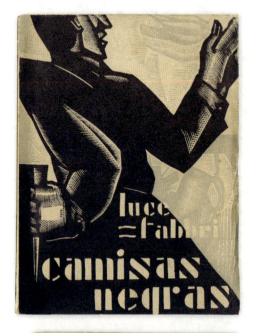

Cover by unknown artist for Edgar Ansel Mowrer, *Alemania atrasa el reloj*, Buenos Aires. Librerías Anaconda, 1933. 19 x 14 cm. Private collection, Granada

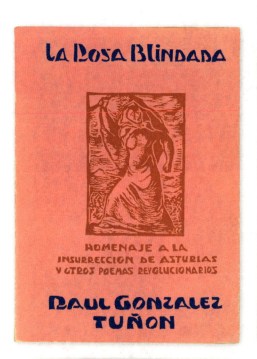
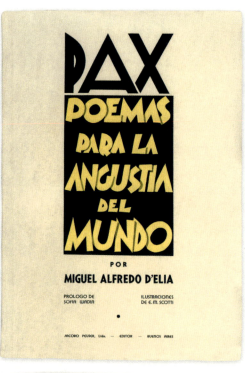

ARGENTINA **155**

Cover and inner page by Demetrio Urruchúa for José Portogalo, *Tumulto*, Buenos Aires. Imán, 1935.
19 x 25 cm.
Archivo Lafuente

←
Cover by Juan Carlos Castagnino for Raúl González Tuñón, *La rosa blindada: homenaje a la Insurrección de Asturias y otros poemas revolucionarios*, Buenos Aires. Federación Gráfica Bonaerense, 1936.
23 x 17 cm.
Archivo Lafuente

Inner pages by Ernesto Scotti for Miguel Alfredo D'Elia, *Pax: poemas para la angustia del mundo*, Buenos Aires. Jacobo Peuser, 1936.
23.7 x 16.7 cm.
Archivo Lafuente

Cover by Julio Vanzo for Juan Lasarte, *Líneas y trayectoria de la Reforma Universitaria*, Rosario. Argos, 1935. 17.5 x 12.8 cm.
Private collection, Granada

Cover by José Planas Casas for Jorge F. Nicolai, *Mortalidad infantil y natalidad*, Buenos Aires. Imán, 1935. Cuadernos Económicos, no. 22. 17.7 x 13.1 cm.
Private collection, Granada

Cover by unknown artist for Ernst Henri, *El plan de Hitler*, Buenos Aires. Mañana, 1934. 19 x 14 cm.
Private collection, Granada

Cover by José Planas Casas for Pierre Besnard, *Mundo nuevo*, Buenos Aires. Imán, 1935. 17.2 x 12 cm.
Private collection, Granada

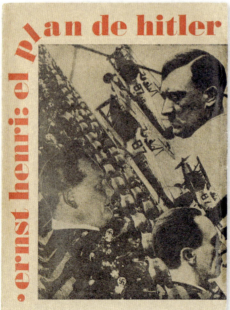

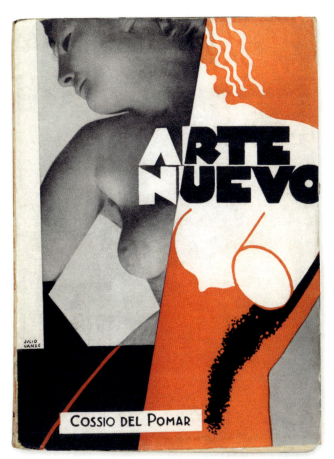

Cover by Julio Vanzo for Felipe Cossío del Pomar, *Nuevo Arte*, Buenos Aires. "La Facultad," Juan Roldán y Cía., 1934. 20.5 x 15 cm. Archivo Lafuente

Covers by Braulio Mate (author) for *Una novela de actualidad: 60 días al margen de una novela contra el comunismo, del 1º de marzo al 1º de mayo de 1933 / Humanización del hombre: un intento de ubicación y restauración científica*, Buenos Aires. Porter Hermanos, 1934. 25.4 x 17.4 cm. Archivo Lafuente

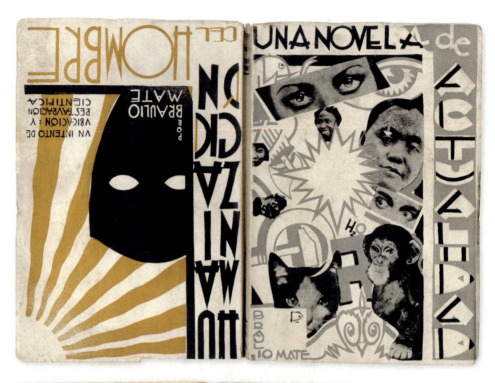

Covers by Eliseo Montaine for Nicolás Olivari, *El hombre de la baraja y la puñalada: estampas cinematográficas*, Buenos Aires. Manuel Gleizer, 1933. 18.5 x 14.5 cm. Archivo Lafuente

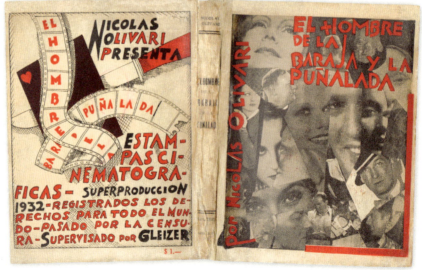

→

Covers by Luis Macaya for Sixto C. Martelli, *Concéntricas: motivos de Buenos Aires*, Buenos Aires. Talleres Gráficos A. Pantié y Cía., 1932. 24.3 x 17.9 cm. Archivo Lafuente

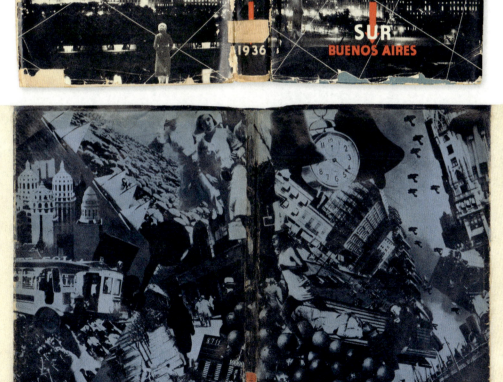

Covers by Attilio Rossi and Horacio Coppola for Eduardo Mallea, *La ciudad junto al río inmóvil*, Buenos Aires. Sur, 1936. 21 x 15 cm. Private collection, Granada

Illustration by Fausto Aóiz Vilaseca for *Amautta: Órgano Mensual de Educación Campesina*, year II, no. 4, February 1942. La Paz. Consejo Nacional de Educación, 28.8 x 18.5 cm. Flavio Machicado Viscarra Foundation, La Paz

Bolivia

Rodrigo Gutiérrez Viñuales

This chapter on Bolivia has no doubt been one of the most difficult to structure, and the essay in which the idea of a "journey without maps" mentioned in the introduction has acquired greater meaning. Indeed, apart from loose notes taken from here and there, and from books that would suddenly appear and we would add to our list—some of which were on the limits of the esthetic standards we had established when drawing up the list of works to be included in the narrative—we believe that our survey lays the foundations for subsequent research that will necessarily have to corroborate its relevance. The Bolivian books we located were so few and so different from one another, like the books from Paraguay, that we decided to offset them by moving them to the cross sections. Eventually, we were satisfied with what we considered was a sufficiently compact collection, and saw we could establish a useful path for those who would like to continue or challenge this study.

At the end of the process, once this chapter had been completed, we learned of the existence of the monumental work titled *Bolivia. Lenguajes gráficos* (2016), published in three volumes by Fundación Simón I. Patiño. While the study doesn't systematically examine most of the material chosen for our theses, it does present a very broad outlook on both historical and contemporary design in the country. As such, it is a great leap for knowledge in the field and a stepping stone toward future research. Hence, our survey complements and expands this task and provides a new means of analysis.

Our journey begins with two books of 1918, written by two of the poets who, along with Franz Tamayo, are considered the most prominent authors in Bolivian Modernist poetry: Ricardo Jaimes Freyre and Gregorio Reynolds. The first works is an edition of *Castalia bárbara*, a book originally published in 1899 by Jaimes Freyre in Buenos Aires, where he had already forged a

friendship with Rubén Darío (like Darío, Jaimes Freyre occupied several positions representing Bolivia abroad); the second book, by Reynolds (another Bolivian diplomat in Brazil and in Jujuy, Argentina, and dean of the St. Francis Xavier University in Chuquisaca, is *El cofre de Psiquis*.

In 1917, that is to say, the year before the publication of the two volumes, a new institution opened that would prove essential for the modern cultural direction of the city of La Paz: the Fine Arts Circle, founded by Ángel Ismael Dávalos, Avelino Nogales and poet and draftsman Raúl Jaimes Freyre, Ricardo's brother who was then based in Tucumán, where he would remain until the year 1921. Raúl was precisely who made the illustrations for the cover of *Castalia bárbara* and of *El cofre de Psiquis*, two comparable Symbolist compositions, in tune with the period, that were virtually identical. The former, signed with the initials R. J. F., presents a somewhat ambiguous figure of Christ, without a cross though in a crucified position; the latter, features the angelical figure of Psyche. Both covers present simple linear drawings, characterized by popular notes and the playful calligraphy of their titles. The authors' names are underlined in the upper left-hand corner of each volume, while the titles appear on the right, in columns, beside a straight line that runs throughout the covers. The two designs can clearly be considered "modern" and therefore provide a perfect starting point for our analysis of Bolivian book covers.

These years, in which the Liberal Party governments, "with positivist pragmatism, preferred engineers to artists and therefore barely supported the arts," as described by Pedro Querejazu (2013), were marked by the first appearance of the figure of the Indian in Bolivian art, that would soon become one of its characteristic traits. This was quite likely a consequence of events such as the performance of the plays *Ollantay* and *Sumaqt'ika* by the Incan Cusco Drama Company on tour in La Paz in 1917, directed by Luis Ochoa, with highly decorative stage sets and costumes. The performance preceded the even more memorable presence of the troupe, this time directed by Luis. E. Valcárcel, on route to Buenos Aires, and its three performances at the Municipal Theater in 1923. Speaking of Bolivian painting, the fact is that in 1918 the painter Arturo Borda, a friend of Gregorio Reynolds, was working on his paradigmatic portrait *El Yatiri*, often mentioned as the first work that depicts an indigenous woman in contemporary Bolivian art. The following year, Alcides Arguedas would publish his emblematic book *Raza de bronce*, whose cover featured a view of Lake Titicaca with an aurochs commanding a canoe, with a perspective that reminds us of some of the photographs taken during those years in the region by Manuel Mancilla.

In the graphic itinerary we are tracing, a key role would be played by some of the artists discussed who were from other Latin American countries and who had either settled or sojourned in Bolivia. To a certain extent, their career followed the opposite path to those of local artists like Víctor Valdivia, from Potosí, who was making a name for himself as an illustrator in Buenos Aires, working for magazines of mass circulation and publishing his designs in books. The most well-known case is that of Luis Toro Moreno from Ibarra, in Ecuador, who fostered the esthetics of Art Nouveau in his country of residence. He left Ecuador after the assassination of General Julio Andrade, and moved to Chile and Argentina before settling in Bolivia in 1916. One of his most outstanding literary connections was with the legendary cultural movement Gesta Bárbara in Potosí, established around the year 1920, when he produced a series of murals for the Palais Concert theater in Oruro, probably his most remarkable work made in the country. In 1921 he made the cover of *El oro negro*, a book by Julián Céspedes Rivero, with a Symbolist, socially driven design in which a group of afflicted

laborers carrying their tools makes its way toward an oil mine, where an allegory of death with her scythe awaits them. The following year, Toro Moreno founded a painting school in La Paz, and in 1923 illustrated the cover of *Horas turbias*, by aforementioned Gregorio Reynolds, another Symbolist design in which the representation of death takes center stage, as in *El oro negro*, in this case handling a pendulum-heart. Toro Moreno returned to Ecuador around the year 1928; in the Ecuadorian section of this book we have included a cover he illustrated in 1932 for *Barro de siglos*, by César Andrade y Cordero (see p. 413), in which his signature Symbolism is still relevant.

The presence of Alfredo Guido was more sporadic, yet he was clearly committed to the culture of the Altiplano. As regards the number of genres he explored—painting, engraving, furniture design, stained-glass windows, ceramics, murals, illustration and a long et cetera—Guido was one of the most prolific artists in the Argentine avant-garde, whose career we have studied in several essays. In 1918, along with José Gerbino, he won First Prize at the 1st National Salon of Decorative Arts in Buenos Aires, with *Cofre de estilo incaico*, that clearly revealed his taste for indigenous and pre-Hispanic ornamentation. In 1920, Alfredo made his (first) long-awaited journey across Peru and Bolivia in the company of his brother, architect Ángel Guido, the main figure of Neo-colonial art in the country.

Distinguished in the technique of etching, on another journey to Bolivia in 1923 he designed a large series of prints with landscape and genre motifs characteristic of the country. He also worked in the field of illustration, in which he designed the cover of *Cuestión de ambiente*, by Gustavo Adolfo Otero (self-christened Nolo Beaz), where we see an indigenous authority, slightly unsteady, dressed in party clothes, a bowler-style hat (over the knitted woolen cap with ear flaps) and a stick, set against an Andean landscape. Another of Guido's pre-Hispanicist drawings made the same year in La Paz, depicts two female figures in the foreground—a spinner and a woman bearing a decorated vessel—and features an Incan building set in a characteristic landscape in the background. This illustration would reappear five years later made for the cover of *Páginas de Bolivia* (1928), published in Buenos Aires by Horacio Carrillo.

Alfredo Guido's "Andean" career would continue over the following years: his Bolivian prints would be displayed to great success at Madrid's Autumn Salon in 1924, and in 1930 he published the splendid portfolio *Aguafuertes del Altiplano* in an extremely limited edition of only fifteen copies in Rosario. By then he had obtained other recognitions such as First Prize at the Argentine National Salon for his *Chola desnuda*, a sort of "Incan Venus," and in 1927 he was praised for his murals with pre-Hispanic and contemporary high plateau motifs to decorate the house of Ricardo Rojas (designed by his brother Ángel) and for that of the Fracassi family in Rosario.

In the mid-1920s, a number of decisive initiatives were undertaken in La Paz that consolidated the city's art scene, in particular the founding of the National Academy of Fine Arts in 1926. In the field of graphic art, despite being a work we couldn't strictly call "modern," mention must be made of the humorous cover that Fernando Guarachi Villarreal, one of the founders of the Academy, created for *Crónicas de la vida inquieta*, by Daniel Pérez Velasco, author whose *Agua de torrente* (1927) he would also illustrate. We have learned these facts in an article by Freddy Zárate (2015) we discovered during our research, devoted precisely to a number of illustrators who designed covers of books by Pérez Velasco. Two main figures described in the article also deserve a mention here, renowned Bolivian artists Genaro Ibáñez and David Crespo Gastelú, both of whom cultivated Indianist and

indigenous features. As for Guarachi, in 1932 he joined the Association of Free Painters of the Earth in Potosí.

In 1928, the year of publication of *Brújula*, by Omar Estrella, one of the avant-garde books *par excellence* both in Bolivia and in the rest of Latin America which included a bunch of visual poems (see p. 718), Ibáñez made one of his most remarkable covers for Pérez Velasco, that of *La mentalidad chola en Bolivia*. Framed by pre-Hispanic decoration, along the lines of other works of the period made in the cultural axis formed by Cusco and Buenos Aires, to a certain extent—bearing in mind their material differences—this design is related to the wonderful carved wooden frames with Tiwanaku motifs we find in certain works by Raúl González Prada (two entitled *Fiesta campesina*) on display at the Museo Nacional de Arte in La Paz. The social content that would characterize Ibáñez's work in the 1930s, once back from Madrid, was foreshadowed in this illustration. Later on, we will return to this moment in connection with other covers designed by Ibáñez.

As pointed out by Zárate, during the following years two further editions would be printed of the book most remembered by Pérez Velasco; the cover of the third would be designed by Crespo Gastelú. Nevertheless, before discussing it in greater depth we shall refer to another cover by Genaro Ibáñez, made for the poem collection *Cuando el alma siente* (1929), by M. Teresa Solari, in which the graphic design was even more polished and framed the composition, as in the case of the previously mentioned copy. This time, however, although the ornamentation evoked pre-Hispanic motifs, its zigzagged lines had more in common with Art Deco. The drawing is of a rural, nocturnal landscape with a moon and a star shining in the sky, and high branches above which flutter a butterfly. The bell gable of a church appears in the lower area, before a radiant half-sun. The predominance of black ink forms a balanced contrast with the green ink of the title in the center of the composition, with its strongly Expressionist calligraphy. Shortly after making this work, Ibáñez moved to Madrid, where he trained in engraving techniques under Galician master Manuel Castro Gil. He went on to study at the San Fernando Royal Academy of Fine Arts, from where he graduated in 1934, shortly before returning to Bolivia.

We shall now refer back to the third edition of *La mentalidad chola en Bolivia* (1930), in order to focus on the author of the illustrations, David Crespo Gastelú. Self-taught, Crespo Gastelú had been working as an artist for a luster, chiefly in the field of caricature. Indeed, the above-mentioned cover is distinguished by its cartoon, a large green stain that provides the background of the composition and evokes the art of Luis Bagaría, specifically the porticos he had created years before and were published in the Madrid magazine *España* (1915-1924) founded by José Ortega y Gasset, widely distributed in Spanish-speaking countries. This was an age in which the circulation of illustrated reviews throughout the continent was a constant factor. In the lower area of the cover of the book by Pérez Velasco, the mention of the "third edition" featured prominently in large red-ink letters (like the title), as a way of emphasizing the book's success.

More interesting, however, was Crespo Gastelú's design for another book published the previous year, *Sombras de mujeres* (1929), by Alberto de Villegas. In this volume, the author glosses a series of "lives" of women—intellectuals, literati, artists, adventurers, transgressors—some from past centuries, such as Saint Rose of Lima or La Perricho. and other more contemporary figures, such as María Bashkirtseff, Chilean Teresa Wilms Montt or Isadora Duncan. The main point of interest is the fact that besides the cover, the artist designed several illustrations for the inner pages. Although the presence of the caricature for which he was usually known—and which, to a

certain extent, would pervade his entire career, as recalled by Pedro Querejazu (2015)—isn't that obvious here, neither do the designs stand out for the modernity they would acquire in the 1930s. In this case, the illustrations are tinged with Symbolism, and are especially inclined towards Orientalism.

Conceptually close although esthetically different, *Ciudad de piedra*, by Manuel Frontaura Argandoña, was also published around this time and has one of the most interesting covers of the decade, designed by Pacheco U. Markedly modern, the illustration appears in the lower right-hand corner and the rest of the composition is spacious; in some of the copies the author used the space for his handwritten dedications. Inside a vertical rectangle of green ink (the same ink used for the title, in bold calligraphy) a nocturnal scene featuring a skull—Symbolist icon *par excellence*—is presided over by what appears to be a question mark. The scene is flanked by a series of trees in the negative (white on black) that could also be sheer mountains, and are the leitmotif of several of the book's inner illustrations. Solitary landscapes, some of them deserted, verging on the metaphysical, make the ensemble one of the most outstanding examples of modern Bolivian illustration at the end of that decade.

Manuel Frontaura Argandoña and his sister María were members of the Bolivian intelligentsia who sought inspiration in pre-Hispanic art. María Frontaura Argandoña, like David Crespo Gastelú, belonged to the intellectual circle of Alberto de Villegas. The group's connections, particularly Gastelú, have recently been studied by Mary Carmen Molina Ergueta (2017). In December 1931 the Indianist Week / Pro-Native Art Crusade was organized in La Paz by Villegas, María Frontaura Argandoña, and archaeologist Arturo Posnansky. The activities staged included a visit to the ruins of Tiwanaku—an incarnation of the glorious past that were regarded essential for Bolivia's promising future—and another to the *ayllu* or community school in Warisata. In both cases, the idea was to promote knowledge of what they considered to be the legitimate autochthonous art of the country. Much of the research and reflections on these issues that we owe to Villegas (who passed away in 1934) appeared in Buenos Aires newspapers, especially *La Nación*, which was distributed in La Paz (see Brusiloff et al., 2013).

Although a few examples of pre-Hispanic graphic art can be found in Bolivian books of the 1920s, such as those published by Sociedad de Autores Teatrales (see p. 747), they were explored to a much greater extent in Peruvian and Argentine editions, some of which were also known in La Paz. Not until the following decade would more significant works be produced along these lines, chiefly by Crespo Gastelú. Before describing the relevance of his designs, however, we must mention another artist, Emilio Amoretti Cassini, two of whose works we discovered during our research and whose true importance remains to be established. Of Italian origin, Amoretti Cassini settled in La Paz in 1922. Despite the decade elapsed between the publication of the first and the second books whose covers he illustrated, both designs share the same subject matter and the same pre-Hispanic esthetic reflection. The lower half of the composition on the first cover, *Reflexiones* (1929), by Adhemar Gehain, depicts a Tiwanaku door, while the upper half is particularly outstanding for its ornamentation of the pre-Hispanic calligraphic title and the geometric decoration of Incan origin. These latter traits proved equally effective ten years later, in the cover of *Memorias histórico-políticas* (1939), by Vicente Pazos Kanki.

Nevertheless, the most prominent work of those we have surveyed in this "pre-Hispanic" journey is the graphic design of the book *Mitología aymara khechua* (1935), by aforementioned author María Frontaura Argandoña. The notable full-scale illustrations on

the cover and inner pages are filled with avant-garde calligraphy, geometrized figures—some of which can be described as neo-popular—and ornamentation that complement the scenes. The figures are by one of the foremost Indianist painters of the period, Alejandro Mario Yllanes, husband of María Frontaura Argandoña and maker of the mural paintings of the Warisata School.

During the celebrations of the Indianist Week, María Frontaura Argandoña delivered the lecture "El problema del indio." She had previously delivered a speech on occasion of the 25th International Congress of Americanists held in La Plata (Argentina), and had published her book *Hacia el futuro indio* (1932) in La Paz. The illustration for the cover of this volume was a socialist theme featuring two native Americans, the man tilling the land with a modern tractor and the woman working at other tasks, all framed by pre-Hispanic ornamentation, the same as was applied to the lettering of the title. This composition and the inner woodcuts, that alternated the social imaginary with reproductions of pre-Columbian works, were by Max Portugal Zamora, who had trained as an artist at the School of Applied Arts in La Paz and as an archaeologist with Arturo Posnansky. The following year, Portugal Zamora made a series of vignettes for the volume *Más fuerte que la tierra*, by sociologist Alfredo Sanjinés. This book, published at the height of the Chaco War, was conceived to teach the origins of Andean culture in schools, and also contained reproductions of oils by Cecilio Guzmán de Rojas and archaeological drawings by Hugo Salas.

By this time, the first artistic-cum-literary collaboration of another married couple—Gloria Serrano (pen-name of Rosenda Caballero Ambolumbet) and previously mentioned David Crespo Gastelú—was in the making. Crespo Gastelú had travelled repeatedly to Lake Titicaca and the Corocoro region, where he had farmlands, and during his journeys he sketched landscapes and indigenous figures that would form the basis of his subsequent production (Querejazu, 2015), leading Carlos Salazar Mostajo (1989, 75) to consider Crespo Gastelú of the same status as Cecilio Guzmán de Rojas among "Indianist" painters, the one "from a rational stance, and the other from a sensitive angle." Another art historian, Rigoberto Villarroel Claure (1952, 49), declared that Crespo Gastelú's best composition was the one titled *Venta de Karachis*, a small illustration reproduced in the book *Jirones Kollavinos* (1933), by his wife, Gloria Serrano. Indeed, this was the couple's first known joint literary and artistic project in the field of illustrated books. The cover, decorated with a localist cartoon, stands out for its overall design and Art Deco calligraphy, its balanced use of black and red ink, and the vertical off-center line that divides the space into two planes, placing the authors' names on the left, along with the year of publication in a column of Roman numerals.

These are key years for Crespo Gastelú. In 1932, year when the Chaco War between Bolivia and Paraguay broke out (1932-1935), which he would illustrate—as would Guzmán de Rojas, among other artists—he won the First Gold Kantuta Prize at the Indianist Salon. In March 1934, along with Gloria Serrano and the Núñez del Prado sisters, Marina and Nilda, the poet Yolanda Bedregal and her brother Gonzalo, he travelled to Cusco on occasion of the festivities commemorating the fourth centenary of the city's foundation by the Spanish. The following month, Crespo Gastelú displayed his work at the city's Municipal Theater, sharing the exhibition space with Marina Núñez del Prado, Cecilio Guzmán de Rojas, and Jorge de la Reza. After visiting several archaeological sites and colonial settlements (Anta, Chinchero, Ollantaytambo, Pisac, San Jerónimo, San Sebastián), the journey culminated in an ascent of Machu Picchu, an unforgettable adventure through an area

difficult to access via the "labyrinth of mountains that must be crossed to arrive at the magical, thousand-year-old city," as described by Marina in her memoirs (Núñez del Prado, 1973, 33). The book titled *Tierras del Kosko* (1938), on which Serrano and Cresp Gastelú again worked together, was produced as a result of the journey and shall be studied later in further detail.

1934 was also the year in which Crespo Gastelú designed the splendid cover for the collection of poems titled *Wipfala: cantos del dolor del indio*, by Arequipa-born author Carlos Gómez Cornejo based in La Paz, a book of Andean subject matter with some activist content. On the cover, the two-colored, calligraphic letters of Incan inspiration (that Riccardo Boglione is tempted to consider an anticipation of the pixelated letters of the 1980s), most of which are placed diagonally, are arranged on a background that actually depicts the *wiphala*, the colorful, geometrized standard representative of several Andean cultures, particularly the Aymara, to whose origin Gómez Cornejo dedicates one of his compositions. One issue that worries us is that in the colophon of the two copies we have seen of the book, stating that "the cover and caricature were made by David Crespo Gastelú," the word "cover" has been crossed out, as if to deny the artist's authorship; we have been unable, however, to discover the reason for this.

In 1935 Crespo Gastelú broadened his subject matter considerably, to include indigenous fairs and religious motifs, among other genre scenes, with a dramatic esthetic and "a peaceful accent, a slow rhythm, bonded with the land; and placid men, of a stony race, gnawing away at their monotony;" his paintbrush goes in search of "collective scenes, mass approaches, the panorama that is objectified in the distance and that physiognomizes rural scenes. The landscape is a complement that closes the frame" (Villarroel Claure, 1952, 48).

This gentle penetration, lacking any aggressiveness in the physiognomy of the Indian, is what prompted Salazar Mostajo not to include him among the "Indigenists," and place him instead among the "Indianists," posing the difference between the two terms that are quite common in today's historiography, in order to differentiate social criticism from esthetic pretension. No doubt, Crespo Gastelú was already familiar with the paintings by artists belonging to the Peruvian Indianist school, especially those by the master José Sabogal, together with works by other artists such as his disciple from Cusco, Camilo Blas, possibly Jorge Vinatea Reynoso, Manuel Domingo Pantigoso (whose taste for decorativism, dynamic characters and expressive lines he shared), and two artists who also took part in the expedition to Machu Picchu, Francisco Olazo and Alejandro González Trujillo, "Apu-Rímak." In 1936, as if to ensure that he did not forget his roots, he became one of the organizers of the First National Salon of Humorists.

1938 (despite the fact that the cover bears, in Roman numerals, the date of MCMXXXIX) saw the publication of Crespo Gastelú's best work as a book illustrator, *Tierras del Kosko*, by Gloria Serrano. The graphic design included reproductions of several of the paintings, drawings, and woodcut vignettes inspired by the journey to Cusco and its region. For the upper part of the cover, he chose one of the genre scenes most admired by artists working there, the *pascana*, i.e. a stop made by a group of native Indians on a voyage. In the inner pages of the book the repertoire of illustrations is wide and varied, and forms a perfect complement to the "fourteen friezes" or chapters explored by Gloria Serrano. For both artists, this book was one of the keys to the dissemination of their respective works abroad, and its continental circulation was greater than that of *Jirones Kollavinos*; every now and then a copy still appears in private collections, particularly in Buenos Aires. Crespo

Cover by José Rovira for
Academia Nacional de Bellas Artes. Exposición (exh. cat.), La Paz. Fénix, 1937.
26.1 x 18.9 cm.
Private collection, Granada

Gastelú's oeuvre would also be admired in Chile, where in 1939 he was awarded Second Prize at the Official Fine Arts Salon in Santiago.

Let's get back to Salazar Mostajo's proposal of grouping Crespo Gastelú among the "Indianists" (rather than the "Indigenists"), on account of what he considers his lack "of any aggressiveness in the physiognomy of the Indian." Contrarily, other artists expressed themselves in images of social activism. Along these lines, the figure of the poet and artist Pablo Iturri Jurado is quite relevant, largely rediscovered in recent years by Alan Castro Riveros (2015-2019). Here we shall focus only on his graphic work, initially Symbolist in nature, as reflected in his illustrations for the review *Argos* (1923) and in the cover for *Ansiedad. Poemas de antaño y hogaño* (1928), by Víctor Ruiz, which proves the persistence of the style well into the decade.

By then, Iturri Jurado had begun to sign his works with the initials R. L., for his brush name Román Latino, that would appear in yet another

cover illustration the following year, that of *La Revolución* (1929), a literary work by Aureliano Belmonte Pool (under the pseudonym Ramsés), where Symbolist traits were complemented by an Expressionist air and an allusion to social issues. A range of different elements coexist in this design: long red flames taper in the background, behind a representation of the classicist Legislative Palace in La Paz. In the center of the scene, a giant dragon is depicted in green ink; besides having originated the blaze, the dragon sharpens its claws close to a group of demonstrators. Especially worth a mention, in purely ornamental terms, are the L of the title, located in the upper middle area, and the design in the lower right-hand corner, both of which are characterized by pre-Hispanic traits. This novel by Ramsés is usually considered a slight anticipation of Bolivia's social revolution, as in the case of his *Carne de conquista* (1927) as regards the Chaco War.

To return to Iturri Jurado, in an attempt to embrace Indigenism— a growing ideology in those years—he decided to change his brush name to that of Ramón (or Ramún) Katari, name under which he signed the illustrations of *Aukakallu*, a book "of Aymara novels and legends" published by Víctor M. Ibáñez in 1930. In *Aukakallu* he consolidated his prestige in the art of woodcutting, a discipline in which he had already proven his worth when designing the cartoons for *Inti* magazine he had co-founded and co-edited with Francisco Villarejos between the years 1925 and 1926 in La Paz, and to which Arturo Borda, Fernando Guarachi, David Crespo Gastelú, and Genaro Ibáñez would also contribute works (Ortiz et al., 2016-2017, 41-44).

One of the masterpieces of the Bolivian Indigenist avant-garde, and possibly the most noteworthy volume of those we have surveyed in this chapter, would be the high point of his woodcut engravings: his own book *Hathawi* ("genesis" in Aymara), which he signed as Ramón Katari and published in 1931 under the illustrative subtitle of "poems in wood and verse." Prefaced by the Peruvian author Serafín Delmar (pen-name of Reynaldo Bolaños Díaz), Katari mentions "La Paz (Bolivia)" as the place of publication of the book, adding the significant reference "Indoamerica." As explained by Alan Castro (2015), in *Hathawi* Ramón Katari "creates an Andean typography hieroglyphical of the Latin alphabet." Besides the splendidly colorful woodcut cover dedicated to Indigenist-pre-Columbian subject matter, *Hathawi* has a sort of central booklet made up of a series of twelve full-page woodcuts, some of markedly social and revolutionary content, whose impact was reinforced by a unconventional format for poetic compilations that in this case measures 30 x 25 cm.

When *Hathawi* was launched, the conflict between Bolivia and Paraguay was in the making. The Chaco War mentioned in several parts of this essay would give rise to numerous literary works and artistic creations (see Pentimalli, 2008). In the field of illustrated books, one of the best expressions of those published in La Paz is *Poemas de sangre y lejanía* (1934), where Raúl Otero Reiche poetically transcribes the pathetic feelings triggered in him by his participation in the warfare, in Detachment 115, from the confrontation of combatants to a tragic view of the war scenes. The cover of this collection of poems was designed by renowned painter Jorge de la Reza, who summed up the horror in the four distressed military figures depicted in red ink. Another remarkable work is *Mirajes de un soldado* (1935), by Julio C. Guerrero, highly Symbolist, signed by Fausto Aóiz Vilaseca, an artist renowned above all for his career as a sculptor who in those years was associated with the Warisata School.

Several of the most distinguished literary works related to the Chaco War by Bolivian authors were launched outside the country. Santiago de Chile, Buenos Aires, and, in some cases, publishing houses belonging to the Madrid-Barcelona axis,

were receptive to these works and offered to distribute them. Emblematic books like *Aluvión de fuego* (1935), by Óscar Cerruto, *Sangre de mestizos* (1936), by Augusto Céspedes, with a wonderful cover-cum-poster by Arturo Adriasola, and *Prisionero de guerra; la novela de un soldado del Chaco* (1936), by Augusto Guzmán, were published in the Chilean capital, the latter in 1937. In those same years, another writer, Tristán Marof (penname of Gustavo Adolfo Navarro Ameller) would release his books in Buenos Aires and Montevideo; in 1934, the Argentine publishing house Claridad launched *La tragedia del altiplano*, with a cover designed by Herminio Rondano.

As regards social subject matter in Bolivian art, the work produced by artist Genaro Ibáñez upon his return from Madrid was also impressive. Chiefly dedicated to prints, after his sojourn in the Spanish capital, where he trained under Castro Gil, he became an expert in the technique of linocutting. In this context of Bolivian graphic art, the well-remembered exhibition of works by Belgian-Argentine artist Víctor Delhez on the Holy Gospels staged in 1936 at the Military Circle in La Paz was no minor event. Fine examples of Genaro's book illustrations of these years are the cover of *Rumbo socialista* (1936), by Félix Eguino Zaballa, in which he already proves himself as an artist whose work is diametrically opposed to the image of the "amicable" Indian portrayed by Crespo Gastelú and even by Guzmán de Rojas, and rather as a true "Indigenist" on account of his frank expression. The illustration shows a tight group of native Indians, as if on a march. In effect, the theme of demonstrations would be explored throughout the continent, including the Argentine Antonio Berni, the Cuban Marcelo Pogolotti, and, of course, numerous Mexican artists.

This illustration anticipated what has been considered Ibáñez's most transcendental work, the print titled *Rebelión* (1937), set in the style of Social Realism. Starting from previous compositions, such as the illustration for Eguino Zaballa's book, this design goes one step further for, as described by Salazar Mostajo (1989, 92), it reveals: "A crowd brandishing sticks, their eyes like dark sockets, with no white or pupil, their mouths open in wailing screams ... Taken to Viña del Mar, this work deserved second prize. Here it became a poster advertising rural schools, which rather than favor them contributed to their destruction a few years later, confirming the libertarian position they had adopted, under the guidance of Warisata. So, that was a picture that would be repeated several times by Ibáñez, who was never satisfied with what he'd done, and embarked on a tenacious search for perfection and synthesis ... Race in progress! This could be Ibáñez's masterpiece ..."

Aside from these affiliations albeit at the same time and in the same place, new forms of graphic expression applied to books were appearing that, in some cases, revived and revised esthetic trends that had emerged the previous decade, from Art Nouveau and Art Deco to caricature, Expressionist traits and even post-Cubist faceting. Such is the case of a publication in Cochabamba of *Sonetos y poemas* (1932), by Brazilian author Gilka Machado, whose Symbolist portrait dominates the cover. This work brought together Gregorio Reynolds as translator (reminiscences of his past as a diplomat in Brazil) and Argentine author Arturo Capdevila as prologue writer.

These "continental" links, that only confirm what we indicated earlier in the paragraphs dedicated to literature during the Chaco War, were heightened in other works, such as *Poemas de ultramar* (1935), by Chilean Víctor Domingo Silva, published in La Paz. Its treatment of marine subject matter (who would have thought that a war was being waged?) harked back to the 1920s, and the illustration was entrusted to Hugo Loayza, an artist on whom we still have little information. From the same period are his covers for *Realidades de la guerra* (1935), by Lizardo

Álvarez, a plaintive composition that also focused on the Chaco War, and *Figuras animadas*, a book published by Juan Francisco Bedregal around the year 1935, when he was dean of the Greater University of San Andrés in La Paz (1930-1936). For the inner engravings of the volume, Bedregal, one of the figures of Bolivian modernism and father of the poet Yolanda Bedregal, counted on the collaboration of Santiago Rosoli Dávila, who was also a photographer. The cover by Loayza alternates black and red ink, playfully combined in the calligraphic title and in the two planes of silhouetted figures, in the middle of a dance.

In the postwar period, modern Bolivian graphic art would continue to produce highly relevant artistic and literary works. Such is the case of *Pirotecnia* (1936), the only book published during the lifetime of the poet Hilda Mundy (pen-name of Laura Villanueva Rocabado, and daughter of the well-known architect Emilio Villanueva), that she presents as a "faint-hearted experiment in Ultraist literature" and closes with a colophon that reads: "The quixotism of writing a book has been consummated." The cover, by the then young artist Gil Coimbra Ojopi, who had been on the war front and made several drawings and paintings of combat scenes and soldiers, reveals a more optimistic outlook, featuring skyscrapers and a modern automobile penetrated by two fleeting pyrotechnic rays whose semicircular form also appears in the book's title. In the foreground, the figure of a modern young girl, her nape raised and a distant look in her eyes, completes the scene. In contrast, the cover by an unknown artist of the novel *Rodolfo el descreído* (1939), by David S. Villazón, is dominated by the full-size figure of a gentleman in tails, and the two-colored shadows of two buildings and other less relevant elements, all printed on a silver background. This cover is also distinguished by its vertical title in Art Deco calligraphy.

Another notable post-Symbolist and geometric work is the design by the artist from Cusco, Mariano Fuentes Lira, based at the time in La Paz following his exile in 1935, for the book titled *Prisma* (1938), by Gregorio Reynolds. One of the most outstanding covers in Peruvian and Bolivian graphic art presents a popular design with playful calligraphy inspired by geometric avant-garde trends; hand-pasted on the inner pages of the volume are creative illustrations printed on glossy paper featuring figures in the foreground and several geometrized backgrounds verging on abstraction.

That same year, Fuentes Lira—known to his friends as Manolo, which explains why he is sometimes quoted as Manuel Fuentes Lira, as he appears in fact in *Prisma*—was creating other notable graphic designs, such as the drawings for *Huilka. Cuentos del Kosko* (1938) (see p. 759), by Fausto Burgos. One of the Argentine authors more inclined to explore indigenous and pre-Hispanic themes—perhaps along with Ernesto Morales—then active in the town of San Rafael (Mendoza), Fausto Burgos had published several works with covers illustrated by Víctor Valdivia from Potosí, like *La cabeza del Huiacocha* (1932), *Cachisumpi. Cuentos de la Puna* (1934), and *El salar* (1935), all released by Butti publishing house in that city. As to Fuentes Lira, he was working on the preparation of one of his masterpieces: the carved sculptures and doors for the Warisata School (during the years of the Second World War, 1939-1945) which, according to Carlos Salazar Mostajo, is the most outstanding decorative work produced in Bolivia.

As a colophon, we would like to repeat our opening remarks: we sincerely hope that these notes can help future authors extend this repertoire of examples, esthetics, artists and authors, and hence broaden the discourses surrounding book illustration and graphic art in Bolivia as an exceptional chapter in the history of art in the country. Our study is, of course, rudimentary, but we are convinced of its future expansion.

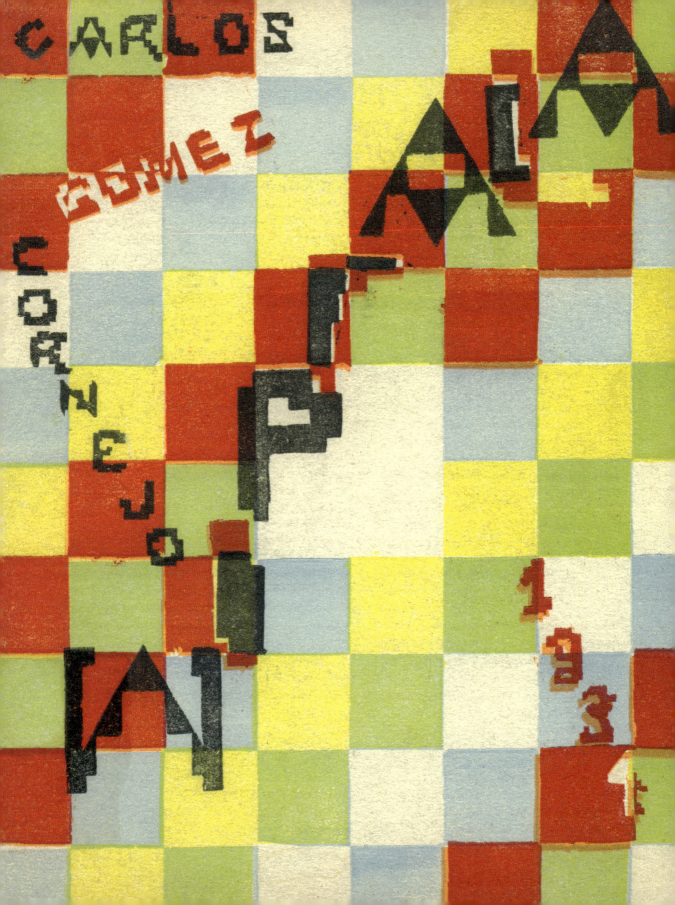

Bolivia

Cover by Raúl Jaimes Freyre for Gregorio Reynolds, *El cofre de Psiquis,* La Paz. Alfredo H. Otero, 1918. 19.5 x 13 cm. Archivo Lafuente

Cover by Luis Toro Moreno for Gregorio Reynolds, *Horas turbias,* La Paz. Renacimiento, 1923. 19.5 x 14 cm. Flavio Machicado Viscarra Foundation, La Paz

Cover by Alfredo Guido for Gustavo Adolfo Otero (Nolo Beaz), *Cuestión de ambiente,* La Paz. E. Riccio, 1923. 18 x 11.8 cm. Private collection, Granada

Cover by Genaro Ibáñez for Mª Teresa Solari Ormachea, *Cuando el alma siente: poesías,* La Paz. López, 1929. 19.7 x 14.4 cm. Private collection, Granada

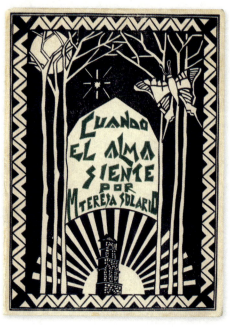

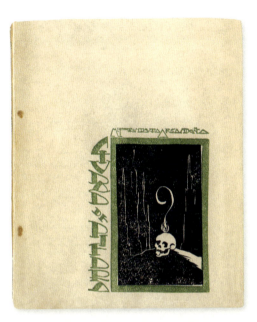
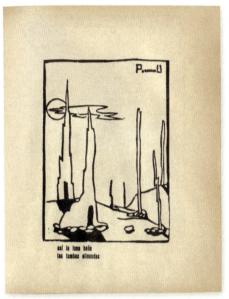
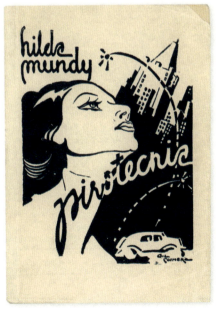
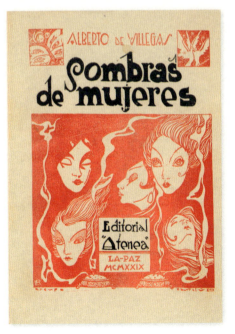

Cover and inner page by Pacheco U. for Manuel Frontaura Argandoña, *Ciudad de piedra MCMXXVIII-MCMXXIX*, La Paz. Sagitario s.c., n.d. [1929?], 18 x 14.5 cm. Private collection, Granada

Cover by Gil Coimbra Ojopi for Hilda Mundy, *Pirotecnia*, La Paz, n.p., 1936. 19.2 x 13.8 cm. Flavio Machicado Viscarra Foundation, La Paz

Cover and inner page by David Crespo Gastelú for Alberto de Villegas, *Sombras de mujeres*, La Paz. Atenea, 1929. 20 x 15 cm. IberoAmerican Institute – Prussian Cultural Heritage Foundation, Berlin

Cover by J. Torres Donoso for Jaime Mendoza, *El lago enigmático: novela*, Sucre. Charcas, 1936. 19 x 14 cm.
Latin American Arts and Literature Documentation Center, Simón I. Patiño Space, La Paz

Cover by González y Medina for Alcides Arguedas, *Raza de bronce*, 2nd edition, La Paz. González y Medina, 1919. 19 x 14 cm.
Latin American Arts and Literature Documentation Center, Simón I. Patiño Space, La Paz

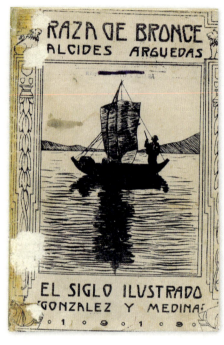

Cover by Emilio Amoretti Cassini for Adhemar Gehain, *Reflexiones*, La Paz. Talleres Gráficos de la Librería Cervantes, 1929. 18.9 x 13.5 cm.
Private collection, Granada

Cover by Emilio Amoretti Cassini for Vicente Pazos Kanki, *Memorias histórico-políticas*, La Paz. Ministerio de Educación, Bellas Artes y Asuntos Indígenas, 1939. 18.5 x 13.4 cm.
Private collection, Granada

Cover by unknown artist for Gilka Machado, *Sonetos y poemas*, Cochabamba. López, 1932. 25.5 x 17 cm. Archivo Lafuente

Cover by Genaro Ibáñez for Daniel Pérez Velasco, *La mentalidad chola en Bolivia*, La Paz. López - Talleres La Patria, 1928. 19.7 x 14.1 cm.
Flavio Machicado Viscarra Foundation, La Paz

Cover and inner pages by Ramón Katari (pen-name of Pablo Iturri Jurado) for Víctor M. Ibáñez, *Aukakallu (hijo del diablo). Segundo libro de novelas y leyendas aymaras*, first volume, La Paz. Tipografía Económica, 1930.
22.5 x 15.3 cm.
Flavio Machicado Viscarra Foundation, La Paz

Cover and inner page by David Crespo Gastelú for Gloria Serrano and Crespo Gastelú, *Jirones Kollavinos,* La Paz. Escuela Salesiana, 1933. 22 × 23 cm. National Library of Peru, Lima

Cover and inner page by David Crespo Gastelú for Gloria Serrano and Crespo Gastelú, *Tierras del Kosko*, La Paz. Renacimiento, 1938.
21.7 x 22 cm.
Private collection, Granada

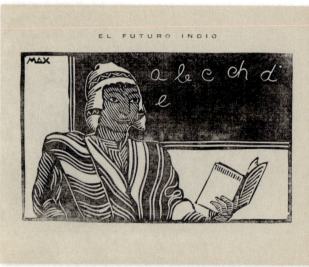

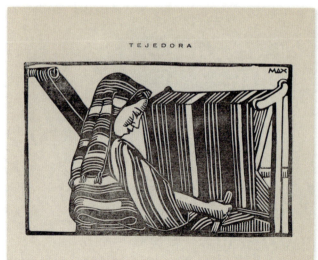

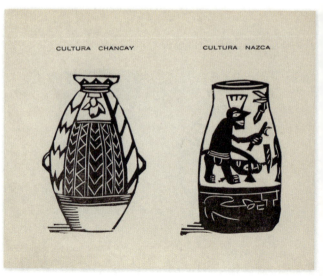

Cover and inner pages by Alejandro Mario Yllanes for María Frontaura Argandoña, *Mitología aymara khechua*, La Paz. Editorial América, 1935. 16.7 x 12 cm. Private collection, Granada

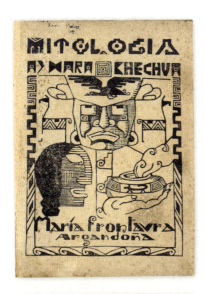
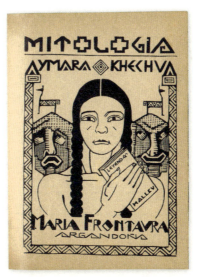

←
Cover and inner pages by Max Portugal Zamora for María Frontaura Argandoña, *Hacia el futuro indio*, La Paz. América, 1932. 17 x 21 cm. IberoAmerican Institute – Prussian Cultural Heritage Foundation, Berlin

Cover and inner pages by Manuel Fuentes Lira (brush name of Mariano Fuentes Lira) for Gregorio Reynolds, *Prisma*, La Paz. Biblioteca de la Revista México, 1938.
19.5 x 14.2 cm.
Private collection, Granada

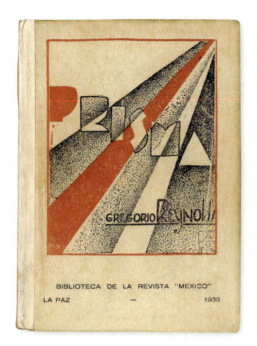
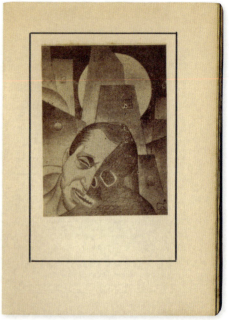
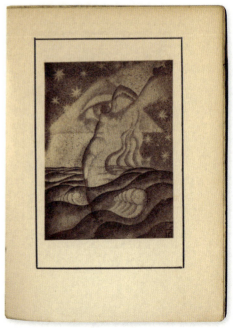

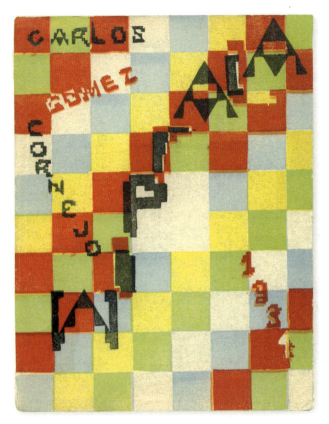

Cover by David Crespo Gastelú for Carlos Gómez Cornejo, *Wipfala: cantos del dolor del indio*, La Paz. Talleres Gráficos de la Editorial Boliviana, 1934.
23.5 x 18.1 cm.
Casa del Poeta, La Paz

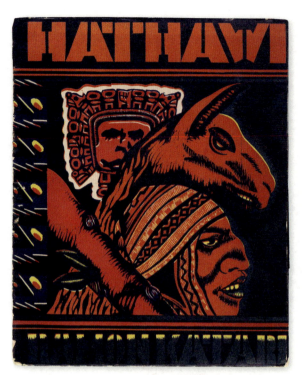
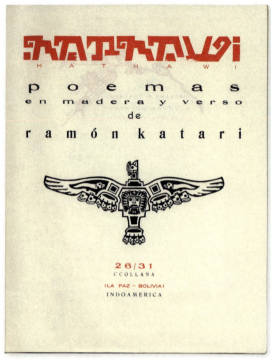
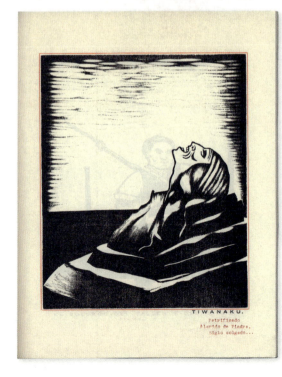
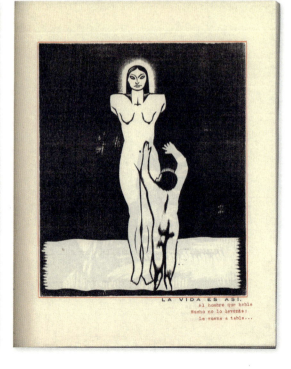

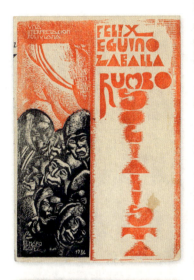

Cover by Genaro Ibáñez for Félix Eguino Zaballa, *Rumbo socialista*, La Paz. Talleres Gráficos de la Editorial Boliviana, 1936. 20 x 14 cm. IberoAmerican Institute – Prussian Cultural Heritage Foundation, Berlin

Cover by Cecilio Guzmán de Rojas, Max Portugal and Hugo Salas for Alfredo Sanjinés, *Más fuerte que la tierra*, La Paz. Renacimiento, 1933. 27.5 x 19 cm. Private collection, Granada

Cover by Jorge de la Reza for Raúl Otero Reiche, *Poemas de sangre y lejanía*, La Paz, n.p., 1934. 18.5 x 13.5 cm. Boglione Torello Collection

Cover by Fausto Aóiz Vilaseca for Julio C. Guerrero, *Mirajes de un soldado: problemas de la paz y de la guerra*, La Paz. Intendencia General de Guerra, 1935. 17.4 x 12.5 cm. Archivo Lafuente

←

Cover and inner pages by Ramón Katari (pen-name of Pablo Iturri Jurado, author) for *Hathawi: poemas en madera y verso*, La Paz. Editorial América, 1931. 30.1 x 25.2 cm. Private collection, Granada

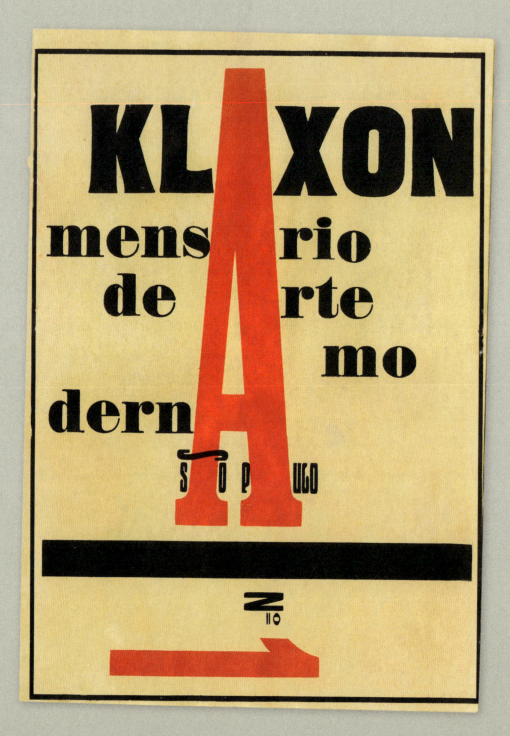

Cover by Guilherme de Almeida for *Klaxon. Mensario de arte moderna*, no. 1, 15, May 1922. São Paulo. Tipografía Paulista, 26 x 18.2 cm. Archivo Lafuente

Brazil

Rodrigo Gutiérrez Viñuales

The study of graphic design in general, and of the illustration of books and magazines in particular, is thriving in Brazil. We could say that it even has its own narrative. Dedicating a chapter to Brazilian illustrated books is both easy and challenging—easy, because over the past decades a host of references have been studied by numerous authors, and challenging because we have had to find new outlets for recent contributions to the subject. Perhaps as regards texts this has proven difficult, as they respond to personal visions of specific themes, but we have striven to propose a visual journey through the covers and inner illustrations of books to which we might add examples not hitherto surveyed in previous studies.

The considerable corpus of books and periodical publications we have assembled here could be grouped in a section dedicated to Rio de Janeiro, the third emblematic city as regards publishing in general, and illustrations in particular, after São Paulo and Porto Alegre. Indeed, the starting point for this virtual tour is the visionary work *A ilustração na produção literaria (São Paulo-década de vinte)* (1985), by Yone Soares de Lima, that almost forty years later is still valid as a research tool, for its exhaustive information and structured method, despite the handicap of having black-and-white illustrations. Our closing publication is the monumental work *A modernidade impressa. Artistas ilustradores da Livraria do Globo-Porto Alegre* (2016), by Paula Ramos. This author based her study on her own private collection of works, as did Ubiratan Machado in his (also monumental) *A capa do livro brasileiro, 1820-1950* (2018), no doubt the most complete graphic survey of those published in Brazil, that includes more than 1700 entries. All these studies form a vast visual repository to which our study is partly indebted, and a broad image of the world of publishing and of the graphic arts in Brazil.

The same year that Yone Soares de Lima published her book saw the appearance of another of the cornerstones of our journey, *O livro no Brasil (sus história)*, by English researcher Laurence Hallewell, the second Portuguese edition of which would be published in 2005. We say "Portuguese" because the study was originally drawn up in the 1970s as a Ph.D. thesis at the University of Essex and published in English in 1982; the two São Paulo editions came later. The scope of the book is vast and focuses on Brazilian publications between the times of European colonization and the present. In many cases, the chapters are titled with the names of the persons involved and their work, as exemplified by authors Monteiro Lobato, Octalles Marcondes Ferreira and José Olympio, among others, for the period in hand.

To return to the book by Yone Soares de Lima, it describes a unique figure in modern Brazilian publishing, that of collector José Mindlin. Mindlin was a trailblazer who had previously played a key role, in 1972, on occasion of the fiftieth anniversary of the São Paulo Week of Modern Art, retrospective exhibition for which he loaned a number of illustrated first editions. Articles, books and catalogs published by Mindlin himself in the 1990s formed a representative body of such editions, where the importance of authors equaled that of illustrators. Among the articles we should mention "Illustrated Books and Periodicals in Brazil, 1875-1945," published in 1995 in *The Journal of Decorative and Propaganda Arts* at the Wolfsonian-Florida International University in Miami; *Uma vida entre livros. Reencontros com o tempo* (1997); and "Não forço nada sem alegría". *A biblioteca indisciplinada de Guita e José Mindlin* (1999). After his death in 2010, his collection formed the basis of The Guita and José Mindlin Brasiliana Library housed in the University of São Paulo.

For those unfamiliar with the subject, the term *brasiliana* (Brazilian) is worth noting, as it is applied to all collections dedicated to Brazilian themes. Besides the Mindlins' collection, a number of others would also trigger significant exhibitions and publications in our context of study. Of course, one of the most important is the *Brasiliana Itaú* show, staged in 2015 at the Itaú Cultural Center on Avenida Paulista. The voluminous catalog published for the occasion, boasting over seven hundred pages and coordinated by Pedro Corrêa do Lago, proves the size of organization's collection and includes several copies we consider crucial.

The list of exhibitions that have displayed illustrated books is now quite long. Besides the aforementioned 1972 show held at the Museu de Arte de São Paulo (MASP), and *Brasiliana Itaú*, we must mention *Da Antropofagia a Brasilia. Brasil 1920-1950*, coordinated by Jorge Schwartz at the Institut Valencià d'Art Modern (IVAM) in Valencia in 2000. Among other works, this show displayed books from the private collection of Juan Manuel Bonet, then director of the museum, who also played an active part in the elaboration of the catalog.

A few years before this exhibition was staged, under the direction of Fernando Paixão, another key work on our subject was published, *Momentos do livro no Brasil* (1997), to which we must add the publication in São Paulo of the book *O design brasileiro antes do design* (2005), a compilation of texts coordinated by Rafael Cardoso, one of the most prominent historians of modern books and illustration in Brazil, who also wrote an insightful essay on the origins of book illustration in the country. We must also speak of the work carried out by Cosac Naify publishers, that launched the book in question, as well as the voluminous *Linha do tempo do design grafico no Brasil* (2012), by Chico Homem de Melo and Elaine Ramos.

To all this we must add many other texts (books, chapters, magazine articles), some of them mentioned in this essay, including a corpus of works that deal specifically with the illustrations

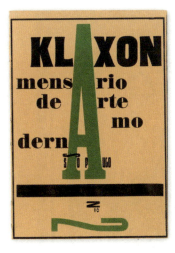
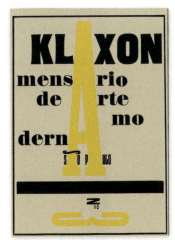
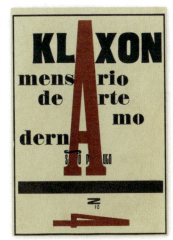
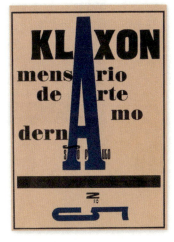
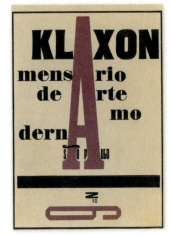
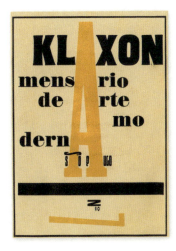
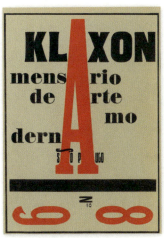

Covers by Guilherme de Almeida for *Klaxon. Mensario de arte moderna*, nos. 2 to 8/9, June 1922. São Paulo. Tipografía Paulista, 26 × 18.2 cm. Archivo Lafuente

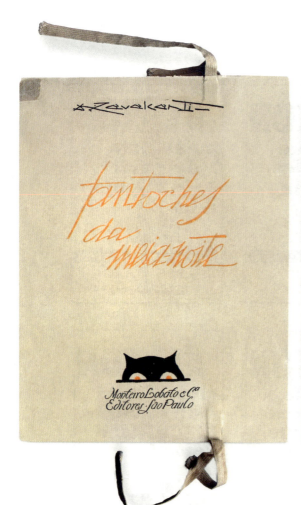
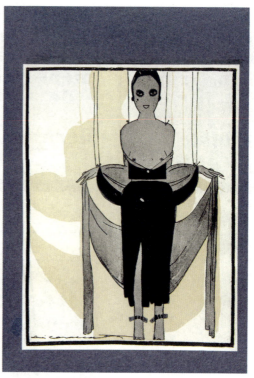

Cover and inner page by Emiliano Di Cavalcanti (author) for *Fantoches da Meia-Noite*, São Paulo. Monteiro Lobato e Cª., 1921.
29 x 24 cm.
Itaú Cultural Center, São Paulo
Photo: Humberto Pimentel

made by certain artists of the period, that proves the growing interest in the subject. Remarkable in this sense are the revisions of the works by Fernando Correia Dias, Emiliano Di Cavalcanti, Nicola de Garo, Manoel Bandeira, Tomás Santa Rosa, J. Carlos (even when the latter's more memorable work was published in magazines) and Tarsila do Amaral herself, among others. These contributions have significantly complemented the information and theses found in the general bibliography previously mentioned, and our own search for copies to be included in this edition, chiefly in *sebos*, or second-hand bookstores in São Paulo and Rio de Janeiro, those around Rúa Riachuelo in Porto Alegre, and on the Internet.

We would like to clarify that the term "Modernism" has a very different meaning in Brazil to the one it has in other countries of the region, as is well known by historians of Latin American art. Not so much in the sense of *fin-de-siècle* expressions in the Art Nouveau style as in that of the avant-garde São Paulo group that emerged in the second decade of the 20th century, and made its public presentation during the Week of Modern Art in 1922, on occasion of the centenary of the country's independence. We will do our best to avoid any possible confusion in this essay.

* * * * *

As was the case in most Latin American countries, "modernity" dates back to the early 20th century in Brazil, when progressive artists began to move away from academicism. Initially, several artists would adopt European Art Nouveau and Symbolist trends, among them Eliseu D'Angelo Visconti, a key figure in artistic publications, exhibitions and catalogs who merited a special section at the second São Paulo Biennale (1953) and more recent significant retrospectives such as those held at the Pinacotheca of the State of São Paulo in 2008 and 2011. Over and above his pictorial production, mention must be made of his "modern" praxis as regards the extension of his repertoire, which encompasses applied and industrial arts, works in iron, ceramics, stained glass, printed fabrics, wallpaper designs, ex libris, and, of course, graphic design chiefly published in magazines. Almost a visionary, Visconti anticipated a plural way of working that would become the countersign of the Brazilian avant-garde.

In the field of illustrated books, the first important step was taken by the Portuguese artist Fernando Correia Dias, who designed the cover of the collection of poems titled *Nós* (1917), by Guilherme de Almeida, a man of letters who will reappear often throughout this survey, being as he was the key figure in the Modernist group and due to his recurrent interest in having his books illustrated by "cutting-edge" artists. In fact, in 1925 Correia Dias would illustrate the cover of another book by Almeida, *Encantamiento*, with a nocturnal scene also in Symbolist style that followed similar esthetic principles to those expressed two years earlier in *Nunca mais... e poema dos poemas*, by the poet Cecilia Meireles (who in 1922 had married Correia Dias). To a certain extent, these two *veins* would reappear in the work of another illustrator of the time, J. Carlos, who made quite a name for himself in magazines.

But to return to the cover of *Nós*, in which Correia Dias added the name of the city, "Rio" to his signature, as he would do in several of his works, the design is a Symbolist image presided over by a distressed young woman (who also features on the subsequent cover, albeit at a mature age), for which Meireles herself was the model, combined with a Neo-medievalist typography with plant inspiration and floral decorations in the main vignette. The two features of the illustration, the female figure and the presence of flowers, are emblematic of Modernist and Symbolist trends and will reappear

continuously throughout the illustrations made in the first half of the 1920s.

Correia Dias, the main figure in this section, had arrived in Brazil in 1914 (at the age of eighteen), and took his first steps as a draftsman in the field of caricature, before turning his hand to book illustration and other forms of graphic design, particularly from 1917 onward (Macedo de Sousa, 2013). We should not forget that that same year the first and controversial show of works by Anita Malfatti was held in São Paulo, event which is usually signaled as marking the onset of the Brazilian avant-garde. The different covers designed by Correia Dias reveal the persistence of the movement and certain variations toward Art Deco in the late 1920s. In *Castellos na areia* (1923), by Olegario Mariano, still in the sphere of Symbolism, our artist resorts to outlining in white on a black (nocturnal) ground, while in *Cantaro de ternura* (1931), by Maura de Sena Pereira, he clearly turns to Art Deco. In the field of the applied arts, another important area for Correia Dias, his ceramic work certainly deserves mentioning, inspired as it was by the decorated designs of Marajoara pottery—distinctive of the island of Marajó in northern Brazil, from where it takes its name—that had just been discovered. Along similar lines, he designed the swimming pool for the home of Guilherme Guinle (1930), now a part of Parque da Cidade in the Gávea neighborhood. Correia Dias committed suicide in 1935.

In the section dedicated to Modernist and Symbolist illustrators, we have included a group of books designed by famous artists, such as Juvenal Prado, and other less known artists, like Staio Murco o Chin (brush name of the Italian designer Enrico Castello, who joined forces as an illustrator with Benjamim Costallat, publisher and author who insisted on illustrating his own books). Prado, active in magazines and who, in principle, appeared as one of the illustrators boasting a wider repertoire in São Paulo, isn't particularly relevant in our discourse given that his esthetic was not among the most "progressive." Nevertheless, in the early 1920s, his design for the cover of *Fim* (1921), by Medeiros e Alburquerque, is a significant contribution to book illustration as the title is formed by the smoke of a snuffed candle. This design is related to the anonymous illustration for *Horas* (1923), by Armando de Oliveira Santos, whose title is formed by the sound reverberations of a bell.

The name of the publishers of *Fim*, Monteiro Lobato & Cía., appears three times on the book's cover. We have repeatedly drawn attention to this firm as a decisive example of the modernization of book design in Brazil and, along with a few others, the driving force behind the art of illustration. This was a favorable moment for the development of Brazilian books, due to the fall in imported goods during the aftermath of the First World War. Monteiro Lobato was shrewd when it came to the mass distribution of books and magazines. A staunch defender of regionalist designs (that would distance him from the group of Modernist illustrators), the books he wrote and those he published were best sellers. Up until then, books launched locally were usually printed in magazine or newspaper offices (Cintra Gordinho, 1991, 49), and the appearance of Monteiro Lobato, together with other commercial ventures, marked a change—in 1925, the Monteiro Lobato publishing house became the Companhia Editora Nacional, with which another key figure, Octales Marcondes Ferreira, would be closely associated.

In the field of illustration, periodical publications did a great deal to consolidate and disseminate a visual modernity. Besides recognizing key figures such as J. Carlos, Emiliano Di Cavalcanti, J. Prado, Andrés Guevara and Belmonte, among many others, certain media popularized Art Deco and other styles that transcended the prevailing trends of Modernism and Symbolism—journals like *Novissima*, *Arlequim* (designed by Jean Gabriel Villin) which, along

Cover by Emiliano Di Cavalcanti for *Semana de Arte Moderna: catalogo da exposição*, São Paulo. Teatro Municipal de São Paulo, 1922.
Institute of Brazilian, Studies, University of São Paulo. Courtesy of the Institute of Cinematography and Audiovisuals Arts

with the avant-garde review *Klaxon*, are perhaps the worthiest of note, *Para Todos* (that published prominent works by J. Carlos and Di Cavalcanti, as did *Fon-Fon*), *O Papagaio*, *O Malho*, *A Maçà*, *Jazz*, etc.

 The female image, that appeared on the covers of most of the magazines cited and others, besides featuring in book illustrations, became a meeting point between Symbolism and Art Deco. We shall mention a number of examples, one by Enrico Castello (Chin) for Benjamim Costallat. Costallat was a very popular author at the time and yet fell into oblivion before being recently rescued (Souza França, 2011). He founded Benjamim Costallat & Miccolis publishing house (1923-1927) that launched *Divino inferno* (1924), the only (and posthumous) work by Rodolpho Machado prepared by his wife, the poet Gilka Machado, the cover of which featured the typical sensual female nude with long hair in a Symbolist setting. Costallat's own writings and those he promoted through his publishing house were audacious and

Revista de Antropofagia — 3

MANIFESTO ANTROPOFAGO

Só a antropofagia nos une. Socialmente. Economicamente. Philosophicamente.

Unica lei do mundo. Expressão mascarada de todos os individualismos, de todos os collectivismos. De todas as religiões. De todos os tratados de paz.

Tupy, or not tupy that is the question.

Contra todas as cathecheses. E contra a mãe dos Gracchos.

Só me interessa o que não é meu. Lei do homem. Lei do antropofago.

Estamos fatigados de todos os maridos catholicos suspeitosos postos em drama. Freud acabou com o enigma mulher e com outros sustos da psychologia impressa.

O que atropelava a verdade era a roupa, o impermeavel entre o mundo interior e o mundo exterior. A reacção contra o homem vestido. O cinema americano informará.

Filhos do sol, mãe dos viventes. Encontrados e amados ferozmente, com toda a hypocrisia da saudade, pelos immigrados, pelos traficados e pelos touristes. No paiz da cobra grande.

Foi porque nunca tivemos grammaticas, nem collecções de velhos vegetaes. E nunca soubemos o que era urbano, suburbano, fronteiriço e continental. Preguiçosos no mappa mundi do Brasil.

Uma consciencia participante, uma rythmica religiosa.

Contra todos os importadores de consciencia enlatada. A existencia palpavel da vida. E a mentalidade prelogica para o Sr. Levy Bruhl estudar.

Queremos a revolução Carahiba. Maior que a revolução Francesa. A unificação de todas as revoltas efficazes na direcção do homem. Sem nós a Europa não teria siquer a sua pobre declaração dos direitos do homem.

A edade de ouro annunciada pela America. A edade de ouro. E todas as girls.

Filiação. O contacto com o Brasil Carahiba. **Oú Villeganhon print terre.** Montaigne. O homem natural. Rousseau. Da Revolução Francesa ao Romantismo, á Revolução Bolchevista, á Revolução surrealista e ao barbaro technizado de Keyserling. Caminhamos.

Nunca fomos cathechisados. Vivemos atravez de um direito sonambulo. Fizemos Christo nascer na Bahia. Ou em Belem do Pará.

Mas nunca admittimos o nascimento da logica entre nós.

Desenho de Tarsila 1928 — De um quadro que figurará na sua proxima exposição de Junho na galeria Percier, em Paris.

Contra o Padre Vieira. Autor do nosso primeiro emprestimo, para ganhar commissão. O rei analphabeto dissera-lhe: ponha isso no papel mas sem muita labia. Fez-se o emprestimo. Gravou-se o assucar brasileiro. Vieira deixou o dinheiro em Portugal e nos trouxe a labia.

O espirito recusa-se a conceber o espirito sem corpo. O antropomorfismo. Necessidade da vaccina antropofagica. Para o equilibrio contra as religiões de meridiano. E as inquisições exteriores.

Só podemos attender ao mundo orecular.

Tinhamos a justiça codificação da vingança A sciencia codificação da Magia. Antropofagia. A transformação permanente do Tabú em totem.

Contra o mundo reversivel e as idéas objectivadas. Cadaverizadas. O stop do pensamento que é dynamico. O individuo victima do systema. Fonte das injustiças classicas. Das injustiças romanticas. E o esquecimento das conquistas interiores.

Roteiros. Roteiros. Roteiros. Roteiros. Roteiros. Roteiros. Roteiros.

O instincto Carahiba.

Morte e vida das hypotheses. Da equação **eu** parte do **Kosmos** ao axioma **Kosmos** parte do **eu.** Subsistencia. Conhecimento. Antropofagia.

Contra as elites vegetaes. Em communicação com o sólo.

Nunca fomos cathechisados. Fizemos foi Carnaval. O indio vestido de senador do Imperio. Fingindo de Pitt. Ou figurando nas operas de Alencar cheio de bons sentimentos portuguezes.

Já tinhamos o communismo. Já tinhamos a lingua surrealista. A edade de ouro.
Catiti Catiti
Imara Notiá
Notiá Imara
Ipejú

A magia e a vida. Tinhamos a relação e a distribuição dos bens physicos, dos bens moraes, dos bens dignarios. E sabiamos transpor o mysterio e a morte com o auxilio de algumas formas grammaticaes.

Perguntei a um homem o que era o Direito. Elle me respondeu que era a garantia do exercicio da possibilidade. Esse homem chamava-se Galli Mathias. Comi-o.

Só não ha determinismo - onde ha misterio. Mas que temos nós com isso?

Continua na Pagina 7

controversial. Several of them were set in the peripheral areas of Rio de Janeiro, their leading characters were usually female, and also appeared as cover illustrations. They were frequently depicted nude, as in *Modernos... (Contos)* (1920), by Costallat himself, and in *Fagulhas* (1926), by Carlos Bacellar, illustrated by Rubens Ferreira Trinas Fox. Costallat's literary and artistic precepts resembled those of the Italian author Pitigrilli and Juan José de Soiza Reilly in Buenos Aires.

Some of Costallat's book covers were designed by Emiliano Di Cavalcanti, to whom we have reserved a special place in our story for he connects Symbolist trends with those explored by the Modernist generation and which actually have more in common than could be thought.

The book illustrations made by Di Cavalcanti during the 1920s give us a perfect idea of the esthetic changes in his graphic art, as expressed both in reviews and in books. His early works were clearly Symbolist, as we see in his illustrations for two editions of Oscar Wilde books translated by Elysio de Carvalho, *Ballada do enforcado* (1919) and *Uma tragédia florentina* (1924), the first of which reveals a distinct influence of the English draftsman Aubrey Beardsley. This is the period in which he designed the illustrations for *Le départ sous la pluie* (1919), by Guilherme de Almeida, and *O jardim das confidencias* (1921), by Ribeiro Couto.

The illustrations for album titled *Fantoches da Meia-Noite* (1921), co-written by Di Cavalcanti and Ribeiro Couto and financed by Monteiro Lobato, were of a different kind. Mário de Andrade described the book as an example of "macabre realism" and signaled it as the first luxury edition published in Brazil, with a supposed print run of fifty copies. When the work was presented at the solo exhibition staged at Livraria O Livro, the idea for what would become the legendary São Paulo Week of Modern Art began to take shape. Di Cavalcanti met Graça Aranha and, through him, Paulo Prado, a São Paulo historian and millionaire who would become one of the sponsors of the event held the following February. The presentation of *Fantoches da Meia-Noite* was also attended by Oswald de Andrade, Mário de Andrade and Menotti del Picchia. A few months later, Di Cavalcanti was entrusted with the design of the program of the Week of Modern Art, and the style of this new work could be described as Brazilian Expressionism, perhaps closer to Anita Malfatti, as revealed by the sculptural female nude set against a background of a tropical glade. Within a wide survey of his illustration of these years, the poster appears as a one-off design. In fact, broadly speaking, the works on display at the São Paulo Week of Modern Art were more in keeping with existing trends such as Post-Impressionism, Art Nouveau or Symbolism and, save for a few exceptions (Malfatti or the Swiss artist John Graz, for instance), no great "avant-garde" leaps were made.

The journey Di Cavalcanti made to Europe between 1923 and 1925 proved crucial in the evolution of his graphic production, which would subsequently reveal the influence of Post-Cubism and Art Deco, as we see in the outstanding work *Os deuses vermelhos* (1925), by Adolpho Agorio; in the even more outstanding (and very strange) *O bébé de Tarlatana rosa* (1925), by Jõao do Rio, with wonderful illustrations in black and red reproduced on illustration paper and adhered to the pages by hand; and in the first edition of *Martim Cererê* (1928), by Cassiano Ricardo. *Losango cáqui* (1926), by Mário de Andrade, a book dedicated by the author to Anita Malfatti, belongs to the same post-Europe period.

Bordering on the 1930s, his style would take another turn, as we see in several books related to social themes that mirrored events in his personal life marked by his joining of the Communist Party in 1928. The illustrations for *O pobre Christo* (1930), by Mario Mariani, exemplify the new style, as do those for *Momentos decisivos da humanidade* (1934), by Stefan Zweig. Besides the calligraphic composition by Di Cavalcanti, the

cover of the latter features a black silhouette that reverberates like an echo into the background, the same resource he had previously used in one of his illustrations for *Substancia* (1928), by Manoel de Abreu. We must also point out the significant colored cover for *Historia do Brasil* (1932), by Murilo Mendes, and, the same year, another artist's album that included a dozen satirical drawings of Brazilian politics, titled *A realidade brasileira* (1932), with reminiscences of Georg Grosz and Lasar Segall. By then, the growing social, economic, and political crisis would be reflected in versions of Expressionism explored in the engravings by Oswaldo Goeldi, Lívio Abramo and Segall himself, published as illustrations. In those days, to a great degree being a "national" artist implied expressing the country's social dramas and relegating purely esthetic issues to a secondary plane.

As we were saying, Di Cavalcanti's career as an illustrator helps us examine the esthetic changes in the art of book illustration in the 1920s and 1930s, although we could also base our study on the literary works by previously mentioned authors such as Bejamim Costallat and Guilherme de Almeida. The latter was a member of the group of writers who took part in the São Paulo Week of Modern Art, in 1922. And vice versa, their literary production may also be analyzed starting from the graphic design of the artists who collaborated with them. Besides Di Cavalcanti, these included Tarsila do Amaral and Vicente do Rego Monteiro, even though he produced most of his artwork in Paris, as we mentioned in the section dedicated to Latin American illustrators who were active in other continents. Anita Malfatti, who is considered the initiator of the avant-gardes in Brazil, illustrated

Covers by Jean Gabriel Villin for *Arlequin: revista de actualidades*, nos. 5, 15, 17 and 20, December 1927 to June 1928. São Paulo. Irmãos Ferraz.
The Guita and José Mindlin Brasiliana Library, University of São Paulo

two of the books written by members of the group, *O homem e a norte*, by Paulo Menotti del Picchia, and *Os condenados*, the first instalment of *A trilogia do exilio*, by Oswald de Andrade, both of which were published in 1922. Malfatti's figures are closer to Symbolism than to what we could call "avant-garde," as we see in the torsos characterized by academic anatomical drawing (Soares de Lima, 1985, 172). The former contains remarkable features such as the ornate head of an indigenous female figure, produced at a time when such themes were becoming commonplace. A similar motif appears on the cover of *Fetiches e fantoches* (1922), by Agrippino Grieco, a book published in Rio de Janeiro, where the native fetish is accompanied by a puppet, another common element along with the harlequin and the clown that featured on covers throughout the 1920s and 1930s. A curious fact we would like to mention here is that Grieco and Gastão Cruls, the author of *Ao embalo da rêde* (1923), would subsequently purchase Ariel Editora publishers. To return to Malfatti, the geometrized and calligraphic composition she designed for *Os condenados* is also well worth a mention.

The names of Oswaldo de Andrade and Guilherme de Almeida carry their own weight in our study. The latter was the designer and layout editor of the cover of *Klaxon*, rendered, as described by Bonet, in the style of the Russian avant-garde. Almeida is also attributed with having designed the emblematic harlequinesque cover for *Paulicea desvairada* (1922), by Mário de Andrade, that has a single inner illustration, clearly Symbolist, by the Spanish artist Antonio García Moya who in those years was designing ideal architectural projects. The book was launched by Casa Mayença, the same publishing house that released the second edition of *Era uma vez...* (1922), by Almeida, the cover of which was designed by another leading figure of the Week of Modern Art, the Swiss illustrator John Graz.

Verde. Revista mensal de arte e cultura, year I, no. 1, September 1927. Editor: Henrique de Resende. Cataguases (Minas Gerais), n.p. 26.6 x 21.2 cm. Archivo Lafuente

Graz had arrived in Brazil in 1920 and went on to become one of the most notable practitioners of autochthonous applied arts in the country, along with his wife Regina Gomide and his brother-in-law Antonio Gomide. Graz based his design for the cover in question on a simplification of the anonymous illustration that had appeared that same year in the first edition of the book, showing two common Modernist motifs, the female figure and flowers. Besides the "French" books by Oswald de Andrade we would like to cite two other works he produced after the Week of Modern Art: *Memórias sentimentais de Jõao Miramar* (1924), with an avant-garde cover by Tarsila, and *A estrella de absyntho* (1927), a one-off incursion into graphic design by Víctor Brecheret in which, as highlighted by Cardoso, his language also verged on sculpture.

Tarsila do Amaral's work as an illustrator, halfway between Paris and São Paulo, is characterized by graphic simplification, a practice which would also distinguish her painting. Two books published in the French capital by Sans Pareil, *Le Formose*, the first and only installment of the five intended by Blaise Cendrars for *Feuilles de route* (1924), and *Pau Brasil* (1925), by Oswald de Andrade (see pp. 58-59 and 708), were illustrated by Tarsila's "solid and serene" lines, as described by the critic Francisco Martins de Almeida (Fabris y Teixeira, 1985, 8). Together with *Légendes, croyances et talismans des indiens de l'Amazone* (1923) and *Quelques visages de Paris* (1925), by Vicente do Rego Monteiro (see pp. 56-57), they helped disseminate "Brazilian traits" in the bosom of contemporary art, where landscape and its inhabitants, be they from Minas Gerais, the Amazon, or other regions, emphasized the recuperation and reinterpretation of autochthonous features in accordance with the literature and plastic arts being produced at the time in the country.

Indeed, the conservative regionalism promoted by agents like Monteiro Lobato was complemented by the avant-garde practice of the intellectuals who took part in the Week of Modern Art, and by that of other creators who also left abundant evidence of their obsession with autochthonous creation, both in the field of literature and in that of the plastic arts. In the realm of books, besides the aforementioned works by Tarsila and Rego Monteiro in Paris, Brazilianness, indigenousness, tropicalism, and other trends would give rise to notable covers and inner pages filled with ornamentation, frames and vignettes displaying Brazilian fauna and flora, as we see in several books by Di Cavalcanti, Paim and Correia Dias.

Guilherme de Almeida appears again here as two of his books, *Raça* and *Meu*, both of 1925, perfectly embody the new trends. Illustrated, respectively, by Yan (Jõao Fernando) de Almeida Prado and Antônio Paim Vieira, the panoramic drawing of the first cover (i.e., that extends to the back cover) shows scenes of the conquest and colonization of Brazil, as analyzed by Soares de Lima. In the case of the second cover, also panoramic, the composition is filled with tropical fruit. Both books also have in common the design of their inner pages, characterized by thick black typography and the entire text is framed in green—the same color of the cover illustrations, superimposed with black titles. The presence of green is worthy of mention because besides further promoting the ideas of nature and the tropic it would become one of the leitmotifs of Brazilian graphic design during the years in question (Soares de Lima, 1985, 143). This is proven by other covers of the period, including that of the first edition of *Vamos caçar papagaios* (1926), by Cassiano Ricardo; designed by Belmonte, it is also a panoramic cover, in this case one of the author's rare forays into book illustration, being as he was a prolific magazine illustrator.

Although we shall be later discuss the Amazon in greater depth, in the chapter "Pre-Columbian

and Ancestral Traits," it deserves a mention in this review of Brazilian trends. In effect, the Amazon, its landscape and indigenous cultures became a crucial reference in the reappraisal of nativism in the field of art. As regards design, the above-mentioned books by Rego Monteiro produced in Paris, *Légendes, croyances et talismans des indiens de l'Amazone*, is the most authoritative, although *Quelques visages de Paris* is equally interesting, for its illustrations reveal a vision of the City of Light through the eyes of a native of the Amazon region, who interprets its monuments and urban features using his own signs as an ideogrammic model. Autochthonous covers too, in terms of illustration or calligraphy, are those of *Gritos bárbaros* (1925), by Moacyr de Almeida, designed by Cornélio Penna, and *Muirakitans. Poemas do Paraíso Verde* (1928), by Carlos Marinho de Paula Barros, with drawings by the author herself, in which green ink is again predominant, along with indigenist titles and decoration in black.

In the field of the applied arts, the Marajoara style (under the influence of the designs made by the natives on Marajó island in Pará) was prominent, as exemplified by the works of Theodoro and María Braga, Manoel Pastana and Fernando Correia Dias, makers of pottery, fabrics, and other decorated objects. The textile works by Regina Gomide also reflect the creative inspiration of indigenous ornamentation. Such designs coexisted perfectly with the Deco inspiration that arrived from Paris, as a result of which they were accepted as modern works that, in keeping with the times, sought to connect with everyday life.

Emblematic "Amazonian" books published in this period are *Macunaíma* (1928), by Mário de Andrade, of little interest in its graphic design, and *Cobra Norato* (1931), by Raul Bopp. Conceived in Belém do Pará though completed in São Paulo, this work is considered the flagship of the Anthropophagic Movement. Two other volumes belonging to the same movement are also included in our survey, the first one with a splendid three-color cover by Flávio de Carvalho depicting a half-woman, half-beast; the other, featuring woodcuts by Oswaldo Goeldi, can almost be described as an artist's book and had a print run of a hundred and fifty copies.

Carvalho, considered a member of the second generation of Modernists, is another uniquely plural, avant-garde artist of the period remembered in his professional capacity as an architect for the entry he submitted to the Faro de Colón (Columbus Lighthouse) competition in Santo Domingo (1928), among other projects. The monument to Columbus design was Rationalist and yet included Marajoara ornamentation on the paving, besides Toltecan and Mayan decoration. In 1931 he published *Experiência n. 2 realizada sobre uma procissão de Corpus Christi. Uma possível teoria e uma experiência*, filled with numerous decorations of his own, in black ink and mostly Expressionist, some of which verged on Surrealism. The book documented a performance he himself staged in São Paulo during a Corpus Christi procession in which he began to walk in the opposite direction to the crowds, without taking off his hat, provoking the furious reactions of the Catholic throngs, as his intention was to analyze the "psychology of the masses."

Thanks to the progress of Art Deco and of other pioneering currents that were gradually disseminated, marked angularities highlighted the geometrization of figurative motifs as another sign of modernity in the graphic design of the mid-1920s to mid-1930s. Several of the authors mentioned in earlier paragraphs who had previously cultivated Symbolism now adopted these trends in their book and magazine illustrations, such as Antônio Paim Vieira. Other authors are now mentioned for the first time, such as Ferrignac (Ignácio da Costa Ferreira), an artist connected with the 1922 Week of Modern Art, or the almost legendary Nicola de Garo,

barely known until his recent rediscovery (Briquet de Lemos, 2017).

Paim's cover for *A boneca vestida de arlequim* (1927) is noteworthy for its geometric features and calligraphy, while two works by Ferrignac also deserve a mention, both in terms of theme and composition, particularly his design for *A hora futurista que passou...* (1926), by Mario Guastini. In his turn, Nicola de Garo (brush name of Bulgarian artist Nicolai Abracheff) designed two notable compositions for another participant in the Week of Modern Art, Ronald de Carvalho, both published by Pimenta de Mello in Rio de Janeiro in 1926: the indigenist cover of *Toda a América* and the even more outstanding cover of *Jogos pueris*, an avant-garde edition depicting children at play, with a print run of less than fifty copies, which partly explains its rarity. As Raul Bopp recalled, one of the most important focal points for modern artists in Rio de Janeiro was Ronald de Carvalho's home on Rúa Paissandú (Bopp, 1966, 33).

As mentioned, geometric designs abounded in the 1920s and 1930s, which is why our visual survey includes works by artists such as Flávio de Andrade and Paulo Cavalcanti; the latter's notable cover for *O macaco eléctrico*, by Hildebrando de Lima, was published in Recife in 1928. This goes to prove the decentralization that Modernism was beginning to experience in the country, that until then had been limited to São Paulo, Rio de Janeiro and, to a less degree, Porto Alegre thanks to Livraria O Globo bookstore. Another "peripheral" gem is the splendid cover of the novel *Quarta-Feira de cinzas* (1932), by Martins D'Alvarez, illustrated by Catunda and characterized by geometric features that contain the book's Expressionist calligraphic title. Similar works are the cover of *Belazarte*, published by Mário de Andrade in 1934 and designed by Joaquim Alves, and those of two books by Oswald de Andrade, *O homem e o cavalo* and *A escada vermelha*, illustrated by his son Oswald who had trained along with Portinari, Malfatti and Segall and designed covers that still relied on avant-garde traits and which included neo-popular imagery in the illustrations and lettering.

This chapter's visual journey also touches on a number of covers that could well have been included in the one dedicated to the "Word-Image." Although we shall not analyze them in depth here, we will mention Tarsila do Amaral's design for *Primeiro caderno do alumno de poesis Oswald de Andrade* (1927), book which includes a series of childish lines (very much in keeping with the ideas of the avant-garde) made by Oswald himself, almost as a tribute to the drawings of Tarsila's Brazilian cityscapes and rural landscapes.

In contrast with the calm balance of the cover, Arnaldo Barbosa's composition for the cover of *Cartazes* (1928), by Paulo Mendes de Almeida, is one of the most accomplished in Brazilian modern art, characterized precisely by the depiction of posters, arranged as if on an untidy table, and by the dynamic titles, well-suited to the rhythm of the posters. We are familiar with two versions of this book, both of which are reproduced in these pages; the most well known is black and the other, less traditional, is red. The same year saw the design of the cover for *Laranja da China*, by António de Alcântara Machado, former editor of *Revista de Antropofagia* during the journal's first period, from May 1928 to February 1929. The book's title is divided into four lines, framed in a white triangle, while the rest of the text is laid out in five bands of color, making the book conspicuous at a distance. Alcântara Machado himself had previously produced two key books in Brazilian modern art, the cinematographic *Pathé-Baby* (1926), illustrated by Paim, who defines it as an "alternate montage between writing and illustration, giving rise to a double (or triple) narrative that, according to Valêncio Xavier, 'runs simultaneously along two tracks': the film written by Alcântara Machado and the film illustrated by Paim Vieira which, in its turn, branches off into

Inner pages by Theodor Preising y Vamp (brush name of Benedito Junqueira Duarte) for *S. Paulo*, no. 1, January 1936. Editor: Cassiano Ricardo, Menotti del Picchia and Leven Vampré. São Paulo, n.p. 45.3 x 32 cm. Archivo Lafuente

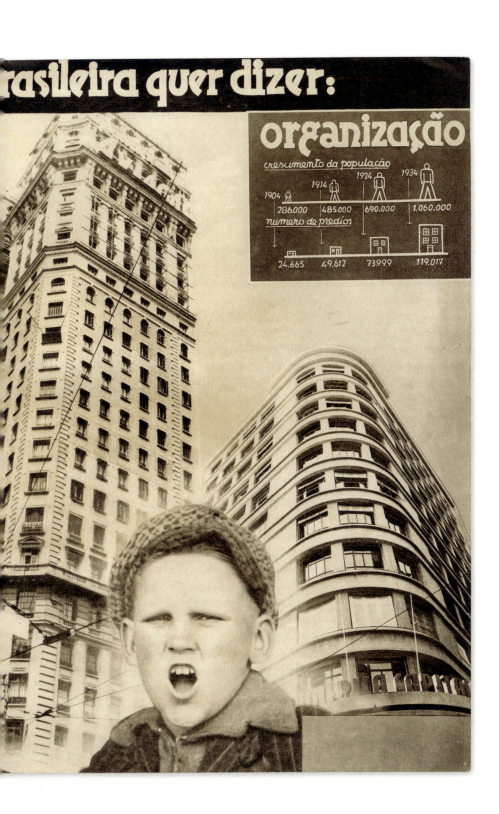

the ribbon-drawing projected on the screen and the story-drawing about the vicissitudes of the orchestra" (Gárate, 2017, 188).

We should also add a group of "modern urban designs" in which new imaginaries are essentially revealed by the movement of traffic, chaos and the presence of skyscrapers. The use of diagonal lines in the illustrations and in some cases in the titles heightens the sense of vertigo that the artist intends to convey. Outstanding among these works is the cover of *Meia pataca* (1928), practically a collective work by the group of artists who produced *Verde* review in Cataguases (Minas Gerais), signed by Guilhermino César and Francisco Inácio Peixoto. The Tarsilian illustration on the cover was by another member of the group, Rosário Fusco, chief editor of the journal. These are examples of the avant-garde presence in inland Brazil. *Substancia*, by Manoel de Abreu, another notable work of 1928, boasts one of the most avant-garde series of illustrations by Di Cavalcanti.

In the remarkable panoramic design of the cover of *Chronicas da cidade maravilhosa* (c. 1934), by the journalist, librarian, and poet Bastos Tigre, J. Carlos presents an idealized view of Rio de Janeiro, including a symbiosis of the Pão de Açúcar, or Sugar Loaf, and the figure of Christ the Redeemer on the peak of the Corcovado mountain in the distance. This symbolic setting is the backdrop for the unfolding of Modernism, chromatically expressed by disproportionate electric towers, a water tank, a telephone, and a light bulb, all featured on the back cover, that is connected to the front cover by the electricity cables that appear in the upper part of the composition, and by a bus and a tram moving in front of a Rationalist building that, in turn, stands in front of a group of skyscrapers.

Other skyscrapers, more vertical yet also shaky, appear in the cover designed years later by Armando Pacheco for another book by Bastos Tigre, *Uma coisa e outra* (1937). Also set in Rio de Janeiro (again, in the background we see the Sugar Loaf, this time with the cables of the aerial tramway), the scene is governed by chaos, forming a sharp contrast with the order of *Chronicas da cidade maravilhosa*, far removed from any trace of a "marvelous city." An airplane, smoking chimneys, antennas, factories, a tram, and a modern car, among other elements, are combined with buildings in a deliberate confusion. The cover almost makes itself heard: a saxophone and bugles emit their sounds, further emphasizing the noise and turmoil, from which a figure comfortably seated in the foreground and about to enjoy a cocktail strives to abstract himself. The tower of a colonial church seeming about to collapse, humble houses and even a longshoreman at work appear as victims of the new urban order. The subtle appearance in the upper area of a woman with a serious, solemn face resting her hand on one of the skyscrapers and watching the fanciful scene with misgivings is not a minor element in the composition.

Cidade Maravilhosa (1930) is also the title of a collection of poems by Olegario Marianno, the cover of which depicts a night scene lit by the light of a waxing moon and a group of electric lamps creating chiaroscuro facets that define a character in the foreground, while skyscrapers, some of them seeming to hover, are again featured in the background. The scene chosen by Monteiro Filho for the cover of *Século XXI* (1934), by Berilo Neves, is also nocturnal. A Paleo-Futurist exercise, the illustration features dehumanized hovering skyscrapers, counterbalanced by the unease reflected in two "blind" faces. The same disquiet appears too in the faces emerging from the cover designed by Emiliano Di Cavalcanti for another book by Benjamim Costallat, *Arranha-céo* (1929), i.e. "skyscrapers," that once again preside over a composition. The same goes for the cover of *Hoje* (1930), by Newton Belleza, also designed by Di Cavalcanti, that anticipates the artifice of

the aforementioned volume *Uma coisa e outra* by Bastos Tigre, and where a disproportionate human figure comes forth from behind the high-rise blocks. In this case it is the figure of a man who seems to embrace the buildings, complemented by the slender figure of a naked woman, almost an extrapolation of the central figure in Picasso's *Les Demoiselles d'Avignon*.

In earlier paragraphs we mentioned Basto Tigre's preference for stories that unfold in vibrant, modern urban settings, materialized in matching covers, and the same applies to Berilo Neves, who two years later complemented *Século XXI* with *Cimento armado* (1936). In this case the cover features a Rodchenko-like image of skyscrapers viewed diagonally, a low-angle perspective that highlights the city's verve and the physically irrelevant role of the citizen, who is no longer present in the scene. Two works by the Franco-Brazilian artist Jean Gabriel Villin, *Garçon, garçonnette, garçonnière* (1930), by Orígenes Lessa, and *Onde Canta o Sabiá* (1930), by Jonny Doin, also resort to the cliché of skyscrapers, in this case seen through flat and vertical prismatic bodies, enhanced by the play of light and shadow.

The 1930s was a decade marked by the world crisis that followed the crash of the New York stock exchange in 1929. In the specific case of Brazil, the critical situation coexisted with that produced by the Constitutionalist Revolution of 1932. The move of Livraria José Olympio from São Paulo to Rio de Janeiro in 1934 marked a turning point in the publication of Brazilian literature, becoming the most important firm in the sector (Cintra Gordinho, 1991, 68). Another key moment in our account of events was the appearance and consolidation in the company of the illustrator and publishing designer Tomás Santa Rosa (Bueno, 2015). Born in João Pessoa, Santa Rosa initially worked with Ariel Editora, a fruitful collaboration that produced two significant volumes dedicated to Afro-Brazilian themes: the covers of *Urucungo* (1932), by Raul Bopp, and *Cacáu* (1933), by Jorge Amado, that revealed his talent in the genre. The striking title of *Urucungo* is divided into three lines (which reminds us of the title of *Libertinagem*, by Manoel Bandeira) and the name of the author is placed at an angle. In its turn, *Cacáu* contains numerous half-page illustrations characterized by the synthesis of the white linear drawing on black ground.

These are the years of social crisis during which Rio de Janeiro would become a gathering point for artists from different parts of the country. As recalled by Jorge Schwartz (2000, 149), "the Brazilian publishing market begins to be established. The typical practically self-financed authors' editions that marked the works of the Modernist generation are beginning to be a thing of the past, and the new period is characterized by the consolidation of large, high-quality print runs."

Driven by sociological and documentary concerns, Northeastern literature, narrative poems, and novels that focus on subjects such as agrarian life, poverty, class relations, sugar mills and their decadence took center stage (Corrêa de Lago, 2009, 408). The list of successful authors included aforementioned Jorge Amado, along with Graciliano Ramos, José Lins do Rego and Jorge de Lima, whose works were either illustrated by Santa Rosa or by another "modern" artist of the period, also from Northeast Brazil, Manoel Bandeira (not to be mistaken with the author of *Libertinagem*). His bold covers, distinguished by Post-Cubist and Futurist designs, are among the finest specimens produced in the early 1930s in Rio de Janeiro. Those of the books *Menino de engenho*, by Lins do Rego, and *Poemas escolhidos*, by Jorge de Lima, both published by Adersen Editores in 1932 are particularly striking: the first is a three-color mosaic (black, red, and white) in which the figure of the boy merges into that of the factory building; the second, verging on abstraction, depicts a landscape with plantain

trees, cacti, toadstools, and birds, and its title is broken up into four stepped lines. During these years, Bandeira made outstanding avant-garde contributions to the Pernambuco-based review *P'ra Você*.

Shortly afterward, while still working for Ariel, Santa Rosa produced a series of paradigmatic covers that included those of *Doidinho*, by Lins do Rego, *Cahetés*, by Graciliano Ramos (both published in 1933), and *Suor*, by Jorge Amado, in 1934, the same year in which he designed the cover of *Corja*, by João Cordeiro, published by Augusto Frederico Schmidt. The fact that all these books had one-word titles, hence less text, gave Santa Rosa more space to elaborate his designs. Subsequently, when he was working with José Olympio, he decided to change his style in keeping with the publishers' need to have well-defined series. His new compositions would be more ordered and sober. Despite occasionally tending to have less creative freedom, which made his illustrations less interesting in graphic terms, the artist did manage to create a style all his own and a way of "making books" that would exert a great influence on Brazilian graphic design of the 1930s and 1940s.

As regards socially significant designs, numerous relevant books from this period have been included in other anthologies. A factory is a common motif; highly praised during the 1920s as a symbol of progress, the following decade, after the economic crash, its meaning began to change and it was often associated with the oppression of workers, as expressed by artists in different contexts, such as the Cuban Marcelo Pogolotti or the Mexican Diego Rivera. One of them is *Onde o proletariado dirige... Visão panoramica da U.R.S.S.* (1932), a book by the Communist psychiatrist Osório César, illustrated by his then partner Tarsila do Amaral, that relates events of the three-month journey the couple had made to Moscow the year before. The iconography of the cover illustration gradually developed, as we see in the decisive oil painting *Operários* (1933), described by Juan Manuel Bonet as "the last truly significant Tarsilian work" (2009b, 88). A series of drawings by Tarsila can be found inside the book, resembling those made in the 1920s, distinguished—as Mário de Andrade would say— by the "structural calm of precise lines." On the cover of *Onde o proletariado dirige...* the factory landscape is a black silhouette cut out against

Cover by Flávio de Carvalho (editor) for *Revista Anual do Salão de Maio* (RASM), no. 1, May 1939. São Paulo, n.p.
20 x 20.5 cm.
Archivo Lafuente
Photo: Belén Pereda

a white ground—the same feature as appears in the book *Parque industrial. Romance proletário* (1933), by Mara Lobo, pen-name of Patrícia Rehder Galvão, Pagú, then the partner of Oswald de Andrade with whom two years before she had co-founded the socially engaged *O homem de povo* newspaper. This cover was designed by a young Lívio Abramo, an outstanding figure in contemporary Brazilian engraving, excelling particularly in woodcuts.

Among the sociopolitical alignments characterizing the early 1930s was that of the series of books on the Paulist Revolution published by Companhia Editora Nacional: *Ilha Grande. Do jornal de um prisioneiro de guerra* (1933), by aforementioned Orígenes Lessa. The splendid cover of this volume, by an unknown artist, depicts Lazareto penitentiary of the island-cum-prison where Lessa himself had been jailed, complemented by the spectacular typography of the title-place, stonily vertical.

Other creations of the 1930s worthy of mention reveal revitalized vestiges of the typical Art Deco symbolism of the previous decade. Such are the cases of the covers by Noemia Mourão, the well-known prolific designer of magazine covers J. Carlos, the less famous João Novo Pacheco, and the *gaúcho* Nelson Boeira Faedrich. Among the works by Noemia we must cite the cover of *Ouro velho* (1933), by Allegretti Filho, made the same year that its author married her master Emiliano Di Cavalcanti (the influence of whose ornamental Symbolist style of the 1920s can be traced in her work). In his turn, Boeira Faedrich deserves a mention, among other things, for his illustrations that contributed to the huge success of Livraria de Globo in the 1930s, furthered by the publishing house's advertising campaign launched in its *Almanaque* (from 1917 onward) and its *Revista do Globo* (founded in 1929), studied in depth by Paula Ramos (2016).

We shall conclude this summarized diagrammatic overview of Brazilian book illustration with three compositions by renowned artist Cândido Portinari: *Presença de Santa Teresinha* (1934), by Ribeiro Couto, *Meditações* (1936), by Manoel de Abreu, and *As metamorfoses* (1938), by Murilo Mendes, halfway between metaphysical and surreal, in keeping with some of his pictorial works of the time, and the already quoted edition of *Cobra Norato* (1937), with woodcuts by Oswaldo Goeldi.

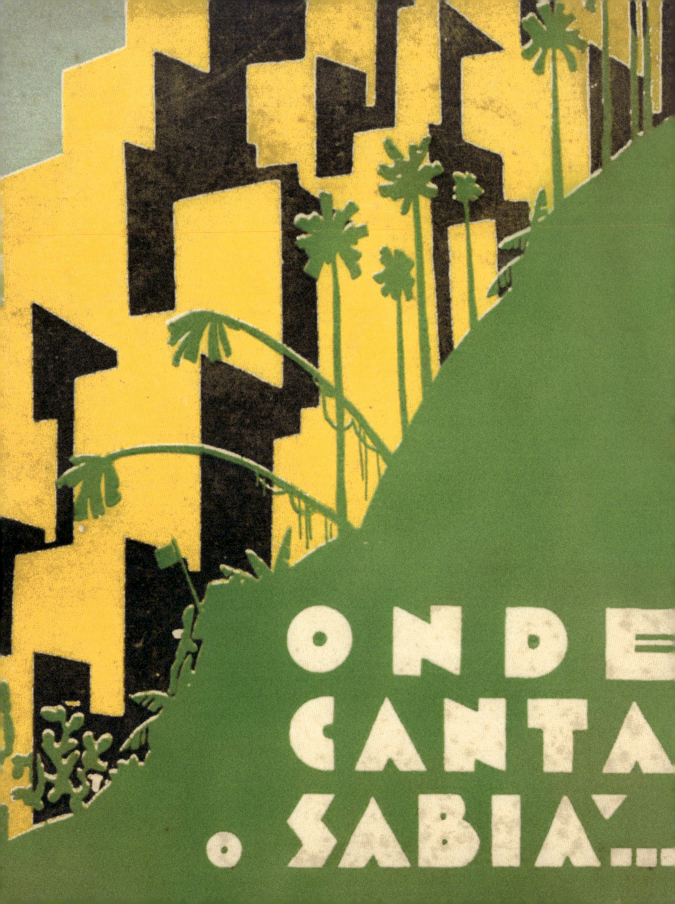

Brazil

Cover by Fernando Correia Dias for Guilherme de Almeida, *Nós,* n.p. [São Paulo?]. O Estado de São Paulo, 1917. 23 x 15.7 cm.
Archivo Lafuente

Cover by Juvenal Prado for José Joaquim de Campos da Costa de Medeiros e Alburquerque, *Fim,* São Paulo. Monteiro Lobato & Cía., 1921. 17 x 12 cm.
Archivo Lafuente

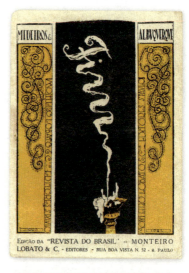

Cover by Emiliano Di Cavalcanti for Sérge Milliet, *Le départ sous la pluie,* São Paulo / Geneva. Groupe littéraire Jean Violette, 1919. 19.1 x 13.1 cm.
Archivo Lafuente

Cover by Emiliano Di Cavalcanti for Ribeiro Couto, *O Jardim das confidencias,* São Paulo. Monteiro Lobato & Cía., 1921. 16.4 x 12.2 cm.
Archivo Lafuente

→
Covers and inner pages by Emiliano Di Cavalcanti for Oscar Wilde, *Ballada do enforcado,* Rio de Janeiro. Publishers of Revista Nacional, 1919. 25.7 x 19.8 cm.
Itaú Cultural Center, São Paulo.
Photo: Humberto Pimentel

Cover and inner page by Emiliano Di Cavalcanti for João do Rio, *O Bébé de Tarlatana Rosa*, Rio de Janeiro. Brasileira Lux, 1925. 19 x 14 cm.
The Guita and José Mindlin Brasiliana Library, University of São Paulo

Cover by unknown artist for Rodolpho Machado, *Divino inferno*, Rio de Janeiro. Benjamim Costallat & Miccolis, 1924. 19.5 14 cm.
Private collection, Granada

Cover by unknown artist for Gastão Cruls, *Ao Embalo da Rêde (contos)*, Rio de Janeiro. Livraria Castilho, 1923. 19 x 13.2 cm.
Archivo Lafuente

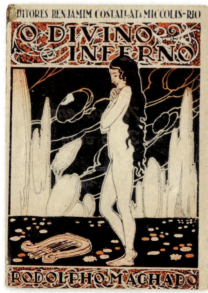
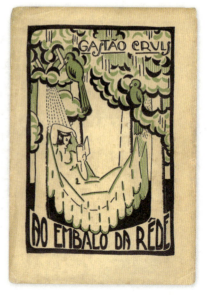

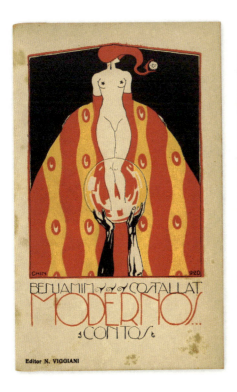
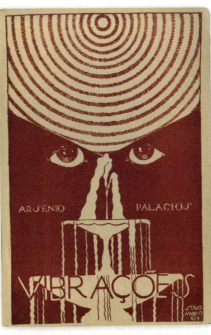

Cover by Chin (pen-name of Enrico Castello) for Benjamim Costallat, *Modernos... (Contos)*, Rio de Janeiro. N. Viggiani, 1920. 24 x 15.5 cm. National Library Foundation, Rio de Janeiro

Cover by Staio Murco for Arsenio Palacios, *Vibrações*, São Paulo. Prometheu, 1924. 22.6 x 15.4 cm. Private collection, Granada

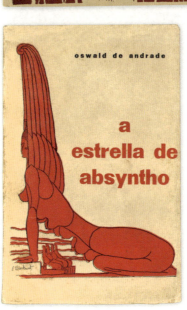

Cover by Victor Brecheret for Oswald de Andrade, *A Estrella de Absyntho*, São Paulo. Hélios, 1927. 19.5 x 12.5 cm. Archivo Lafuente

Cover by Tarsila do Amaral for Oswald de Andrade, *Memórias sentimentais de João Miramar*, São Paulo. Indepêndencia, 1924.
16.5 x 12 cm.
The Guita and José Mindlin Brasiliana Library, University of São Paulo

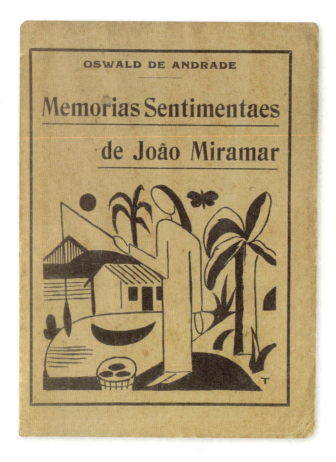

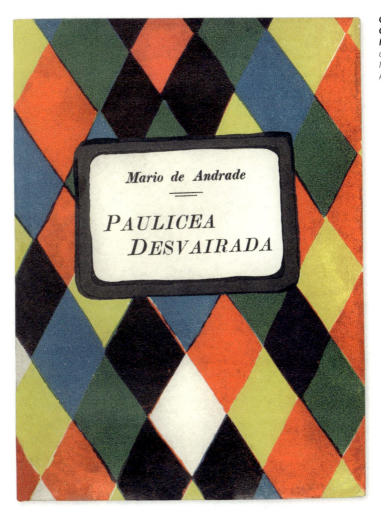

Cover attributed to Guilherme de Almeida for Mário de Andrade, *Paulicea desvairada*, São Paulo. Casa Mayença, 1922. 19 x 14 cm. Archivo Lafuente

Cover and inner page by Nicola de Garo (pen-name of Nicolai Abracheff) for Ronald de Carvalho, *Jogos pueris*, Rio de Janeiro. Officina de Pimenta de Mello & Cía., 1926.
27 x 18 cm.
The Guita and José Mindlin Brasiliana Library, University of São Paulo

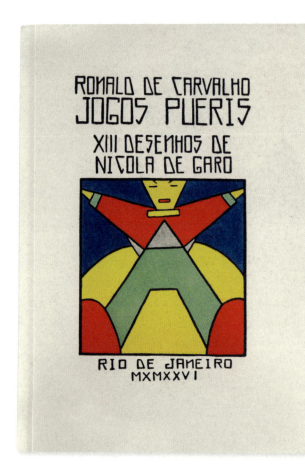

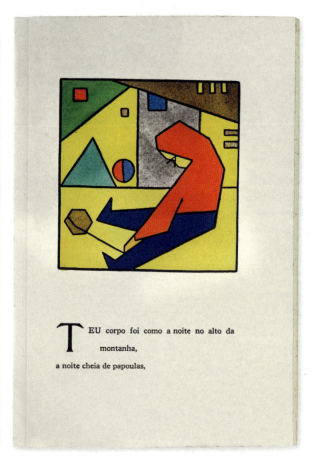

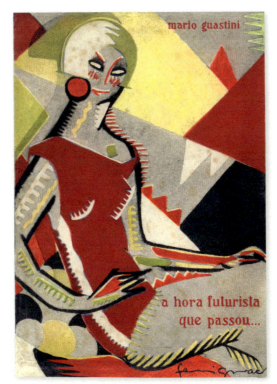

Cover by Ferrignac (pen-name of Ignácio da Costa Ferreira) for Mario Guastini, *A hora futurista que passou...*, São Paulo. Casa Mayença, 1926. 19 x 14 cm. Echaurren Salaris Foundation

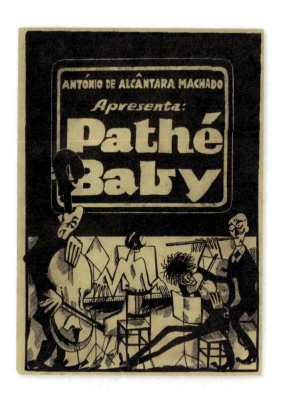

Cover and inner pages by Antônio Paim Vieira for António de Alcântara Machado, *Pathé-Baby*, São Paulo. Hélios, 1926. 20 x 15.5 cm.
Archivo Lafuente

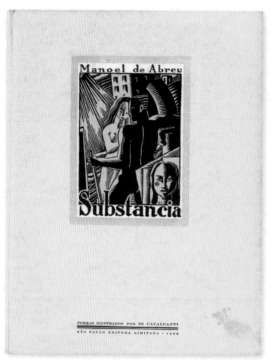

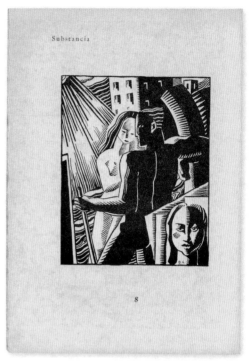

8

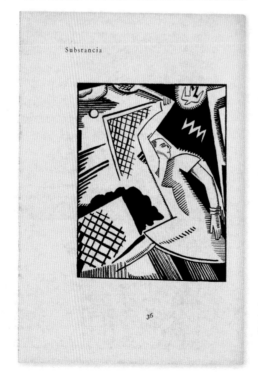

36

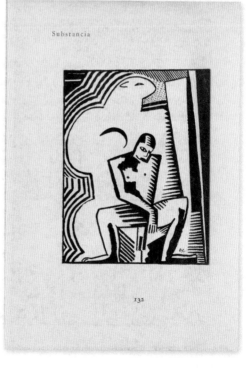

132

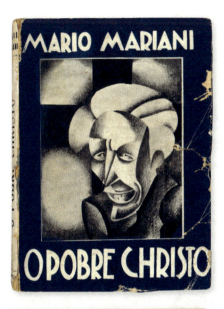
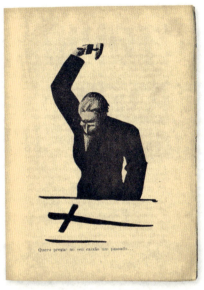
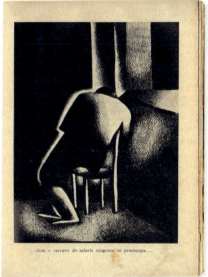
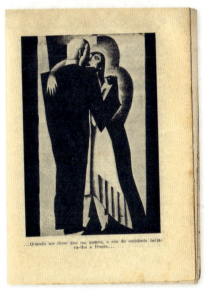

Cover and inner pages by Emiliano Di Cavalcanti for Mario Mariani, *O pobre Christo*, Rio de Janeiro. Freitas Bastos & C., 1930. 19 x 14 cm. Private collection, Granada

←
Cover and inner pages by Emiliano Di Cavalcanti for Manoel de Abreu, *Substancia*, São Paulo. São Paulo Editora Limitada, 1928. 24.8 x 19 cm. Archivo Lafuente

Cover by unknown artist for António de Alcântara Machado, *Laranja da China*, São Paulo. Officinas da Empreza Graphica Limitada, 1928. 19.2 x 14.3 cm. Archivo Lafuente

Covers by Arnaldo Barbosa for Paulo Mendes de Almeida, *Cartazes*, São Paulo. Livraria Liberdade, n.d. [1928?]. 19.2 x 14.1 cm / 18.5 x 14 cm.
Archivo Lafuente / Boglione Torello Collection

Cover and inner pages by Emiliano Di Cavalcanti for Cassiano Ricardo, *Martim Cererê ou o Brasil dos meninos, dos poetas e dos heróes*, São Paulo. Hélios Limitada, 1928. 26 x 19 cm. Eros Grau Collection

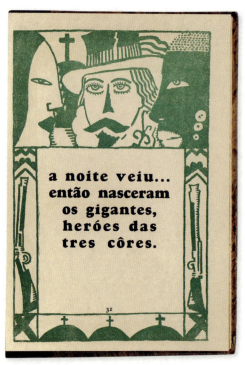
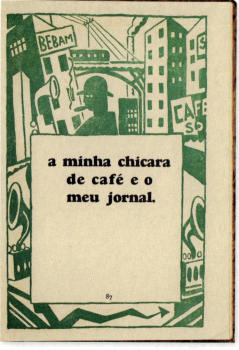

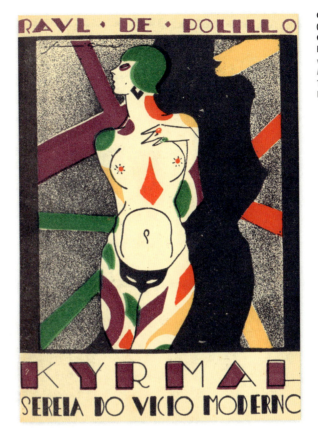

Cover by Ferrignac (pen-name of Ignácio da Costa Ferreira) for Raúl de Polillo, *Kyrmah. Sereia do vicio moderno*, São Paulo. Monteiro Lobato, 1924. 18.3 x 13.5 cm. Private collection, Granada

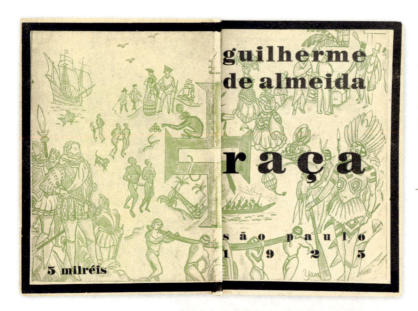

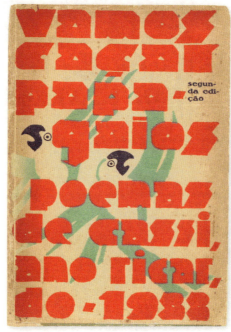

Covers by Yan (João Fernando) de Almeida Prado for Guilherme de Almeida, *Raça*, São Paulo. Typographia Paulista de José Napoli e Comp., 1925. 18.7 x 14.1 cm.
Archivo Lafuente

Cover by Belmonte (pen-name of Benedito Carneiro Bastos Barreto) for Cassiano Ricardo, *Vamos caçar papagaios*, 2nd edition, São Paulo. Empreza Graphica da Revista dos Tribunais, 1933. 22.5 x 16 cm.
Archivo Lafuente

Covers by Belmonte (pen-name of Benedito Carneiro Bastos Barreto) for Cassiano Ricardo, *Vamos caçar papagaios*, São Paulo. Hélios, 1926. 19.5 x 14.5 cm.
The Guita and José Mindlin Brasiliana Library, University of São Paulo

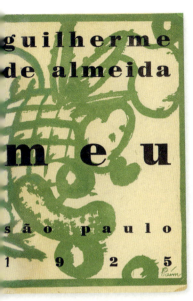

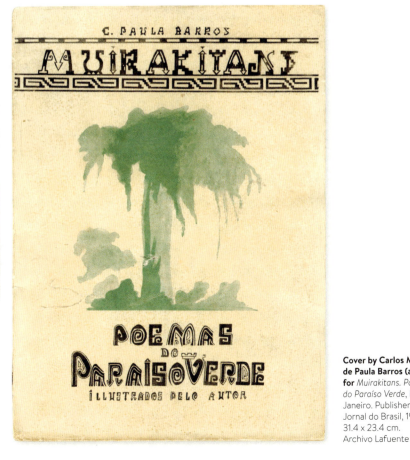

Covers by Antônio Paim Viera for Guilherme de Almeida, *Meu (livro de estampas)*, São Paulo. Typographia Paulista de José Napoli e Comp., 1925. 18.8 x 14.1 cm. Archivo Lafuente

Cover by Carlos Marinho de Paula Barros (author) for *Muirakitans. Poemas do Paraíso Verde*, Rio de Janeiro. Publishers of Jornal do Brasil, 1928. 31.4 x 23.4 cm. Archivo Lafuente

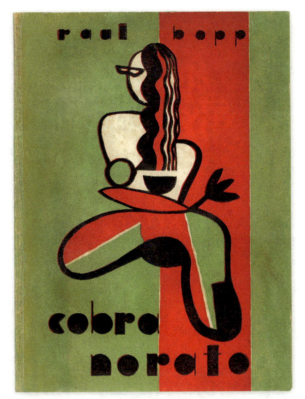

Cover by Flávio de Carvalho for Raul Bopp, *Cobra Norato: Nheengatú da margem esquerda do Amazonas*, São Paulo. Irmãos Ferraz, 1931.
19 x 14 cm.
Archivo Lafuente

←
Covers and inner pages by Flávio de Carvalho (author) for *Experiência n. 2: realisada sobre uma procissão de Corpus Christi. Uma possível teoria e uma experiência*, São Paulo. Irmãos Ferraz, 1931.
19 x 13 cm.
Archivo Lafuente

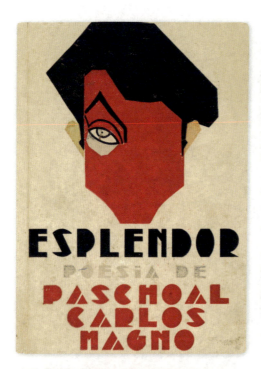
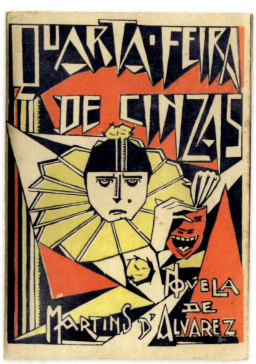
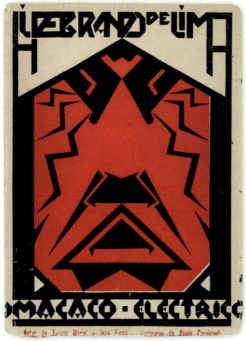
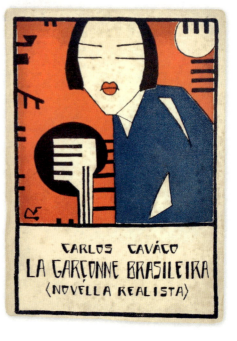

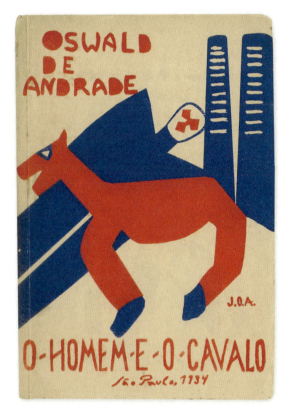

Cover by Oswald de Andrade Filho for Oswald de Andrade, *O homem e o cavalo. Espetáculo em 9 quadros*, São Paulo. Author's edition, 1934. 18.5 x 12.8 cm. The Guita and José Mindlin Brasiliana Library, University of São Paulo

←
Cover by Flávio de Andrade for Paschoal Carlos Magno, *Esplendor*, 2nd edition, Rio de Janeiro. Forja, 1932. 19.1 x 13.5 cm. Archivo Lafuente

Cover by Catunda for José Martins D'Alvarez, *Quarta-Feira de cinzas (novéla)*, Fortaleza (Ceará). Tipografia Carneiro, 1932. 20.8 x 15 cm. Private collection, Granada

Cover by Paulo Cavalcanti for Hildebrando de Lima, *O macaco electrico*, Recife (Pernambuco). Typographia Central, 1928. 20.3 x 14.5 cm. Boglione Torello Collection

Cover by unknown artist for Carlos Caváco, *La garçonne brasileira (novella realista)*, Rio de Janeiro. Private edition, 1925. 17 x 12 cm. Institute of Brazilian Studies, University of São Paulo

Cover by Manoel Bandeira for José Lins do Rego, *Menino de engenho*, Rio de Janeiro. Adersen - Officinas Graphicas Alba, 1932. 18.5 x 13 cm. Institute of Brazilian Studies, University of São Paulo

Cover by Manoel Bandeira for Jorge de Lima, *Poemas Escolhidos (1925-1930)*, Rio de Janeiro. Adersen, 1932. 19.2 x 13 cm. Archivo Lafuente

Cover by Tomás Santa Rosa for Graciliano Ramos, *Cahetés: Romance*, Rio de Janeiro. Schmidt, 1933. 18.9 x 12.4 cm. Archivo Lafuente

Cover by Tomás Santa Rosa for José Lins do Rego, *Doidinho: Romance*, Rio de Janeiro. Ariel, n.d. [1933?]. 18.6 x 12.4 cm. Archivo Lafuente

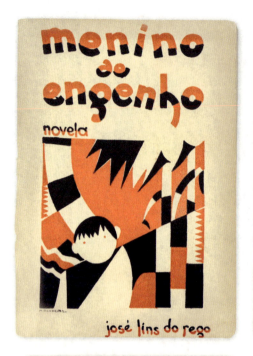
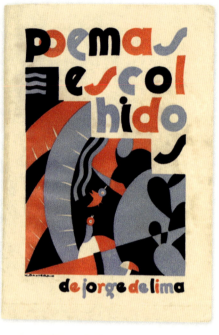
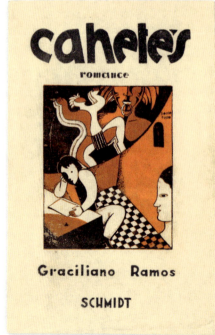
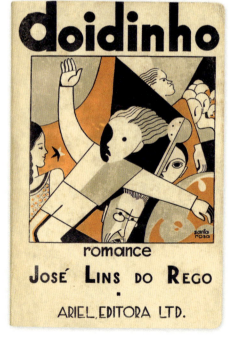

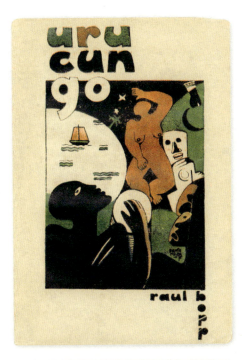
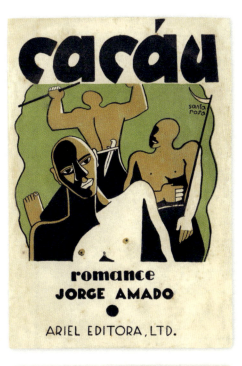

Cover by Tomás Santa Rosa for Raul Bopp, *Urucungo: Poemas Negros*, Rio de Janeiro. Ariel, n.d. [1932?]. 19 x 13 cm.
Archivo Lafuente

Cover by Tomás Santa Rosa for Jorge Amado, *Cacáu: Romance*, Rio de Janeiro. Ariel, 1933. 19 x 13 cm.
Archivo Lafuente

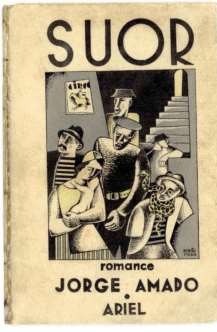
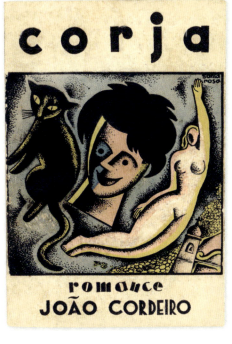

Cover by Tomás Santa Rosa for Jorge Amado, *Suór: Romance*, Rio de Janeiro. Ariel, 1933. 19 x 13 cm.
Archivo Lafuente

Cover by Tomás Santa Rosa for João Cordeiro, *Corja: Romance*, Rio de Janeiro. Calvino Filho, 1934. 19.1 x 13 cm.
Archivo Lafuente

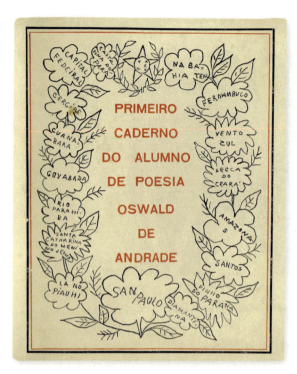

A Mario Guastini

Anachronismo

O portuguez ficou commovido de achar
Um mundo inesperado nas aguas
E disse: Estados Unidos do Brasil

Do quintal eu avistei
Casas torres e pontes
Rodaram como gigantes
Até que emfim parei

Roda roda São Paulo
Mando tiro tiro lá

Hoje a roda cresceu
Até que bateu no céo
E' gente grande que roda
Mando tiro tiro lá

As quatro gares

Para o Alvaro Moreyra

Infancia

O camisolão
O jarro
O passarinho
O oceano
A visita na casa que a gente sentava no sofá

Ao Alcantara

Adolescencia

Aquelle amor
Nem me falle

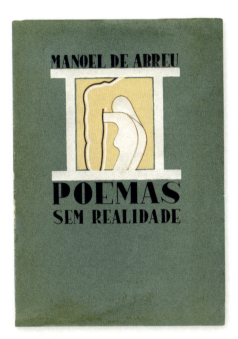

Cover and inner pages by Manoel de Abreu (author) for *Poemas sem realidade*, São Paulo. São Paulo Editora Limitada, 1934.
22.5 × 16 cm.
Archivo Lafuente

←

Cover by Tarsila do Amaral and inner pages by Oswald de Andrade (author) for *Primeiro caderno do alumno de poesia Oswald de Andrade*, São Paulo. Typographia da Rúa San Antonio, 1927.
26.5 × 21.5 cm.
The Guita and José Mindlin Brasiliana Library, University of São Paulo

Inner page by Cândido Portinari for Manoel de Abreu, *Meditaçoes*, Rio de Janeiro. Officina Graphica Mauá, 1936. 23.9 x 17 cm. Archivo Lafuente

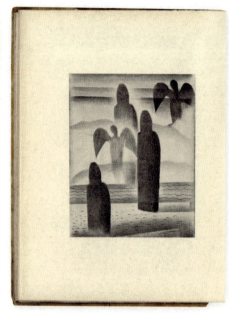

Cover by Tomás Santa Rosa and inner page by Cândido Portinari for Murilo Mendes, Cândido Portinari for *As metamorfoses: Poemas*, Rio de Janeiro. Occidente Ltda., n.d. [1938?]. 18.7 x 13.2 cm. Archivo Lafuente

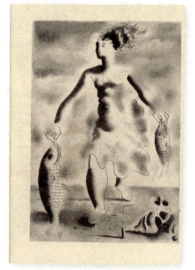

→
Cover and inner pages by Cândido Portinari for Ribeiro Couto, *Presença de Santa Teresinha*, Rio de Janeiro. Civilização Brasileira, 1934. 19.6 x 15.2 cm. Archivo Lafuente

Cover by Nelson Boeira Faedrich for Dámaso Rocha, *Festa de luz e de cor*, Porto Alegre. Livraria do Globo, 1933. 24 x 16.6 cm. Private collection, Granada

Cover by José Carlos de Brito e Cunha for Hyldeth Favilla, *Guiso de ouro*, São Paulo. Pimenta de Mello, 1935. 13.5 x 18.5 cm. Private collection, Granada

Cover and inner page by Nelson Boeira Faedrich for Nilo Ruschel, *Canções de luz e sombra*, Porto Alegre. Livraria do Globo, 1934. 22 x 16.8 cm. Paula Ramos Collection. Photo: Fábio del Re - Carlos Stein

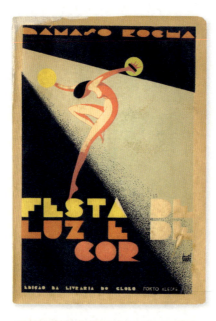
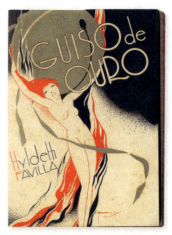
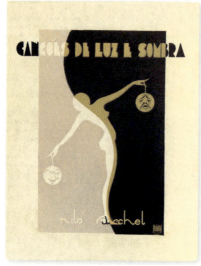

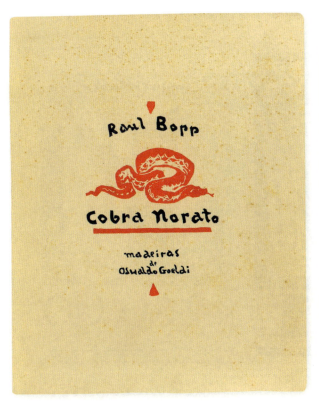
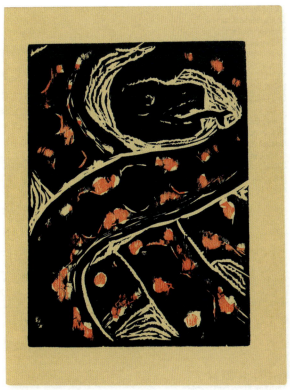

Cover and inner page by Oswaldo Goeldi for Raul Bopp, *Cobra Norato (nheengatu da margem esquerda do Amazonas)*, Rio de Janeiro. Mestre Armindo Di Mônaco, 1937. 34.5 x 27.5 cm. The Guita and José Mindlin Brasiliana Library, University of São Paulo

Cover by Emiliano Di Cavalcanti for Newton Belleza, *Hoje*, Rio de Janeiro. Empresa Gráphica Editora Paulo, Pongetti & C., 1930. 19 x 13.5 cm. Institute of Brazilian Studies, University of São Paulo

Cover Emiliano Di Cavalcanti for Benjamim Costallat, *Arranha-céo: Chrônicas*, São Paulo. Companhia Editora Nacional, 1929. 18 x 12.5 cm. Archivo Lafuente

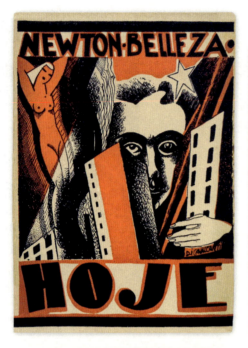
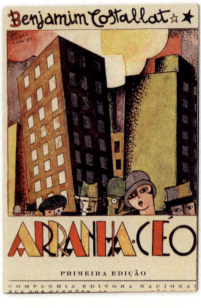

Cover by Oswald de Andrade Filho for Oswald de Andrade, *A escada vermelha*, São Paulo. Companhia Editora Nacional, 1934. 18 x 12.6 cm. Archivo Lafuente

Cover by Monteiro Filho for Berilo Neves, *Século XXI (Contos)*, Rio de Janeiro. Civilização Brasileira, 1934. 18.5 x 12.7 cm. Archivo Lafuente

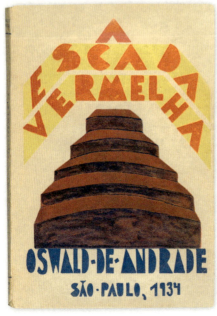
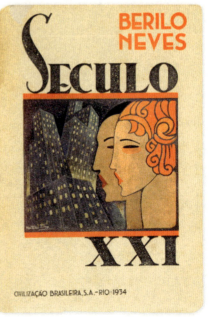

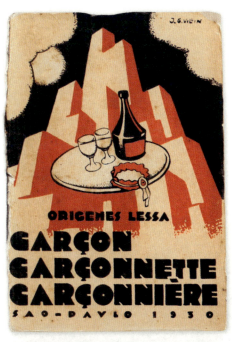
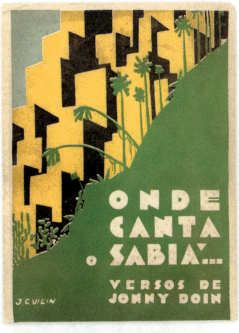

Cover by Jean Gabriel Villin for Orígenes Lessa, *Garçon, Garçonette, Garçonnière (novella e outros contos)*, São Paulo. Heros Graphica, 1930. 19 x 12 cm.
Ubiratan Machado Collection

Ubiratan Machado Collection. First reproduced in the book *A Capa do Livro Brasileiro, 1820-1950*, Ateliê Editorial, Brasil, 2018

Cover by Jean Gabriel Villin for Jonny Doin, *Onde Canta o Sabiá...: Versos*, São Paulo. Irãos Ferraz, 1930.
19 x 14 cm.
Archivo Lafuente

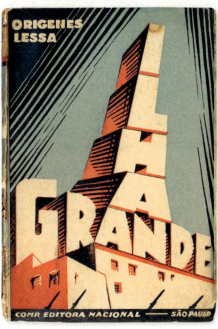
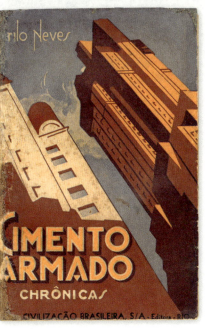

Cover by unknown artist for Orígenes Lessa, *Ilha Grande. Do jornal de um prisioneiro de guerra*, São Paulo. Companhia Nacional, 1933.
18.5 x 12.2 cm.
Private collection, Granada

Cover by unknown artist for Berilo Neves, *Cimento Armado (Chrônicas)*, Rio de Janeiro, Civilização Brasileira, 1936.
18.5 x 12.3 cm.
Archivo Lafuente

Covers by Tarsila do Amaral for Osório César, *Onde o proletariado dirige… (Visão panoramica da U.R.S.S.)*, São Paulo. Brasileira, 1932. 19 x 14 cm.
Archivo Lafuente

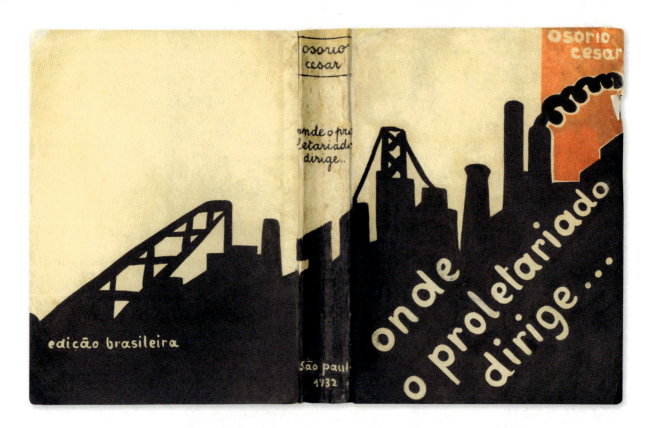

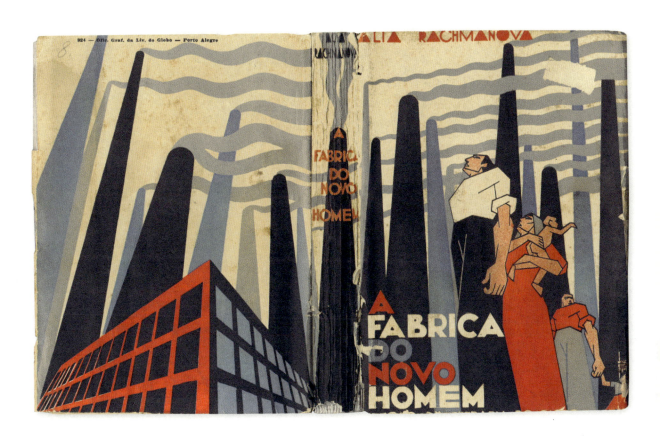

Covers by Nelson Boeira Faedrich for Alia Rachmanova, *A fabrica do novo homem*, Porto Alegre. Globo, 1937. 19.3 x 14 cm; 19.4 x 30.5 cm (open). Private collection, Granada

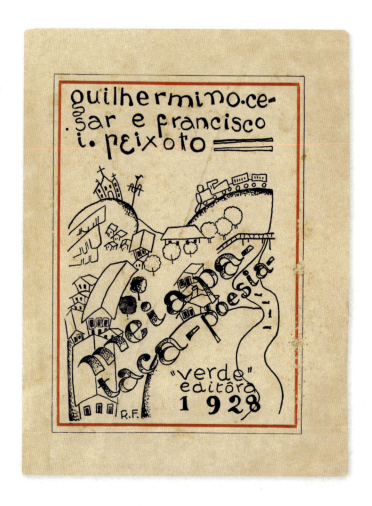

Cover by Rosário Fusco for Guilhermino César and Francisco Inácio Peixoto, *Meia pataca*, Cataguases. Verde, 1928. 23.5 x 17 cm. Private collection, Granada

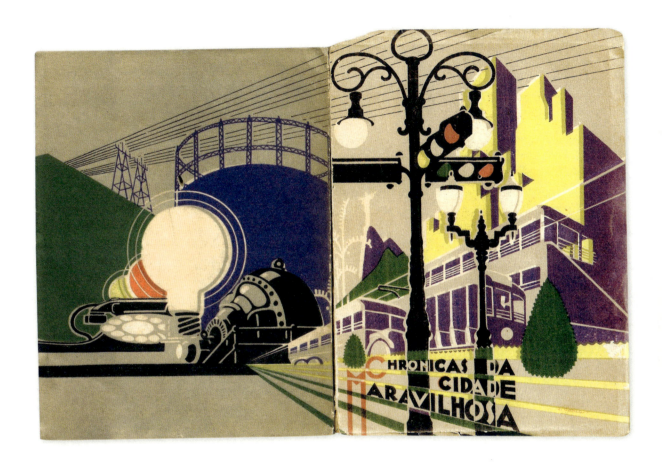

Cover by José Carlos de Brito e Cunha for Bastos Tigre, *Chronicas da cidade maravilhosa*, Rio de Janeiro. Departamento de Publicidade da Light, n.d. [1934?]. 17.5 x 13 cm. Ubiratan Machado Collection

Ubiratan Machado Collection. First reproduced in the book *A Capa do Livro Brasileiro*, 1820-1950, Ateliê Editorial, Brasil, 2018

Ricardo Dueñas T., *Ego*,
San Salvador. Talleres
Gráficos Cisneros, 1941.
25.5 x 25.5 cm.
Archivo Lafuente

The Caribbean and Central America

Riccardo Boglione

Contrary to others, this chapter isn't dedicated to a single theme or a single country. It encompasses a few, grouping them together according to their geographic proximity. This principle could of course be considered arbitrary, and perhaps we should have avoided it, but we believe it's important to explain why instead of describing books about graphic art in the countries in question (which, in any event, can be found in the bibliography quoted at the end of the study) we've chosen to vary the structure followed in the rest of *Diagraming Modernity*. In part, the decision is related to existing bibliography, which at present is decidedly scarce on the subject of graphic design in Central America and the Caribbean. However, the main and more pressing reason for our choice is another deficiency (save a few exceptions): that of the production of modernist covers and illustrations for books in this "region." In a nutshell, the primary causes of this state of affairs is that the number of printed works is notably smaller than in other areas of the continent, and the meagre arrival of avant-garde influences or allusions (again, there are exceptions) has prevented those that did arrive from attaining full expression. This is not to say that part of the responsibility concerning the reduced representation of this group of countries in our survey is ours, but in spite of our efforts and repeated searches, all we have been able to find of worth and in keeping with our approach is what follows. Naturally, there is quite a difference between what we have found and what there was to find, so we insist: this section, more so than the others, is a preliminary attempt to chart a terrain that we invite other researchers to explore in greater depth.

This section of "The Caribbean and Central America" also has gaps: we found no Modernist or even late-Symbolist works with a hint of change in books produced in Belize, in any of the Antillean Islands (with the exception of the

Dominican Republic and, of course, Cuba, that has a chapter of its own), or in the territories dependent on France, the United Kingdom, the Netherlands or the United States (apart from the Free Associated State of self-governed Puerto Rico). Instead of basing our analysis on the number of copies printed, we have preferred to trace a route from north to south.

In the Antilles, **Puerto Rico** is probably the place where the literary avant-garde trends were more apparent, and distinguished by being more "fragmentary, cutting-edge, innovative, and experimental than the Cuban and Spanish trends with which they maintained certain contact" (Teles and Müller-Bergh, 2002, 151). Even if we broaden our scope and observe the continent as a whole, Puerto Rico boasts a truly astonishing number of movements (with their corresponding manifestos). Between 1913 and 1948, nine isms succeeded one another (all of them short-lived), among them *euforismo*, *noísmo*, *atalayismo* and *meñiquismo*. But the art scene was different. As pointed out by Mari Carmen Ramírez, the reaction of the local art world to the American invasion of 1898 differed from "the formal and iconographical opening experienced by Latin American arts of the same period." In effect, Puerto Rican arts "retracted into their shells" in an attitude of seeming rejection of exterior styles and forms, and an exaltation of "Jívaro" culture, as a way of resisting the penetration and assimilation of the values of American culture. "In formal terms, this attitude was translated into the preservation of an artistic language that was, to a great extent, anachronistic …" (Ramírez, 1989, 13).

The graphic art we shall be discussing dates from 1935 onward, a period immediately after the country's first direct contact with works by prominent artists such as Picasso, Braque, Marie Laurencin, Diego Rivera, and David Alfaro Siqueiros, that had been displayed in exhibitions of foreign art staged by American watercolorist Walt Denher in Río Pedras in the mid-1930s (Torres Martinó, 1989, 54).

The first work is a cover by Enrique Riverón, a cosmopolitan Cuban illustrator who spent long periods working in the United States and whose graphic vocabulary confidently included modernist traits. In his cover for *Raíces azules* (1936), by Carmen Alicia Cadilla, Riverón created a dreamlike sea atmosphere playing with color "chiasms," blue and white, oblong and biomorphic shapes, jauntily moving back and forth between figuration and abstraction in an ensemble that could finally be described as Surrealist. Still more evanescent, though with letters that are greatly indebted to the impulses of late "Deco-Futurism" is the cover that Rafael D. Palacios—a distinguished Puerto Rican painter, illustrator and mapmaker whose interest in portraying the social reality of black Puerto Ricans and Antilleans was early and important—created for *Sombras paralelas* (1936), by Manuel Siaca Rivera.

The theme of the book *Tuntún de pasa y grifería* that the poet Luis Palés Matos published in 1937, a milestone in the Latin American avant-garde, was Afro-Antillean. This volume was absolutely crucial in the defense of the island's black culture, despite the criticism it received. The theme wasn't new, as William Luis declared apropos Cuba, but its discourse could be extended to other realities of the region: "[D]uring the avant-garde period it resurfaced as a way of changing the color of European esthetics, challenging the social, political, and racial values of the literate city, and wisely reflecting the composition of Caribbean culture." (Luis, 2010, 4).

Its cover was entrusted to Carmelo Filardi, a notable caricaturist of *Puerto Rico Ilustrado* magazine whose wise play of chiaroscuros and curvatures managed to create a dynamic portrayal of a dance framed by flames, stars, masks, vegetation and agile red letters forming the title: the central figure is the Antillean mulatta, which can be read as a "novel" figure of

THE CARIBBEAN AND CENTRAL AMERICA

Inner page by Eduardo Matos-Díaz (author)
for *Caricaturas*, Santo Domingo. La Cuna de América, 1924.
23.3 x 15.7 cm.
Private collection, Granada

desire in literature (Albada-Jelgersma, 1997, 357), and the ensemble as an attempt to visualize the ritual and rhythmic universe of the onomatopoeic poems by Palés. In any discussions of Filardi, we must note the existence of two works made for Carmelina Vizcarrondo: the essentialist cover for *Pregón en llamas* (1935) and the delicately Surrealistic illustrations characterized by strong color contrasts of *Poemas para mi niño* (1938). The anonymous cover of *Poema en 20 surcos* (1938), the first book by Julia de Burgos—a figure that critics have associated with avant-garde circles (Morales Faedo, 2009, 265-266)—has a very attractive combination of naïve execution and imaginative use of "modern" resources, a rhythmic repetition of figures (one of which is a surreal heart with an eye) and unusual angularities.

In the case of the **Dominican Republic**, the early literary avant-garde of *postumismo* (literary movement in which rhyme is abandoned, rhythm is disordered and ideas expressed as they surface in the mind of the author) practiced by Andrés Avelino and others didn't have an artistic counterpart. Of the two artists whose main features can be described as Modernist, Jaime González Colson spent the first decades of his career between Spain, France and Mexico (with a Dominican sojourn in 1938), and Darío Suro held his first solo exhibition in Santo Domingo in the 1940s. Perhaps for this reason we shall only mention two covers, both of them late contributions: for *El viaje. Ensayo de novela de la vida capitaleña* (1940), by Manuel A. Amiama, the Catalan painter Joan Junyer Vidal—who had just arrived in Santo Domingo, fleeing from the Second World War—chose a drawing with superficial, fragmented lines, while the unknown author of *Poemas de una sola angustia* (1940), a collection of socially-themed poems by Héctor Incháustegui Cabral, is a display of calligraphic letters and a small vignette with a Surrealist air that chaotically condenses a house and a horse, stars, a hut and Masonic symbols in a few centimeters, alternating black (for objects) and green (for animate beings).

It is not surprising that the first cover produced very early (1915) in **Guatemala** should have been signed by Carlos Mérida, proving that his modern praxis preceded his settling in Mexico (1919). Indeed, while still in Guatemala he belonged to a group of artists, Los Modernos, which included the sculptor Rafael Yela Günther, that, inspired by the Catalan Jaime Sabartés, came into contact in the second decade of the twentieth century with "the changes brought to art by the Impressionist model and its application to landscape, and the incipient Cubism practiced by Braque, Cézanne [sic] and Picasso" (Vásquez Peralta, 2011, 17), that he had already seen first-hand during a sojourn in Paris. The cover in question is that of the volume of short stories titled *El hombre que parecía un caballo*, the first book by Rafael Arévalo Martínez, a "happy synthesis of avant-garde trends and techniques" (Muñoz Reoyo, 1997, 328). Mérida drew, in profile, the head of a horse with expressive eyes that was, perhaps, an echo of the typical posture found in certain pre-Columbian bas-reliefs.

When a new edition of *El hombre que parecía un caballo* was published in 1927, the cover was illustrated by the poet and playwright Manuel José Arce y Valladares, less known as a draftsman. In this design, a caricatural figure, geometric and categorical —possibly the dandy of the story— appeared halfway between areas of black and white. Arce y Valladares illustrated the cover of another book by Arévalo Martínez, *Las noches en el palacio de la Nunciatura* (1927), a design also presided over by a central figure—a geometrized seated Buddha, set against an impressive yellow ground. A similar compositional procedure is found in the third book by Arévalo Martínez, *La signatura de la esfinge* (1933), where the anonymous illustrator positioned a slender sphynx in the middle of an abstract and contrasted

ground, literally divided into two parts, between the black of the print and the light blue of the paper used for the binding.

Befittingly, the anonymous illustrations of *Tezulutlán* (1936), by Manuel Chavarría Flores, and *Kukulcán* (1939), by Valentín Abascal, were dedicated to pre-Hispanic themes. While the former portrayed a rigorously symmetrical, almost heraldic, figure with ornamental motifs of Mayan origin in a striking combination of black, yellow, and red, the latter apparently preferred an unsettling representation of three owls, one of the sacred creatures in that ancient culture.

Finally, the aforementioned sculptor Yela Günther, who had worked in Mexico for a number of years in the circle of the Muralists, designed two covers in Guatemala. *La tierra de las nahuyacas* (1933), by Carlos Wyld Ospina, depicts a landscape of Alta Vera Paz in earthy colors, the contours of which are defined by an unusual white line and where different elements symbolically coexist: a colonial bell tower in the foreground (an emblem of historical and identity concerns) and a volcano in the background (representing nature) are separated by the village we see through the eyes of the character surveying the horizon from the terrace of the temple. In its turn, the splendid cover of *Romances de tierra verde* (1938), by Francisco Méndez and Antonio Morales Nadler, shows a surprisingly free-flowing and powerful play between image and word: in a jerky continuum of black lines that express letters, the titles and authors' names are superimposed on a naïf landscape made with a few watercolor brushstrokes (barely two for the sky).

In **El Salvador**, new languages were gradually introduced by figures who worked individually, without managing to form an avant-garde art movement *per se*. By the way, the caricatures by Toño Salazar have the synthetic characteristics of Futurism yet, in spite of being inspired by El Salvador, they basically developed abroad (see p. 61) in the early 1920s, due to the fact of him having settled in different places—first in Mexico (where, among other magazines, he worked on *La Falange*, mouthpiece of the group of literati who years later would call themselves Los Contemporáneos), then in 1923 in Montparnasse, Paris, followed by New York and Buenos Aires, before returning to El Salvador in 1953. The other great figure in the renewal of the art of El Salvador was his cousin Salvador Efraín Salazar Arrué, better known under the brush name Salarrué. Having been awarded a scholarship in 1916 (Cañas Dinarte, 2018), Salarrué trained in America and in the early 1930s went on to work as an illustrator for several magazines, such as *Cactus y Mujer*, by Clementina Suárez. Before then, he had produced an almost caricatural and distorted version of what would have previously been considered an Art Nouveau design for *El poeta egoísta* (1922), by Julio Enrique Ávila, and years later, in 1936, he made the cover for the second edition of *El cristo negro* he himself had written (funnily enough, he was more renowned as an author than as a plastic artist). The plot of this short novel—a sort of paradoxical hagiography in which the character of Uraco, a future saint, led a life of crime to prevent others from sinning—was reflected in Salarrué's brilliant drawing of a slender crucifix (that reminds us of the famous *Cristo negro*, sculpted in 1954 by Quirio Cataño and kept in Esquipulas) where the sacred figure, on a red cross set against a yellow ground, is colored in black and white sections in a chequerboard pattern, summing up the continuous tension between good and evil on which the story is based.

Although several artists who had trained in Europe—including Pablo Zelaya Sierra, Max Euceda, Carlos Zúñiga Figueroa, Confucio Montes de Oca—returned in the 1920s to **Honduras** to "promote the country's national artists who had, until then, been self-taught" (López y Becerra, 2014, 33), their impulse was barely noticed in the field of book illustration. We can, however,

Tegucigalpa: semanario de información y variedades, no. 422, 10 February 1935.
Editor: Alejandro Castro.
Tegucigalpa, n.p.
29.6 × 22.1 cm.
National Library of Spain, Madrid

mention the work that a certain J. A. Paz made for the novel *Alturas y abismos* (1955), by Carlos Izaguirre, in which the two words of the book's title stand out on a sunny rocky landscape, and whose position emphasizes their meaning: horizontal the first word, *alturas* (heights), placed in the upper region; vertical the second, *abismos* (abysses), placed in the center of the composition and read from top to bottom.

As regards **Nicaragua**, another country whose art took a step forward in the 1940s, we shall discuss the covers of two volumes printed abroad, in Costa Rica and Chile, respectively. The first book is a curious case of a geographic intersection between three Central American countries; the second book by the poet Alberto Guerra-Trigueros, born in the Nicaraguan city of Rivas to a Salvadoran mother, whose literary and journalistic career developed in El Salvador (after having educated in France and England up to the age of twenty-four), *El surtidor de estrellas* (1929) was published in the poetry collection of the prestigious magazine *Repertorio Americano*, directed by Joaquín García Monge in San José, Costa Rica. Its elegant cover had stenciled letters, well-combined colors, and a simple yet effective use of symmetry by Guerra-Trigueros himself.

The other cover we consider worth mentioning in this section is that of *Poemas nicaragüenses* (1934), being as it is the first and probably the most outstanding book by Pablo Antonio Cuadra. In the early 1930s, along with poets José Coronel Urtecho, Luis Alberto Cabrales and Manolo Cuadra, the author co-founded an avant-garde movement in the Nicaraguan city of Granada called Nicaraguan Anti-Academia, which was joined by Joaquín Zavala Urtecho (whose caricatures and prints, to date overlooked, were the first expressions of modernism in the country). The impressive cover of *Poemas nicaragüenses*—clearly hovering between abstraction and the Minimalist depiction

Ateneo Puertorriqueño, vol. 1, no. 2, second quarter 1935. Editors: Samuel R. Quiñones et al. San Juan de Puerto Rico, Ateneo Puertorriqueño. 22.6 × 15.1 cm. National Library of Spain, Madrid

of mountains, opposing the sharpness of the peaks to the roundness of the letters—isn't signed, but could well be by Cuadra himself who, as an "art lover," had previously decorated "in the Cubist style" the Café de las Artes in Granada, where the group offered "scandalous recitals" (Arellano, 1991, XIII).

The period between the late 1920s and early 1930s was very lively for the art world of **Costa Rica**, which was gradually consolidated and professionalized, and even managed to create a (small) market for its productions, some of them avant-garde. To a great extent, this was the result of a competition, first held in 1928 and that would continue to be celebrated for almost a decade. As summed up by Eugenia Zavaleta Ochoa (2004, 113), "In Costa Rica, the 'Expositions of Plastic Arts' (1928-1937) evinced the emergence of a new generation of artists with diverse esthetic inclinations. Some of the young creators followed in the footsteps of former academic masters, others were bolder and adopted modern trends such as Impressionism and Post-Impressionism, and a few looked to more advanced tendencies—such as Cubism and Expressionism—and their contemporaries considered them the most avant-garde artists of the time. Gradually, the two last groups consolidated their position in the art world by obtaining most of the prizes awarded. This is how modern art was introduced in Costa Rica."

Hence, artists like Teodorico Quirós, Francisco Zúñiga, and Juan Manuel Sánchez, among others, sometimes described as devotees of the "new sensitivity," would occupy increasingly significant symbolic positions. Modernist graphic art, in its turn, developed in parallel. We should mention here that graphic design had begun to make a place for itself a few years earlier, as "in 1921, Alberto H. Garnier opened the first advertising agency of Central America in Costa Rica" (Soto Morúa, 2018). Although Quirós created a tense, angular combination of Cubist and Expressionist forms in his impressive cover for *Unos fantoches*

(1928), by Max Jiménez, the most prominent names were no doubt those of other members of the group: Francisco Amighetti, and, above all, Jiménez himself.

Amighetti, a self-taught artist born in 1907, was a curious experimenter in whose work we can trace more than a dozen influences, including German Expressionism, Italian Trecento and Quattrocento, "a touch of Spilimbergo," the Mexicans Posada and Rivera, Japanese printmakers, and, what is more relevant to our first cover, "transitory" Cubism (reproduced in Gutiérrez, 1989, 17). Indeed, the picture reproduced on the cover of *Mi 2.ª dimensión* (1928), by Moisés Vincenzi, reflects Amighetti's exploration of the postulates of the French school, with interesting hints of caricature and an obvious play between the title of the book and the issue of dimensions in Cubism, a style interpreted by Amighetti as the source of a similar "intellectual pleasure" to that of the truth of mathematical formulas (cf. Zavaleta Ochoa, 2004, 85). Another book that is worthwhile mentioning is *El tunco* (1932), by Honduran author Arturo Mejía Nieto. Published in Buenos Aires, the book's illustrations, images "sculpted" by Amighetti, reveal his synthetic skill as an engraver.

Without a shadow of doubt, the greatest of Costa Rican "graphic artists" was Max Jiménez, who was also a sculptor, painter, journalist, and writer. After training at a seminary, he traveled to England to study Economics, and by the early 1920s was in Paris working as an artist. In the French capital he produced sculptures that were "very slender and geometric, without abandoning figuration," and "probably the first works by a Costa Rican artist that followed the esthetic canons of European avant-garde trends" (Herrera, 1999, 89), although when they were made, in spite of appearing in *Repertorio Americano* review, they wouldn't have any bearing on the development of plastic art in his country of origin. In fact, this "geometric slenderness" appears, albeit only sporadically, in the first book we have mentioned here, the author's last collection of verses, *Revenar* (1936), published in Chile: "[Here], if the poems are characterized by traditional forms of expression ... the prints are characterized by slender distortion, withdrawal from Realism, experimentation with formal languages derived from sources quite dissimilar and yet mostly related by their contemporary nature" (González Kreysa, 1999, 96).

The convergence of the strains in Jiménez's artwork during the mid-thirties is even more obvious in the woodcuts he made for *El domador de pulgas* (1936), published in Cuba. A satirical novel, its twenty prints explore abrupt and different forms of Expressionism that include suggestions of Surrealism (Ortiz, 2007, 43). González Kreysa (1999, 98-99) has classified the illustrations into three types: geometric, Munchian, and another that preserves Parisian geometrization and yet "increases the importance of figuration and the presence of natural and human elements characterizing American reality." Similar motifs resurface barely one year later in *El Jaúl*, a novel published in Chile that intended to destroy "Costa Rican mythology," to which we may add the appearance of another stimulus, the "Constructivism of plastic artists like El Lissitzky" (González Kreysa, 1999, 103).

Our survey would be incomplete without the mention of the Costa Rican works by Salvadoran Salarrué (see pp. 259, 266, 267 and 276), who had produced an exquisite Art Deco illustration, subtly based on the form of the circle, for *Canción redonda* (1937), by Claudia Lars. The same figure would reappear in the anonymous composition of pure letters and shapes in *El punto muerto* (1938), by Alfredo Castro Fernández. Finally, two other covers by unknown artists deserve to be examined. Both were made for books by Venezuelan author Isola Gómez and appeared the same year, 1938, published by Trejos Hermanos. The cover of *Colmena* reveals an interesting

Cover by Max Jiménez for *Repertorio americano: semanario de cultura hispánica*, year XVIII, no. 798, vol. XXXIII, no. 14, 10 April 1937. Editor: J. García Monge. San José. Borrasé Hermanos, 35.3 × 24.5 cm. Archivo Lafuente

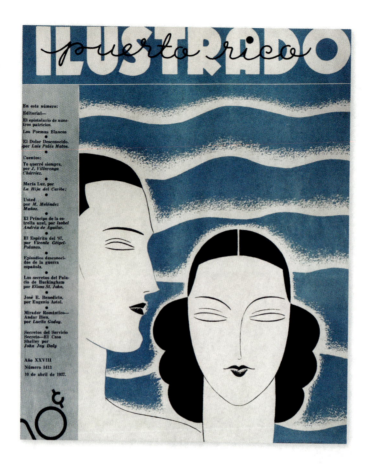

Cover by unknown artist for *Puerto Rico ilustrado*, year XXVIII, no. 1413, 10 April 1937, San Juan. n.p. Private collection

interaction between bees and the letters of the title, literally transported by them to a honeycomb, geometrically ascending and distinguished by straight lines, whereas that of *Verde claro*, on the other hand, can almost be described as proto-Pop, depicting a female face that closely resembles an advertisement illustration of the period, her eyes behind a pane of green glass that is an obvious reference to the book's title.

From what we may infer from the study *Diseño gráfico: evolución en Panamá 1900-1950* (by Mariela Vilar), limited in scope because it only focuses on one newspaper, *Star & Herald, La estrella de Panamá*, the appearance of modernist traits in the graphic art of **Panama** was late and timid. As to the period we are surveying, it is worth mentioning the clearly Symbolist cover vigorously drawn by Ecuadorian draftsman and printmaker Alberto Pallete Varas for the novel titled *Leyenda bárbara* (1921), the second book by the poet Demetrio Korsi. The style of this novel was still Postmodernist, although the poet's subsequent verses can be said to prefigure local avant-garde literary trends (Müller-Bergh and Mendonça Teles, 2007, 323).

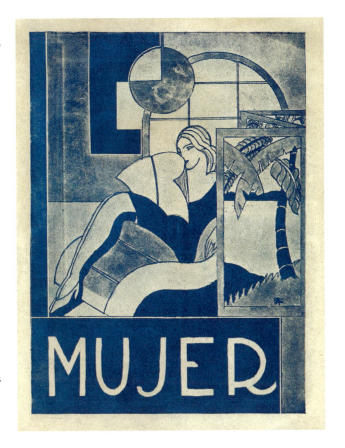

Cover by Salarrué (pen-name of Salvador Efraín Salazar Arrué) for *Mujer*, year I, no. 1, 10 November 1933. Editor: Clementina Suárez. Tegucigalpa, n.p. Private collection

The Caribbean and Central America

Cover by Carmelo Filardi for Luis Palés Matos, *Tuntún de pasa y grifería: poemas afroantillanos*, San Juan. Biblioteca de Autores Puertorriqueños, 1937.
17.2 x 13.4 cm.
Archivo Lafuente

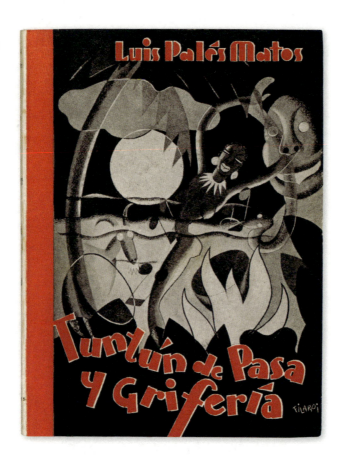

→»
Cover and inner pages by Carmelo Filardi for Carmelina Vizcarrondo, *Poemas para mi niño*, San Juan. Imprenta Venezuela, 1938.
19. 8 x 17.5 cm.
Archivo Lafuente

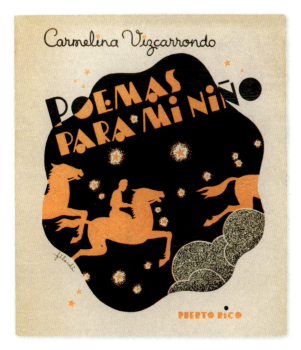

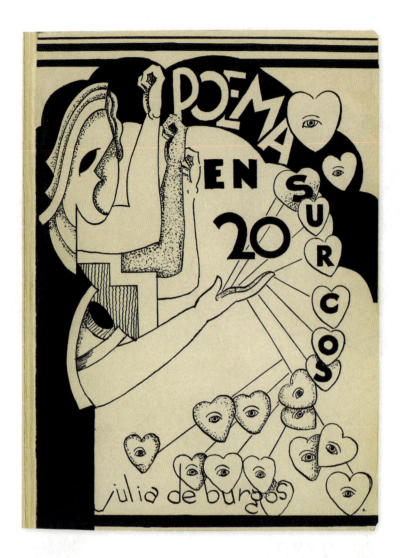

Cover by unknown artist for Julia de Burgos, *Poema en 20 surcos*, San Juan. Imprenta Venezuela, 1938. 25.2 x 18 cm.
National Library of Spain, Madrid

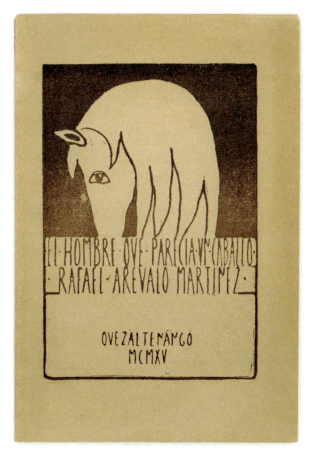

Cover by Carlos Mérida for Rafael Arévalo Martínez, *El hombre que parecía un caballo. El Trovador Colombiano. Las Rosas de Engad*, Quezaltenango. Tipografía Arte Nuevo, 1915. 21.8 x 15 cm.
Archivo Lafuente

Cover by unknown artist for Valentín Abascal, *Kukulcán*, Guatemala City. Tipografía Nacional, 1939. 19 x 12.6 cm.
Archivo Lafuente

Cover by Salarrué (pen-name of Salvador Efraín Salazar Arrué, author) for *El cristo negro (Leyenda de San Uraco)*, 2nd edition, San Salvador. Ediciones de la Biblioteca Nacional - Tipografía La Unión, 1936. 14.3 x 10.4 cm.
Archivo Lafuente

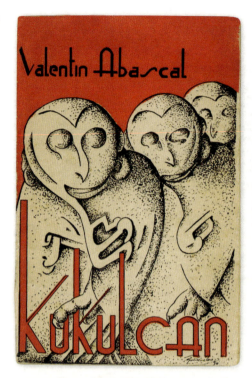

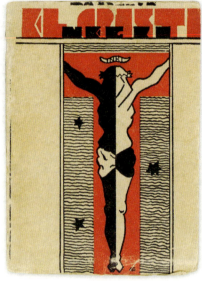

Cover by unknown artist for Manuel Chavarría Flores, *Tezulutlán*, Guatemala City. Sánchez y de Guise, 1936. 18.5 x 12.5 cm.
Archivo Lafuente

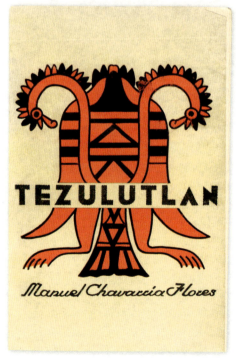

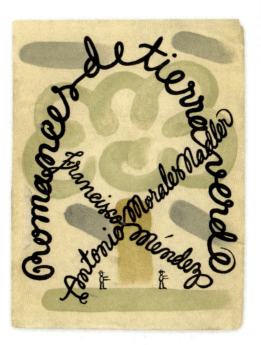

Cover by Rafael Yela Günther for Francisco Méndez and Antonio Morales Nadler, *Romances de tierra verde*, Guatemala City. Tipografía América, 1938. 16.2 x 12.5 cm. Archivo Lafuente

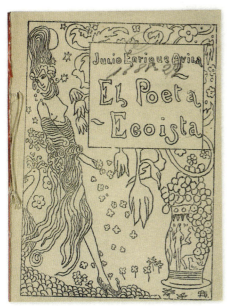

Cover by Salarrué (pen-name of Salvador Efraín Salazar Arrué) for Julio Enrique Ávila, *El poeta egoísta*, San Salvador. Imprenta Nacional, 1922. 15.3 x 11.5 cm. National Library of Spain, Madrid

**Cover by J. A. Paz for
Carlos Izaguirre,** *Alturas
y abismos*, Tegucigalpa.
n.p. [Talleres Tipográficos
Nacionales?], 1935.
19 x 13.6 cm.
Archivo Lafuente

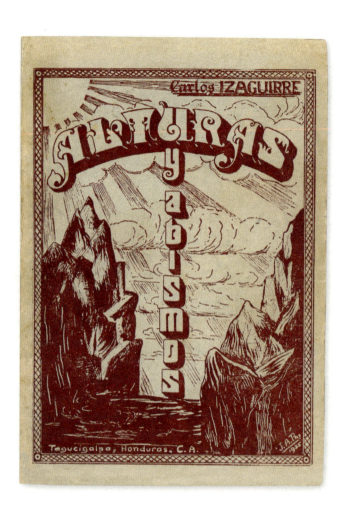

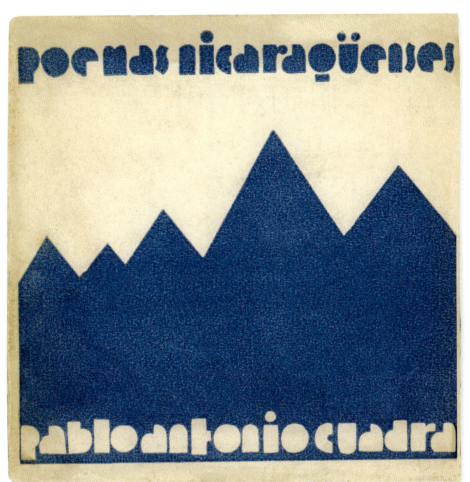

Cover by Pablo Antonio Cuadra [author?] for *Poemas nicaragüenses 1930-1933*, Santiago de Chile. Nascimento, 1934. 19.9 x 19.4 cm. Archivo Lafuente

Cover by Francisco Amighetti for Moisés Vincenzi, *Mi 2.ª dimensión,* José Vasconcelos (preface), San José. Trejos Hermanos, 1928. 20 x 13.5 cm. Private collection, Granada

THE CARIBBEAN AND CENTRAL AMERICA 271

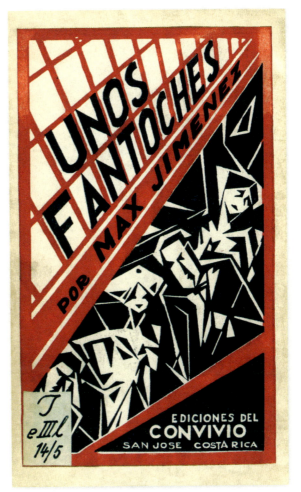

Cover by Teodorico Quirós for Max Jiménez,
Unos fantoches..., San José.
El Convivio, 1928.
19 x 11.5 cm.
University of Hamburg, Hamburg

Cover and inner pages by Francisco Amighetti for Arturo Mejía Nieto,
El tunco: novela, Buenos Aires. Tor, 1932.
18.7 x 12.5 cm.
Private collection, Granada

→
Cover and inner pages by Max Jiménez (author) for
Revenar, Santiago de Chile. Nascimento, 1936.
24.5 x 19.5 cm.
Archivo Lafuente

MARINESCA

NAUFRAGO en espuma de mar,
estela en fiesta blanca,
y brazos que aletean;
burbujas que se rompen
en el vaho blanco
de las aguas de sal.
Aguas que se modelan de los vientos
y sueltan
su cabellera al sol.

Agua de mar,
señora de toda la existencia.
Asombro de pupilas
en peces,
pulidos de nadar.
Cetáceos rodados en las manos,
pan negro del polo;

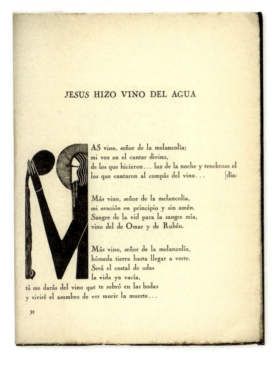

JESUS HIZO VINO DEL AGUA

MAS vino, señor de la melancolía;
mi voz en el cantar divino,
de los que hicieron… luz de la noche y tenebroso el
los que cantaron al compás del vino… [día:

Más vino, señor de la melancolía,
mi oración en principio y sin amén.
Sangre de la vid para la sangre mía,
vino del de Omar y de Rubén.

Más vino, señor de la melancolía,
húmeda tierra hasta llegar a verte.
Será el costal de odas
la vida ya vacía,
tú me darás del vino que te sobró en las bodas
y viviré el asombro de ver morir la muerte…

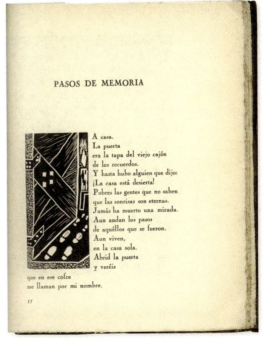

PASOS DE MEMORIA

A casa.
La puerta
era la tapa del viejo cajón
de los recuerdos.
Y hasta hubo alguien que dijo:
¡La casa está desierta!
Pobres las gentes que no saben
que las sonrisas son eternas.
Jamás ha muerto una mirada.
Aun andan los pasos
de aquéllos que se fueron.
Aun viven,
en la casa sola.
Abrid la puerta
y veréis
que en ese cofre
me llaman por mi nombre.

Cover and inner pages by Max Jiménez (author) for *El domador de pulgas*, Havana. Hermes, 1936. 18.5 x 14 cm. Private collection, Granada

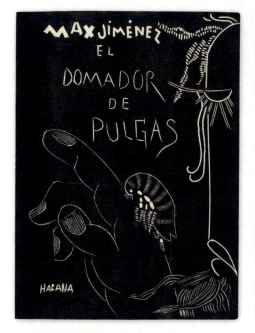
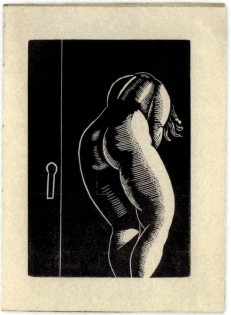
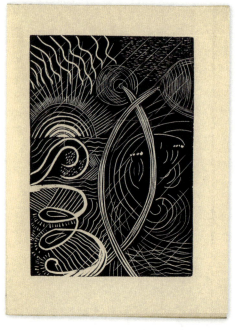
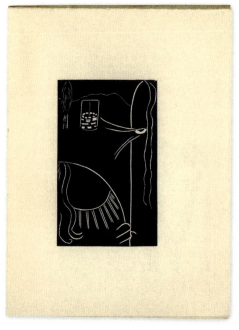

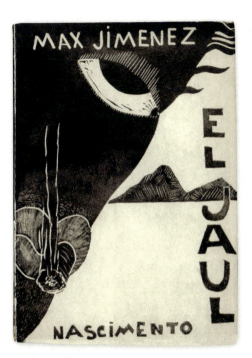
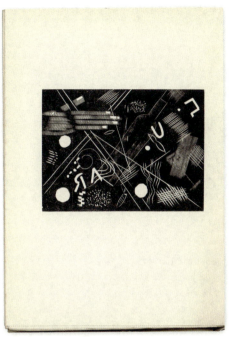
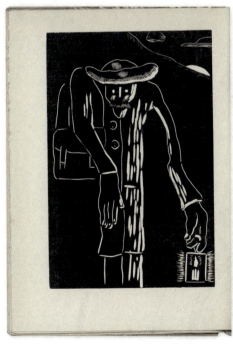
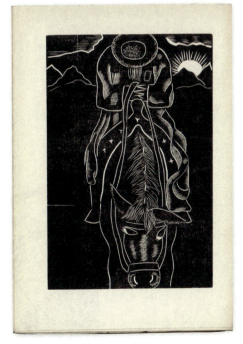

Cover and inner pages by Max Jiménez (author) for *El Jaúl*, Santiago de Chile. Nascimento, 1937.
18.8 x 13.9 cm.
Spanish Agency for International Development Cooperation Library, Madrid

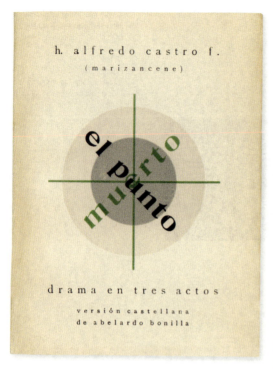

Cover by unknown artist for H. Alfredo Castro Fernández (Marizancene), *El punto muerto: drama en tres actos*, San José. Trejos Hermanos, 1938. 17.5 x 13.2 cm. Archivo Lafuente

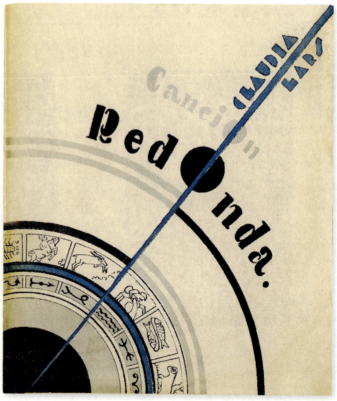

Cover by Salarrué (brush name of Salvador Efraín Salazar Arrué) for Claudia Lars (brush name of Carmen Brannon Vega), *Canción redonda*, San José. Convivio, 1937. 20 x 17.3 cm. Private collection, Granada

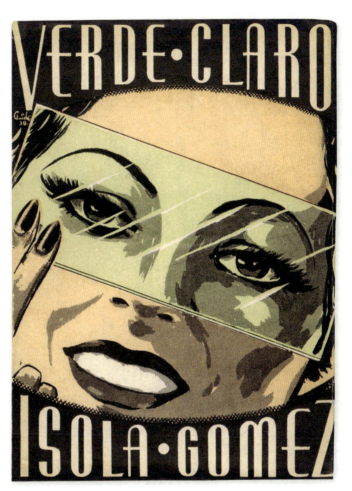

Cover by unknown artist for Isola Gómez, *Verde claro*, San José. Trejos Hermanos, 1938. 23 x 16.3 cm. Archivo Lafuente

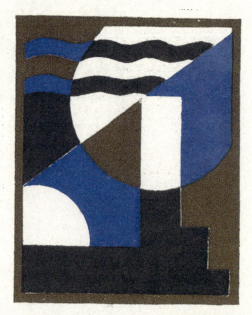

Composiciones decorativas del curso del profesor Isaías Cabezón, 1, 2 y 3, Marcial Lema; 4, Roberto Humeres

Chile

Rodrigo Gutiérrez Viñuales

In the continental jigsaw puzzle, Chile boasts one of the most comprehensive showcases of graphic design linked to publishing houses. This has been noted by art historians, and over the course of the 21st century a number of key works have been published that stress the country's heritage in illustrated books, not only during the period we are surveying but further back in time, and further into the future. In this sense, the volume *Hdgch. Historia del diseño gráfico en Chile*, by Pedro Álvarez Caselli (2004), now out of print (although we look forward to a prompt re-edition), is essential reading as it touches the central themes of our study along with other aspects, such as poster and advertising design.

Over the course of the last decade, new publications have appeared almost uninterruptedly. Thus, a publisher like Quilombo in Valparaíso made a name for itself with *Editado en Chile (1889-2004)*, by Paula Espinoza O., in 2012, and *Antología visual del libro ilustrado en Chile*, by Claudio Aguilera Álvarez, in 2014, the latter focused on illustration. Other more specific works that are basic to further our understanding of the subject are those dedicated to *Nascimento. El editor de los chilenos* (2013), by Felipe Reyes Flores, and to [Mauricio] *Amster* (2011), by Juan Guillermo Tejeda, among others. All these materials, and other sources scattered throughout publications on the history of Chilean art and literature, enable us to define the context in which we will trace our story, through the books we have discovered and selected.

As we have pointed out in our analysis of other Latin American countries, the process of modernization of Chilean graphic design is based on the experiences of Art Nouveau and Symbolism in the early 20th century. This is exemplified in the practice of a series of artists whose works were published in magazines, and hence became rapidly popular. Such are the cases of the Italian draftsman José Foradori and

of Alejandro Fauré, one of the forerunners of Chilean graphic art. The two played a key role in the decoration of *Chile Ilustrado* review, launched in 1902 and characterized by its Modernist design. Fauré also illustrated *Noticias Gráficas* (1903) and Foradori made numerous graphic contributions to *La Ilustración* (1905), where he gave free rein to a floriated repertoire inspired by his Italian origins.

Around the year 1915, when the country's publishing industry was thriving, some of the artists working in the field of books began to try their hand at illustration. Jorge Délano (Coke) and Luis Meléndez Ortiz, two such figures, departed from Modernist and Symbolist trends and moved on to more advanced trends in an ongoing process of comings and goings. Among the examples of works by Meléndez included here is the cover of the popular *Selva lírica* anthology, coordinated by Julio Molina and Juan Agustín Araya in 1917, the same year in which Nascimento publishing house was founded. Meléndez's Symbolist inspiration can also be traced in two collections of poems: *La isla de oro* (1919), by Alfredo Guillermo Bravo, and *Los horizontes* (1920), by Daniel de la Vega; later on, in the cover of *La muerte de Vanderbilt*, by Joaquín Edwards Bello (1922), he takes the style one step further, synthesizing and geometrizing the design's details. In the early 1920s other artists, like Laureano Guevara, Pascual Brandi Vera and Efraín Estrada Gómez, were still creating Modernist illustrations before establishing connections with avant-garde groups.

The emergence of the Grupo de los Diez in Santiago in 1916, a collective led by Pedro Prado that brought together several men of letters, plastic artists, architects and musicians, favored relations such as those established at European coteries which were just beginning to appear in Latin America. Characterized by the convergence of artists from different disciplines, these gatherings were usually held at private homes, cafés or publishing houses. Collaborations between these artists significantly promoted book and magazine illustration among members of the group. Prado, himself a writer and a plastic artist, had studied Architecture and took on the graphic design and illustration of his own books, as in the case of *Alsino* (1920). These relationships were highlighted by the group's organs, like *Revista de Artes y Letras*, the covers of which were illustrated by artists such as Alfredo Bustos and Isaías Cabezón. The latter would later be one of the main driving forces of poster design in Chile, and in 1920 produced the for us unknown cover of *Los poemas lunados*, a book condemned and removed from circulation by its author, Rosamel del Valle (pen-name of Moisés Filadelfio Gutiérrez Gutiérrez).

By the early 1920s, some of the focal points of the Chilean avant-garde making notable though one-off contributions to graphic art had been clearly established, and certain designers would continue to produce these works over the course of time. In particular, we should mention the experience of Valparaíso, where the importance of the Hungarian author Zsigmond Remenyik was revived by László Scholz (2009). In Valparaíso in 1922 he published *La tentación de los asesinos!*, with remarkable illustrations by Jesús Carlos Toro, a Mexican artist yet to be recognized in historical terms. Toro designed a disturbing cover in which a face is attacked by two daggers, held by the figure himself, and a faceted drawing made on a structure that resembles a pane of broken glass in which he inserted gruesome Expressionist compositions, all of them featuring the face on the front cover. This design must necessarily be mentioned in relation to the creation around the same time of the avant-garde poster *Antena* (1922) published by Tour Eiffel, with its clearly Huidobrian air, that included the manifesto of Rosa Náutica avant-garde group, to which Remenyik contributed an Expressionist engraving titled *Aktivizmus* by his friend Sándor Bortnyik, a Hungarian artist linked to the Bauhaus.

As regards the artists just mentioned, in April 1922 Jesús Carlos Toro made the picture reproduced on the cover of the literary sheet *Elipse. Ideario de nuevas literaturas*, and a couple of years later collaborated with Neftalí Agrella and Pablo Garrido on *Nguillatún* (1924), one of the avant-garde magazines that resorted to titles taken from autochthonous traditions (in this case, Mapuche), and with *Litoral* review (1927-1928), published by the Valparaíso group of the same name of which he was a member. By then, Remenyik had already moved to Peru, where in 1923 he would publish *Las tragedias del lamparero alucinado*, which he himself illustrated and which we shall study in the chapter dedicated to that country (see p. 534).

While all this was taking place in Chile, another avant-garde trend was developing in Paris, led by members of Montparnasse Group (a tribute to its place of origin). Examples of the trend can be traced in Santiago as early as 1923. In 1924, Luis Vargas Rosas, one of its practitioners, made the splendid woodcut cover for *Crónicas*, by Joaquín Edwards Bello; in his turn, José Perotti illustrated *Amaneció nevando*, a collection of poems by Daniel de la Vega. *Crónicas* was subtitled *Valparaíso-Madrid*, and Vargas Rosas's composition combines an image of a port with that of a Flamenco guitarist, while the design by Perotti, who would go on to become a leading figure in Chilean applied arts, portrays an angular female nude in the foreground and a mountainous snowy landscape seen through a window.

Drawing by hand was gradually established as the standard practice, for it enabled artists to understand covers as total compositions rather than as a sum of independent texts and images. This is revealed in numerous works, such as the elegant cover of the first edition of *Crepusculario*, by Pablo Neruda (1923), that is also memorable for its woodcuts by Juan Gandulfo (the anarchist doctor to whom three years later the poet would dedicate the second edition of the book), and for a charcoal portrait of Neruda made by Juan Francisco González junior, whose work we shall discuss later.

In the 1920s, a number of other artists would also make a name for themselves as illustrators. We shall begin by mentioning Alfredo Molina La Hitte, better known in the history of Chilean art as a society photographer, particularly from the 1930s onward. But in the previous decade he produced numerous designs for illustrating books and for the short novels published in *Lectura selecta* magazine.

The illustrations Molina La Hitte made in the 1924-1929 luster reveal the variations and progression of his graphic design, from deliberately Symbolist compositions to geometrized works indebted to Art Deco. Similar traits can be discovered in the work of aforementioned Luis Meléndez. Among the Symbolist designs by Molina La Hitte feature his illustrations for *Samaritana* (1924) and *Arcoiris* (1925), books written by his then partner the poet María Rosa González, who a few lusters later would marry the Argentine avant-garde artist Emilio Pettoruti. In these books, as in the collection of poems titled *A través de la mañana* (1925), by Caupolicán Montaldo, we may trace the influence of Aubrey Beardsley. The two works by González were launched by Nascimento in the horizontal, almost square format that became one of the distinguishing features of their poetry collections, described by Juan Bonilla as follows: "With an excellent criterion, seeing that the new age was characterized by long free verse and preferring the verse to feature in its entirety on the page rather than cutting it, breaking up lines and using margins, the graphic designer at Nascimento chose to create books in which there was more than enough space for each long verse, and hence were much wider than taller in shape" (Bonilla, 2018, 149-150).

A gradual geometrization of figures and planes, inspired by Art Deco, first appeared

Illustration by Aníbal Alvial for *Andarivel: revista bimestral de arte y crítica*, no. 1, May 1927. Editors: J. Moraga Bustamante and Juan Florit. Santiago de Chile, n.p. 21.5 × 17.1 cm. Boglione Torello Collection

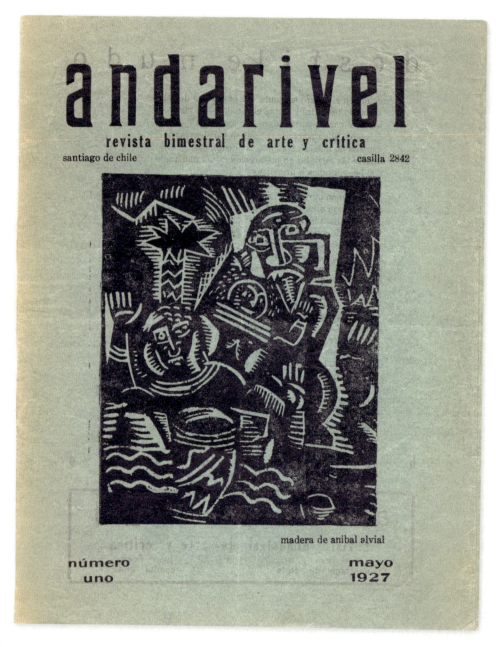

←
Marcial Lema and Roberto Humeres, "Decorative compositions made in the course taught by Isaías Cabezón," in *Revista de Arte*, year I, no. 1, September 1928. Editor: Carlos Humeres Solar, Santiago de Chile. Department of Artistic Education, Ministry of Public Education, 37 × 26.4 cm.
Private collection, Granada

after his graphic contributions to several issues of *Lectura selecta*, exemplified by his covers for *La moscovita de los trasatlánticos*, by Juan Pére Domenech, and for *Rumbo hacia ninguna parte*, by Luis Enrique Délano, both published in 1927. The reference to Délano seems to be no coincidence, as the friendship between him and Molina La Hitte would lead to one of the most fruitful collaborations of the decade. The cover Molina La Hitte designed for *La niña de la prisión* (1927), by Délano, is perhaps his most avant-garde, at least among those we have come across. We must also mention the cover of *Confesiones de una profesora*, by Rafael Maluenda (1928), for its combination of black and red ink on a silver ground, a technical proposal that relates this cover to the one designed by Alejandro Sirio two years earlier in Buenos Aires for *El empresario del genio*, by Carlos Alberto Leumann.

Besides *Lectura Selecta*, others magazines generated a great publishing activity. One was *Panorama*, whose first issue saw the light in April 1926 edited by Rosamel del Valle. Del Valle also founded *Ariel* review, and his collection of poems titled *Mirador* was launched by the publishing house of the same name. Both the magazine and the books published in that context, and that year, were characterized by the modern typography of their covers; in some cases, the titles were placed at an angle and in color, as is the case of *Ariel* itself and of *El aventurero de Saba*, by Humberto Díaz Casanueva (1926), a book that includes numerous lyrical illustrations by Argentine artist Norah Borges such as those produced during her Post-Expressionist phase. The first book by Luis Enrique Délano also reproduced illustrations by Norah, along with others by Estrada Gómez, Ricci Sánchez, Germán Baltra, the Alvial brothers (Lautaro and Aníbal), Juan Sarko, Manuel Briones (including an engraving made from a drawing by Luis Vargas Rosa), Oscar Reynold and Tristán Hirka. Co-published with Alejandro Gutiérrez, the

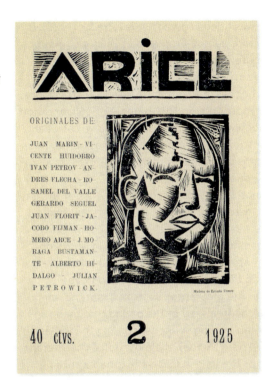

Illustration by Efraín Estrada Gómez for *Ariel: publicación mensual de arte y crítica*, no. 2, 1925. Authors: Rosamel del Valle (pen-name of Moisés Filadelfio Guitiérrez Gutiérrez), Juan Florit, J. Moraga Bustamante and Homero Arce. Santiago de Chile. Vicente Huidobro Foundation, Santiago de Chile

book was titled *El pescador de estrellas* (1926). It was a rare edition produced in Quillota, found in very few collections and remarkable for its execution, consisting of loose sheets joined together by a metal ring. The book, furthermore, is the most outstanding example of collaboration between writers and artists in Chile in the years in question, to the extent that almost every page of text is complemented by a print or a drawing—thirty-one in all.

Another of the literary movements of the late avant-garde that also set up its own publishing house was Runrunism, that emerged in 1928 and had five practitioners: Benjamín Morgado, Clemente Andrade Marchant, Raúl Lara Valle, Alfredo Pérez Santana and Alfonso Reyes Messa. The group took its name from the *run-run*, a children's toy of the period that made an annoying buzzing sound. According to Hernán Díaz Arrieta (Alone), the most influential literary critic of the time in Chile, the group wanted to give "an impression of novelty using old elements" (Morgado, 1961, 44). We would also like to quote the description made by Ricardo A. Latcham in his "Diagnóstico de la nueva poesía chilena": "We now come to the poetic Kindergarten, populated by small and unruly families of sharp mischievous little devils. Their clamor usually disturbs and irritates critics, whose censorship is soon condemned with aggressive stoning. But there is also talent and emotion in this small and rowdy reserve of beauty" (Latchman, 1931, 152).

Among the Runrunists, Pérez Santana was the group's illustrator and typographer, responsible for the illustrations for books like *Esquinas*, by Benjamín Morgado, published in 1927 by Círculo de Artes y Letras in Santiago before the group had actually established itself, and for the splendid typographic cover of *S.O.S. Imagódromos* (1929), by Raúl Lara Valle, launched by Run-run publishing house and printed on brown paper. The cover of *El poeta automático*, published in 1930, subtitled *Calendario Run-Rúnico*, is also worthy of mention, made as it was out of scraps of cardboard produced by the Hucke company (Verdugo, 2016). Pérez Santana and Alfonso Reyes Messa signed *12 poemas en un sobre* (1929), written—as we learned from Morgado and was quoted by Juan Bonilla (2013)—during a dozen stops between the bar they frequented and the printers commissioned with printing them and placing them in envelopes to be sent to readers.

Un montón de pájaros de humo (1929), by Andrade Marchant, is another example of Runrunism produced in uncharacteristic horizontal format (see p. 650). As regards another of the poets in the group, Benjamín Morgado, we must mention the graphic work he would make for his own books during the 1930s, most of which were published by Senda. The strictly calligraphic composition he made for *Las aldeas de vidrio* (1930) is one of the most prominent, while other covers, such as *Trébol de 4 hojas* (1937) and *Un hombre triste en el fondo del mar* (1938) stand out for their subtle illustrations.

Another artist who was at once a writer and an illustrator like Morgado, and who worked in the area of influence of Runrunism despite not being a member of the group, was Gustavo Martínez Sotomayor. Largely forgotten by Chilean art historians, in the 1920s he was already working in both fields, as we see in his poem collection *Semilla de dolor* (1928), the cover of which had both Symbolist traits and a geometrized Art Deco atmosphere, although by then he had already made one of the most avant-garde illustrations of the time in Chile for the review *Telarañas* (1927), edited by Runrunist author Raúl Lara. Martínez Sotomayor took part in several art salons of the period, where he displayed works that were more advanced than those of his colleagues, some of which included Post-Cubist and Futurist traits. In 1934, Martínez Sotomayor (nicknamed El Chico) would be one of the founders of Los inútiles literary group in

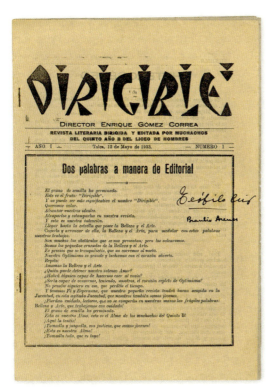

Dirigible: revista literaria, year I, no. 1, 12 May 1933. Editor: Enrique Gómez Correa. Talca, Liceo de Hombres, 27.3 × 19.3 cm. Archivo Lafuente

Rancagua and illustrated the cover of the book *Viaje del alba a la noche* (1940) by the group's foremost author, Oscar Castro.

Looking back to the second luster of the 1920s, we come across traces of Art Nouveau that alternate with other more innovative trends, including Symbolism and Art Deco. Jorge Délano (Coke) and Luis Meléndez were the most prominent artists of this years, whose works would become increasingly geometrized. Coke's cover for *La tragedia del arte*, by Nathanael Yáñez Silva (1926), reveals his esthetic progression since his early covers of the late 1920s. On the other hand, Meléndez, whose work has yet to be studied in depth and whose repertoire as an illustrator is vast, designed the wonderful cover of *Las horas perdidas* (1926), by Caupolicán Ponce. Among the books for which he made inner illustrations we should mention *El último pirata* (1925), by Salvador Reyes, and perhaps the most outstanding of all, *Primicia de oro de las Indias* (1934), by José Santos Chocano, illustrated in partnership with Huelén, another important Chilean artist of the period.

Huelén was the pen-name of Juan Francisco González, the son of one of the most famous painters of *fin-de-siècle* Chile who went by the same name. As we saw in the case of Alfredo Molina La Hitte, linked as an illustrator to the ongoing editorial project *Lectura selecta*, Huelén was associated with La Novela Nueva publishers between the years 1929 and 1930. This collaboration marked the beginning of a long career as a cover designer, during which he produced at least nine volumes. From an esthetic point of view, his repertoire is quite varied, ranging from Art Deco works to others verging on what could be described as avant-garde, along with Realist compositions that are less interesting in our current survey. All these compositions combine two shades of color with bold typography intended to deliver direct messages, even to viewers who may just happen

to be passing by a store window. Each volume included a portrait the artist made of the author.

The series of works opens with the attractive transatlantic cover of *Cap Polonio*, by Joaquín Edwards Bello, followed by perhaps the most striking, that of *El dueño de los astros*, by Ernesto Silva Román, who was also the driving force behind La Novela Nueva editorial project. Indeed, a Futurist cover that included the silhouette of an airplane and skyscrapers, along with other elements that are combined with the titles, were followed by more advanced illustrations, some of them abstract vignettes that would subsequently feature in other volumes in the series. *Chilenos en París* is the last book in the series, and its cover features the silhouette of a couple, in black ink, cut out against the base of the Eiffel Tower in white, the outline of the Moulin Rouge (motif of an inner illustration by Huelén) and of Notre Dame, also in white. Authors such as Jacobo Nazaré (Luis Barriga Figueroa), Salvador Reyes (*Tripulantes de la noche*), Daniel de la Vega, Marta Brunet, Lautaro Yankas and Luis Enrique Délano complete the group of local men of letters linked to La Novela Nueva.

By then, Huelén was associated with other editorial ventures, including his work for reviews like *Comuna y Hogar*, in which he displayed his thematic and esthetic versatility. This work would continue over the course of the following year. In the field of book illustration, the modernity of *Cap Polonio*, or that of *El dueño de los astros*— even more original—would gradually diminish, despite the presence of Art Deco elements that were nevertheless almost always diffused by Neo-Symbolist trends the artist could never quite shake off, save in a few exceptional cases, as proven by books like *Velero de tréboles*, by Amanda Amunátegui (1935), or *Nostalgia*, by María Letelier (1939).

Another important name in the field of book-cover illustrations was Georges Sauré, of French descent though born in Concepción, whom

Dinamo, no. 1, January 1925.
Editor: Pablo de Rokha.
Concepción.
Vicente Huidobro Foundation, Santiago de Chile

Panorama, no. 1, April 1926. Editor: Rosamel del Valle (pen-name of Moisés Filadelfio Gutiérrez Gutiérrez). Santiago de Chile. Vicente Huidobro Foundation, Santiago de Chile

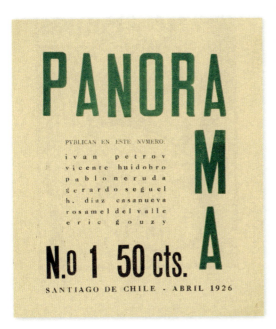

Luis Enrique Délano (2004, 38) remembered as "the creator of artistic photography in Chile, the introducer of Cubism, initiator of *vitrinismo* [window dressing] when he brought a sophisticated air to the windows of the electricity company." As a photographer, besides having taken some of the first pictures of Pablo Neruda at the onset of his literary career, in the 1920s he took others of artists belonging to the so-called Group of Paris, such as Camilo Mori and Sara Malvar, among others. Sauré was also a forerunner of designs for posters and linocuts in Chile. Three of his covers are worthy of mention, characterized by a moderate avant-garde that reveals his taste for mixed compositions: that of the novel *El tronco herido*, by Luis Orrego Luco, *Chilenos en el mar*, by Mariano Latorre, and *En el antiguo solio virreynal. Film limeña*, by Jorge Schneider Labbé, all produced between 1929 and 1930.

These were years in which the number of artists devoted to illustrating book covers in the modern style grew exponentially. In this context, we shall quote a few examples we consider particularly relevant, among them three compositions of 1929, one by Dora Puelma, an artist from Antofagasta, another by Jorge Domínguez Sierra, and the third by Lupercio Arancibia, virtually forgotten by Chilean art history, save for a few exceptions, who in the mid-1940s set up his own advertising firm. Among the works by Puelma, a renowned painter, writer, and cultural activist, we shall mention the exceptional cover of *Noches y días*, by Raúl Cuevas, in two versions (black and white, and red and white), featuring a reiterated face on the front cover and an abstract vignette on the back cover. Domínguez Sierra's illustration for *Poemas tornasoles*, a book of his own, presented various calligraphic designs including one that reproduced his name assembling a sailboat at sea. In his turn, Arancibia's linear illustrations for the poem collection *Molino*, by Alejandro Galaz, a book divided up into four chapters or "blades,"

seem indebted to Huelén although in some cases Galaz's designs are more synthetic and modern than those by Huelén.

We must now mention the avant-garde book *par excellence*, indispensable in any literary or visual history of the period: *Looping* (1929) by Juan Marín, with its splendid cover depicting a tilted airplane seen from the front, whose calligraphic title ("Looping 1929") describes a complete spiral, imitating the aerial stunt to which the book refers. Marín, who as well as a doctor was an aviator (Juan Manuel Bonet has defined him as "almost an *aeropoet*"), produced other books in the genre, *Margarita, el aviador y el médico* (1932), *Alas sobre el mar* (1934), and *Un avión volaba* (1935); the covers of the last two were illustrated, respectively, by Marcial Lema and De Nino. These works can no doubt be likened to other similar designs produced on the continent. Along these lines, we mustn't forget the obvious ties with the Futurist vision, "that placed aviation at the heart of his program for transforming all aspects of modern life. [...] Convictions such as the idea that the aviator is the new master and creator of the industrial world [...] that flight is the basis of contemporary civilization, architecture, and expressions of beauty, that the impact of air travel on individuals produces a transformation ..." (Schnapp, 2008, 146 and 149).

As regards the depiction of means of transportation, given Chile's connection with the ocean, boats are no doubt the most favored. While we have already quoted the works *Cap Polonio*, *Velero de tréboles* and *Chilenos en el mar*, among others, in the 1930s the repertoire expanded greatly, encompassing works like *Música de puerto* (1940), by the poet, painter, and journalist Pascual Brandi Vera, a key figure in the modern circles of Valparaíso. Our survey traces his esthetic developments, from the remarkable Symbolist drawings he conceived for his first book, *La quietud del farellón* (1919),

Cover by Gustavo Martínez Sotomayor for *Telarañas: revista mensual de la juventud*, year I, no. 2, October 1927. Editor: Raúl Lara. Santiago de Chile. Imprenta Monopol, 18.7 x 12.9 cm.
Private collection, Granada

to the compositions indebted to Art Deco, such as the dynamic cover design depicting beams of light and elements allusive to music for his novel *Jazz* (1935)—we should not forget that jazz had entered Chile through the port of Valparaíso in the 1920s—and his masterpiece as an illustrator, the aforementioned *Música de puerto*, presented as a portfolio of "drawings and poems" tied together with a piece of string. The illustrations by Brandi Vera—skyscrapers, marine undulations, guitars, still lifes, superimposed images, an all-pervasive presence of light beams, and many other resources—reveal a wide repertoire of his skills, always around the motifs of the port and the ocean.

With regard to figures and landscapes, this is the iconographic setting in which we come across wonderful examples, such as the Post-Cubist cover of *Cameraman: relatos de un presidiario* (1932), by Plinio Enríquez, or the faceted illustrations by Lautaro Alvial for *Espejos andariegos* (1933), by Maclovio Munizaga Hozven, and those that the poet and artist Ciro Bascuñán made for *La casa sin ventanas* (1934), by the Italian author Pasquale Casaula. Furthermore, this book contained textual elements that were not that common at the time: a preface that refers specifically to the work of the illustrator—signed by Mario Vilac (Jorge Abollo Monasterio)—and a "modernolatric" prologue, in a poetic key, by Bascuñán himself. In the first of these, Vilac describes him as "Symbolist and iconoclastic," adding that "his drawings and poems form two trends that were sought after and identified there, in the domains of his psyche, where Art in its purest expression has proclaimed the biphasic dictatorship of Symbol and Truth" (Vilac, 1934, 10).

Another field of analysis is that of the covers containing portraits, like the one designed by F. Diesler for the rare edition of *13 Club. Tragi-comedia futurista en 3 actos y medio* (1934), by the nomadic Peruvian avant-garde writer Luis Berninsone, that included a caricature

Cover by Enrique Miralles R. for *Revista del Colegio San Luis*, yearbook, 21 June, course 1930-1931. Editors: Lucio Reyes et al. Antofagasta. Skarnic, 26.2 x 18.8 cm. Private collection, Granada

by his fellow countryman Julio César Málaga. Berninsone is the author of elusive works, ranging from his compilation of poems titled *Walpúrgicas* (Lima, 1917) and his sojourn in Buenos Aires in the early 1920s, where he was portrayed by Antonio Bermúdez Franco, to works like the above-mentioned *13 Club* or *Pirámide para la momia de Lenin. Interpretación apocalíptica de Trotsky. Anatomía del hombre de acero* (1935), a large-format edition with a wonderful calligraphic cover in which the work's three titles are arranged in the form of a pyramid (see p. 668).

Another cover portraying a likeness is the one designed by Marcial Lema for the novel titled *La avalancha*, by Diego Muñoz (1931), that reveals the significant advances in Chilean poster design during that period, particularly as a result of the pedagogical work carried out by Isaías Cabezón (who would be Lema's master around the year 1928) at the Fine Arts School, and of Ana Cortés Jullian at the School of Applied Arts in the 1930s. Thanks to this institution, that in 1929 would be linked to the Fine Arts College at the University of Chile, design was gradually defined in the country as a practice independent of painting and of other artistic expressions. To all this we must add the surge in local editorial activity when the importation of books was restricted as a consequence of the global crisis suffered in the early 1930s.

Editorial ULAM is well worth a mention among the publishers relevant to our study, particularly on account of the foreign books it launched. Included here are the modern covers of the Chilean edition of *Mancha de aceite*, by César Uribe Piedrahita (the first Bogotá edition was illustrated by Gonzalo Ariza) (see p. 365), and of *Hotel América*, by María Leitner (the 1931 Madrid edition by Cénit included photomontages made by John Heartfield, retouched by Mauricio Amster). The entrance of foreign authors would also characterize the field of illustration, where we discover the reutilization of covers previously published outside of Chile. This in the case of two Spanish designs: the first by Santiago Pelegrín for *El pescador de esponjas* (1933), by Panait Istrati, the hues of which varied from those in the version published two years before in Spain; the second by Francisco Rivero Gil for *Policéfalo y señora* (1936), by Ramón Gómez de la Serna, that is actually more like an adaptation in Santiago of the original that had appeared in Madrid in 1932. Funnily enough, the signatures of the illustrators would be removed from both Chilean editions, despite appearing in the Spanish volumes.

Just as we mentioned D. Salinas D., a host of given names successively appeared throughout the 1930s, chiefly connected with publishing houses like Nascimento, Ercilla, and Zig-Zag and characterized by granting ample space to illustration on covers and inner pages. Among the most prolific figures were Alfredo Adduard Corbalán, Arturo Adriasola, Nino and Alhué (the last two being the pen-names of Italo-Argentine artist Giovanni Corradini and Talcan-born Luis Sepúlveda Donoso, respectively. Like their predecessors before them, they all practiced their craft by publishing their illustrations, caricatures and other designs in magazines, often also creating advertising posters—in this field both Adriasola and Nino were as prolific as they were distinguished.

In the case of Adduard, we should mention the cover he designed for the compilation of poems titled *Heida...* (1926), by Carmen Bruner, characterized by two elements that would be widespread in his works of the 1930s, most of them connected to Zig-Zag publishing house. On the one hand, the use of color silhouettes, black especially, popularized in posters in the late 19th century by Henri de Toulouse Lautrec and from then on all-pervasive, and on the other, Symbolist features. Silhouettes enabled illustrators to present highly contrasted designs. Nino and Alhué, both of whom were active at Ercilla publishing house (founded in 1928) and

also devoted to drawing for advertisements, were other artists who deliberately chose Symbolism, the former in several works of equestrian theme and the latter, a seasoned satirical draftsman for reviews such as *Topaze* and whose work we consider more interesting, in books like the exceptional *Contracorriente* (1936), by Blanca Luz Brum, and the second edition of *Los hombres obscuros* (1939), by Nicomedes Guzmán, a wonderful two-colored cover in black and red where we discover another of his virtues—typographical design—and traces of the influence of the Spanish artist Ramón Puyol.

But to return to the work by Adduard, of all the covers he designed our favorite is no doubt the unusually modern and rare edition of the book *De profundis* (1933), by the Polish author Stanislas Przybyszewsky. In their turn, covers such as those of *Malasia* (1933), by Henri Fauconnier, and *Borrachera verde (motivos benianos)* (1938), by Raúl Botelho Gosálvez, are characterized by a certain tropical air.

As regards Adriasola, his career as a book illustrator in the 1930s, having returned from a sojourn in Europe, was chiefly linked to Nascimento publishing house. His works for Nascimento showed the influence of his work as a poster designer and his passion for typographical games, sometimes combined with the use of photography, as in *Los dueños del mundo* (1933), a cover thematically related to another he made that same year for the pamphlet *El pan nuestro* (1933), by Ilya Ehrenburg. In comparison, his output is more varied and interesting than that of Adduard. Covers like those of *Historia de una curruca* (1934), by Giovanni Verga, and *El cachorro*, by Víctor Domingo Silva, betray reminiscences of Art Deco and also reflect his interest in synthetic depictions of landscape. The influence of his work in the field of poster design can be traced in his covers for *Sangre de mestizos* (1936), by Augusto Céspedes, a compilation of short stories about the Chaco War. Finally, his

Illustration by Winold Reiss for *Más: revista quincenal*, no. 2, 6 October 1933. Santiago de Chile. Society of Friends of Art, 37.5 x 27.2 cm. Private collection, Granada

Design by Alfredo Pérez Santana for Alfredo Pérez Santana, Clemente Andrade Marchant, Raúl Lara and Benjamín Morgado, *Cartel runrúnico*, no. 1, April 1928. Santiago de Chile. n.p. 38.3 x 55 cm. National Library of Chile, Santiago de Chile

taste for calligraphy is particularly obvious in his wonderful double cover for *Antología de poetas españoles contemporáneos (1900-1933)* (1934), compiled by José María Souvirón, in black, red and green ink and with a couple of synthetic still lifes for all figuration, and in his elegant cover for *Llegando al camino* (1936), a collection of poetry by San Juan author Ofelia Zúccoli that includes Surrealist illustrations by the author herself and whose interior includes a photograph of a neo-Pre-Hispanic portrait of the poet carved in brick by Basque sculptor Jorge Oteiza shortly after his arrival in Chile.

As we have spoken of Surrealism, we cannot avoid mentioning the six illustrations made by a young Roberto Matta for *Milibil* (1935), by René Arriagada Hermosilla. A wide repertoire of signs, ranging from mountains, crosses, insects, and butterflies to hearts, stars, and other celestial bodies anticipate, to a certain degree, the series titled *Morfologías psicológicas* he would begin shortly afterward (1937-1949). By then Matta, having graduated as an architect at the Catholic University of Chile in 1932, had set out on a journey to Europe and joined Le Corbusier's office; once established in Paris, he went on to become one of the most renowned international figures of Surrealism.

While all this was taking place, Vicente Huidobro—back in Chile since 1932—was continuing his career as an author in collaboration with illustrators. The first interesting work of this

Arunrunko

ñuble 1128
nataniel 1037
santiago
chile (s. - a.)

drade lara morgado

ro y le dividió la cabeza en tres mitades
dos aterrizaron en la garganta colgó una
e en el dolor
el que me mata mitosauro
ó la puerta hacia el kremlin donde le espe-
el CZAR y su respuesta
a mitad del cráneo no le había obteni-
se quedó abrazada al filo de la espada
va dos y de ellas en el bolsillo a
ta te rechazaron el traspuso los andenes
 las manos apegadas al epílogo de sus bi-
 ncogibles
 las rodillas junto al soberano que ve-
 de las dos cosas
cráneo o mesopotamia preguntó EL
 soldado le hizo traspasar la puerta en la grú-
 pies
 de nuevo hozar el templo de jerusalem
 los atravó por las axilas y lo
 ó hasta la puerta
 o pedazo de cabeza microcélulas
 entréguenmela

ardia lo garabateó a puntapiés y le ech-
 las narices y le esperó con las manos apai-
 los ojos amarrados cerca de la nariz des-
 no se si ivan petruyeff continua
 ado de botánica

canto a las chumaceras

— ENERO —

las tachuelas de tu risa endotérmica
acerme un cinturón entusiasmado

— FEBRERO —

uelgas gaitas de la luna sin somieres
otones rieles en tu espejo endecasílabo

— MARZO —

uvias olvidan sus vejigas
 palco reservado de los circos

— ABRIL —

ier planeta agrario
 arta de ciudadanía

— MAYO —

RVA juega al golf
 sombrero de pita

— JUNIO —

cuelgan paracaídas vítreos
el agua del volantín obeso

— 7 —

IMÁN ESPIRITISTA
AYO DE TU AGONIA

salmo al viento

Z.— llevo una llave entre los dientes
 para abrir el diccionario de los postes
H.—DE LOS BARES SALEN 3 BARILLAS DE MIMBRE
A.—como un hemisferio envejecido
 las esquinas erizan sus lomajes
 PAM! PAM! PAM!
 el molino desierta mis caricias
 saltan los eucaliptus
 la simetral de los hijos
 y en el mesón de tu espalda
 se puede archivar a FIRPO
A.—cabellera ecuatoriana de la imprenta
 los linoleums odian las montañas
A.—jemidos bailarines de la escuela
 DIVIDAMOS EL TROPICO DE CANCER.

"3 cachimbas rotas mas allá de la muerte"

— novela —

— Primer Tomo —

de repente se enrojeció el visillo......
sonaron tus cortinas al doblarse cuando los 5
muertos se amarraron de acuerdo.—
—¡yo te lo había advertido!—
sinembargo los paladares del Osorno gritaron has-
ta enmarcarse de rodillas, y tú, siempre canalla,
indiferente.— el puñal hacía su jira acostumbra-
da, los semáforos despiertas arrugaban las costi-
llas en jesto de cansancio, y entonces me dijiste
aquella frase:
 — detén la escalera si ella pasa, y no olvides
al canario.
 — pero antes: no he bebido y soy idealista,—
los 5 muertos callaron nuevamente.
 —¿pasó?
 —marcha al polo antártico por la libertad téc-
nica de los vasos sindicales.
 —¿y el frío?
 —fué fusilado esta mañana.—
los 5 muertos repitieron los tambores.

II tomo

mas que nunca la égloga se trizó aterrizando.—
solo un muerto sobrevivía los suicidas, los otros
desenmascaraban las zapatillas del DICTADOR.—
de repente se enrojeció el visillo.—
 la contraórden era supuesta.
 —¡sinembargo yo no olvidé el canario!—
 100 DISPAROS herméticos.
 ¿viene?—
y por fin amaneció entre tus dedos.—
 —tú misma trepaste la escalera, y grabaste
aquel puñal en forma de equinoccio.

— EPÍLOGO —

aquella tarde profesaba en el claustro.

— FIN —

Imprenta El Comercio Diez de Julio 1073

— teatro —

la bufanda del piano

ESCENARIO: una corbata de rosa frente a un
 espejo cóncavo.— la longitud de un
 timbre fallecido

decorado: (a la derecha) un farol enternecido.
 (dándose vuelta, a la otra derecha
 solloza un patín.
 (al fondo), tres escalones, estrangu
 lando un reloj-campana.

personajes: la sombra de un hombre que no está,
 y un hombre que está sin sombra.

— acto final —

la sombra:— jira un metro y ensombrece el es
 pejo cóncavo. (el patín no dice nada

el hombre:— hace esfuerzos ortodimensionales por
 encontrar algo debajo del farol en-
 ternecido.—(aquí el patín solloza).

la sombra:— sube un escalón, y dice:—¿quien de-
 jó en la fragua del ORIENTE estu-
 pefacto?

el escalón rechina:— ¡el reloj!!

todos:— (en coro) ¡no hay perdón!! ¡tán!! tán!!.—
 (el reloj agoniza)

— acto anterior —

la sombra:— (hace mutis) avanza hacia el espejo
 cóncavo, y se coloca la corbata de
 rosa.

el patín alegremente:— "yo soy el fado
 fadiño, fadeiro...!
 (un bombo oculto en parte baja de
 platea, toca el intermezzo del drama)

el hombre:— (continúa en sus esfuerzos ortodi-
 mensionales).

el último escalón:— (descendiendo por los otros
 hasta la lonjitud del timbre).

—¡¡patín, silencio por el reloj ha muerto!!— ¡soy
 la justicia!!

el hombre:— (mirando el escalón de hito en hito)
 ¡asesino!, ¡aquí está la bufanda! (saca
 una bufanda de tinte ampolleta des-
 de un rincón del farol).

todos:— (en coro) ¡el reloj era inocente!!!!
 (los escalones se juntan y huyen
 esfumándose en la sombra).

rapidísimo

el león al pie de la vaca
fábula endecasílaba

si
pero como el septentrión no era grande un día se
amarraron los camellos a las colchas y el león par-
tió de bruces al sonido de la escarcha
 naturalmente
aquello distaba de la cuerda
sin embargo al pie de la vaca abrocharon los tim-
bres sus distancias
el león expuso su tesis comprimida

afeitaría ella el dínamo de la flauta
no he pesado a mi pesar la densidad de los faroles
derrimidos
la vaca torció la respiración y cantó en canastos
los huesos del herrero
se HABÍA TERMINADO LA AMPOLLETA
el león juntó sus manos y cerró la garganta junto
al cero
RESPUESTA
NO ADAPTO MI CORRIENTE A LOS CILIN-
DROS
la segadora de pasto elucubra tres sonrisas y desa-
parece por el foro mientras el cazador se agiganta
digeriendo la punta del fusil la sombra de los ojos
tropieza en el agua panacústica
nos quedamos comiendo subterráneos
ahora el cazador se le ocurre amasar la carabina y
suelta la corbata de barajas
la cola se separa del león y adquiere un tinte car-
dinal.
 R. R. R.

tres ras por la paz universal
1) uno
2) dos
3) el reloj gira un segundo y se coloca detrás del
paraguas
interrogación
 despacharon anacronismos las bo-
degas
respuesta
 no se quien vive debajo del tornillo tres
insultos desaparecen por el margen y dormitan a
la sombra de las aguas
llanto llanto LLANTO LLANTO
 LLANTO
el pañuelo de la vaca mojado como los hemisti-
quios
la cola del león acelera sus miradas y se bautiza
en los cordeles
 su canto se bifurca y dobla los
resortes
donde habrán dejado la flauta del piel roja la luz
se esconde tras un sauce y aparecen los días ves-
tidos de colores
más
ya el calendario no vendía velocípedos
entreacto
 un silencio se dibuja hasta la sies-
ta y rocía la punta de las lluvias
ahora el periosodáctilo es portátil y construye cami-
nos en tranvías
así como el tenedor comienza a lagrimear y el pa-
ñuelo hipnotiza los botones
el león
siempre los estornudos acarrean estampillas de a
peso
el icono continua en la colina cardinal y rescata la
flecha de un escupo
se cae el garabato de la cuesta y el león pone tér-
mino a su danza hermafrodita
descienden los alambres hacia el valle y capturan
hipopótamos rosados
desarrolla el problema fratricida
5 por 8 setenta y cinco y un scout
sentimental dan como resultado
la prostitución al alcance de los niños
el león se opuso ferozmente lo que trajo como con-
secuencia un incendio occipital
MORALEJA
 el epitalamio se celebró en la madru-
gada

phase in his career would be *Cagliostro*, a novel-cum-film released in 1934. That same year, in which he produced the only preface he is known to have written for the poetry collection *Defensa del ídolo*, by Luis Omar Cáceres, Huidobro published two works with Julio Walton, the owner of a small bookstore on Calle Teatinos where the author would deliver a number of lectures during the years in question: *La Próxima. Historia que pasó en un tiempo más* and *Papá o el diario de Alicia Mir*. With regard to the composition of their covers, we are more interested in the former, of which we have discovered three different versions, one in red ink, another in blue inks, and another in green inks. *Tres inmensas novelas* was published in 1935, signed by Huidobro and Hans Arp, and *Sátiro o El poder de las palabras* appeared in 1939, and included a portrait of Huidobro that the Czechoslovakian painter Joseph Sima, who designed the cover, had made in 1931.

Having mentioned Julio Walton, we must now devote a specific paragraph to the publishing venture he launched in the mid-1930s, characterized by the quality of his publications, chiefly of a Socialist bent, such as those by Huidobro previously cited and others we shall refer to now. A poet from Viña del Mar, Walton had been one of the signers of the "Rosa Náutica" manifesto published on the avant-garde sheet *Antena* in Valparaíso. Walton's bookstore, that sold Marxist and Soviet texts and avant-garde political journals, would be a frequent gathering point for poets and artists during those years. Some of the publications were truly outstanding in graphic terms, such as *Aquarium* (1934), by Juan Marín (once again at the top), with a print run of one hundred numbered copies and a wonderful two-colored cover and illustrations by Pedro Olmos. That same year, Olmos also designed the cover of *Caminantes*, by Lidia Seifulina, for Walton's publishing house, shortly after having illustrated an edition of *Juan sin pan* (1933), by Vaillant-Couturier, published by Editorial Documentos that had been founded by Gregorio Guerra, Julio Walton, and Gerardo Ortúzar.

Another of Walton's editions, the book *Hombres de máquina*, by Laurencio Gallardo, is worthy of mention for its splendid cover by Laura Rodig, a member of the Communist Party engaged with the Chilean feminist movement and, at the time, producing graphic work for *Lecturas* magazine; for its photographs by Mario Vargas, some of them with aerial perspectives reminiscent of Rodchenko; and for its woodcut ex libris by Pedro Olmos. Vargas also wrote a series of works titled "Notas sobre la fotografía en Chile" printed in *Revista de Arte* published by the University of Chile (1935), an essential organ for the dissemination of the achievements of the School of Applied Arts.

The prints for books by Pedro Olmos deserve a special mention. Olmos is better known as a painter, as is usually the case in the history of Latin American art, where painting overshadows illustration even when it is of poorer quality. Olmos's drawing is chiefly linear and has a great lyrical quality (perhaps more so than any other illustrator of the time), inspired by Art Deco, Post-Cubism, and Surrealism, particularly in the second half of the 1930s. Olmos created a number of woodcuts and even made several notable photomontages, as we see in the sixteen compositions he designed for *España en el corazón* (1937), by Pablo Neruda, some of which are very impressive, such as the one depicting a smiling Francisco Franco surrounded by photos of dead children, victims of the Spanish Civil War.

Earlier on we referred to two renowned women in Chilean book illustration, the Argentine Ofelia Zúccoli and Laura Rodig (who incidentally designed the poster of the First National Congress of the Pro-Emancipation of Women of Chile in 1937). Other women artists also committed to renewing graphic art in Chile were Mireya Lafuente, a well-known collaborator

of Gabriela Mistral's and a primary school drawing teacher in who created the wonderful compositions of *Flautas de sombra*, by María Tagle, in which the geometrized female figure is a constant feature that sometimes verges on abstraction. We must also mention Filomena Ibáñez (Mena), who illustrated the cover of *Mitologías de Chiloé* (1934), by F. Santibáñez Rogel and Guillermo Miranda, with a splendid design, woodcut in relief, in which the marine motif is combined with hand-drawn typography.

We have previously mentioned the growing importance of poster design in Chile. Isaías Cabezón and Ana Cortés joined forces and trained a wide circle of artists in the genre, who would also try their hand at book illustration (Arturo Adriasola is an eloquent example). At the School of Applied Arts, a Graphic Art workshop was set up by Marco A. Bontá—author of covers such as that of *Rutas* (1937), by Gunter Richter—where a number of artists, including Alejandro Aguilera, Emilio Cruzat, Francisco Parada, and Carlos Hermosilla Álvarez, learned engraving techniques and approached the medium from a nationalist perspective. Although Hermosilla Álvarez's woodcuts and linocuts for publishing projects have yet to be studied in depth, in terms of its scope and quality his work deserves a special mention in our survey.

One of his first experiences as an illustrator was for *Litoral* review (Valparaíso, 1927-1928), that also included designs by Jesús Carlos Toro, Germán Baltra, Lautaro Alvial, Pedro Plonka and Pedro Celedón, among draftsmen. All these xylographic prints were influenced by either German Expressionism or Russian Constructivism, avant-garde trends their authors had come into contact with through the works of the Hungarian artist Zsigmond Remenyik and the Russian artist Marko Smirnoff (Alberdi Soto, 2012, 66-69). By the following decade, Hermosilla had gained recognition for his woodcuts and linocuts, both those he made as individual artworks and those that were conceived as book illustrations. The year 1934 was one of his most fruitful, chiefly on account of the publication of his album of ten woodcuts titled *Caras de la raza y del trabajo*, a publication that combined Social Realism and popular American Indigenism, comparable to Mexican and Andean graphic art by artists such as Leopoldo Méndez, Eduardo Kingman and even José Sabogal. Hermosilla's admiration for the Popular Graphic Art Workshop (TGP, for its initials in Spanish) and for David Alfaro Siquieros, in his opinion "the most brilliant of artists," is reflected in a photograph in which he appears alongside Siqueiros's works in Forest Park in Santiago in 1959.

As regards book illustration, we shall begin by mentioning two works produced in 1934: *15 poemas*, by C. Alberto Rendón, printed on brown paper, with a cover and several prints depicting landscapes and figures, and *Los amores del diablo en Alhué*, by Justo Abel Rosales, the front cover of which includes a woodcut by Hermosilla. From then on, he would work almost uninterruptedly, producing illustrations such as those of *Experiencia de sueño y destino* (1936), by Alberto Baeza *Flores*, *Orestes y yo* (1939), by Juan Marín, and *Yayay* (1940), by Rafael Coronel, for which he made the cover, while aforementioned Pedro Plonka, pen-name of Pedro Valenzuela Páez, designed the inner cover (ex libris). Plonka, a poet and engraver, probably trained by Hermosilla and also active in Valparíso, is another of the artists whose work deserves a systematic review. His output of woodcuts in the 1930s was chiefly destined to covers of books published in Valparaíso, such as *El arte contemporáneo* (1931), by Julio C. Salcedo C., *Jai-Von* (1932), by David Rojas González, and *Ropa vieja. Poesía proletaria* (1939), by aforementioned Rafael Coronel; both the latter and *Yayay* were published by the General Board of Prisons of Valparaíso.

To return to Hermosilla, this was the context in which one of his most long-standing

Cover by Pedro Celedón and Olga Díaz García for *Gong: tablero de arte y literatura*, year II, no. 9, September 1930. Editor: Oreste Plath. Valparaíso, n.p. 38.5 × 27.7 cm. Archivo Lafuente

collaborations was initiated with his friend the poet Pablo de Rokha (pen-name of Carlos Díaz Loyola). At the time, De Rokha was producing woodcuts for books like *Jesucristo* (1936) and *Gran temperatura* (1937), characterized by a highly social content, in which text and image combined to perfection; to quote Claudio Aguilera Álvarez (2014, 35): "the abrupt and incisive verse perfectly matches the sharp stroke of the illustrator." The woodcuts included in books dedicated by Chilean writers to Spain at the height of the Spanish Civil War were of similar subject matter. Such is the case of *Horizonte despierto*, by Gerardo Seguel, another book printed on brown paper (of which there is at least one other version of a cover in dark red, without the prints), and of the rare anthology *Escritores y artistas chilenos a la España popular*, both of 1936.

As in other countries, the implications of the international political and social landscape in Chile from the mid-1930s onward led to a sharp growth in publications, generally illustrated with striking images; the designs of most of their covers can almost be described as portable posters. Among the books related to the Spanish Civil War, besides those we have already discussed we should mention *No pasarán!* (1937), by Upton Sinclair, with an anonymous poster-like cover; *Fontamara. El fascismo en una aldea italiana* (1935), by Ignacio Silone, also by an unknown artist; and the panoramic and symbolically militaristic design by Aníbal Alvial for *Apocalipsis*, by the English author David Herbert Lawrence, a book launched by the emblematic Editorial ULAM around 1935. In 1936, Zig-Zag published two editions of *México en marcha*, by Manuel Eduardo Hübner, one of them with a panoramic cover by E. Nicolás and another designed by Gustavo Carrasco Délano.

The late 1930s fully consolidated book illustration as an art in Chile. During these years the artists we have surveyed in this chapter continued to produce designs, accompanied by new names beginning to work in the field. The visual journey we shall now briefly trace presents a select range of their works, to which we have added the specific case of above-mentioned Gustavo Carrasco Délano, whose career reached its peak in the 1930s with graphic designs of the quality as those he made for *Federico García Lorca a través de Margarita Xirgu* (1937), by Arturo Aldunate Phillips, and *De Carlota a Werther a través de un siglo* (1940), by Gema de Tharsis. Like his colleagues, Carrasco Délano worked as a draftsman for several newspapers, and in particular for *Zig-Zag* review. His contributions to book design were esthetically akin to poster design, as revealed by the works reproduced here. A teacher at the Fine Arts School in Santiago, he was married to Matilde Pérez, a key figure in Chilean Geometric Art.

The arrival in Chile in 1939 of Polish artist Mauricio Amster, following his exile in Spain, symbolically brings this period to a close. Amster's work as a typographer and illustrator certainly marked a before and after in Chilean graphic art, as exemplified by one of the first covers he illustrated in the country, that of *Viejos relatos* (1940), by another leading figure in the story we've been telling, the writer Luis Enrique Délano. A vessel presides over the cover, further proof of the importance of marine subject matter in Chilean graphic art, that could well symbolize the arrival of exiles in Chile, giving rise to a period of splendor in the arts, what Justo Pastor Mellado defined as the "Winnipeg effect," mentioning the ship in which Amster himself and other decisive artists like Leopoldo Castedo, José Balmes and Roser Bru had arrived in Latin America.

Chile

Cover by Luis Meléndez Ortiz for Julio Molina Núñez and Juan Agustín Araya, *Selva lírica: estudios sobre los poetas chilenos*, Santiago de Chile. Universo Printing and Literature Society, 1917. 26 × 17.2 cm.
Archivo Lafuente

Cover by Luis Meléndez Ortiz for Alfredo Guillermo Bravo, *La isla de oro y otros poemas*, Santiago de Chile. Minerva, 1919. 19 × 12.8 cm.
Private collection, Granada

Cover by Luis Meléndez Ortiz for Joaquín Edwards Bello, La muerte de Vanderbilt: novela del Trasatlántico, Santiago de Chile. Cóndor, 1922.
21.7 x 15 cm.
Private collection, Granada

Cover by Alfredo Molina La Hitte for Caupolicán Montaldo, A través de la mañana: poemas, Valparaíso. Victoria, 1925.
18 x 13 cm.
National Library of Chile, Santiago de Chile

Cover by José Perotti for Daniel de la Vega, Amaneció nevando, Santiago de Chile. Universo, 1924.
17.8 x 14.1 cm.
Private collection, Granada

CHILE 303

Cover by unknown artist and inner pages by Juan Gandulfo for Pablo Neruda, *Crepusculario*, Santiago de Chile. Revista Claridad, 1923. 14 x 15 cm. IberoAmerican Institute – Prussian Cultural Heritage Foundation, Berlin

Cover and inner pages by Pascual Brandi Vera (author) for *La quietud del farellón*, Valparaíso. Siembra, 1919. 15.5 x 13 cm. Archivo Lafuente

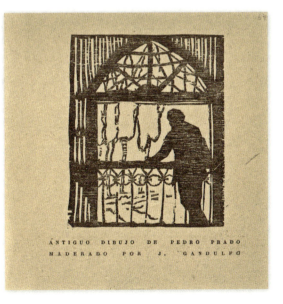

Cover and inner page by Jesús Carlos Toro for Zsigmond Remenyik, *La tentación de los asesinos!*, Valparaíso. Tour Eiffel, 1922. 26.7 x 19 cm. National Széchényi Library, Budapest

Cover by Luis Vargas Rosas for Joaquín Edwards Bello, *Crónicas*, Santiago de Chile. La Nación, 1924.
20 x 13.5 cm.
Archivo Lafuente

Cover by unknown artist for Juan Marín, *Looping*, Santiago de Chile. Nascimento, 1929. 19.6 x 19.8 cm. Archivo Lafuente

Inner pages by Norah Borges, Germán Baltra and Tristán Hirka for Alejandro Gutiérrez and Luis Enrique Délano,
El pescador de estrellas,
Quillota. Más Allá, 1926.
14.2 × 13.6 cm.
Private collection, Granada

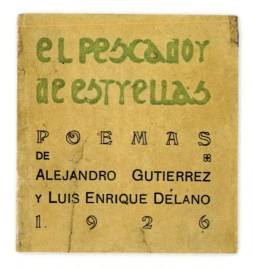
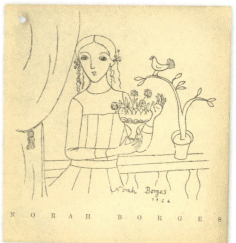
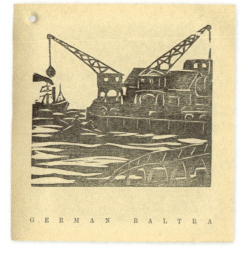
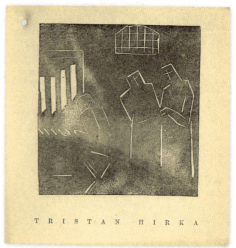

CHILE **309**

Inner pages by Alberto Paschin (*sic*) **(Abelardo "Paschin" Bustamante), Aníbal Alvial, Efraín Estrada Gómez and Ricci Sánchez for Alejandro Gutiérrez and Luis Enrique Délano,** *El pescador de estrellas*, Quillota. Más Allá, 1926.
14.2 x 13.6 cm.
Private collection, Granada

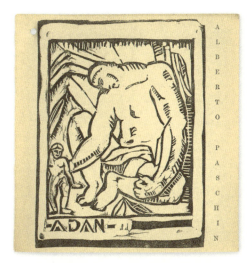
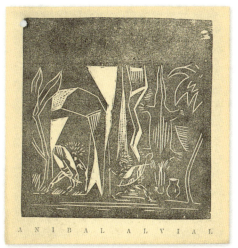
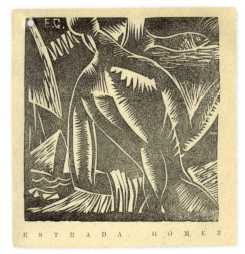
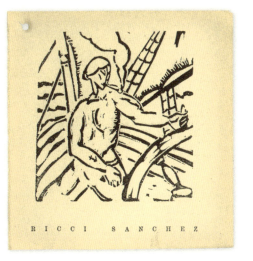

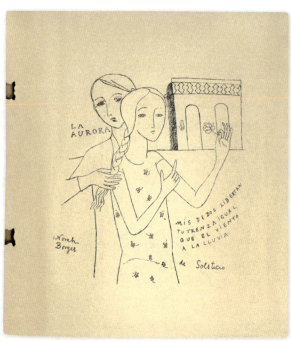
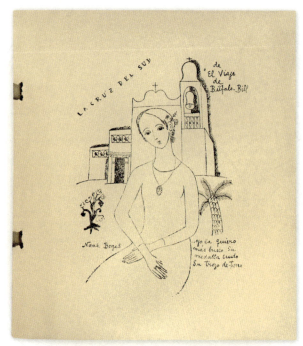
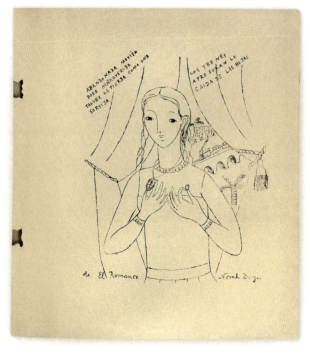

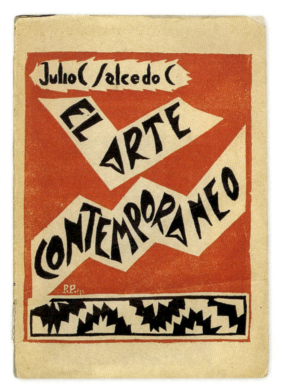

Cover by Pedro Plonka (pen-name of Pedro Valenzuela Páez) for Julio C. Salcedo C., *El arte contemporáneo: ¿Se intelectualiza, se deshumaniza o huye de la razón? (ensayo crítico)*, Valparaíso. Sud-América, 1931. 18.7 x 13.8 cm. Archivo Lafuente

←
Inner pages by Norah Borges for Humberto Díaz Casanueva, *El aventurero de Saba*, Santiago de Chile. Panorama, 1926. 20.4 x 18.6 cm. Private collection, Granada

Inner pages by Gabriel de Medina (author) for *Los que se fueron*, Santiago de Chile. Nascimento, 1925.
13 x 9.8 cm.
Archivo Lafuente

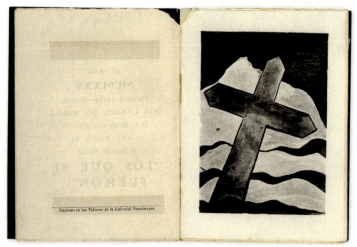

→»
Cover and inner page by Winnét de Rokha for Pablo de Rokha, *Suramérica: poema*, Santiago de Chile. Printers: Bardi, 1927.
23.7 x 23 cm.
Archivo Lafuente

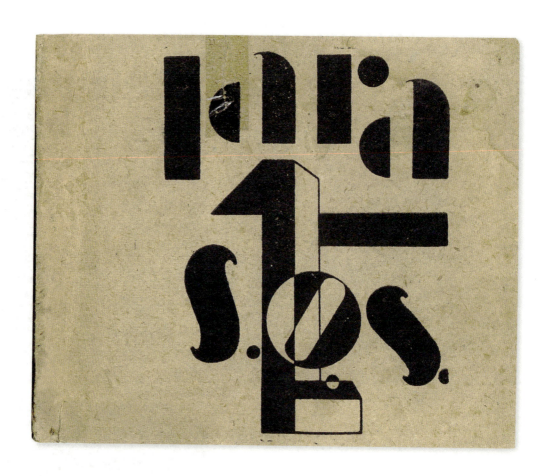

Cover by Alfredo Pérez Santana for Raúl Lara Valle, *S. O. S. Imagódromos*, Santiago de Chile. Run-run, 1929. 16.7 x 19.4 cm. National Library of Chile Collection

Cover by Alfredo Pérez Santana for Raúl Lara Valle, *El poeta automático: calendario Run-Rúnico*, Santiago de Chile. Run-run - El Comercio, 1930. 17 x 12.5 cm. National Library of Chile, Santiago de Chile

Cover and inner pages by Alfredo Pérez Santana for Benjamín Morgado, *Esquinas*, Santiago de Chile. Círculo de Artes y Letras, 1927. 19.5 × 13.8 cm. Archivo Lafuente

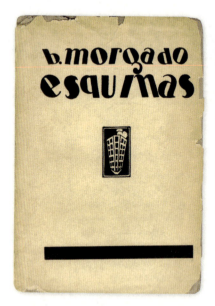
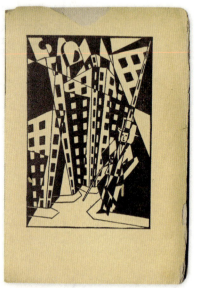
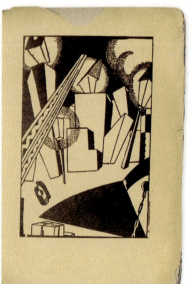
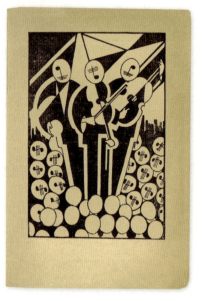

→

Inner pages by Germán Baltra for Zoilo Escobar, *Girasoles de papel*, Santiago de Chile. Nascimento, 1928. 19.5 × 19.5 cm. Archivo Lafuente

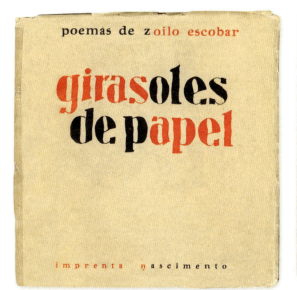
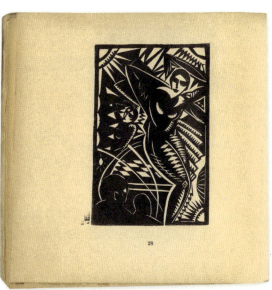
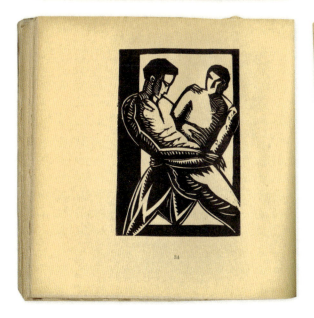
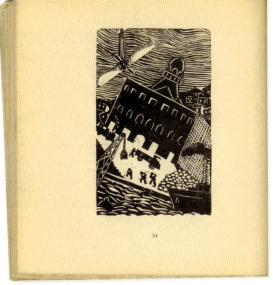

Cover and inner pages by Lautaro Alvial Bensen for Maclovio Munizaga Hozven, *Espejos andariegos*, Santiago de Chile. Ercilla, 1933.
19.4 x 13.3 cm.
Boglione Torello Collection

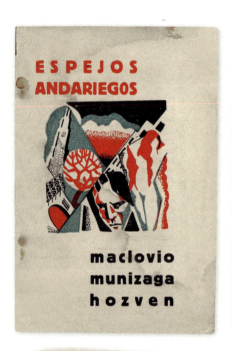

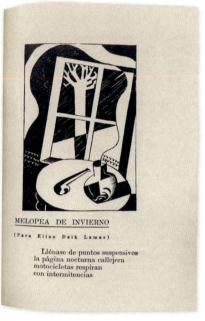

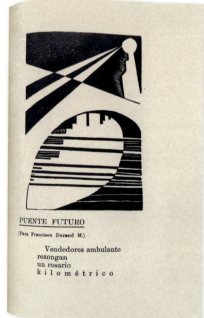

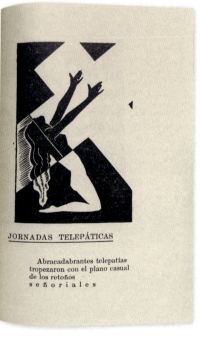

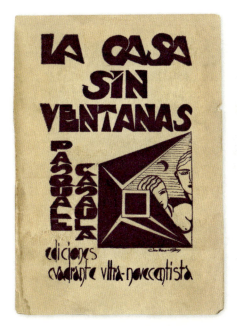
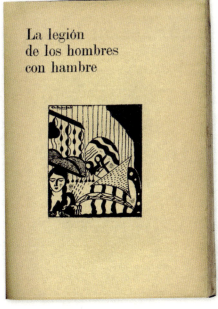
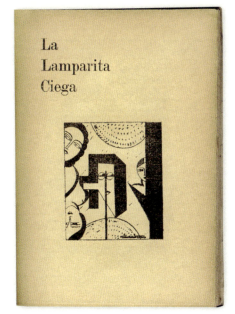
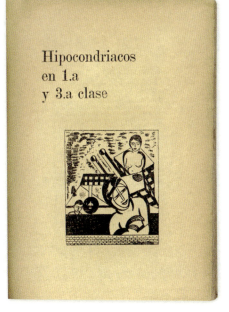

Cover and inner pages by Ciro Bascuñán for Pasquale Casaula, *La casa sin ventanas*, Santiago de Chile. Cuadrante Ultra-Novecentista, 1934. 19 x 13.5 cm. Archivo Lafuente

Cover and inner pages by **Huelén (pen-name of Juan Francisco González) for Salvador Reyes,** *Los tripulantes de la noche,* Santiago de Chile. La Novela Nueva, vol. 4, November 1929. 18 x 13 cm. Archivo Lafuente

Cover and inner pages by **Huelén (pen-name of Juan Francisco González) for Alberto Rojas Giménez,** *Chilenos en París,* Santiago de Chile. La Novela Nueva, vol. 9, April 1930. 17.7 x 12.7 cm. Private collection, Granada

Cover and inner page by **Lupercio Arancibia for Alejandro Galaz,** *Molino: poemas,* Santiago de Chile. Caupolicán Ponce, 1929. 19 x 16.1 cm. Private collection, Granada

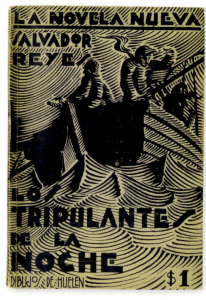
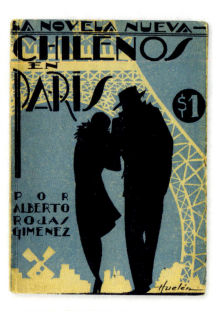
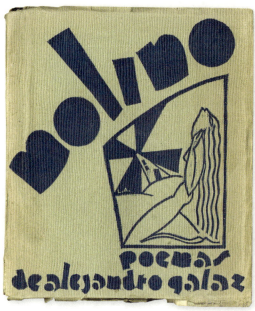
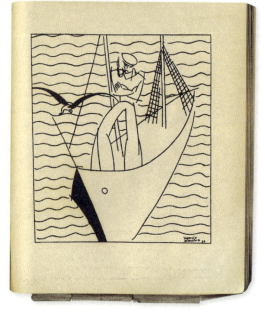

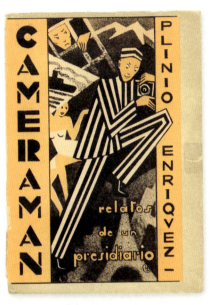
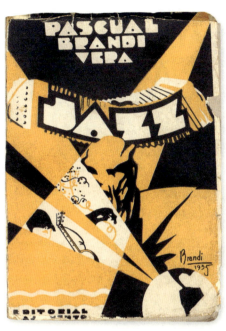
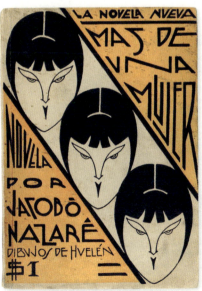
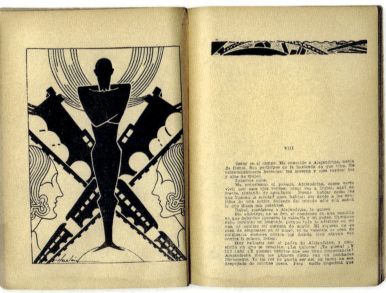

Cover by unknown artist for Plinio Enríquez, *Cameraman: relatos de un presidiario*, Valparaíso. Universo, 1932. 18 × 12.6 cm. Archivo Lafuente

Cover by Pascual Brandi Vera (author) for *Jazz: novela*, Santiago de Chile. Nascimento, 1935. 19.5 × 13.5 cm. Archivo Lafuente

Cover and inner page by Huelén (pen-name of Juan Francisco González) for Jacobo Nazaré (pen-name of Luis Barriga Figueroa), *Más allá de una mujer*, Santiago de Chile. La Novela Nueva, vol. 3, October 1929. 18 × 12.8 cm. Private collection, Granada

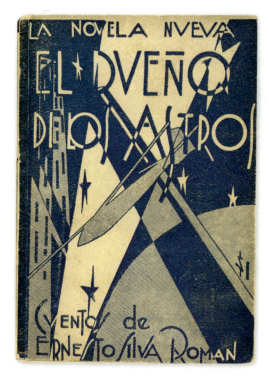
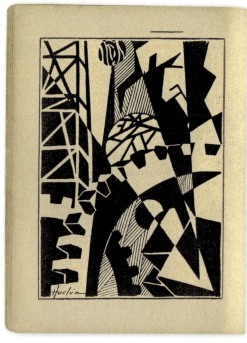
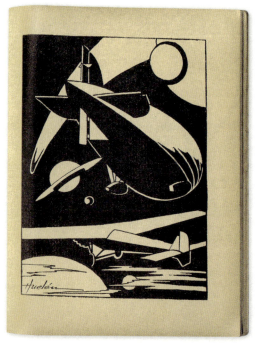

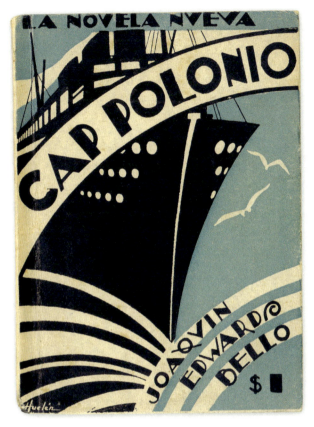

Cover and inner page by Huelén (pen-name of Juan Francisco González) for Joaquín Edwards Bello, *Cap Polonio*, Santiago de Chile. La Novela Nueva, vol. 1, September 1929. 17.5 x 12.8 cm. Archivo Lafuente

«←
Cover and inner page by Huelén (pen-name of Juan Francisco González) for Ernesto Silva Román, *El dueño de los astros (cuentos)*, Santiago de Chile. La Novela Nueva, vol. 2, October 1929. 18 x 13 cm. Archivo Lafuente

Cover by Jorge Délano (Coke) for Jacobo Nazaré (pen-name of Luis Barriga Figueroa), *Destrucción: la verdad sobre la sublevación de la Escuadra*, Valparaíso. Europa, n.d. [1930s?], 18 x 13 cm.
Archivo Lafuente

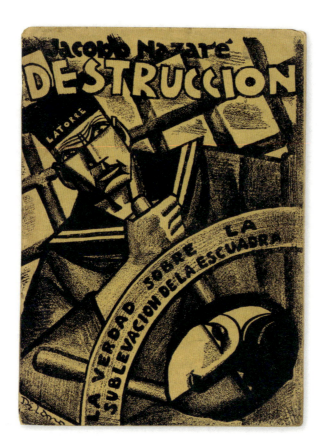

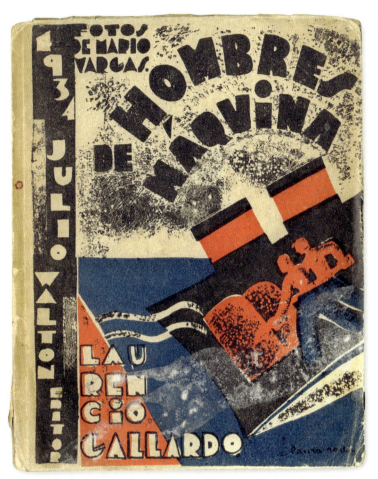

Cover by Laura Rodig for Laurencio Gallardo, *Hombre de máquina*, Santiago de Chile. Walton, 1934. 21 x 17 cm. Private collection, Granada

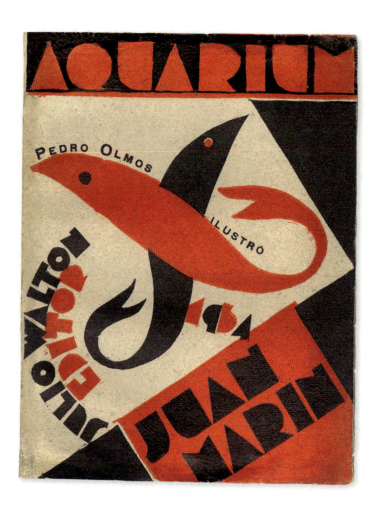

Cover by Pedro Olmos for Juan Marín, *Aquarium*, Santiago de Chile. Editorial del Pacífico, 1934. 23 x 17.6 cm. Archivo Lafuente

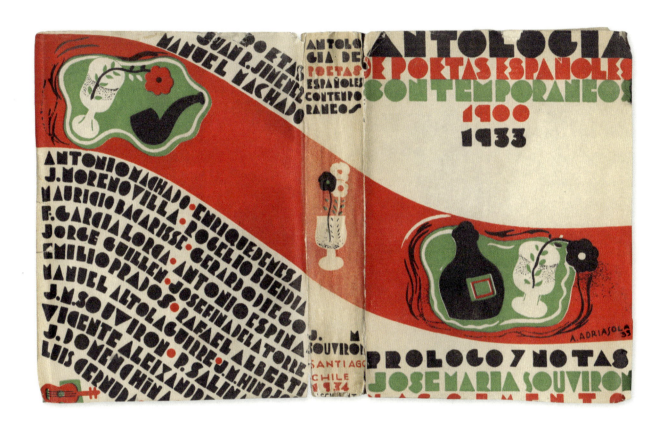

Covers by Arturo Adriasola for José María Souvirón, *Antología de poetas españoles contemporáneos (1900 - 1933)*, Santiago de Chile. Nascimento, 1934. 19 x 14 cm. Archivo Lafuente

Cover and inner page by Mireya Lafuente for María Tagle, *Flautas de sombra: versos*, Santiago de Chile. Nascimento, 1934.
19.2 x 18 cm.
Archivo Lafuente

Cover and inner page by Gustavo Carrasco Délano for Gema de Tharsis, *De Carlota a Werther a través de un siglo: trozos psíquicos y poemas en prosa*, Santiago de Chile. Nascimento, 1940.
17 x 14.1 cm.
Private collection, Granada

→

Cover and inner page by Gustavo Carrasco Délano for Arturo Aldunate Phillips, *Federico García Lorca a través de Margarita Xirgu: ensayo leído en la Universidad de Chile*, Santiago de Chile. Nascimento, 1937.
19.8 x 19.5 cm.
Archivo Lafuente

Cover by Arturo Adriasola and inner page by Ofelia Zúccoli (author) for *Llegando al camino: poemas*, Santiago de Chile. Nascimento, 1936.
19.8 x 19.9 cm.
Private collection, Granada

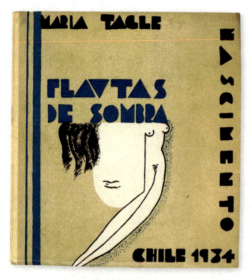
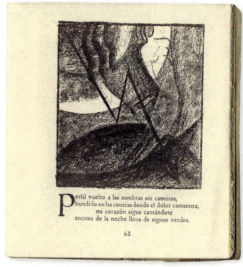
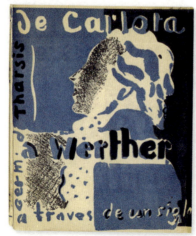

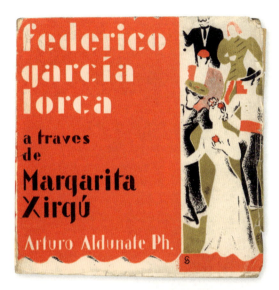

Inner pages by Roberto Matta Echaurren for René Arriagada Hermosilla, *Milibil*, Santiago de Chile. Lers, 1935. 27 x 19.5 cm. Archivo Lafuente

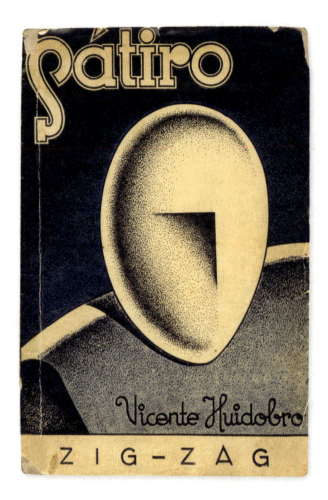

Cover by Joseph Sima for Vicente Huidobro, *Sátiro o El poder de las palabras*, Santiago de Chile. Zig-Zag, n.d. [1939?]. 20.3 x 14 cm. Archivo Lafuente

Cover attributed to Hans Arp for Vicente Huidobro and Hans Arp, *Tres novelas ejemplares (Arcachón 1931)* [on the cover, "Tres inmensas novelas"], Santiago de Chile. Zig-Zag, 1935. 18 × 12.8 cm. Archivo Lafuente

Cover by Arturo Adriasola for Xavier de Hauteclocque et al., *Los dueños del mundo*, Santiago de Chile. Guía-Nascimento, 1933. 19.2 x 14.1 cm. Private collection, Granada

→
Cover and inner pages by Pedro Olmos for Pablo Neruda, *España en el corazón: himno a las glorias del pueblo en la guerra (1936-1937)*, 2nd edition, Santiago de Chile. Ercilla, 1938. 27.2 x 20.9 cm. Archivo Lafuente

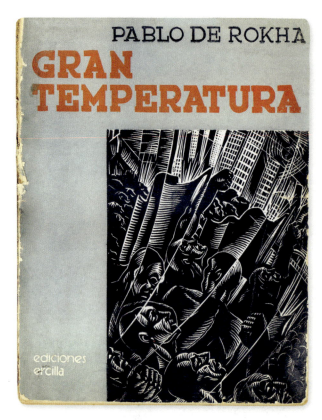
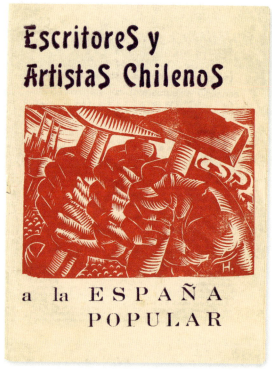

Cover by Carlos Hermosilla for Pablo de Rokha,
Gran temperatura, Santiago de Chile. Ercilla, 1937.
28.4 x 22 cm.
Private collection, Granada

Cover by Carlos Hermosilla for several authors,
Escritores y artistas chilenos a la España popular, Santiago de Chile.
Imprenta Marión, 1936.
26 x 20.5 cm.
Vicente Huidobro Foundation, Santiago de Chile

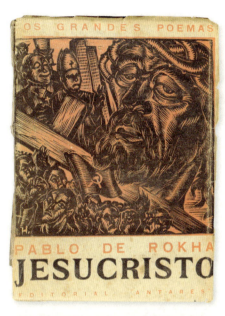
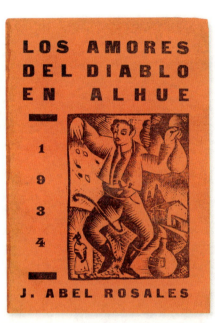
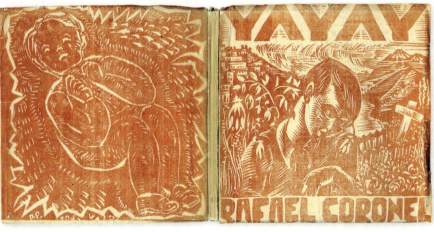

Cover by Carlos Hermosilla for Pablo de Rokha, *Jesucristo 1930-1933*, 2nd edition, Santiago de Chile. Santiago de Chile. Antares, 1936. 18.8 x 14 cm. Archivo Lafuente

Cover by Carlos Hermosilla for Justo Abel Rosales, *Los amores del diablo en Alhué: acontecimiento extraordinario, fantástico y diabólico*, Santiago de Chile. Editorial del Pacífico, 1934. 18.5 x 13.3 cm. Archivo Lafuente

Covers by Carlos Hermosilla and Pedro Plonka (pen-name of Pedro Valenzuela Páez) for Rafael Coronel, *Yayay*, Valparaíso. Dirección General de Prisiones, 1940. 14 x 14 cm. Private collection, Granada

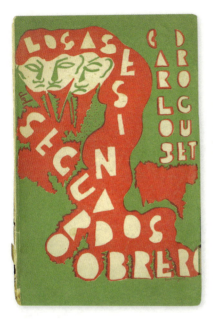

Cover and inner pages by Luis O. Droguett for Carlos Droguett, *Los asesinados del Seguro Obrero*, Santiago de Chile. Ercilla, 1940. 22.3 x 14.5 cm. Private collection, Granada

←
Cover and inner pages by Pascual Brandi Vera (author) for *Música de puerto*, Valparaíso, n.p., 1940. 26.7 x 24 cm. Private collection, Granada

Cover by Sergio Trujillo Magnenat for *Fagua*, year I, no. 1, November 1934. Editor: Diógenes Osorio Quesada. Bogotá, Tipografía Bruño. 23.5 x 16.5 cm. Private collection, Granada

Colombia

Riccardo Boglione

To sketch out the critical context of the development of Modernism in the covers of Colombian books, before the various articles we shall be quoting in this chapter we may begin by mentioning the volume *Una historia del libro ilustrado para niños en Colombia*, by María Fernanda Paz-Castillo; the impressive publication *Cartel ilustrado en Colombia*, coordinated by Pedro José Duque López; the monograph on the most outstanding designer of the period, *Sergio Trujillo Magnenat artista gráfico, 1930-1940*, by Juan Pablo Fajardo, and *Piedra, tijera, papel: una mirada a la historia del diseño gráfico en Colombia*, a visual work-in-progress developed on the Internet that "seeks to restore and visualize the history of graphic design in Colombia," as explained on the corresponding website. In spite of the time differences and theoretical distinctions between these and other books, we soon easily understand that, as in most Latin American countries, graphic art in Colombia began to turn to Modernism in the 1920s, although it only attained consistency well into the 1930s.

The appearance of Cubism, Futurism and Constructivism in the visual arts was slow and had much opposition. With the exception of the anti-academic open-mindedness of a philo-Impressionist like Andrés de Santa María at the beginning of the 20th century, historians coincide in pointing out that the first direct contact with a visual proposal clearly removed from the classical and genre canons prevailing in the country was an *Exposition of French Modern Painting*, staged at the Fine Arts Pavilion located in Bogotá's Forest of Independence in 1922 (and that a few months later toured to Medellín, though with less works). Despite presenting works by a large number of artists, from various dates and in a range of styles, "122 works from the period comprised between the second half of the 19th century and the first two decades of the 20th century," it did show pictures by "Albert

Gleizes, André Lhote and Francis Picabia" (Suárez, 2008, 66), which caused quite a stir in the cultural sphere, particularly in the capital. Broadly speaking, the show's most "novel" displays were criticized, not only by general newspapers and magazines but also by popular critics of the time: Roberto Pizano and Rafael Tavera, themselves painters, rejected the Cubist works, upholding national art and traditional, academic styles (Suárez, 2008, 81 and ff.), although we should mention that the National School of Fine Arts in Colombia had only opened in 1886, and was therefore a relatively recent institution. Be that as it may, there were also artists who defended the boldest canvases (such was the case of the influential critic Gustavo Santos) and that the exhibition promoted certain interests but, as suggested by Fernández Uribe and Villegas Gómez (2017, 91), "its objectives don't appear to have been completely fulfilled," as it didn't produce direct, long-lasting consequences for the generation of young Colombian artists (the fact that for some time art students were banned from visiting it is meaningful). Indeed, as Álvaro Medina sustains, only on occasion of the second show of French art in 1928, funnily enough much more conservative than the first exhibition (almost organized, or so it seems, to eliminate dangerous memories of the latter), did a group of artists linked to the Fine Arts Center (recently established) begin to explore alternative paths. On the other hand, the historical situation had changed, "industrialization had advanced, overcoming obstacles, there was a working class that would exert an influence on the art of the young [...], liberalism was about to bring the industrial bourgeoisie to power" (Medina, 1978, 185). Furthermore, a literary avant-garde had been consolidated thanks to the Los Nuevos group and its homonymous review founded in 1925, in which those who would become the key figures in the renewal of Latin American poetry, such as León de Greiff and Luis Vidales. The opening of visual art toward the "new" benefitted from this ideological flexibilization.

It would be around the year 1930 when, thanks to the return home of several Colombian artists based in Europe, that painting and sculpture began to show the first timid formal efforts to shake off nineteenth-century, academic considerations. Others, however, had paved the way in the field of graphic art. The fading though still visible impact of the Panidos (a group of "rebellious" intellectuals that was active in Medellín in the second decade of the century), a team of caricaturists had the "unexpected and unsuspected merit of having set up the first group of artists to break with the past, the true avant-garde of our plastic arts" (Medina, 1978, 186). This phenomenon wasn't exclusive to Colombia though: as is the case of several Latin American countries, the emergence of an artistic language set on distorting and geometrizing forms—the local version or healthy "perversion" of the "isms"—can be traced in the field of graphic art before that of the fine arts, among other things thanks to the fact of being less scrutinized than "serious" art (and perhaps, in this case, due to the force of the arrival in Colombia of an Italian illustrator, Rinaldo Scandroglio, whom we shall discuss later).

In those days, newspapers and magazines began to assign space to a group of "Colombian artists who aspired to be modern, particularly draftsmen and caricaturists who were somehow linked to Cubism, Futurism or Abstract Art" (Gallo, 1977, 24). Given the spirt of the printed medium, some of them also ended up working with book publishers, drawing covers.

In this environment, that took advantage of the noise and attention provoked by the "modern" in graphic art, "the first advertising agencies [were set up] like Gómez Leal in Bogotá, Núñez Novas in Bucaramanga, Etelberto Isaza and David Álvarez in Medellín," that praised the "draftsman as an idea man." In the mid-1930s,

Pan review gave rise to "the concept of graphic design as we know it today" (Ochoa, 2010, 111), and the main figure in Colombian Modernist publishing design, albeit in a phase characterized by Art Deco, or post-avant-garde, who reworked certain formal avant-garde traits, was Sergio Trujillo Magnenat.

We shall begin our survey of Colombian works with a couple of examples that sum up the atmosphere in the world of the country's graphic art in the early 20th century, an atmosphere shared by several other countries on the continent. On the one hand, an anonymous, succinct though refined example of Art Nouveau motifs applied to the title *Trébol* (1907) by Guillermo Posada, a green phytomorphic design, and on the other, an accomplished vignette by Marco Tobón Mejía, a notable sculptor most of whose career developed in Paris where he trained under Auguste Rodin. Although his sculptural style has on occasion been described as an academic "slightly idealized verism" (Gil Tovar, 2002, 104), the influences of Art Nouveau on his work are obvious, as we see in the cover for *Mis buenos tiempos*, by Raimundo Cabrera, published in the French capital around the year 1910, a design characterized by a delicate play between the figure in the foreground, built on graceful lines, the background that forms a landscape, and the title with its cheerful color fields.

In the early 1920s the caricaturist Ricardo Rendón, a member of the aforementioned Panidas and Los Nuevos groups, was popular for his unsparing political satires published in newspapers like *La República* and *El Tiempo* (Guerrero, 1994). Rendón made extremely succinct caricatures that were therefore likened to Futurist works. Nonetheless, in his cover for *El frío de la gloria* (1922), by Francisco Jaramillo Medina, he resorted to Symbolist features enlivened by the movement of the figure of death that seems to pierce the cover and rise above the composition that should be delimited by the title and the image. Funnily enough, another skeleton appears in an anonymous cover of 1930, that of *Andanzas*, by Mario Libero; in this case, the almost comic drawing is somewhat diluted by the robust construction of oblique planes with powerful red and black backgrounds.

As mentioned, the Italian artist Rinaldo Scandroglio was an important though perhaps not indispensable figure in the development of Modernist graphic art in Colombia, on account of his esteem for Cubism, according to Medina (1978, 187), and of Futurism, according to Garay (2010, 50). In this sense, the highpoint of his art were the exultant illustrations made for *Homenaje al doctor Enrique Olaya Herrera* (1935), by Carlos Lleras Restrepo, although broadly speaking his style was more like a hybrid between "new" forms and traditional resources. Three years after his work first appeared in Colombia published in the pages of *Cromos* magazine, he produced the outstanding cover for the anonymous volume *Catay. Poemas orientales* (1929), translated by the writer and politician Guillermo Valencia. A highly expressive sharp-angled, black and white stylization of a folding screen decorated with figures of geishas and "typically" Asian ornamental motifs (fish, birds, tigers, flowers, etc.), the composition shows an impressive play of shadows. The structure of his image for the cover of *La guerra con el Perú* (1932), by Luis María Murcia, presents a similar combination of opposite shades, organized on the red and blue that invade the vegetation of a forest, attacked by a ghostly black and white army. In the late 1930s, Sandroglio produced a less contrasting design to illustrate the cover of *El hombre, la mujer y la noche* (1938), by Adel López Gómez: a slender drawing, a sketch almost, of a man accompanied by large red letters framing the figure.

In the 1930s a number of artists stretched the limits of graphic art by applying new compositional resources to book design. In 1931, the book *Cosas viejas*, by Eduardo López, was

published, its cover designed by Efraín Gómez Leal. A few years later, Leal Gómez would be one of the contributors to—and, for a short time, art director of—*Tierra* review, the organ of the newly formed Communist Party of Colombia (founded in 1930), characterized by its woodcuts and linocuts of social themes with "dramatic accents in their composition" (Peters, 2014, 68) and "a marked influence of Constructivism" (Duque López, 2009, 313). Here the atmosphere is different, yet the parallel scenes of the visual field divided into four irregular sections focus on anomalous spaces and objects cleanly drawn and colored: a hand winding up a pendulum clock, the hands of which are flexed like those in Dalinian clocks while its chains appear over the author's name; a statue of Cupid broken into several pieces (with its arrow engaged "in dialog" with the clock's hands); a foreshortened square with the shadow cast by a metaphysical monument; and an abandoned "villa."

Another one-off and felicitous foray into the field of cover design is that of Adolfo Samper, who in 1931 illustrated the short stories in *El fugitivo*, by Adel López Gómez. Samper, remembered above all for being the country's first strip cartoonist, was one of the founders of the controversial Fine Arts Center in 1924, and in 1929 won a scholarship for a sojourn in Paris (Segura, 1989, 12 and ff.). A refined woodcutter and a contributor to several newspapers of the time (especially *Universidad* and *Cromos*), in this graphic proof he achieved a powerful representation of the character mentioned in the title, the fugitive, thanks to two large geometrically determined "patches" that create a contrast between a red background cut by a beam of light and an impressive black silhouette with two conspicuous frenzied eyes, in an image that combines traces of Constructivism with the artist's penchant for caricature. Alberto Arango Uribe, another caricaturist born in Manizales who worked chiefly in Bogotá, became one of the most admired draftsmen of the decade, together with Ricardo Rendón. Between 1930 and 1936 he "designed covers for books (by Fernando González, León de Greiff, Arango Villegas, Enrique Otero D'Acosta, and others) and occasionally illustrated them (as in the case of *El estudiante de la Mesa Redonda*, by Germán Arciniegas)" (Velásquez Garcés, 1988, 47), which made him one of the most prolific book illustrators of the period. Besides the drawings he made for *Viaje a pie* (1929), by Fernando González, a book of thoughts that emerged during a long journey through the country, published in Paris and banned in Medellín by the Church, we have chosen a couple of designs in which the artist showed great talent for creating letters: the striking *Mi Simón Bolívar (vol. 1): Lucas Ochoa* (1930), by González himself; *Panorama de cuatro vidas* (1934), by Roberto Pineda, that is constructed around a huge 4, where the little dog peeing on the graphic feature itself reveals his caricatural vein; the intelligent use of the score to structure a play of letters, notes, empty and full, linked to musical variation, from one of the key Colombian avant-garde books, *Variaciones alrededor de nada* (1936), by León de Greiff.

After this series of caricatures and before focusing on the absorbing figure of Trujillo Magnenat, it is worthwhile to mention the remarkable career of the painter Ignacio Gómez Jaramillo (who won the National Award for Painting on two occasions in the early 1940s and was one of Colombia's most important muralists). Shortly after arriving in the country following a long stay in Paris he designed the cover for *Espejo de naufragios* (1935), by Arturo Camacho Ramírez, an inspiring play between the title, that almost fills the entire space with agile, vigorous serifs, and an extremely succinct drawing that refers directly to the book's title and leaves no room for chiaroscuros or perspective.

The various scholars who have studied Colombian graphic art agree on signaling Sergio

Cover by Sergio Trujillo Magnenat for *Revista de las Indias*, no. 8, January 1938.
Editor: Arcadio Dulcey.
Bogotá, Ministerio de Educación Nacional.
28 x 21 cm.
Beatriz González Collection, Bogotá

Trujillo Magnenat as the most important artist of the 1930s and 1940s. Nonetheless, Trujillo, born in 1911 in Manzanares (Caldas), explored other fields and worked as a painter, sculptor, photographer, ceramicist, muralist, furniture and toy designer. In short, he embodied the ideal of the artist-cum-artisan and experimenter whose output crosses different social perimeters, blurring the limits between decorative art and "high" art. Trained in classical tradition (he attended the Fine Arts School in Bogotá), as described by Fajardo (2013, 16), Trujillo considered "drawing almost as a tool of thought," and soon absorbed some of the features of Art Deco that would define his style, "an impeccable line, clear-cut and refined, tending toward abstraction, and the "distinct and angular muscles of his figures, with penetrating gazes and strong features" (Duque López, 2009, 309), along with a bold use of color. This heterodox form of Art Dec is associated by some authors with Tamara de Lempicka (Medina, 1995, 124) and seems to be related to the treatment of volumes by French artist Jean Dupas, particularly in the field of poster design, although it is often startling and free of external influences, as is obvious in two covers. The first, that of *Lo que mis ojos vieron* (1933), by Joaquín Quijano Mantilla, strove to compress a chaotic list of different things, places and times (experienced by the writer) in the rectangular space of the cover: the vertical and horizontal axes soar, the figures, superimposed, cross space obliquely, trampling on one another, while faces with different features appear in the scene (one of which evokes the huge Olmecan heads), and symbols (the swastika, the hammer and sickle) are combined with figures (the Art Deco silhouette of a female sphere thrower, a variation on a Greek motif) and objects (a "trendy" transatlantic). Everything is flustered: figures are geometrized, waves and other zigzagging elements are repeated while colors and their combinations—acid green and

violet—give rise to a certain aggressiveness intrinsic in the image, that is in fact a highly accomplished and original combination of Art Deco tension and Expressionist color. If the nervous landscape of *La mesa de Juan Díaz* (1938), by Pedro Alejo Rodríguez, is a recognizably a design by Trujillo, his design for the children's book *El País de Lilac*, by Oswaldo Díaz Díaz, published the same year, is unclassifiable. Not only do the interior illustrations "accompany the text in a harmonious though daring way," playing "with positions and sizes throughout the discourse of the book, surprising readers with the composition of each double-page spread" (Paz Castillo, 2010, 80), but the front and back covers are dominated by fields of bright colors, with no depth, that create a female portrait and a somewhat showy pre-Pop Art wild background. Popular and cartoonish are the covers of *Del rosal de Afrodita* (1937), by Aurelio Caballero Acosta, designed by one Frog; *Risaralda*, by Bernardo Arias Trujillo, conceived by Arango Uribe in 1935; and *Los Juegos de Azar y la Especulación* (1933), by Rafael Torres Mariño, drawn by KaiKu and nuanced by a dominant geometrization and an unprecedented brightness of color.

Parallel to these works, a series of book designs produced between the years 1934 and 1939 reveal the importance that Trujillo Magnenat assigned to the creation of types, exultant "types", that were the core of his artistic output—Fajardo describes a few complete typographies drawn by Trujillo (2013, 64 and ff.)—and feature in simple though intense drawings in books like *Alabanzas del hombre y de la tierra* (1934), by Rafael Maya; *Itinerario de fuga* (1934), by José Umaña Bernal; *Muros de la ciudad* (1934), by Felipe Antonio Molina; and *Poemas para luna y muchachas* (1939), by Vidal Echevarría. Last but not least, we should mention the central role played by Trujillo in some of the publications produced by the Colombian Ministry of Education in the 1930s, including *Rin Rin* and one of the most important cultural newspapers of the time, *Revista de las Indias*, conceived to show "different ways of looking at Latin America through her poetry, her fiction, her criticism, and her scientific progress; in short, ways of illustrating a certain America as 'one and multiple'" (Restrepo, 1990, 26) that would exist up until 1950. "The general image of the review is based on its typography, a manifesto of the expressive capacity of the letters drawn by Trujillo" (Fajardo, 2013, 45) and their cardinal elements—the large, spaced and rational green and black letters on a white ground that cover the entire surface—would also feature in the books published by the newspaper in the form of supplements, such as *Cuaderno del Trópico*, by Darío Samper (1936), and *Prosas de Gaspar. Primera suite*, by León de Greiff, the same year, both adorned with superb interior illustrations in black and white by Trujillo himself.

A refined play with letters, elongated to create an unfinished, continuous effect that spreads to the volumes, presides over the anonymous composition for *Lámparas de piedra* (1934), by Ciro Mendía, while the early lettering—almost a modernized, frenzied version of "former" Art Nouveau preciosities—in *Cachos y dichos* (1923), by Federico Trujillo, enables us to introduce its author, Pepe Mexía, another important book illustrator in Colombia. In this volume, Mexía, one of the founders of Panidas, already displayed the main stylistic trait of his production—line. Born in 1895 in Concepción (Antioquia), Mexía worked chiefly as an architect (and briefly as a politician), parallel to which he developed an advantageous practice as a caricaturist and illustrator, characterized by formal experiments inspired by the avant-garde (rarefaction, the collapse of figuration, a move toward abstraction, etc.). As summed up by Miguel Escobar Calle, Mexía's intention was "by refining lines, to make them as synthetic as possible, until they 'vibrate' in themselves and achieve a unique form of Expressionism,

a 'psychic-abstruse' (in his own words) and undeniably original product." This process is perfectly visible in the graphic works produced by Estudio Nuti, founded by Mexía, Carlos Obregón and Eduardo Vázquez in the mid-1930s. Line is the main feature in a simple drawing that seems no more than a "preparatory sketch" on the cover of *Hace tiempos* (1935), by Tomás Carrasquilla. In another book by Carrasquilla, *Dominicales* (1934), on an idyllic rural landscape created in a few strokes Mexía splendidly and arbitrarily superimposed an abstract grid—almost a nod to Mondrian—with barely suggested patches of color. However, in *Panorama antioqueño* (1936), by Jaime Barrera Parra, the process of abstraction is radicalized, leaving silhouettes of softened colors that evoke familiar shapes (clouds, trees, houses and an intrusive guitar).

The illustrations for two books published between 1935 and 1936, with a social subject matter depicted in a tragic mood and sharp contrasts of black, white, and red (a combination that had been tested in 1931 on the bold cover of *David, hijo de Palestina*, by José Restrepo Jaramillo, designed by Penell in a Cubist vein) are quite likely the high point of the decade. The novel titled *Mancha de Aceite* (1935), by César Uribe Piedrahita, anti-imperialist in tone and critical of foreign (in this case Venezuelan) exploitation and of the violence against indigenous peoples, an "original idea on account of its social condemnation and its style and structure" (Pineda Botero, 2001, 39), extends this "condemnatory force and its technical innovations" (idem.) thanks to twenty-four splendid woodcuts and to the cover made by Gonzalo Ariza, one of the most prominent Colombian painters of the 20th century and a friend of the author's. The prints are "so realistic and expressive that their sequence allows us to reconstruct the narrative as a cartoon strip or a film" (Escobar Mesa, 2004, 38). If the novel and its pictures "together, provide a double or multiple look at something which must be considered, due to its complexity [...] from different perspectives" (idem.), Ariza's woodcuts are refractive: ancient masks and Indian make-up, rings and cacti, oppressors and oppressed, jarring scenes of exploitation and landscapes are opposed in a series of angular drawings that comes to a close in a shadowy image of an oil well burning under a sky blacker than the earth.

The book *Presidios de Venezuela*, published in Bogotá by Selecta in 1936, also included prints by Ariza, besides illustrations by the sculptor Gomer Medina and other artists already mentioned in our survey—Arango, Jaramillo, and Trujillo Magnenat. The volume compiles testimonies by ex-prisoners of Venezuelan jails during the Juan Vicente Gómez dictatorship that detail the atrocities they endured. The terrifying and emotional impact of the words is transferred perfectly to the harsh images, each in a different style, that highlight the clash between light and dark areas, as in the cover by Ariza, structured around a figure in the position of Christ on the cross, whose face isn't shown and whose belly is pierced by a piece of barbed wire.

Around the end of the decade we come across one of the few examples of the use of photographs on the covers of Latin American books of the period: a photo in green tones of a woman with an intense expression, on which bulging black letters stuck to one another as if compressed have been superimposed, forming the title, *Canción de los pobres del mundo*, an anthology compiled by Lino Gil Jaramillo in 1937, obviously social in nature. Diametrically opposed, in political terms, is the rhetorical and ambivalent though visually forceful cover of *Sangre de España* (1939), by Eugenio Ayape, drawn by a young Gabriel Largacha Manrique, who would subsequently become a renowned architect.

We could conclude our journey with three books that explain the recovery of Indigenism by the "new" languages that can be traced in

Cover by J. González Gutiérrez for *Arte: órgano del Conservatorio*, no. 22, February 1936. Editor: Manuel Antonio Bonilla. Ibagué (Tolima), Imprenta Departamental. 24 x 16.4 cm. Private collection, Granada

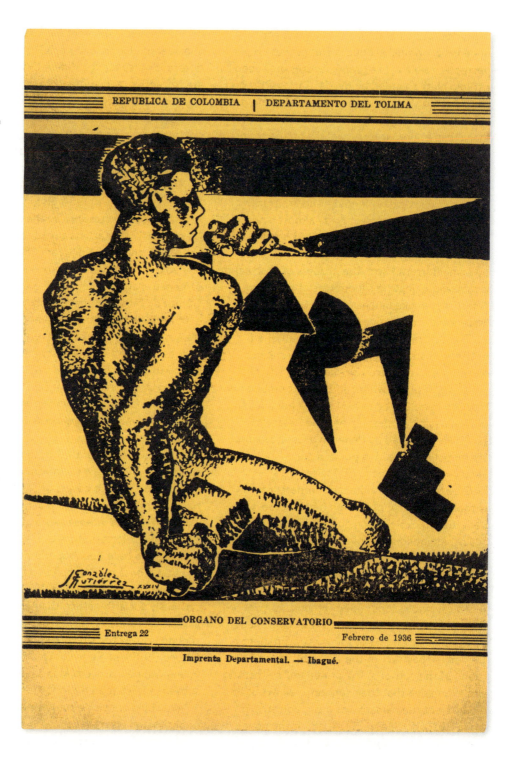

several Latin American countries. In Colombia, this was only possible in the 1930s, when the work of artists like Ramón Barba and Rómulo Rozo (although this could be applied to many others) "no longer attempted to limit itself to the recovery of pre-Columbian models" and allowed "the imagination to soar" (Pini, 2000, 226). Thus, in 1937 we have the cover and illustrations of the volume *La Roma de los chibchas*, by Gabriel Camargo Pérez, conceived by Carlos Reyes Gutiérrez, Julio Abril, Luis Alberto Acuña, Luis B. Ramos, as well as Ariza. In a dry essential, almost Chibchan style filtered by Art Deco, the cover by Reyes features a figure—that reappears inside—of an Indian in profile, kneeling down facing the sun and its rays. In the interior illustrations, sharply defined curves, vibrant repetitions of regular elements, and the opposition of light and dark areas "modernize" the *mise-en-scène* of the pre-Hispanic culture.

The book *Cuentos de la conquista*, by the ethnologist and archeologist Gregorio Hernández de Alba, a member of the artistic and literary group Bachué, committed to rescuing and valuing indigenous culture, was published that same year. The cover of the volume was by the aforementioned Rómulo Rozo, whose sculpture *Bachué* gave the group its name. Rozo, who in the mid-1920s, still in Europe, "had deliberately begun to create a complex iconographic ensemble chiefly based on Chibcha culture, its deities and habits" (Gutiérrez Viñuales, 2015b, II), later became one of the most outstanding artists working with indigenous motifs. The cover shows a colorful depiction of a ritual and a temple, a fascinating combination of pre-Columbian elements, precise symmetry, and Modernist tonalities—we must not forget that Rozo displayed a metal sculpture at the famous Exposition Internationale des Arts Décoratifs et Industrielles Modernes held in Paris in 1925, the event that made Art Deco a mass phenomenon (Gutiérrez Viñuales, 2015b, 44-45).

To conclude this chapter, we must mention the cover of *Del Vaticano al Catatumbo* (1940), by Gonzalo Canal Ramírez, a toned-down version of the work made by Trujillo for *Lo que mis ojos vieron* (previously analyzed). Created by an anonymous artist, in a forceful black and white composition the cover neatly combines elements as disparate as a tank, the dome of St. Peters, a *fascio littorio* (fasces), the Nazi and Communist symbols, and a seemingly stylized monolithic sculpture devoted to the Augustinians.

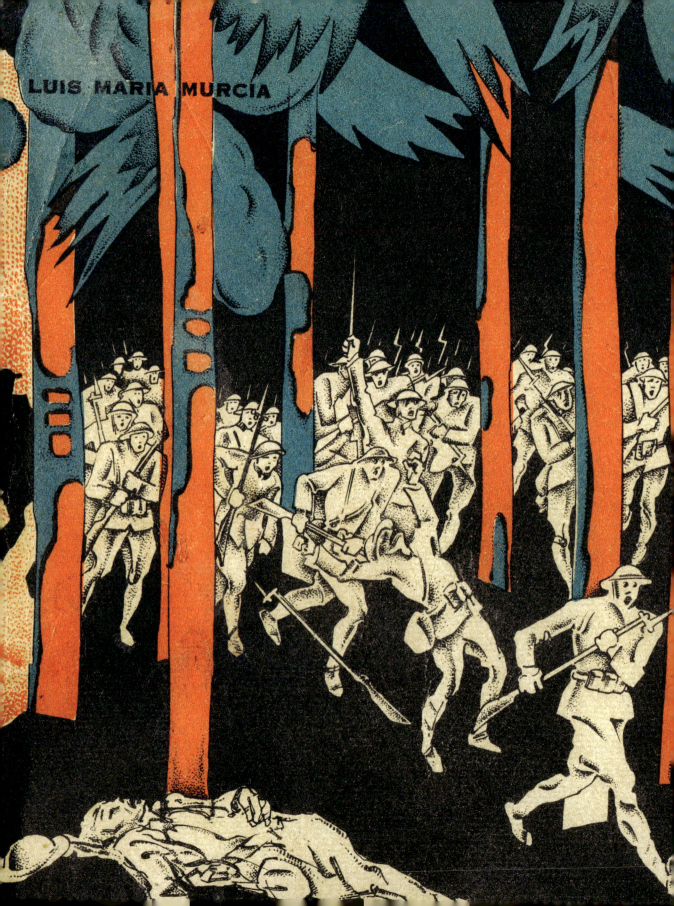

Colombia

Cover by Marco Tobón Mejía for Raimundo Cabrera, *Mis buenos tiempos (Memorias de un estudiante),* Paris. Paul Ollendorff, n.d. [c. 1910?] 18.9 × 13 cm.
Private collection, Granada

Cover by unknown artist for Guillermo Posada, *Trébol*, Bogotá. Tipografía de Eduardo L. Sarmiento, 1907. 11.7 × 17.4 cm.
Private collection, Granada

Cover by Ricardo Rendón for Francisco Jaramillo Medina, *El frío de la gloria*, Medellín. A. J. Cano, 1922. 21.8 × 14.3 cm.
Private collection, Granada

Cloth binding and cover by Rinaldo Scandroglio for Guillermo Valencia, *Catay: poemas orientales*, Bogotá. Cromos, 1929.
26 x 20.5 cm.
Archivo Lafuente

Cover by Alberto Arango Uribe for Fernando González, *Mi Simón Bolívar* (vol. 1): *Lucas Ochoa*, Manizales. Cervantes, 1930. 17.5 x 12.5 cm.
Archivo Lafuente

Cover by Alberto Arango Uribe for Roberto Pineda, *Panorama de cuatro vidas*, Medellín. Arturo Zapata, 1934. 17 x 12.7 cm.
Private collection, Granada

Cover by Alberto Arango Uribe for Bernardo Arias Trujillo, *Risaralda: película de negredumbre y de vaquería, filmada en dos rollos y en lengua castellana,* Manizales. Arturo Zapata, 1935. 17 × 12.7 cm.
Archivo Lafuente

Cover by Rinaldo Scandroglio for Luis María Murcia, *La guerra con el Perú,* Bogotá. Nueva-Casa Bookstore, 1932.
17.2 × 12.3 cm.
Private collection, Granada

Cover by Rómulo Rozo for Gregorio Hernández de Alba, *Cuentos de la conquista*, Bogotá. ABC, 1937. 21.5 x 17 cm. Private collection, Granada

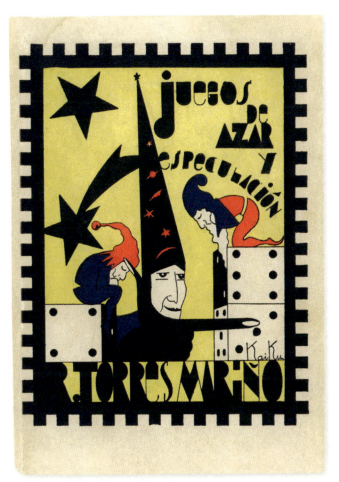

Cover by KaiKu for Rafael Torres Mariño, *Los juegos de azar y la especulación: sus probabilidades de ganancia*, Bogotá. Escuela Tipográfica Salesiana, 1933. 20 x 14 cm. Archivo Lafuente

Cover by Pepe Mexía for Federico Trujillo, *Cachos y dichos: edición completa*, Medellín. Félix de Bedout e Hijos, 1923. 19.4 x 12.6 cm.
Private collection, Granada

Cover by Estudio Nuti (Pepe Mexía) for Tomás Carrasquilla, *Dominicales*, Medellín. Atlántida, 1934. 17.8 x 12.6 cm.
Private collection, Granada

Cover by Estudio Nuti (Pepe Mexía) for Jaime Barrera Parra, *Panorama antioqueño*, Medellín. A. J. Cano Bookstore, 1936. 19.3 x 13.5 cm.
Private collection, Granada

Cover by Estudio Nuti (Pepe Mexía) for Tomás Carrasquilla, *Hace tiempos. Memorias de Eloy Gamboa* (tomo I): *Por aguas y pedrejones*, Medellín. Atlántida, 1935. 19.2 x 12.6 cm.
Private collection, Granada

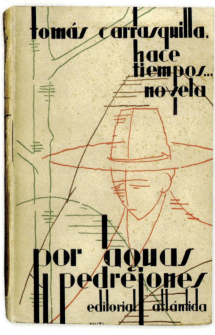

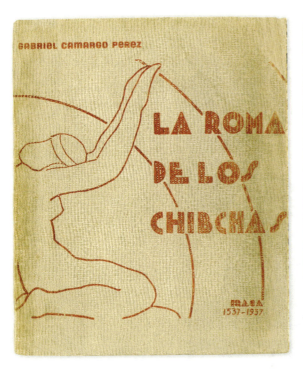

Cover and inner page by Carlos Reyes Gutiérrez for Gabriel Camargo Pérez, *La Roma de los chibchas*, Tunja. Imprenta Departamental de Boyacá, 1937. 20.4 x 16.8 cm. Private collection, Granada

Cover by Adolfo Samper for Adel López Gómez,
El fugitivo: cuentos,
Bogotá. Minerva, 1931.
19.3 x 12.7 cm.
Private collection, Granada

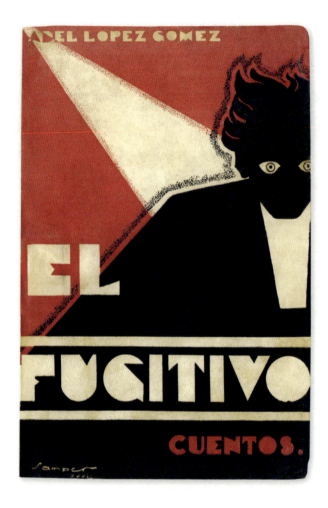

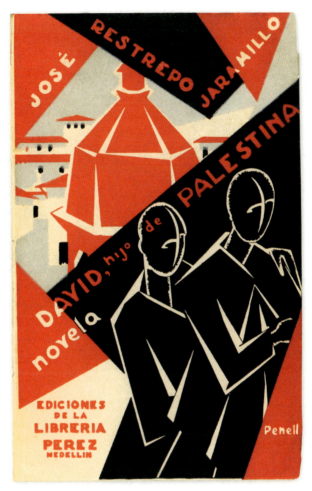

Cover by Penell for José Restrepo Jaramillo, *David, hijo de Palestina: novela*, Medellín. Imprenta Editorial y Librería Pérez, 1931. 20 x 12.8 cm. Archivo Lafuente

Cover by Sergio Trujillo Magnenat for Joaquín Quijano Mantilla, *Lo que mis ojos vieron*, Bogotá. Minerva, 1933. 17.8 x 12.6 cm. Private collection, Granada

Cover by Sergio Trujillo Magnenat for Pedro Alejo Rodríguez, *La mesa de Juan Díaz*, Bogotá. Cromos, 1938. 17.5 x 12.5 cm. Private collection, Granada

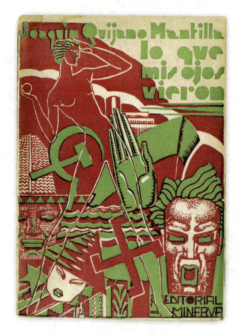
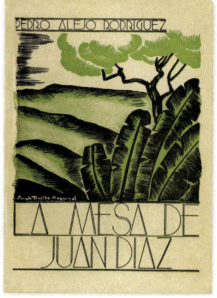

Cover by Sergio Trujillo Magnenat for Oswaldo Díaz Díaz, *El país de Lilac*, Bogotá. Ministerio de Educación Nacional, 1938. 34 x 25 cm.
Private collection, Granada

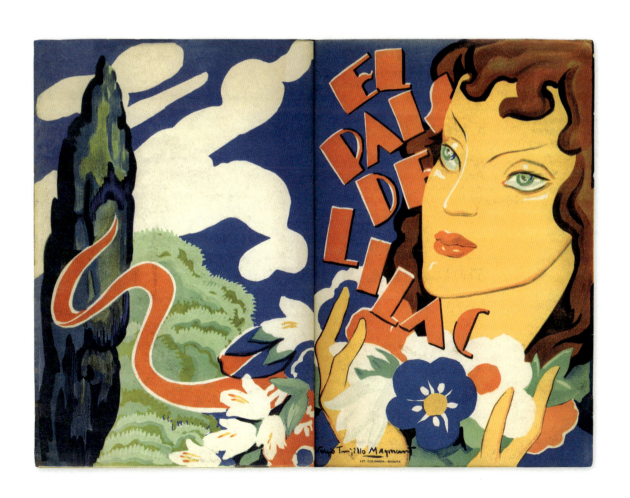

Cover and inner page by Sergio Trujillo Magnenat for Darío Samper, *Cuaderno del Trópico*, Bogotá. Ministerio de Educación Nacional, Publications Section, Supplement of *Revista de las Indias*, 1936. 19.2 x 17 cm. Private collection, Granada

Cover and inner page by Sergio Trujillo Magnenat for León de Greiff, *Prosas de Gaspar: primera suite. 1918-1925*, Bogotá. Ministerio de Educación Nacional, Publications Section, Supplement of *Revista de las Indias*, no. 4, 1936. 19.6 x 17 cm. Private collection, Granada

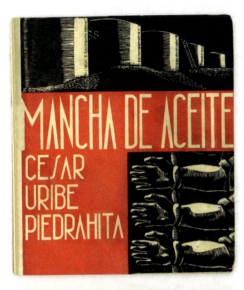
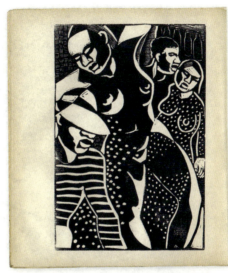

Cover and inner page by Gonzalo Ariza for César Uribe Piedrahita, *Mancha de aceite*, Bogotá. Renacimiento, 1935. 20 x 17.7 cm. Private collection, Granada

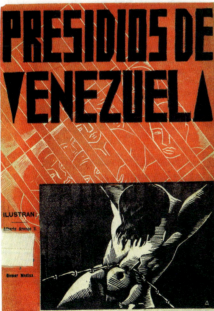
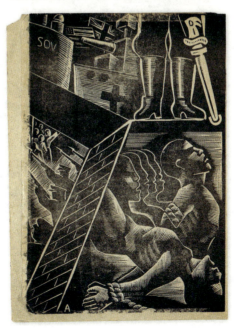

Cover and inner page by Gonzalo Ariza for several authors, *Presidios de Venezuela (memorias de secuestrados)*, Bogotá. Selecta, 1936. 24 x 17 cm. Luis Ángel Arango Library, Bogotá

Cover by Eduardo Abela
for *Arte Nuevo: primera exposición del XII Salón de Bellas Artes* [exh. cat.], n.p. [Havana?], n.p., May 1927.
26.5 x 19.3 cm.
Archivo Lafuente

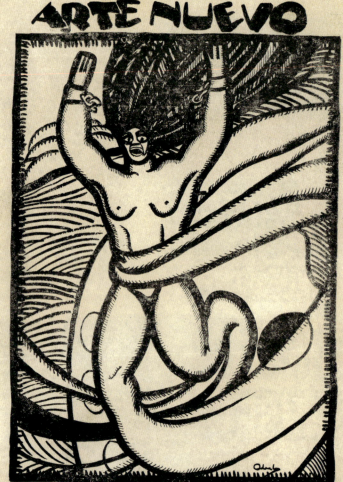

Cuba

Riccardo Boglione

Contrarily to Cuban design during the post-revolutionary years, which has been studied in great depth, particularly the field of poster design in which Cuban artists were renowned worldwide, systematic research into the birth of modern graphic art on the island—that, parallel to several Latin American countries, developed in the 1920s—is limited to a few well-grounded studies. These are the recent books *José Manuel Acosta y el arte moderno en Cuba* (2019), by Mireya Cabrera Galán, and *Arte cubano. La espiral ascendente* (2019), by Roberto Cobas Amate; the latter based on material taken from the exhibition titled *La mirada inédita: La gráfica y el dibujo en los años veinte y treinta* that Cobas himself curated in 2017 at the Museo Nacional de Bellas Artes in Cuba, and a few articles we shall be quoting throughout this chapter.

The earliest appearance in Cuba of the visual ruptures characterizing European art in the first decade and a half of the 20th century was absolutely short-lived. At the third National Fine Arts Salon held in 1918 in Havana, the American artist Curtis Moffat—who would later become a prestigious photographer and collaborated with Man Ray in Paris in the 1920s—presented several pictures, one of which was branded "Futurist" in *Social* magazine, even though he was usually defined as a Cubist painter. Although "we have no idea what these paintings by Moffatt were like" (Llanes, 2015) and there is therefore "total ignorance about the subject," it would be "the first visual proof of modern painting in Cuba" (idem).

As opposed to these vague early expressions, the foundational outline of the avant-garde on the island was clearly defined. Indeed, we could say that it was self-founded by artists through *Revista de Avance* magazine (in actual fact, this was the subtitle of the periodical publication; its ever-changing title was the year it was printed): "[A]fter this *1927* exhibition, we may speak of the existence and activism of a new avant-garde

art in Cuba" (*1927*, unknown author, 114-115). The reference was to the *Exposition of New Art* that several plastic artists in the orbit of the aforesaid review staged between the May 7 and 31, 1927 at the Association of Painters and Sculptors. According to the legend surrounding the group, "undoubtedly the most interesting collective exhibition of those held in Cuba, at once the first one to exclusively embrace avant-garde artistic expressions" (*1927*, op. cit., 114-115).

And yet, as has recently been highlighted in an essential article, "José Manuel Acosta en *Social*," and in the previously mentioned book by Mireya Cabrera Galán, it would appear that the first experiments with a post-Cubist language precede that seminal year of 1927 and can be discovered in several graphic works by José Manuel Acosta, a self-taught illustrator who had joined the Grupo Minorista along with other artists and men of letters. During that *annus mirabilis*, the group published "a manifesto that called for defending Cuba's economy against American imperialism and confronted false and old-fashioned values, setting itself up as the supporter of vernacular art and so-called new art" (Cabrera Galán, 2016, 46). Nonetheless, *Social*—an eclectic review that smoothly combined mundane articles and other superficial stories with notes on Soviet politics (López Hernández, 2021)—had already featured relevant new visual elements. Although "the years between 1923 and 1928 [was] the period during which Grupo Minorista flourished in Havana [and] the review was practically its organ" (Romero, "*Social* en su segunda etapa. 1823-1928"), the graphic renewal that was to transform the conservative position that had until then characterized Cuban publications, particularly in the field of lithography (Satué, 1998, 406) as a result of the intense activity of graphic designers linked to products in the tobacco industry, had taken root four years before and had already borne fruit. In its barely mentioned second phase, its boldest both in graphic and in literary terms, the magazine had Conrado Walter Massaguer as art director—who designed many of its covers—and Emilio Roig de Leuchsenring as literary director. It was also clearly influenced by the European isms, such as the work by the Russian artist Adia Madlein Yunkers, a painter and draftsman who had rubbed shoulders with Natalia Goncharova, Alexander Block and Marc Chagall during the Russian Revolution (Llanes, 2015). The pages of *Social* reproduced Acosta's para-Cubist compositions, revealing his exceptional talent for synthesis and a fundamental geometrization, that are among those "discontinuous images, fragmentary forms, and a certain expressive distortion [that] invade the publishing world [...], welcomed by the public as art, and disseminate the avant-garde repertoire to an extended audience" (Merino, 2008, 112).

Nevertheless, and we now come to our field of study, we must add that *Social* wasn't the only domain in which this artist managed to express his new ideas. In the 1923 cover of a book that Alberto Lamar Schweyer dedicated to Friedrich Nietzsche, *La palabra de Zarathustra*, the novelty of his solutions produced dazzling results: a portrait of the philosopher, traced from one of his most well-known photographs, shows a dynamic contrast of black and white in the center, from where different elements seem to issue in a Dionysian confusion, "illuminated" by rays that dynamically pierce the composition. In 1923 he illustrated *Hermanita*, the second book by his brother, the poet Agustín Acosta, the cover of which radically combines a range of heterogeneous elements taken from his previous work to create an almost total abstraction (we barely make out a pianist playing, drawn from above). José Manuel also made a contribution to his brother's third poetic endeavor, the key work *La zafra* (1926), a poetic landmark in the country's letters and a bold criticism, whose significance "consisted in its vision of the Cuban landscape in three dimensions: natural, human, and historical-social, in which the poet manages to present his island's bittersweet drama through art" (Capote, 1900, 110). Its cover, painstakingly designed and also exploiting the tension between black and white, showed a female worker almost "devoured" by the intricate mechanical processing of sugar cane, the same cogs that inside the poetic compilation are transformed, like vignettes, into vigorous Cubist motifs without betraying the book's social subject matter: "[I]n the pages and sketches of *La Zafra* we discover a quasi-historical repertoire of what the title has meant in the development of the nation" (Cabrera Galán, 2019, 68).

The full-color cover created for Fernando Ortiz's book *Glosario de afronegrismos* (1924) was also extremely modern and was the first avant-garde design conceived to illustrate the

Cover by Morrón for *Bohemia*, year XIX, vol. 19, no. 48, 27 November 1927. Havana. n.p. 30.1 x 22.6 cm. Boglione Torello Collection

Cover by José Cecilio Hernández Cárdenas for *Bohemia*, year XX, vol. 20, no. 32, 5 August 1928. Havana, n.p. 30 x 21.6 cm. Private collection, Granada

Revista de Avance, April 1927 to June 1930. Editors: Francisco Ichaso, Félix Lizaso, Jorge Mañach and Juan Marinello. Year I, nos. 3, 5, 8 and 17; year II, nos. 32, 35, 36 and 38; year IV, no. 47. Havana. Otero / Hermes.
26.5 x 20 cm.
Archivo Lafuente

Afro-Cuban issue of capital importance for the country's identity. In his peculiarly caricatural style, Acosta divides a face into micro-planes that are cut out against a bright green ground in which they seem to float, while totems and other graceful ornaments pile up in the lower area of the drawing, in a style that seems to herald Pop Art. After a sojourn in the United States, in the 1930s Acosta gave up illustration to devote himself to artistic photography, mostly experimental in nature, an aspect of his work that is now belatedly being recognized.

Another artist who displayed work in the famous 1927 show was the Venezuelan Luis López Méndez, who conceived the book *Estampas de San Cristóbal* (1926), by Jorge Mañach, an absolutely central figure in the country's cultural renovation. This book, characterized by a restrained, classical architecture that revealed a syncretism of the seascape in the cover's central vignette, also included "sketchy" illustrations by Rafael Blanco. The same compositional scheme of the book is found in many other Cuban publications; its structure, balanced and austere despite the dynamic drawings and modern typefaces (stenciled, as in the title of *Revista de Avance*, and different dry-stick fonts), envisages titles, names of authors and publishers in the upper and lower areas of the cover, and a central vignette, variable in size. Thus, *Tiempo muerto* (1928), by Mañach himself, features a woodcut showing interaction between a factory and the countryside that could perhaps be attributed to the Spanish painter Gabriel García Maroto, then living in Mexico; *Pulso y onda* (1932), by Manuel Navarro Luna, has a totally Art Deco drawing of an archer by an unknown artist; and *¡Ecue-Yamba-Ó!* (1933), the first book by Alejo Carpentier, a striking combination of Futurism and indigenism, disavowed by its author at the height of his career, which was published in Madrid with a cover designed by Federico Tomás Franco and Marcelo Pogolotti (a painter who had

also displayed his work in the fundamental 1927 exhibition).

The collection of books published by *Revista de Avance* followed a similar pattern. The various volumes launched between 1928 and 1930 had the same format, as we see in the "Futurist" *Kodak-sensueño* (1929), by Regino Boti, and *El renuevo y otros cuentos* (1929), by Carlos Montenegro, that included an illustration by Víctor Manuel, whereas *Torre de Babel* (1930), by the great Guatemalan experimental author Luis Cardoza y Aragón already reflected the new graphic style displayed by the review from its very first issue in 1930 (Manzoni, 2001, 75). This book is outstanding for its wonderful interior illustrations by the Mexican artist Agustín Lazo who, besides creating the "linear portrait" of the author (Bonet, 2010, 35), displayed his talent in other delicate, slender compositions of a Surrealist air, marked by simplicity and rhythm.

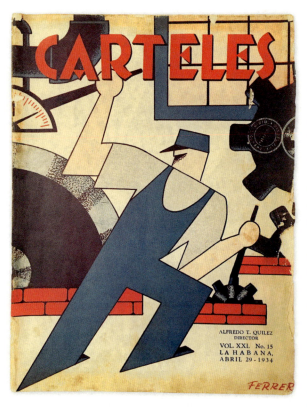

Cover by Gilberto Ferrer for *Carteles*, vol. XXI, no. 15, 29 April 1934. Director: Alfredo T. Quílez. Havana. Oscar H. Massaguer. 32.3 × 25 cm. Boglione Torello Collection Photo: Silvia Badalotti

Pérez Morales also seemed to adopt a plain, almost cartoonish style, both in his work for *Poemas de amor y frivolidad* (1927), by Pedro López Dorticós, characterized by a combination of old and modern—a lyre, the visualization of music, a certain overall energy attained through the use of inclined planes—and in "the most avant-garde book of Cuban poetry" (Fernández Retamar, 1977, 200), *Surco* (1928), by Navarro Luna, in which a vaguely "mythological" character splits the ground in two with his sword, "resting" its tip on the middle letter of the book's title in an interesting interaction between word and drawing.

Another slash, governed by a certain preference for the diagonal line—that, as regards lettering, was not foreign to the pre-Modernist esthetic although it would be recovered and intensified by its opposition to the rule of the orthogonal—connects a variety of actually very different examples. Pablo de La Torriente-Brau, a Cuban writer and journalist who passed away during the Spanish Civil War, illustrated the cover of his own work *Batey. Cuentos cubanos* (1930, co-authored by Gonzalo Mazas), by dividing the compositional space into two parts, one of them red and the other white, confining a graceful drawing of factories to an area on the left, while impressive letters dominate the ensemble. Years later, Manuel Roldán Capaz, a member of the Society of Modern Artists who in 1937 had executed the first official mural art project on the island, inspired by both European Modernism and Mexican Muralism (Barretto Sedano, 2010, 22), Roldán Zapaz applied a similar procedure when cutting the drawing of a cactus in inverted colors in his illustration of the book *En los puestos constructivos de la revolución* (1934), by Salvadorean author Gilberto González y Contreras, who was also a journalist. Last but not least, an anonymous artist made a huge red number cut through the word "versos" (verses) in the book by Ángel L. Augier, obliquely piercing the cover of *1. Versos* (1931).

We shall now speak of two other covers in which, like the latter, letters take center stage, highlighted by strong lines on the curve in the design that Nieves conceived for *Vendimia de huracanes* (1939), by Isa Carballo, and on straight lines and angles with a subtle para-Constructivist design using the colors black and red and extraordinary typefaces for the key book *Sóngoro Cosongo* (1931), of which Nicolás Guillén printed three-hundred copies that he didn't even put on the market but gave away to his friends. The following year this cover seems to have inspired that of *Velocidade*, by Renato Almeida. Letters were also the most important feature in the anonymous cover designed for *Bongó* (1934), by Ramón Guirao (whose alternation of red and black evokes the sketch of the Spanish edition of *Realismo mágico* (1927), by Franz Roh, and in the tentative cover that Roberto Vázquez composed for *Casi una mujer* (1933), by José Sánchez-Arcilla, although what is truly remarkable about this book is the caricature of the author by the painter and draftswoman María Luisa Ríos, structured by circles and brilliantly synthetic.

In an interview in the seventies, Juan Marinello, one of the innovators of Cuban literature, declared: "[T]he scope of its confessed concerns and the circumstances of combining old and new make our avant-gardism less representative of the latest trends than its appearance would suggest. If we measure its importance according to its correspondences with European isms, its results are slighter than those of its contemporaries on the Continent. On the other hand, if we consider its aspirations to renovate ideas and perspectives, and as a service to numerous objectives, it is more significant, even though it should not be excused for its many shortfalls" (Marinello, 1977, 217).

Although we don't agree with all Marinello's reservations regarding the merits of the new developments in Cuban art, it cannot be denied that one of those "objectives" was the defense of blackness and the research into the African roots and traditions of the Cuban population that characterized groundbreaking movements in the Caribbean. In Cuba, "Afro-Cuban themes, often confined in previous painting to picturesque scenes or sketches dedicated to superficial folklore, was now interpreted by the first avant-garde artists recreating music and dance scenes, exploring the ethnic features of blacks, and representing critical concerns such as unemployment and racial discrimination" (Cobas, 2019, 190).

No doubt, like in the simultaneous defense of *blackness* as an inevitable component of Paulist Modernism in Brazil, the influences arriving from Paris, city fascinated with jazz bands and the dances of Josephine Baker, helped nurture national pride and the sense of belonging. Like Brazilians, Cubans had no need to travel to draw inspiration from African culture—they found it on the island.

In visual terms, besides the aforementioned *Glosario de afronegrismo*, *Sóngoro Cosongo* and *¡Ecue-Yamba-Ó!*, we must discuss the colossal *Cuaderno de poesía negra*, published by Emilio Ballagas in 1934: its twelve poems are accompanied by six woodcuts, three (and the cover) by Domingo Ravenet and three by Ernesto González Puig. The two engravers favored images lacking in depth which could almost be seen as emblems, providing them with Surrealist "biological" features—particularly in the case of Puig, then barely twenty-one years of age—and masterfully creating a dynamic relationship of contrasts. Ravenet's compositions reveal clear traces of the designs included by Gabriel García Maroto in his wonderful portfolio titled *Cuba: 20 grabados en madera*. Published in 1931 it had, however, been conceived in 1930 upon his return to the country to carry out pedagogical tasks in Caimito de Guayabal, similar to those performed at the Plein Air painting schools in Mexico and those he himself would subsequently implement

in Michoacán, as depicted in *6 meses de acción artística popular* (see pp. 488-489).

After the pioneering works by Acosta, the designs by José Cecilio Hernández Cárdenas were another landmark in Cuban graphic art. Hernández Cárdenas, renowned as a political humorist, set out as a caricaturist in *El País* newspaper in 1923, signing as Juvenal until 1925, when he chose the pen-name Her-Car. Of African descent himself, in 1931 he displayed some of his drawings devoted "to 'black subject matter,' a definition that the critics of the time applied to his works on the customs of the black and mestizo population" (Unknown author, "José Cecilio Hernández Cárdenas") in Havana. Characterized by his leftist convictions and political dissension that led to his incarceration during the dictatorship of Gerardo Machado (Blanco Ávila, 2010), it comes as no surprise that one of his first cover illustrations were that of *Nosotros* (1933), by Regino Pedroso, "proletarian" poetry effectively introduced by this drawing, that includes the motif of the laborer and the wheel we find in other designs of the moment (in one of the issues of *Carteles* of 1934, signed by Gilberto Ferrer, for example). Her-Car reinforces and adds visual weight to these motifs, and his colors are dominated by powerful black lines. The same strength characterizes the huge letters of the novel *Tam Tam* (1941) by Federico Ibarzábal, that seem to embody the sound from a small musician playing a drum who appears just above the name of the city of publication. Quite the opposite is the lightness of the letters and of the vignette showing a character working with sugar cane at a mill we see in *West Indies Ltd.*, a book of poems published by Nicolás Guillen in 1934, and in the similar "childish" cover, elaborately simple, of *Niña y el viento de mañana* (1937), by Emma Pérez. For the second "gaseous" novel by Enrique Labrador Ruiz, *Cresival* (1936), Her-Car created a cover that confirmed his huge talent as a caricaturist, while among his interesting woodcuts for interior pages is a print that depicts a cinema screen, a rare witness of the attempt to capture cinematographic light in the visual arts of the period (that reminds us of another design by Adolfo Bellocq in *Historia de arrabal*, by Manuel Gálvez) (see p. 112).

A very young Mario Carreño, who was to enjoy a long career in Cuban painting, produced two notable covers. Having sojourned in the great art centers of the time, first in Paris and then in New York, with intermittent periods spent in Spain and Mexico, and a significant finale in Chile, Carreño produced graphic works that also combined "the primitive and the modern, created with the skill of a classical painter," as described by Manuel Altolaguirre (1989, 216). In the book titled *Cartas de la ciénaga* (1930), that Navarro Luna published under the pen-name Mongo Paneque, Carreño (who presented himself here simply as K) elaborated an exquisite "childish" composition made up of figures that resemble cut-outs, a highly accomplished work that eliminated absolutely all traces of mimesis. After two silhouetted vignettes that bring together motifs of modernity and of the political avant-garde (including a suicidal Mayakovsky) decorating two pages in *Barraca de feria* (1933), by José Antonio Fernández de Castro, Carreño produced his best work—the enigmatic drawing of a female statue silhouetted against a background showing the Eiffel Tower, in a delirious ensemble of surreal metaphysical motifs not devoid of references to Picasso, that would resurface at other moments in his career, even in works painted four decades later. We are thinking of the cover for the strange book *En el país de las mujeres sin senos* (1938), by Octavio de la Suarée (homophonous pen-name of Octavio Suárez). The work of Guatemalan artist Jorge Rigol is represented here by a single though exceptional cover. An outstanding Cuban illustrator and print maker, Rigol worked alternately on avant-garde and social themes (Cobas, 2019, 190), and in the

late 1930s joined the Mexican Popular Graphic Workshop set up by Leopoldo Méndez. This influence is clear in his cover for *Bufa subversiva* (1935), a key work by the Communist dissident Raúl Roa in which a complex play of post-Cubist intersections framed by forceful letters forms what appears to be an innocent still life (with alcohol) that also features a character shouting inside a prison cell (with a barred window).

The last important artist surveyed in Enrique Riverón, a painter and illustrator who lived and worked in Buenos Aires, New York, Mexico City and Paris, regularly returning to his native Cuba, and whose work can be traced in countless publications; a chronicler of the period described Riverón as "a case of mobile restlessness" (Roselló, 1934, 28). His cover for the book *Poesía americana* (1941), by Vidal Álvarez Everoix, published in Mexico City, is characterized by a geometrically structured though dreamlike Art Deco composition.

Four further covers, two of them by unknown artists and the other two "illustrious" designers, were also inspired by a modern imaginary. The cover conceived by Enrique Caravia for *La odisea del cuatrovientos* (1933), by Ricardo Villares and Francisco C. Bedriñana, depicts an airplane set against an abstract backdrop of colored stripes. An ocean liner seen from a low angle features in both the front and back covers of *Dos barcos* (1934), by Carlos Montenegro, wisely designed by Hernández Cárdenas, and in the anonymous cover of *Derelictos y otros cuentos* (1937), by Federico de Ibarzábal. Finally, the discreet sketch of a building that is at once a geometric abstraction illustrates the cover *Municipalerías* (1938), by José Luciano Franco. Almost as a counterpoint to this repertoire of representative objects of modern times, seemingly neutral, a fair number of politically engaged works boasted exceptional graphics and a wide range of styles. Synthetically and impressively structured in the manner of the best posters we may mention

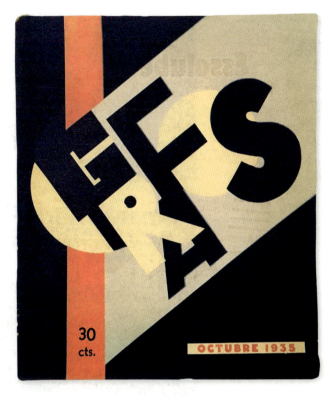

Cover by unknown artist for *Grafos*, year 3, vol. III, no. 31, October 1935. Directors: María Radelat de Fontanils, María Dolores Machín de Upmann. Art director: J. L. Horstmann. Havana, Úcar, García y Cía. 32.1 x 27.7 cm. Boglione Torello Collection
Photo: Silvia Badalotti

Cover and inner pages by Gabriel García Maroto (author) for *Cuba: 20 grabados en madera*, n.p, n.p., 1931. 29 × 23 cm. Librería L'Argine, Madrid. Photo: Andrés Vargas Llanos

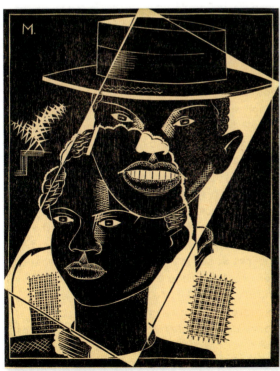

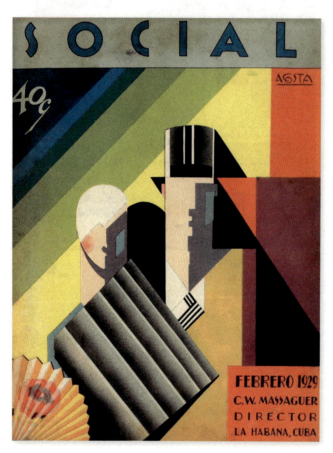

Cover by José Manuel Acosta for *Social*, vol. XIV, no. 2, February 1929. Director: Conrado W. Massaguer. Havana, Conrado W. Massaguer. 31 x 24 cm.
Private collection

Liberación. Poemas revolucionarios (1934), by Leopoldo Carballeyra, where a threatening hammer is created in barely a few lines, a large black rectangle occupies the center of the composition, and block letters feature across its width. An equally powerful style though more composed characterizes a caricatural drawing of two soldiers seen from the back, quite evocative of the monumental figures conceived by the Argentine artist Demetrio Urruchúa around the same time for several books published by Imán in Buenos Aires, such as the emblematic design for *Tumulto* (1935), by José Portogalo (see p. 155), and a group of stencil-like letters presided over by a huge number 3 (so large that it occupies half of the illustration) for the cover of *3 meses con las fuerzas de choque (División Campesino)*, by aforementioned Montenegro. Published in 1938, the book chronicles the combats of the Spanish Civil War, where the Cuban author had fought on the Republican side. The artist from Cienfuegos Juan David Posada, who usually signed his works "David" and was possibly the most famous caricaturist on the island, whose works would appear for decades in the most prestigious Cuban newspapers, chose an eerie horizon to decorate both the front and the back cover. The flat and simply sophisticated cover for *La tragedia de Cuba* (1934), by Fernando G. Campoamor, drawn by the author himself, also has a political character, depicting a workman trying to knock down the chimneys of a factory. This design is remarkable for its fine play between the sharp angles of all its elements, including letters, and the sinuosity of the red smoke almost complete covering the sky.

The complex relationship between letters and inks we see in the cover for *Instantáneas del exilio*, by José Diego Grullón, published in 1937, and in others launched the same year, is quite extraordinary. It is exemplified by the stylized portrait of Martí de Carlos Enríquez that adorns the cover of *La juventud entusiasta* de Martí, by Gilberto González y Contreras; the anonymous

drawings in that of *La unión por Cuba por la democracia y el mejoramiento popular*, where the circular shape of a sun on the horizon contains the book's title and "illuminates" the characters passionately filling the space of the cover; and the delicate play of ethereal lines, little stars, and the use of black and white that Andrés García Benítez (artist who that very years would take part in the First Modern Art Salon staged in Havana) created for *Mar cautiva*, by Serafina Núñez.

In spite of the fact that the three most popular magazines of the 1920s and 1930s—*Social*, *Bohemia* and *Carteles*—were inspired, in graphic terms, by American publications such as *The New Yorker*, *Fortune*, and *Vanity Fair*, and were characterized by a local and on occasion accomplished version of Art Deco, this trend is not to be found in book illustrations of the same period. The lettering showed no Constructivist elements, although these did appear in the cover and logo of *Grafos* review, launched in Havana in 1933. What we do discover in book illustration, on the other hand, is a timid trace of Surrealism. Mexican art critic Jorge Juan Crespo de la Serna made a rare foray into the genre. Having trained as a painter at the Fine Arts Academy in Vienna in the early 20th century, up until the year 1938, at least, he devoted himself to painting, an activity he combined with his critical writing (Moyssén, 1979, 161). Around the middle of the decade, Crespo created a somewhat clumsy though disturbing image for *Caniquí* (1936), by José Antonio Ramos, a novel that recreated life in Trinidad during the colonial age. The huge face, far from realistic and partially covered by a tormented body flogging itself, is a super-real and nightmarish design that verges on Expressionism. A similar somber and dreamlike atmosphere suggested by means of a powerful chiaroscuro characterizes the cover that Carlos Sánchez, "Carlos," made for *Dolientes* (1931), by Ofelia Rodríguez Acosta.

In the cover of *Anteo* (1940), another "gaseous" novel by Labrador Ruiz, Juan David Posada—David—created a fantastic drawing with delicate lines and disquieting features that evoke certain works by André Masson. Our survey draws to a close with two seminal books for French Surrealism and the *négritude* movement, or black culture, and landmarks in pre-revolutionary Cuban design. The poem *Fata Morgana* (1942), by André Breton, published by Roger Caillois in Buenos Aires in the Éditions Lettres Francaises collection he supervised for Victoria Ocampo's publishing house Sur, contained six drawings by the famous Cuban painter Wifredo Lam. Breton had commissioned the illustrations from Lam in Marseilles, where he had composed the poem in 1940 and where the other two had sought refuge, in the company of other intellectuals, following the Nazi invasion of France. Lam, who had spent a few years working as an artist in Europe backed by Picasso, was a felicitous choice for the Surrealist leader, fascinated as he was by the Cuban artist's "surprising" origins (Lam's mother was of African descent and his father was Chinese). Breton was also captivated by Lam's imagination, that knew no bounds and had managed to assimilate key elements of Surrealism, enhancing them with the Cuban taste for the Baroque, as pointed out by Leopoldo Castedo (1988, 168). His drawings for the book, the result of an "absorbing Super-realism," depicted the metamorphosis of hybrid beings, similar to those featured in the three illustrations of another capital book, *Retorno al país natal*, by Aimé Césaire. Lam had met the author in Martinique, and had invited the anthropologist and woman of letters Lydia Cabrera to translate the book into Spanish; it was printed in Havana in 1943. There can be no doubt that the drawings Lam made for the two poetic compilations marked the zenith of his career, and, *tout court*, of Cuban book illustration as a whole.

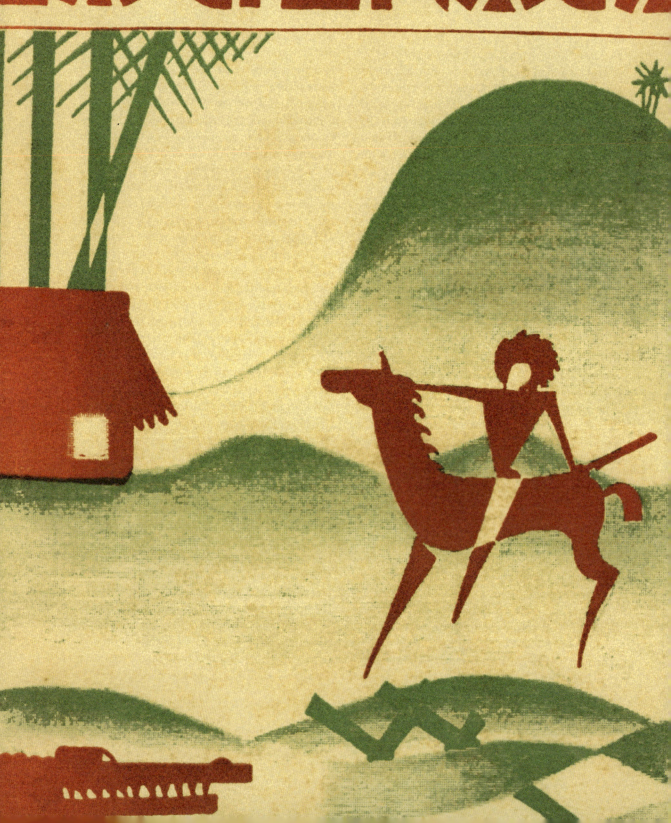

Cuba

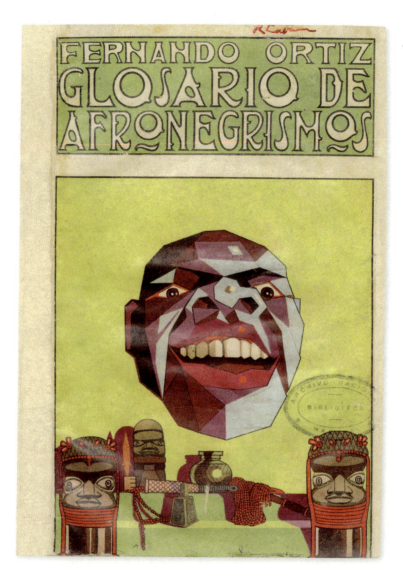

Cover by José Manuel Acosta for Fernando Ortiz, *Glosario de Afronegrismos,* Havana. El Siglo XX, 1924. 22.6 x 16 cm. Archivo Lafuente

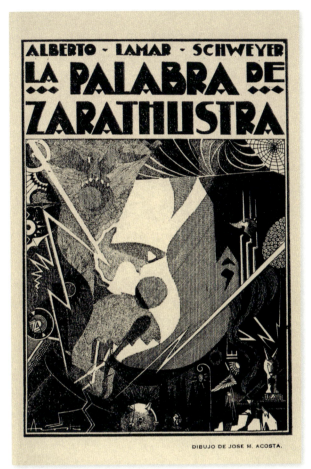

Cover by José Manuel Acosta for Alberto Lamar Schweyer, *La palabra de Zarathustra: Federico Nietzsche y su influencia en el espíritu latino*, Havana. El Fígaro, 1923. 19.4 x 12.5 cm. Spanish Agency for International Development Cooperation Library, Madrid

Cover by José Manuel Acosta for Agustín Acosta, *Hermanita: poemas*, Havana. El Siglo XX, 1923. 19 × 14 cm. Archivo Lafuente

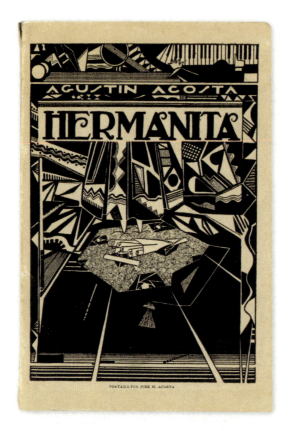

→»
Cover and inner pages by José Manuel Acosta for Agustín Acosta, *La zafra: poema de combate*, Havana. Minerva, 1926. 18 × 13 cm. Private collection, Granada

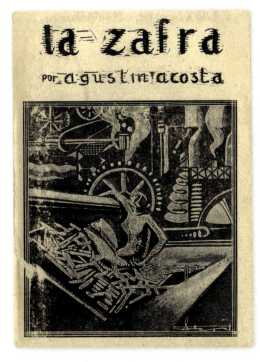

CANTO IX

TOQUE DE CLARIN

Embriaguez de fortuna: yo te haría una oda.
Embriaguez de nobleza: pides el epigrama...
La prestancia española se exhibía a caballo...
El blasón heredado paseaba en volanta...

CANTO X

LOS SENDEROS PERDIDOS

Oh los dulces ayeres
en que un gozo profundo
concentraba placeres
en la entraña del mundo...!

CANTO XII

LA MOLIENDA

Es el ingenio. Se perfila
como un palacio entre la bruma.
En torno suyo las carretas
cargadas de caña se agrupan,
y el almacén, lleno de sacos,
exhala un dulce olor de azúcar...

Cover by Fernando G. Campoamor (author) for *La tragedia de Cuba: estudio social en "Marcos Antilla"*, Havana. Hermes, 1934. 18 x 13.5 cm. Archivo Lafuente

Cover by Pérez Morales for Manuel Navarro Luna, *Surco*, Manzanillo. El Arte, 1928. 20 x 14 cm. Archivo Lafuente

Cover by Andrés García Benítez for Serafina Núñez, *Mar cautiva: poemas*, Havana. Author's self-edition, 1937. Private collection, Granada

Cover by Pérez Morales for Pedro López Dorticós, *Poemas de amor y de frivolidad*, Havana. El Siglo XX, 1927. 21 x 14.5 cm. The University Library, University of Illinois at Urbana-Champaign

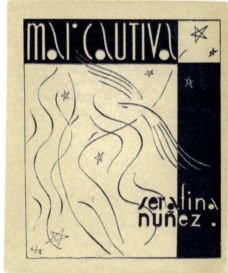
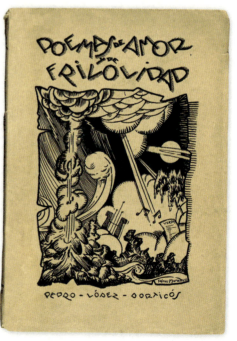

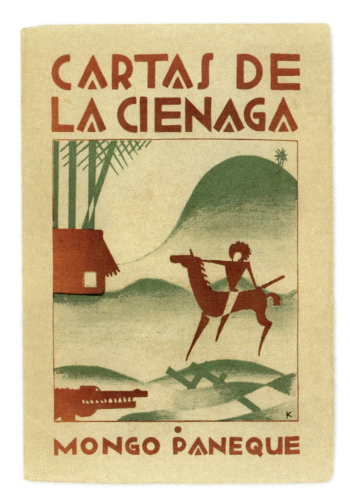

Cover by Mario Carreño for Mongo Paneque (pen-name of Manuel Navarro Luna), *Cartas de la Ciénaga*, Havana. Hermes, 1930. 20.5 x 14.5 cm. Archivo Lafuente

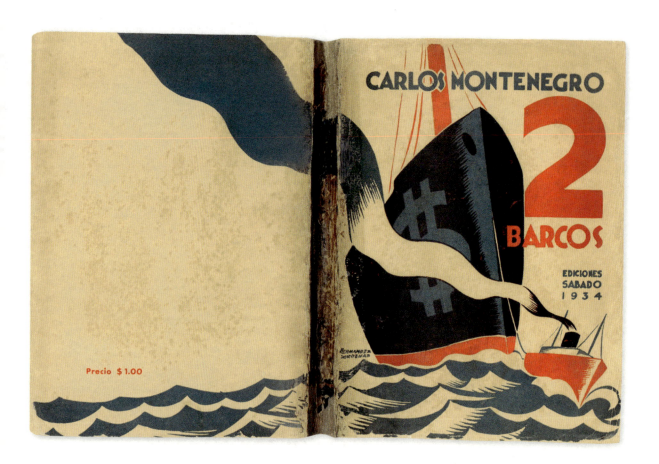

Covers by José Cecilio Hernández Cárdenas for Carlos Montenegro, *Dos barcos (cuentos)*, Havana. Sábado, 1934. 22 x 16 cm. Archivo Lafuente

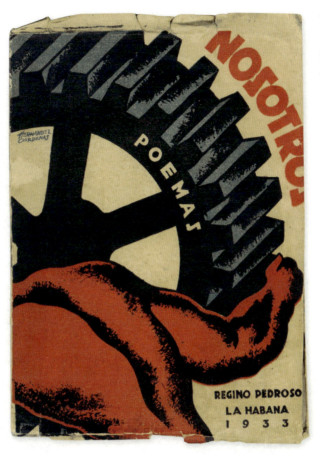

Cover by José Cecilio Hernández Cárdenas for Regino Pedroso, *Nosotros: poemas*, Havana. Trópico, 1933. 23.5 x 16.5 cm. Archivo Lafuente

Cover by Domingo Ravenet and inner pages by Domingo Ravenet and Ernesto González Puig for Emilio Ballagas, *Cuaderno de poesía negra*, Havana / Santa Clara. La Nueva, 1934. 20.7 x 16.5 cm.
Archivo Lafuente

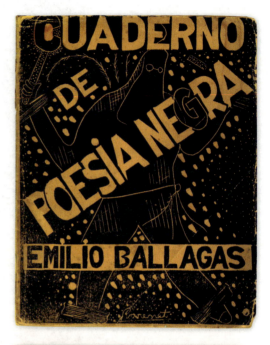
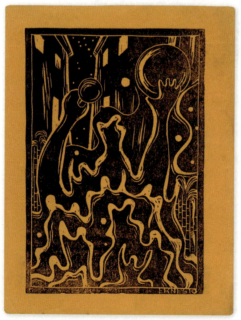
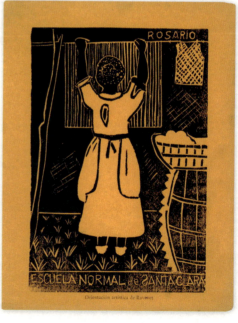

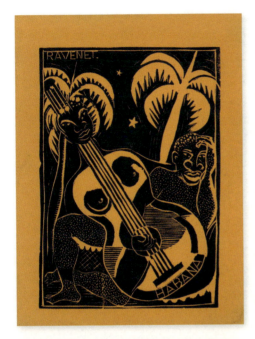
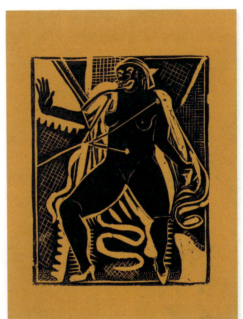
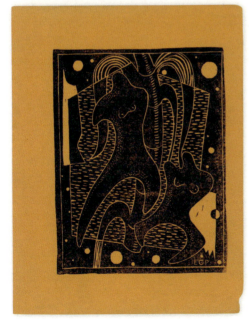
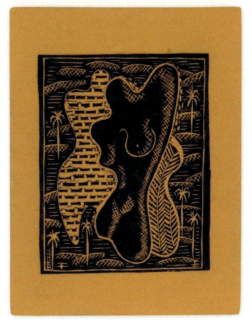

Cover by Jorge Rigol for Raúl Roa, *Bufa subversiva*, Havana. Cultural, 1935.
24.5 x 16 cm.
Private collection, Granada

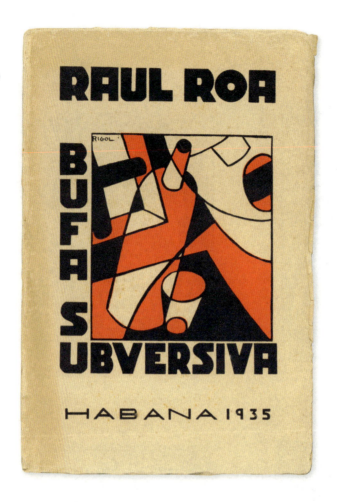

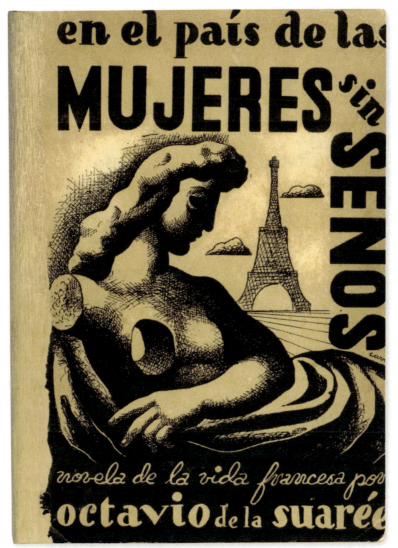

Cover by Mario Carreño for Octavio de la Suarée (pen-name of Octavio Suárez), *En el país de las mujeres sin senos: novela de la vida francesa,* Havana. Lectura (M. Pedrol y Hermanos), 1938. 19.2 x 13.5 cm. Archivo Lafuente

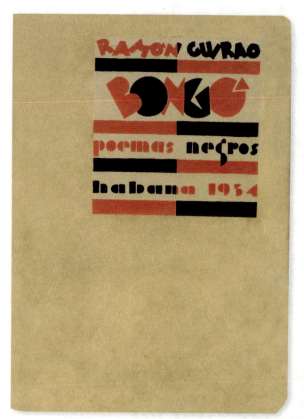
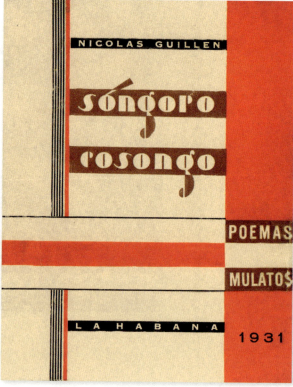

Cover by unknown artist for Ramón Guirao, *Bongó: poemas negros*, Havana. Talleres de Úcar, García y Cía., 1931. 20 x 15 cm.
Juan Bonilla Collection, Seville

Cover by unknown artist for Nicolás Guillén, *Sóngoro Cosongo: poemas mulatos*, Havana. Talleres dec Úcar, García y Compañía, 1931. 20 x 15 cm.
Juan Bonilla Collection, Seville

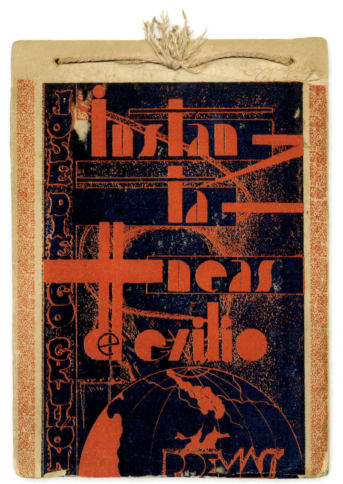

Cover by unknown artist [Serrano?] for José Diego Grullón, *Instantáneas del exilio: poemas*, Santiago de Cuba, n.p., 1937.
5.5 x 21 cm.
Private collection, Granada

Inner pages by Wifredo Lam for André Breton, *Fata Morgana*, Buenos Aires. Sur / Éditions des Lettres Françaises, 1942. 26.8 x 18.3 cm. Private collection, Granada

Cover and inner pages by Wifredo Lam for Aimé Césaire, *Retorno al país natal*, Havana. Molina & Cía., n.d. [1943?]. 23.7 x 18.6 cm. Archivo Lafuente

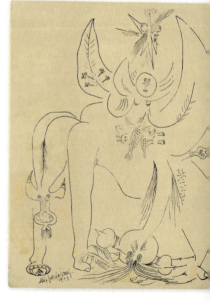

CUBA 397

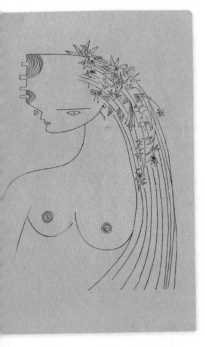
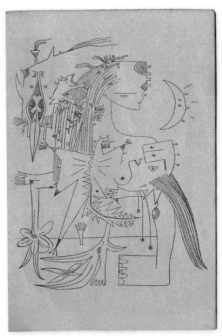
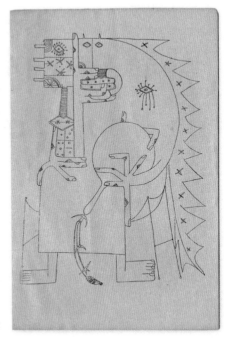

RETORNO AL PAIS NATAL

★

Al morir el alba, de frágiles ensenadas retoñando, las Antillas hambrientas, las Antillas picadas de viruelas, las Antillas dinamitadas de alcohol, varadas en el fango de esta bahía, siniestramente fracasadas en el polvo de esta ciudad.

Al morir el alba, la extrema, engañadora, desolada pústula sobre la herida del agua; los mártires que no testimonian; las flores de sangre que se marchitan deshojándose en el viento inútil como gritos de loros parlanchines; una vieja vida sonriendo mentirosa, sus labios abiertos por desamorada angustia; una vieja miseria pudriéndose silenciosamente bajo el sol; un viejo silencio reventado de postillas tibias.

la aterradora inanidad de nuestra razón de ser.

Al morir el alba, sobre este más que frágil espesor de tierra que sobrepasa de manera humillante su porvenir grandioso—estallarán los volcanes, el agua desnuda arrastrará las manchas maduras del sol y no quedará más que un tibio hervor picoteado por los pájaros marinos—la playa de los sueños y el despertar insensato.

Al morir el alba, esta ciudad chata—expuesta, su buen juicio titubeante, inerte, asfixiándose bajo el fardo geométrico de su cruz recomenzando eternamente, indócil a su suerte, muda, de todos modos contrariada, incapaz de crecer nutrida por la savia de esta tierra, impedida, roída, reducida, en ruptura de fauna y de flora.

Y átame, átame sin remordimientos
átame con tus grandes brazos de arcilla luminosa
liga mi negra vibración al ombligo del mundo
Lígame áspera fraternidad
Y luego estrangulándome con tu lazo de estrellas
sube, Paloma
sube
sube
sube
Te sigo impresa en mi ancestral córnea blanca
Sube lamedor de cielo
Y en la gran cavidad negra donde quise ahogarme
La otra luna, allí quiero pescar ahora
la lengua maléfica de la noche en su cristalización inmóvil!

★

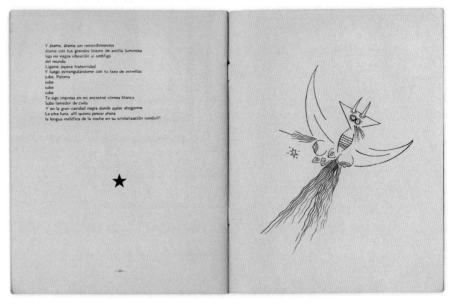

Cover by Leonardo Tejada Zambrano for *Trópico: revista mensual de arte, literatura e historia, órgano del Museo Único y del Archivo Nacional de Historia*, year I, no. 2, May–July 1938. Editorial board: Demetrio Aguilera Malta et al. Quito, Trópico. 43.7 × 31.8 cm. Archivo Lafuente

Ecuador

Rodrigo Gutiérrez Viñuales

The first thing we discover in our research and compilation of references on illustrated books in Ecuador during the period we are surveying is the scarce volume of significant publications in the 1920s and, in contrast, the very great number of such works published the following decade.

From a historiographical point of view, substantial progress has been made as regards the location, classification and study of illustrated magazines, a field in which we must mention the artistic output of María Elena Bedoya, Ángel Emilio Hidalgo and, more recently, Marilú Vaca. To these names we should add those of Humbert Robles, Yesenia Villacrés, María Ángeles Vázquez, and Óscar Javier González Molina, in the literary sphere, and Gustavo Salazar Calle, who produced a few designs for book covers. Besides illustrating texts of her own that we shall be studying, María Elena Bedoya displayed books and magazines that included her designs at several exhibitions such as *Umbrales del arte en el Ecuador* (Guayaquil, 2005), now considered a landmark, or more recently, *desMarcados: Indigenismos, arte y política* (Quito, 2017). We ourselves included this material in the exhibition and catalog *Alma mía. Simbolismo y modernidad. Ecuador, 1900-1930* (Quito, 2013), coordinated with Alexandra Kennedy Troya, which presented the first global view of Symbolism and Art Nouveau in Latin American art.

The chroniclers of contemporary Ecuadorian art have often stressed the role played by two foreign figures in laying the foundations of modernity: the Catalan artist José María Roura Oxandaberro, who had arrived in Guayaquil in 1910 and a few years later moved to the country's capital, and the French artist Paul Bar, who founded the Chair of Applied Art and Ornamentation at the Fine Arts School in Quito. Both cities and, to a lesser degree, Cuenca, marked the beat of modern art. In the specific field of graphic art, the way was paved by caricature. Indeed, as had occurred in other

countries, caricature in Ecuador anticipated avant-garde trends, and these leaps forward were provoked by draftsmen and caricaturists inspired by Roura Oxandaberro and Bar.

One of the decisive factors in the consolidation of modernity was the mutual collaboration between plastic artists and writers in cafés and publishing spheres. This was pointed out by José Alfredo Llerena as early as 1942, in his essay *La pintura ecuatoriana del siglo xx* (Llerena and Chaves, 1942, 11). Magazines like *Caricatura* (Quito, 1918-1924), for instance, resulted from these encounters and showcased the work of artists of the stature of Antonio Bellolio, Guillermo Latorre, Nicolás Delgado, Camilo Egas, Víctor Mideros, Enrique Terán or Carlos Andrade Moscoso (Kanela), who, years later, would create the covers of key books in our field. Their work as caricaturists initially revealed the influence of artists such as the Spaniard Luis Bagaría, whose impact can be traced in most Latin American practitioners of the genre, and extended well into the 1920s, in some cases even later.

Our survey begins in 1920 with the publication of *La flauta de ónix*, by the poet Arturo Borja, a forerunner of Ecuadorian Modernism and a member of the so-called Beheaded Generation who had committed suicide in 1912 at the age of twenty. Three of the leading figures in our narrative joined forces in this book—artists Nicolás Delgado (who designed the cover), Kanela, and Antonio Bellolio. Besides promoting the edition, they contributed a number of Symbolist illustrations to it, in keeping with the poems and with the period. Soon afterward, Roura Oxandaberro designed illustrations and *ninots* (cartoons) for *Del país de los sabios* (1921), a book of children's stories published by Ramón Junoy in San José de Costa Rica, Quito, and Kanela conceived the cover for *Poemas íntimos* (1921), by Augusto Arias, a Symbolist design that still bore traces of his caricatural style, traces we discover the following year in his cover illustration for *El estanque inefable* (1922), by Jorge Carrera Andrade.

As regards books, our study must now proceed to the year 1927, when Guillermo Latorre designed what, as far as we know, is the first strictly avant-garde cover in Ecuador, that of *Debora*, by Pablo Palacio. In the meantime, two significant events in the history of the country had taken place: the popular uprising in Guayaquil on November 15, 1922, and the military revolution on July 9, 1925. Despite the groundbreaking design for the cover of Palacio's book, a style consolidated the following year in the splendid cover for *Voz de bronce y otras voces*, by Telmo Neptalí Vaca, published in Guayaquil, many Ecuadorian covers of the 1930s were still Symbolist and Modernist, as exemplified by that of Antonio Bellolio for *Sinfonías de América* (1930), by Vaca himself, a dynamic symbiosis of sky, mountain, and waves, enhanced by the book's calligraphic title, and *Río arriba* (1931), by Alfredo Pareja and Díez-Canseco, with Expressionist edgings. More outstanding, perhaps, were the cover designed by Luis Toro Moreno, upon his return from Bolivia, for *Barro de siglos* (1932), by César Andrade and Cordero, and the one by the twenty-year-old Diógenes Paredes for the novel titled *Ghismondo* (1932), by Ricardo Descalzi. Little could we suspect that barely a few years later the artist would begin to explore Expressionism in depth.

The central years of the 1920s showed growing signs of a standstill in the avant-garde. This could may be summed up in the Actualist, and even Futurist, titles of several of the magazines launched during these years, most of them short-lived, as was so often the case throughout the continent. The very names *Hélice* (1926), *Llamarada* (1926-1927), and *Motocicleta* (1927) express the desire for change; another more "moderate" titles was *Savia* (1925-1927), published in Guayaquil and characterized by essentialism. Of them all, the review that has

deserved most attention since its first issue is *Hélice*, directed and promoted by the painter Camilo Egas, although only five issues would appear in all. It included articles by writers such as Gonzalo Escudero (author of the manifesto "Hélice" published in the first issue), Hugo Mayo (founder of the aforementioned *Motocicleta*), Jorge Carrera Andrade, and Pablo Palacio, who the following decade would write several of the books we shall be discussing later. In graphic terms, besides contributions by Egas, it reproduced designs by Kanela and Guillermo Latorre, who thus continued the line of work they had begun in *Caricatura*.

Inspired by Futurism, *Hélice* was also noted for its publication of texts by foreign authors, such as the Argentine Oliverio Girondo, the Peruvian Alejandro Peralta, and the French writer Max Jacob (González Molina, 2013). This was quite a common way of internationalizing local artistic and literary movements, eager to establish their modernity. In his turn, Camilo Egas contributed to foreign publications, as we see in his illustrations for the magazine titled *Valoraciones* (La Plata). In 1927 he settled in New York.

So, the appearance of these magazines prepared for the emergence of a tangible connection between art and literature in book-cover designs, insinuated in the early 1920s and consolidated in the 1930s. Book covers became testing grounds for the artistic avant-garde, whose esthetic and thematic variations would be clear to follow from then on.

The artists who would crystallize this reality halfway between the two decades were those whose magazine work of the 1920s we have already discussed, besides a few newcomers. In this sense, some of the covers by Guillermo Latorre and Galo Galecio are exceptionally bold. The outstanding frontispiece by Latorre for the aforementioned book *Debora* (1927) by Pablo Palacio is a post-Cubist monochromatic composition structured by both straight and curved lines, revealing architectural and anatomical elements, signs, numbers, and other disparate features. Latorre was also responsible for the almost abstract cover of *Taza de té* (1932), by Humberto Salvador, shaped out of faceted areas of color pierced by the aggressive calligraphy of the title, where we barely make out a mask-like face and a human silhouette. In the interior, the artist has played with typography, particularly by placing titles diagonally. Two years later, Latorre illustrated the cover of another book by Salvador, *Esquema sexual* (1934), also worthy of note for its advanced graphic style and calligraphic treatment.

In his turn, Galo Galecio created one of the most memorable compositions of the early 1930s, that of *Poemas automáticos* (1931), a book with a short print run (a hundred and twenty copies) published by Manuel Agustín Aguirre. The cover is characterized by the unique dynamism of its curved title, its diagonal structure and the appearance of a bell and an airplane in vertical ascent. Around this time, Galecio was creating superb caricatures for the magazine *Cocoricó* (Bedoya, 2007a, 20) in Guayaquil, and in October 1931 he took part in *Alere Flamman*, the first exhibition organized by the Society for the Promotion of the Fine Arts, with a series of sculptural caricatures.

In the previous paragraph we mentioned Humberto Salvador, a figure not only worthy of attention for his literary output, which covered a range of genres from the esthetically advanced to Social Realism, but also for being one of the Ecuadorian writers of the decade—during which his books were published in other countries such as Argentina and Chile—most inclined to have each and every of his works illustrated. We've already cited *Taza de té*, which had been preceded in 1930 by *En la ciudad he perdido una novela* and *Bambalinas*, both with covers created by the artist Sergio Guarderas, well known for his colonial depictions of the city of Quito. These designs

are so versatile that they could in fact have been conceived by two different artists.

For the first of the two, Guarderas chose an orthogonal composition divided by a column of rhombuses. The left area shows a cityscape with hints of colonial architecture, a bridge in the foreground and a church in the background, while in the right we see an interesting example of calligraphy created by the fragmented title in a column; the author's name appears vertically, parallel to the center column, on the left. In the second cover, however, Guarderas opted for a totally avant-garde black-and-white design, and dedicated himself wholeheartedly to create a stage set whose various elements seem to dance in space; the rhythm is highlighted by the ubiquitous presence of three drops in which he placed the book's title, the author's name, and the city of publication, Quito, in a new play on calligraphy.

In 1933, with *Camarada*, Humberto Salvador adopted Social Realism, which he would continue to explore in *Esquema sexual* (1934), and other works like *Trabajadores* (1940) which we shall study later. Suffice it here to point out that both *Camarada* and *Esquema sexual* would be published in Buenos Aires at the same time as they were

Cover by Camilo Egas (Director) for *Hélice: revista quincenal de arte*, year I, no. 3, May 23, 1926. Quito, n.p. 30 x 22 cm. Aurelio Espinosa Pólit Ecuadorian Library, Quito

in Quito, with covers illustrated by Jaimes and Abraham Regino Vigo, respectively. The latter was one of the 'People's Artists' and social illustrator *par excellence* at Claridad publishing house.

Broadly speaking, specialists in Ecuadorian literature cite the book *Los que se van. Cuentos del Cholo y del Montuvio* (1930), by Joaquín Gallegos Lara, Enrique Gil Albert, and Demetrio Aguilera Malta, as the forerunner of Social Realism in the country. These three writers, along with José de la Cuadra and Alfredo Pareja Díez-Canseco, formed the so-called Guayaquil Group. This book's cover (see p. 659) is an undeniable example of modern art, expressed by means of unique calligraphic patterns that could well be attributed to Guillermo Latorre or José de la Cuadra. The taste for such compositions is clear in Ecuador, as expressed in the typography of this volume, in the paradigmatic cover by made an unknown artist for *Vida del ahorcado* (1932), by Pablo Palacio, and in the calligraphy of the book of short stories published in Cuenca, *Llegada de todos los trenes del mundo* (1932), by Alfonso Cuesta y Cuesta, its title, fragmented, in columns and arranged in the form of a rectangular triangle. By the way, when we organized the show titled *Alma mía* in 2013 we displayed an anonymous caricature signed with the initials A. C.—which could perhaps be Alfonso Cuesta himself—that depicted him writing the title of his book (Kennedy Troya and Gutiérrez Viñuales, 2013, 196).

Covers like those of *Sin sentido* (1932), by Jorge Icaza, and *Agonía y paisaje del caballo. 18 poemas* (1934), by José Alfredo Llerena, not to mention the extremely innovative *Paralelogramo* (1935), by Gonzalo Escudero, designed by the well-known music critic Francisco Alexander, the translator of works by Walt Whitman and other authors, are brilliant examples of these practices in the country (see pp. 655, 686 and 673).

This repertoire must, of course, include the leading creator of Ecuadorian visual poetry, José de la Cuadra, whose combination of different kinds of typography and calligraphy anticipated in *Horno* (1932) the wonderful typographic figurations of *Guásinton* (1938). The first of these books, *Horno*, has another avant-garde cover conceived by Carlos Zevallos Menéndez, an artist and archeologist from Guauquil who the year before had displayed a series of drawings (geometric and zoomorphic interpretations) inspired by the pre-Hispanic adornments of the indigenous peoples of the island of Puná in the aforementioned *Alere Flammam* exhibition. For the third show organized by the society, which was the *Primera exhibición del poema ecuatoriano* (1933), honoring the slogan *Alentad la llama* (Fan the Flame) that characterized it, he designed a splendid cover with calligraphy of his own that included Indigenist evocations and a structural symmetry, crowned by a caricature in a half sphere. Reminiscences of this taste for Indigenism seem to be confirmed in the cover of *Horno*, where a stylized bird with a crest and a long beak, twisting its neck and seeming to form a circle on itself, is superimposed on the dancing calligraphy of the title.

This visual itinerary, as we shall see in the illustrations to this text, reveals the interest numerous artists had in designing book covers, intertwining illustration, typography, and calligraphy. Gonzalo Bueno, better known as a writer (the father of Mauricio Bueno, one of the most important Conceptual artists in Ecuador), produced an outstanding completely abstract and gestural cover for *Antonio ha sido una hipérbole* (1933), by Jorge Fernández. Fernández and Ignacio Lasso were codirectors of *Élan* review, founded early in 1932 as a continuation of *Lampadario* (1931). The typography used in the illustrations for *Antonio ha sido una hipérbole* released by Élan publishing house was markedly modern, anticipating those that would later flourish. In *Cromática sentimental* (1933), by Aurelio Falconí, Víctor Mideros still resorted to Symbolism, albeit in a synthetic and linear vein.

In his turn, Nicolás Delgado created another cover for *La lengua castellana* (1933), by Alfredo Pérez Guerrero, placing a symbolic lighted torch at the center of the scene. Even though the book wasn't published in Ecuador, its transcendence in the country's literature makes it well worth our while to mention the frontispiece of *Hélices de huracán y de sol* (Madrid, 1933), by Gonzalo Escudero, created by the Polish artist Mauricio Amster who enjoyed a reputation in Spain as a graphic designer and would shortly afterward seek exile in Chile.

The writer Demetrio Aguilera Malta also made a foray into the field of graphic design for the cover of *Yunga* (1933), by his friend and colleague in the Guayaquil Group, Enrique Gil Gilbert. Sergio Guarderas deserves another citation, on account of his cover for *Escafandra*, by Ignacio Lasso, founder of the Élan Group, and for the romantic 'Indianist' cover of *Siembras*, a compendium of short stories by aforementioned Gonzalo Bueno, both published in 1934. In a bolder composition than the one he had produced for *Río arriba* (1931), Antonio Bellolio designed the cover of *2 corazones atravesados de distancia* (1934), by Gonzalo Humberto Mata, who worked in Cuenca and was another of the authors who made sure his books were illustrated. Horizontal in format, this book was designed as an album, the pages of which were tied together with a piece of string.

If we spoke earlier of Humberto Salvador, and now of Gonzalo Humberto Mata, as writers convinced of the need to commission illustrations for their books, one of the most seminal figures in contemporary Ecuadorian literature, Jorge Icaza, must also be cited in this category of authors. Most his local publications and those he launched abroad were illustrated, his early works by an artist associated with the Guayaquil art scene, Humberto Gavela O, to whom we owe the covers of *Barro de la sierra* (1933) and the emblematic work *Huasipungo* (1934), high point of Indigenist literature that reveals his taste for calligraphy though more specifically for the geometrization and vibration of planes with a hint of Art Deco. *Huasipungo* was presented in at least two versions, one in pale green ink and the other in red ink.

The covers of Icaza's books are characterized by the geometric compositions of their titles, that could almost be described as early forms of visual poetry, playing with horizontal, vertical, and diagonal lines, as we saw in the case of Guillermo Latorre's design for *Taza de té*, by Humberto Salvador. *Flagelo* (1936), published by the newly founded Union of Writers and Artists (SEA, for its initials in Spanish), was almost certainly freely illustrated by Icaza himself—the cover insinuating the simple linear combinations that readers would find fully developed in the book's inner pages, where the texts interact with geometric figures. *Flagelo*, "a drama in one act," as quoted in the frontispiece, would be staged in 1940 at the Theater of the People in Buenos Aires, managed by Leónidas Barletta (see p. 726).

By the mid-1930s the repertoire of illustrated books in Ecuador had been consolidated in numerous examples, ranging from clearly avant-garde designs like the (sadly anonymous) covers of *Latitudes* (1934), by Jorge Carrera Andrade, and of *Luz* (1935), by Francisco A. Villavicencio, to neo-popular works such as the cover designed by the renowned sculptor Antonio Salgado for *A través de los libros* (1935), by Alejandro Andrade Coello.

Germania Paz y Miño, also well known in the field of sculpture, created the highly innovative illustrations (cover and interior pages) for one of the key books in the development of Ecuadorian art of the period, *El movimiento artístico de México* (1935), by Salvador Navarro Aceves, published by Élan. The text promoted Mexican muralism and reviewed pre-Columbian art and popular arts and crafts. Almost instantly, this spark kindled in local circles (Rodríguez Castelo,

ECUADOR

Cover by unknown artist
for *Hontanar: órgano del grupo Alba*, year I, no. 3, March 1931. Director: Carlos M. Espinosa. Loja, Talleres del Colegio Bernardo Valdivieso, 23.5 x 16.6 cm.
Boglione Torello Collection

Cover by Enrique A. Terán
for *Élan: revista de arte y literatura*, period II, nos. 4 and 5, March and April 1932. Directors: Jorge Fernández and Ignacio Lasso. Quito, n.p. 26 x 18 cm.
Aurelio Espinosa Pólit Ecuadorian Library, Quito

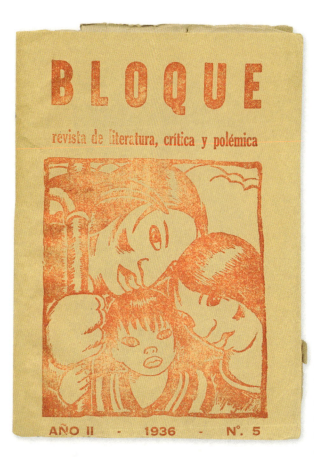

Cover by Alfredo Palacio for *Bloque: revista de literatura, crítica y polémica*, year II, no. 5, May-September 1936. Editors: Alfonso Aguirre S. et al. Loja, Imprenta del Colegio Bernardo Valdivieso. 22 x 15.8 cm. Private collection, Granada

1985, 23), and would be expressed, as we shall see, in the works of artists such as Eduardo Kingman, Oswaldo Guayasamín and Leonardo Tejada. As regards Germania, to whom José de la Cuadra had dedicated one of the chapters of his *12 siluetas* (1934), she established her practice as an illustrator in the splendidly colored cover of *Cartas al conscripto* (1938), by Luis Coloma Silva. Her design showed obvious traces of Art Deco, notably in the calligraphy and the image of the line of soldiers, over which an Ecuadorian flag waves, held tightly in the closed fist of a large hand. During these years Germania also left her mark on the art world through her lectures and theoretical texts, among them *Apuntes sobre el arte mexicano* (1938).

Indeed, the second half of the 1930s would be intense and prolific in terms of art institutions and publications. As stated, in 1936 the SEA, or Union of Writers and Artists, was founded in Quito—which in 1939 would set up the May Salon—and in 1937 the Society of Independent Writers and Artists (SAEI, for its initials in Spanish) was constituted in Guayaquil, presided over by the aforementioned Carlos Zevallos Menéndez, to continue the tasks previously carried out by the Alere Flammam association. The inauguration of the Ecuadorian House of Culture in 1944 took the institutionalization of arts and letters one step further.

As regards theoretical essays, in 1937 *El arte de Mideros*, by José Rumazo González, was published, a large-format edition with a cover by Mideros himself, which deserves a mention in this survey for its remarkable Symbolist and Deco style, including its calligraphy and motif. Four relevant essays were published in 1938: *Ideas acerca de la pintura moderna*, by Pedro León, *La pintura moderna en el Ecuador*, by Jorge A. Díez, *Orígenes del arte ecuatoriano*, by Nicolás Delgado, and *Aspectos de la fe artística*, by José Alfredo Llerena. In terms of design, the esthetic of Symbolism evolved and paved the way for a

form of Expressionism that was more pertinent for addressing social issues, particularly those connected with the defense of Indigenist culture, theme of the day *par excellence*. A prominent figure in this style was Eduardo Kingman Riofrío.

Although he was born in Zaruma, Kingman began to make a name for himself in Guayaquil after having held his first solo exhibition in the city in 1933, a show staged at Alere Flammam gallery that also displayed works by Antonio Bellolio. Already influenced by social concerns, that by then were popular in the literature of Guayaquil, and inspired by the growing diffusion of Mexican art, Kingman settled in Quito late in 1935, and the following year was awarded the prestigious Mariano Aguilera Prize for his oil painting *Los carboneros*; among the members of the jury were Pablo Palacio, Gonzalo Escudero, and the sculptor Antonio Salgado. In 1936 Kingman also illustrated most of the poetic compositions included in the first exhibition of illustrated mural poems organized by the Union of Writers and Artists of Ecuador (Llerena and Chaves, 1942, 26). In 1937 he joined the secretary's office of the Fine Arts School in Quito, in 1938 he held an exhibition in Bogotá, in 1939 he worked with Camilo Egas and Bolívar Mena Franco on the decorations of the Ecuadorian Pavilion at the International Exhibition of New York, and in 1940 he opened Caspicara Gallery in Quito. These select references offer us a glimpse into Kingman's prominence in Ecuadorian art.

In the sphere of books, too, Kingman became an outstanding artist, chiefly thanks to his woodcut prints. His work in this graphic genre betrayed the influence of Leonardo Tejada, born into a family of wood carvers. Both artists reinforced the modern xylographic tradition that had emerged in the 1920s with artists such as Pavel, Camilo Egas, and Sergio Guarderas (active in *Hélice* review), and had continued in the early 1930s with others like Enrique Terán, M. A. Saavedra, and Alfonso Ayerve (in *Élan* review). The most conspicuous writers in modern Ecuadorian literature, both in the literary circles of Guayaquil and Quito, turned to Kingman to illustrate their works. As the artist himself recalled, "Painters and writers were very close; we formed a small, active fraternity, and we mutually influenced one another. This explains why the literature and plastic art of the period followed a similar course" (Villacís Molina, 1988, 108).

One of the first of these expressions would be the panoramic cover Kingman made for the novel *Agua* (1936), by Jorge Fernández, in which he used black and red inks to compose an image of a hand hardened by time and hard work, that the author himself described as follows: "In the deserted, barren field, the men who have climbed down the hill, their gazes gloomy, their hearts resentful …". (Fernández 1936, pp. 424-425)

In 1937, the same year that the Popular Graphics Workshop (TGP, for its initials in Spanish) was set up in Mexico, Kingman published his impressive album *Hombres del Ecuador* under the auspices of SEA in Quito. The volume included twenty woodcuts and was prefaced by Alejandro Carrión, Augusto Sacoto Arias, and Pedro Jorge Vera, authors whose works he would illustrate with several woodcut prints devoted to social and military themes that year and the following year. These were Carrión's *Luz del nuevo paisaje* (1937) and *¡Aquí, España nuestra!* (1938); Vera's *Nuevo itinerario* (1937), a compilation of poems previously reproduced in *La Tierra* newspaper in Quito and *Bandera Roja* newspaper in Guayaquil, and which he had considered publishing under the title *Carteles para las paredes hambrientas*; and Sacoto's *Velorio del albañil* (1938). Élan and Atahuallpa publishing houses were especially receptive to such works.

Velorio del albañil, whose illustrations can be counted among the bluntest of those dedicated by Kingman to social themes, was the second volume in the Cuadernos del Pacífico series

published in Quito. The first, the aforementioned *¡Aquí, España nuestra!*, by Alejandro Carrión, had appeared that same year and, along with *Nuevo itinerario*, by Pedro Jorge Vera, revealed the sensitivity of these authors and, by extension, of Kingman, to the Spanish Civil War and their support of the Republican side. The collective edition of *Nuestra España: homenaje de los poetas y artistas ecuatorianos* (1938) marked a high point in such publications. Horizontal in format, besides illustrations by Kingman the volume included woodcuts by Diógenes Paredes, Alba Calderón de Gil, Leonardo Tejada, Galo Galecio, and Alfredo Palacio. Its highly Symbolist scenes of war action, destruction and devastation were complemented by images of maternal figures, as we see in the works by Calderón, Galecio, and Palacio.

The growing success of Kingman's woodcut prints for books led to constant requests for illustrations until well into the 1940s. Other relevant authors such as Ricardo A. Paredes, Jorge Icaza, Humberto Salvador, or the Bolivian writer Roberto Hinojosa, would soon be counted among the admirers who commissioned his designs. In his cover for *Oro y sangre en Portovelo: el imperialismo en el Ecuador* (1938), by Paredes, Kingman resorted to a print that seemed (but wasn't) extracted from the *Hombres del Ecuador* album; framed by the titles in red, the center of the composition featured a money symbol. In the cover for Icaza's novel *Cholos* (1938) he superimposed an ink drawing (that included the titles) on a woodcut in orangey tones. The following year, the cover illustration for the second edition of the book was entrusted to Leonardo Tejada, whose attractive design combined woodcut and calligraphy in red and green inks. In 1938 Tejada had created the cover for *Guásinton*, the famous book of stories and chronicles by José de la Cuadra.

Back from the International Exposition of New York, Kingman would work with the authors quoted in the previous paragraph, creating covers for *Noviembre* (1939) and *Trabajadores* (1940), both by Humberto Salvador, and for *El cóndor encadenado* (1941), by Roberto Hinojosa. The most outstanding of the three designs is that of *Noviembre*, its title fragmented into syllables and arranged in a column to the left, while the figures of two workers (in woodcut) appear to the right and diagonally, on which Kingman has superimposed a sword (in black ink) facing the opposite direction.

Although we have only mentioned Oswaldo Guayasamín in passing, his Indigenist designs of the next few decades rivaled and even surpassed those by Kingman. Without surveying his career in detail, we shall review four of his compositions for books. The first two, made in 1938, were for books by Adolfo Sotomayor Febres Cordero, a poet from Guayaquil: the collection of ballads titled *Amanecer en cualquier camino* and *Rumbas y niebla*, in which Guayasamín proved his skill as a draftsman and woodcutter, respectively. The following year he produced the cover design for *Estallido de la anémona* (1939), by Humberto Navarro Guayasamín, a thin book with a horizontal format whose striking cover is characterized by a dramatic contrast created with red and black inks, and a white star placed in the center of the scene. The right half of the cover is occupied by a woman with a mournful rictus, whose gesture clearly evokes that of the Christ in agony of the last of the four works, *Desde la cruz* (1940), by Manuel Efraín Munive. In 1942 Guayasamín would produce a series of Surrealist vignettes to decorate *La furiosa manzanera. Tragedia en 2 actos*, by Augusto Sacoto Arias, which revealed him to be a versatile artist in other themes, besides his favored social subject matter.

The truth is that Ecuadorian literature was in the process of being consolidated, not only within the country's borders but also on an international scale, throughout Latin America. Argentina, about to enter into a golden age of publishing after the disengagement of Spanish institutions provoked

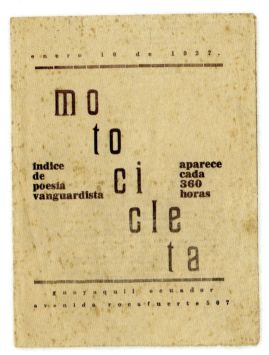

Cover by unknown artist for *Motocicleta: índice de poesía vanguardista*, no. 1, 10 January 1927. Director: Hugo Mayo. Guayaquil, n.p. 21.2 × 16.2 cm.
Nettie Lee Benson Latin American Collection, The University of Texas at Austin Library

by the Spanish Civil War, and where we previously saw the publication of works by Humberto Salvador by Editorial Claridad, produced a second edition of *Huasipungo* (1935), by Jorge Icaza, with a cover by the Catalan artist José Planas Casas. The following year, Icaza published *En las calles* (1936), for which Ecuadorian artist Ricardo Warecki, born in Rosario, created a very modern frontispiece, one of his best designs in the field. In his turn, José de la Cuadra brought out *El montuvio ecuatoriano* (1937), produced by Imán publishing house and featuring a cover design by one of the leading representatives of social art in the country, Demetrio Urruchúa.

The highly regarded variety of graphic proposals linked to books characterizing Ecuador in the late 1930s and early 1940s is confirmed by many other covers, such as the one designed by Alfredo Palacio for *Parábola roja* (1938), by Gustavo Serrano, the one created by Carlos Rodríguez for *Esbozos* (1939), a volume dedicated to his caricatures, and some of the books that Gonzalo Humberto Mata released in Cuenca by Biblioteca Cenit publishing house. These included *Sumag Allpa* (1940), which included a linocut by Ricardo León and an ex libris by Luis Toro Moreno on the back cover, both artists who had trained abroad, in Chile and Bolivia respectively. The ex libris appears again in *Ecuador en el hombre* (1943), also by Mata and with an interesting cover by Rigto (J. Rigoberto Andrade), where the compositional space is presided over by a large red star.

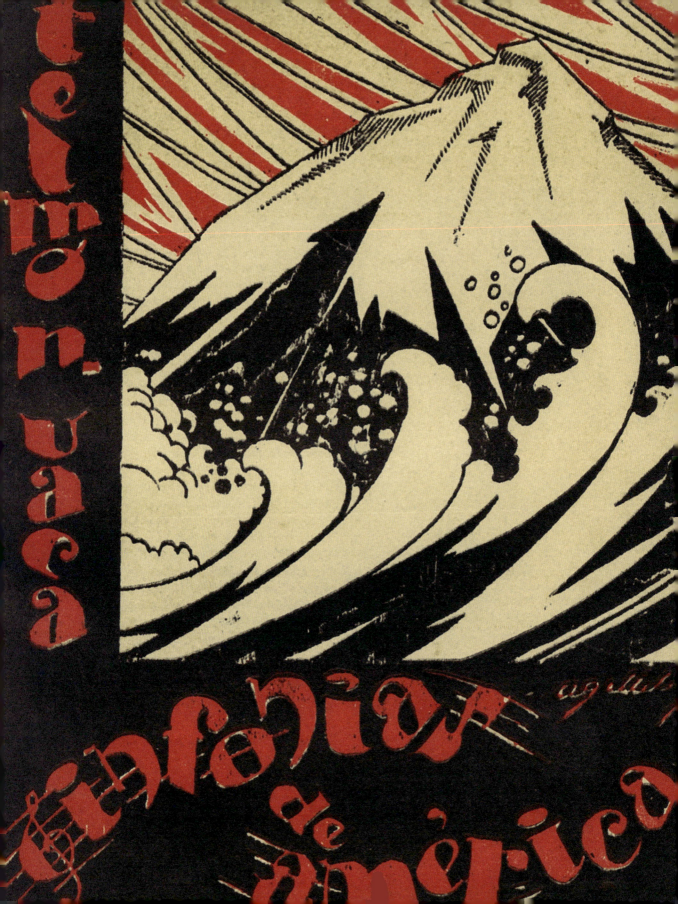

Ecuador

Cover by Kanela (pen-name of Carlos Andrade Moscoso) for Jorge Carrera Andrade, *El estanque inefable*, Quito. Central University, 1922.
17 x 13.8 cm.
Jacinto Jijón y Caamaño Library, Ministry of Culture and Heritage, Quito

Cover by Kanela (pen-name of Carlos Andrade Moscoso) for Augusto Arias R., *Poemas íntimos*, Quito. Municipal Printers, 1921.
19 x 14 cm.
America Library, University of Santiago de Compostela

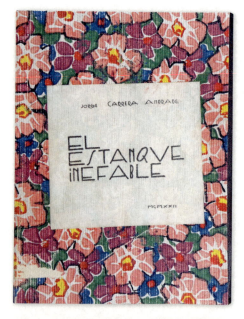
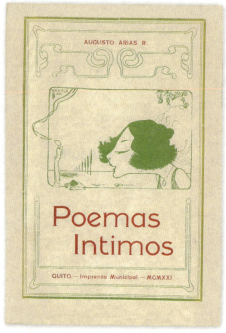

Cover by Antonio Bellolio for Telmo Neptalí Vaca, *Sinfonías de América*, Guayaquil. Artes Gráficas Senefelder, n.d. [1930?].
17.5 x 14.3 cm
Archivo Lafuente

Cover by Nicolás Delgado for Arturo Borja, *La flauta de Ónix*, Quito. Central University, 1920.
18 x 13 cm.
Eugenio Espejo National Library, Quito

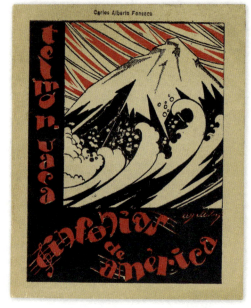
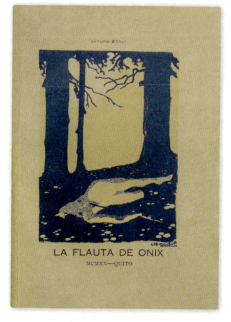

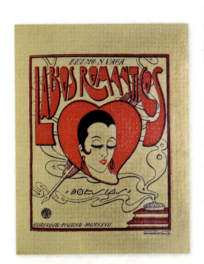
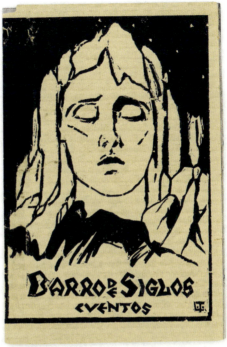

Cover by unknown artist for Telmo Neptalí Vaca, *Labios románticos*, Quito. La Rápida, 1927. 13.3 x 10.4 cm. Aurelio Espinosa Pólit Ecuadorian Library, Quito

Cover by Luis Toro Moreno for César Andrade y Cordero, *Barro de siglos: cuentos del ande y de la tierra*, Cuenca. Indoamérica, 1932. 20 x 13 cm. Private collection, Granada

Cover by Antonio Bellolio for Alfredo Pareja y Díez-Canseco, *Río arriba (novela)*, Guayaquil. Talleres Gráficos, 1931. 18 x 12 cm. Archivo Lafuente

Cover by Diógenes Paredes for Ricardo Descalzi, *Ghismondo: novela*, Quito. Tipografía L. I. Fernández, 1932. 17.9 x 13.3 cm. Aurelio Espinosa Pólit Ecuadorian Library, Quito

Cover by Guillermo Latorre for Pablo Palacio, *Debora: novela*, Quito. n.p. 1927. 15.1 x 11.8 cm. National Library of Chile, Santiago de Chile

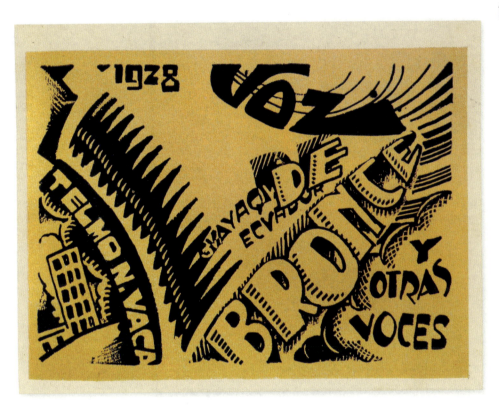

Cover by unknown artist [Guillermo Latorre or Antonio Bellolio?] for Telmo Neptalí Vaca, *Voz de bronce y otras voces*, Guayaquil. Artes Gráficas Senefelder, 1928. 11.5 × 15.2 cm. Aurelio Espinosa Pólit Ecuadorian Library, Quito

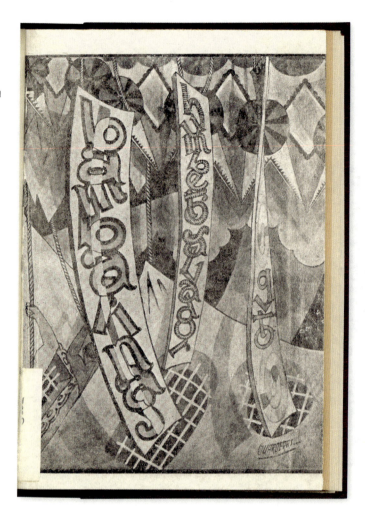

Cover by Sergio Guarderas for Humberto Salvador, *Bambalinas*, Quito. n.p. 1930. 18.6 × 13.3 cm. Spanish Agency for International Development Cooperation Library, Madrid

Cover by Galo Galecio for Manuel Agustín Aguirre, *Poemas automáticos,* Guayaquil. Gutemberg, 1931. 25.5 x 18 cm.
Benjamín Carrión Cultural Center, Quito

Cover by Gonzalo E. Bueno for Jorge Fernández, *Antonio ha sido una hipérbole*, Quito. Élan, 1933. 19.8 x 14.1 cm. Aurelio Espinosa Pólit Ecuadorian Library, Quito

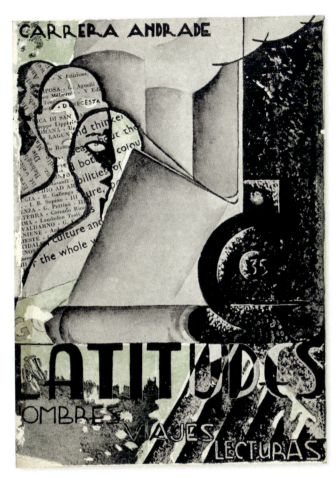

Cover by unknown artist for Jorge Carrera Andrade, *Latitudes: hombres, viajes, lecturas,* Quito. Talleres Gráficos Nacionales, 1934. 17.3 x 13 cm. Spanish Agency for International Development Cooperation Library, Madrid

Cover by Carlos Zevallos Menéndez for *Primera exhibición del poema ecuatoriano* [exh. cat.], Guayaquil. Janer, 1933, 19 x 14 cm.
Aurelio Espinosa Pólit Ecuadorian Library, Quito

Cover by Sergio Guarderas for Gonzalo Bueno, *Siembras: cuentos*, Quito. Labor, 1934. 19 x 14 cm.
Aurelio Espinosa Pólit Ecuadorian Library, Quito

Cover by Sergio Guarderas for Ignacio Lasso, *Escafandra: poemas*, Quito. Élan, 1934. 19 x 14.5 cm.
Private collection, Granada

Cover by Antonio Bellolio for Gonzalo Humberto Mata, *2 corazones atravesados de distancia*, Cuenca. n.p. n.d. [1934?]. 18 x 25 cm.
Archivo Lafuente

Cover by Sergio Guarderas for Humberto Salvador, *En la ciudad he perdido una novela*, Quito. Talleres Gráficos Nacionales, 1930. 18.1 x 13.2 cm. Boglione Torello Collection

Cover by Germania Paz y Miño for Salvador Navarro Aceves, *El movimiento artístico de México*, Quito. Élan, 1935. 19.9 x 14.5 cm. Boglione Torello Collection

Cover by Ángel Eduardo Dávila for Pablo Hannibal Vela, *Arca sonora: poesías*, Quito. Talleres Gráficos de Educación, 1938. 20.5 x 15 cm. Boglione Torello Collection

Cover by Guillermo Latorre for Humberto Salvador, *Esquema sexual*, Quito. Imprenta Nacional, 1934. 23 x 16 cm. IberoAmerican Institute – Prussian Cultural Heritage Foundation, Berlin

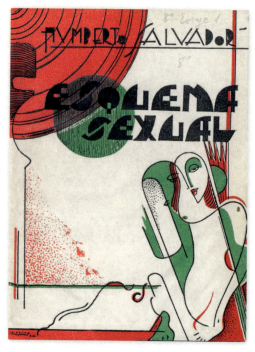

Cover by Víctor Mideros for José Rumazo González et al., *El arte de Mideros*, Quito. Artes Gráficas, 1937.
38.5 x 28.5 cm.
Private collection, Granada

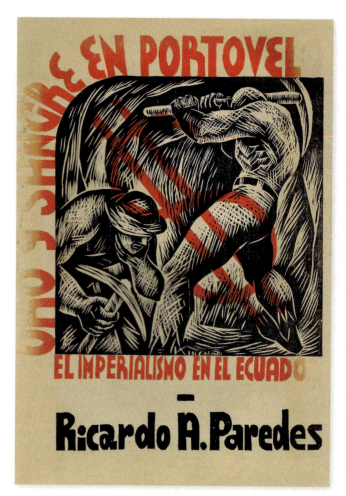

Cover by Eduardo Kingman for Ricardo A. Paredes,
Oro y sangre en Portovelo: el imperialismo en el Ecuador,
Quito. Artes Gráficas, 1938.
22.5 x 15.5 cm.
Private collection

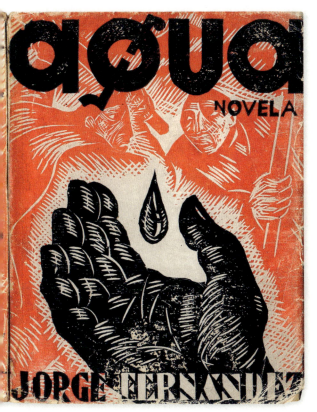
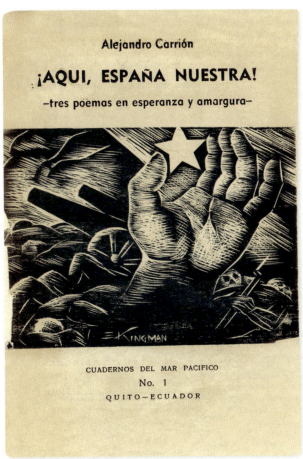

Covers by Eduardo Kingman for Jorge Fernández, *Agua: novela*, Quito. Élan, 1936. 18.4 × 14.2 cm (open) Private collection, Granada

Cover by Eduardo Kingman for Alejandro Carrión, *¡Aquí, España nuestra!: tres poemas en esperanza y amargura*, Quito. Agencia General de Publicaciones, 1938. Cuadernos del Mar Pacífico Series, no. 1. 22 × 15 cm. Archivo Lafuente

Cover and inner page by Eduardo Kingman for Alejandro Carrión, *Luz del nuevo paisaje: libro de poesía (1934-1935)*, Quito. Élan, 1937. 29 x 19.4 cm.
Private collection, Granada

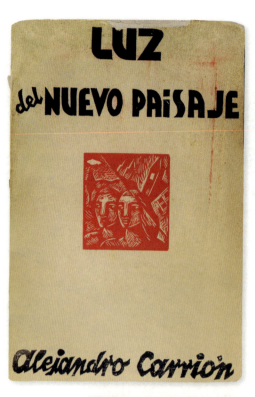

Cover and inner page by Eduardo Kingman for José Alfredo Llerena, *Aspectos de la fe artística*, Quito. Atahuallpa, 1938. 1 5.4 x 10.8 cm.
Private collection, Granada

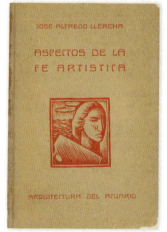

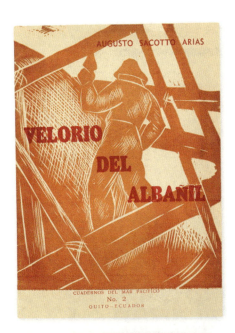
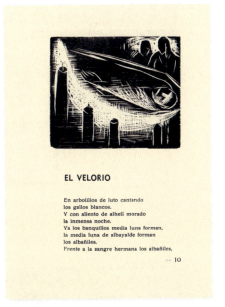

Cover and inner page by Eduardo Kingman for Augusto Sacotto Arias, *Velorio del albañil*, Quito. Agencia General de Publicaciones, 1938. Cuadernos del Mar Pacífico Series, no. 2. 22.5 × 16 cm. Archivo Lafuente

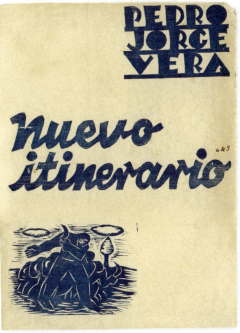
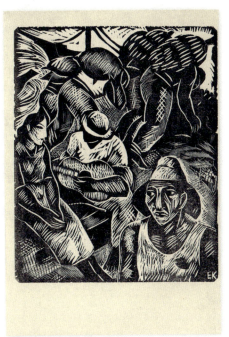

Cover and inner page by Eduardo Kingman for Pedro Jorge Vera, *Nuevo itinerario*, Quito. Atahuallpa, 1937. 25 × 18.5 cm. Private collection, Granada

Cover and inner page by Eduardo Kingman for several authors, *Nuestra España: homenaje de los poetas y artistas ecuatorianos*, Quito. Atahuallpa, 1938. 15.8 x 22.2 cm. Archivo Lafuente

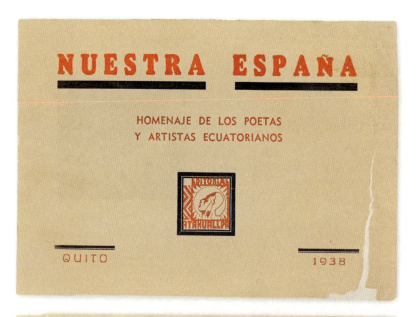

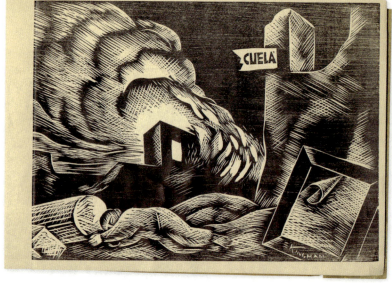

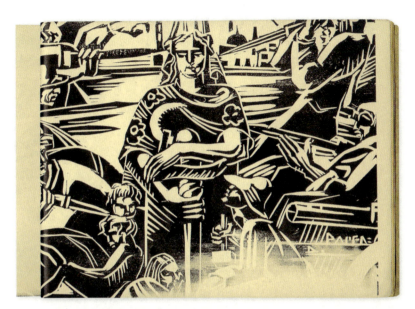
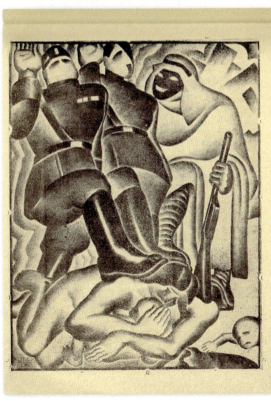
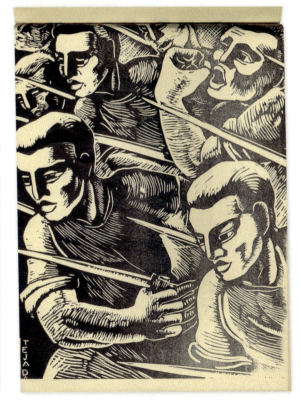

Inner pages by Diógenes Paredes, Alfredo Palacio, and Leonardo Tejada Zambrano for several authors, *Nuestra España: homenaje de los poetas y artistas ecuatorianos*, Quito. Atahuallpa, 1938.
15.8 x 22.2 cm.
Archivo Lafuente

Cover and inner pages by Eduardo Kingman (author) for *Hombres del Ecuador: 20 grabados en madera*, Quito. Atahuallpa, 1937. 30 x 39.7 cm.
Archivo Lafuente

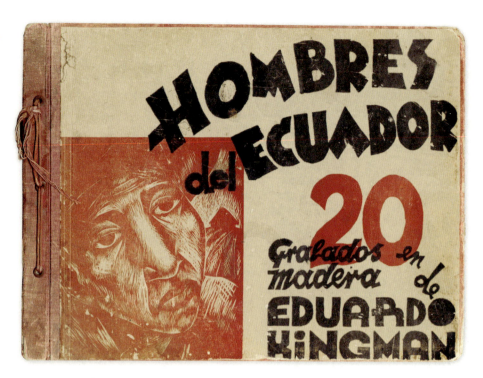

ECUADOR 431

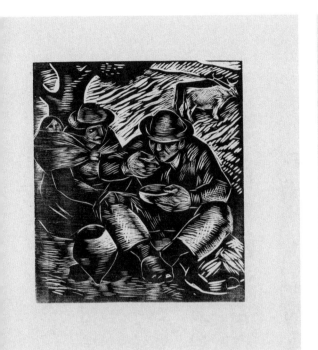
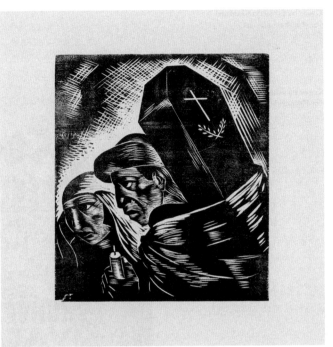
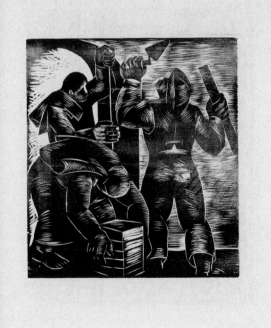
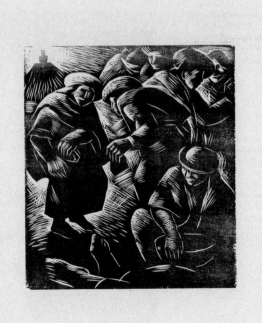

Cover by Eduardo Kingman for Humberto Vacas Gómez, *Canto a lo obscuro*, Quito. n.p. 1937. 19 × 13 cm. National Library of Chile, Santiago de Chile

Cover by Eduardo Kingman for Humberto Salvador, *Trabajadores: recuerdos de un muchacho desvalido*, Quito. Tipografía L. I. Fernández, 1940. 18.3 × 13.4 cm. Private collection, Granada

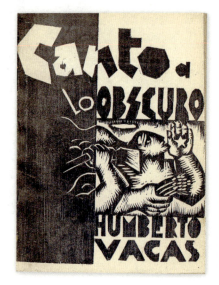

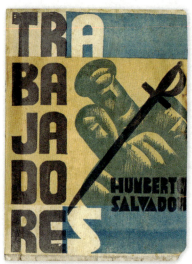

Cover by unknown artist [Carlos Rodríguez or Alfredo Palacio?] for Manuel Agustín Aguirre, *Llamada de los proletarios*, Guayaquil. Luis Zea C., 1935. Cuadernos Series, 3. 24.8 × 18.5 cm. Benjamín Carrión Cultural Center, Quito

Cover by Oswaldo Guayasamín Calero for Adolfo Sotomayor Febres Cordero, *Rumbos y niebla*, Quito. Atahuallpa, 1938. Nueva Poesía Collection, 22.1 × 16 cm. Private collection, Granada

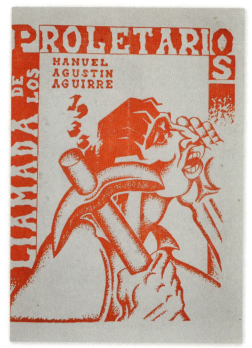

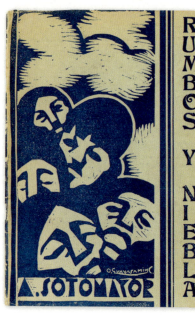

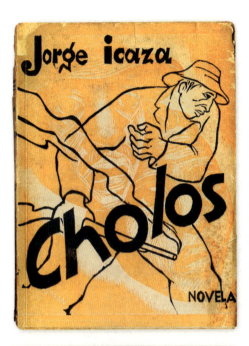
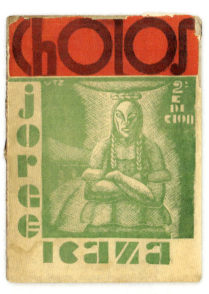

Cover by Eduardo Kingman for Jorge Icaza, *Cholos: novela*, Quito. Romero, 1938. 22.5 x 16.5 cm.
Archivo Lafuente

Cover by Leonardo Tejada Zambrano for Jorge Icaza, *Cholos*, 2nd edition, Quito. Atahuallpa, 1939.
19.8 x 15.2 cm.
Private collection, Granada

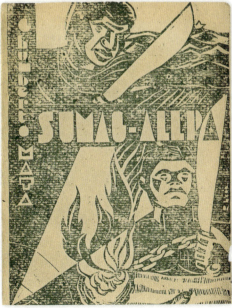
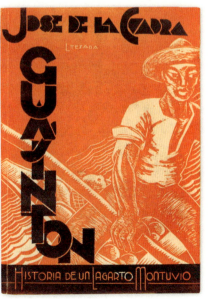

Cover by Ricardo León for Gonzalo Humberto Mata, *Sumag Allpa*, Cuenca. Biblioteca Cenit, 1940.
22.2 x 17.3 cm.
Archivo Lafuente

Cover by Leonardo Tejada Zambrano for José de la Cuadra, *Guásimton: relatos y crónicas*, Quito. Talleres Gráficos de Educación, 1938. 21.3 x 15.5 cm.
Archivo Lafuente

Cover by Carlos Zevallos Menéndez for José de la Cuadra, *Horno: cuentos*, Guayaquil. Talleres de la Sociedad Filantrópica, 1932. 18 x 12.4 cm.
Juan Bonilla Collection, Seville

Cover by Guillermo Latorre for Humberto Salvador, *Taza de té*, Quito. Talleres Gráficos Nacionales, 1932. 21.8 x 14 cm.
Spanish Agency for International Development Cooperation Library, Madrid

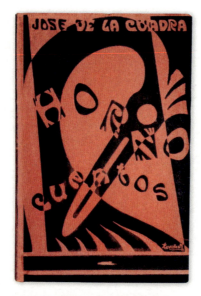
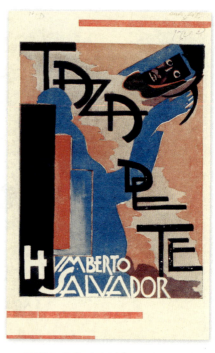

Cover by Humberto Gavela O. for Jorge Icaza, *Barro de la sierra (cuentos)*, Quito. Labor, 1933. 19.9 x 14.4 cm.
Archivo Lafuente

Cover by Humberto Gavela O. for Jorge Icaza, *Huasipungo (novela)*, Quito. Imprenta Nacional, 1934. 20 x 15.4 cm.
Archivo Lafuente

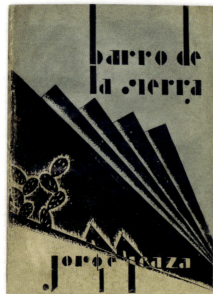
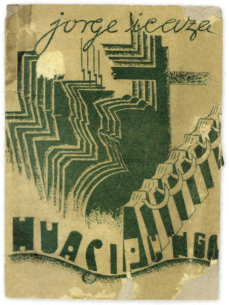

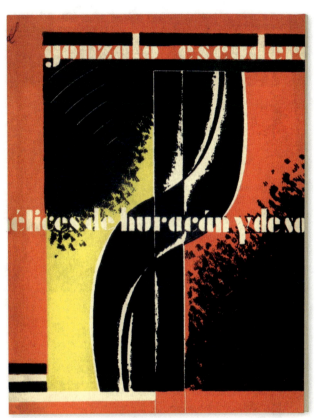

Cover by Mauricio Amster for Gonzalo Escudero, *Hélices de huracán y de sol*, Madrid. Compañía Iberoamericana de Publicaciones, 1933.
19.7 x 15 cm.
Spanish Agency for International Development Cooperation Library, Madrid

Actual: hoja de vanguardia. Comprimido Estridentista, no. 1, December 1921, Mexico City. Manuel Maples Arce. 60 x 40 cm. National Art Museum, National Institute of Fine Arts, Mexico City

Mexico

Marina Garone Gravier

There are two prominent positions in the historiography of Mexican graphic design as regards the origin of the discipline: one maintains that design, i.e. the configuration of highly visual communicational messages for creating serial products, dates back at least to the 16th century, when typographic printing first appeared in the country; the other holds that one cannot speak of graphic design until the second half of the 20th century. In any event, both positions apply the term "design" to the field of books, magazines, and to a lesser extent, posters, which reveals that the history of graphic design in Mexico is inextricable from the world of publishing. Both positions, however, are distinguished by the concept of *modernity*—the modernity of the esthetic designs, of the forms and techniques of production, and of the social and cultural role adopted by those in charge of creating the graphic works.

And yet, how were the ideas of modernity expressed in these works? What can we learn from documentary sources, from the printed matter itself, from newspaper and magazine archives, and from other memory devices? In order to place readers in the context of that local setting, I will begin by quoting Enrique Fernández Ledesma and Francisco Díaz de León, key figures for understanding the design and publication of Mexican books and magazines in the first half of the 20th century. The journals titled *Mexican Art and Life*, particularly issue number 7 that appeared in 1939, and *Revista de la Escuela de Artes del Libro*, published by the organization of the same name founded by Díez de León, are equally enlightening and can be consulted at the National Periodicals Library (HNM, for its initials in Spanish). Secondly, I will examine printed materials produced by the editorial activity that formed the backdrop of that modernity: the graphic works associated with the avant-garde movement known as Stridentism; Cultura publishing house (the typography of which was

characterized by its replacement of the u with the v: Cvltura); Talleres Gráficos de la Nación (TGN) publishers; reviews such as *El Maestro* and *Mexican Folkways*; and the work by Dr. Atl (brush name of Gerardo Murillo), Montenegro, Rivera, Charlot, and Alva de la Canal. Comments on these factors structure our analysis and enable us to understand some of the landmarks in the history of Mexican publications and, above all, the effervescent vitality of its visual renovation.

Historia crítica de la tipografía en la ciudad de México is a clear example of Enrique Fernández Ledesma's knowledge of the state of graphic arts in the Mexican capital as it contained a detailed account of 19th-century printers. The book was commissioned by the Fine Arts Department at the Secretariat of Public Education (SEP, for its initials in Spanish) to commemorate the fourth centenary of the arrival of printing in Mexico, despite appearing in 1935. It would subsequently be explained that the art of typography in the capital of New Spain dated back to 1539. In the book's introduction, Fernández Ledesma (1934-1935, XII) mentions how his intention: "[W]as not to formulate an overall critique of 'typographic bibliography,' which would be ridiculous, but simply to classify the analysis of the most outstanding and representative Mexican works in typographic fields. This essay intends to fill in the huge gaps, still intact, in the account of the typographical particularities and conditions of our books in a short summary."

The author points out that his aspiration was to "represent a specific period of the 19th century—a year or a decade—from an exclusively graphic point of view as exemplified by its distinctive books" (Fernández Ledesma, 1935, XII). The statement defined his proposal of creating a canon of "old" bookish objects (a construction of the past) on which he and other authors would gradually establish comparisons enabling them to speak of steps forward and backward in the art of making books in Mexico.

This is the esthetic, literary, and material canon on which a certain idea of modernity was based.

Following the fluctuations of graphic memory, that traveled to the past and returned strengthened to the present, in July 1939 issue number 7 of the magazine titled *Mexican Art & Life* was published, dedicated to the true date of birth of American typography. The publication was edited by José Juan Tablada and counted on Francisco Díaz de León as art director. The cover of this issue featured a medievalist woodcut designed by Gabriel Fernández Ledesma, brother of the author of the book of poems titled *Con la sed en los labios* (1919). The contents of this issue, published in English, were series of essays on the varied forms and periods in the art of book making: from the text by Rafael García Granados on pre-Hispanic Mexican manuscripts, to *Bookbinding in Mexico*, by Manuel Romero de Terreros. Of chief interest here is the article "Outline of Mexican Contemporary Typography," in which the art historian Justino Fernández traced a sort of curatorial guide that would be revisited years later by Cuauhtémoc Medina (1991) when describing "design before design."

Fernández (1939) pointed out that the parallelism between political events in the early 19th century explained the difficulties that the publishing industry experienced after the Mexican Revolution, suggesting that the term contemporary typography refers to the production of the years of the country's national reconstruction. Referring to this period, he mentions five forms of typographic compositions: 1. Those that reconstructed former (historical) styles. 2. Those inspired by recent occurrences. 3. Those that limited themselves to technical guidelines of the craft, with no artistic aspirations. 4. Those that endeavored to create artistic compositions. 5. Those that employed technical typography as opposed to artistic typography.

After complaining about certain anachronistic compositions, he speaks of "popular typography,"

considering it a downgraded alternative to colonial printing practices anchored in the decadent taste of the 19th century, and considered that the three factors that had contributed to the advances in book printing were first-class commercial editions, not-for-profit private editions, and official editions, sponsored by the government and the National University. Some of the agents on his list are now undisputed among those that ushered modernity into Mexico.

Besides the opinions of art critics, mention must be made of those of the artists themselves, those materially responsible for the works. Francisco Díaz de León, for instance, was a privileged interlocutor of Enrique Fernández Ledesma's. His work as a publications designer flourished between 1930 and 1933 when, along with the younger of the Fernández Ledesma brothers, Gabriel, he worked as codirector of the Art Salon of the Secretariat for Public Education (SEP, for its initials in Spanish), and also as a woodcutter. A characteristic example of his talent is found in the book by Mariano Silva y Aceves, *Campanitas de plata. Libro de niños*, published by Editorial Cvltura in 1925, for which he designed fifty-four original woodcuts. The following year he produced another design for the same publishing house, this time for the book *Oaxaca* by the art historian Manuel Toussaint.

The career as a publisher of Díaz de León took off in 1934, when he was appointed coordinator of the Fine Arts editions, a position he juggled with that of director of the Central School of Plastic Arts at the National University of Mexico, and editor of *Mexican Art & Life* magazine between the years 1937 and 1940.

Francisco Díaz de León has been considered "the greatest professional, technical, and educational promoter of book culture, and the forerunner of the ideal of editorial design" (Portillo, 2011, 10-16). In 1932 he suggested setting up a School of Arts and Crafts of the

Cover by Adolfo Best Maugard for *La Falange: revista de cultura latina*, no. 1, 1 December 1922. Staff writers: Aurelio de Alba et al., Mexico City. Cultura. 23.5 x 19 cm. Archivo Lafuente

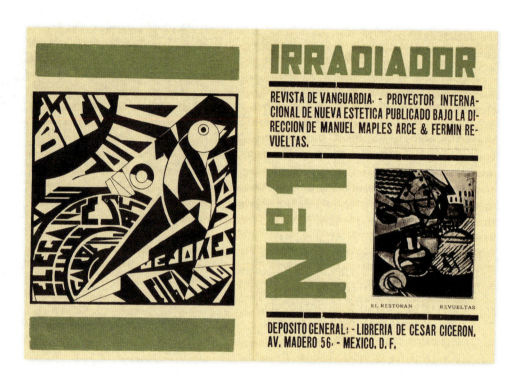

Covers by Fermín Revueltas for *Irradiador*, no. 1, 1923. Editors: Manuel Maples Arce and Fermín Revueltas, Mexico City. Librería de César Cicerón. 23.5 x 17.5 cm. Gerardo Diego Library, Gerardo Diego Foundation, Santander

Design by Fermín Revueltas for *Irradiador* (poster), Mexico City. Ediciones del Movimiento Estridentista, 1923. 30 x 40 cm. Gerardo Diego Library, Gerardo Diego Foundation, Santander

Book, a project that only materialized in 1937 when SEP opened the School of the Arts of the Book (EAL, for its initials in Spanish), under the wings of the Department of Workers' Education (an organization that would subsequently become the Department of Special Teaching) and appointed Díaz de León director. He remained in the position until 1957 when, having retired, he was named lifelong honorary director.

In 1943 the school was reorganized to prepare for four professions: director of editions, engraver, binder, and typographer. Having closed temporarily in 1946, after much paperwork by Díaz de León it reopened under the name National School of Arts of the Book (ENAL, for its Spanish initials) yet only to offer teachings in Bookbinding, Editions, and Engraving. In 1958 ENAL became ENAG, the Spanish acronym for National School of Graphic Arts. The review titled

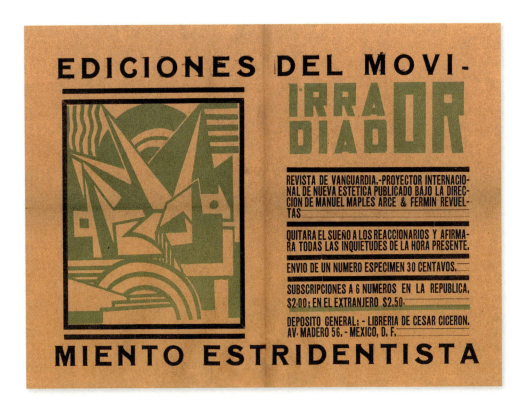

Artes del Libro, a direct result of the stimulus of the new school, was produced entirely by teachers and students. During the years in which it appeared, its ten issues were a genuine window onto the state of design education and edition. Besides the complementary informative contents that proved useful for students, they also published political and relevant opinions related to the school's internal affairs.

It is important to mention that in issue number 4 of *Artes del Libro* (1958) the Dutch printer Alexander Stols, who had settled in Mexico in 1956 (Garone Gravier, 2011a, 83), described the task of *designers*; in other articles he would speak of *book designers*, *typographic designers* and *type designers*. Issue number 10 of the review also included the term *diseñista* (designist), employed by Luis Zepeda in an article on the planning of originals, although the most usual term for book designer in Mexico was *maquetista* (typesetter), an expression we find in several colophons on Mexican printed matter, even in the 1930s. The conceptual transition in descriptions of today's graphic design is but one example of the change of position regarding the new visualities. The practice of traditional typographers and graphic workers gingerly gave way to more across-the-board professionals who did not only concern themselves with technical aspects, but also with esthetic issues and editorial composition.

While visual, literary, and commercial exchanges between Mexico and Europe were produced steadily from the mid-19th century onward, it wasn't until the 1920s that they had a more decisive impact on national culture, in general, and on the arts of the book, in particular. Only after that period would the turbulent political waters of Mexico gradually begin to

still, the country's institutions begin to relax and guarantee the first subtle continuities in decision-making procedures, and a new model of country begin to be rehearsed, a territory reborn after internal strife and warfare. This was the context in which concerns regarding effective literacy programs and the cultural integration of rural and urban areas were clearly expressed by SEP and its printing press, the TGN, or National Graphic Workshops. Several publishing projects would soon be displayed as standards to try and eradicate the educational lag and ignorance. Among the most relevant are the magazine titled *El maestro. Lecturas clásicas para niños*, with beautiful drawings by Roberto Montenegro, assisted by a young Gabriel Fernández Ledesma, and books such as *La Ilíada*, *La Odisea*, and *La Divina comedia*, promoted by the Minister for Education José Vasconcelos in the collection of classics bound in green cloth that was widely circulated.

As regards book illustration, and bearing in mind the works in which aforementioned Montenegro played a role, a special mention must be made of the sinuous Modernist lines in the cover of *Música suave: versos* (1921), by José de Jesús Núñez y Domínguez, in keeping with a long list of books he illustrated during those years. The funny thing about such expressions of Art Nouveau in "Mexican style" is that they were also explored by other artists whom we would never associate with that esthetic trend—we are referring specifically to David Alfaro Siqueiros, who produced vignettes depicting ivy and animals for *Bélgica en la Paz*, published in 1919. Plant motifs featured in several covers during this period, including the neo-romantic or neo-popular cover for *Ensayos* (1917), by Robert Louis Stevenson, that we could relate to certain formulas in the manual *Método de dibujo* published by Adolfo Best Maugard in 1923, and *El corazón delirante* (1922), by Jaime Torres Bodet, characterized by a stylized Symbolism.

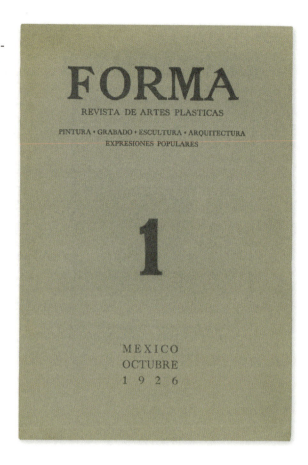

Forma: revista de artes plasticas, year I, no. 1, October 1926. Mexico City. Public Secretariat and National University of Mexico. 34 x 22.8 cm. Private collection, Granada

→

Cover by Gabriel García Maroto for *Contemporáneos: revista mexicana de cultura*, year I, no. 1, June 1928. Editors: Bernardo J. Gastelum, Jaime Torres Bodet, et al., Mexico City. n. p. 22.8 x 16.2 cm. Ramón Reverté Collection, Mexico City

The reference to Best Maugard and the emergence of the "popular" is no minor issue, for the trend would be interwoven in graphic design and other artistic expressions in Mexico after the memorable exhibition of folk art promoted by Roberto Montenegro, Jorge Enciso, and Dr. Atl in 1921. The following year, two volumes on the subject were published by Atl, with stenciled covers. That of *Itinerario contemplativo* (1923), by Francisco Monterde, depicts plants and animals that resemble embroidery; Carlos Mérida conceived two wonderful and synthetic covers for *La casa* and *Los días*, by Jaime Torres Bodet, both of 1923.

To return to Montenegro, he would soon turn from Symbolism to proto-avant-garde designs, a proven by the three illustrations he made for *Colores en el mar y otros poemas* (1921), by Carlos Pellicer, removed from the long shadow of Beardsley. Notably dynamic, in formal terms their influences range from *The Great Wave off Kanagawa*, by Hokusai, to the curved abstractions of the Delaunays. The dizzy impression would soon be further highlighted in the cover he designed for *Radio: poema inalámbrico en trece mensajes* (1924), by Luis Quintanilla (Kyn Taniya), perhaps the most avant-garde illustration ever conceived by Montenegro. It includes details such as the marine undulations that appear in the lower part of the composition and that liken it to Art Deco, a trend that would continue to appear almost a decade later in one of the strangest books he ever illustrated, *Esquizofrénico* (1933), by José Gómez Robleda, in which he deliberately emphasized the outlines of the figures, somehow monumentalizing them, as he had previously done in his portfolio *20 litografías de Taxco* (1930).

We mentioned earlier the editorial project of Talleres Gráficos de la Nación. Other similar ventures launched during these years concerned new conceptions of the literary canon, or rather of the ways in which it was expressed, transcending traditional newspaper and magazine

columns where it had appeared in the 19th century to associate itself with the ideas of series, collections, and publishing houses. This was the case of the hundred-year-old Cvltura (Cervantes and Valero, 2016)—born as a collection, it would subsequently become a publishing house that produced some uniquely beautiful and quite original works, such as those by the Stridentists or others by Dr. Atl. In keeping with his previous illustration for *Las artes populares en México* (1922), he continued to skillfully use stencils to produce literally unrepeatable designs for editions published by Cvltura, Botas, and México Moderno, as exemplified by his cover for *Óptica cerebral: poemas dinámicos* (1922), by Nahui Olin, his handmade versions for the portfolio *El paisaje: un ensayo* (1933), and *Cuentos de todos colores* (1933-1936).

So it was in the 1920s that foreign currents and movements coalesced with local esthetic concerns: Art Nouveau proposals, Expressionism,

Cubism, Futurism, Suprematism, De Stijl, and Art Deco were combined with independent, local trends as can be perceived in the works and procedures of members of the Mexican Muralist movement, Stridentism, the Group of Independent Artists, ¡30-30!, the League of Revolutionary Writers and Artists (LEAR, for its initials in Spanish), the Popular Graphics Workshop (TGP, for its Spanish initials), to mention but a few.

Some of these groups, that represented different ideological positions and were associated with a range of avant-garde isms, would have connections with political figures and sectors of power, thereby shaping a sort of Mexican cultural ecosystem. To a certain extent, they all enjoyed state favors, although some were chiefly peripheral and tangential while others were closely related to the central administration. Without wanting to generalize too much, we could say that it is difficult to find a cultural and editorial activity in Mexican history of the period outside the confines of the State. Even those trends that completely embraced the avant-garde played a key role in the government arts project, as exemplified by the members of the Stridentist group who established their administrative and cultural capital—Stridentopolis—in the state of Veracruz.

The Stridentist project was nourished by the work of a series of artists who made distinctive contributions to the illustration of book covers and inner pages. During the five years in which the movement was active, its books were published by Cvltura, Librería Cicerón and Ediciones Estridentistas, from1921 to 1925, and later by Ediciones de Horizonte, from 1926 to 1927. Representative of the first period were *Andamios interiores* (1929), *La señorita Etcétera* (1922), *Avión* (1923), *Esquina* (1923), *Urbe: súper poema bolchevique en cinco cantos* (1924) [the last two illustrated by Jean Charlot, who decided to follow the example of Cvltura publishers and replace the letter u with the letter v, hence, *Vrbe*], *Radio (poema inalámbrico en trece mensajes)* (1924) and *El pentagrama eléctrico* (1925). The second period, also known as the Jalapeño era, saw the publication of the trilogy titled *El café de nadie. Novelas*, by Arqueles Vela (1926), *El movimiento estridentista* (1927), by List Arzubide, and *Poemas interdictos* (1927), by Maples Arce, all displaying the same cover design by Ramón Alva de la Canal (Garone Gravier, 2014).

Besides Alva de la Canal, the other great Stridentist illustrator was Fermín Revueltas, who diagrammed covers and inner pages of the three issues of *Irradiador* (1923), the first mouthpiece of the movement, and collaborated more sporadically with the magazine that followed it, *Horizonte* (1926-1927). As regards book illustration, Revueltas would be particularly active in the 1930s, at the time of the outstanding amount of work—twenty-seven cover designs—he produced for *Crisol. Revista de crítica*, published by the Block of Workers and Intellectuals (BOI, for its initials in Spanish), which he came into contact with through Juan de Dios Bojórquez (Djed Bórquez), an agronomic engineer and politician for whom Dr. Alt had designed one of the boldest covers, that of *Pasando por París (Notas de viaje)* in 1929. Also for Bojórquez and Ediciones BOI, Revueltas designed the Japanesque cover of *El mundo es igual* (1931) and composed the typographic design of the cover of *Lázaro Cárdenas. Líneas biográficas* (1931). These illustrations anticipated the composition for *El son del corazón* (1932), a design inspired by Suprematism with a balanced text whose letters were characterized by geometric patterns. The book, a compilation of poems by Ramón López Velarde, also included nine ink illustrations by the same artist. His most avant-garde book illustrations were made in 1931: the cover for *...Y otros cuentos*, for Francisco Rojas González, and especially the compositions included in *Umbral*, by René Tirado Fuentes, which, according to Carla Zurián, would have been a Stridentist "classic"

had it been produced at the time the movement's members were active. Some of these are "made up of collages, bold typographic designs, concentric circles and a display of buildings, staircases, and airplanes that converge amidst letters, arrows, and bright advertisements" (Zurián, 2002, 69). Revueltas created another cover for aforementioned Rojas González, more realistic and in keeping with the social demands that in the 1930s were becoming increasingly important: *El pajareador* (1934), designed one year before his death.

Without attaining the exceptional quality of the images rendered by Revueltas in his book illustrations, we do come across others in the 1930s that extend the influence of Art Deco and of the avant-garde designs of the previous decade, albeit less experimentally, perhaps because they seemed to intend to popularize those styles and make them more palatable. This can be seen in the anonymous cover designed for *Horas grises* (1930), by José Vázquez Méndez, published in Querétaro, further proof of the existence of editorial activity in cities in inland Mexico. For *Urbe, campiña y mar* (1932), by Leopoldo Ramos, Héctor D. Falcón designed a discreet Art Deco cover that included visual references to the three places [city, countryside and seaside], among them the inevitable skyscraper and the synthetic marine undulations, and the title in a semi-circle. Fernando Bolaños Cacho, who designed numerous covers for Editorial Botas publishing house, illustrated both covers of the poetry compilation *Humaya* (1934), by Alejandro Hernández Tyler: the back cover with an abstract-geometric composition and the cover with a play on horizontal and vertical lines for the title, around an Indianist vignette.

Another form of modern illustration created between the late 1920s and early 1930s was practiced by a number of artists who preferred more linear drawing. Several of these worked for *Contemporáneos* review, founded in 1928. During these years this taste for drawing produced several unique works, such as the illustrations by Julio Castellanos for *Red*, by Bernardo Ortiz de Montellano, those by Xavier Villaurrutia for his own book *Dama de corazones*, that Juan Manuel Bonet associates with the esthetics of Jean Cocteau (Bonet, 2010, 34), and the cover of *El joven*, by Salvador Novo, designed by Roberto Montenegro.

This enthusiasm for lyrical drawing linked to book illustration was experienced throughout the continent, and in many cases had Mexican connections. In Buenos Aires, Norah Borges explored the genre after working with woodcuts, and among the many illustrations she created were those of *Fuga de navidad* (1929), by Alfonso Reyes. Also in Buenos Aires worked Mané Bernardo, Silvina Ocampo, Jorge Larco, and later on, Luis Seoane, in the wake of the Lithuanian-Brazilian artist Lasar Segall. In São Paulo, Manoel de Abreu illustrated his own *Poemas sem realidade*, published in 1934 (see p. 237), years after the Spaniard José Moreno Villa, who would later seek exile in Mexico, made the drawings for another work by Reyes, *La saeta*, published in Rio de Janeiro in 1931. During a stay in Buenos Aires, Federico García Lorca (also from Andalusia, like Moreno Villa) produced his personal style of lyrical illustrations for *El tabernáculo*, a booklet—*plaquettes*—by the Argentine author Ricardo Molinari (see p. 140), and *Seamen Rhymes*, by the Mexican writer Salvador Novo. Both books appeared in 1934, that is, the year after *Oda a Walt Whitman* by Lorca was published by Alcanía in Mexico; with a print run of fifty copies, decorated with subtle lines by Manuel Rodríguez Lozano, it is quite likely the most exceptional of Lorca's works, a collector's item.

The work of another Spanish artist who had close ties with Mexico, Gabriel García Maroto, deserves a paragraph of its own. The author of several self-illustrated books published in Spain in the 1920s, in a few of which he aspired to

 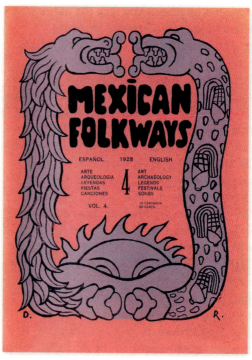

modernize regional traits of the peninsula by means of synthetic and often dynamic drawings, Maroto revealed his attraction for Mexico when he presented the *Escuelas de Pintura al Aire Libre* exhibition in Madrid in 1926, in the context of which he delivered the lecture "La revolución artística mexicana. Una lección" (subsequently published) in December 1926. In 1928, once his relationship with the intellectuals who belonged to Los Contemporáneos group had been consolidated, La Gaceta Literaria publishers in Madrid launched his book titled *Galería de los poetas nuevos de México*. In all probability, he also designed the cover of *Antología de la poesía mexicana moderna*, by Jorge Cuesta, released by the group's own publishing house. Of what we are completely sure is that he was responsible for the cover of *Contemporáneos* review, characterized by a combination of neo-Pre-Hispanism (represented by a mask) and modernism (embodied in a post-Cubist composition with an aerial and a still life), that would be repeated throughout the life of the magazine since its birth in 1928, the only variation being the plays of color. That same year, besides publishing his exceptional *Veinte dibujos mexicanos*, he created the lithographs illustrating the poetry book *Crucero*, by Genaro Estrada, published by Cvltura, and the work *España fiel*, illustrated with fourteen markedly avant-garde drawings. Following his experience as a teacher in inland Cuba (1931), no doubt the high point of his career was a similar task carried out in Michoacán, that culminated with the brilliant edition *6 meses de acción artística popular* (1932) printed on sheets of different color and size and including strong reminiscences of poster design, superimposition of illustrations, calligraphic games, and even a wide repertoire of woodcuts made by the pupils he taught during his sojourn in the state.

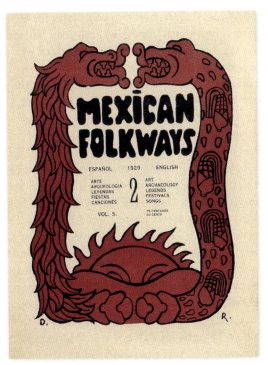 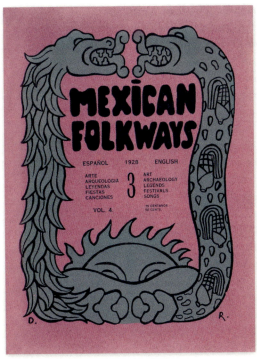

Covers by Diego Rivera for *Mexican Folkways*, vol. 3, no. 2; vol. 4; and vol. 5, no. 2, 1927-1929. Editor: Frances Toor, Mexico City. Frances Toor. 28.5 × 21 cm. Ramón Reverté Collection, Mexico City

In the first half of the 20th century, different production and printing techniques coexisted, bringing a special uniqueness to many bibliographic projects. Woodcut prints, that were first produced in Mexico during the colonial period, would continue to be favored throughout the 19th century and flourished in the 20th century thanks to artists such as José Guadalupe Posada, who passed away in 1913. The oeuvre of this artist from Aguascalientes, which is now synonymous with popular graphic art although it certainly stands for much more, would be rediscovered for Mexico and the rest of the world by a dazzled Jean Charlot.

The success and survival of xylography was not only a result of the reduced costs of its production in comparison with photomechanical media, but also of the flexibility and variety of formats it offered and of its plastic possibilities. The works produced by the Popular Graphics

Workshop, TGP, from its foundation in 1937 onward, and the use of woodblocks in numerous covers and decorated capitals in the inner pages of the books launched by various publishing houses are proof enough of the preference of Mexican artists for the technique. However, the appearance of rough materials and supports like wood didn't interfere with the existence of technically equipped establishments such as those of Manuel León Sánchez, or the TGN, that, founded around 1919, by the mid-1920s were serving the Secretariat of Public Education, SEP, the Secretariat of Foreign Affairs, or the Diario Oficial (Official Bulletin). To the aforementioned traditional techniques and the improved printing presses that appeared on the market we must add photography as a compositional element in modern editions. This area of the graphic arts that had secured its presence in the regular press would gradually conquer the space of the covers and inner pages of books.

In the visual gallery we have included at the end of this chapter we discover varied and meaningful examples of the inclusion of woodcuts in books. As seen in the chapters dedicated to other countries in the continent, in the early 1920s woodcuts were a form of expression favored in Argentina (where its practitioners included Norah Borges, Adolfo Bellocq and Ret Sellawaj), Uruguay (Federico Lanau, Melchor Méndez Magariños, and several other artists), and in Peru (where, under Mexican influence, José Sabogal would create remarkable headings). In the case of Mexico, the aforementioned Francisco Díaz de León and Gabriel Fernández Ledesma were key figures—the former renowned for his fifty-four woodcuts for *Campanitas de plata* (1925), by Mariano Silva y Aceves, and for the sixteen wooden cameos included in *Oaxaca* (1926), by Manuel Toussaint, a neo-popular design that imitates the silhouettes of the perforated paper (*papel picado*), anticipating the cover designed by Miguel Covarrubias two years later for *La feria (poemas mexicanos)*, by José Juan Tablada. As regards Fernández Ledesma, many of whose works were reproduced in several avant-garde reviews throughout the continent, he was very active in the field of woodcutting for books, as exemplified by the covers of *Las tristezas humildes* (1928), by Joaquín Méndez Rivas, or the colorful cover of *Juguetes mexicanos* (1930), emblematic within the wide repertoire dedicated to children's themes in Mexico, a sphere that included *Carretoncito* (1935), by Rubén W. López, illustrated by José Chávez Morado. It is quite probable that Fernández Ledesma, given his ties with Peruvian artists, designed the little-known woodcut cover of *El nuevo poema i su orientación hacia una estética económica* (1928), by Magda Portal, published by Ediciones Apra in Mexico just one year before he produced his wonderful album *15 grabados en madera* in Madrid, taking advantage of his sojourn in Spain to attend the Ibero-American Exposition staged in Seville.

Other artists were also producing meaningful works at this time. Roberto Montenegro made a well-known portrait of Salvador Novo that was used to illustrate the cover of *XX poemas* (1924), and other editions of works by the poet. Dr. Atl made the woodcuts for his own book *Cuentos bárbaros* (1930), but the most outstanding designer was Leopoldo Méndez, the future founder of the Popular Graphics Workshop (1937). In 1928 Méndez had produced two notable panoramic covers. One was for *Un fragmento de la Revolución*, by Praxedis Guerrero and Enrique Barreiro Tablada, and the other was for the second edition of *Emiliano Zapata: exaltación*, by Germán List Arzubide (the first edition, which he had also designed, combined a portrait of the revolutionary leader with a calligraphic game of horizontal and vertical lines, highlighted by yellow lines). These books, published in Veracruz (in Córdoba and Jalapa, respectively), revealed the convinced social

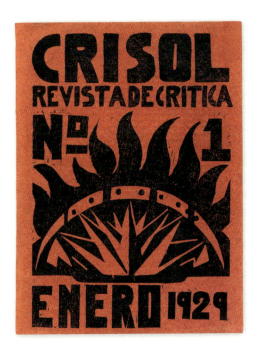

Covers by Fermín Revueltas for *Crisol: revista de crítica*, nos. 1 and 21, January 1929 and September 1930. Editor-in-chief: Miguel D. Martínez Rendón, Mexico City. Bloque de Obreros e Intelectuales. 22.5 x 16 cm. Ramón Reverté Collection, Mexico City

and political bias that characterized much of Méndez's career from then on, exemplified in the two-colored cover of *La ciudad roja* (1932), by José Mancisidor (that did not contain woodcuts). In all likelihood he also designed the cover of *La asonada. Novela mexicana* (1932), by José Mancisidor, launched, like *La ciudad roja*, in Jalapa by Integrales publishing house, championed by Grupo Noviembre.

Of what there is no doubt is that he designed the cover for *Corridos de la Revolución* (1934), by Celestino Herrera Frimont, published in Pachuca, that includes a composition with a strong presence of calligraphy. The same artist has also been credited with the design for *Cartucho. Relatos de lucha en el norte de México* (1931), by Nellie Campobello (brush name of Francisca Ernestina Moya Luna), governed by two crossed belts of bullets, inscribed within the wide repertoire dedicated to revolutionary iconographies. This category also encompasses

other illustrations, such as those made by Aurora Reyes for *Flechas* (1937), by Lázara Meldiú, or, earlier, those by Julio Prieto for *Los fusilados* (1934), by Cipriano Campos Alatorre, published in Oaxaca one year before one of Prieto's masterpieces—the au pochoir illustrations for the second edition of *Corrido de Domingo Arenas*, by Miguel N. Lira, with a print run of two hundred and thirty copies.

Diego Rivera's career in the field of graphic illustration was prolific, so much so that it has been the object of exhibitions and specific books, but in the limited space we have in this chapter we would like to dedicate a few lines to his work. Besides his European and North American designs (see pp. 35, 40, 41 and 82), we must mention his book illustrations characterized by their social engagement, a characteristic of his murals: the early work for *El soldado desconocido* (1922), by Salomón de la Selva, but also *México en pensamiento y en acción* (1926), by Rosendo Salazar, and the cover of *Tercera Convención de la Liga de Comunidades Agrarias y Sindicatos Campesinos del Estado de Tamaulipas* (1928).

In the context of Stridentism, an avant-garde artist like Ramón Alva de la Canal designed the cover of *Plebe (poemas de rebeldía)* for his friend Germán List Arzubide. Published in Puebla in 1925, the composition was also clearly social, in keeping with the artist's early inclinations, and depicted a giant fist—the symbol of rebellion *par excellence*—in a setting filled with smoking chimneys. Alva de la Canal also designed the woodcuts included in *Panchito Chapopote* (1928), by Xavier Icaza, a book that could be described as ruralist, and *Madre Tierra. Poemas al Ejido* (1933), by Enrique Othón Díaz, with a woodcut design on the cover by Agapito Rincón Piña and neo-avant-garde inner illustrations by Eliseo Ramírez. As regards prints reproduced in books, the exceptional poem *Incienso en el rescoldo* (1935), by Antonio Moreno y Oviedo, with a print run of just two hundred copies, included original etchings by the artist from Veracruz, Isidoro Ocampo, who had previously been a disciple of Francisco Díaz de León's. This book was published by Cvltura, whose editorial decisions remained firm several lusters after its foundation.

Parallel to the literary project designed by Cvltura, Editorial Botas developed its own project. After having opened a bookstore in 1916, it went on to publish books until the mid-20th century. Its catalog encompasses over three thousand titles embracing literary themes, bullfighting and economics, and includes a long list of Mexican authors (including Mariano Azuela, Federico Gamboa, José Vasconcelos, Julio Jiménez Rueda, Alfonso Reyes, and Amado Nervo), besides translations such as those in the collection *Libros de Eça de Queiroz*. Botas was perhaps the most versatile and diverse publishers of this period, displaying a range of numerous styles and esthetic trends on its covers, among which those by the (still) enigmatic artist F. A. G are particularly outstanding. Chiefly produced in the late 1930s, the covers designed by this graphic artist present accomplished drawings of letters in works like *Ante el gran enigma*, by Teresa Farías de Isassi, *El hombre y otros poemas*, by José Inés Novelo, or *Semáforo*, by Roberto Núñez y Domínguez, all published in 1938. Characterized by a synthetic style, the compositions by this designer represented intersections of planes and geometric figures; his palette was unusually limited and included silver inks, which gave his work a schematic appearance, as opposed to the "persistent" figurative style of the period.

One of the artists who contributed numerous graphic works to Botas was Dr. Atl. The three volumes of his *Cuentos de todos colores* reproduced his own designs on their stenciled covers. The first of the three, published in 1933, harked back to the covers he had made for *El arte popular en México* the year before. The second one was a colorful abstraction of imperfect geometric designs combined with multiple

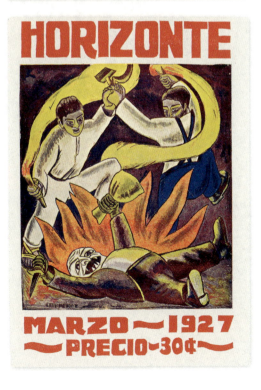

Cover by unknown artist for *Pulgarcito: órgano de la Sección Técnica de Dibujo, Departamento de Bellas Artes*, year VI, 3rd era, no. 38, May 1931. Editor and founder: Juan F. Olaguíbel. Mexico City, Secretaría de Educación Pública. 24.5 × 19.7 cm. Private collection, Granada

←
Covers by Ramón Alva de la Canal and Leopoldo Méndez for *Horizonte: revista mensual de actividad contemporánea*, vol. I, nos. 3, 10, 8 and 9, June 1926 to April-May 1927. Editor: Germán List Arzubide. Xalapa, n. p. 27 × 21 cm. Erik List Collection / Francisco Reyes Palma Collection, / National Art Museum, National Institute of Fine Arts, Mexico City

calligraphic games, and appeared in 1936. The third, also abstract although more measured, presented a greater use of lettering. Launched in 1941, it had much in common with the one he had designed five years before for *¡Oro más oro!* (1936), notable for its use of red inks and especially for the gold ink of the title, set against a black ground in what would be one of the most recognizable of the artist's compositions. Atl designed other significant covers for Botas, such as the one for *Un hombre más allá del universo* (1935), combining calligraphy with stenciled illustrations in three colors and brightly inserting blue diagonal lines that create a sort of inverted triangle. Contrarily, the pyramid as such, beside a giant cactus, the insertion of the word "italia," very expressionistic , and the use of calligraphy and diagonal lines in blue define the cover of *La defensa de Italia en México* (1936), a book published by the Italian colony in Mexico. On account of her personal closeness to Atl, who had been her partner the previous decade, we must speak of Nahui Olin (artist's name of Carmen Mondragón), who published and illustrated in black and white her book *Energía cósmica* (1937), characterized by a huge radiant and blazing sun, and the use of three different types of letters.

Another type of productions, apart from those derived from artistic avant-garde trends, literary movements, and the publishing houses themselves, are what we could call self-editions. The 1930s saw the appearance of the splendid calligraphic covers by Horacio Salvador Zúñiga Anaya. Born in Toluca, Zúñiga devoted his life to writing and teaching in several schools in the State of Mexico and the capital of the country; among his students were Octavio Paz and the ex-president of Mexico, Adolfo López Mateos. The composition of his covers seems to follow an absolutely personal model, as the letters show traits of what we call "signature-writing." Besides the practically uniform style of his covers, what leads us to consider his work self-editions is the fact that he published with an almost annual regularity during a whole decade, with different printing presses: J. M. Carrillo B., the Library and Archeology Department of the State of Mexico, and the Lino-typographical Workshops of the Industrial School of Arts and Crafts for Men, although the printers that produced most of his works was the Typographic Workshops of Gómez and Rodríguez.

In iconographic terms, the most outstanding proposals of the 1930s were no doubt those of a social and political nature, in keeping with the radicalization of conditions in society during that decade. While these circumstances have been discussed in other parts of this chapter, we will mention a number of references and thoughts. One of these is the profusion of symbolic elements present in traditional political graphic art. In this sense, we emphasize the presence of torches brandished in the virile arms of workers, as in the cover of the *Manifiesto anarquista* (1925), by Pierre Ramus. That same year saw the publication of the aforementioned *Plebe*, by Germán List Arzubide, with illustrations by Ramón Alva de la Canal, where we find another such emblem, the tightly closed fist, raised upward, like the one that would appear a decade later in the collage-drawing designed by Máximo Pacheco for the cover of *Programa económico y social de México (una controversia)*, published by Ramón Beteta in 1935.

Another author of the period, the Bolivian revolutionary Roberto Hinojosa, was one of those writers who enjoyed seeing his books published in several different countries of the continent. In Uruguay, *La rebelión de la raza de bronce* (1932) was launched, with a wonderful cover by one of the most important graphic designers in Montevideo, Humberto Frangella. In the case of Mexico, two editions are worth mentioning: *Justicia social en México* (1935) and *El tren olivo en marcha* (1937), modern in their conception, with handwritten texts moving in

different directions, diagonal planes and others with highly contrasted colors that strengthen the compositions, along with synthetic illustrations with a common feature, the sickle, another of the allegorical elements often repeated. In the first of these books, the crossed hammer and sickle are cut out against a blazing sun that rises behind the mountains; in the second, the sickle is tightly held in a hand and appears behind the presidential train in motion. In the cover that Clemente Islas Allende made for *Historia de las luchas proletarias de México* (1938), by Rosendo Salazar, the hands that clutch the hammer and sickle are the leitmotif of the composition, along with the factory with its steaming chimneys, although the design also includes an interesting calligraphic game in red, alternating horizontal and vertical lines in the title.

Another frequent theme were large crowds of workers, usually depicted in protest marches or strikes. Their presence in the graphic arts is closely related to the pictorial tradition of oils like *El cuarto estado* (1901), by the Italian painter Giuseppe Pellizza da Volpedo, and others closer in time and space, such as those painted in the mid-1930s by Marcelo Pogolotti in Cuba or Antonio Berni in Argentina. Two years after having designed the cover of *Madre Tierra* for Enrique Othón Díaz, Agapito Rincón Piña composed that of *Ante el futuro de México* (1935) for the same author, representing a column of workers marching in front of a factory. The cover of *1º de Mayo. Pro 8 horas de jornada* (1936), by Felipe Leija Paz, was even more gloomy, as four workers hang in the foreground, set against the backdrop of the factory. In both these compositions (especially in the latter), the verticality of the composition is emphasized by the presence of chimneys.

Funnily enough, *Chimeneas* was the title of the only novel published by Gustavo Ortiz Hernán. Launched by Editorial México Nuevo in 1937, it appeared in a classic edition with a sober typographic cover, and a de-luxe edition, which boasted one of the most impressive covers of the decade with geometric letters arranged at an angle that, in turn, frame a splendid vignette of factory silhouettes and delicate chimneys issuing smoke that rises vertically in straight lines. Rendered in four colors, it was designed by Salvador Pruneda. This book is still remembered (and sought as a collector's item) on account of its photographic section, that includes photomontages by Agustín Jiménez, Enrique Gutmann, and Agustín Víctor Casasola.

In some provincial Mexican towns we also come across unique books with "social" illustrations that are scarcely known. This is the case of *Levadura: novela del camino real de la vida* (1934), a book published in Mérida by Carlos Duarte Moreno, with graphic illustrations by the artist Raúl Gamboa Cantón from Yucatán. The cover presents a number of paradigmatic features: in the foreground we see a vigorous worker dressed in overalls, almost held up by the raised hands of a crowd—some of whose members carry tools—set against a backdrop of huge flames. In the inner pages we discover a few Symbolist scenes (a triple crucifixion) combined with city scenes characterized by the presence of skyscrapers in angular perspectives in which the laborers appear to be oppressed. A certain chaos of elements unfolds on the faceted cover, in six planes, of *Calles y su gobierno* (1931), by Luciano Kubli, illegibly signed; its inner drawings are by Diego Rivera and Salvador Pruneda. Pruneda would also design the cover of *Sureste proletario* (1935) for Kubli, with angular titles and the dominant presence of the black silhouette of a farmer at work set against a red ground. Farmers tilling the land also appear on the cover of *Mezclilla* (1933), by Francisco Sarquis, designed by Luio De la Fuente, and in the panoramic composition in *Las montañas y los hombres* (1939), by M. Ilin, one of the first works by the exiled Spanish artist Josep Renau.

On the subject of Renau and artists in exile, and in keeping with what was happening throughout the American continent, numerous illustrated Mexican editions would be dedicated to the Spanish Civil War and other political and social events of the Iberian Peninsula. Notable for their design were books like *El octubre español* (1935), by Luis Octavio Madero, that includes one of the best compositions by aforementioned Salvador Pruneda, and the anonymous cover of *Euzkadi en llamas* (1938), by Ramón de Belausteguigoitia, that depicts the bombing of a Basque village. Of course, many books were published directly by émigrés as they arrived in Latin America. Such is the case of the poet from Zamora León Felipe, who shortly after reaching Mexico launched *La insignia* under a publishing house of the same name (1938), with a cover characterized by a large red star. This edition was followed by that of *El hacha. Elegía española* (1939), with a cover designed by Gregorio Prieto.

Futuro: revista bimensual, nos. 2 and 3, January and February 1934. Editor: Vicente Lombardo Toledano, Mexico City. 21.5 x 32.5 cm. Ramón Reverté Collection, Mexico City

Although we have so far chiefly discussed publishers that had Mexican capital and workforces, we should also refer to the renewed impulse to the publishing industry after the arrival of a great number of artists, intellectuals, and professionals who, like León Felipe, Renau, and so many others, entered the country having fled from the Spanish Civil War. While not all the projects connected with their exile made the same impact on Mexican cultural life, indeed some were really short-lived, there can be no doubt of their influence on publishing, graphic culture, and the arts of the book in the country. Suffice it to mention figures like Elvira Gascón, a prolific book illustrator, and Manuel Altolaguirre, who, together with Concha Méndez, worked on numerous cultural projects in Mexico, some of which emerged from La Verónica printing press, reborn in Mexico.

The discursive continuity of the characters, texts, and works we have just surveyed in the history of books and printing presses can also be traced in the history of graphic design in Mexico. After a few earlier examples, in the 1920s Mexican graphic design began to spread its wings, becoming a clear focal point and an ideal space for experimentation and fine-tuning of graphic modernity. It is no coincidence that, of all the possible spheres of cultural action, the one that produced the most plentiful and obvious expressions of modernity was editorial production. We are not excluding music, theater or dance, but it was precisely the repetition and reproduction of objects—in this case, publications—that intensified the effect of cultural progress.

The standards of printed matter that were established between 1920 and 1940 would be reinforced over time, and embodied by a few significant characters. The group of four artists (Spanish and Mexican) Fernández Ledesma, Díaz de León, Miguel Prieto, and Vicente Rojo had been preceded by other renowned creators in traditional means of artistic expression. Mexican Muralists, accompanied by numerous draftsmen and easel painters, considered the making of book and magazine covers and the organization of inner pages with drawings and capital letters a tangible option for carrying out a craft that paralleled other artistic practices, a turn toward smaller and more malleable formats, though not less important. From then onward, books and magazines would be a launch pad for ideas proposed by graphic modernity in Mexico.

So was there any particular aspect characterizing Mexican visual modernity, in comparison with those existing in other Latin American countries? Perhaps what enables us to speak of *modernity* isn't in fact a schism but a continuity of the graphic art propounded by the European avant-garde. The angles of forty-five degrees and the orthogonal arrangements of texts on covers, the use of a contrasted chromatic palette, idealized and stylized images of technology and the city, the counterpoint of the sizes of letters and the use of typefaces without finishing strokes are undeniable proof of the continuity, in varying degrees, we find in the books published in other countries in the region. "Mexican" traits are visible in the technological coexistence of past and present, the result of a healthy acquiescence of the invariably lethargic material conditions of production. They will also appear in certain traditional graphic motifs, presented as novelties: autochthonous plants and animals, and pre-Hispanic buildings stylized in order to be integrated in a universal language. And it is precisely this interaction between past and present that is perhaps the most distinctive sign of local graphic modernity. Modern Mexican art would never completely dissociate itself from the bygones it appeared determined to leave behind.

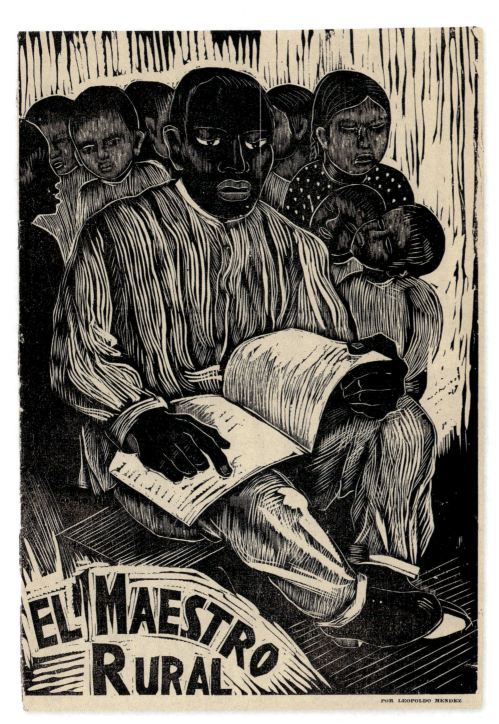

Cover by Leopoldo Méndez for *El maestro rural: Órgano de la Secretaría de Educación Pública consagrado a la educación rural*, no. 1, March 1932. Mexico City, Secretaría de Educación Pública. 43.2 × 27.9 cm. Rafael Barajas Collection

Mexico

Cover by unknown artist for Gonzalo de la Parra, *De cómo se hizo revolucionario un hombre de buena fe,* Mexico City. n.p. 1915. 20 x 15 cm.
Archivo Lafuente

Cover by Cordero for Jaime Torres Bodet, *El corazón delirante,* Mexico City. Porrúa, 1922. 18.8 x 12 cm.
Archivo Lafuente

Cover by Roberto Montenegro for José de Jesús Núñez y Domínguez, *Música suave: versos,* Mexico City. Librería Española, 1921. 17.2 x 14.7 cm.
Private collection, Granada

Cover by Matilde Eugenia for Robert L. Stevenson, *Ensayos,* Mexico City, Cultura, 1917. 17.5 x 11.5 cm.
Archivo Lafuente

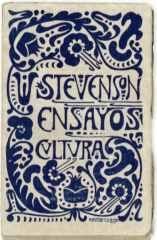

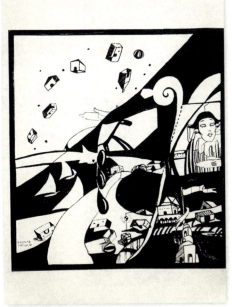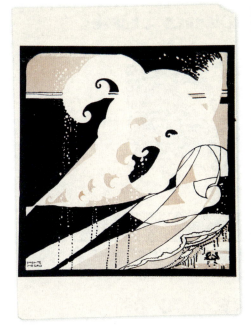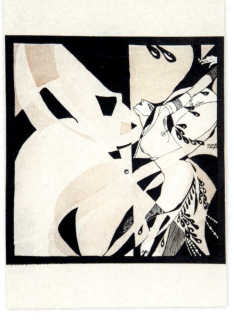

Inner pages by Roberto Montenegro for Carlos Pellicer, *Colores en el mar y otros poemas*, Mexico City. Cultura, 1921.
23.5 x 17.5 cm.
Ramón López Quiroga Collection, Mexico City

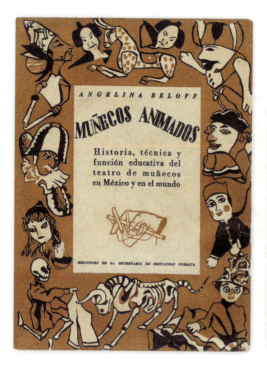
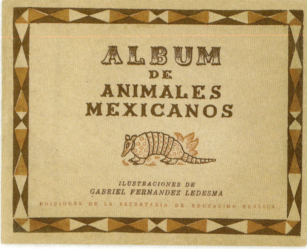
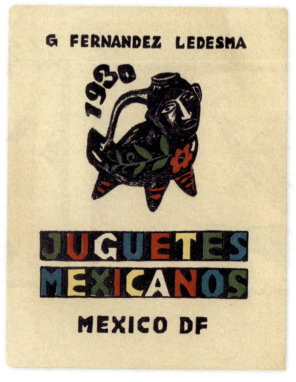

Cover by Gabriel Fernández Ledesma for Angelina Beloff, *Muñecos animados*, Mexico City. Secretaría de Educación Pública, 1945. 22.5 × 17 cm.
Mercurio López Casillas Collection, Mexico City

Cover by Gabriel Fernández Ledesma for *Álbum de animales mexicanos*, Mexico City. Secretaría de Educación Pública, 1944. 17 × 21 cm.
Ramón Reverté Collection, Mexico City

Cover by Gabriel Fernández Ledesma (author) for *Juguetes mexicanos*, Mexico City. Publishers of La Nación, 1930. 23.3 × 18.6 cm.
Private collection, Granada

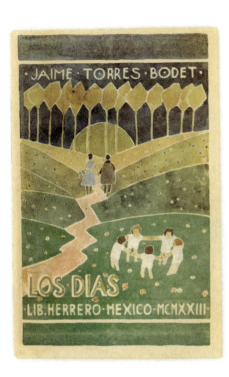 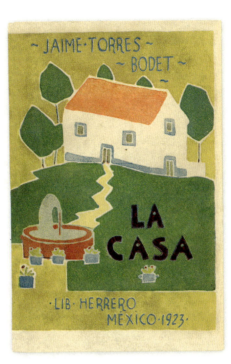

Cover by Carlos Mérida for Jaime Torres Bodet, *Los días*, Mexico City. Herrero Hermanos, Sucesores, 1923.
19.4 x 12.8 cm.
Archivo Lafuente

Cover by Carlos Mérida for Jaime Torres Bodet, *La casa: poema*, Mexico City. Herrero Hermanos, Sucesores, 1923.
19.4 x 12.8 cm.
Archivo Lafuente

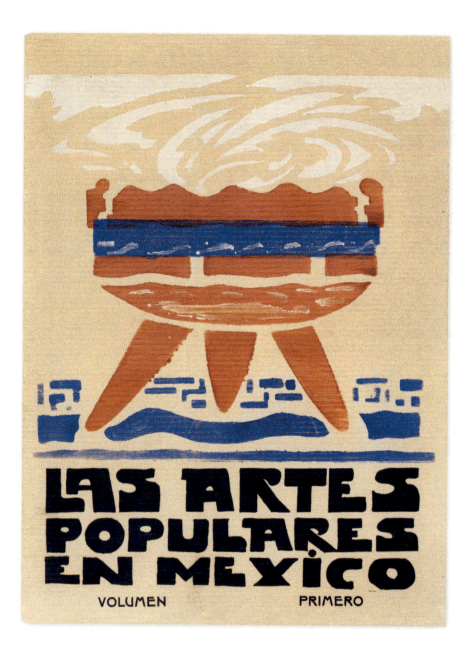

Cover by Dr. Atl (brush name of Gerardo Murillo, author) for *Las artes populares en México*, vol. I, Mexico City. Cultura, 1922. 29.5 x 22.5 cm.
Ramón López Quiroga Collection, Mexico City

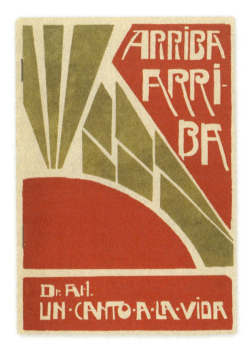

Cover by Dr. Atl (brush name of Gerardo Murillo, author) for *¡Arriba, arriba! Un canto a la vida*, Mexico City. n. p., 1926.
Ramón Reverté Collection, Mexico City

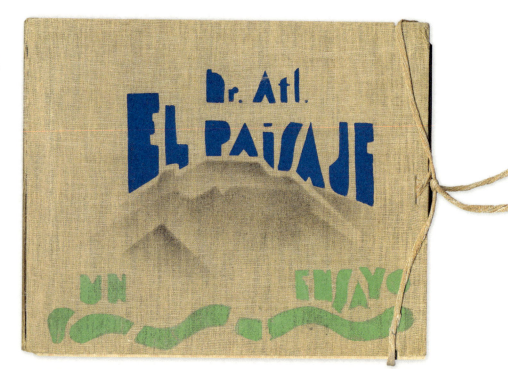

Cover by Dr. Atl (brush name of Gerardo Murillo, author) for *El paisaje: un ensayo*, Mexico City. n. p., 1933. 24.5 x 30.5 cm. Private collection, Granada

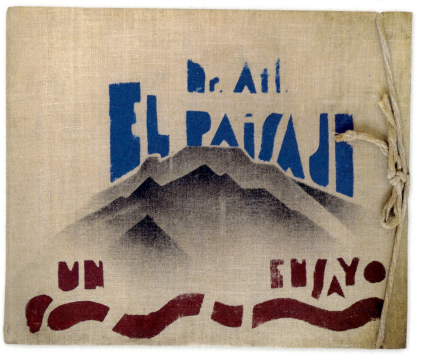

Cover by Dr. Atl (brush name of Gerardo Murillo, author) for *El paisaje: un ensayo*, Mexico City. n. p., 1933. 13.8 x 17 cm. Ramón López Quiroga Collection, Mexico City

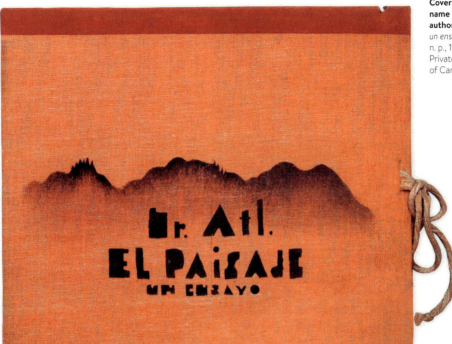

Cover by Dr. Atl (brush name of Gerardo Murillo, author) for *El paisaje: un ensayo*, Mexico City. n. p., 1933. 21.3 x 26.3 cm. Private collection, Courtesy of Carmen Alonso, Spain.

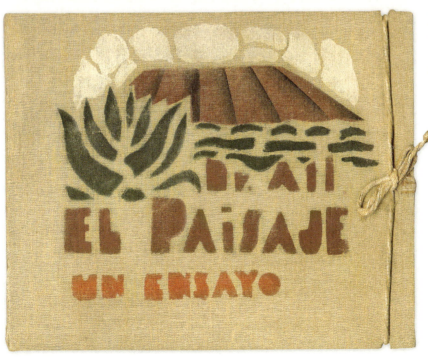

Cover by Dr. Atl (brush name of Gerardo Murillo, author) for *El paisaje: un ensayo*, Mexico City. n. p., 1933. 22.6 x 28.3 cm. Ramón López Quiroga Collection, Mexico City

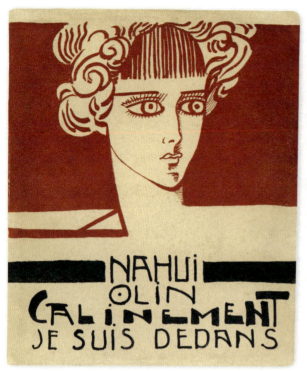
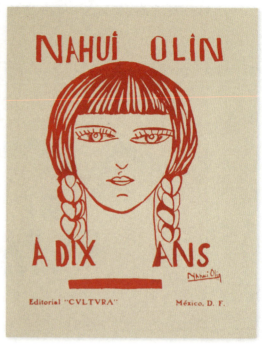
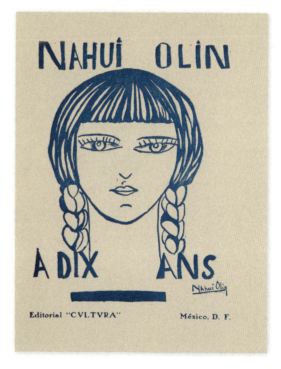

Cover by Dr. Atl (brush name of Gerardo Murillo, author) for Nahui Olin (artist's name of Carmen Mondragón, author) for *Câlinement: je suis dedans*, Mexico City. Librería Gullot, 1923. 25 x 19.7 cm. Ramón López Quiroga Collection, Mexico City

Cover by Dr. Atl (brush name of Gerardo Murillo, author) for Nahui Olin (artist's name of Carmen Mondragón, author) for *À dix ans. Sur mon pupitre*, Mexico City. Cultura, 1924. 24.4 x 19.4 cm. Ramón López Quiroga Collection, Mexico City

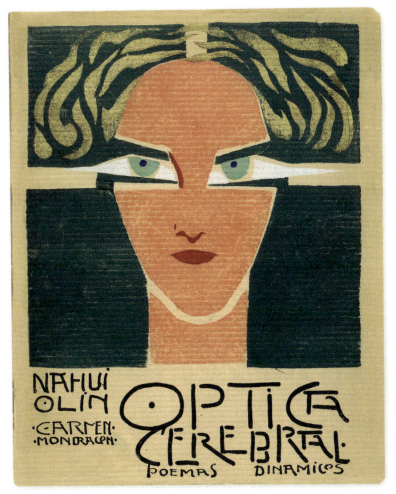

Cover by Dr. Atl (brush name of Gerardo Murillo, author) for Nahui Olin (pen-name of Carmen Mondragón, author) for *Óptica cerebral: poemas dinámicos*, Mexico City. Ediciones México Moderno, 1922. 24.7 x 19.6 cm. Ramón López Quiroga Collection, Mexico City

Cover by Ramón Alva de la Canal for Salvador Gallardo, *El pentagrama eléctrico*, Puebla. Germán List Arzubide, 1925.
24 x 17 cm.
Ramón López Quiroga Collection, Mexico City

→»
Cover by Dr. Atl (brush name of Gerardo Murillo) for Kyn Taniya (pen-name of Luis Quintanilla), *Avión: 1917-poemas-1923*, Mexico City. Cultura, 1923.
23.4 x 17.4 cm.
Archivo Lafuente

Cover by Vargas for Manuel Maples Arce, *Andamios interiores*, Mexico City. Cultura, 1922, 21 x 16 cm.
Echaurren Salaris Foundation

Cover by Jean Charlot for Germán List Arzubide, *Esquina*, Mexico City. Talleres Gráficos del Movimiento Estridentista, 1923. 23.5 x 17 cm.
Archivo Lafuente

Cover by Roberto Montenegro for Kyn Tanilla (pen-name of Luis Quintanilla), *Radio: poema inalámbrico en trece mensajes*, Mexico City. Cultura, 1924.
23.5 x 16.6 cm.
Archivo Lafuente

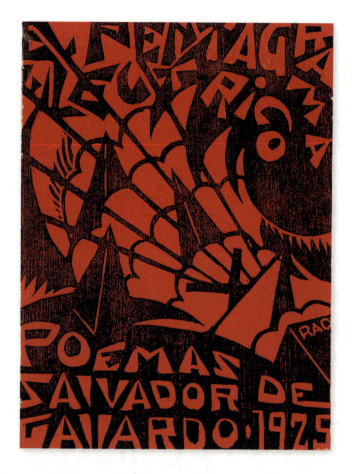

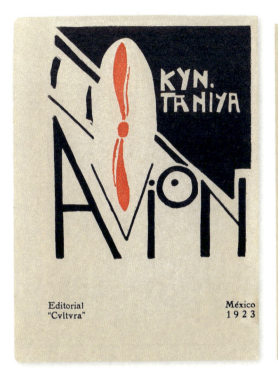
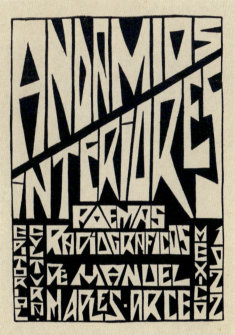
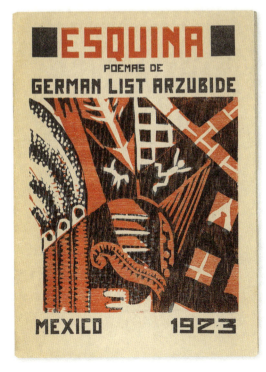
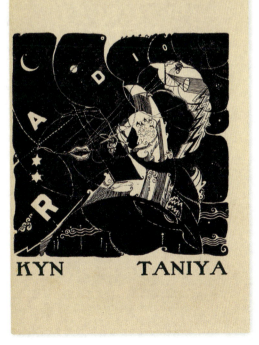

Cover and inner pages by Ramón Alva de la Canal for Germán List Arzubide, *El viajero en el vértice: poema,* Puebla. List Arzubide - Colón Gallardo, 1926. 23.7 x 17 cm. Ramón López Quiroga Collection, Mexico City

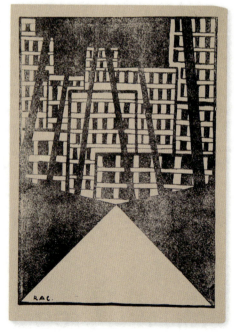

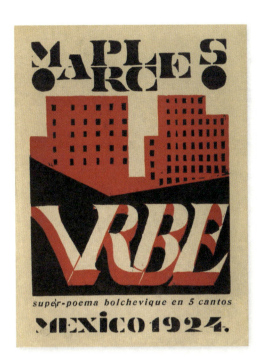
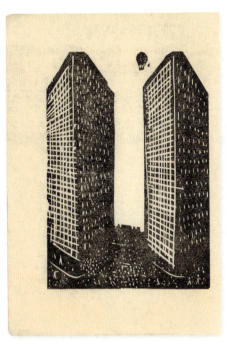
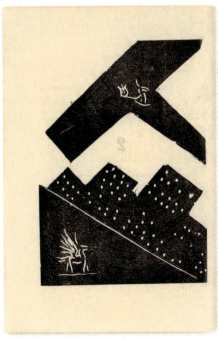

Cover and inner pages by Jean Charlot for Manuel Maples Arce, *Urbe: súper-poema bolchevique en 5 cantos*, Mexico City. Andrés Botas e hijo, Sucesores, 1924. 23 x 17 cm. Archivo Lafuente

Cover and inner pages by Ramón Alva de la Canal for Germán List Arzubide, *El movimiento estridentista*, Xalapa. Horizonte, 1927. 20.2 x 14.8 cm. Archivo Lafuente

Cover by Ramón Alva de la Canal for Arqueles Vela, *El café de nadie*, Xalapa. Horizonte, 1926. 20.6 x 14.6 cm. Archivo Lafuente

Cover by Ramón Alva de la Canal for Manuel Maples Arce, *Poemas interdictos*, Xalapa. Horizonte, 1927. 20.8 x 14.7 cm. Archivo Lafuente

Cover by Fermín Revueltas for Francisco Rojas González, *...Y otros cuentos*, Mexico City. Libros Mexicanos, 1931. 18 x 13 cm. Ramón López Quiroga Collection, Mexico City

Cover and inner pages by Fermín Revueltas for René Tirado Fuentes, *Umbral*, Mexico City. Author's self-edition, 1931. 24 x 16 cm. Archivo Lafuente

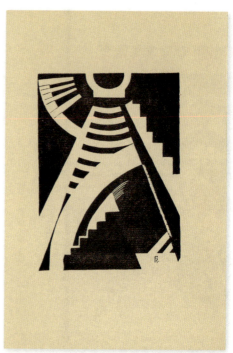
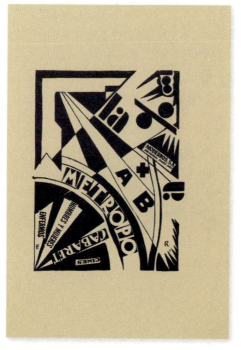
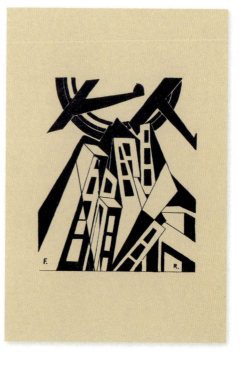

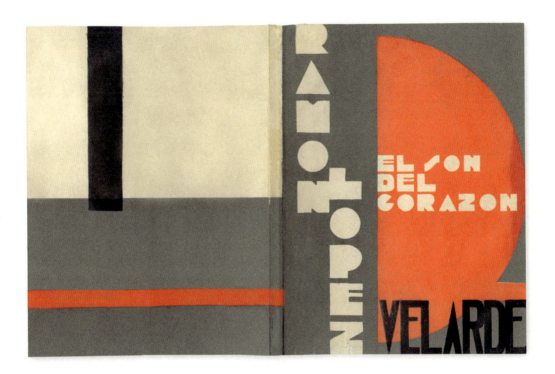

Covers by Fermín Revueltas for Ramón López Velarde, *El son del corazón: poemas*, Mexico City. Crisol, 1932. 23.3 x 17.5 cm. Archivo Lafuente

Inner pages by Gabriel García Maroto for Genaro Estrada, *Crucero: poemas*, Mexico City. Cultura, 1928. 24.3 × 16.3 cm.
Archivo Lafuente

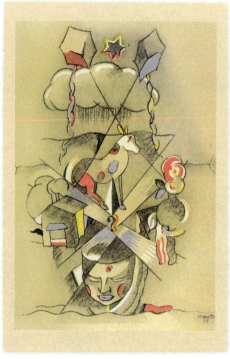

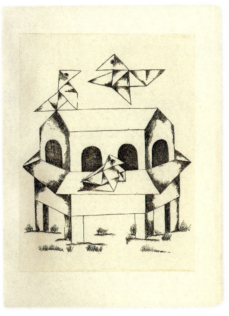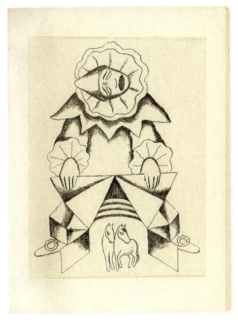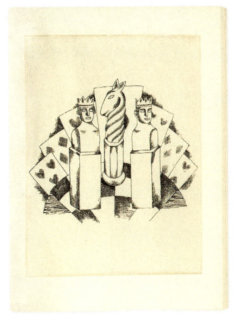

Cover and inner pages by Julio Castellanos for Bernardo Ortiz de Montellano, *Red*, Mexico City. Contemporáneos, 1928. 19.8 x 15.2 cm. Archivo Lafuente

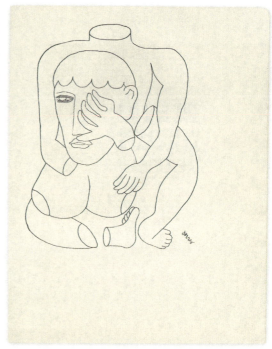
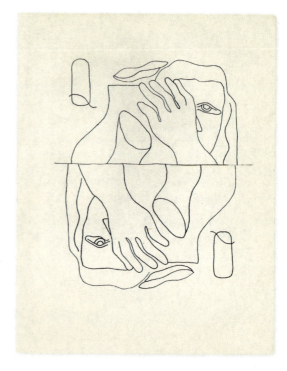

Inner pages by Xavier Villaurrutia (author) for *Dama de corazones*, Mexico City. Ulises, 1928. 25.3 x 19.5 cm. Ramón López Quiroga Collection, Mexico City

Cover by unknow artist (Gabriel García Maroto?) for Jorge Cuesta (editor), *Antología de la poesía mexicana moderna*, Mexico City. Contemporáneos, 1928. 20.7 x 15.5 cm. Archivo Lafuente

Cover and inner page by Isidoro Ocampo for Antonio Moreno y Oviedo, *Incienso en el rescoldo: poemas*, Mexico City. Cultura, 1935. 23.4 x 17.8 cm. Archivo Lafuente

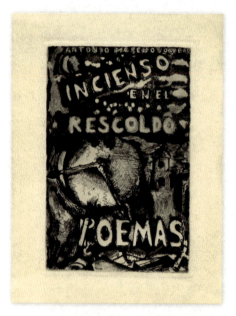
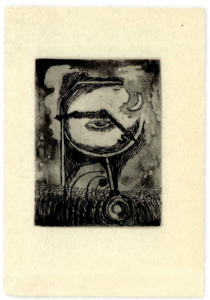

Cover and inner page by Alfredo Maya for Justino César Alcán, *"Yo": poemas*, Mexico City. Alcán y Lebrún, 1936. 20.4 x 14.5 cm. Archivo Lafuente

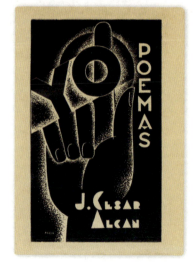

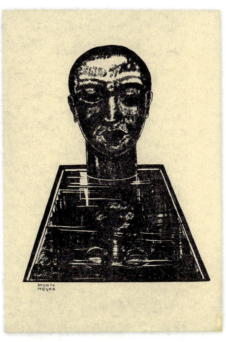
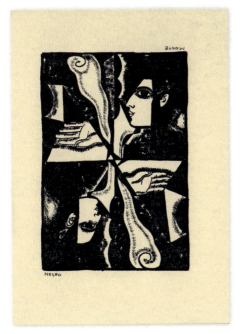
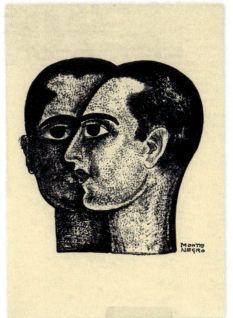

Inner pages by Roberto Montenegro for José Gómez Robleda, *Esquizofrénico*, Mexico City. Imprenta Mundial, 1933.
27.6 x 19.4 cm.
Private collection, Granada

Cover by Roberto Montenegro for Salvador Novo, *El joven: novela mexicana*, Mexico City. Popular Mexicana, August 1928. La Novela Mexicana Collection, vol. I, no. 2. 18.8 x 14.7 cm. Ramón López Quiroga Collection, Mexico City

Cover by Fermín Revueltas for Mario Pavón Flores, *El poeta del sol: ensayo*, Xalapa. Ediciones Integrales, 1933. Mercurio López Casillas Collection, Mexico City

Cover by Horacio Zúñiga (author) for *Mirras: poemas orfébricos*, Mexico City. Juan Manuel Carrillo B., 1932. 22.1 × 16.7 cm. Archivo Lafuente

Cover by Horacio Zúñiga (author) for *3 poemas a la madre*, Mexico City. Imprenta Gómez y Rodríguez, 1936. 22.7 × 16.8 cm. Archivo Lafuente

Cover by Horacio Zúñiga (author) for *La selva sonora: poemas orquestales*, Mexico City. Juan Manuel Carrillo B., 1933. 23.2 × 18.3 cm. Archivo Lafuente

Cover by Horacio Zúñiga (author) for *Verbo peregrinante: artículos, arengas, discursos, conferencias*, Toluca. Talleres Linotipográficos de la Escuela Industrial y de Artes y Oficios para Varones, 1939. 22.3 × 17.5 cm. Archivo Lafuente

Cover by Horacio Zúñiga (author) for *El hombre absurdo*, Mexico City. Imprenta Gómez y Rodríguez, 1935. 23 x 17 cm. Archivo Lafuente

**Cover and inner pages
by Gabriel García Maroto
(author) for** *México
Michoacán. 6 meses de
acción artística popular*, Morelia. Ediciones del
Gobierno del Estado, 1932.
33.1 x 22.2 cm.
Private collection, Granada

Cover and inner page by Francisco Díaz de León for Mariano Silva y Aceves, *Campanitas de plata: libro de niños*, Mexico City. Cultura, 1925. 23.3 x 18 cm.
Private collection, Granada

Cover and inner page by Francisco Díaz de León for Manuel Toussaint, *Oaxaca*, Mexico City. Cultura, 1926. 12.5 x 9.5 cm.
Archivo Lafuente

Cover and inner pages by Ramón Alva de la Canal for Xavier Icaza, *Panchito Chapopote: retablo tropical o relación de un extraordinario sucedido de la heroica Veracruz*, Mexico City. Cultura, 1928.
24 x 17.8 cm.
Archivo Lafuente

Cover and inner pages by Julio Prieto for Miguel N. Lira, *Corrido de Domingo Arenas*, 2nd edition, Mexico City. Fábula, 1935. 23.5 x 17.8 cm. Ramón López Quiroga Collection, Mexico City

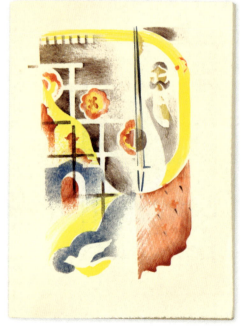

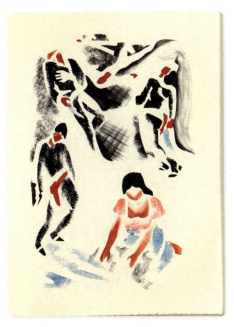 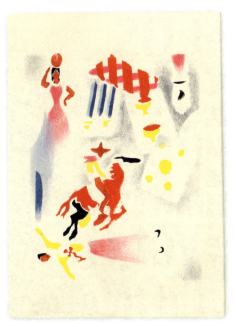
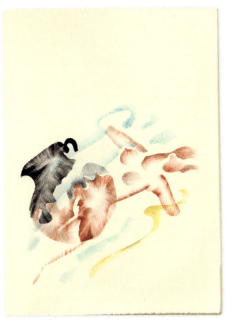

Cover attributed to Leopoldo Méndez and inner page by Leopoldo Méndez for Celestino Herrera Frimont (compiler), *Corridos de la Revolución*, Pachuca. Instituto Científico y Literario, 1934. 23.4 × 17.2 cm. Archivo Lafuente

Inner pages by Leopoldo Méndez for María del Mar, *La corola invertida: novela*, Mexico City. Author's self-edition, 1930. 21 x 25 cm. Ramón Reverte Collection, Mexico City

Cover by Diego Rivera for Rosendo Salazar, *México en pensamiento y en acción*, Mexico City. Avante, 1926. 23.7 x 17.5 cm. Archivo Lafuente

Cover by Diego Rivera for *Tercera Convención de la Liga de Comunidades Agrarias y Sindicatos Campesinos del Estado de Tamaulipas*, Mexico City. n. p., 1928. 22.5 x 17 cm. Archivo Lafuente

Covers by Leopoldo Méndez for Praxedis Guerrero and Enrique Barreiro Tablada, *Un fragmento de la Revolución*, Córdoba. Norte, 1928. 19.3 x 14.7 cm. Ramón Reverte Collection, Mexico City

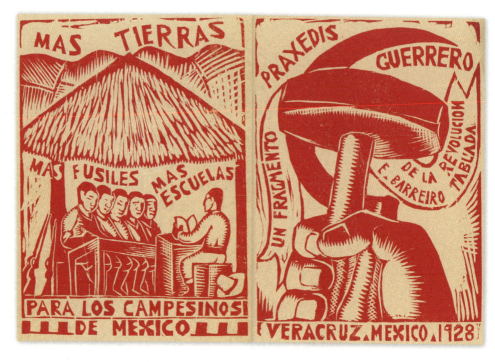

→»
Cover and inner pages by Raúl Gamboa Cantón for Carlos Duarte Moreno, *Levadura: novela del camino real de la vida*, Mérida. Imprenta Gamboa Guzmán, 1934. 19.5 x 14.3 cm. Archivo Lafuente

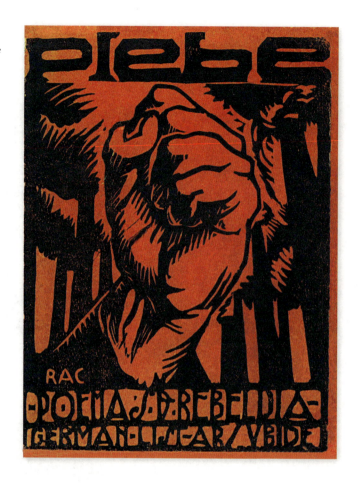

Cover by Ramón Alva de la Canal for Germán List Arzubide, *Plebe (poemas de rebeldía)*, Puebla. Author's self-edition, 1925.
20.5 x 15.5 cm.
Archivo Lafuente

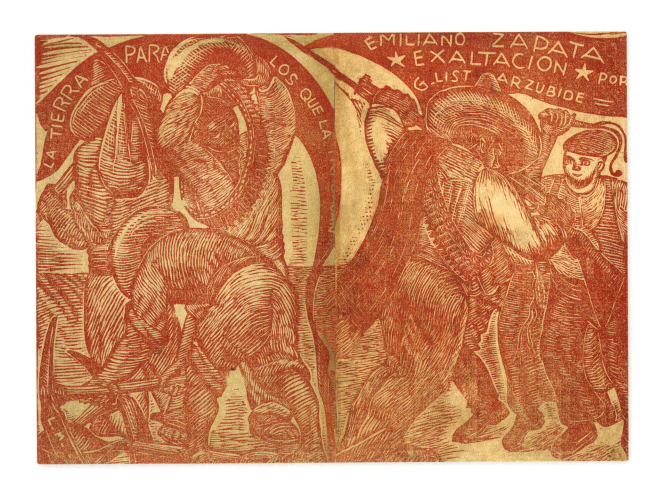

Covers by Leopoldo Méndez for Germán List Arzubide, *Emiliano Zapata: exaltación*, 2nd edition, Xalapa. n. p., 1928. 21 x 15 cm.
Ramón López Quiroga Collection, Mexico City

Cover by Julio de la Fuente for Francisco Sarquis, *Mezclilla*, Xalapa. Gleba, 1933. 19 × 13.5 cm. Private collection, Granada

Cover by unknown artist for Germán List Arzubide, *La lucha contra la mentira religiosa en la U. R. S. S.*, Mexico City. Federación Ateísta Mexicana, 1931. 21 × 15 cm. Ramón López Quiroga Collection, Mexico City

→
Covers by Josep Renau for Max Beer, *Historia general del socialismo y de las luchas sociales*, Mexico City. A. P. Márquez, 1940. 21 × 15.5 cm. Ramón Reverté Collection, Mexico City

Covers by Josep Renau for M. Ilin, *Las montañas y los hombres: ocho relatos sobre la transformación de la naturaleza*, Mexico City / New York / Paris. Estrella, editorial para la juventud, 1939. 18.8 × 15.2 cm. Archivo Lafuente

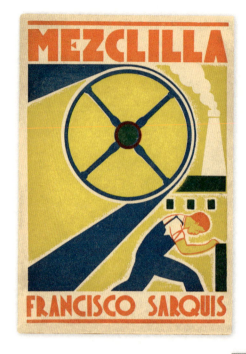
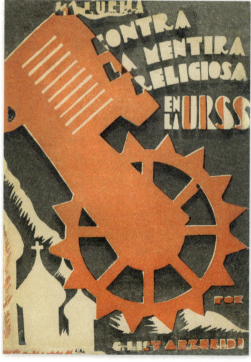

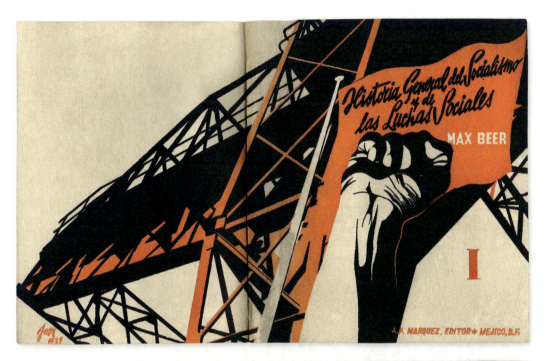
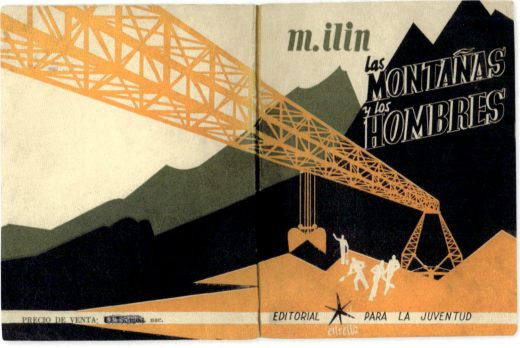

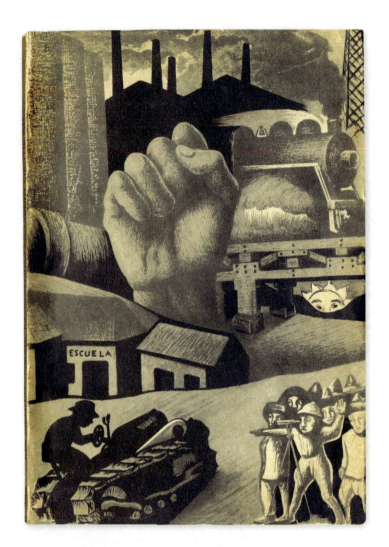

Cover by Máximo Pacheco for *Programa económico y social de México (una controversia)*, Mexico City. Ramón Beteta, November 1935. 23.1 x 16.4 cm. Mercurio López Casillas Collection, Mexico City

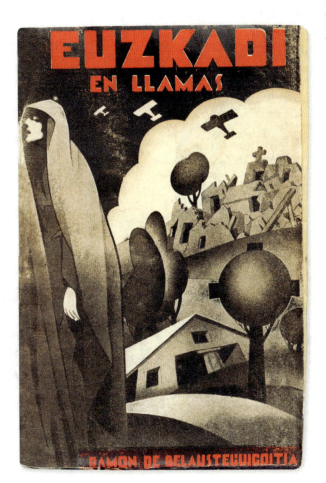

Cover by unknown artist for Ramón de Belausteguigoitia, *Euzkadi en llamas*, Mexico City. Botas, 1938. 20 x 13 cm. Archivo Lafuente

Cover by Salvador Pruneda and inner pages by Agustín Jiménez and Enrique Gutmann for Gustavo Ortiz Hernán, *Chimeneas: novela*, Mexico City. Editorial México Nuevo, 1937. 27.5 x 21 cm. Ramón López Quiroga Collection, Mexico City

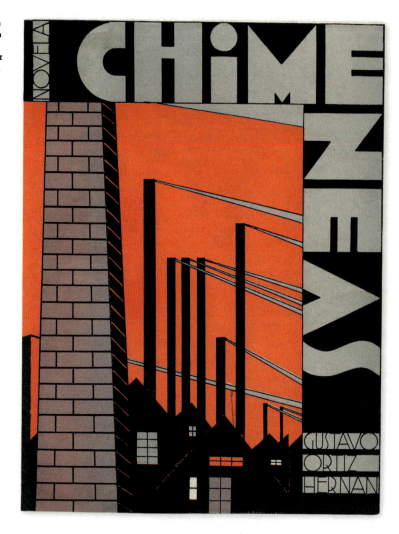

Foto Gutmann.

La fuga.

Fotomontaje feminas.

Un hombre que piensa.

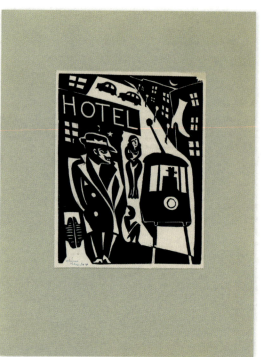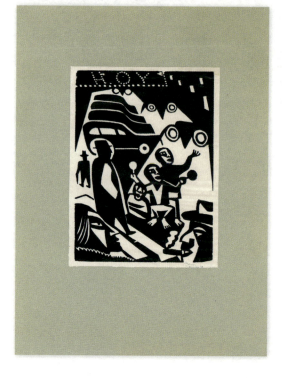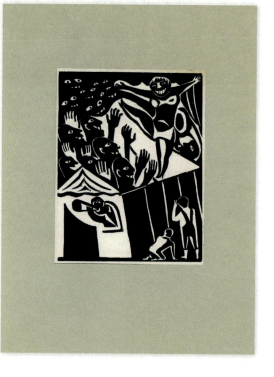

Dust jacket by Jorge González Camarena for *Molino verde*, 1932. Editors: Agustín Jiménez and Juan J. Ortega, México City. Montmartre, 23 x 16.8 cm. Alexis Fabry Collection, Paris

←
Inner pages by José Chávez Morado (author) for *Vida nocturna de la ciudad*, Mexico City. Ediciones Arte Mexicano, 1936. 23 x 18.9 cm. Mercurio López Casillas Collection, Mexico City

Cover by José Sabogal for *Amauta: revista mensual de doctrina, literatura, arte, polémica*, no. 28, January 1930. Editor: José Carlos Mariátegui, Lima. Sociedad Editora Amauta. 24.5 x 17.5 cm. Archivo Lafuente

Peru

Rodrigo Gutiérrez Viñuales

Unlike the cases of illustrated magazines and the facsimilization of several reviews, very few studies have dealt with the illustration of books in Peru during the period we are surveying. Nonetheless, in the past few years interest appears to have grown in book illustration, not only as an independent form of expression but also as narratives interwoven in the accounts of Modernist and avant-garde Peruvian art. The specific contribution of one of the most prominent of the artists working in the field, José Sabogal, renowned forerunner of Indianism/Indigenism in the country, whose designs were included in the catalog of his retrospective exhibition held in 2013 at the Lima Art Museum (MALI, for its Spanish initials), deserves a mention, as do the recent shows titled *Un espíritu en movimiento. Redes culturales de la revista* Amauta, staged in 2017 at the House of Peruvian Literature in Lima, and *Redes de vanguardia. Amauta y América Latina, 1926-1930*, that opened in Madrid in 2019 and toured to Lima, Mexico City and Austin.

We ourselves included numerous materials, both books and magazines, in *Cuzco-Buenos Aires. Ruta de intelectualidad americana (1900-1950)*, published in 2009, and to further emphasize the subject, in the article "Modernidad expandida. Perú en el libro ilustrado argentino (1920-1930)," that appeared in 2013 and included comments and references to several books published in Peru. That same year we extended the scope of our analysis of the "South American" texts included in the exhibition catalog *Alma mía: Simbolismos y modernidad en Ecuador (1900-1930)*, published in Quito. In these essays we traced an itinerary of Modernist Peruvian illustration, encompassing the Symbolist works of José García Calderón in Europe, those by José Sabogal and followers of his, such as Julia Codesido and Camilo Blas, and those of other "modern artists" like Carlos Quízpez Asín, Raúl Pro, Alejandro

Illustrations by Germán Suárez Vertiz, Germán Baltra and Manuel Domingo Pantigoso for *Guerrilla*, year I, nos. 2 - 4, March - May 1927. Editor: Blanca Luz Brum, Lima. Vicente Huidobro Foundation, Santiago de Chile

González Trujillo (Apu-Rimak), Manuel Domingo Pantigoso, Raúl Vizcarra, Emilio Goyburu or Carlos Raygada, among others.

These "precedents" are the basis of this brief introductory text to our visual journey which begins with an early example of Modernist trends in the illustration of literary works, such as the cover of *Las voces múltiples* (1916), an anthology launched in Lima by the French publishers Rosay, which included contributions by distinguished authors such as Alfredo González Prada, Abraham Valdelomar, Félix del Valle and Pablo Abril de Vivero, among other members of the literary group Colónida. The cover is a very early testimony of Reynaldo Luza's work as an illustrator. Calligraphy plays a key role in the composition: the names of the authors are framed in a sort of square-root that enriches a Modernist tree that symbolizes a certain sector of Peruvian letters. The color games and, especially, the use of yellow in the title and the treetop, set against a blue ground, produce a simple yet delicate effect. After an early European experience, Luza—an artist linked to the Colónida circle—had returned to Peru in 1914, upon the outbreak of World War One. In 1918 he left for New York, where the following year he made his first contributions to *Vogue*, a magazine he greatly admired, and in 1922 he began to design for *Harper's Bazaar*, becoming one of the publication's most outstanding cover designers.

On other occasions we have mentioned the year 1919 as a landmark in the influence of Modernist trends in Peruvian plastic art, for it was the year that two important events took place: on the one hand, the National Fine Arts School (ENBA, for its Spanish initials) was founded, under the direction of the painter Daniel Hernández, on April 15; on the other, José Sabogal arrived in Lima to exhibit at Sala

 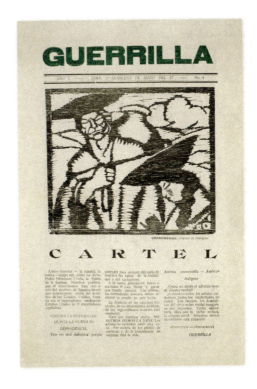

Brandes, after a long sojourn spent abroad, between Europe and Argentina. The show, titled *Impresiones del Ccoscco*, opened on July 15, barely ten days after Augusto B. Leguía had become President of the country, thereby ushering in the period known as the "Eleven-Year Regime" (1919-1930) during which the centenary of the country's independence would be lavishly celebrated in 1921. Despite the birth of ENBA and the appearance of Sabogal, the esthetics of Art Nouveau could already be traced in the country's illustrated reviews, as is particularly evident in *Variedades*, founded in Lima in 1908. These magazines reproduced numerous illustrations, vignettes, and caricatures that portrayed the dynamics of modern, everyday life with its gallantries, clothing, and other customs (Rivera Escobar, 2006).

During these years, the idea implemented by teachers at ENBA of including graphic design among their classes furthered the modernization of art that was under way in other cultural institutions in the continent. The new realm, still incipient in 1919, would soon be consolidated by the school, thanks to the work of teachers such as Daniel Hernández; often considered the most traditionalist of masters, in the field of graphic design ne proved to be one of the most advanced.

Several key artists in the Peruvian avant-garde trained under Hernández. Jorge Vinatea Reinoso, for instance, who designed the cover of the first edition of *Cuentos andinos* (1920), by Enrique López Albújar, and aforementioned Carlos Quízpez Asín, who illustrated that of *Deucalión* (1920), by Alberto Guillén; this was a Symbolist work—in 1921 he had received a prize awarded in Viña del Mar (Chile) for his Beardsleyesque design for *Bailarines*—produced shortly before he moved to Madrid to train at the Royal Academy of Fine Arts of San Fernando. His brother Alfredo

Illustrations by Manuel Morales Cuentas for *Boletín Titikaka*, May and July 1927. Puno, Vicente Huidobro Foundation, Santiago de Chile

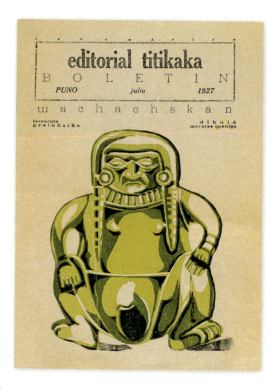

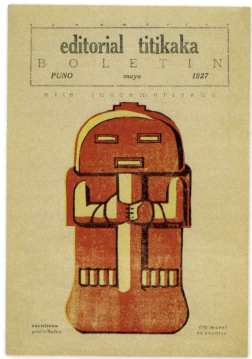

Quízpez Asín created two striking covers in 1922, one for *Atalaya*, by Federico Bolaños, with synthetic traits and a developing taste for geometrization that would soon characterize his plastic oeuvre produced under the artistic name César Moro he would adopt the following year, and one for *Alma errante*, by Roberto Mac-Lean y Estenós, more Symbolist in nature, that foreshadowed the composition by Jorge Seoane for *Piedras filosofales* (1923), also by Mac-Lean.

The writer Alberto Guillén we spoke of earlier, no doubt one of the authors who showed the greatest interest in having the covers of his books designed, deserves a special mention. Indeed, a survey of his covers could actually trace the history of editorial illustration in Peru. Among his works of Symbolist designs we find *Laureles* (1925), illustrated by Arístides Vallejo, uncle of the poet César Vallejo, many of whose works were published in magazines of the period.

Another of the teachers at ENBA was the Andalusian Manuel Piqueras Cotolí, known for his Neo-Peruvian architectural work which culminated in the construction of the Pavilion of Perú at the Ibero-American Exposition held in Seville in 1929. Piqueras taught several artists who would eventually devote themselves to illustration, among them Raúl Pro and Alejandro González Trujillo, who produced noteworthy examples of modern book design. In the Symbolist cover of *Prosas poemáticas* (1921), by Félix del Valle, Pro used the silhouette to achieve greater expressiveness; his cover for *Joyería* (Rome, 1927), by Juan Lozano y Lozano, was similarly relevant. In 1924, on occasion of the centenary of the Battle of Ayacucho, both Pro and Trujillo would take part in one of the most striking illustrated editions, Symbolist in style, made in Peru, that of *El hombre Sol. Trazo de una epopeya panteísta. Canto IV. Ayacucho y los Andes*, by José Santos Chocano, that also included illustrations by Raúl Vizcarra and Efrén Apesteguía. The design reveals the combination of Symbolism and the country's national history, quite abundant in those years.

Within the Symbolist repertoire we must mention a rarity—the collaboration between two key figures in the history of Peruvian architecture of the 20th century, between the literary author Héctor Velarde Bergmann and the illustrator Emilio Harth-Terré. Indeed, the latter produced a series of designs, including that of the cover, for the poetry compilation *En passant...* (1824), by Verlarde, consisting of linear drawings, many of them of landscapes, that had a slightly synthetic quality despite having freed themselves of canons of Symbolism. In his turn Velarde, chiefly known as one of the distinguished figures in modern Peruvian architecture, boasted a long literary career of which *En passant...* was an early expression. This book, which could almost be described as a poetic travelog with compositions signed in Paris, Buenos Aires, Boulogne-sur-Mer, Washington and New York (a poem devoted to skyscrapers), Colón and Lima between 1922 and 1924. Anecdotally, in order to reinforce the French-like quality of the book—Velarde had perfected his studies as an architect in Paris—Emilio Harth-Terré adapted his name, so on the cover we may read "illustrations d'Émile Harth-Terré." The same choice was made by the Brazilian author Sérgio Millet, who rechristened himself Sérge in *Le départ sous la pluie* (1919) with the same intention.

Despite the work of these aforementioned artists, the fields of painting and illustration in the 1920s were characterized by the work of José Sabogal. As a painter he was greatly influenced by Spanish regionalism, which he encountered on his trips to Europe (the first of which took place in 1908), and by Argentine genre painting and the esthetic defense of Andean Indigenists, assumed during his years in Tilcara (north Argentina), between 1913 and 1918, where he worked with Jorge Bermúdez, a renowned artist in these styles.

Coming into contact during his Argentine years with illustrated magazines such as the sumptuous *Plus Ultra*, that appeared in 1916, he familiarized himself with the Symbolist designs after Aubrey Beardsley made by famous draftsmen like Gregorio López Naguil, Jorge Larco, Rodolfo Franco or Alfredo Guido (colleague of Sabogal's at the Fine Arts Academy in Buenos Aires). Back in Peru, after displaying his work at Brandes art gallery in Lima (1919), Sabogal set out on a monumental task as an illustrator for the books by author Daniel Ruzo, for whom he made the illustrations for *Así ha cantado la naturaleza* (1920, with a second edition to follow in 1921 for which he varied the cover design) that could be considered more realistic, despite the traces of a Symbolist esthetic. Such changes would be obvious in the design for Ruzo's next book, *Madrigales* (1921), where Sabogal adopts linearly synthetic representations more

decidedly. His style in *El atrio de las lámparas* (Madrid, 1922), also by Ruzo, is halfway between the two trends, for it reproduces illustrations in the two earlier books, to which he adds a few avant-garde features. From this period in his oeuvre we have included—albeit in the section dedicated to pre-Hispanic illustrations—the cover for *Los hijos del sol* (1921), a posthumous book by Abraham Valdelomar (see p. 748) and an early example of his Incan style that would extend to later designs and anticipate the illustrations he published in *Amauta* and their pre-Hispanic Indigenist subject matter.

In 1922 Sabogal made what to turn out to be a decisive trip to Mexico where, from the following year onward, his experiments in woodcutting would characterize much of his production as an illustrator of books and magazines, as proven by *Croquis de viaje* (1924), by his wife María Wiesse. This technique would define the work of several of his followers in Peru and establish Indianist prints as a substantial chapter in the construction of artistic modernity in Peru. Without a shadow of doubt, Mexican artists such as Gabriel Fernández Ledesma, linked as a printer to several Latin American reviews and publishing houses throughout these years (this would certainly be a fine, albeit difficult, subject for a Ph.D.), or Francisco Díaz de León, a decisive figure in wood engraving and book production in the northern country, as we may read in the chapter written by Marina Garone Gravier in this book, influenced this stage in Sabogal's career.

The height of Sabogal's work as an illustrator would be the covers and inner pages of *Amauta* (Lima, 1926-1930), a journal founded by José Carlos Mariátegui that was widely distributed abroad. Save for a few odd occasions, Sabogal clearly left his mark, particularly in the woodcuts, both as regards their Indigenist subject matter and reinterpretations of folk art as in the calligraphic exercises of which he was so fond, several of which featured on covers of books by María Wiesse, as exemplified in some of the illustrations reproduced here.

The fact that many of the agents of Peruvian culture at this time were from inland areas of the country, and often worked in their own local media, configuring a true poetic, intellectual, and artistic regionalism intent on extending Peruvianism to all the arts was extremely important. Mariátegui, for instance, who would also found the Socialist Party in 1928, was from Moquegua and Sabogal was from Cajabamba. Similarly, many avant-garde groups were based far from Lima, although this was not to say they didn't make a mark on the capital. Orkopata, which in turn derived from the so-called Andean Bohemia, had been set up in Puno, while Grupo Norte was established in Trujillo, and another group was formed around the Portugal publishing house in Arequipa, which we shall be discussing shortly.

As to editorial companies, we must speak of José Carlos Mariátegui who in 1925, together with his brother Julio César, had launched Minerva publishers, that would be very active over the next few years. They used Minerva, whose logotype had been designed by Emilio Goyburu, as a base for creating a Peruvian and continental network of distribution and exchange with other publishing firms and cultural groups, That same year, Mariátegui would release his book *La escena contemporánea* with Minerva, the cover of which featured a vignette that was halfway between Symbolism and Art Deco, although it was really a label attached by hand to the binding.

By this time, sufficient "avant-garde" information was circulating, chiefly through magazines, in the spheres of literature, plastic art or the theater. Automobiles, airplanes, radios, film, sports, etc., were all present in the periodical publications of the time. In 1924 the Russian drama company directed by Duvan Torzoff had

performed in Lima, characterized by its Cubist-inspired costumes (Villegas Torres, 2015, 122-128). Nevertheless, just as we had studied in the case of Argentina (although this is also applicable to other countries), such events were one-off occasions, barely perceptible as a homogeneous and programmatic at the time.

Even so, this was the moment of the avant-garde trends in graphic art, which would begin to carve out a space all their own in the oeuvre of several local artists and even in the work of foreign artists. Such was the case of the Hungarian Zsigmond Remenyik after his sojourn in Valparaíso (Chile), where he had been one of the driving forces of the avant-garde. In that city he had written "La tentación de los asesinos" (see p. 304), "La angustia," and "Los muertos de la mañana," texts that would be published in the book *Las tres tragedias del lamparero alucinado*, published in Lima in 1923. Remenyik made his own self-portrait as a lamp bearer for the cover, that also played with calligraphy. Surprisingly, Serafín del Mar and Magda Portal dedicated their work *El derecho de matar* (La Paz, 1926) to this book and to Henri Barbusse (see p. 655).

Among Peruvian artists, Alfredo Quízpez Asín, under his new name, by which he would be better known, César Moro introduced an early avant-garde statement with his splendid cover of the book *Ideario de acción* (1924), by the Mexican José Vasconcelos, that revealed his perfect knowledge of Cubist trends despite having to wait another year before taking his long-yearned-for trip to Paris in search of "the atmospheres his art needed to emerge from the forced shadows of the unknown in which it lived in Lima," as declared by Carlos Raygada (1925). To this composition he added distorted female figures and even unsteady skyscrapers, a feature that would reappear in numerous Latin American avant-garde illustrations. No doubt, he preferred "a new arbitrariness to the ignominious cliché" (Raygada, 1925).

So we find ourselves before a genuine anticipation, a journey on which César Moro would add other experiences, like the ornamentation for the book *Democracia* (1926), by Roberto Mac-Lean y Estenós, and where he featured together with other important artists such as Raúl Vizcarra, Jorge Seoane (who made the ex libris, reusing the cover design he had created for *Piedras filosofales*, published in 1923 by Mac-Lean) and Emilio Goyburu, whose illustration verged on *art informel* and inaugurated a long trajectory in the field of geometric abstraction. In those days Vizcarra, who designed the Symbolist cover of *Democracia*, contributed his illustrations and photographic collages to the well-known review *Variedades*. The following year Goyburu, who had trained under Hernández at ENBA, would create one of the most emblematic covers in the Peruvian avant-garde thanks to expressionistic woodcuts—the cover of the foldable book *5 metros de poemas* (1927), by Carlos Oquendo de Amat.

Another of the most striking covers made that year, also by Roberto Mac-Lean y Estenós, was that of *Cosmópolis llega: estampas limeñas*, whose design was by one of the greatest artists of the Peruvian avant-garde, Carlos Raygada, who had also studied at ENBA. In the mid-1910s, Raygada published a few geometrical caricatures in *Variedades*, that anticipated by several years the *archicaricatures* by the Uruguayan artist Dardo Salguero de la Hanty and the Italian-Argentine Francisco Salamone, the caricatures by the Chilean Julio Arévalo reproduced in the journal titled *Arquitectura y arte decorativo* (Santiago de Chile), and a few others made by their countrymen Juan Devéscovi and Ernesto Bonilla del Valle. He was also director of *Stylo* review (five issues published in 1920), a prominent art critic, man of letters, and editorial entrepreneur. Inexplicably, Raygada's work hasn't been sufficiently studied, a fact which is even more difficult to understand given that his archive

is available at the National Library of Peru. The first of his designs reproduced here is that of the spectacular cover of the poetry compilation *Levante* (1926), by the Uruguayan author Blanca Luz Brum de Parra del Riego, the widow of the Peruvian Juan Parra del Riego, who had passed away in Montevideo the previous year, shortly before publishing his book *Blanca Luz*, dedicated to Brum.

Designing the calligraphy of the title of *Levante*, Raygada tried his hand at words in freedom; both the title and the other words on the cover, in green ink, are printed on a dynamic mountainous landscape with clouds and sunrays, in shades of red and white. He would go even further in the Futurist cover of *Cosmópolis llega* (1927), a faceted composition that combines, more vigorously than in *Levante*, unsteady skyscrapers, the musical notes of a saxophone, a car, a woman smoking a cigarette reminiscent of Art Deco, and audacious calligraphy.

These calligraphic proposals, bold for the medium, also appeared repeatedly in another scenario of the Peruvian and Latin American avant-garde to which we have devoted another chapter in this book, i.e. that of pre-Columbianist revivals and reinterpretations. The covers of Los *poemas humildes* (1927), by José Z. Portugal, and *Un chullo de poemas* (1928), by Guillermo Mercado, published by Kuntur in Sicuani (Cuzco), run by Portugal himself, are emblematic volumes in both literary and in graphic terms. The splendid "pre-Columbian" covers were the work of the still to be discovered Andean artist Lucas Guerra Solís. Highly dynamic, the compositions combine ad hoc calligraphic experiments and several ornamental references along the same lines. Reproduced in black and white in *La Sierra* review, the spectacularity of the former is obvious, while in the latter we have to "discover" the woolen cap (*chullo*) among a wide range of features, two of which are very common in the graphic works of the period—a Symbolist female nude (in this case a Native American) and a decorated ceramic vase.

In this same context mention must be made of the cover of *7 ensayos de interpretación de la realidad peruana*, by José Carlos Mariátegui (1928), published by Amauta. Designed by Julia Codesido, by then already an outstanding disciple of Sabogal's, the avant-garde composition presents a colorful abstract ground with pre-Hispanic decoration, on which a trapezoidal label—like the openings in Incan architecture—contains the title of the book, conveniently calligraphed and punctuated with ornamental glints. Codesido also created the cover of the poetry compilation titled *Junín* (1930), by Enrique Bustamante y Ballivián. This design comes closer to the popular art of engraved matt compositions of which her master Sabogal was so fond. The upper area contains the most avant-garde feature, the subtle depiction of a train crossing the Andean landscape, and a couple of electricity poles.

During these years, Peruvian modern graphic art was also characterized by the portraits of authors drawn by artists for the decoration of book covers. A paradigmatic example is the cover of the first edition of *Trilce*, by César Vallejo, printed by the Typographic Workshop of Lima Penitentiary. The composition was designed by Víctor Morey, whose illustrations appeared in numerous magazines, books, albums and other editions, many of which exalted pre-Hispanic indigenous figures, and who remained for the most part loyal to Modernism, Symbolism and Art Deco without embracing the avant-garde (at least in the works with which we are familiar). Morey was a member of the group formed by Emilio Goyburu and Carlos Quízpez Asín, and in the 1920s made a name for himself as a caricaturist in Cuba and an illustrator in Buenos Aires.

The book *Ccocca* (1926), by Mario Chabes, was published in the Argentine capital. Its cover, featuring the face of the author, was by an artist

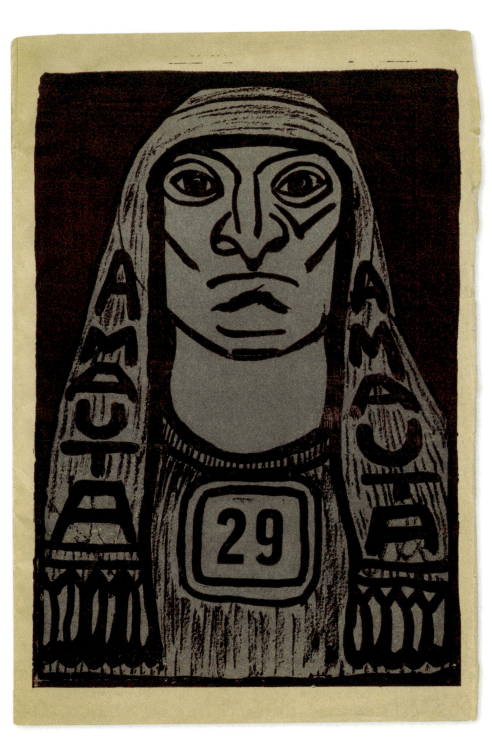

Cover by José Sabogal for *Amauta: revista mensual de doctrina, literatura, arte, polémica*, no. 29, February - March 1930. Editor: José Carlos Mariátegui, Lima. Sociedad Editora Amauta. 24.5 x 17.5 cm.
Archivo Lafuente

who did take a leap forward to embrace the avant-garde—Manuel Domingo Pantigoso; after a long period of neglect, this artist has fortunately been rediscovered of late (Pantigoso Pecero, 2007). Chabes's face, rendered in charcoal, features alongside the calligraphed title *Ccocca*, characterized by the repetition of consonants in an adaptation of a reputed Quechua alphabet to Spanish (Haya de la Torre, 2018, 357), a common practice among Peruvian intellectuals of the period (suffice it to recall the use of "Ccoscco" by Sabogal in his 1919 exhibition). Pantigoso also created a synthetic composition for the cover of *Ande* (1926), by Alejandro Peralta, a member of the Orkopata group in Puno. The book contained a series of woodcuts on Andean themes and Lake Titicaca, similar to those he included in *Cunan* (Cuzco, Puno and Arequipa, 1913-1932) he himself directed. To a certain extent, this journal filled the gap left by *Amauta* and the *Boletín Titikaka* (mouthpiece of the Orkopata Group in Puno), both of which were published, funnily enough, between the years 1926 and 1930. Besides the influence exerted by Sabogal on the choice of wood engraving, in all likelihood Pantigoso's visits to Buenos Aires and Montevideo in 1924, brought him into contact with the works made in the River Plate region by artists such as Adolfo Bellocq, Norah Borges and Federico Lanau.

Besides *Ande*, printed by the José G. Herrera Commercial Typographers by the Camacho Ávila brothers, another emblematic avant-garde book would be published in Puno in 1926, *Falo*, by Emilio Armaza (see pp. 657 and 716). With a cover characterized by huge red typeface letters, it became one of the most recognizable publications of the period. More delicate, combining black and green inks and including a small vignette, is the typographic cover of *Radiogramas del Pacífico* (1927), by Serafín Delmar (pen-name of Reynaldo Bolaños), an author from Huanca and partner of the poetess from Lima Magda Portal (who had been previously

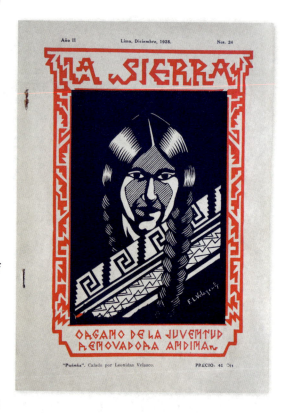

Cover by F. Leónidas Velazco R. for *La Sierra: órgano de juventud renovadora andina*, year II, no. 24, December 1928. Editor: J. Guillermo Guevara, Lima. Minerva. 24.6 x 17.2 cm.
Private collection, Granada

married to his brother Federico Bolaños). The book in question, published by Minerva (Delmar collaborated with Mariátegui and contributed to *Amauta*), was illustrated by a splendid series of woodcuts by the Chilean artist Germán Baltra.

As regards Magda Portal, in the chapter dedicated to Mexico we mention her essay *El nuevo poema i su orientación hacia una estética económica*, published in 1928 at a time when she and Delmar had been expelled to Mexico for being *apristas* (supporters of APRA, the American Popular Revolutionary Alliance). In fact, the imprint of the book is Ediciones Apra, Mexico. While we have been unable to identify the maker of the excellent woodcut cover that, besides the lettering of the title, includes an illustration, it comes as no surprise to learn that it were by Gabriel Fernández Ledesma, not only on account of its quality and resemblance to other of his works of those years, but also because of the close ties between the artist and Peru, as proven by his presence in reviews like *Amauta* and *Boletín Titikaka* (more specifically, issue number 13 of *Amauta*, published in March 1928, published a woodcut portrait of Serafín del Mar—Delmar—by Dernández Ledesma). Nevertheless, it remains a hypothesis.

The 1930s were characterized by a multiplicity of typographic and especially calligraphic proposals. For the importance of their literary authors (although we are unaware of the authors of the designs), mention must be made of the cover of *El Kollao* (1934), by Alejandro Peralta, a beautiful composition of which we have discovered two variations (one in yellow shades on a violet ground, and the other in red letters on a white ground), and that of *Descubrimiento del alba* (1937), by Xavier Abril, the brother of Pablo Abril de Vivero (see p. 655), probably by a graphic artist employed by Front publishing house given the unusual relevance awarded to the firm's name, placed vertically in red ink. The cover of the book dedicated to *Leoncio Prado* (1939) by prominent political activist Esteban Pavletich (see p. 674) was signed by Carlos Quízpez Asín. Notably calligraphic, this cover is one of the most unique of the period, and combines the precision governing the position of the author's name, in red ink, with the carefree dynamism of the title, in blue, and a balanced lower area depicting a half-sword also in red.

More than a decade before, Pavletich himself had published his *6 poemas de la Revolución* (1927), advertised by a woodcut poster by the Mexican artist Gabriel Fernández Ledesma in which the title is complemented by an anti-imperialist fist striking and destroying a skyscraper like the ones in his well-known print *Nueva York* (1922), engraved in red cedar. Fernández Ledesma was extremely busy on the artistic and institutional fronts in Mexico at the time, for he would soon be opening Talla Directa (Direct Carving) art school, founding the first Museum of Modern American Art (short-lived and yet a forerunner of the soon-to-open Museum of Modern Art in New York), and editing *Forma* art review. Together with Fernando Leal and Ramón Alva de la Canal he was also setting up the ¡30-30! movement (in 1928), and preparing a journey to Spain in 1929, where he would present works related to his endeavors at the Ibero-American Exposition in Seville and would publish the portfolio *15 grabados en madera* in Madrid.

Fernández Ledesma's aforementioned poster designed for Pavletich featured in the center of the cover of the second edition of *América Latina frente al imperialismo* (1931), a book by Magda Portal who that year would take part in the 1st Congress of the Peruvian Aprista Party, going on to become Secretary for Feminine Affairs within the party's National Executive Committee. The panoramic composition of the cover appears as an untidy tabletop on which the works of four Mexican artists are superimposed—along with the print by Fernández Ledesma were two

Inner page by Ernesto Bonilla del Valle for *Altura: cuaderno de arte, literatura, ciencias sociales, crítica y economía*, year I, no. 1, June 1936. Editor: José Varallanos, Huancayo. n. p., 22.5 x 17.2 cm. Archivo Lafuente

Altura: cuaderno de arte, literatura, ciencias sociales, crítica y economía, year I, no. 2, August - October 1936. Editor: José Varallanos, Huancayo. n. p., 21.8 x 17 cm. Archivo Lafuente

APRA posters designed by Santos Balmori, and the drawing titled *El campesino revolucionario*, by Diego Rivera, bearing the slogan "Tierra y libertad" (Land and Freedom), and even a red flag. These works by Balmori and Rivera had been reproduced in issue number 9 of *Amauta* (May 1927), which is quite likely where they were discovered by the author of the composition.

Political books were published in abundance during the early 1930s, and Magda Portal herself would create other notable works from the graphic point of view, such as the cover for *El aprismo y la mujer* (1933), although what appears in writing is "Hacia la mujer nueva" (Towards the New Woman). This was an age in which the term "new" was used profusely, as we see in several of the Peruvian books included in our survey. To quote but two examples, we could mention *El nuevo indio* (1930), by José Uriel García (see p. 754), or *Nuevo arte* (1934), by Felipe Cossío del Pomar (see p. 157). Of course, the idea of a new fatherland (*patria nueva*) that Leguía had defended during the Eleven-Year Regime was still in force. The cover of Portal's book, with its diagonal title and dynamic use of diagonal lines, was designed by Julio Esquerre Montoya, whose artistic name was Essquerriloff. Esquerre had been a member of Grupo del Norte (1921-1930), from which the Peruvian branch of APRA derived, a group made up of authors and artists who had previously belonged to the Bohemia del Trujillo group (1914-1921), christened by Juan Parra del Riego, along with César Vallejo and Víctor Raúl Haya de la Torre (Haya de la Torre, 2018, 76-78). In 1926, Essquerriloff, who also contributed woodcuts and caricatural portraits that harked back to those by Catalan artist Lluís Bagaria, created a series of vignettes for the poetry compilation *El libro de la nave dorada*, by Alcides Spelucín, and in 1931 produced the cover of one of the most unique avant-garde books in Peruvian graphic design, that of the collection of poems titled *Meridiano de fuego*, by Gerardo Berríos, published by Cajamarca and characterized by its trapezoidal format.

Esquerre's sympathy for the Russian Revolution and the esthetics of Constructivism is obvious from his artistic name Esquerriloff. In an outburst of Sovietism, Ernesto Bonilla del Valle, another avant-garde Peruvian illustrator, had similarly chosen to be known as Bonilloff del Valleski, as he signed his post-Cubist and sometimes even almost abstract compositions published in *La Sierra* journal. Ernest Bonilla was yet another of the artists who has been overlooked by those tracing the history of the construction of avant-garde discourses in Peruvian art. *La Sierra* promoted the development of new graphic trends, while in the field of books, the cover of *Filosofía del supranacionalismo* (1930), by Víctor J. Guevara, designed by Amadeo de la Torre—one of the directors of *La Sierra* and

the author of several of the journal's covers—is remarkable for its almost Op Art appearance, based on the zigzagging sunrays. The cover designed by José Sabogal for *Don Manuel*, by Luis Alberto Sánchez, a book dedicated to the figure of González Prada, was made that same year and was in keeping with some of the covers he would create for *Amauta*. Displaying certain references to Art Deco, the composition presents a quarter of a sun with fiery rays that alludes to González Prada's personality.

Also by Guevara is the design of the leaflet *Defensa del Perú contra la Peruvian* (1932), illustrated by Raúl Vizcarra, an artist we mentioned earlier, connected to the avant-garde trends of the 1920s. This composition happens to combine features described in earlier works, which could be used metaphorically: here, the destructive, "anti-imperialist" fist depicted by Fernández Ledesma in the poster he designed to advertise *6 poemas de la Revolución* (1927), by Pavletich, becomes the clutch of "imperialism" gripping a train on its journey through the Andes, that could well be the train drawn by Julia Codesido for *Junín* (1930), by Bustamante y Ballivián, including as it does the mountainous landscape and electricity posts.

The list of artists who made few forays into the field of graphic art includes names such as Ángel Brescia Camagni. Connected with the Huancas Quechua people of central Peru, he produced at least two covers for leaflets by the "cub" Manuel Seoane. In the mid-1920s, Seoane, another of the founders of the Aprista Party, had published *Con el ojo izquierdo mirando a Bolivia* (1926) in Buenos Aires, identified by one of the first abstract covers published in Argentina, and was no doubt fond of having his works illustrated. *Páginas polémicas* (1931) and *Las calumnias contra el aprismo* (1932), designs made by Brescia Camagni for Seoane, could both be interpreted as belonging to a "neo-popular avant-garde." Their fresh and slightly naïve drawings and calligraphy evoke words-in-freedom. The illustration by J. A. Parga for *Tawantinsuyo* (1934), by Emilio Vásquez, can also be described as neo-popular and shows a Native American bearing the weight of the world, his world, emphasizing his physical, Herculean strength, very much in keeping with certain representations found in academic history paintings of the 19th century.

In earlier paragraphs we have touched upon the role played by the city of Arequipa on the Peruvian cultural stage of the 1920s, and which by the 1930s would be more prominent as regards book design. In the field of literature, we cannot elude mentioning key figures like Alberto Hidalgo, Alberto Guillén, or other unparalleled names such as César Atahualpa Rodríguez and Antero Peralta, director of *Chirapu* magazine (1928). Of the four, Alberto Hidalgo would achieve the greatest renown. Describing himself as a Futurist from very early on, he ended up creating his own avant-garde ism, "simplism," and would work chiefly in Buenos Aires; some of his designs are included in this volume (see pp. 132-133, 706, 707 and 711).

But other artists and authors would also make a name for themselves in Arequipa in the 1930s (the decade in which Mario Vargas Llosa was born in the city), and some important figures have still to be fully recognized. Such is the case of the poet and illustrator Carlos Alberto Paz de Noboa, absent from the histories of the Peruvian avant-garde and only occasionally mentioned on account of his archeological work carried out in the 1940s, having been appointed curator at the Archeological Museum in the University of Arequipa. His study *Kuntur. Primer cuaderno de dibujo autóctono*, printed in Arequipa in 1936 (see p. 753), drew from both fields—artistic avant-garde and archeology—and was a pedagogical venture inspired by pre-Columbian sources and conceptually based on the two portfolios published the previous decade by Elena Izcue (*El arte peruano en la escuela*), on the two

unpublished volumes that Francisco E. Olazo drafted around the same date (*100 motivos de la decoración inka*, Lima Art Museum) or *Dibujo peruano. Motivos nazquenses*, the series of seven portfolios published by Próspero L. Belli in Ica (1935-1936).

Paz de Noboa, also in the 1930s, contributed drawings to *Noticias* newspaper in Arequipa and woodcuts to *Bloque* magazine published in Loja (Ecuador), among whose editors were Alejandro Carrión and Manuel Agustín Aguirre. We have included two splendid examples of graphic works by Paz de Noboa: the covers of *Madurez galante*, by Max, and *Flechero satírico*, by Manuel Gallegos Sanz, both published in Arequipa in 1934 and that preserve the "pure" spirit of the 1920s, combining illustration with typographic games. The latter was printed by Portugal (publishing house run by Edilberto Portugal), one of the promoters of the literature of those years which would also print *7 poemas* (1934), edited by Paz de Noboa in an almost miniature format (11 x 8.2 cm) and with a very delicate cover composition where the number 7 features on the left and a red bow ties the loose pages. In Chile we discovered a large copy in a dust jacket, illustrated in a panoramic format in three inks (black, red, and green) with rural themes. This copy isn't signed but we believe it was designed by Paz de Noboa himself, although its notable compositional resemblance to with the design made by the Chilean artist Arturo Adriasola, also in 1934, for *Antología de poetas españoles contemporáneos*, by José María Souviron (see p. 327).

The option of a miniature book had already been chosen the previous year by Alberto Guillén—author of the prologue of Paz de Noboa's *7 poemas*—for *Leyenda patria* (11 x 8.5 cm), decorated with birds designed by Rodríguez Escobedo and inspired by Quechua vessels on the front cover and ex libris on the back cover, and counted on the collaboration of Paz de Noboa. The Indianist pattern also appeared in the last book written by Guillén, *Cancionero* (also published by Portugal in 1934), illustrated by Manuel Domingo Pantigoso in brown inks on a yellow ground. On the cover, characterized by the use of calligraphy, presents two emblems of Indianist symbolism, the nude female body and the vessel, both depicted in simple lines. On the back cover we see a pre-Hispanic ex libris, also by Pantigoso.

Peruvian graphic art in the 1930s broadened the fields tentatively explored in the 1920s, preserving certain themes and styles and adding a few exceptional innovations, at least from the point of view of the material we have studied. The ephemeral nature of several avant-garde magazines the previous decade, particularly the closing of *Amauta* and of *Boletín Titikaka* in 1930 were, of course, a blow for those who called for experimental scenario in so far as they had acted as true laboratories of new forms. Nevertheless, as we saw in Arequipa, some of the books published continued to include an interesting proportion of innovations. This was the case of the filmic *Dibujos animados* (1936), by the author Rafael Méndez Dorich, from Mendoza, and of projects such as those by E. B. Camino for the cover of *Doce novelas de la selva* (1934), by Fernando Romero, that recreates a tropical landscape clearly contrasted with the ubiquitous highland landscape mostly expressed in earlier decades, and the imaginative (and anonymous) design for *El panal de los días* (1936), by Rosa María Rojas.

Woodcut illustrations continued to appear in books, as proven by further remarkable prints by José Sabogal, chiefly accompanying the literary works published by his wife María Wiesse. Two such cases are *Trébol de cuatro hojas* (1932), and the outstanding *Quipus* (1936), "Peruvian children's stories" complemented by a variety of woodcuts in a pre-Hispanic vein. We must also mention a one-off work by aforementioned Julio Esquerre Montoya, Esquerriloff: the series of

woodcut prints included in *Las barajas i los dados del alba*, by Nicanor A. De la Fuente (Nixa), a book published in Chiclayo in 1937 (see p. 725) and that Juan Manuel Bonet believes corresponds to a book announced toward the end of the previous decade under the title *Placas, discos, kláxones y una emoción de celuloide para este barrio del Pacífico* which was to be prefaced by Antenor Orrego (as the other one would be) and illustrated by Esquerriloff (Bonet and Bonilla, 2019, 450).

To return to Sabogal, besides his xylographic work he also tried his hand at linear drawings that often resembled popular designs on engraved maté gourds. *Balseros del Titicaca* (1934), by Emilio Romero, is a clear example.

One of Sabogal's main disciples, Camilo Blas from Cuzco, followed the same esthetic principles, based on Indianist and genre scenes, as we see in the two books we have surveyed, the "cholo tale" titled *Cumbrera del mundo* (1935), by Pedro Barrantes Castro, and the even more outstanding *La elegía tremenda y otros poemas* (1936), by Luis Valle Goycochea, an author with whom he had previously collaborated on *Las canciones de Rinono y Papagil* (1932), for instance, that also evoked popular folk art. According to Álvaro Medina (2005, 167), Blas used simple lines and combined full and empty areas in a reference to the drawings of polychrome Moche clay jars.

Two other important artists also deserve a mention, Alicia Bustamante and Alejandro González Trujillo, the latter (mentioned at the beginning of this chapter) associated with ENBA. Alicia Bustamante was one of the animators at the Institute of Peruvian Art, directed by José Sabogal, an art center that in the 1930s and 1940s played a key role promoting popular art in the country (Villegas, 2006). Closely connected to the writer José María Arguedas, Bustamante would design for him the covers of two paradigmatic books, both in literary and in graphic terms: that of *Canto quechua* (1938) and that of *Yawar fiesta* (1941), both characterized by a delicate Andean lyricism that paid special attention to calligraphy.

In the 1920s, González Trujillo, better known by his artist's name Apu-Rimak (born in the department of Apurínac), like many others, had moved from Symbolism to a post-Cubist avant-garde style he often applied to Indianist and pre-Hispanic subject matter (Echazú Conitzer and Gutiérrez Viñuales, 2020). He also experimented with social themes, as we discover in some of the covers he designed for *Apra* review published in Lima. Besides his cover for *América: novela sin novelistas* (1933), by Luis Alberto Sánchez (see p. 762), we have included two late works by Apu-Rimak in our survey (both of 1940): his design for the poetry compilation *Kollasuyu*, by Emilio Vásquez, and that of the essay *Toponimia y Pre-Historia: Apurímac*, by J. Américo Vargas Fano, both of which reveal his talent as a designer. For the former he created a sort of popular map resembling those that were common in the colonial period, where Lake Titicaca is shown as a huge central patch (of color), and bulrush canoes, the Aymara people, a pan pipe, stars, flora and fauna (birds, fish, cattle) and the mountain range appear as a symbolic combination of characteristic Kollasuyu elements. The idea of a map is clearer in the second of the aforesaid works, where the department of Apurímac and some of its provinces are represented as a chart held by two professionals; the scene is completed by a crouching indigenous figure and a series of allegorical elements linked to labor and culture in the lower area of the composition.

From among the huge amount of Peruvian material studied during the drafting of this chapter, a heterogeneous group of works made in the late 1930s and early 1940s is particularly relevant. These include the cover for *Cuentos y leyendas inkas* (1939), a book by Luis E. Valcárcel,

from Cuzco, that also resorts to pre-Hispanic motifs. The cover of the second edition of *El Cusco y sus monumentos. Guía del viajero* (1940), by R. P. Zárate, portrays the god Inti, a radiant sun that fills most of the composition, shining on an Incan construction. The cover of the travel book by Ricardo Cavero Egusquiza, *Paisajes sudamericanos* (1940), is a slightly abstract composition by Manuel Domingo Pantigoso. Last but not least, the illustrations with a childish touch made by Isabel de Jaramillo, Isajara, for *La ronda en el patio redondo* (1941), by Catalina Recavarren de Zizold, present a two-color calligraphic design in a horizontal format.

To conclude this chapter, we should point out that our account of book illustration in Peru is but one of many possible approaches and analyses. The subject requires further research, particularly as regards the unearthing of elusive first editions, to form a more complete picture, as does the illustration of magazines in the 1920s and 1930s (some of which we have mentioned, although there are, of course, many more). New interpretations of Peruvian artistic modernity and its avant-garde must emerge to ensure that graphic art occupies its rightful place in the historiography, to date devoted almost exclusively to painting.

Cover by Alejandro González Trujillo (Apu-Rimak)
for *Revista del Instituto Arqueológico del Cusco*,
year VI, nos. 10-11, 1942.
Editor: Luis A. Pardo, Cusco.
H. G. Rozas Sucesores Librería e Imprenta,
21.5 x 16.5 cm.
Private collection, Granada

Peru

Cover by Reynaldo Luza for Pablo Abril y de Vivero, et al., *Las voces múltiples*, Lima. E. Rosay, 1916.
20.1 x 14.6 cm.
Private collection, Granada

Cover by Jorge Vinatea Reinoso for Enrique López Albújar, *Cuentos andinos: vida y costumbres indígenas*, Lima. La Opinión Nacional Printers, 1920.
20.4 x 15.5 cm.
Archivo Lafuente

Cover by Alfredo Quízpez Asín for Federico Bolaños, *Atalaya*, Lima. n. p., 1922.
19 x 10 cm.
National Library of Peru, Lima

Cover by Emilio Harth-Terré for Héctor Velarde, *En passant*, Lima. Torres Aguirre, 1924.
19.2 x 19.3 cm.
Archivo Lafuente

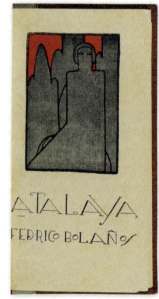

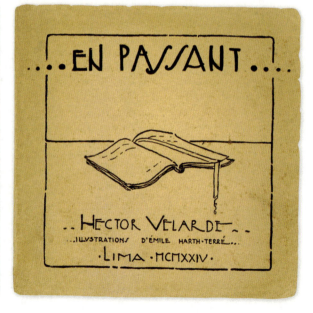

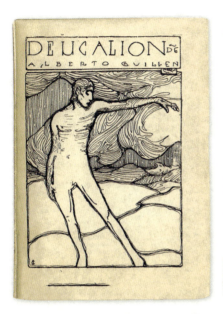
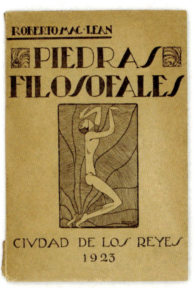
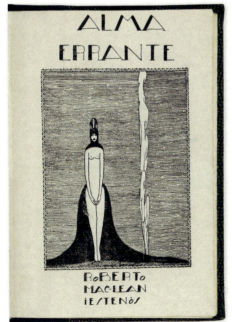
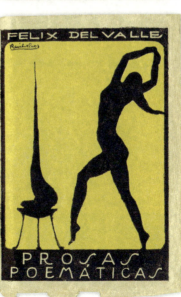

Cover by Carlos Quízpez Asín for Alberto Guillén, *Deucalión*, Lima. Librería Francesa E. Rosay, 1920. 18.3 × 13 cm. Private collection, Granada

Cover by Jorge Seoane for Roberto Mac-Lean y Estenós, *Piedras filosofales*, Lima. Lux (E. L. de Castro), 1923. 17.8 × 12.4 cm. Archivo Lafuente

Cover by Alfredo Quízpez Asín for Roberto Mac-Lean y Estenós, *Alma errante*, Lima. Lux (E. L. de Castro), 1922. 21 × 14.5 cm. National Library of Peru, Lima

Cover by Raúl Pro for Félix Del Valle, *Prosas poemáticas*, Lima. Librería e Imprenta Gil, 1921. 18.4 × 12.3 cm. Private collection, Granada

Cover and inner page by José Sabogal for Daniel Ruzo, *Así ha cantado la naturaleza*, Lima. Publishers of *La Opinión Nacional*, 1920. 17 × 12.1 cm. Private collection, Granada

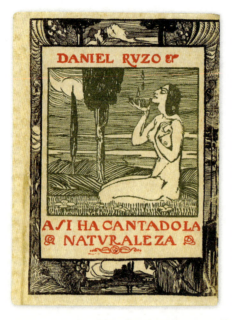
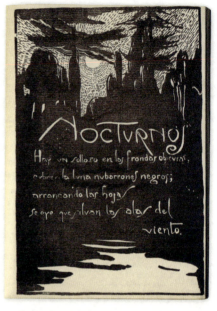

Covers by Arístides Vallejo for Alberto Guillén, *Laureles*, Lima. Lucero, 1925. 18.7 × 13.4 cm. Private collection, Granada

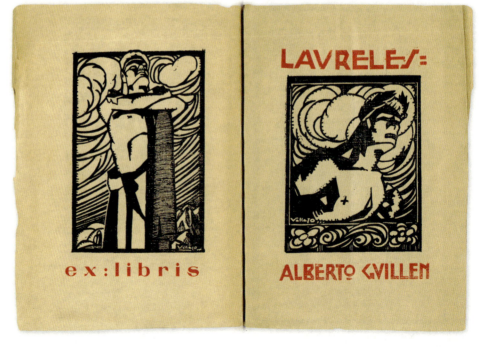

Cover and inner page by José Sabogal for María Wiesse, *Croquis de viaje*, Lima. Librería Francesa Científica y Casa Editorial F. y E. Rosay, 1924. 17.5 x 13.5 cm. Archivo Lafuente

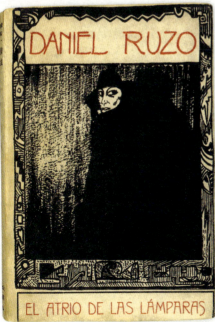
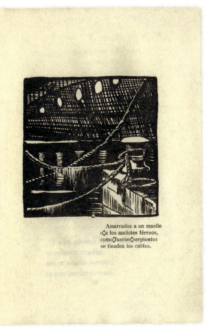

Cover and inner page by José Sabogal for Daniel Ruzo, *El atrio de las lámparas*, Madrid. Mundo Latino, 1922. 18.4 x 12.5 cm. Private collection, Granada

Cover by Carlos Raygada for Blanca Luz Brum de Parra del Riego, *Levante: poemas*, Lima. Minerva, 1926. 17.1 x 12.4 cm. Archivo Lafuente

Cover by Zsigmond Remenyik (author) for *Las tres tragedias del lamparero alucinado*, Lima. Agitación, 1923. 28 x 20 cm. National Széchényi Library, Budapest

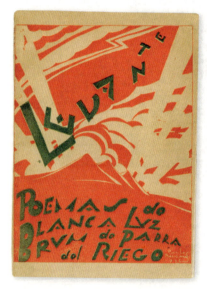

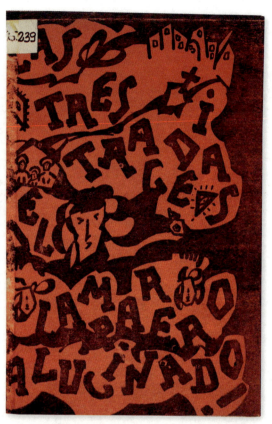

Covers by César Moro (artist's name of Alfredo Quízpez Asín) for José Vasconcelos, *Ideario de acción*, Lima. Actual, 1924. 19.5 x 16 cm. Private collection, Granada

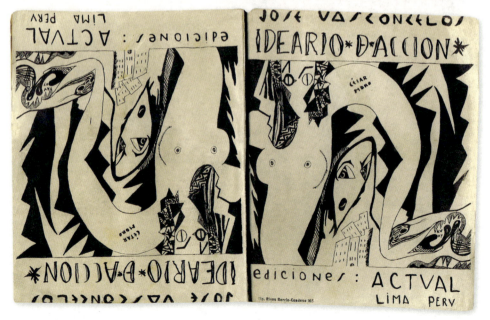

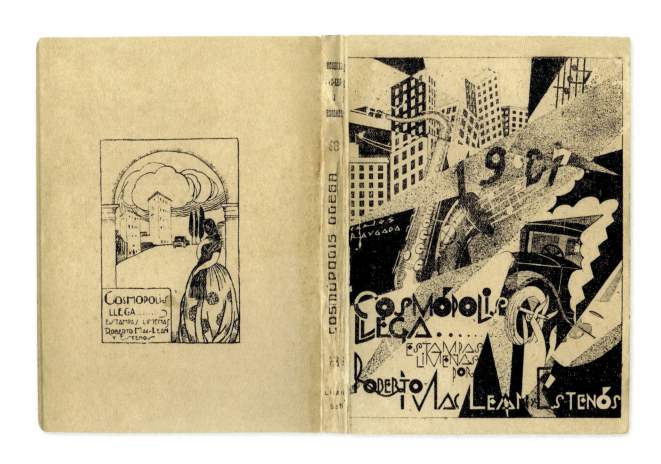

Covers by Carlos Raygada for Roberto Mac-Lean y Estenós, *Cosmópolis llega: estampas limeñas*, Lima. P. Caballero e Hijos, 1927. 16.6 × 12.3 cm. Private collection, Granada

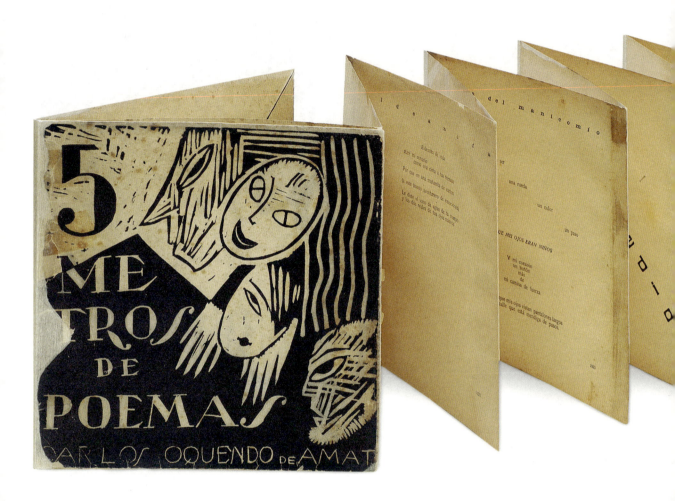

Cover by Emilio Goyburu and inner pages by Carlos Oquendo de Amat (author) for *5 metros de poemas*, Lima. Minerva, 1927.
22.5 x 23 cm.
Archivo Lafuente
Photo: Belén Pereda

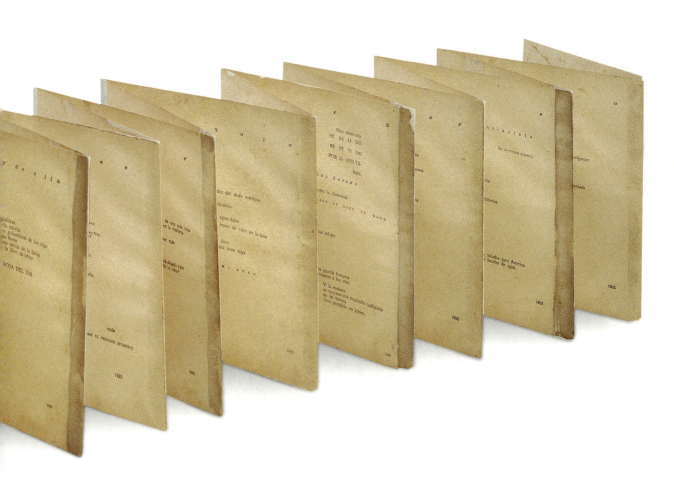

Cover by Víctor Morey Peña for César A. Vallejo, *Trilce*, Lima. Penitentiary press, 1922. 19.3 x 13.3 cm. Archivo Lafuente

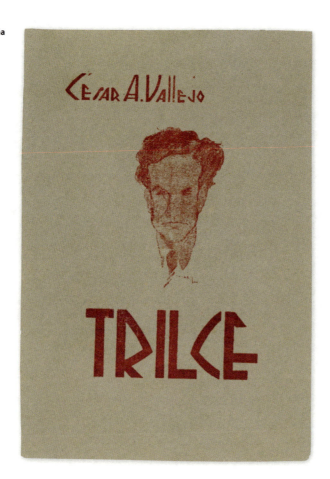

→»
Cover and inner pages by Manuel Domingo Pantigoso for Alejandro Peralta, *Ande: poemas*, Puno. Titicaca, 1926. 30 x 30 cm. Manuel Pantigoso Collection

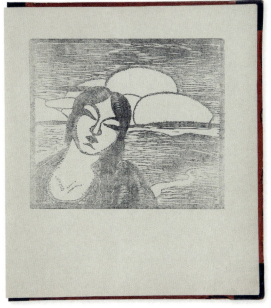

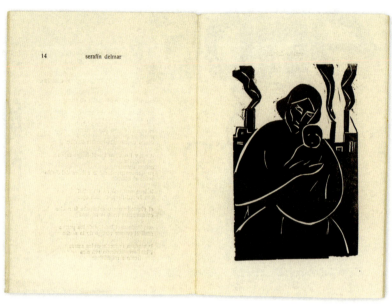
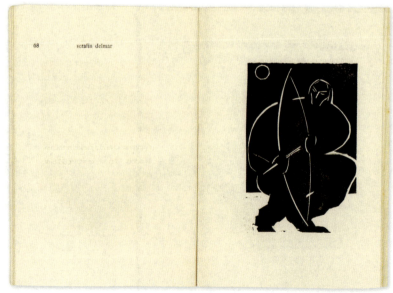

Cover by unknown artist and inner pages by Germán Baltra for Serafín Delmar (pen-name of Reynaldo Bolaños), *Radiogramas del Pacífico*, Lima. Minerva, 1927. 18.2 x 12.5 cm. Archivo Lafuente

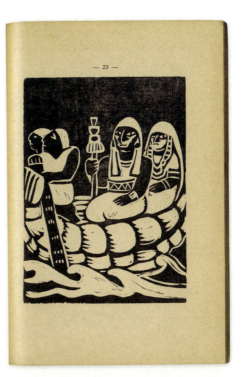
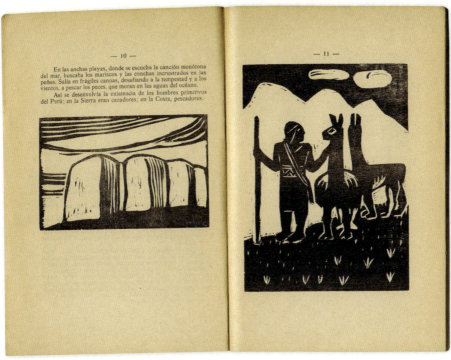

Cover and inner pages by José Sabogal for María Wiesse, *Quipus: relatos peruanos para niños*, Lima. Publishers of *La Voce d'Italia*, 1936. 25 x 17.5 cm. Private collection, Granada

Cover by Esquerriloff (artist's name of Julio Esquerre Montoya) for Gerardo Berríos, *Meridiano de fuego: poemas*, Cajamarca. Publishers of *El Perú*, 1931. 16.5 x 21.5 cm. Walter Sanseviero Collection

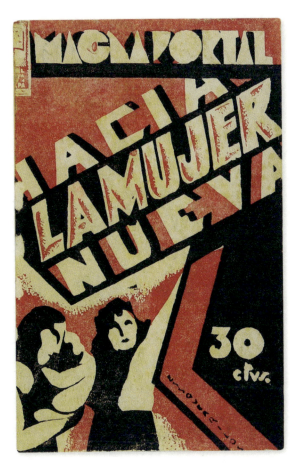

Cover by Esquerriloff (brush name of Julio Esquerre Montoya) for Magda Portal, *El aprismo y la mujer* [on the cover: *Hacia la mujer nueva*], Lima. Cooperativa Aprista Atahualpa, 1933. 18 × 12 cm. National Library of Peru, Lima

**Cover by Lucas Guerra Solís
for Guillermo Mercado,**
Un chullo de poemas,
Sicuanti. Kuntur, 1928.
17.9 × 13.2 cm.
Private collection, Granada

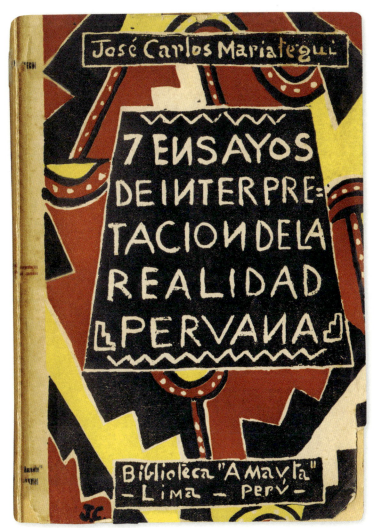

Cover by Julia Codesido for José Carlos Mariátegui, *7 ensayos de interpretación de la realidad peruana,* Lima. Amauta, 1928.
24.5 x 17.1 cm.
Private collection, Granada

Cover by José Sabogal for Luis Alberto Sánchez, *Don Manuel*, Lima. Librería Francesa Científica y Casa Editorial E. Rosay, 1930. 21.3 x 14 cm. Private collection, Granada

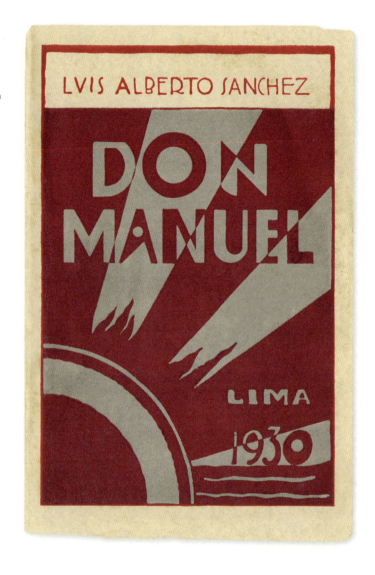

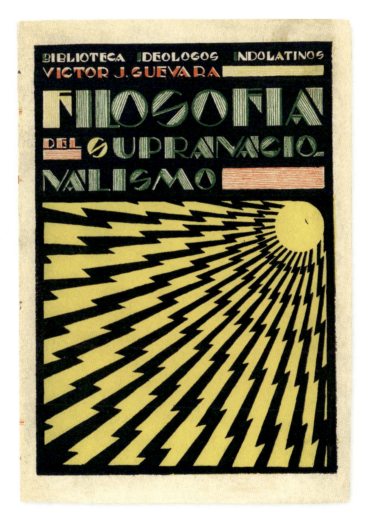

Cover by Amadeo de la Torre for Víctor J. Guevara, *Filosofía del supranacionalismo*, Lima. Publishers of *La Sierra*, 1930. 20.2 x 14.2 cm. Private collection, Granada

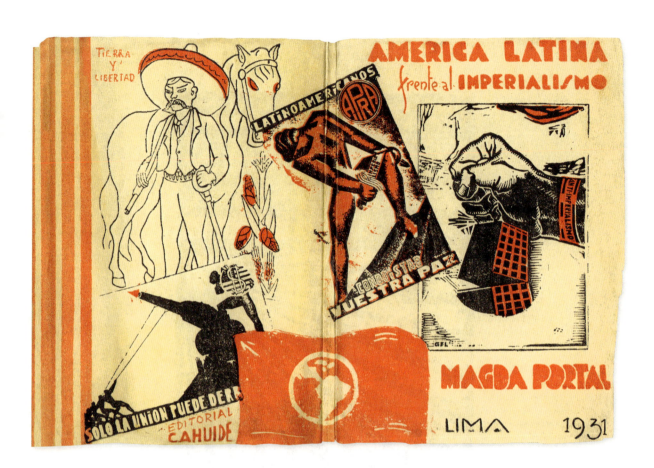

Covers by unknown artist for Magda Portal, *América Latina frente al imperialismo*, 2nd edition, Lima. Cahuide, 1931. 17.7 x 12.8 cm. Private collection, Granada

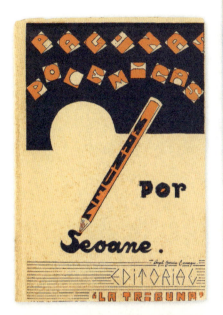
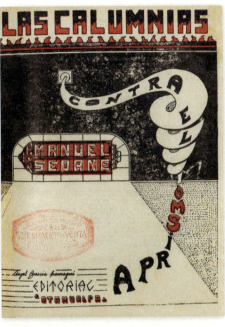

Cover by Ángel Brescia Camagni for Manuel Seoane, *Páginas polémicas,* Lima. La Tribuna, 1931. 17 x 12 cm.
Private collection, Lima

Cover by Ángel Brescia Camagni for Manuel Seoane, *Las calumnias contra el aprismo,* Lima. Atahualpa, 1932. 19 x 16 cm.
University of Texas at Austin. Benson Collection

Cover by Carlos Alberto Paz de Noboa for Manuel Gallegos Sánz, *Flechero satírico (versos),* Arequipa. Editorial Portugal, 1934. 19.6 x 14 cm.
Private collection, Granada

Cover by Carlos Alberto Paz de Noboa for Max, *Madurez galante,* Arequipa. Impulso, 1934. 19.7 x 14 cm.
Private collection, Granada

Cover by unknown artist for Rosa María Rojas, *El panal de los días*, Lima. Compañía de Impresiones y Publicidad Enrique Bustamante y Ballivián, sucesor, 1936. 22.5 x 17.5 cm. Archivo Lafuente

Cover by José Sabogal for María Wiesse, *Trébol de cuatro hojas: poemas*, Lima. Compañía de Impresiones y Publicidad, 1932. 19 × 14 cm. National Library of Peru, Lima

Cover by José Sabogal for Emilio Romero Padilla, *Balseros del Titicaca*, Lima. Ediciones Perú Actual, 1934. 18.4 × 13.1 cm. Private collection, Granada

Cover by Camilo Blas for Luis Valle Goycochea, *La elegía tremenda y otros poemas*, Lima. Compañía de Impresiones y Publicidad, 1936. 18.1 × 16.5 cm. Private collection, Granada

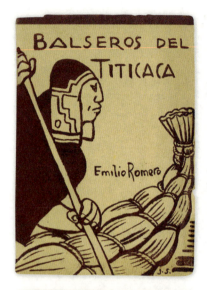

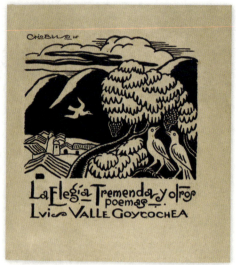

Cover by Camilo Blas for Pedro Barrantes Castro, *Cumbrera del mundo (relato cholo)*, Lima. Ediciones Perú Actual, 1935. 18 × 12.9 cm. Private collection, Granada

Cover by Julia Codesido for Enrique Bustamante y Ballivián, *Junín: poemas*, Lima. La Revista, 1930. 22.2 × 17.1 cm. Private collection, Granada

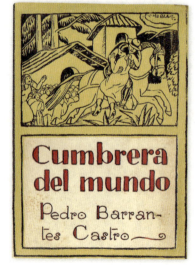

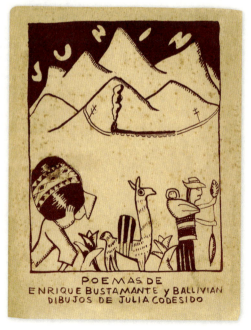

Cover by Apu-Rimak (artist's name of Alejandro González Trujillo) for J. Américo Vargas Fano, *Toponimia y pre-historia: Apurímac*, Lima. n. p., 1940.
24.7 x 17.5 cm.
Private collection, Granada

Cover by Raúl Vizcarra for Víctor J. Guevara, *Defensa del Perú contra la Peruvian*, Lima. Compañía de Impresiones y Publicidad, 1932. 17 x 12.5 cm.
Private collection, Granada

Cover by Apu-Rimak (brush name of Alejandro González Trujillo) for Emilio Vásquez, *Kollasuyu: poemas*, Lima. Baluarte, 1940.
18.1 x 12.7 cm.
Private collection, Granada

Cover by unknown artist for Brother Rosario Pedro Zárate, O. P. [Order of Preachers], *El Cusco y sus monumentos: guía del viajero*, 2nd edition, Lima. Lumen, 1940.
16.9 x 12.5 cm.
Latin American Architecture Documentation Center

→»
Cover and inner pages by Isajara (brush name of Isabel de Jaramillo) for Catalina Recavarren de Zizold, *La ronda en el patio redondo: cantos, fábulas, cuentos de gesta*, Lima. Compañía de Impresiones y Publicidad Enrique Bustamante y Ballivián, 1941. 18 x 23 cm.
Private collection, Granada

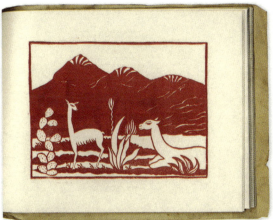
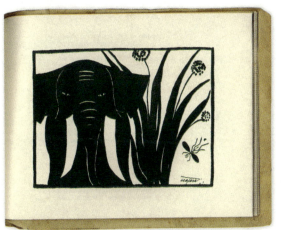
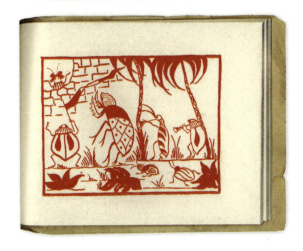

Primera exposición en el Uruguay de Torres-García: obras retrospectivas y recientes desde 1898 hasta 1934 [exh. cat.], June 1934, Montevideo. Amigos del Arte. 16.4 x 12.2 cm. Archivo Lafuente

Uruguay

Riccardo Boglione

Among the elements characterizing the configuration of modern Uruguay in the first decades of the 20th century, Gerardo Caetano (2001, 10) recalled "the cult of *Uruguayan exceptionality*". However, without wanting to round off that idea, chiefly rhetorical, it is easy to trace a certain degree of extraordinariness, both as regards the quality and the quantity (especially in connection with the small size of the country) of illustrated books and magazines produced between the 1920s and the 1940s. Although the phenomenon has only begun to be studied of late, luckily research has intensified in recent years. In the bibliographic sphere, the pioneering books and exhibition catalogs edited by Gabriel Peluffo, such as *Los veinte. El proyecto uruguayo. Arte y diseño de un imaginario 1910-1934* (1999) and *El grabado y la ilustración. Xilógrafos uruguayos entre 1920 y 1950* (2003), published by the Juan Manuel Blanes Fine Arts Museum, would be followed by *Poesía e ilustración uruguaya 1920-1940*, the catalog of the show organized by Pablo Thiago Rocca at the Museo Figari in 2013, and *Vibración gráfica. Tipografía de vanguardia en Uruguay 1923-1936*, that accompanied the exhibition I myself curated that same year at the the National Museum of Visual Arts in Montevideo. The catalog that complemented the touring exhibition *Del plomo al píxel. Una historia del diseño gráfico en Uruguay* staged in 2013-2014, which comprised the years we are surveying here, was published subsequently, in 2020. Last but not least, in 2014 Rodrigo Gutiérrez Viñuales published the article "Modernidad rioplatense. Ilustradores de libros en Uruguay en una era de transformaciones artísticas (1920-1934)," that encompassed graphic design of key years in Uruguay. One thing on which all these surveys agree is the idea that graphic production in the Uruguayan book industry—understood in the modern sense, i.e. design intended to seduce, in which the visual

component markedly "supports" the text—emerged in the late 19th century and gradually developed, reaching a climax in the early 1920s, from whence it followed the progress made in several other Latin American countries, tending toward modernization.

Of course, the increase in designs for covers and the illustration of literary works kept in tune with the technological advances in printing presses and the consequent growth in the number of titles published. Yet it is also true that new proposals in the field of popular illustration, Art Nouveau in particular, also appeared relatively early, almost at the same time as this style reached its height in Europe. In the first years of the 20th century, artists in Montevideo began to show an interest in the design and collecting of Belle Époque posters, the most characteristic features of which had already been identified in France when "the mature style of [Jules] Chéret [produced around 1880] was first adopted and developed by other artists, particularly by Pierre Bonnard and, most notably, by Henri de Toulouse-Lautrec" (Hollis, 1994, 12). As pointed out by Luis Scarzolo Travieso, the author of *Figuras, figuritas y figurones* (1904), an extraordinary lithographic album of caricatures vaguely reminiscent of Lautrec, in a lecture delivered in Montevideo in 1902: "It cannot be denied that posters exert a certain influence on the esthetic education of audiences. We need go no further than Montevideo to observe this. Our audiences are beginning to get used to the examples of modern European (and even national) art displayed on walls and windows and to consider them highly, endeavoring to obtain them to bring lively decoration to their homes" (Scarzolo Travieso, 1902, 28-29).

Hence, Uruguayan audiences were quite receptive in those days to the new decorative motifs that, as described by Scarzolo Travieso, had arrived in the world of publishing where "books had already lost [...] their monotonous, gray, uniform, and purely typographic look: they now appeared in an attractive guise, full of wonderful, almost astonishing effects" (1902, 27).

This probably explains why first-rate painters (such as Pedro Blanes Viale) began to allow their works to be reproduced by publishing houses and even to create works deliberately for publishers. And yet, before 1920, very few particularly elaborate or outstanding book covers were free of regular ornamentation. Two striking exceptions that anticipated future combative positions deserve a mention, both associated with the shock value desired by their authors—poets, fops, and friends—and possibly conceived as dramatic elements for bookstore windows. *Mujeres flacas* (1904), by Pablo Minelli, drawn by the author himself, was perhaps the first cover to be analyzed decades later by a Uruguayan literary critic, and could have been "a challenge or a provocation for ordinary readers in those days" (Visca, 1971, XLI). Despite its amateurish execution, it proved disturbing due to the presence of a "woman as skinny as a skeleton," whose hands were "positioned and shaped in a way that suggested slightly pornographic overtones" (ibidem). The woman portrayed bears a certain resemblance to the nude female figure in the etching made in 1886 by Felicien Rops, *Le plus bel amour de Don Juan*.

Two years later, Roberto de las Carreras published *Diadema fúnebre*, as a reaction to having been seriously injured with a revolver by a man jealous of his sister, whom the poet had courted. Printed on cardboard, bound with a golden thread and with golden letters printed on tombstones, the volume is striking on account of the huge red stain on the cover that evokes the blood shed by the poet, pervading the front cover and spilling over into a small part of the back cover, thereby "desecrating" the book as a whole and generating a sensationalist graphic effect, full of symbolic echoes (Boglione, 2017, 20).

Not surprisingly, the ornamental style in vogue at the dawn of the 1910s was Symbolism, which

had various sub-trends. One of the first attempts at an expressive use of covers was timidly made by the immigrant Italian publisher Orsini Bertani, who would release the greatest number of books throughout that decade, including works by the most prominent Uruguayan authors of the period, in popular editions. The target audience of his books consisted of manual laborers, to whom "they were given at extremely low prices, very often even free of charge" ("Falleció Orsini Bertani," 1939, 11). Generally lacking any original graphic strategies, with the exception of those in which illustrations were commissioned to prestigious painters, the designs in most of these publications were relatively conservative. A collection of plays was characterized by the presence of caricatures on their covers, among them the design by Rafael Barradas for *La moral de Misia Paca* (1912), by Ernesto Herrera (just before he traveled to Spain and became the most outstanding figure in the graphic art related to Ultraism) and Mario Radaelli (an Italian artist who settled early in Uruguay, where he would be a key illustrator for several decades). Other works in the collection included two books whose covers, similarly illustrated, were drawn by Carlos Alberto Castellanos, one of the most important painters of the period who also designed exceptional posters: *Las leyendas milagrosas* (1910), by Ovidio Fernández Ríos and, especially, *Los cálices vacíos* (1913), by Delmira Agustini. The female figures in both these works, enhanced by curved lines and details of their clothing, are also evocative of Art Nouveau despite their firm outlines that verge on the logic of *vitraux*. The Symbolist repertoire—Grotesque, Orientalism, femmes fatales—appeared often and was brilliantly rendered by strong contrasts between blacks and whites, by personalities as opposed as José Luis Zorrilla de San Martín and Antonio Pena, chiefly known for their work as sculptors. Theirs were free-flowing designs and drawings that elegantly included titles in the images of *Humo de incienso* (1917), by Fernán Silva Valdés, and *Los místicos* (1915), by Eduardo Dieste, respectively.

As mentioned earlier, not until the 1920s did a "sense of modernization, shaken by technological innovations, accelerated changes in cities, female protagonism, new indicators of the mass market in urban societies" (Peluffo, 1999, 37), being to emerge in Uruguay, a phenomenon that was inevitably reflected in a significant renewal of the graphic arts. Artists' travels and the reproductions of modern European artworks in newspapers and magazines must needs have inspired local "graphic artists" to freely seize and rework dissenting elements and styles, often abandoning the sinuousness of Art Nouveau in favor of quasi Cubist or Expressionist designs. There were even two "late" examples of a direct use of the new: the drawing for the cover of *El sueño de Chaplin* (1030), that Ildefonso Pereda Valdés borrowed (quite likely without asking for permission) from Fernand Léger, one of the four with which the French artist had embellished the first edition of *Die Chaplinade* (1920), by Ivan Goll, and the fake Pablo Picasso reproduced on the cover of *El pozo* (1939), the first book by Juan Carlos Onetti, probably published by Casto Canel, who "invented a miniature false Picasso for the cover, without concealing the fact that the signature was a convoluted joke. Seen today through a magnifying glass, it seems to read 'Picasso 3'" (Alsina Thevenet, 1993, 5).

By the first luster of the 1920s time was ripe for the widespread presence of woodcuts and linocuts in the country's editorial production, particularly literature, and became the most systematic and convincing graphic feature in the design of books and magazines. Peluffo attributes the choice of xylography as the favorite means of expression of the new artists of the Teseo group (that published its own homonymous magazine) and the Fine Arts Circles as a form of legitimization, because the technique was an "important bearer of meaning" (Peluffo, 2003, 8).

Cover by Melchor Méndez Magariños for *La Cruz del Sur: revista mensual de arte e ideas*, year III, no. 16, April 1927. Editor: Alberto Lasplaces, Montevideo. Peña Hermanos. 34.2 x 25.6 cm. Gerardo Diego Library, Gerardo Diego Foundation, Santander

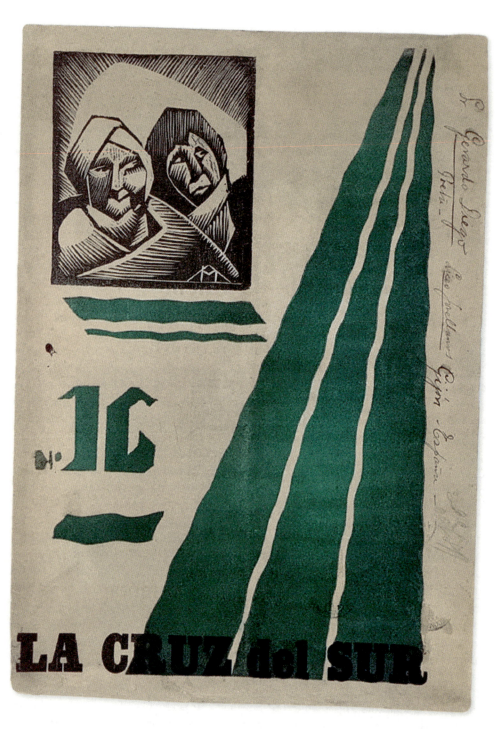

"[T]he reasons for the resurgence of xylography as a discipline in Montevideo in 1920 lie in the creation at that time of a social core made up of intellectuals, artists, and writers seeking to define their own system of power via magazines, books, teaching and painting exhibitions furthering a greater independence of the cultural field" (Peluffo, 2003, 7-8).

Engraving in wood and linoleum also had a certain "synthetic" quality to which those who aspired to transcend a pompous, academic idea of images were drawn. According to Eduardo Dieste (1940, 160), an influential leader in the Teseo collective: "[F]or instrumental reasons, in woodcutting, which in our days has reached the height of its classicism, light and shade appear in a proximity closer to the picture plane."

Finally, we should bear in mind that in Germany and Switzerland, for instance, the first decades of the 20th century were filled with examples of the marriage between avant-garde radicalism and publications illustrated with woodcuts (or linocuts). Suffice it to mention the ephemeral *Die Brücke* publications (1906-1913), the *Blue Rider Almanach* (1912), with woodcuts by compilers Wassily Kandinsky and Franz Marc, among other artists, or the collection of Dada verses by Tristan Tzara, *The First Celestial Adventure of Mr. Antipyrine* (1916), illustrated with famous linocuts by Marcel Janco. Thanks to direct contacts (the numerous European fellowship journeys awarded after the Scholarship Law passed in the country in 1907) and indirect relations (magazine exchanges with countries on the Old Continent, besides other countries like Mexico, Peru and Argentina, where xylography had developed quite early), Uruguayan artists established a connection between woodcutting and the break with tradition, and adopted the discipline well aware of its potential for renewal.

The sculptor and ceramicist Federico Lanau, one of the artists who had trained in Europe, where "his main interest had been to acquire the critical concern, the passionate desire for originality characterizing those European realms," (Mora Guarnido, 1925, 127-128), was in some way responsible for beginning this collaboration between engravers (woodcutters and linocutters), and men of letters. In 1922 he designed numerous covers, including the one for *Poemas del hombre. Libro del mar*, by Carlos Sabat Ercasty, an author with whom he would often work, inaugurating a style that would lead other artists like Melchor Méndez Magariños and Gervasio Furest to explore similar paths. According to Peluffo, the style was an "essentially Symbolist graphic lyricism, that on occasions had allegorical connotations and a strong influence of sculptural modeling in its drawing" (Peluffo, 2003, 8). The repercussions of the style were also, in part, indebted to Lanau's position as art director of the magazines *El camino* (1923) and *La Cruz del Sur* (first period, 1924), standards of the new generation and key vehicles for the dissemination of the new visual sensitivity of the 1920s. Not to mention the compelling etching in the middle of the first (of two) issues of the extraordinary review *Mural*, launched in 1926, designed to be put up on the streets. To "the forcefulness of the black in the print, the pristine perfection of the lines, the firmness of a composition that appears to be tautened by an electric brightness, carved by a single blow of the axe" (Rocca, 2014, 32), we must add a certain thematic continuity, metaphysical in nature, whose volatility is preserved thanks to a line broken into shards. Inside *El vuelo de la noche* (1925), by Ercasty, we discover what is perhaps his most mature work: among headings, *culs-de-lampe*, and full-page plates, Lanau created a series of tormented figures, wandering in space, arranged according to their distorted shapes, the spiral, and the turbine, characterized by a dreamlike Expressionism, exalting the contrast between black and white with a dense alternation of stripes and eddies. One of the

few color proofs, *El nardo del ánfora* (1926), by Emilio Oribe, presented a bold design that contrasted the emerald green of the etching with an atypical pink ground. Meaningfully, as if the idea were to assign him the role of leader among the illustrators of book covers (a role that was brought to an end with his early death in 1928), in 1925 Lanau was chosen to design the cover of a collective book that paid tribute to an author who had just passed away, *La emoción de Montevideo ante la muerte del poeta Julio Raúl Mendilahrsu, recogida por Juan Parra del Riego con alto amor de su memoria*, a book that moreover revealed absolute proximity between the literary and artistic communities—the entire who's who of Uruguayan art of the time contributed an image to the volume.

Other important practitioners of woodcut book illustration worked during those years. The aforementioned Melchor Méndez Magariños, Adolfo Pastor and Gervasio Furest almost seemed to form a common front; despite not constituting a group or a movement, they did leave traces of their affinities. On the one hand, we have the volume on *Lautréamont & Laforgue* (1925), written by the Guillot Muñoz brothers, Gervasio and Álvaro, that contains four woodcuts by Magariños, one by Furest, and an early imaginary portrait of the French-Uruguayan poet by Pastor, the only precedent of which is probably the portrait by Félix Vallotton. On the other, the book which could perhaps be considered the most representative work of the Uruguayan avant-garde, *El hombre que se comió un autobús* (1927), by Alfredo Mario Ferreiro, that displays a forceful cover by Magriñas characterized by the interplay of black and green, and several woodcuts, by the same artist and by Furest, besides some sketches by another absolutely outstanding figure in the genre—Renée Magariños Usher. This young female artist deserves to be remembered for her international collaboration with leading Peruvian newspapers such as *Boletín Titikaka* and *Amauta*, as much as for her prints in Ferreiro's second book, *Se ruega no dar la mano* (1930), dynamic images, several of which verge on abstraction. Méndez Magariños was born in Spain and moved to Uruguay as a child. Having trained under Pío Collivadino in Buenos Aires and André Lhote in Paris (Aller, 1931, n.p.), he became a very active as artist. A number of his covers of 1927 were organized following similar schemes to that of *El hombre que se comió un autobús*, that is, with sharp geometrical elements and the superimposition of colored drawing (red) on a black ground, as we see in *Esquinita de mi barrio*, by Juan Carlos Welker, and *Sendas contrarias*, by Adda Laguardia. These volumes followed another group of books illustrated the previous year—*El rosal*, by Luis Giordano, *Júbilo y miedo*, by Pedro Leandro Ipuche, and *Lejos*, by María Elena Muñoz—that had already established "his avant-garde course" (Gutiérrez Viñuales, 2014b, 77). As suggested by Gutiérrez Viñuales (ibidem), there is no doubt that in the field of painting "he didn't attain the same degree of progress as in his graphic work." This was, in fact, a characteristic of other Uruguayan artists, such as Héctor Sgarbi and José María Pagani, for example, as we shall see. In his turn, Pastor was a delicate artist who always combined the attitude of an "inquisitive researcher" with that of a "disciplined esthete" (Haedo, 1947, 145), and coped with a "temperament as deep as it was deliberate, as intimate as it was severe, as Dionysian, in the sense of his understanding of nature and her rhythms, as it was Apollonian in his architecture of awareness" (Vitureira, 1943, 18). In this way he managed to preserve decadent traits that even alluded to Aubrey Beardsley, as in the early plates for *Mi báculo* (1920), by Juan Mario Magallanes, and subsequently conflate them with modern drives in the covers for two books that could perhaps be considered his masterpieces on account of their economy of lines and their

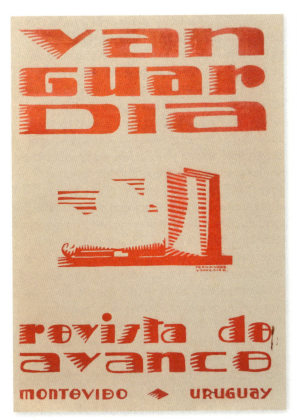

Cover by Héctor Fernández y González for *Vanguardia. Revista de avance*, year I, no. 2, October 1928. Editors: Juan Carlos Welker and Juvenal Ortiz Saralegui, Montevideo. n.p. 25 x 18 cm. Héctor Gómez Estramil Collection

balance between the grace of Art Nouveau and compositional boldness—*La trompeta de las voces alegres* (1925), by Nicolás Fusco Sansone, and *Línea del alba* (1930), by Juvenal Ortiz Saralegui. Finally, Leandro Castellanos Balparda, a direct disciple of Lanau's (Rocca, 2014, 30) deserves to be recognized for the sophisticated grid created by his burin in *Suicidio frustrado* (1929), by Luis Giordano, and for the political vein of several of his works, including the "militant" prints for *Frente al gobierno de fuerza* (1936), by Ofelia Machado Bonet. Julio Verdié, himself a writer, is also worthy of recognition for having illustrated his own books with elaborate, invigorating woodcuts, as we see in the second edition of *Adotico cielo* (1931) and its interesting etching, which is inclined with respect to the book's margins.

Besides the strong presence of woodcuts and linocuts, Uruguayan graphic work encompassed a huge range of styles and motifs clearly influenced, as mentioned, by European avant-garde trends. We could say that para-Cubist and para-Futurist formal features, absent from the painting produced at the time, did appear in typography. We should make it clear that in Uruguay, and possibly throughout Latin America, graphic modernization formally tended to break away from the literature it adorned. Save for a few exceptions, it was difficult for covers or inner illustrations that responded more or less distinctly to avant-garde requests to find the same innovative elements in the texts for which they had been conceived. As the years advanced, this would become increasingly frequent on

account of the decline of Latin American literary avant-gardism after the early 1930s.

As no biographical information has been discovered about Héctor Fernández González, one of those who worked the hardest to modernize publishing houses in Montevideo, his figure remains a mystery. And yet he was possibly the most active artist in the field of editorial illustration from the second half of the 1920s to the early 1930s. In 1927 he surged to fame with a cover that did in fact match the revolutionary spirit of the book it illustrated, *Palacio Salvo*, by Juvenal Ortiz Saralegui—a perfect Planist synthesis of the building, a symbol of Uruguayan modernism, that provides the book its title. One year later he composed the daring red woodcut for the cover of the second issue of *Vanguardia. Revista de avance*, and the brilliant cover drawings for *Eutrapelia pastoril y gandulesca*, by Junio Aguirre, where the figurative silhouette and the letters of the title form a perfect union of opposites, and for *Los juegos*, by Juan José Morosoli, whose "beautiful and expressive cover [...] has distinctly captured attention and received much praise" (Vasyl, 1928, 26). The book was printed by Albatros, where Fernández y González was probably art director, given that several of his designs—besides other unsigned yet stylistically similar works—embellished the production of a publisher (see p. 714) who, as advertised in the pages of its homonymous magazine, "was in vogue in our medium thanks to the typographical layout of all his editions" (Vasyl, 1928, 26).

Broadly speaking, all the important painters of the decade—whether or not they belonged to the planist school, a trend that had "close affinities with the graphics of modernism" (Boglione, 2019a, 33)—made forays into the editorial world, either lending or creating images for publications. Among others, José Cúneo, Carmelo de Arzadun, Carlos Pesce Castro, who took great pains to illustrate *Blanca luz*, by Juan Parra del Riego, in 1925, and Alfredo De Simone, with his impressive cover drawing for *Él*, by Mercedes Pinto, in 1926. Some of them dedicated much of their time to this task with notable results. We shall begin by returning to Mario Radaelli, who was really more of an illustrator than a painter. From 1909 onward Radaelli would contribute his drawings to various newspapers. Over the decades he would adopt very different styles in a vast and eclectic production, among which a few high spots proved his fluent understanding of modernism: the cover for *El libro de las rondas* (1924), by Boy, alternates a wise play of colored planes and a synthetic and effective drawing, while in his own book *La sonrisa de Xunú* (1936) he used several different Indian inks to suggest a highly personal and tense reinterpretation of an African-inspired Art Deco setting. Humberto Frangella, who was also a photographer together with his brother Enrique, skillfully negotiated what appears to be a distortion of classicism in *Selva sonora* (1926), by Mario Castellanos, and a re-elaboration of Cubist and Art Deco features which perhaps triggered his best and most original graphic works of the period, as in the representation of an Indian in *La rebelión de la raza de bronce* (1932), by Roberto Hinojosa, where he resorted to a very slight metallic effect for the character's complexion.

Luis Alberto Fayol, who has been overlooked despite being one of the most prominent planist painters, produced a series of notable graphic works in the field of lettering (see pp. 675 and 677) that almost appeared to be a reference to Bauhaus, and flirted with dynamic abstraction, both in his pure design for *Diálogos de las luces perdidas* (1927), by Sarah Bollo, and in the pictorial *El astro de los vientos* (1929), by Carlos Scaffo, whose sepia monochromy à la Giacomo Balla is a sort of paradoxically nostalgic Futurism. Also connected with Planist designs, though less effective than that by Fayol, was the painting by Héctor Sgarbi. Sgarbi produced two perfect covers in terms of design: the crucial and tautological cover of *Ladrillos rojos* (1931),

by Hugo L. Ricaldoni, with its balanced yet bold use of the red, orange, and yellow spectrum, and the violent blend of Expressionism and impetuous dynamism of *Cartelario* (1932), by Juan Carlos Faig. We shall also discuss two covers by Barradas, produced shortly after his brief though definitive return to Uruguay (he arrived in Montevideo in November 1928 and passed away three months later), that probably include designs not made specifically for editorial works despite exemplifying his unmistakable temperament: *La expresión heroica* (1928), by Vicente Basso Maglio, and *El hermano Polichinela* (1929), by Jesualdo.

Less assiduously, other painters also designed memorable covers. The anti-naturalist, almost toxic, colors that the watercolorist Francisco L. Musetti used to highlight a defiant female face set against a black ground in *Cuentos risueños* (1930), by Santiago Dallegri, for instance. Or the layout with complexly combined inks and an anomalous perspective derived from Futurism created by José María Pagani for the book titled *Perfil de viaje* (1932), by Eduardo de Salterain y Herrera, with a striking fusion of word and figure that, as pointed out by Gutiérrez Viñuales (2014b, 84), also characterizes the anonymous drawing on the covers of *Flechas quebradas en vuelo* (1934), by Ernesto Pinto, and of *Kaleidoscopio lírico* (1935), by Edison Bouchalón, created by A. D'Agosto. The use of diagonal lines in the compositions that Víctor Poggi (a patronizer of the Torres-García Workshop) created for the fourth volume of *Juan Cristóbal* (c. 1934), by Romain Rolland and that Leónidas Spatakis (a novelist and illustrator) drew for the cover of *Poemas de mujer* (1935), by Elena Rossi Delucchi, are a case in point. Two other examples are the late-Futurist appearance of the two covers that Marco Aurelio Bianchi composed for *La senda oscura* (1932) and *El hombre absurdo* (1933), by Edmundo Bianchi. Last but not least, the series of illustrations that embellish *Libro de pausas* (1934), by Cipriano Santiago Vitureira, are perhaps the only incursion made by the prominent painter Norberto Berdía into graphic art, and reveal a delicate approach to abstraction rather than a complete surrender to the style.

We have already spoken of Renée Magariños. The role played by women in Uruguayan illustration of the 1920s, while minor in numerical terms, produced a few extraordinary artworks. The Argentine artist María Clemencia López Pombo was a remarkable engraver who began by illustrating *La guitarra de los negros* (1926), by Ildefonso Pereda Valdés, a co-edition by La Cruz del Sur and Martín Fierro in Buenos Aires, and went on to design an impressive map of Uruguay for the cover of *Antología de la moderna poesía uruguaya* (1927), compiled by Pereda Valdés himself, a book released in Buenos Aires that also included designs by Norah Borges, Méndez Magariños, and Lanau. Other female engravers would also make brief appearances in the art scene of Montevideo, such as Célica Silva or, later on, Blanca de Garibaldi, who made an attractive linocut for *Retornos del ápex* (1938), by Juan Carlos Sábat Pebet. Giselda Zani de Welker, the most distinguished of all female artists working in the field of graphic art and herself a writer, designed woodcuts for *Muchacha del alma verde* (1929), by Juan Carlos Welker. The cover of this book, also illustrated with a drawing by Zani, is one of the greatest works discussed in our survey, an extremely synthetic work structured by strips of color where the letters of the title and the central figure vie for protagonism. Zani's work is also surprising on account of her excellent handling of opposing registers of strong visual impact in alternating curved and straight lines and a categorical combination of yellow, black, and white on the cover of *Antena de pájaros* (1929), by María Carmen Ízcua de Muñoz, and because of her relaxing use of gentle colors in a definitive style resembling a childish collage in the book *Poesías y leyendas para niños*, that Fernán Silva Valdés published one year later.

Design by Federico Lanau
for *Mural: revista de arte*,
no. 1, February 1926.
Editor: Humberto Zarrilli,
Montevideo. n.p. 58 x 81 cm.
Santiago Vitureira Collection
Photo: Marcel Loustau

Works by female artists would continue to appear sporadically throughout the 1930s, sometimes to surprising results, as in the simple yet impressive cover that Ema Santandreu Morales created for the translation of *El libro de Mara* (1937), by the Italian poetess Ada Negri, or the one that Lila Lery composed with a superb economy of means for *Liceo nocturno* (1938), by Jorge Arzúa.

But not all illustrated books and magazines were produced by artists who lent their hands to the applied arts. As Rodolfo Fuentes clearly states, "[D]raftsmen in advertising agencies and printing presses executed graphic design work unaware that they were 'graphic designers'" (Fuentes, 1999, 28).

These makers of "graphic design before the existence of graphic designers," a category that David Jury assigns to the years 1900 to 1914 but that could be extended three or four more decades in Uruguay, anonymously created several fundamental covers. They were driven by "an interest in the intersection between literary fiction and plastic elements, painstaking attention to design, diagrammatization, 'modern' typography" (Rocca, 1999, 104) triggered by magazines like *La Cruz del Sur* and *La Pluma*, and that systematically extended to several publishing houses, such as Barreiro y Ramos and Impresora Uruguaya, S. A.

Mural

REVISTA DE ARTE — MONTEVIDEO

DIRECTOR: HUMBERTO ZARRILLI

FUNDADORES:

Emilio Frugoni, Federico Lanau, Juan Carlos Abella, Roberto Abadie Soriano, N. Peña y Thode, Emilio Oribe, Fernán Silva Valdés, Alfredo Larrobla y Euclides Collazo.

Xilografía de Federico Lanau.

...eso de un ideal que nosotros no sentimos

VACAS DE LOS TAMBOS URBANOS

Rumiando la distancia de praderas nativas,
Para las que nacieron sus grandes ojos claros,
Dejan colmar la ubre de lechosa ternura
Que beberá insaciable el labio ciudadano.

El arco de los cuernos apuntando hacia un muro
No flecharà los astros de los campos abiertos,
Ni el sonar del olbo de su laringe grave
Cubrirá la llanura hasta besar el monte.

Mirando sus pupilas, húmedas de recuerdos,
Se adivina la última visión de vida agreste:
El ternero que bala,
Mientras el horizonte con religiosidad
Comulga la dorada hostia del sol poniente.

Alfredo Larrobla.

APOLINEO Y DIONISIACO

Este señor tan gordo, que bebe rojo vino
y os mira con un gesto malicioso y cordial
es un viejo borracho. Su destino
se la disuelto en la copa de cristal.

Es hombre bonachón y amigo conveniente
y al vino de su copa mezcla filosofía;
si lo viera beber agua o aguardiente
Fué lo envidiaría.

Fué bella y apolínea su juventud gloriosa
pero hoy el hombre huele a sidor y a laboso.
Una mujer le pasó en la senda penosa
que va de Apolo a Baco.

Su vivir, pues, resume un concepto nietzcheano
y es digno del amor y la alabanza.

Cuando muera tendrá como un jarrón pagano,
un dibujo de sátiros y ninfas en la panza.

Emilio Oribe.

POEMA

Caminos estelares, alfombrados de auroras,
que mi vida perfuma con racimos de canto.
Se encendieron mis lámparas de emoción y de dueña
en la noche más larga de obscura claridad.

Sentía emoción cual sonrisa de niño,
ascendía de mi ser lo quisieras vagancia.

No sé qué milenarias esencias
ni qué manojos de astrales pesadumbres asimiló mi ser.

Ascendiendo alcánzase maduró mi infancia
y hoy
sobre mi frente como ardiente rosa,
pesa una quemante caridad astral.

Peña y Thode.

SILENCIO

En el silencio están todas las cosas
como en el hondo seno de la tierra;
gérmenes que no brotaron todavía,
potencias escondidas
que pueden ser maravillosas rosas.

Gestación inconsciente, duerme en el silencio
la música triunfal de todas las poesías.
Antes de hablar el último mensaje
se hará un vasto silencio misterioso
sobre la tierra henchida de esperanza.
¡Silencio creador!... Sólo el canto murmullo de los
impide tu creación!... [hombres
¡Ah, si algún día
cesara todo ruido sobre el mundo,
el alma estremecida
sucumbiría a la potencia muda
del silencio de Dios!...

Luisa Luisi.

1925.

BAJO UN ARBOL

Yo quisiera acostarme bajo un árbol
bien situado en mi potrero
sobre los yuyos verdes y fragantes,
y con los ojos a medio cerrar
ver nacer y agonizarse los astros
de una noche santicausa.

Yo quisiera acostarme holgadamente
y dormir, y dormir,
con el sueño tranquilo que antes tuve,
maravillao por el aire puro y agrio del campo,
y arrullado como un niño
por la voz afónica del silencio.

Yo quisiera dormirme bajo un árbol
con un sueño de niño
y luego despertarme fresco y ágil
entre los pliegues de mi poncho,
a la hora en que el alba en el Oriente
está como un relámpago que se ha quedado inmóvil.

Fernán Silva Valdés.

COMO NORA

Trasfumante de melita locura,
Ser y no ser por frívola y por trágica;
Vida de odio y amor, de honda pavura,
De simple placidez y de alma mágica.

Y mas, por dulce, un ensoñar de niña,
Y gravedad de pensamientos sabios.
En el alma dos ímpetus en riña
Y una flor de alegría por los labios.

ALEGRIA

Esta ventosa tarde de febrero,
(alegre bailarina por las calles en voz
voy con la sangre en vivo y el alma toda ruda,
espiritual arrequía sin calvario y sin cruz).

Del trampolín fumante de su alegría ligera,
dando saltos mortales las ideas se van
y sus copos parecen como aeroplanos albos
sobre las nubes grises en un supremo afán.

Un rebaño de faldas se agita levantisco.
La tarde
bailarina mocedad pimpante y juvenil,
con impúdicas manos va remangando faldas
hasta mostrar las rosas rosadas del cuadril.

¡Yo soy todo deseo; ¡Sangre empapada en vino
Carne ardiente de sol, soy sediente un hacete!
¡Florecen en mis labios las canciones eróticas!
¡¡Hoy olvide la capa raída de Verano!!

Julio D. Verdie.

CANTARES

I

Nube ausente de la tierra
hoy in destino compre,
El agua por la que vives
ta ena su día morirendo.

II

Corazon, que no to dan
¡para qué te ha de servir?
Es mas tuyo el corazón
cuando te alejas de ti.

III

Agua mia que impaciente
te vas corriendo sin sentir,
Lo que vale es el camino,
llegar es como morir.

IV

Como el agua entre los dedos
a fuerza los años niños
¡Caya es la mano que cierra
mi abanico de recuerdos!

V

Arroyo que vas cantando
camino de la mar,
arroyo que vas cantando
y al mar te vas a llorar
Yo también soy cantando
Y todo el día canto,
hasta que al llegar la noche
con las estrellas lloro.

VI

Es lago mi corazón
donde la bajada tu estrella.
Es lago mi corazón,
y en la sombra de su pena
está brillando tu estrella
que no la alcanzo jamás.
Dulce pena de tenerte,
Pena triste de perderte.

Humberto Zarras.

Meéis en su lugar con algo eterno,
Inasequible, inquietuna, y tanto
Que del incorruptible y desconforme.

Que hay en mí, lo engrandecera en destino.
La evoluca, y destruyere de su amante
La inefable atracción de los cominos.

Arturo S. Sytra.

PRECIO del ejemplar: UN PESO

Con la firma de los autores que colaboran en este
número: 20 PESOS

En venta: en el PALACIO DEL LIBRO - 25 de Mayo 577

| AÑO III | JUNIO DE 1928 | NÚM. 2 |

A Gerardo Diego, poeta de "vanguar-
dia" "humea y cola"
homenaje de juventud artis paraguay
1704 Av. Gonzalo Ramirez - Montevideo Uruguay S.A.

Mural
REVISTA DE ARTE
Director: Humberto Zarrilli

ENUNCIADOS

1. Anhelamos una poesía desligada de todo elemento ajeno a su propia esencia.
2. Creemos que el verso debe sostenerse por sí mismo, no por su limitación retórica, sino por cuanto representa el instrumento de la Poesía, expresado en su más amplia libertad, dentro de un contenido de emoción y de pensamiento que justifique una alineación tipográfica distinta de la da la prosa.
3. Desechamos lo puramente objetivo y pictórico, cuando no está mezclado a un hondo poder de subjetividad, por considerarlo un elemento inferior de la poesía.
4. Distinguimos perfectamente la profunda diferencia que existe entre la imagen poética y la comparación. La primera es el pensamiento total, y la segunda representa la atención óptica puesta al servicio del mundo objetivo.
5. Pretendemos una poesía antiespontánea —y aquí nos referimos tanto a la espontaneidad pseudo romántica, como a la de los vanguardistas — rehabilitando la expresión virginal, el poder del vocablo insustituible, aun usando toda libertad de lenguaje.

MURAL reconoce la existencia de un espíritu moderno en arte; pero advierte que a veces se confunde espíritu moderno con industria moderna.

ADÓTICO CIELO

Rojas auroras de la luna...
Nocturnas auroras de la luna...
Playas flageladas, olas bituminosas, campanas de la
 [Mar.
Sólo yo las escucho, Campanero.
Sólo yo los veo, Marinero,
Marineros de niebla sobre el Mar.

Si estás triste, alégrate.
Si te alegras, es que la tristeza va a durar.

Horizontes incrustados de alas.
Vestálicas estrellas exangües de llamear
por la sombra solitaria de las estrellas rebeldes,
por el grito submarino de las estrellas de mar.

Si estás triste, alégrate.
Si te alegras, es que la tristeza va a durar.

Millonaventurero, Bimbad, sarca la nube
cuoñta, de las aguas de Ormuz.
Shakleton agoniza en un polo de Luna.
Iceberg vagamares que arrastra sin caminos
antártica memoria.

Los bucentauros nupciales llevan un faro a babor:
duras proas de diamante, velamen del Más Allá.
Los bucentauros de fuego, buscan adóticos cielos,
bíar sin constelaciones, sargazos de obscuridad.

Si estás triste, alégrate.
Si te alegras, es que la tristeza va a durar.

JULIO VERDIE.

PERO HABRÁ UN DIA...

He aquí que mi flor me ha dado flores
en vez de frutos.
He aquí que mi flor tiene una espina
incandescente hacia los cielos últimos.

Sangre de luz en carne de las sombras
brota mi espina y riega mis capullos,
y cada gota es un lucero mío
recién nacido y húmedo.
¡Bienhayas, cruel y agudo constelador de noches,
sangrador de lo puro!

Pero habrá un día séptimo y aciago
para mi sueño único,
y una estrella fugaz alicaída
rubricará mi creación de mundos.

ANGEL ESPINOSA.

INSTANTE

Frente a estos grandes árboles solitarios de la llanura,
a escuchar me detengo la música libre de los espacios;
siento el gran viento sonoro que levantan las tempes
 [tades,

el coro de la luz,
la carrera del astro,
el silencio de mis fuertes soledades!

... Y suspira mi anhelo:

Gracia de las colinas!
 Profunda llama del cielo!
Regocíjate, corazón, anegado en tinieblas;
corazón de grave signo mortal:
 copa nocturna
 encendido vino celeste
de la sombra taciturna.
Sobre la angustia del polvo,
 tuya es la melodía,
 tuya es la danza final!

MANUEL DE CASTRO.

EL NUEVO FIAT-LUX

Un grito!...
Un grito que surja cortando el silencio con un hondo
 [tajo de fuego.
Un grito que sea chorro de misterio
brotado de pronto del fondo del tiempo.
Un grito afilado en la piedra del odio,
forjado en la fragua de un dios rudo y ciego,
templado en el río del dolor humano
y al fin empuñado por mil corazones,
mil puños sangrientos.

Siendo relámpago de voz en la noche,
lanzado al espacio para hendir el cielo
y alcanzar tras las sombras eternas
a los rígidos dioses soberbios.
Lazo que se tiende a apresar las estrellas
y en el infinito corre tras el eco.
Flecha que se clava en la frente del día
o quiebra en los astros su punta de acero.

Un grito que prenda sobre las montañas
las hogueras rojas del último incendio.
Un grito que suba a las más altas cumbres
de los Andes, y con un salto inmenso
trasponga las selvas, el mar, el desierto.
Que levante a su paso las olas
de los océanos
y arrastre en las urbes y campos las almas
con la fuerza cósmica del viento.

Un grito que eleve del fondo sombrío
de la vida, sobre el universo,
la angustia del dios encelado
que hunde en el planeta sus garras de hie
escupe su rabia desde los volcanes,
agita los mares y desata el trueno.

Un grito que raje la noche
y ponga de pie el alma humana
en el alma del indio, del gaucho, del siervo
Un grito que salte desde los abismos
por sobre la muerte, la sombra, el silencio,
y abra de un golpe las puertas del día
con su puño de cólera y fuego.

EMILIO FR

VÉRTI

Para llegar a ti aparejé mi nave
Ingrávida de anclas y afinada de antenas:
 ni reposo, ni límite.
El falso firmamento de los puertos
 su timón no dobló.

Las islas de colinas que las auroras visten
Rincones pastorales donde mi dicha espera
Arrulladoras playas donde el mar es una ilu
No de mi absorta nave, la ruta distrajeron.

Las velas triangulares que los regresos de
El sol que lleva al día a dormir en los mos
La confidencia antigua de la estrella a la o
No de mi nave absorta la ruta distrajeron.

Pasa el viento que guía ancha tropa de nu
El viento que fustiga los rebaños de olas.
Clavado en roca viva, alto de soledad
Inmutable está el faro
entre el profundo cielo y la profunda mar.

Faros: columnas de pureza del único Destin
Pupilas que no miran, atentas a su luz
y orientan pasajeros destinos.
Pasó mi nave entre ellas, como un faro imp

Superficiales mares, superficiales cielos.
Las nubes vagabundas y las volubles olas.
Las perceptibles voces y el paisaje ofrecido
No de mi nave absorta, la ruta distrajeron.

Por primera vez en Montevideo "REVISTA O

Todos los jueves a las 18 y 30 en la Tabern

A great number of works were either anonymous or else the names of their creators have not been identified, and they have consequently been overlooked by history. It is worth our while to discuss them briefly here. A significant trend in Uruguayan design derived from pictorial Planism, complemented by a common and intrinsic synthetic capacity. Thus, combinations of fields of color shape the imaginative nocturnal skyline with a projectionist in *Álbum biográfico de artistas de cine*, probably published in the late 1920s; the image of *Hacia la montaña* (1930), by Ivan III; and the cover that Eladio Peña created for *Antología de narradores del Uruguay* that same year. Other styles include the powerful Expressionism of the cover of *Wall Street y hambre* (1931), by Tristán Marof; the sharp contrast between straight lines (the lightning bolt) and a sphere (the globe) in "cool" and "warm" versions for each of the two volumes of *En zigzag por los paralelos* (1933 and 1935), by Arturo Carlos Masanés. Evocative of

Mural: revista de arte, no. 2, February 1928. Editor: Humberto Zarrilli, Montevideo. Publishers of *El Siglo Ilustrado*. 57 x 74.5 cm. Gerardo Diego Library, Gerardo Diego Foundation, Santander

Constructivism yet assuaged by a certain naïve decorativeness is the geometric face in *Párpados de piedra* (1931), by Paulina Medeiros. By the end of the 1920s, Art Deco had made a place for itself among the country's options of graphic composition, as proven by one of the topoi in this style, the elegant couple, geometrically mathematized by a wise though frugal use of line and color in the cover of *Del tiempo moderno* (1931), by Ramón Pérez Moré. Akin to a taste for the exotic, we must mention the Orientalism of the kaleidoscopic cover of *Mujeres, paisajes y templos. Japón y China* (1930), by Eugenio Orrego Vicuña, while the sober and rationally enigmatic image adorning *Los éxtasis de la noche y la estrella!* (1932), by María Teresa Beraldo Fuentes was unaffected by stylistic precepts.

Finally, the works produced by the graphic team at La Tribuna Sonora publishing house (a famous radio station of the period) were effortlessly modern. The wonderful cover of *Pétalos* (1934), by Lika Prats, had a Futurist structure almost reminiscent of Prampolini, and its interior was equally well designed. That same year, the design for *La mujer que pasa*, by José Luis, could be described as a dissection of Cubism and of the Art Deco "style of 1925," while the design of the later work *Páginas* (1937), by the same author, evokes the incipient modernist graphic art produced at the time in the United States, with its extra feature of silver ink and curved lower right angle, a design that directly alters the shape of the volume.

It is altogether impossible to conclude this survey without mentioning the handwritten books that Torres-García began to publish in facsimile editions upon his return to Montevideo in 1934, after long years of absence from his native country. Amidst a large number of publications, such as the journals titled *Círculo y Cuadrado*—the Uruguayan "continuation" of *Cercle et Carré*—and *Removedor*, and far from following the guidelines of other schools, Torres-García produced a number

Cover by unknown artist for *Combutibles Alcohol Portland*, year I, no. 1, September 1932. Editors: Luis R. Ponce de León and Carlos A. Clulow, Montevideo. n.p.
33 x 24.7 cm.
Archivo Lafuente

of volumes entirely written by hand (a practice he had begun abroad and would continue until the end of his days). *La tradición del hombre abstracto* (1938) is a dense essay in which he employed a few of his typical resources, i.e. raw paper, revealing his preference for natural materials, and letters of different size and importance, interspersed with drawings, both symbolic and figurative, that are combined with the text, "pictographic signs [that] are superimposed, interfere with one another, strike up a dialog with the writing, like gestures, alternating continuities and discontinuities according to the needs dictated by the contents, releasing readers from any discrimination between text and images" (Battegazzore, 1999, 161). The cover of *Arte simple* (1937), by Cipriano Vitureira, and those of other books published by Nueva América editions, perhaps designed by the painter Carmelo de Arzadum, hark back to Torres-García.

Possibly the last examples of the process of modernization and introduction of avant-garde elements in Uruguayan book design were indeed Torres-García's Constructivist manuscripts. In the early 1940s the presence of Expressionist prints in books was drastically reduced, with very few exceptions that included the striking cover in black and yellow that Alfredo Lanau (perhaps a relative of Federico's) composed for *Luna de hospital* (1941), by Roberto Salgueiro Silveira. Bold perspective, bright colors, and the influence of Art Deco would also diminish, leaving ingenuous remains, as in the totally *naïf* modernist illustrations made by María del Carmen Smith for *Líneas cortas* (1941), by Juan Ángel Capra.

With the onset of the new decade, editorial graphic design continued its process of professionalization. The Asociación de Impresores y Anexos del Uruguay had been established in 1929, but only came of age in 1945 when it organized the First National Exhibition of Graphic Arts, which would be followed by a second show, five years later. Nonetheless, there can be no doubt that its taste for experimentation had gradually begun to wane.

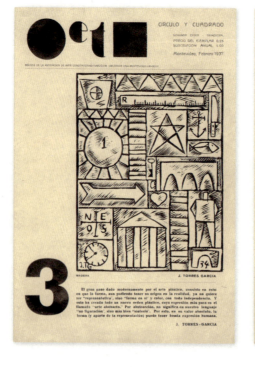
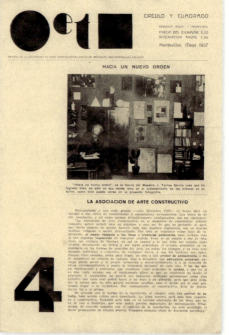

Círculo y Cuadrado: revista de la Asociación de Arte Constructivo, 2nd period, issues 1 to 8/10, May 1936 to December 1943. Editor: Joaquín Torres-García, Montevideo. Imprenta América / Lacaño Hermanos Impresores. 29.5 × 20 cm. Archivo Lafuente

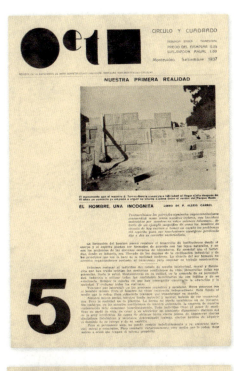
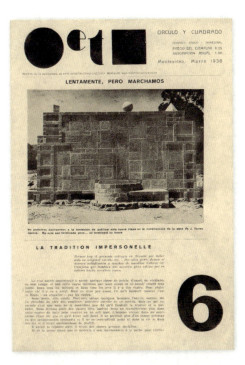

J. TORRES-GARCÍA
HISTORIA DE MI VIDA

Uruguay

Covers by unknown artist for Roberto de las Carreras, *Diadema fúnebre*, Montevideo. n.p., 1906. 23 x 14.5 cm. Boglione Torello Collection

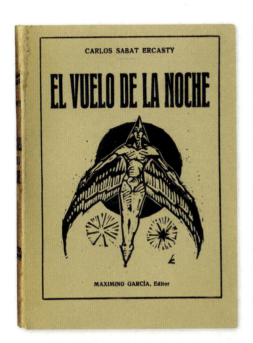
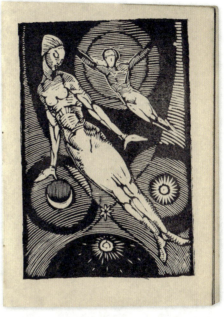

Cover and inner page by Federico Lanau for Carlos Sabat Ercasty, *El vuelo de la noche*, Montevideo. Maximino García, 1925. 18.5 x 13.2 cm. Private collection, Granada

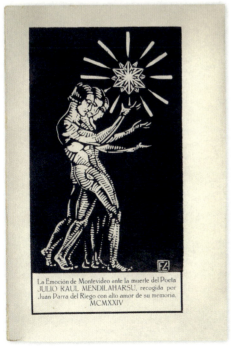
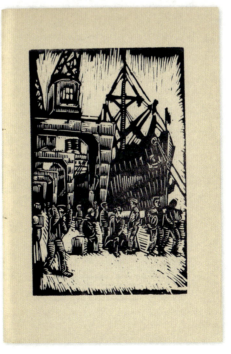

Cover and inner page by Federico Lanau for Juan Parra del Riego (compiler), *La emoción de Montevideo ante la muerte del poeta Julio Raúl Mendilaharsu*, Montevideo. Luis y Manuel Pérez, 1924. 27.6 x 19 cm. Private collection, Granada

Cover by Antonio Pena for Eduardo Dieste,
Los místicos, Montevideo.
Librería Mercurio, 1915.
18.3 × 11.7 cm.
Private collection, Granada

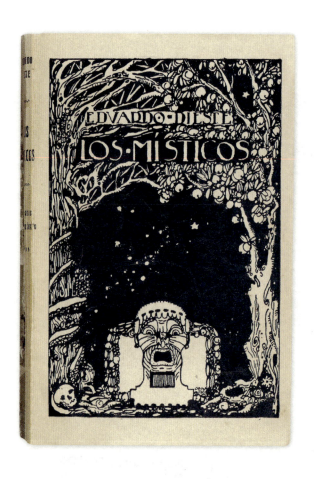

URUGUAY 579

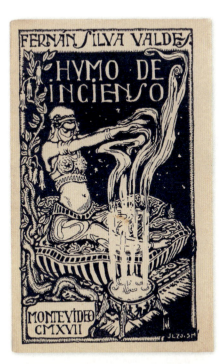

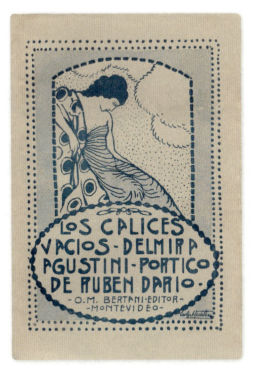

Cover by José Luis Zorrilla de San Martín for Fernán Silva Valdés, *Humo de incienso*, Montevideo. Renacimiento, 1917.
18.5 x 11.7 cm.
Boglione Torello Collection

Cover by Carlos Alberto Castellanos for Delmira Agustini, *Los cálices vacíos*, Montevideo. Bertani, 1913.
19.3 x 13 cm.
Héctor Gómez Estramil Collection

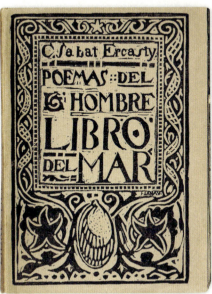

Cover by Federico Lanau for Carlos Sabat Ercasty, *Poemas del hombre: libro del mar*, Montevideo. Talleres Gráficos de la Escuela Industrial, no. 1, 1922.
16.1 x 11.7 cm.
Private collection, Granada

Cover by Federico Lanau for Emilio Oribe, *El nardo del ánfora*, Montevideo - Buenos Aires. Agencia General de Librería y Publicaciones, 1926.
18.5 x 14 cm.
Private collection, Granada

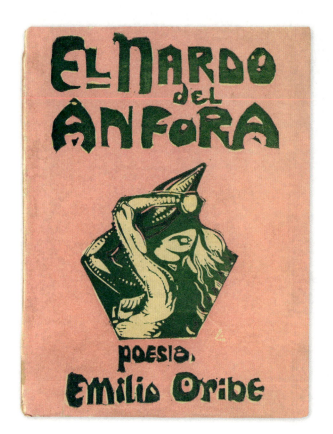

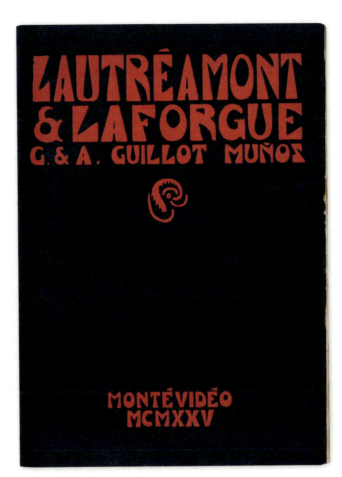

Cover by unknown artist for Gervasio and Álvaro Guillot Muñoz, *Lautréamont & Laforgue*, Montevideo. Agencia General de Librería y Publicaciones, 1925. 20.8 x 15 cm. Private collection, Granada

Cover by Melchor Méndez Magariños for Adda Laguardia, *Sendas contrarias (novela),* Montevideo. Palacio del Libro, 1927. 22.3 x 16 cm. Private collection, Granada

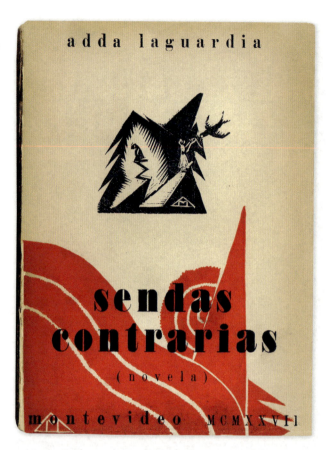

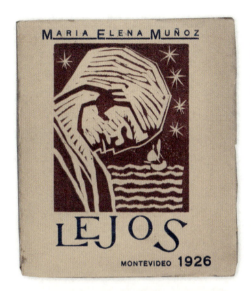

Cover and inner page by Melchor Méndez Magariños for María Elena Muñoz, *Lejos*, Montevideo. La Cruz del Sur, 1926. 17.2 × 15.5 cm. Boglione Torello Collection

Cover and inner page by Melchor Méndez Magariños for Pedro Leandro Ipuche, *Júbilo y miedo*, Montevideo - Buenos Aires, Agencia General de Librería y Publicaciones, 1926. 19.1 × 14.3 cm. Archivo Lafuente

Cover and inner pages by María Clemencia López Pombo and Norah Borges for Ildefonso Pereda Valdés, *La guitarra de los negros,* Montevideo - Buenos Aires. La Cruz del Sure - Martín Fierro, 1926. 19.7 x 14.5 cm. Archivo Lafuente

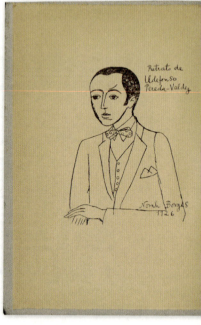

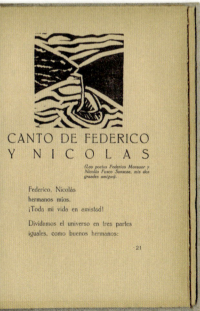

Cover by María Clemencia López Pombo for Ildefonso Pereda Valdés (compiler), *Antología de la moderna poesía uruguaya: 1900-1927,* Buenos Aires. El Ateneo, 1927. 20.7 x 15 cm. Archivo Lafuente

Cover by Adolfo Pastor for Nicolás Fusco Sansone, *La trompeta de las voces alegres*, Montevideo. Agencia General de Librería y Publicaciones, 1925.
19 x 13.9 cm.
Private collection, Granada

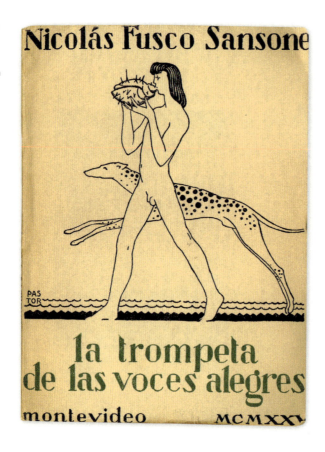

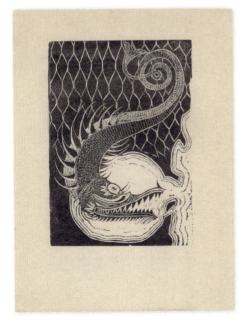
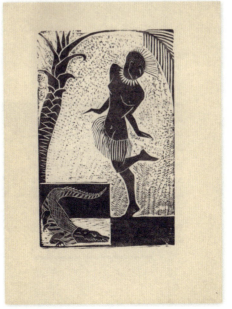

Inner pages by Leandro Castellanos Balparda for Luis Giordano, *Suicidio frustrado. 1 cuento de Giordano. 3 maderas de Castellanos Balparda*, Montevideo. La Cruz del Sur, 1929. 24.8 x 19 cm. Boglione Torello Collection

Cover by Alfredo Mario Ferreiro (author) and inner pages by Renée Magariños for *Se ruega no dar la mano: poemas profilácticos a base de imágenes esmeriladas*, Montevideo. Impresora Uruguaya, 1930. 25 x 17 cm. Archivo Lafuente

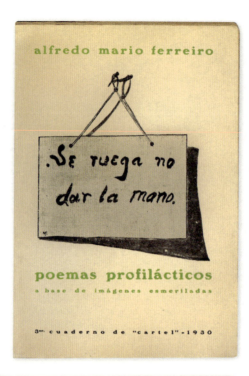

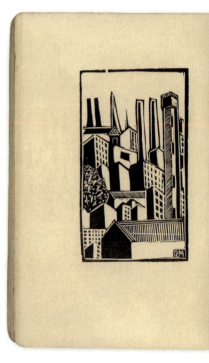

Cover by Melchor Méndez Magariños for Alfredo Mario Ferreiro, *El hombre que se comió un autobús (poemas con olor a nafta),* Montevideo. La Cruz del Sur, 1927. 19.8 x 14.5 cm. Archivo Lafuente

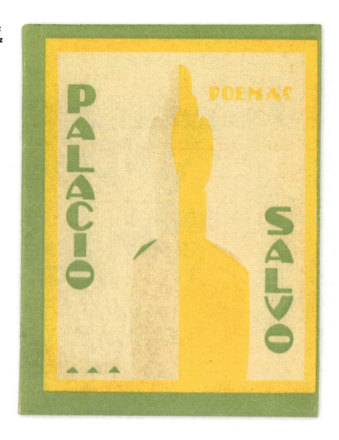

Cover by Héctor Fernández y González for Juvenal Ortiz Saralegui, *Palacio Salvo*, Montevideo. A. Barreiros y Ramos, 1927. 16.4 x 13 cm. Archivo Lafuente

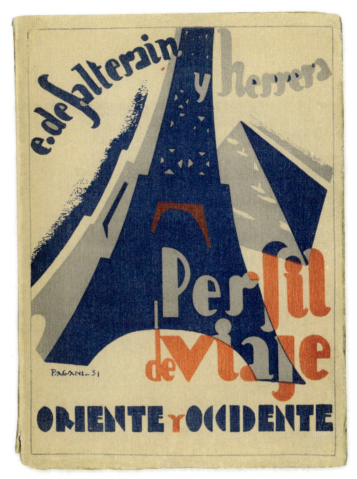

Cover by José María Pagani for Eduardo de Salterain y Herrera, *Perfil de viaje. Oriente y Occidente (A bordo: Egipto; Palestina; Siria-Constantinopla; Grecia; Italia; París; Londres)*, Montevideo. Impresora Uruguaya, 1932.
20.5 x 15.2 cm.
Private collection, Granada

Cover by unknown artists for Lika Prats, *Pétalos*, Montevideo. García Morales, 1934. 19.1 x 19 cm. Boglione Torello Collection

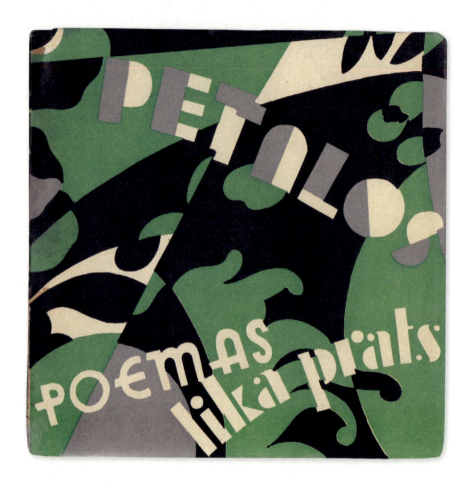

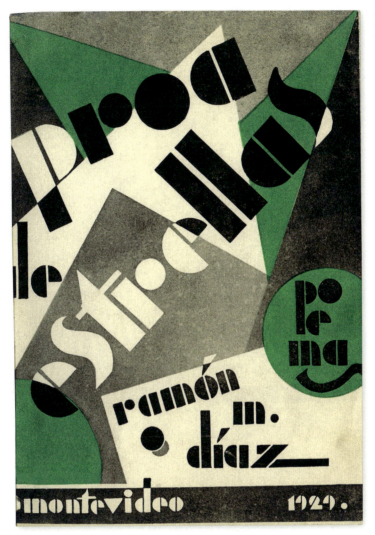

Cover by Humberto Frangella for Ramón M. Díaz, *Proa de estrellas: poemas*, Montevideo. Ministerio de Instrucción Pública, 1929. 23 × 16 cm. National Library of Mexico, Mexico City

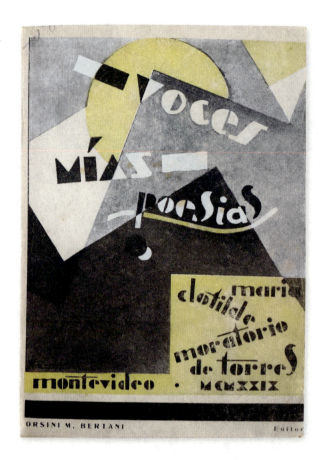

Cover by Humberto Frangella for María Clotilde Moratorio de Torres, *Voces mías: poesías*, Montevideo. Orsini M. Bertani, 1929. 17.5 x 12.7 cm.
Mario Sagradini Collection, Montevideo

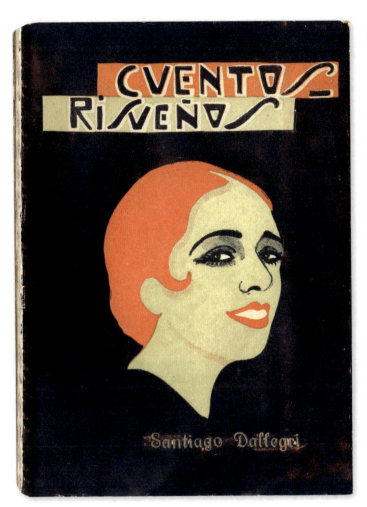

Cover by Francisco L. Musetti for Santiago Dallegri, *Cuentos risueños*, Montevideo. Palacio del Libro, 1930. 20.3 x 15 cm. Private collection, Granada

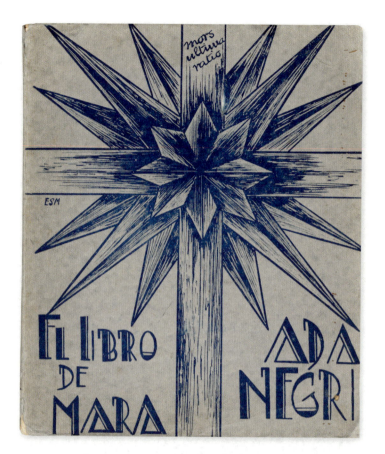

Cover by Ema Santandreu Morales for Ada Negri,
El libro de Mara,
Montevideo. Libertad, 1937.
19.7 x 16.8 cm.
Archivo Lafuente

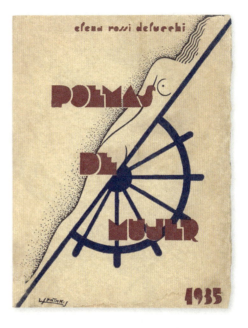

Cover by Leónidas Spatakis for Elena Rossi Delucchi, *Poemas de mujer*, Montevideo. n.p., 1935.
18.3 × 14 cm.
National Library of Spain, Madrid

Cover by Marco Aurelio Bianchi for Edmundo Bianchi, *La senda oscura*, Montevideo. Imprenta Nacional Colorada, 1932.
20.4 × 14.8 cm.
Archivo Lafuente

Cover by Héctor Sgarbi for Juan Carlos Faig, *Cartelario*, Montevideo. La Industrial, 1932. 20 x 15 cm.
Boglione Torello Collection

Cover and inner pages by Héctor Sgarbi for Hugo L. Ricaldoni, *Ladrillos rojos*, Montevideo. Impresora Uruguaya, 1931.
20.8 x 15 cm.
Private collection, Granada

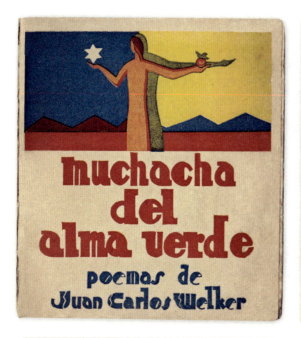

URUGUAY 601

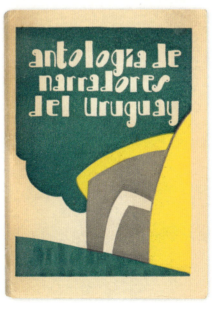

Cover by Giselda Zani de Welker for María Carmen Ízcua de Muñoz, *Antena de pájaros*, Montevideo. Palacio del Libro, 1929. 18.5 x 14.6 cm. Boglione Torello Collection

Cover by Carlos Pesce Castro for Juan Parra del Riego, *Blanca Luz: Poemas*, Montevideo. Agencia General de Librería y Publicaciones, 1925. 16.6 x 13.4 cm. Private collection, Granada

Cover by Giselda Zani de Welker for Fernán Silva Valdés, *Poesías y leyendas para los niños*, Montevideo. A. Monteverde y Cía., 1930. 19.4 x 13.5 cm. Private collection, Granada

Cover by Eladio Peña for Juan M. Filartigas (compiler), *Antología de narradores del Uruguay*, Montevideo. Albatros, 1930. 19 x 14 cm. Boglione Torello Collection

←

Cover and inner pages by Giselda Zani de Welker for Juan Carlos Welker, *Muchacha del alma verde*, Montevideo - Buenos Aires. Agencia General de Librerías y Publicaciones, 1929. 20 x 18 cm. Boglione Torello Collection

Cover by Rafael Barradas for Vicente Basso Maglio, *La expresión heroica*, Montevideo. Biblioteca Alfar, 1928. 17 x 11.7 cm. Private collection, Granada

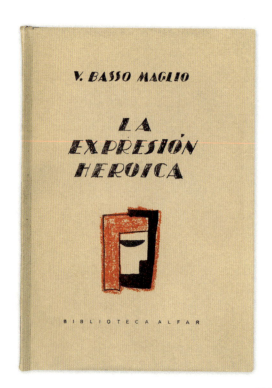

Cover by unknown artist (Casto Canel?) for Juan Carlos Onetti, *El pozo*, Montevideo. Signo, 1939. 15.8 x 11.5 cm. Archivo Lafuente

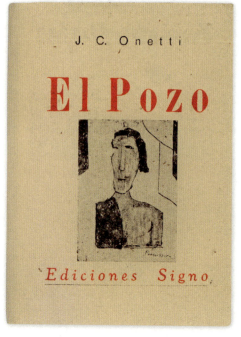

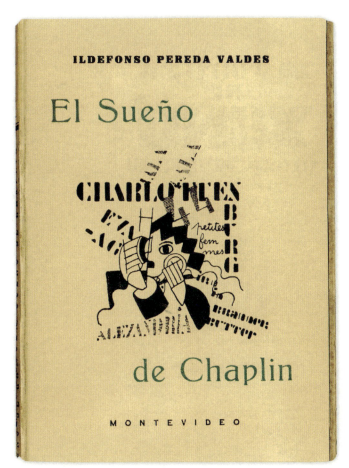

Cover by Fernand Léger for Ildefonso Pereda Valdés, *El sueño de Chaplin*, Montevideo. Editorial Río de la Plata, 1930.
20.4 x 14.8 cm.
Private collection, Granada

Cover and inner pages by Mario Radaelli (author) for *La sonrisa de Xunú (leyendas de Zululand)*, Montevideo. Author's self-edition, 1936. 25.5 x 18 cm.
Boglione Torello Collection

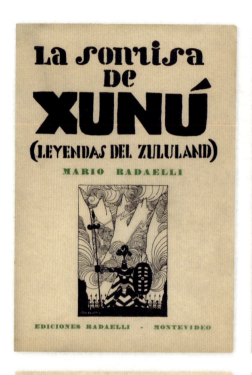

Leyenda del terrible Kalahari y el divino Zululand

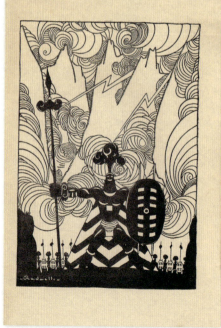

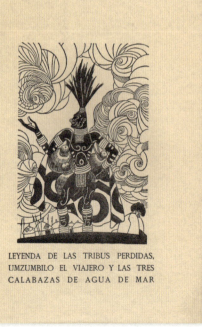

Leyenda de las tribus perdidas, Umzumbilo el viajero y las tres calabazas de agua de mar

Cover by unknown artist and inner pages by Luis Scarzolo Travieso for Víctor A. Rocca, *Ápex,* Montevideo. Ediciones Rosgal, 1937. 18 x 13.4 cm. Archivo Lafuente

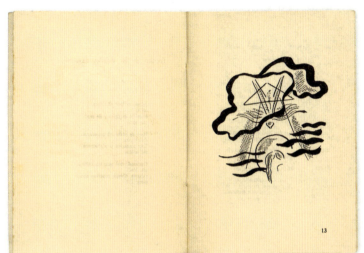
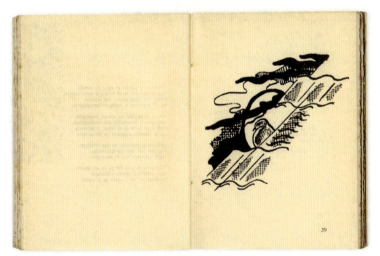

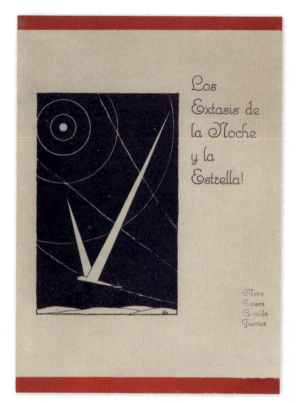

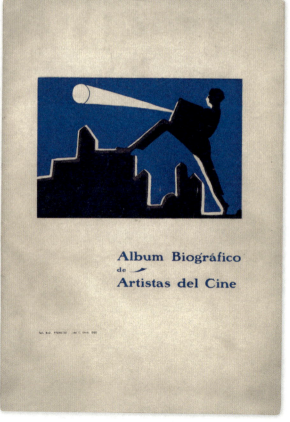

Cover by unknown artist for María Teresa Beraldo Fuentes, *Los éxtasis de la noche y la estrella!*, Montevideo. Tipografía La Industrial, 1932. 26 x 19 cm.
Boglione Torello Collection

Cover by unknown artist for *Álbum biográfico de artistas del cine*, Montevideo. Gráficas Prometeo, 1929. 28.2 x 19.9 cm.
Boglione Torello Collection

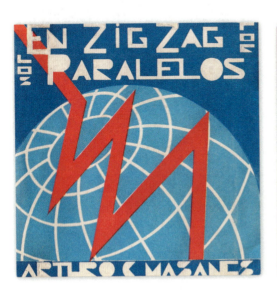
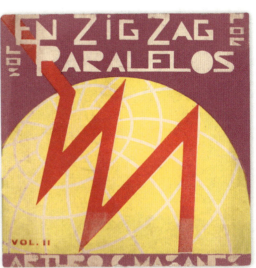

Covers by unknown artist for Arturo Carlos Masanés, *En zigzag por los paralelos*, vol. I, 1933, and vol. II, 1935, Montevideo. El Siglo Ilustrado, 1933-1935, 16 x 16 cm.
Boglione Torello Collection

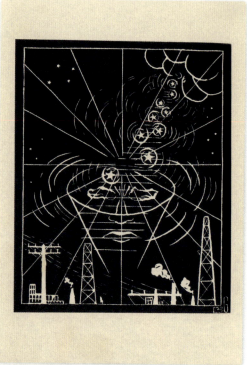

Cover by unknown artist for José Luis, *Páginas de José Luis*, Montevideo. La Tribuna Sonora, 1937. 25 x 20.5 cm. Boglione Torello Collection

←

Cover by María Matilde G. de Sábat Pebet and inner page by Blanca Garibaldi for Juan Carlos Sábat Pebet, *Retornos del ápex*, Montevideo. Hiperión, 1938. 26.5 x 18 cm. Private collection, Granada

Covers by Lila Lery for Jorge Arzúa, *Liceo nocturno*, Montevideo. Casa A. Barreiro y Ramos, 1938. 20 x 14.7 cm. Archivo Lafuente

Cover by Joaquín Torres-García (author) for *Estructura*, Montevideo. Biblioteca Alfar, 1935. 21.2 x 15.7 cm. Archivo Lafuente

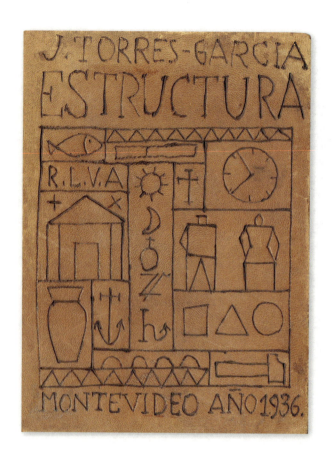

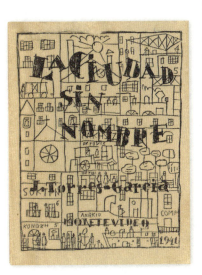
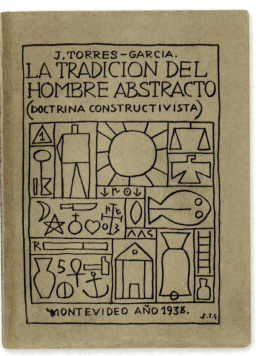
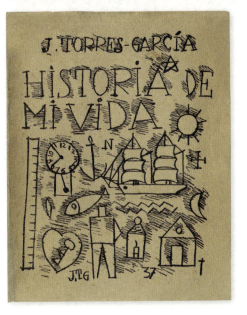

Cover by Joaquín Torres-García (author) for *La ciudad sin nombre*, Montevideo. Asociación de Arte Constructivo, 1941. 14.8 x 11.5 cm. Archivo Lafuente

Cover by Joaquín Torres-García (author) for *La tradición del hombre abstracto (doctrina constructivista)*, Montevideo. Asociación de Arte Constructivo, 1938. 21 x 16 cm. Archivo Lafuente

Cover by Joaquín Torres-García (author) for *Historia de mi vida*, Montevideo. Asociación de Arte Constructivo, 1939. 17.9 x 14.4 cm. Archivo Lafuente

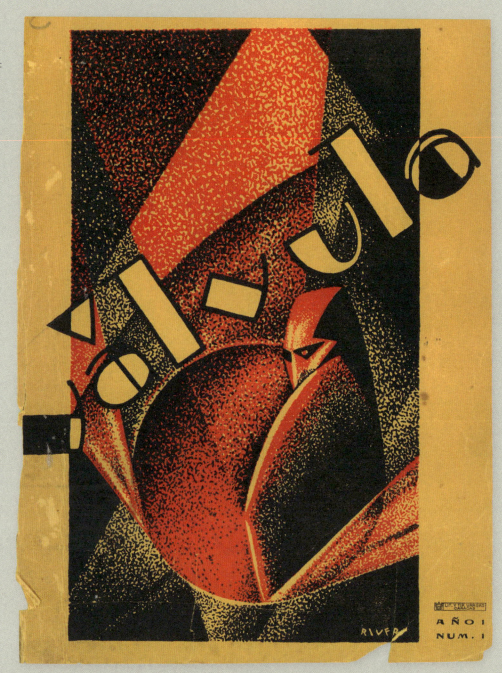

Cover by Rafael Rivero Oramas for *Válvula. Mensuario*, year I, no. 1, January 1928. Administrative coordinator: Nelson Himiob, Caracas. Litografía y Tipografía Vargas. National Library of Venezuela, Caracas

Venezuela

Riccardo Boglione

According to Elina Pérez Urbaneja (2008, 216), the development of Venezuelan graphic design began to take shape in the early 20th century thanks to "pioneering" artists who, having attended the Academy of Fine Arts, worked as self-taught designers, given that "no schools in the country trained professionals in the field of design until 1964." Regardless of the supposed emergence of modern graphics in the country at the dawn of the century, and of a possible consequent shortage of information, a few relevant bibliographic works on the subject have now been published. *Diseño gráfico en Venezuela* (1985), by Alfredo Armas Alfonzo, encompasses a broader time span than the one we are surveying, although it also describes the atmosphere of those early days and some of the period's leading figures. *El humorismo gráfico en Venezuela* (1989), by Ildemaro Torres, focuses above all on caricature artists and cartoonists, but also touches on other figures whose contributions transcended the realm of satire in publications of the moment. The monograph *Medo. Caricatura de lucha, 1936-1939* (1991), by illustrator Mariano Medina Febres (Medo), is a remarkably innovative graphic designer dedicated to the role of a political cartoonist.

Having mentioned this name, we may anticipate that in the field of books, the dissemination of a style pervaded by modernist tensions and concerns originated in the 1920s throughout most of Latin America at the same time. Essentially, it pivoted around two figures—Medo himself and Rafael Rivero Oramas—and Elite publishing house, although we also come across a few other artists, both anonymous and known, who ventured along similar paths.

We shall, however, begin our narrative with three separate cases from different periods in time that preceded the true moment of change, despite having emerged from the status quo of publishing design. The first is Mexican poet Juan

José Tablada. On a diplomatic mission in Caracas, besides the poem *Li-Po* (see pp. 704-705), Tablada released the extremely refined *Un día… poemas sintéticos* (1919), a compilation of haikus, each one accompanied by hand-colored drawings that reveal his love of Japanese culture and the indivisibility of word and image characterizing his first poetic period. An initial manuscript of *Un día… poemas sintéticos*, also dated 1919 and drawn up by Tablada at Quinta la Esperanza in Bogotá (García Rodríguez, 2019), has survived to this day. We could also mention Tablada's publication of two other books during the same period, *Hiroshigué. El pintor de la nieve y de la lluvia, de la noche y de la luna* (Mexico City, 1914) and *En el país del sol* (London, 1919).

The second case is the wonderful green and white cover designed by Carlos Luis Bohórquez, engraver from the state of Zulia, who in *La inquietud sonora* (1924), by Héctor Cuenca, seems to electrify what is essentially an Art Nouveau decoration by means of a lightning bolt, a zigzagging figure that would reappear in subsequent Venezuelan book covers. Finally, the only example we have in book form of the work of an outstanding contemporary cartoonist, Nina Crespo Báez—better known by her artistic name Ninón—is *Teatro de caricaturas* (1927), by José Ramírez, dedicated to Crespo herself. Her figures, in a "synthetic" caricatural style, are characterized by strong geometric accents achieved thanks to a "process of refined schematization in which we are surprised to see how only a few lines are able to achieve such a high degree of expressiveness" (Torres, 1988, 215). Other representatives of this style in Latin America were Carlos Raygada (in Lima in the 1910s), Uruguayan Dardo Salguero Dela Hanty, Ernesto Bonilla del Valle, also Peruvian, and, later on, Italian-Argentine architect Francisco Salamone.

To all appearances, the artist who produced a greater number of compositions consistent with several of the tenets of modernism was no doubt Rafael Rivero Oramas. Born in 1904 and hence a member of a younger generation of associates of the Fine Arts Circle, he does indeed seem to have been the first artist to introduce Cubist and Futurist trends in the visual imagery of Venezuela. In their first public forays, the members of the Circle—founded in 1912 and recognized by and large as the country's first disruptive movement that strove to rise above the "Realism of the Academy" (Calzadilla, 1982, 34)—did not rule out embracing the latest styles. At the opening of the Circle, Jesús María Semprúm, one of its members, declared: "It is our wish that, along with the followers of the most rigorous classicism, along with the firmest defenders of Romanticism and its spin-offs, we should be joined by fervent partisans of the new schools, however extravagant, however absurd they may appear, from those who adhere to esoteric symbolism to those who are frantically in love with the Futurist fellowship" (in Bouldon, 2012, 44).

The passion for avant-garde trends was not so intense, however, given that besides choosing landscape as the almost sole theme of their works, to a greater or lesser extent all members of the Circle, even the extraordinary Armando Reverón, used color "after the lessons of the Impressionists and Post-Impressionists, without resorting to formulas or precepts". In due course, many of them would begin to embody the "general trend […] toward a chromatic Expressionism that is far from manifesting itself primarily in the form employed by the great Expressionists of modern art," and ultimately, in the 1930s, a "trend much truer to reality considered as a pictorial motif rather than as a mere pretext" (Calzadilla, 1982, 35).

Accordingly, a crucial re-elaboration of the most radical European movements of the period was posed, chiefly in printed media, precisely parallel to the formation of a literary avant-garde in the country. As Nelson Osorio recalls,

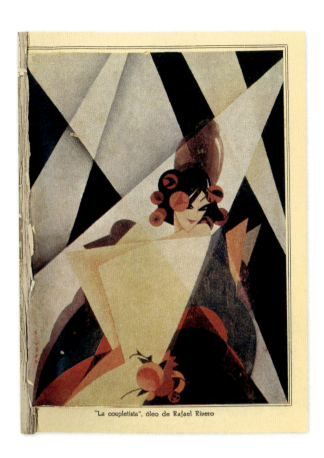

Inner page by Rafael Rivero Oramas for *Válvula. Mensuario*, year I, no. 1, January 1928. Administrative coordinator: Nelson Himiob, Caracas. Litografía y Tipografía Vargas.
National Library of Venezuela, Caracas

the disruptive language of the avant-garde was upheld—first in 1925 by *Élite* magazine (a disseminator of new ideas), and above all from 1928 onward by the group of young authors who founded *Válvula* review—in contrast to the warmongering right-wing content of Italian Futurism championed by Arturo Uslar Pietri barely one year before (Osorio, 1982, 36). Among other things, it announced that the avant-garde "had had to appeal to form in order to tangibly convey to audiences the conviction that its intention was to renew" (*Válvula* magazine, 2011, n.p.). This justified "the use of lower-case letters, the elimination of long-established punctuation, replaced by other signs or blank spaces, the whimsical neo-typography imposed by Apollinaire's *Calligrames* and Marinetti's different colored pages, one specific color for each emotion, vertical writing, etc." (*Válvula* magazine, 2011, n.p.). Moreover, at such a decisive and exciting moment they declared that "their program's expectations included the regular appearance of a Salon of Free Artists, headquarters and nerve center of the new painting and sculpture," and that the magazine "reserved the rights of graphic reproduction of the aforesaid works, while the authors would continue to enjoy their rights of ownership" (*Válvula* magazine, 2011, n. p.).

Unfortunately, only one issue of *Válvula* was published and the Salon was never staged. Yet there is little room to doubt that the prime mover

of the whole idea was Rivero, given that he was the only artist who illustrated the magazine, and that for some time such avant-garde activity spread beyond graphic design, as proven by the fact that the publication included a color reproduction of his accomplished oil painting *La cupletista*, that could be described as the result of a highly individualistic Cubo-Futurism. But who was Rivero? Born in Tácata in 1904 (where he passed away in 1992), today he is chiefly remembered as "Uncle Nicolás" for having used this name to create (first on radio programs and later in several children's volumes) the adventures of Uncle Rabbit, the character of African origin that has enjoyed "the greatest popularity in the wide landscape of the various 'oral literatures' in Venezuela" (Mato, 2003, 101).

In the late 1920s and 1930s Rivero became a major figure, eclectic and committed to his desire for novelty and to his resolve to translate it into popular media: in 1922 he was a contributor to *El sol* newspaper, he wrote for *Caracas Semanal* and illustrated *Billiken*, in 1923 and 1924 he founded children's magazines *Kakadú* and *Fakir*, respectively, and was co-founder of *Cuás Cuás* and *Caricaturas*. His experimental curiosity also led him to the field of film, in which he co-directed with his brother Aníbal *Un galán como loco* in 1929, and in 1938 "the short musical film *Taboga*, the first talkie with a live synchronized soundtrack made in the country" (Pérez, n.d.). But most importantly, he played a leading role among the founders of *Élite* in 1925, published by Juan de Guruceaga.

In this magazine, and on the covers of other works by the same publishing house—highly prolific, for in those days "there was no writer who did not have a book published by Don Juan de Guruceaga" (Armas Alfonzo, 1985, 25), Rivero constructed an advanced graphic vocabulary, a melting pot of different stimuli that was, however, always characterized by a unique use of vivid and dazzling color, a predominantly bright

Cover by Rafael Rivero Oramas (editor) for *Onza, Tigre y León: revista para la infancia venezolana*, year II, no. 22, September 1940, Caracas. Dirección de Cultura del Ministerio de Educación Nacional. 23.1 x 15.9 cm. Archivo Lafuente

palette and a play of shadows and contrasts created by varying an assortment of dots. This sharp effective chiaroscuro first appeared on the cover of *Válvula*, where purely abstract elements coexist with intersecting planes, and spheres with a geometrizing head that emerges from the scheme, the title cutting across the composition. The same principle was applied, albeit less boldly, to the cover that Rivero made for the first book by Arturo Uslar Pietri, *Barrabás y otros cuentos* (1928), where the central head was depicted without resorting to geometric reductionism. A similar portrait of a head, this time the head of a woman, strongly slenderized and set against a colorful ground, appears at the center of the cover of *Gallito de bronce* by José Ramírez, a novel published in 1929.

But it was in the early 1930s that his most accomplished creations were hatched. While it is unclear whether or not Rivero created the sober cover of *Ventanas de ensueño* (1930), by Luisa del Valle Silva, particularly interesting as a result of the refined design of its title, there is no doubt whatsoever that Rivero designed one of the most surprising compositions of those compiled here: the "Siamese" cover he made for the double book titled *Canícula* by Carlos Eduardo Frías, and *Giros de mi hélice* by Nelson Himiob. Both seem to emphasize the eclecticism invoked by the texts, which "could register thematic and aesthetic oscillations that would eventually prove slightly disconcerting" (Lasarte Valcárcel, 2005, 72). While the cover of *Canícula* is a more classical design, even though the heat conveyed by the title—Dog Days—is perfectly and impressively expressed by the orange lightning bolts surrounding the figures in the lower right-hand corner, the cover of *Giros de mi hélice* includes the partial vision of a propeller set against a ground severed by a large white band, while the title swirls around it, as if driven by the mechanism. The ingenious spine of the book is well worth a mention: obliquely bisected to accommodate both titles, its ground evokes the colors and shapes of each separate cover (cleverly worked out in warm and cool tones, respectively). As the name of the publishing house is repeated, when placed on a shelf either of the two works can feature as the "opening" title of the volume.

The complexity and chromatic energy of the cover that Rivero prepared for *El voltaje de Lucila* (1933), by Juan Carlos Bernárdez, is also captivating: the space is crowded, a slender female face on one side is complemented by the slim face of a man on the other, the two united by sinuous, incensed waves and yet crossed by a bolt of lightning, the result of a cutting use of three colors (blue, light blue, and deep red). This "burn" becomes literal in the almost Arabesque flames marked by the designer's characteristic Pointillism that pervades the striking cover of *Candelas de verano* (1937), by Julián Padrón. Highly stimulating designs, unique in the Venezuelan scene, are the abstract covers that Rivero conceived for *Mosaico* (1930), by Víctor Hugo Escala, and, above all, for *Del Pirineo y del Ávila* (1931), by Rafael Seijas Cook, published under the pen-name El arquitecto poeta (The Architect-Poet), in which the landscape was effectively reduced to simply and angularly geometric frameworks.

Medo, the other top name on our list, is remembered above all for his early appearance in the world of publishing as an illustrator (aged fourteen) and, as proven by the volume dedicated to him mentioned earlier, on account of the significance, political significance even, of his unyielding caricatures during the delicate period of transition between the dictatorial government of Juan Vicente Gómez to democracy. His cartoons published in *Ahora* newspaper under the title "Case of the Day" have been described as crucial for the historical circumstances, comments that "sought a clearly democratic, anti-reactionary, anti-fascist definition" that was "fiercely favorable to the sectors that [...]

would achieve the full recovery of a regime of liberties" (Liscano, 1991, XXIII). However, before he gave up his craft as draughtsman in the early 1940s to devote himself to his profession as a dermatologist, he would also create a number of memorable covers that stand out in Venezuelan production, distinguished by the same "refined and modern lines" (Otero Silva, 1991, XXVIII) mentioned in the case of his cartoons. In two covers designed in the early thirties he turned to a style characterized by Futurist traits—particularly in the first of the two—although the dynamism of the depicted planes is absolutely overwhelming. In *Savia* (1930), a book of poems by Julio Morales Lara, Medo divides the space into four parts by means of bold diagonal lines and a descending collection of the words that identify the book. Each one of these stenciled words, that change their color scheme when they enter "foreign" sectors and move along axes with different angles, determines the visual rhythm of the ensemble in which highly stylized figures and large fields of bright colors come to the fore, adding red and green to black. In *Cantas* (1932), by Alberto Arvelo Torrealba, the composition is once again "interrupted" by the shaft of a banner placed diagonally beside a horse: the whole cleverly enhanced by vigorous letters and a bright yellow that highlights the Pointillism, perhaps suggested by Rivero himself. Less attractive though absolutely accomplished are the designs of another book by Morales Lara, *Múcura* (1935), that to a certain extent revisit and standardize previously employed features, and those of the first edition of *Pobre negro* (1937) by Rómulo Gallegos, revealing a powerful contrast between the huge title and the underlying figure. The letters virtually seem to form a part of the load that the character sketched with subtle, almost ethereal multicolored lines, strives to hold.

Judging by other covers of the same period, it would appear that the efforts of Rivero and Medo made quite an impression, at least in part, on graphic design within and without Elite publishing house, although there could also have been other sorts of influences. Indeed, much the same outline and a similar type of lettering to those Rivero used in *Madrugada* (1939), by Julián Padrón, featured on the cover of another book by Padrón, *La guaricha* (1934), designed by Francisco Narváez, an influential sculptor native to Margarita Island with a cosmopolitan background who was less well known as an illustrator. Especially outstanding are the drawings that illustrate the book's interior, characterized by the strength and volume of numerous thick lines shaping crowds that give the figures a dramatic appearance, in spite of the "stripping away of all that is accessory, the move toward what is essential" (Calzadilla, 1982, 76) that in the end defines his entire oeuvre. An unsigned cover whose depiction of a throng in the upper band of the book bears a certain likeness to the aforementioned drawings could perhaps be attributed to Narváez himself, as we see in at least two books by Andrés Eloy Blanco with a slight variation in color, *Abigail* and *Barco de piedra*, both of 1937. A large number of standing figures, this time represented in an impulsive foreshortening, is also found in another Medo's works, *Afluencia* (1937), by Héctor Guillermo Villalobos, the structure and creation of which may be less persuasive although they are no doubt worthy of mention for the modern though rustic quality of the receding perspective.

A similar disorganized and volitionally crude look with unorthodox manual lettering characterizes three other covers of the 1930s. The first is that of the Post-Art Nouveau book by José Antonio Ramírez Rausseo, *Sangre de quimeras* (1932), designed by an interesting painter advanced in years, Antonio Angulo. Born in Maracaibo in 1905, Angulo was sensitive to European avant-garde trends and that same year would paint the false ceiling of Baralt Theater (Semprún and Hernández, 2018, 109), one of the

earliest and most original abstract works made in Venezuela that pushes the boundaries of the term Art Deco used to describe it (Noriega, 1989, 103). The second and third are the more caricatural covers of *Los conuqueros* (1936), by Julio Ramos, and *Estampas* (1938), by Alberto Ravell, the latter signed by Joaquín Pardo, one of the draftsmen of the humorous weekly *Fantoches*.

Three further designs have certain compositional affinities thanks to their titles in large characters and a medium-sized central image. *Por donde vamos…* (1938), by Ramón David León, is the less striking example that nevertheless stands out because of its interesting interaction between the colors red and black in the image, and the letters, highlighting in red the PDV initials that in Spanish stand for the Venezuelan Democratic Party. On the other hand, the illustrations of *El cabito*, by Pedro Maria Morantes (Pío Gil), and *Mene*, by Ramón Díaz Sánchez, both of 1936, concisely and effectively capture the essence of the novels: the window of a prison in the first case, a fiction about the tyranny of José Cipriano Castro; an oil well with a red superimposed hand in the second, a novel focused on the social conflicts unleashed by the actions of foreign companies in the oil exploitation business.

Finally, we should mention a late creation that only just falls within the time scope of this study. Although "impure," it fits in the category of word-image, as it reveals an important annotation on the relationship between letters and shapes. *Glosas al cancionero* (1940), by Alberto Arvelo Torrealba, presents a rigid and yet to a certain extent already domesticated version of those vigorous combinative experiments evocative of the pre-Concretist movement, as illustrated by numerous examples in the chapter devoted precisely to "Word-Image".

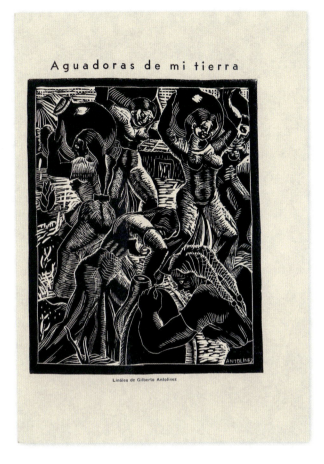

Inner page by Gilberto Antolínez for *Viernes*, no. 5, December 1939. Managing Editor: Pascual Venrgas Filardo, Caracas. Cóndor. 28 x 22 cm.
National Library of Spain, Madrid

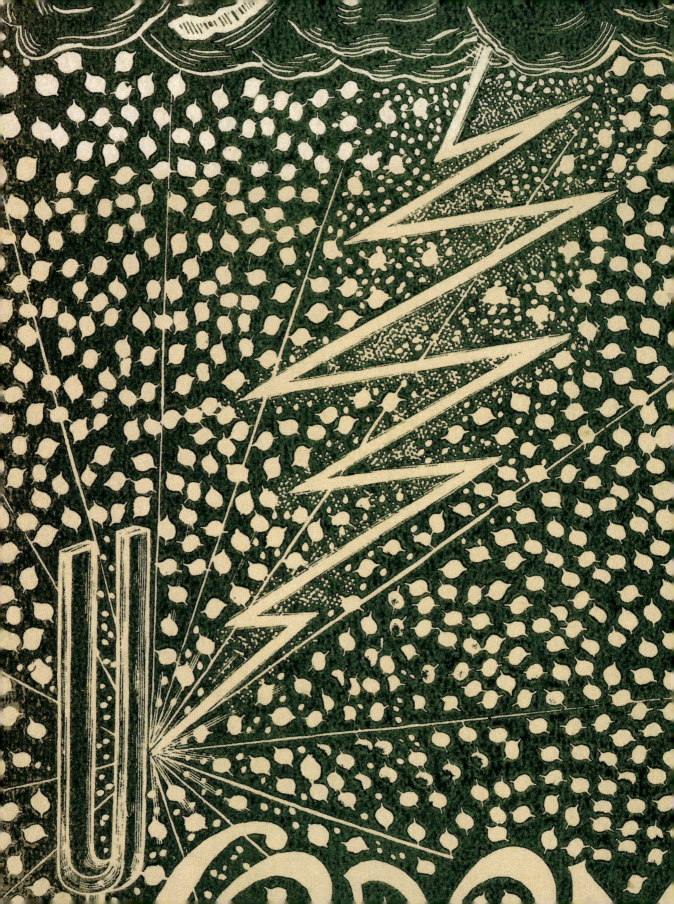

Venezuela

Cover by Carlos L. Bohórquez for Héctor Cuenca, *La inquietud sonora*, Maracaibo. Tipografía Excelsior, 1924. 20.3 x 14.2 cm. Boglione Torello Collection

Cover by Pako and inner pages by Ninón (brush name of Nina Crespo Báez) for José Ramírez, *Teatro de caricaturas*, Caracas. Taller Gráfico, 1927. 17 x 13 cm. National Library of Spain, Madrid

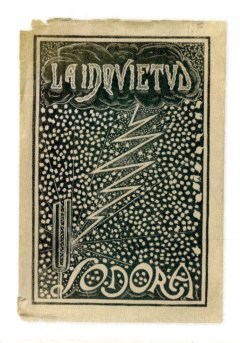
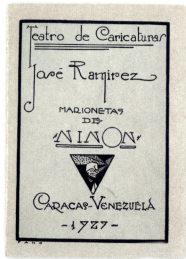

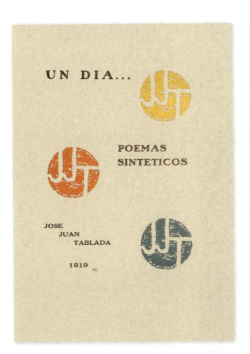

Cover and inner pages by José Juan Tablada (author) for *Un día… poemas sintéticos*, Caracas. Editorial Bolívar, 1919. 21 x 13 cm. Juan Bonilla Collection, Seville

Cover by Rafael Rivero Oramas for Juan Carlos Bernárdez, *El voltaje de Lucila: cuentos*, Caracas. Elite, 1923. 20.5 x 14.4 cm.
Boglione Torello Collection

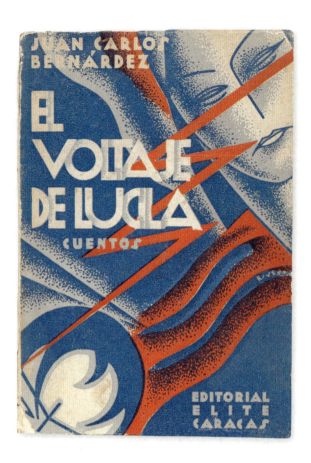

—»
Covers by Rafael Rivero Oramas for Carlos Eduardo Frías / Nelson Himiob, *Canícula / Giros de mi hélice*, Caracas. Elite, 1930. 20.4 x 14.1 cm.
Boglione Torello Collection

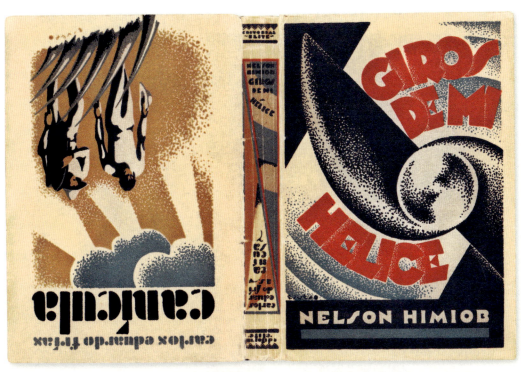

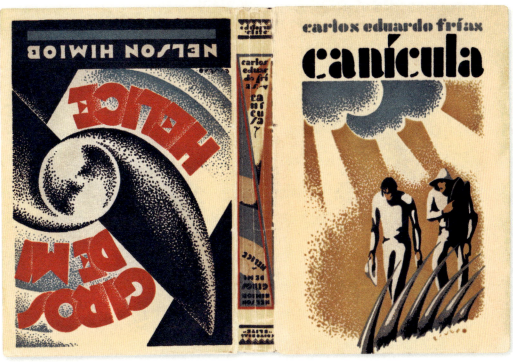

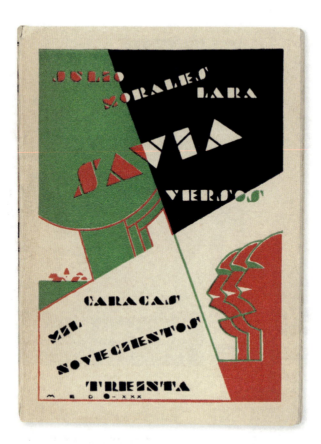

Cover by Medo (brush name of Mariano Medina Febres) for Julio Morales Lara, *Savia: versos*, Caracas. Elite, 1930. 16.4 × 12 cm. Boglione Torello Collection

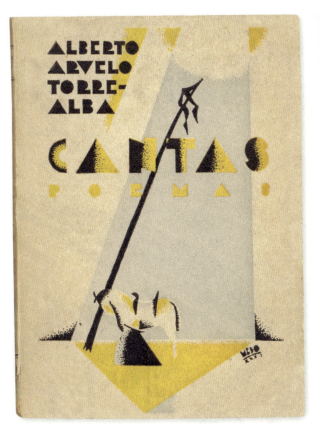

Cover by Medo (brush name of Mariano Medina Febres) for Alberto Arvelo Torrealba, *Cantas: poemas*, Caracas. Elite, 1932.
16.5 x 12.2 cm.
Boglione Torello Collection

Cover by Rafael Rivero Oramas for Víctor H. Escala, *Mosaico*, Caracas. Tipografía Vargas, 1930. 19 x 12.6 cm. Private collection, Granada

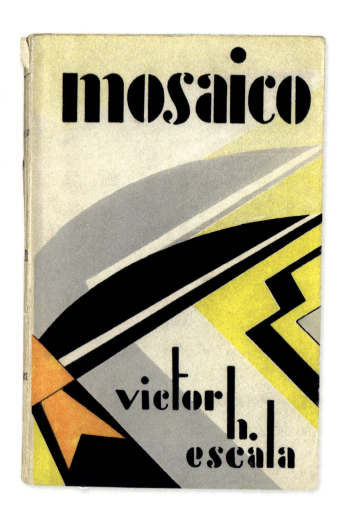

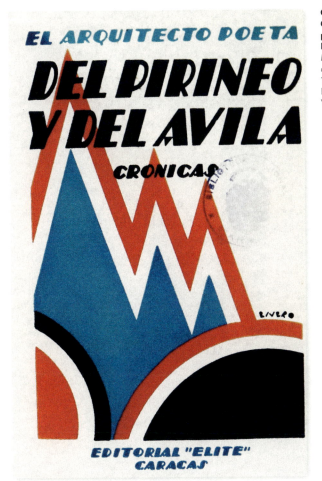

Cover by Rafael Rivero Oramas for El arquitecto poeta (brush name of Rafael Seijas Cook), *Del Pirineo y del Ávila: crónicas*, Caracas. Elite, 1931. 19.4 x 13 cm. National Library of Venezuela, Caracas

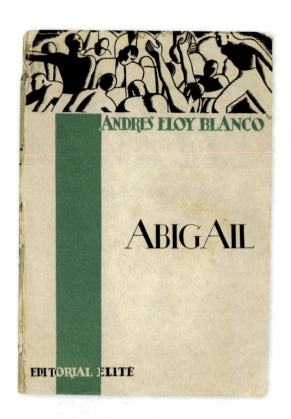

Cover attributed to Francisco Narváez for Andrés Eloy Blanco, *Abigaíl*, Caracas. Elite, 1937. 20.5 x 14 cm.
Archivo Lafuente

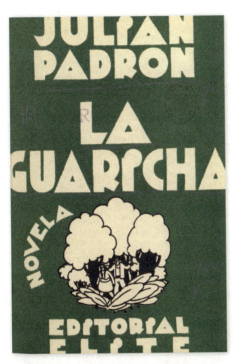
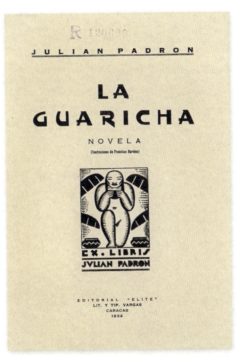

Cover and inner pages by Francisco Narváez for Julián Padrón, *La guaricha: novela,* Caracas. Elite, 1934.
19 x 14 cm.
National Library of Spain, Madrid

ANNO I　　　　　　　　　　　　　　　　　　　　　　　　　　　NUM. 7

FESTA

neste numero:

poemas de: augusto meyer e juana de ibarbourou.
prosas de: adelino magalhães, cardillo filho, zagus ferraz, andrade muricy, murillo araujo, carlos chiaschio, thomaz murat, wellington brandão.

rio de janeiro　　　　　　　　　　　　　　　　　　　　15 - abril - 1928

Cover by unknown artist for *Festa: mensario de pensamento e de arte*, year I, no. 7, April 15 1928. Editors: Porphyrio Soares Netto et al., Rio de Janeiro. Officinas Alba. 31.5 x 23.2 cm. Archivo Lafuente

Word-Image

Riccardo Boglione

The typographic revolution of the early 20th century led typefaces to evolve in such a way as to create *verbovisualidad*, i.e. visual representations of language, unprecedented reverberations within the rectangular spaces of covers and pages. It also favored the growing emancipation of letters, the smallest compositional units, that ceased to be conceived simply as vehicles of meaning and began to be used as pure forms, plastic values, albeit always inextricable from their literary element and hence never innocent. In a text published in the catalog titled *La vanguardia aplicada* that accompanied the exhibition of the same name, Maurizio Scudiero spoke of the "word-image," a definition we adopt here. According to the Italian author, the term derives from the Futurist *parole in libertà*, or "words-in-freedom," although it presents a few differences to the former style as these words, in opposition to the traditional diagrammatic scheme, strove to promote their meanings: "The word-image, however, is based on a very different assumption, one that is not literary and has nothing to do with the meaning of the text, but rather with the logic of the 'spatialization' of the text" (Scudiero, 176).

Thanks to the consolidation of the word-image could perhaps be found in Russian Constructivism, influenced in its turn by Marinetti and his Futurist colleagues, as well as by certain Dadaist works, notably posters. In broader terms, the radical graphic changes characterizing the period, even in popular art forms, both in Europe and in Latin America, the words forming books' "credentials"—authors, titles, and publishers, in some cases their years of publication—gained increasing complexity on their covers. Letters took center stage, any sort of figurative element that referred to reality was abandoned, and the sobriety of classical typographical syntax consolidated in the 19th century, and even the partly iconoclastic beautiful Art Nouveau

arabesques were forsaken to make way for complete compositional freedom, whether in the Expressionist vein (calligraphy, xylography, etc.), or in more rational terms (typography, the insertion of geometric elements, pre-Concrete Art, etc.). Sometimes even the two dimensions of books would be combined—as Jan Tschichold described in his key work *The New Typography* (1928) speaking of the important role played by Dada in the typographical transformations shaping the functional field of diagramming, it was not without "irony that the extremely ordered and rational New Typography should have derived from Futurism and Dada" (Rothschild, 1998, 45).

Heavily influenced by advertising, especially by poster adverts, that became increasingly inventive, leaving greater space for letters (suffice it to think of Lucien Bernhard's posters made in the early years of the 20th century), word-images were not linked "to pages by virtue of their poetic value or their connection with texts, but chiefly because of their visual nature. None of which had the slightest effect on texts' ability to 'convey.' On the contrary, this was often improved" (Scudiero, 2012, 176). Conceived for the shop windows of bookstores of the period, such graphic designs didn't only make a strong impression on customers but immediately put books' authors and publishers on the crest of the wave of modernity in the 1920s, even if neither the works themselves nor the publishers' dispositions could be considered modern. As we've seen on other occasions, the spirit of the designs and that of contents barely coincided, and in the case of these well-worked, striking letters the clash between container and contents was, perhaps, stronger than in other spheres.

In view of the impressive number of examples we have managed to gather together, and bearing in mind, too, that roughly a hundred have been left out of our final selection, we're tempted to say that the word-image, in its countless forms,

was the most frequently used avant-garde "instrument" in book covers throughout Latin America during the period we are surveying, and thus perhaps its most characteristic feature, appearing more or less elaborately and continuously, in varying numbers, in many of the countries examined. It was also a melting pot of different tensions, some of which were seemingly antithetical (handwriting and colder sans serif types, for example), where the conceptual core of such graphic designs was celebrated. Indeed, word-images led to the total emancipation of words and even of letters (in conjunction or not with abstract design), primarily conceived as the nodal element of the graphic structure yet never in a "servile" position as they had appeared in the first decade of the 20th century, save, of course, for a few exceptions. We should mention that in most cases these were anonymous works, created by typographers or proto-graphic designers who either collaborated with publishing houses or with printing presses directly.

We have divided this chapter into two parts, dedicated, respectively, to typographic covers and to lettering. Although some results are similar, these are two different ways of relating words and images, one of them mechanical and the other free, which explains why they deserved separate spaces. Combinations of verbal and geometric elements (lines, circles, rectangles, etc.), a common pairing in which color also usually plays a key role, are indistinct from designs with only letters, as such features were usually employed to enhance the graphic identity of words, not obscure them. As Frassinelli recalled (1948, 186), avant-garde typographers, aware that "all compositions should have a dynamic force," used "decoration simply, and only in accordance with characters."

To conclude, we have reserved a small final section to the use of numbers in titles, making no distinction here between typography and lettering. This was quite a frequent practice

during the years in question, possibly endorsed by a kind of "mathematical" inclination that characterized a determined form of Futurism, given that it appears to have established a compositional code in which the mathematical sign, invariably outstanding in size, becomes the "anti-literary" center of graphic development, with notable results including the sinuous play of letters and figures in *20 poemas de América* (1930), by Humberto Zarrilli and Roberto Abadie, designed by the Uruguayan planar painter Guillermo Laborde.

Typography

The state of affairs in Latin American typographic firms during the first decades of the 20th century varied according to each country and, of course, each city. However, the scarce variety of types in the 1910s was followed by a gradual importation and local production of new types, or of types adapted to European models, in the 1920s but, be that as it may, no particularly complex types appeared. In terms of numbers, *palo seco* or sans serif fonts are more frequent than serif fonts, perhaps on account of the immediate association with the "grotesque" fonts that were being developed during those years in the field of advertising—the most famous of which, Futura, was created in 1925—and of the rigor and clarity that were so central to the new typography, keen to simplify and refine graphic designs.

Our survey begins with a single example of work produced before the 1920s, the early design for *En el reino de las cosas*, by Juan José de Soiza Reilly (1905), a cover by the Argentine artist Arnoldo Moen, himself a publisher, which combined a traditional composition with an "old" version of the Gothic typeface and rhythmical vertical lines interrupted by blocks that bring exceptional dynamism to the ensemble. Although we are now well within the time frame that concerns us, certain Mexican designs seem

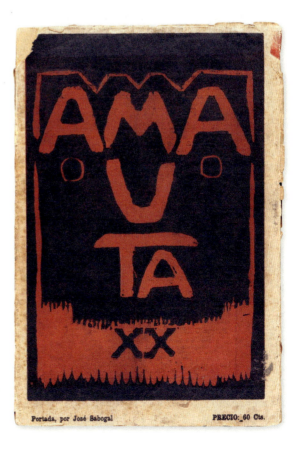

Cover by José Sabogal for *Amauta: revista mensual de doctrina, literatura, arte, polémica*, no. 20, January 1929. Editor: José Carlos Mariátegui, Lima. Empresa Editora Amauta. 25.5 x 17.5 cm. Boglione Torello Collection

inspired by Constructivism and are characterized, too, by the use of red and black, such as *Lázaro Cárdenas* (1933), with its illustrations by Stridentist artist Fermín Revueltas, Djed Bórquez (Juan de Dios), who skillfully negotiated the relationship between horizontality and verticality. Along these lines, the Lino-Typographical Workshops of the Industrial School of Arts and Crafts in Toluca published the "essay in historical philosophy" on *El estado de México* (1933), by Horacio Zúñiga. The same author is worthy of mention for the cascading design of his essay *La universidad, la juventud, la revolución*, published in 1934. By the same token, Mundial publishing house released the historical novel *Atahuallpa* (1934), by Ecuadorian author Benjamín Carrión, and at least two other books with similarly impressive features: *Ensayos literarios y musicales* (1935), by Daniel Castañeda, and, especially, *¡Oid, camaradas!* (1937), by Arnulfo Martínez Lavalle. While in the avant-garde poetry of *Suenan timbres* (1926), by Colombian author Luis Vidales, the combination of three types (a sans serif, a modern serif and a condensed Egyptian type from the early 19th century) that fill the entire space of the cover can be described as eclectic, in another series of books we come across justified and usually grotesque letters inscribed in invisible squares and rectangles, achieving extreme clarity and neatness. This resource was used by numerous avant-garde artists in Chile, as we see in *Mirador* (1926), by Rosamel del Valle, *Heroísmo sin alegría* (1927) and *Escritura de Raimundo Contreras* (1929), by Pablo de Rokha, *Un montón de pájaros de humo* (1928), by Clemente Andrade Marchant, a member of the Runrunist literary movement. In other countries it can be traced in the works *Una esperanza i el mar* (1927), by Peruvian author Magda Portal, *Nave del alba pura* (1927), by Uruguayan author Jesualdo, *Libertinagem* (1930), by Brazilian writer Manuel Bandeira, and in the Argentine exhibition catalog *Novecento italiano* (1930), that furthermore

Cover by unknown artist for *Clave de sol*, no. 2, May 1931. Editors: Horacio I. Coppola, Isidro B. Maiztegui, José Luis Romero, and J. A. Romero Brest, Buenos Aires. Talleres Gráficos de M. Lorenzo Rañó. 21.7 x 16.4 cm. Archivo Lafuente

presents a wonderful play on the colors in the background. Three other works can also be assimilated to this trend, despite not following it as categorically: *Dos campanarios a la orilla del cielo* (1927), by Chilean author Gerardo Seguel, the sober design for *El derecho de matar* (1926), enhanced by the crimson of the paperboard, by Peruvian authors Serafín del Mar and Magda Portal, published in Bolivia, and the slippery letters that literally jolt such grids in the second edition of *El reloj de la hora bailarina* (1930), by Arturo Cambours Ocampo, printed by El Inca avant-garde publishing house in Buenos Aires.

Size was another element used to catch the attention of readers, generally in combinations of large characters for titles and smaller characters for other details, that almost acted as frames. This is exemplified in the design for *U*, striking as well for having such a concise title, published by Pablo de Rokha in Santiago in 1926 by Nascimento. Ten years later the same design was almost identically repeated in the third edition of *Él* (1936), by the Spanish exiled author Mercedes Pinto. The letters in *Falo* (1926) too, by Emilio Armaza, that evoke the condensed Egyptian types, and the "Villa" red in *Francisco Villa y la "Adelita"* (1936), that Baltasar Dromundo published in Mexico, fulfill this catalytic role, whereas another Mexican book, *Presencias* (1937), by Leopoldo Ramos, only enlarges the initial P of the title, crowned by a huge period to its right. In other cases, anonymous typographers strove to find extraordinarily deformed typefaces in order to shake up readers, as illustrated by the hyper-condensed letters in *Poemas análogos* (1927), by Brazilian author Sérgio Milliet, where "the visual expressiveness is created precisely by the disproportion of the letters and their justification, that highlight their verticality" (Soares de Lima, 1985, 152), or by the composition of letters in a powerful game of broken lines, as in *Atmósfera arriba* (1934), by the Uruguayan author Blanca Luz Brum, and particularly by *Las ínsulas extrañas*, by Esther de Cáceres, also Uruguayan, published in 1929 in Santiago del Estero (Argentina) by La Brasa group.

We must also mention a triad of books featuring broad fields of geometrically intersected colors into which the designer has inserted letters characterized by refined and striking tones: the anonymous illustrator of the cover of *Sin sentido* (1932), by Jorge Icaza, the "panoramic" cover with flaps, seldom seen during this period (whose letters are not in fact typographic), of *Los Juan López Sánchez López y López Sánchez de López* (1933), by J. M. Puig Casauranc, which, given the presence of Julio Prieto as illustrator of the inside pages, could have been designed by Ángel Chapero who, once again in the company of Prieto, produced a very similar cover for *Del hampa (teatro sintético)*, by Rafael Taylor Pérez, three years later.

Several anonymous typographers would look to word-image resources that exploited blank space in different ways, scattering letters vertically in compositions that moved from extreme simplicity, as in *Impromptu* (1931), for instance, by the Uruguayan author Julio de Frieri, or in *Cuentos de Micrós* (1932), by the Mexican author Micrós (Ángel del Campo), to constellations that were structurally more articulated, like the one in the volume *Los que se van*, by Joaquín Gallegos Lara, Enrique Gil Albert and Demetrio Aguilera Malta, which appeared in Guayaquil in 1930. Or that of the later work *Sublimaçao* (1938), by the Modernist Brazilian poet Gilka Machado, or again, in Mexico, the covers of a *Selección de poemas* (1932), by Salvador Díaz Mirón, and *Sueños* (1933), by Bernardo Ortiz de Montellano. In order to ensure the movement of letters, lines and semicircles appear in delicate rhythmic interplay in the simple yet clever cover for *Agonía y paisaje del caballo* (1934), an avant-garde experiment by the Ecuadorian José Alfredo Llerena, in which the number 18 becomes the central feature.

Cover by Víctor Valdivia for *Caras y Caretas*, year XXXIV, no. 1700, May 2 1931. Founder: José S. Álvarez. Buenos Aires. Talleres Gráficos de Caras y Caretas. 26.4 × 17.8 cm. Private collection, Granada

Lettering

Much freer and, broadly speaking, complex are the covers that turn to lettering, drawn directly by the artists and proto-designers via xylographic or lithographic processes, or else by means of metal plates, in any event far removed from any predetermined grid, however mobile or strange the latter could be, and from the serial nature of types. However, "it is an important premise for the lettering designer to discreetly use the conventional signs that represent the alphabet, that is, mobile types in printing" (*Rivoluzione*, 2001, 87). In fact, most of the examples quoted here are basically imitations—or, most commonly, variations, sometimes rigorous, sometimes whimsical, almost always displaying considerable inventiveness—of a few specific typographic families that prevailed in avant-garde graphic art, such as stencils and other "extremely black" types, i.e. with a density of more than 30%. We could assume that the prominence of lettering over and above typography in the birth and development of word-images was a result of the scarce number of typefaces in standard Latin American printing presses in the first third of the 20th century, although the flexibility that freehand drawing gave publishers when it came to creating visually memorable cover designs was no doubt crucial. Although these designs flourished around the continent, most of them were created in Mexico and Rio de la Plata. Buenos Aires and Montevideo had their own special connections: *Los alambradores* (1929), by Victor Dotti, published by the Uruguayan Albatros press based in Montevideo, reproduced the design created by the avant-garde publishers Proa and the group of artists who worked on *Martín Fierro* review in Buenos Aires, as seen in several books, like *Don Segundo Sombra* (1926), by Ricardo Güiraldes. Apparently, the design also inspired the cover of *Oriental* (1926), by the Uruguayan author Julio Silva, who, in turn, probably influenced another artist from eastern Uruguay, Manuel Rosé, in the composition of a paperback version of the same motif for *Rutas luminosas* (1930), by Luis Rodríguez Legrand. Given the great number of covers produced during these years, we shall refer only to those that proved outstanding and those that paved the way for trends shared by several works.

The use of word-images in lettering before the period we are surveying here, we shall mention the one that best expresses avant-garde concerns: the cover of *Eu*, the first and only poetry book by Brazilian author Augusto Dos Anjos published in 1912, "one of the most interesting graphic designs of the time, with a huge title situated on the left of the composition and printed in red" (Corrêa do Lago, 2009, 392), that anticipated several successive designs featuring extremely large letters.

Other headings with inordinate letters include those of *Dibujos en el suelo* (1927), by Bernardo Canal Feijóo, where large, angular words fill the entire cover (a similar design to the one in the aforementioned *Las ínsulas extrañas*, by De Cáceres), the disproportionate letters conceived by Rio de Janeiro muralist Paulo Werneck for *O. K.* (1934), by Benjamim Costallat, and the overelaborate, meandering letters that fit together perfectly creating sinuous combinations that Colombian artist Ecco Neli (Cleonice Nannetti) composed for her own book, *Otros cuentos* (1937). A giant T acts as the backbone of the complex superimposition of planes in *El Tabasco que yo he visto* (1935), by Roberto Hinojosa, and *Dónde* (1933), is remarkable for its impressive angular design by Manuel Amábilis, both of whom were Mexican.

Within the stylistic trends of word-images, the relative scarcity of handwriting and imitation calligraphy, which was essential to early Russian Futurism, for instance, is quite surprising. Beyond the extravagant case of aforementioned Horacio Zúñiga, probably the most important and creative

titles designer as we see in the two-page spread dedicated to his designs reproduced in the Mexican chapter of this book (see pp. 486-487), it only appears to have been deliberately used on the powerful cover of *Libro de imágenes* (1928), by the Uruguayan author Humberto Zarrilli, in the same color blue used to print the entire contents of the book of poems. A stiffer form of manual design appears in *Va y ven* (1936), by the Venezuelan author Luis Fernando Álvarez, in *La sonrisa* (1933), by the Argentine writer Luisa Sofovich, and in *Voz y silencio* (1936), a compilation of poems by the Uruguayan author Raquel Saénz. A totally mechanized calligraphic expression is perhaps the one in the special edition of *Suma* (1938), written by the Argentine author Luis Franco and illustrated by Demetrio Urruchúa, where deep red tones contrast elegantly with the silver background. To a certain extent, the draftsman's hand is deliberately emphasized in covers as varied as the early edition of *Vida extincta* (1911), by Felippe D'Oliveira, clearly inspired by Art Nouveau, *La amada infiel* (1924), romantic and anti-romantic verses by Nicolás Olivari, and the Gothic-like letters of *Romancero de niñas* (1932), by Luis Cané.

On the other hand, the (very) free and occasionally (highly) sophisticated versions of foreign typefaces were widespread at this time. Futurism was especially in vogue, and would soon be adopted in advertising, as proven by the Mefistofele typeface created in Italy by the Reggiani foundry (Frassineli, 1948, 193). The design for *El posadero que hospedaba sueños sin cobrarles nada* (1929), by María Paulina Medeiros, is a delicate construction in which the letters are supported by lines of different length, the entire composition characterized by a virtuous use of color. The covers of a small number of books that appeared in Buenos Aires between 1929 and 1931 skillfully alternated red and black letters: *El asesino de sí mismo*, by Isreal Chas de Chruz, illustrated by Mario Rosarivo, *Pandilla de hombres honrados*, by Delio Morales, illustrated by M. Gimeno, and *Festín de los locos*, illustrated by the author of the novel, Carlos Ocampo. In the meantime, the illustrious Chilean draftsman and engraver Carlos Hermosilla created a linocut for *Pirámide para la momia de Lenin* (1935), by Peruvian author Luis Berninsone, with a powerful assemblage of letters forming triangles that, funnily enough, emphasize the year of publication over and above other elements. Another dark European type is Bifur; invented by French graphic designer A. M. Cassandre in 1929, it would be revisited, manipulated, and inserted in striking graphic compositions with inspiring colors in the work *Los caciques*, by Mariano Azuela, and *La escuela de las mujeres*, the translation of a novel by André Gide, both books released in 1931 by the Mexican publishers Ediciones de La Razón.

It is also worthy of interest to note what could be the reappearance of some of the features of Russian Constructivism. Brazil produced *Velocidade* (1932), by Renato Almeida, and what is almost a replica of the red and black squares used by El Lissitzky in his emblematic *About Two Squares. A Suprematist Story* (also known as *A Suprematist Story about Two Squares in 6 Constructions*) published in 1922, delicately superimposed in the cover for *Circo* (1929), by Álvaro Moreyra. Despite the limited number of Uruguayan artists who adopted this style, their works had a strange connection with earlier Russian designs. Rather than the pseudo-mechanical perfection of the Soviet works, Uruguayan designs emphasized the handiwork of their coarse and somewhat precarious yet stylized versions of Constructivism. Humberto Frangella applied himself to creating a sort of "sanguine" version of the style on the cover of *Episodio* (1930), by Arturo Despouey, while *Allegro scherzando* (1929), by Ofelia Machado Bonet, a booklet on the *Memoria artística de la Asociación Coral de Montevideo* (1929), and *Represión del*

Cover by Carlos San Martín Ibarbourou for *Homenaje a Guzmán Papini y Zás*. Editor: Carlos A Barbetti. Montevideo. Talleres Gráficos de José Florensa, 1934. 33.3 x 24.4 cm. Private collection, Granada

⇢
Back cover by unknown artist for *Klaxon. Mensario de arte moderna*, no. 1, May 15 1922. São Paulo. Tipografía Paulista. 26 x 18.2 cm. Archivo Lafuente

proxenetismo (1932), by Horacio Abadie, appear to have designed by the same (anonymous) artist.

In spatial terms, diagonal lines are the easiest way of enlivening designs and hence is a key element in numerous covers. They appear both in shapes that cross the compositional space, like the clever red staircase, climbed by the letters of *El movimiento obrero de México no es marxista* (1937), by Ricardo Treviño, or the light in *Cosmografía*, by Gustavo R. Amorín, and in the actual use of words, as in the large dense letters of *Tientos* (1928), by Ernesto V. Silveira, in the wonderful composition with late-Futurist letters on the front and back covers of *El libro del peregrino* (1931), published in Mexico by Baltasar Izaguire Rojo, in the Uruguayan *Brochazos* (c. 1934), by Gerónimo Yorio, and in the Argentine editions *La novísima poesía argentina* (1931), by Arturo Cambours Ocampo, and the perfect cover of *El tropel* (1932), by Mateo Booz, published in Santa Fe. Besides diagonals, there is also room for curved lines, especially between circles and semicircles, an extremely efficient way of bringing both energy and grace to compositions as we see in the covers of *Rima alfabética* (1937), by José María Dávila, *Mi amigo azul* (1934), by Hortensia Elizondo, the highly elaborate *Paulistana* (1934), by Martins Fontes, possibly designed by Alex Rossato, *Op. Oloop* (1934), by Juan Filloy, and the "cosmic" *Tierra Sur* (1932), by Enrique González Trillo and Luis Ortiz Behety, among others. Similarly, the circle acts as a cohesive or structuring element for the actual letters, as we see in the early work *Rodó* (1919), by Uruguayan author Víctor Pérez Petit, the Mexican book *Ronda de luna* (1934), by María Evelia Monterrubio Sáenz, *La buena mesa* (1935), by Chilean writer Olga Budge de Edwards, that furthermore opposes little circles (silver, like the calligraphy) to cutting lines and sharp angles,

the proto-Pop Art design for *Poemas escolhidos* (1931), by Brazilian Guilherme de Almeida, and the circle/sun in the center of *El Socialismo* (1936), by Mexican author José de Jesús Manríquez y Zárate. The covers for the strange book *Bongó, poemas negros* (1934), by Cuban poet Ramón Guirao (see p. 394), for *Borrões de verde e amarello* (1933), by Brazilian writer Cassiano Ricardo, and for *¡Oro, más oro!* (1936), possibly designed by the artist himself, the Mexican Dr. Atl. All these works took great advantage of circular shapes in the design of their letters.

A series of eclectic combinations that cannot, however, be grouped by analogies, is also worthy of mention. Blending styles in impressive and apparently unrestrained experiments, separated from the avant-garde schools of the second decade of the 20th century by the distance of time, they attained a high degree of heterogeneity. Chronologically, we shall begin by describing the earliest of these designs. The contrast between black and yellow is an essential combination in the modernization of graphic art—suffice it to think of *The Yellow Book* (1894-1897) by Aubrey Beardsley—and characterizes the cover of *Himnos del cielo y de los ferrocarriles* (1925), the Futurist work published in Uruguay by Juan Parra del Riego. *Kilómetro 823* (1931), by the Argentine couple González Trillo and Ortiz Behety, has a delicate black cover with gray stencil-like letters and a vibrant white dust jacket, both designs connected by a drawing of stars. In a square format, the logic of chess presides over the cover of a re-edition of the famous book by Pablo Neruda, *Veinte poemas de amor y una canción desesperada* (1932). The intelligent use of the back cover as the continuation of the front cover, pertinently revealing late echoes of Russian Constructivism, characterizes the volume *Congreso de escritores soviéticos de Moscú* (1935) published in Montevideo. Arango created an elegant, deliberate dance of letters and score for *Variaciones alrededor de nada* (1936), by León de Greiff, while the quivering letters in the double Chilean book *Ánimo para siempre / Vitalidad para el ser* (1938), by Rolando Soto, were more expressionistic.

As mentioned at the beginning of this chapter, the authorship of such works was often unknown. However, among the works that were signed it is worth our while to point out those by active practitioners, as well as those by famous plastic artists who occasionally devoted themselves to graphic design. In Uruguay, possibly the country that boasts the most covers dedicated to word-images, we should discuss the activity of three artists whose titles were superb. Aforementioned Frangella was a photographer and painter who specialized in the genre and produced outstanding illustrations, including the bright colors and figures based on unfeasible contrasts and angles of *Voces mías*, by María Clotilde Moratorio de Torres, and *Proa de estrellas*, by Ramón M. Díaz, both in 1929, and *Rumor* (1931), by Atahualpa del Cioppo, a high point in Art Deco book design. Planar painter Luis Alberto Fayol perfectly combined geometric forms, letters and inks in at least three books, *Canción de los pequeños círculos y de los grandes horizontes* (1927), and *Tragedia de la imagen* (c. 1930), by Vicente Basso Maglio, and *Los cielos* (1935), by Esther de Cáceres. Last but not least, Luis Toasaus, a graphic designer by vocation and the owner of a successful design office in the 1930s (Boglione, 2019, 150), illustrated *Poemas a Mimo* (1933) and, above all, *Campo verde* (1931), by T. M. González Barbé, in a Constructivist vein with reminiscences of Art Deco, "resulting from an accurate game of varied manual types, geometric shapes and black, green and red ink" (Gutiérrez Viñuales, 2014, 83).

Among other signed works we must speak of a sort of verbal labyrinth made with millimetric precision and maximum lightness for the surrealistic play *Paralelogramo* (1935), by Gonzalo Escudero. The cover of the book, described as the

"copy of the one made for *Le mouvement perpétuel* (1926), by Louis Aragon" (Bonet and Bonilla, 2019, 481), was conceived by the Ecuadorian artist Francisco Alexander, a musicologist and literary translator who happened to turn his hand to graphic design. Two other designs follow, by the outstanding Spanish illustrator who worked primarily in Argentina, Alejandro Sirio: the cover for *Fronteras* (1932), by Antonio Pérez-Valiente de Moctezuma, and, especially, the one for *En tu vida estoy yo* (1934), by Samuel Eichelbaum, a perfect fusion of different avant-garde tensions. The ingenious cover for *Prismas* (1928), by Eduardo González Lanuza, is but one of those made for this book, the other being a classical design by Juan Antonio Spotorno, a painter and engraver from Buenos Aires. The great artist from Rio de Janeiro Emiliano Di Cavalcanti, who designed several covers reproduced in our survey, made at least one foray into the field of word-images, effectively introducing the arrow in the dynamic composition *Conduta sexual* (1934), by Antonio Austregésilo.

We would like to draw attention to a handful of books that could be described as *meta*, in which the essence of word-images is respected as much as possible while the meaning of their titles is reinforced. Indeed, their mere iconic presence and superficial visual suggestiveness manage to conceptually complete the actual sentences they graphically construct. Among these works are the Chilean volume *Mester de juglaría* (1934), by Juan Negro, where the words are obviously being juggled, the Uruguayan publications *Proyecciones* (1936), by Sara Rey Álvarez, where the letters increase in size from left to right as if they were a beam of light from a film projector, and *Fuga* (1936), by Marisa Serrano, the title of which, an orange ribbon that crosses both the front and the back cover, ideally oversteps the limits of the volume. Other such designs are the Argentine covers for *Mi ruta: El pasado… El porvenir…* (1936), by Chilean author Ventura Maturana, where both the diminishing size of the letters and the shrinking side bands simulate the perspective of a street, *Cuaderno* (1937), by Manuel Rodeiro, where the details appear to be profusely drawn on the characteristic graph paper of school notebooks, and *Poemas de los círculos concéntricos* (1936), by Graciela Peyró, whose letters, imitating rounded calligraphy, rest on a sequence of hypnotic decreasing circles. All surprisingly published in the mid-1930s, these illustrations seem to suggest that that was the period when the word-image genre came of age.

POEMA

Word-Image

Covers by Arnoldo Moen for Juan José de Soiza Reilly, *En el reino de las cosas*, Buenos Aires. Arnoldo Moen y Hno., 1905. 20.8 x 12.8 cm. Private collection, Granada

Cover by Horacio Zúñiga for *Realidad: novela*, Mexico City. Imprenta Gómez y Rodríguez, 1936. 22.6 x 17 cm. Archivo Lafuente

Cover by unknown artist for Horacio Zúñiga, *La universidad, la juventud, la revolución*, Mexico City. Talleres Lino-Tipográficos Gómez y Rodríguez, 1934. 19.5 x 14.4 cm. Archivo Lafuente

Cover by unknown artist for Horacio Zúñiga, *El estado de México desde la prehistoria hasta la conquista. Ensayo de filosofía histórica*, Toluca. Talleres Lino-Tipográficos de la Escuela Industrial de Artes y Oficios de Toluca, 1933. 29.5 x 19.7 cm. Archivo Lafuente

Cover by Fermín Revueltas for Djed Bórquez (pen-name of Juan de Dios Bojórquez), *Lázaro Cárdenas (líneas biográficas)* Mexico City. Bloque de Obreros Intelectuales, 1933. 19.5 x 14.2 cm. Archivo Lafuente

Cover by unknown artist for Benjamín Carrión, *Atahuallpa*, Mexico City. Imprenta Mundial, 1934. 23.8 x 16.5 cm. Archivo Lafuente

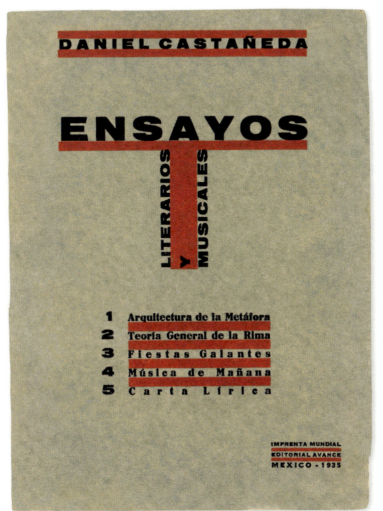

Cover by unknown artist for Daniel Castañeda, *Ensayos: crítica literaria*, Mexico City. Avance, 1935. 23 x 17.2 cm. Archivo Lafuente

Cover by unknown artist for Luis Vidales, *Suenan timbres: poemas*, Bogotá. Minerva, 1926. 22 x 16 cm.
Juan Bonilla Collection, Seville

Cover by unknown artist for Jesualdo Sosa, *Nave del alba pura*, Montevideo. Rodino, 1927. 16.7 x 16.7 cm.
Boglione Torello Collection

Cover by unknown artist for Pablo de Rokha, *Heroísmo sin alegría*, Santiago de Chile. Klog, 1927. 19 x 14.5 cm.
Archivo Lafuente

Cover by unknown artist for Clemente Andrade Marchant, *Un montón de pájaros de humo: poemas*, Santiago de Chile. Run-Run, 1928. 13.2 x 19.7 cm.
Archivo Lafuente

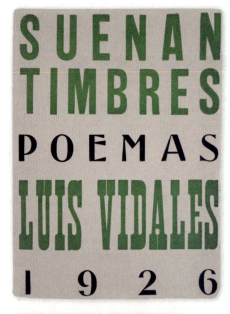
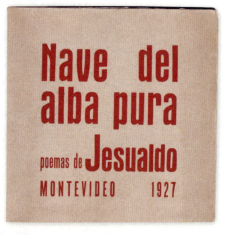
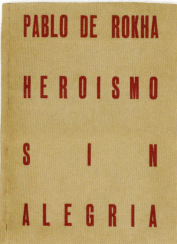

Cover by unknown artist for Magda Portal, *Varios poemas a la misma distancia / Una esperanza i el mar*, Lima. Minerva, 1927. 18 × 12.5 cm. National Library of Peru, Lima

Cover by unknown artist for Rosamel del Valle (pen-name of Moisés Filadelfio Gutiérrez Gutiérrez), *Mirador: poemas*, Santiago de Chile. Panorama, 1926. 21.9 × 18.8 cm. Archivo Lafuente

Cover by unknown artist for Pablo de Rokha, *Escritura de Raimundo Contreras*, Santiago de Chile. Klog, 1929. 19 × 19 cm. Archivo Lafuente

Cover by Manuel Bandeira (author) for *Libertinagem*, Rio de Janeiro. Pongetti & C., 1930. 16.5 × 12.6 cm. Archivo Lafuente

Cover by unknown artist for Ricardo Güiraldes, *Don Segundo Sombra,* Buenos Aires. Proa, 1926. 18.8 x 14.6 cm. Archivo Lafuente

Cover by unknown artist for Víctor M. Dotti, *Los alambradores,* Montevideo. Albatros, 1929. 19.1 x 14.5 cm. Boglione Torello Collection

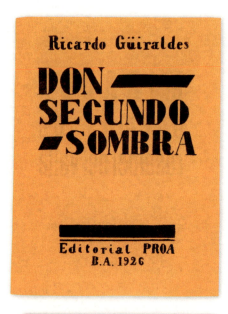
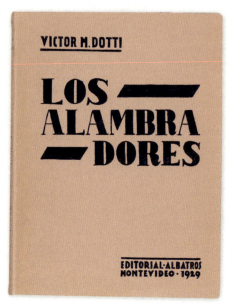

Cover by unknown artist for Julio Silva, *Oriental,* Montevideo / Buenos Aires. Agencia General de Librería y Publicaciones, 1926. 19 x 14 cm. Boglione Torello Collection

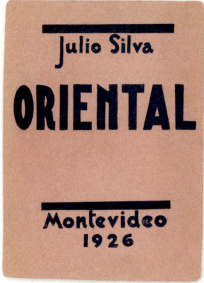

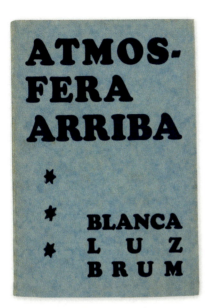
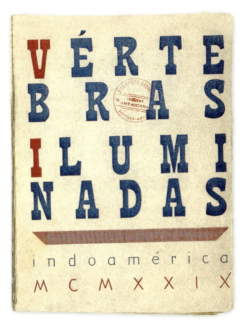
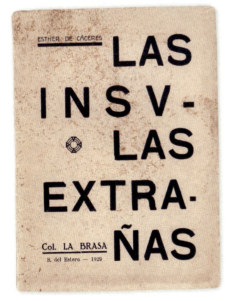

Cover by unknown artist for Blanca Luz Brum, *Atmósfera arriba: veinte poemas,* Buenos Aires, Tor, 1934. 18.7 x 12.7 cm. Archivo Lafuente

Cover by unknown artist for Carlos Alberto González, *Vértebras iluminadas: poemas,* La Paz. Editorial Boliviana, 1929. 20 x 15.5 cm. National Library of Chile, Santiago de Chile

Cover by unknown artist for Esther de Cáceres, *Las ínsulas extrañas,* Santiago del Estero. La Brasa, 1929. 19.1 x 14.1 cm. Boglione Torello Collection

Cover by unknown artist for *Novecento italiano: mostra organizzata dalla Asociación Amigos del Arte di Buenos Aires* [exh. cat.], Buenos Aires. Asociación Amigos del Arte, 1930. 24.8 x 21.2 cm.
Private collection, Granada

Cover by unknown artist for André Gide, *La escuela de las mujeres*, Mexico City, Publishers of *La Razón*, 1931. 21 x 15.2 cm.
Archivo Lafuente

Cover by unknown artist for Gerardo Seguel, *2 campanarios a la orilla del cielo*, Santiago de Chile. Panorama, 1927. 21.2 x 18.2 cm.
Archivo Lafuente

Cover by Juan Antonio Spotorno for Eduardo González Lanuza, *Prismas: poemas*, 2nd edition, Buenos Aires. J. Samet, c. 1928. 16.5 x 12.2 cm.
Private collection, Granada

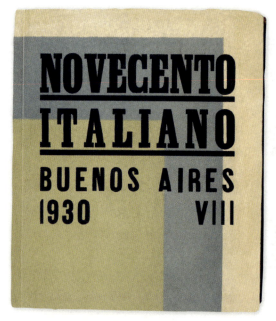

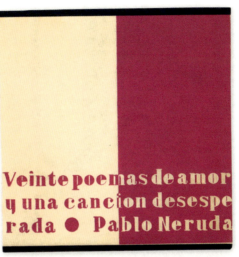

Cover by unknown artist for Jorge Icaza, *Sin sentido*, Quito. Labor, 1932. 16.7 x 12.4 cm. Boglione Torello Collection

Cover by unknown artist for Pablo Neruda, *Veinte poemas de amor y una canción desesperada*, 2nd edition, Santiago de Chile. Nascimento, 1932. 20 x 19.6 cm. Archivo Lafuente

Cover by unknown artist for Serafín del Mar (pen-name of Reynaldo Bolaños) and Magda Portal, *El derecho de matar*, La Paz. Continental, 1926. 20.4 x 19.7 cm. Boglione Torello Collection

Cover by unknown artist for Xavier Abril, *Descubrimiento del alba*, Lima. Front, 1937. 25.5 x 18.2 cm. Archivo Lafuente

Cover by unknown artist for Pablo de Rokha,
U: poema, Santiago de Chile. Nascimento, 1926.
19 x 19 cm.
Archivo Lafuente

Cover by unknown artist for Emilio Armaza, *Falo: síntesis del imaginador*, Puno. Tipografía Comercial, 1926. 32 x 26.5 cm. National Library of Peru, Lima

Cover by unknown artist for Sérgio Milliet, *Poemas análogos*, n.p. [São Paulo?]. Niccolini & Nogueira, 1927. 24.5 x 16.5 cm. Archivo Lafuente

Cover by unknown artist for Baltasar Dromundo, *Francisco Villa y la "Adelita"*, Durango. Victoria, 1936. 23 x 16.5 cm. Archivo Lafuente

Cover by unknown artist for Augusto dos Anjos, *Eu*, Rio de Janeiro, n.p., 1912. 22 x 15 cm. The Guita and José Mindlin Brasiliana Library, University of São Paulo

Cover by unknown artist for Felippe D'Oliveira, *Vida extincta*, Rio de Janeiro, Liga Marítima Brazileira, 1911. 23.3 x 16.5 cm. Archivo Lafuente

Cover by unknown artist for Nicolás Olivari, *La amada infiel: Versos románticos / Versos anti-románticos / Intermezzo neo-platónico*, Buenos Aires. Modesto H. Álvarez, 1924. 15.5 x 11.7 cm. Archivo Lafuente

Cover by unknown artist for Luis Cané, *Romancero de niñas (1927-1932)*, Buenos Aires. Talleres Gráficos de Porter Hermanos, 1932. 16.7 x 12.4 cm. Private collection, Granada

Cover by unknown artist for Bernardo Ortiz de Montellano, *Sueños*, Mexico City. Contemporáneos, 1933. 21 x 13.5 cm. Archivo Lafuente

Cover by unknown artist for Luisa Sofovich, *La sonrisa*, Buenos Aires. La Peña (Agrupación de Gente de Arte y Letras), 1933. 18.5 x 14 cm.
Archivo Lafuente

Cover by unknown artist for María Teresa L. de Sáenz and Raquel Sáenz, *Voz y silencio (el libro de mi madre), poemas*, Montevideo. Tipografía La Industrial, 1936. 21 x 15.5 cm.
Boglione Torello Collection

Cover by unknown artist for Demetrio Aguilera Malta, Enrique Gil Gilbert and Joaquín Gallegos Lara, *Los que se van: cuentos del cholo i del montuvio*, Guayaquil. Zea & Paladines, 1930. 18.5 x 13.5 cm.
Archivo Lafuente

Cover by Humberto Zarrilli (author) for *Libro de imágenes*, Montevideo. El Siglo Ilustrado, 1928. 20.5 x 15 cm.
Private collection, Granada

Cover by unknown artist for Luis Fernando Álvarez, *Va y ven: poemas*, Caracas. Cooperativas de Artes Gráficas, 1936.
22 x 26 cm.
Juan Bonilla Collection, Seville

Cover by unknown artist for Mercedes Pinto, *Él: novela*, 3rd edition, Santiago de Chile. Nascimento, 1936. 19.6 x 14 cm. Archivo Lafuente

Cover by unknown artist for Luis Franco, *Suma: 1927-1937*, Buenos Aires. Perseo, 1938. 26 x 18.5 cm. Gabriel Fabry Collection

Cover attributed to Estefanía Pérez for Marisa Serrano Vernengo, *Fuga*, Montevideo. Impresora Uruguaya, 1936. 17.3 x 16 cm. Private collection, Granada

Cover by unknown artist for Bernardo Canal Feijóo, *Dibujos en el suelo*, Buenos Aires. Juan Roldán y Cía., 1927. 21 x 15 cm.
Archivo Lafuente

Cover by unknown artist for Juan Parra del Riego, *Himnos del cielo y de los ferrocarriles*, Montevideo. Tipografía F. Morales (Hijo), 1925. 21 x 15.5 cm. Archivo Lafuente

Cover by unknown artist for Cassiano Ricardo,
Borrões de verde e amarello, 4th edition, São Paulo. Empreza graphica de Revista dos Tribunais, 1933.
24.2 x 16.8 cm.
Archivo Lafuente

Cover by unknown artist for Cassiano Ricardo,
Deixa estar, jacaré..., São Paulo. Empreza graphica de Revista dos Tribunais, 1931.
23.9 x 16.6 cm.
Archivo Lafuente

Cover by M. Gimeno for Delio Morales, *Pandilla de hombres honrados: vida de aventureros honestos y esforzados martingalistas*, Buenos Aires. Editorial del Plata, 1929. 18.5 x 13.8 cm. Private collection, Granada

Cover by Raúl Mario Rosarivo for Israel Chas de Chruz, *El asesino de sí mismo, y otros relatos*, Buenos Aires. Editorial del Plata, 1929. 18.6 x 13.8 cm. Private collection, Granada

Cover by Alejandro Sirio for Samuel Eichelbaum, *En tu vida estoy yo: pieza en cinco actos breves (el último dividido en dos cuadros)*, Buenos Aires. M. Gleizer, 1934. 19 x 14 cm. Private collection, Granada

Cover by unknown artist for Carlos Ocampo, *El festín de los locos: novelas*, Buenos Aires. Talleres Gráficos Argentinos de L. J. Rosso, 1931. 18.5 x 13.5 cm. Private collection, Granada

Cover by Carlos Hermosilla for Luis Berninsone, *Pirámide para la momia de Lenin. Interpretación apocalíptica de Trotzky. Anatomía del hombre de acero*, Santiago de Chile. Imprenta Lers, 1935. 38.5 x 27.5 cm. Archivo Lafuente

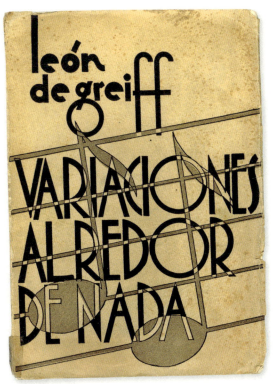

Cover by Alberto Arango Uribe for León de Greiff, *Variaciones alrededor de nada*, Manizales. Arturo Zapata, 1936. 24.8 × 17.8 cm. Archivo Lafuente

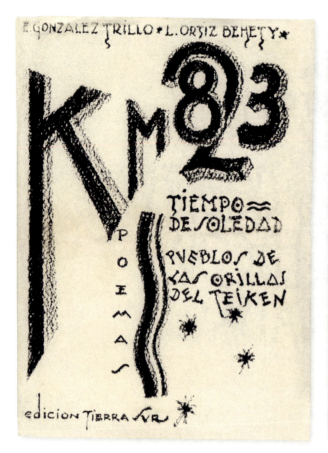 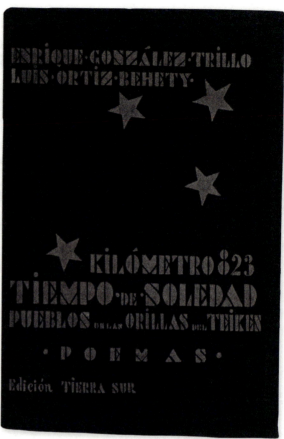

Dust jacket by unknown artist and cover by Andrés Spont Watteau for Enrique González Trillo and Luis Ortiz Behety, *Kilómetro 823. Tiempo de soledad. Pueblos de las orillas del Teiken: poemas*, Buenos Aires. Tierra Sur, 1932. 19 x 13 cm.
Archivo Lafuente

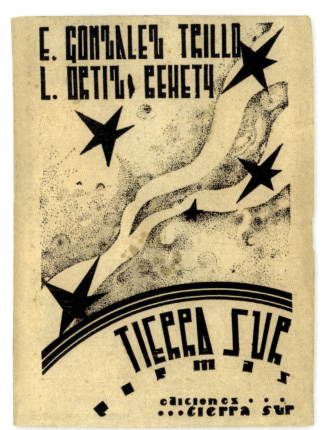

Cover by Carlos Luis for Enrique González Trillo and Luis Ortiz Behety, *Tierra Sur*, Buenos Aires. Tierra Sur, 1932.
18.5 x 14 cm.
Archivo Lafuente

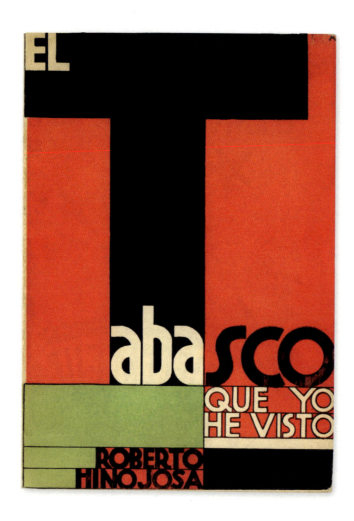

Cover by unknown artist for Roberto Hinojosa, *El Tabasco que yo he visto*, 2nd edition, Mexico City. n.p., 1935. 22.8 x 16.2 cm. Archivo Lafuente

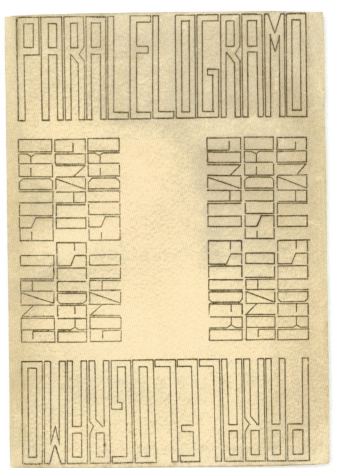

Cover by Francisco Alexander for Gonzalo Escudero, *Paralelogramo: comedia en 6 cuadros*, Quito. Central University, 1935. 22.6 x 16.5 cm. Archivo Lafuente

Cover by unknown artist for José de Jesús Manríquez y Zárate, Bishop of Huejutla, *El socialismo*, Mexico City. Ediciones PAGF, 1936. 22 x 14 cm. Archivo Lafuente

Cover by Carlos Quízpez Asín for Esteban Pavletich, *Leoncio Prado*, Lima. Dermos, 1939. 18.2 x 13 cm. Private collection, Granada

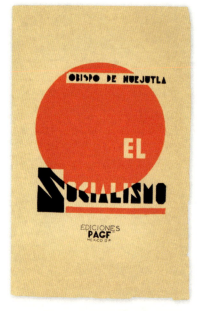

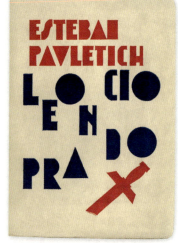

Cover attributed to Alex Rossato for José Martins Fontes, *Paulistania*, São Paulo. Elvino Pocai, 1934. 29.4 x 23.5 cm. Archivo Lafuente

Cover by Paulo Werneck for Benjamim Costallat, *O. K. (cronicas)*, Rio de Janeiro. Guanabara, 1934. 18 x 12.2 cm. Private collection, Granada

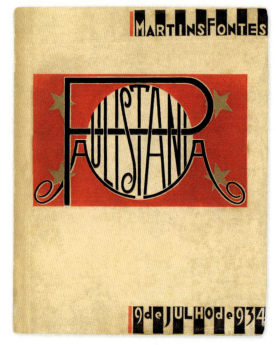

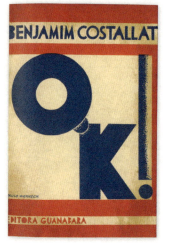

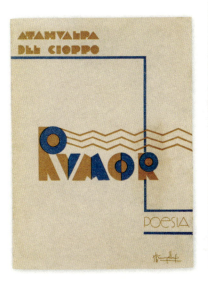
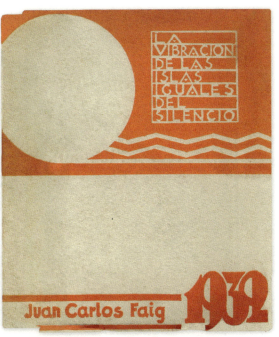

Cover by Humberto Frangella for Atahualpa del Cioppo, *Rumor*, Montevideo. Impresora Uruguaya, 1931. 19 x 14 cm. Archivo Lafuente

Cover by Lucio T. Odiozabal for Juan Carlos Faig, *La vibración de las islas iguales del silencio: poemas*, Montevideo. La Industrial, 1932. 24 x 20.7 cm. Private collection, Granada

Cover by unknown artist for Víctor Pérez Petit, *Rodó: su vida – su obra*, Montevideo. Latina, 1919. 19.9 x 13.2 cm. Boglione Torello Collection

Cover by Luis Alberto Fayol for Vicente Basso Maglio, *Tragedia de la imagen*, Montevideo. n.p., n.d. [c. 1930?]. 23.9 x 16.8 cm. Archivo Lafuente

Cover by unknown artist for Ventura Maturana B., *Mi ruta: El pasado... El porvenir...*, Buenos Aires. n.p., 1936. 18.6 x 14 cm. Private collection, Granada

Cover by unknown artist for Gerónimo Yorio, *Brochazos: películas breves*, n.p. [Montevideo?], n.p., n.d [1934?]. 18.8 x 14 cm. Archivo Lafuente

Cover by unknown artist for Arturo Cambours Ocampo, *La novísima poesía argentina* (collection), Buenos Aires. Ediciones de la Revista Letras, 1931. 19 x 13.4 cm. Private collection, Granada

Cover by unknown artist for Mateo Booz, *El tropel: novela*, Santa Fe. Talleres Gráficos El Litoral, 1932. 17.9 x 14.2 cm. Private collection, Granada

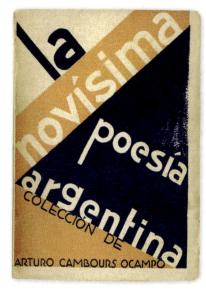
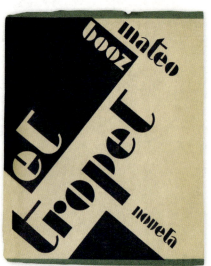

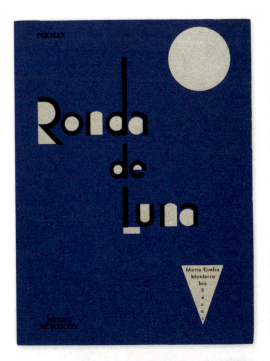
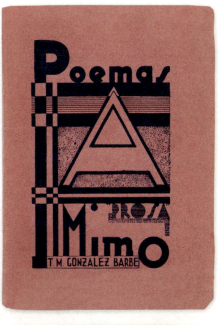

Cover by unknown artist for María Evelia Monterrubio Sáenz, *Ronda de luna*, Mexico City. n.p., 1934. 22.9 x 17.3 cm. Archivo Lafuente

Cover attributed to Luis Totasaus for Traslación Martín González Barbé, *Poemas a Mimo*, Montevideo. Talleres Gráficos A. Fuentes, 1933. 21.5 x 15.5 cm. Boglione Torello Collection

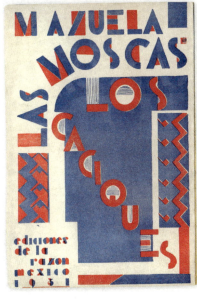
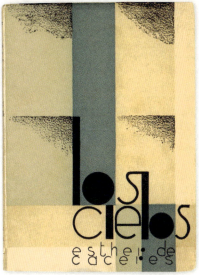

Cover by unknown artist for Mariano Azuela, *Los caciques: novela de la Revolución mexicana*. Preceded by *Las moscas: cuadros y escenas de la revolución*, Mexico City. Ediciones de la Razón, 1931. 20 x 13 cm. Private collection, Granada

Cover by Luis Alberto Fayol for Esther de Cáceres, *Los cielos*, Montevideo. Impresora Uruguaya, 1935. 19.1 x 14 cm. Archivo Lafuente

Cover by Ángel Chapero for J. M. Puig Casauranc, *Los Juan López Sánchez López y López Sánchez de López*, Mexico City. n.p., 1933. 24.5 x 19 cm. Boglione Torello Collection

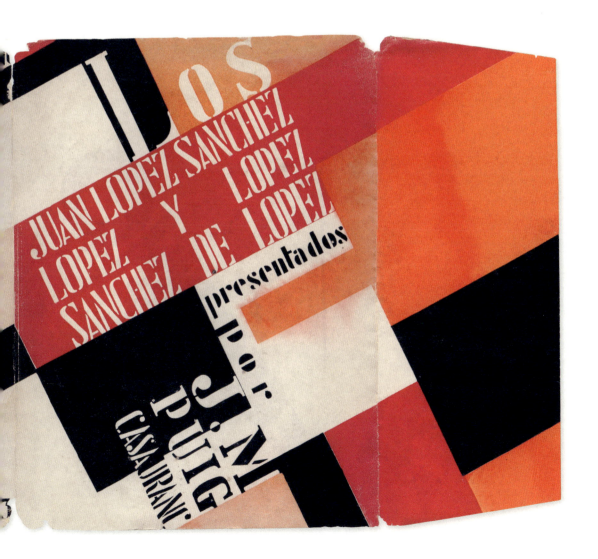

Covers by unknown artist for Baltasar Izaguirre Rojo, *El libro del peregrino: poemas*, Mexico City. La Carpeta, 1931.
20.8 x 15.8 cm.
Archivo Lafuente

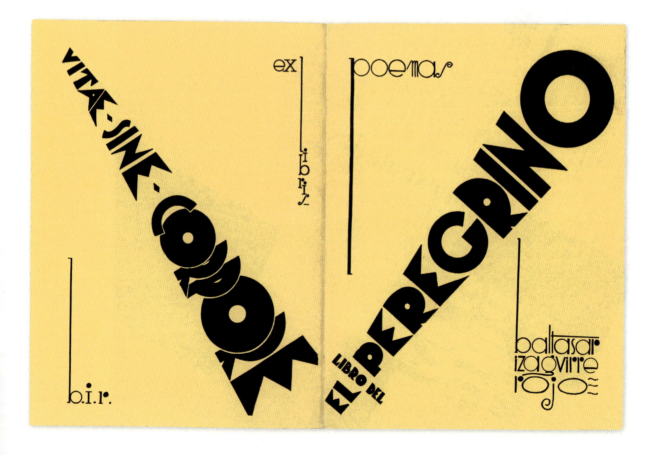

Covers by unknown artist for César A. Guardia Mayorga, *Léxico filosófico*, Arequipa. Tipografía Librería Quiróz Perea, 1941.
21 x 14.5 cm.
Private collection, Granada

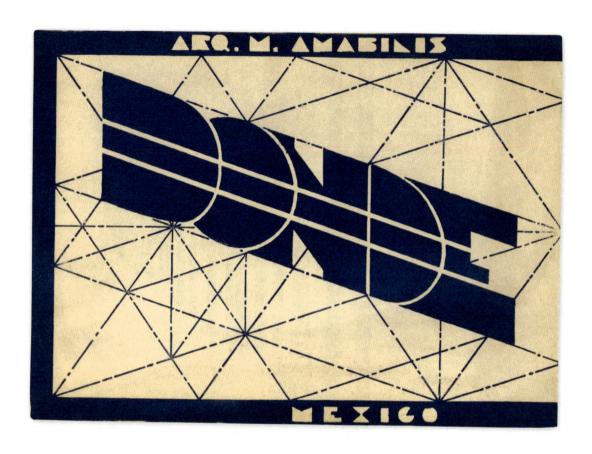

**Cover attributed to
Manuel Amábilis (author)
for** *Dónde*, Mexico City.
E. Gómez, 1933.
16.4 x 22.2 cm.
Archivo Lafuente

Cover by Ecco Neli (brush name of Cleonice Nannetti, author) for *Otros cuentos*, Bogotá. Minerva, 1937.
19.5 x 13.9 cm.
Archivo Lafuente

Cover by Roberto G. Serna for Baltasar Dromundo, *13 romances*, Mexico City. Author's self-edition, 1937. 22.7 x 16 cm. Archivo Lafuente

Cover by unknown artist for Lisandro Z. D. Galtier, *32 poemas de Guillaume Apollinaire*, Buenos Aires. Proa, 1929. 27.8 x 19.3 cm. Archivo Lafuente

Cover by unknown artist for Antonio Alejandro Gil, Álvaro Yunque, Rodolfo Tallon, Juan Guijarro, and José Sebastián Tallon, *5 poemas*, Buenos Aires. Minerva, 1927. 18.8 x 13.6 cm. Private collection, Granada

Cover by unknown artist for Enrique Amorim, *5 poemas uruguayos*, Salto. Author's self-edition, 1935. 22.9 x 17.6 cm. Private collection, Granada

Cover by Guillermo Laborde for Humberto Zarrilli, Roberto Abadie Soriano, and Vicente Ascone, *20 poemas de América para ser cantados por los niños*, Montevideo. Gráfica Industrial, 1930. 32.5 x 24.3 cm. Archivo Lafuente

Cover by unknown artist for José Alfredo Llerena, *Agonía y paisaje del caballo: 18 poemas*, Quito. Universidad Central, 1934. 20.7 x 15.1 cm. Boglione Torello Collection

Cover by unknown artist for Jaime Sánchez de Andrade, *26 poemas de mar, cielo y tierra*, Quito. Antorcha, 1939. 11.5 x 16.2 cm. Archivo Lafuente

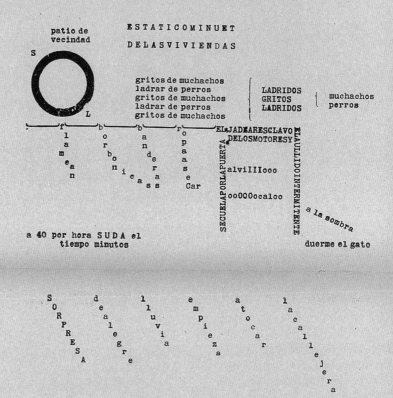

Inner page by Gonzalo Deza Méndez for *Irradiador. Revista de vanguardia*, no. 2, October 1923. Directors: Manuel Maples Arce and Fermín Revueltas. Mexico City, n.p. 24 x 36 cm. University of Hawa'i at Mānoa, Honolulu

Verbovisualidad: Visual Representations of Language

Riccardo Boglione

The backbone of the revolution entailed by the historical avant-garde movements, chiefly in the 1910s and 1920s, was the "visual" use of verbal elements, particularly poetic, that we shall call *verbovisualidad*, a term that in our survey embraces calligrams and earlier *technopaegnion*, i.e. *parole in libertà*, words-in-freedom, and visual poetry.

The graphic use of texts, of course, dates back at least to the Greece of the 3rd century bc, and has therefore a history of thousands of years before its radical emergence in the 20th century. Latin America fits neatly into that tradition, which we may sum up in the figure of *technopaegnion* or *carme figurato* (figured poem), basically an arrangement of verses in different lengths and positions that creates silhouettes of figures, almost always related to the poems themselves. In his fundamental study *Pattern Poetry: Guide to an Unknown Literature*, Dick Higgins traces the genre in the continent through four Brazilian works and thirty-four "in Spanish Latin America, into the 19th century, especially in the works of the Uruguayan poet Francisco Acuña de Figueroa (1791-1862), who wrote twenty-seven pattern poems" (Higgins, 1987, 123). According to recent studies (Italiano, 2014, and Boglione, 2015), Acuña de Figueroa, author of the Uruguayan national anthem, published a total of thirty-five such poems. So it comes as no surprise that in the 20th century this tradition should still bear fruit. It materialized, for instance, in the strange book titled *Palideces i púrpuras* (1905), by the Argentine author Carlos López Rocha, a rare example of the systematic use of inks in two colors, red and black, in a publication of the period, in this case depicting two glasses. Countless popular magazines also resorted to such *technopaegnia* and other typographic extravaganzas in their games sections.

Indeed, the first use of figuration applied to the letters written by a key author in the

Inner page by Luis García (brush name of Luis Pardo) for José Friedric, *"Sinfonía," Fray Mocho*, year III, no. 95, February 20, 1914. Editor: Carlos Correa Luna, Buenos Aires. Talleres Heliográficos de Ricardo Radaelli. 25.8 × 17.3 cm. Private collection, Granada

international avant-garde, Vicente Huidobro, was also indebted to that tradition. In the second section of *Canciones en la noche* (1913), titled "Japoneserías de estío," the Chilean poet revisited the genre, to which he brought small changes, thereby ushering in modern Latin American visual representations of language. In fact, if three of the four *carmina figurata* include previously used elements (diamonds, hourglasses, chapels) in one other, at the very least, "they are duplicated, in the image reflected in the pond, shapes that evoke Japanese constructions that do not correspond to the content of the poem" (Goic, 2012), and therefore seek a certain independence from the earlier legacy of word-images. Critics generally describe these compositions as calligrams, even though they precede Guillaume Apollinaire's *Calligrammes*; perhaps it would be more fitting to consider them derived from Huidobrian compositions, such as "Paisaje," which appeared in the *Horizon Carré* collection published in Paris in 1917 and were reproduced in Richard Huelsenbeck's *Dada Almanach* three years later. In effect, this is a freer poem, both as regards its structure and in the choice of its figures. The "painted poems" displayed by the Chilean author at G. L. Manuel Fréres Parisian gallery in 1922 were even more independent, as we see in the catalog that reprinted "Paisaje" and "Molino" in black and white. *Technopaegnion* continued to be used by Latin American writers well into the 20th century, especially in magazines, where it served moralizing purposes, as in the publicity campaigns against alcohol consumption, in which poems adopted the shapes of bottles and glasses (Boglione, 2015, 22-23). It also featured in the book *Viñetas* (1927), by Juan de Armaza, where the Chilean poet created an arborescent silhouette in his poem dedicated to the poplar tree, "El álamo." Yet the most spectacular of poetic calligrams appeared in 1932, in the work of the Argentine poet Oliverio Girondo who "drew" a scarecrow, "Espantapájaros," on the first page of his book of the same name. This pattern poem, where content appears to be dissociated from image, presents an exquisite interplay of red and black words.

Similarly extraordinary is the visual treatment of the verbal material by the Ecuadorian writer José de la Cuadra in *Guásinton. Historia de un lagarto montuvio* (1938), firstly because he used calligrams to illustrate prose, which was quite unique, and secondly because his shapes were bold and highly complex. By limiting the illustrations to the first page of each story, the author seemed to want to highlight in graphic terms the essence of each tale. Hence, we come across the silhouette of a young girl in "Se ha perdido una niña" (A Little Girl Has Been Lost), Lenin's head in "El santo nuevo" (The New Saint), a paintbrush and a palette in a story about "Blanes, pintor Uruguayo" (Blanes, Uruguayan Painter), a wolf in "Don Manuel y los animales" (Don Manuel and the Animals), et cetera. The dynamism of these incipits is truly astonishing. We should bear in mind that another Ecuadorian author, Jorge Icaza, also shaped a composition in prose, the long preface that introduced *Flagelo. Drama en un acto* (1936), composed, in turn, by Feafa (pen-name of Francisco Ferrándiz Alborz, Spanish critic, writer and activist who spent long sojourns in Quito). This text is like a narrow column that runs diagonally across the numerous pages (almost double the number of those in the play itself), creating a rhythmically dizzying visual effect. Here, the interplay featured in the back matter instead of in the playwright's text.

To return to Huidobro, his early adoption of pattern poems in Latin America, basically parallel to Marinetti's theorization of words-in-freedom. In 1913, the Italian author wrote, "I have initiated a typographical revolution directed against the bestial, nauseating sort of book that contains passéist poetry or verse à la D'Annunzio [...] My revolution is directed against the so-called typographical harmony of the page, which is

contrary to the flux and reflux, the leaps and bursts of style that run through the page itself. For that reason we will use, in the very same page, *three or four different colors of ink*, and as many as twenty different typographical fonts if necessary." (Marinetti, 1913).

Thus, over time, the break with traditional poetry would produce pages of a size larger than standard, destroying classical layouts.

The first conclusive, systematic instance in American soil of the aforesaid liberation of words, resulting from a new awareness of the broadening field of literature, of mature writing to be contemplated and figuration to be read, is found in the book titled *Li-Po y otros poemas* published in 1920 by the Mexican author José Juan Tablada in Caracas. Along with *Aliverti liquida*, which we shall discuss later, it is no doubt the most radical example of visual representation of language on the continent; symptomatically, it boasts an opening quote by Stéphane Mallarmé, the poet whose *A Throw of the Dice Will Never Abolish Chance*, published in 1897, had timidly initiated the typographical revolution we are surveying. In *Li-Po*, not only does "verse express all that stands for the playfulness of reality, the plastic perception of objects and the intuitive (and poetic) perception of the soul that inhabits them" (Velasco, 2000, 13); it also suggests a sort of super-repertoire of the possibilities of combining letters and images. The author composes the calligrams by hand (as Apollinaire had done on several occasions), creating *technopaegnia* "in the negative," dedicated to the moon and to the mirror, "Al espejo" (a mirror that has to be used to read "Día nublado," with the letters printed in reverse). He also renovates the figures of the *carme figurata*, as in "Madrigales ideográficos," creates wonderful landscape poems—more complex than those composed almost simultaneously by Pierre Albert Birot in Paris— such as "La calle donde vivo" and "Impresión de La Habana."

In Uruguay, Alfredo Mario Ferreiro created a slightly restrained form of visual representation of language in 1927, the first poem in the book titled *El hombre que se comió un autobús*, where the loud noise of the traffic, a typically Futurist theme, was enhanced by the graphic agitation of a list of vehicles and their effects. However, in eastern lands the true explosion of the marriage of letters and images would take place five years later, when several members of the Ateniense Troupe comic theater company organized a parody of an exhibition of "advanced" art and simultaneously published *Aliverti liquida*. "Produced with the intention of ridiculing Ultraism, it ends up being an incredible exercise of words-in-freedom," as explained by Maurizio Scudero (2012, 171), although it is probably more indebted to Futurism than to Ultraism— for it has obvious similarities with *BÏF§ZF+18 Simultaneità e chimismi lirici*, by Ardengo Soffici, for example (see Boglione, 2013)—and on occasion even seems to recall elements used by Iliazd in his masterpiece *Ledentu, el faro* (1923), such as extra-alphabetic typographic symbols. *Aliverti liquida* is perhaps the liveliest of Latin American visual books and, to a certain extent, the only one that uses all conceivable resources within the combination of verb and image with humoristic purposes. The result is visually excessive: "[W]here there is no *technopaegnia* or *paroliberismo*, the frenzy of diagrammatization forces its way into each centimeter of the volume thanks to two strategies. Firstly, in most titles and subtitles [...] through sudden changes in character types or dimensions, to astonishing sizes [...] Secondly, thanks to disruptions to the traditional book—the non-existent index [...] the page printed back-to-front [...] = [...] and the inclusion of an endless repertoire of decorative elements, almost a symptom of *horror vacui*" (Boglione, 2012, 159).

In the copy reproduced here, these effects are magnified by anonymous handmade coloring.

Cover by Salvador Bandeira (Editor and secretary) for *Quinzena Ilustrada*, year II, no. 3, May 15, 1929, Pelotas. Livraria do Globo. 32.4 x 23.8 cm. Private collection, Granada

Not all the avant-garde authors who turned to visual representations of language did so in such an excessive way, quite the opposite in fact. A solid group of poets, well aware of what had occurred with the relationship between *logos* and *imago*, turned only timidly to some of its resources, breaking a term down into its letters, for example, and arranging them one per line, sometimes in tiers, usually with the intention of "increasing or decreasing the speed of the reader," as if inspired by Mallarmé (Bartram, 2005, 10). Such is the case of César Vallejo, who brought the poem "LXVIII," published in *Trilce* (1922), to a close with a vertical cascade of letters shaping the phrase "at full mast." By doing so, as described by Juan Larrea, he "places the reader in the presence of a standing coat hanger, visually justified by the capital A of the base which, in turn, is the mast of a flag" (quoted in Vallejo, 2003, 319). Similar "cascades," this time perpendicular, run across pages and also appear in the work of two Bolivian authors, separated

Cover by unknown artist for *Hontanar: órgano del grupo ALBA*, year I, no. 3, March 1931. Editor: Carlos M. Espinosa, Loja (Ecuador). n.p. 23.5 × 16.6 cm. Boglione Torello Collection

by a ten-year gap: *Brújula* (1928), by Omar Estrella, and *Cronos* (1939), by Antonio Ávila Jiménez, in both cases more whimsically than in the book by Vallejo. In "Pentagrama," Estrella used patterns for two words, *madre* (mother) and *mundo* (world), albeit apparently in order to bring movement to the work rather than to create polysemy (we should not forget that in another poem he used *carme figurato* drawing a cross while speaking of maternal sacrifices). With the intention of slowing down the speed of reading, Ávila Jiménez introduced the resource into an almost romantic context, devoid of any special correspondence between word and movement. In *Losango cácqui*, a book of poems about love and military exercises (Pasini, 220, 214), Mário de Andrade employed several visual resources, including "verse cutting, a profusion of dashes and reticence, a systematic use of whole words in capital letters to add emphasis, a proliferation of onomatopoeia, verse framing" (Pasini, 2020, 227). Originally written between 1922 and 1923, the book was published in 1926. Worthy of note, for instance, is how, in the poem titled "O 'Alto'", "the rhythm is conveyed by the visualization of the 'one-two' repetition interrupted by the trees (in capital letters in the poem) that the lyrical subject discovers on his way, before hearing the final whistle, the onomatopoeic 'Prraá,' in a colloquial expression of satisfaction, 'cutuba,' meaning 'great!,' 'perfect,'" (Pasini, 2020, 228). Finally, in *Falo* (1926), the Peruvian author Emilio Armaza systematically and interestingly dilated the space between the invariably capital letters of the keywords in his verses, and even undulated the term *trigales* (wheat fields) as if hoping to transfer the effect of the wind on them. *Las barajas i los dados del alba* (1938), by the Peruvian writer Nicanor A. De la Fuente (Nixa), "conceived in the 1920s though [...] published belatedly" (Beltrán Peña, 1998, 69), contains a sort of summary of previously examined designs, highly expressive and bolder due to their repetition, with visual references to "climbs" and "slopes," "arches," "circles," and "cascades" that typographically represent their meaning.

More complex is the cascade of vertical phrases displayed by the Stridentist artist Kyn Taniya in *Avión* (1923), where the poem "Lluvia" suggested a sort of geometrization of raindrops indebted to—and at once emancipated from—Apollinaire's famous poem "It's Raining" by means of rigid columns of capital letters. A similar resource would be used by El lungo de la cortada, one of the members of the Troupe Ateniense, in "Vertical poema en línea recta" published in *Aliverti liquida*. In the story titled "La señorita, etc.," published as early as 1922 in *El Universal Ilustrado* and revisited in *El café de nadie* (1927), with more complex diagrammatization, another key figure in Mexican Stridentism, Arqueles Vela, depicts a sort of intersection of letters that seem to imitate the tracks of a trolley on which the leading character is traveling but where, like bars, we discover the expressions "danger," "crossing," "all clear," in a perfect confusion of words that refer to what he sees through the window and the description of the woman he is contemplating.

Other letters on pages also undulate in works of Chilean graphic art, as if wanting to imitate the startled and sinuous movements of birds and airplanes in flight. On the one hand, the words surrounding the aerial looping in the poem "Looping the loop" are wonderfully printed in green, like the rest of the book, and refer to a bird which ends up in the water after its verbal and acrobatic leaps (superimposing a mechanical on a natural pirouette) in the book titled *12 poemas en un sobre* (1929) by Runrunist poets Alfredo Pérez Santana and Alfonso Reyes Messa. In another of their poems, the two authors drew an acrobat discarding his trapeze as the letters of the word "descends" rain down, right beside a tree/toadstool *technopaegnion*, while a further poem a line raised slightly to the right visualized an airplane. On the other hand, for

Looping (1929), Juan Marín also designed a spiral somersault, although this pattern poem was more modest. The Argentine author Eduardo González Lanuza preferred a diagrammatic rather than a mimetic approach to such work, as exemplified in the last composition of his book *Prismas* (1924), titled "Poema de las fábricas" (although he attempted a similar design in the last but one, titled "Tarde"), graphic representation of the simultaneity of different emotions and sensory stimuli produced by a factory. Small blocks of text are separated by rhythmical vertical lines that create hazes of words dedicated to factory elements (boilers, forges, workshop, valves, etc.) and to lyrical nodes derived from Futurism ("the epileptic silence / pirouettes on the cables") and Ultraism ("the nestled evening / overshadowed with foreboding"). Finally, in between these "disjointed" verses we must quote two other Chilean works that appeared in the anthology titled *Índice de la nueva poesía americana* (1926), by Huidobro, Borges, and Hidalgo. A "night" that "falls on its face" thanks to Gerardo Moraga Bustamante's "Terraza," and the ingenious meta-literary "domino" in the avant-garde schools composed by Juan Florit for the poem titled "Paris," an example of Creationism from which the other movements of the period literally derived.

Huidobro was the only author who experimented with visual poetry throughout several books. However, two Peruvian writers created several high-quality designs in the genre, concentrated in one single volume. In 1923, Alberto Hidalgo, most of whose intellectual career developed in Buenos Aires, published *Química del espíritu*, filled with controversial wit and humor. His favorite recourse, literally "perverse," was to make letters climb up from the foot of the page in long columns, sometimes with hilarious mimetic effects ("the spiral of music rising like smoke", in "Sabiduría") and always slightly hindering reading, that culminated in another brilliant composition, "Jaqueca." In this design the phrase seems to explode—an explosion obviously caused by the migraine of the title—where the letters float about in the white space like a haze whose meaning cannot possibly be reconstructed. In another poem, "El destino," Hidalgo verged on the conceptual. The verse "in the middle of the land, that is a sigh—a vagabond of God, man is a speck—lost. It's a case for shooting oneself!," is arranged forming a perfect circle in the center of which we discover a circular target evoked in the text by the idea of the shot. This same inclination materialized in another book by the author from Arequipa, *Simplismo*, that by subtraction, is a graphic *coup de théâtre*. His "Nada simplista" is, in fact, a blank page that only features the title of the composition. It is worthwhile to mention here two similar Uruguayan cases: in *Elogio de la primera estrella* (1928), by Julio Casas Araújo, the subject is taken to the extreme, for not even the "poem" bears the title and the page, completely white, is simply indicated as "x x x" in the index. In *Lasteníada* (1928), Luis Bueno drew periods, and exclamation and question marks, without a single letter, creating a "Canción ignota" which, striking up a visual dialog with its title, also seems to delve into the conceptual (Boglione, 2010, 11-12).

Another poetry volume that is filled with typographical jolts is *5 metros de poemas* (see pp. 536-537 and 713), *leporello* bound (i.e. concertina-folded pages with front and back boards), by Carlos Oquendo de Amat. Published in 1927 in Lima, the volume was an experimental extract characterized by a range of typefaces, frequent interruption of the linearity of verses, and un unhurried break of orthogonality.

Despite the small number of pattern poems in Brazil, certain diversions from the classical rules of typography in the back matter of books produced outstanding results: suffice it to note the non-orthographic segmentation, subject to the pure visuality of the colophon to *Pau Brasil* (1925), by Oswald de Andrade; of the

frontispieces of *Pathé-Baby* (1926), by António de Alcântara Machado, resembling a piece of film; and of *Cartazes* (1928), by Paulo Mendes de Almeida, whose huge letters were typical of the posters evoked by its title.

As to posters, we cannot but mention a volume that anticipates the questioning of forms and revitalization characterizing artists' books, as they would begin to be defined in the 1960s: *Descripción del cielo. Poemas de varios lados* (1928), by Alberto Hidalgo (see pp. 132-133). The poetic compositions by the Peruvian author are printed on poster-size foldable sheets that are, however, part of a bound edition, obviously designed to surprise readers. To the painstaking preparation required by this "book for a wall" (Hidalgo, in Chueca, 2009, 8), as defined by its author, and its undeniable intention to extend the field of classical literary transmission we must add the visual language patterns produced by the large size of the letters.

We may conclude this study by mentioning manually drawn patterned poems, a return to "artisanal" printing processes that also inspired Apollinaire and Futurist artists. One of the first examples of such work in Latin America is the hand drawn in letters by the Guatemalan author then living in Paris, Luis Cardoza y Aragón, for *Maelstrom. Films telescopiados* (1926). If, as according to Julio Ortega, Keemby, the book's leading character, "comically and critically embodies the avant-garde program" and reveals "some of the sarcastic anti-conventionalism of the pataphysics and the cultivation of the contradictions of Dadaist nihilism" (Ortega, 2012), it is only natural that in this revolutionary *tour de force* should have also comprised visual representations of language. José de la Cuadra, mentioned earlier, filled the first two pages of the story titled "Chichería" in the *Horno* collection (1923) with "notices" that stand out from the rest of the text for having frames, imitating posters. Funnily enough, in the second edition of the book, published in 1940 in Buenos Aires, De la Cuadra (or perhaps the publishers) replaced some of them with drawings of signs that were "more realistic." In effect, if those made "in oils," as the story goes, remain neatly typographical, those made "in charcoal" appear expressionistically calligraphic, while the last one, made on "very old tin plate," includes the drawing of a flag and a few controversial words written "in chalk" on one side. Still in the realm of manual design, the greatest series was made by Antonio de Ignacios, brother of the Uruguayan painter Rafael Barradas, whose *La visión de un andariego*, published in Buenos Aires in 1931, reproduced a number of visual poems produced in Spain between the years 1917 and 1918 and printed at the time in Ultraist magazines. They can be described as landscapes sketched in barely a few lines, harmoniously punctuated by verses, also handwritten, "clearly Futurist in nature, with a neo-popularist air that may related to the contemporary work of his brother" (Bonet, 2012, 300).

Having covered the whole range of possibilities produced in the field of pattern poetry of the period in question, and with a few absolutely striking results, it is obvious that the visual representation of language was firmly established across Latin American literature as early as the 1920s. Without being plentiful, it sowed select seeds that would subsequently flourish, as proven some years later, in the 1950s and 1960s, when Latin American forerunners in the genre made a name for themselves around the world, beginning with the "theoreticians" of Concrete Poetry, the Brazilian authors of the Noigandres group.

*Es gusano de seda el pincel
guiado por su mano pálida
que formaba en el papel
negra crisálida
de misterioso jeroglífico
de donde surgía como una flor
un pensamiento magnífico
con alas de oro volador
sutil y misteriosa llama
en la lámpara del ideograma.*

Verbovisualidad:
Visual Representations of Language

Carlos López Rocha for
Palideces i púrpuras,
Buenos Aires. Galileo,
1905. 22 x 18.4 cm.
Boglione Torello Collection

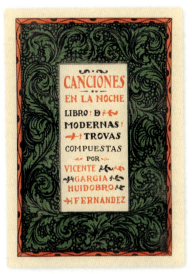

Vicente Huidobro for *Canciones en la noche*, Santiago de Chile. Imprenta y Encuadernación Chile, 1913. 19.5 x 13.8 cm. Archivo Lafuente

HORIZON CARRÉ

VICENTE HUIDOBRO

PARIS 1917

NOUVEL AN

L'échelle de Jacob
　　　　　n'était pas un rêve
Un œil s'ouvre devant la glace
Et les gens qui descendent
　　　　　　　sur l'écran
Ont déposé leur chair
　　　　　comme un vieux pardessus
　　LE FILM 1916
　　　　SORT D'UNE BOITE *GUERRE*
　La pluie tombe devant les spectateurs

　Derrière la salle
　UN VIEILLARD A ROULÉ DANS LE VIDE

A PABLO PICASSO

PAYSAGE

LE SOIR ON SE PROMÈNERA SUR DES ROUTES PARALLÈLES

*La lune
où
tu te regardes*

　　　　L'ARBRE
　　　　ÉTAIT
　　　　PLUS
　　　　　HAUT
　　　　QUE LA
　　　　　MONTAGNE
　　MAIS LA
　　MONTAGNE　　LE
　　ÉTAIT SI LARGE　FLEUVE
　　　　　　　　QUI
　QU'ELLE DEPASSAIT　COULE
　LES EXTRÉMITÉS　NE
　　　　　　　PORTE
　DE　LA　TERRE　PAS
　　　　　　　　DE
　　　　　　　　　POISSONS
　　　　ATTENTION A NE PAS
　　　　JOUER SUR L'HERBE
　　　　FRAICHEMENT PEINTE

UNE CHANSON CONDUIT LES BREBIS VERS L'ÉTABLE

Vicente Huidobro for
Horizon Carré, Paris. Paul
Birault, 1917. 22.7 x 18.3 cm.
Archivo Lafuente

JOSE JUAN TABLADA
Psicografía de Marius de Zayas.

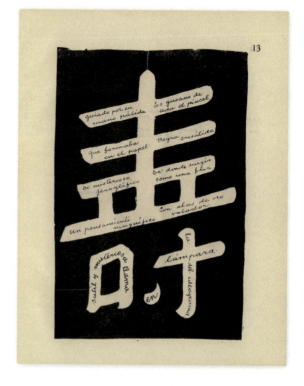

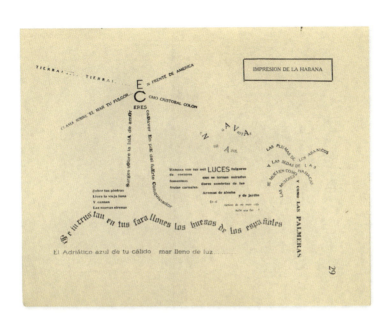

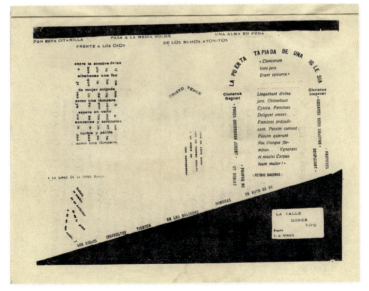

José Juan Tablada for *Li-Po y otros poemas*, Caracas. Bolívar, 1920. 27 x 21.5 cm.
Juan Bonilla Collection, Seville / Alexis Fabry Collection, Paris

Alberto Hidalgo for
Química del espíritu,
Buenos Aires. Mercatali,
1923. 18.6 x 12.5 cm.
Archivo Lafuente

Alberto Hidalgo for
Simplismo: poemas inventados, Buenos Aires. El Inca, 1925. 18.7 x 13.8 cm.
Archivo Lafuente

Luis Bueno for
Lasteníada (poema intenso), Montevideo. Talleres Gráficos Proteo, 1928.
17 x 12.4 cm.
Archivo Lafuente

Cover by Tarsila do Amaral for Oswald de Andrade, *Pau Brasil*, Paris. Sans Pareil, 1925. 16.5 x 13 cm. Archivo Lafuente

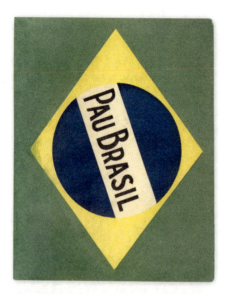

Cover by Antôntio Paim Vieira for António de Alcântara Machado, *Pathé-Baby*, São Paulo. Hélios, 1926. 20 x 15.5 cm. Archivo Lafuente

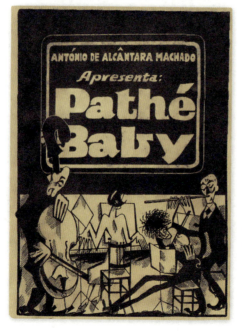
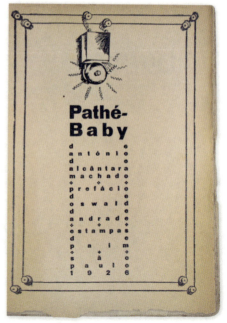

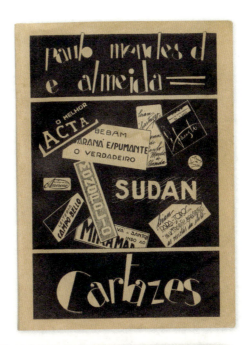

Cover by Arnaldo Barbosa for Paulo Mendes de Almeida, *Cartazes*, São Paulo. Livraria Liberdade, n.d. [1928?]. 19.5 x 14.1 cm. Archivo Lafuente

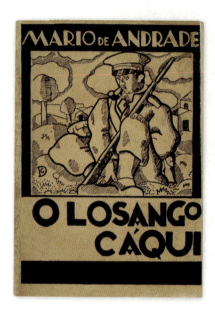
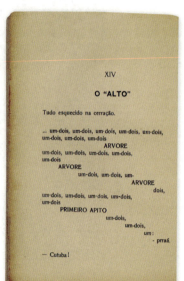

Cover by Emiliano Di Cavalcanti and inner pages by Mário de Andrade (author) for *Losango Cáqui ou afetos militares de mistura com os porquês de eu saber alemão*, São Paulo. A. Tisi, 1926. 17.5 x 12.5 cm. Archivo Lafuente

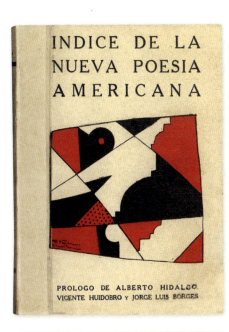
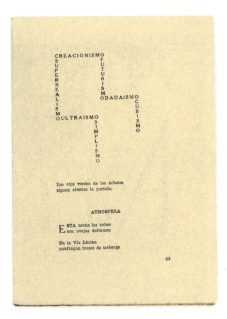

Cover by Carlos Pérez Ruiz and inner pages by Juan Florit, Vicente Huidobro and J. Moraga Bustamante for Alberto Hidalgo, Vicente Huidobro and Jorge Luis Borges (preface), *Índice de la nueva poesía americana,* Buenos Aires. El Inca, 1926. 18.6 × 14 cm. Archivo Lafuente

Cover by Dr. Atl (brush name of Gerardo Murillo) and inner page by Kyn Taniya (pen-name of Luis Quintanilla, author) for
Avión: 1917 –poemas– 1923, Mexico City. Cultura, 1923.
23.4 x 17.4 cm.
Archivo Lafuente

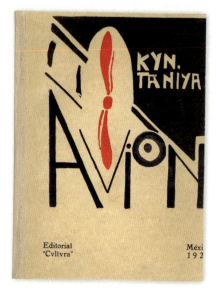

Cover by Ramón Alva de la Canal and inner page by Arqueles Vela (author) for *El café de nadie*, Xalapa. Horizonte, 1927.
20.6 x 14.6 cm.
Archivo Lafuente

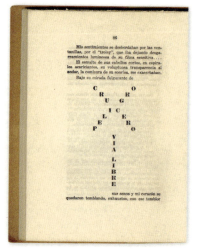

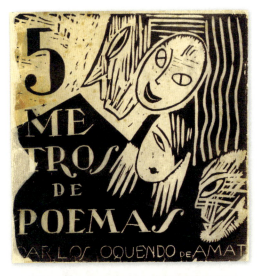
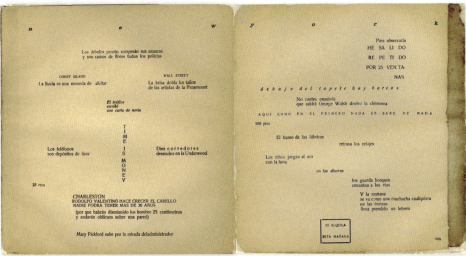
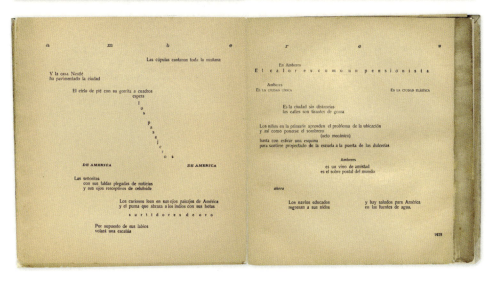

Cover by Emilio Goyburu and inner pages by Carlos Oquendo de Amat (author) for 5 metros de poemas, Lima. Minerva, 1927.
22.5 x 23 cm.
Archivo Lafuente

Vicente Huidobro for
Vientos contrarios, Santiago de Chile. Nascimento, 1926.
19.2 × 13.8 cm.
Archivo Lafuente

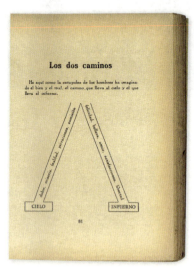

Juan de Armaza (pen-name of Alfonso Bulnes) for
Viñetas, Paris. Editorial París–América, 1927.
23.8 × 18.8 cm.
Archivo Lafuente

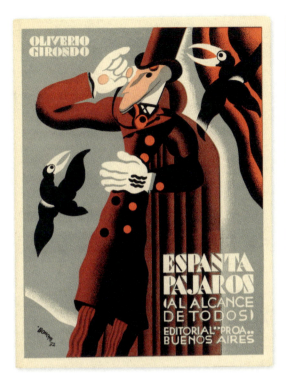
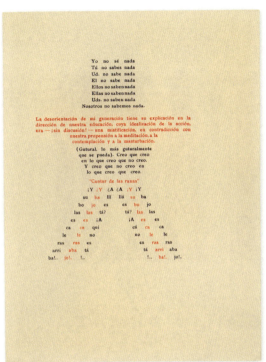

Cover by José Bonomi and inner page by Oliverio Girondo (author) for *Espantapájaros (al alcance de todos)*, Buenos Aires. Proa, 1932. 25.3 x 19.3 cm. Archivo Lafuente

Emilio Armaza for *Falo.*
Síntesis del imaginador,
Puno. Tipografía Comercial,
1926. 32 x 26.5 cm.
National Library of Peru,
Lima

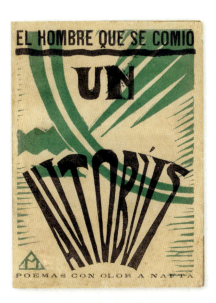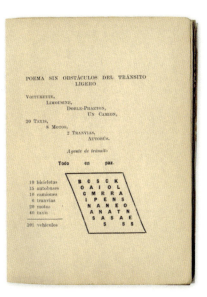

Cover by Melchor Méndez Magariños and inner page by Alfredo Mario Ferreiro (author) for *El hombre que se comió un autobús (poemas con olor a nafta)*, Montevideo. La Cruz del Sur, 1927. 19.8 × 14.5 cm. Archivo Lafuente

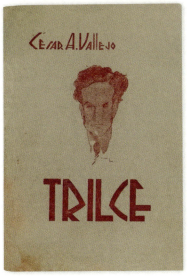

Cover by Víctor Morey Peña and inner page by César A. Vallejo (author) for *Trilce*, Lima. Talleres Tipográficos de la Penitenciaría, 1922. 19.3 × 13.3 cm. Archivo Lafuente

Omar Estrella for *Brújula*,
La Paz. Meridiano, 1928.
16 × 16 cm.
Spanish Agency for
International Development
Cooperation Library, Madrid

Antonio Ávila Jiménez for
Cronos, La Paz. n.p., 1939.
18.2 x 14.8 cm.
Echaurren Salaris
Foundation

```
              diáfana la mañana y ancha
              para un galope de a
                                cor
                                    de
                                       ón
              las nubes cortesanas
                                   abanican
              empolvadas pelucas
              a DIOS
              los corderitos sobre las colinas
              abedules y pinos
                         el color
              de las techumbres que se ponen rouge
              y vuelven los labios al sol
              el piloto juega
                       el piloto juega
                          con su corazón
```

```
     de la futura chancon
     lirismo de la síntesis mecánica
     electrotecnia de un gigante moscardón
                con furor
     los cilindros se descubren los dientes
     el cielo
               estaba sucio
                        anoche
                         ahora
                              es porcelana del Japón
     polvo
         que
            cae
               de las nebulosas
     lo ce pi lla  el AVION
```

```
        CANCION... OH... CANCION
        la del acero esta mañana
        abierta en 100 tajadas rubias
        y envuelta en vendas de algodón

                SPIN

        alza las alas       se empina
                   en una suprema oscilación
        cae
            luego
                en furioso torbellino
        es pi ral
                in
                   ter
                      mi
                         na
```

VERBOVISUALIDAD: VISUAL REPRESENTATIONS OF LANGUAGE

Alfredo Pérez Santana and Alfonso Reyes Messa for *12 poemas en un sobre*, Santiago de Chile. Run-Run, 1929. 18 × 12.2 cm. National Library of Chile, Santiago de Chile

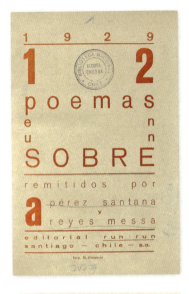
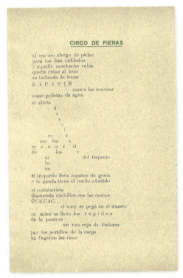
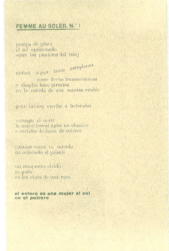
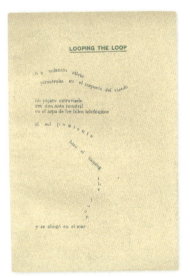

←

Juan Marín for *Looping*, Santiago de Chile. Nascimento, 1929. 19.6 × 19.8 cm. Archivo Lafuente

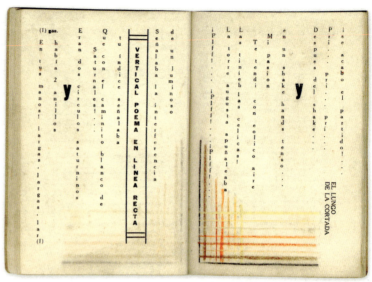
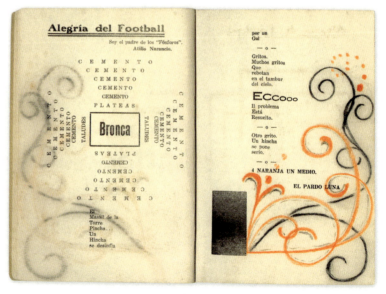

Troupe Ateniense for *Aliverti liquida: primer libro neosensible de letras atenienses: apto para señoritas*, Montevideo. n.p., 1932. 19.5 x 14 cm. Designs executed by hand by the artist. Archivo Lafuente

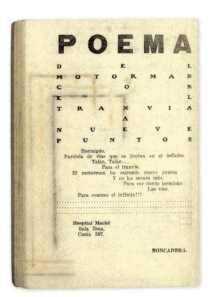

Luis Cardoza y Aragón
for *Maelstrom: films telescopiados*, 3rd edition, Paris. Excelsior, 1926.
18.7 x 11.7 cm.
Archivo Lafuente

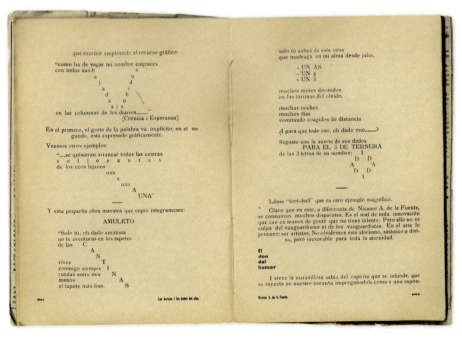

Nicanor A. De la Fuente (Nixa) for *Las barajas i los dados del alba: poemas*, Chiclayo (Peru). Héctor E. Carmona R., 1937. 24 x 17 cm. Archivo Lafuente

Jorge Icaza for *Flagelo: drama en un acto*, Quito. Publicaciones del Sindicato de Escritores y Artistas, 1936. 22.2 x 15.5 cm. Private collection, Granada

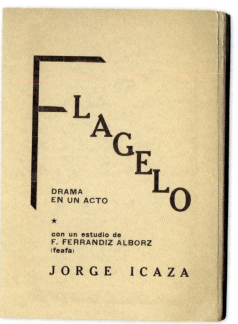

Antonio de Ignacios (pen-name of Antonio Ignacio Pérez Giménez) for *La visión de un andariego*, Buenos Aires. Imprenta López, 1931. 21 x 14.8 cm. Private collection, Granada

Cover by Carlos Zevallos Menéndez and inner pages by José de la Cuadra (author) for *Horno: cuentos*, Guayaquil. Talleres de la Sociedad Filantrópica, 1932. 18 x 12.4 cm. Juan Bonilla Collection, Seville / National Library of Spain, Madrid

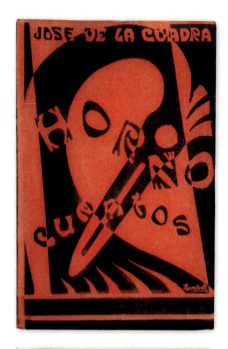

José de la Cuadra for
Horno: cuentos, 2nd edition, Buenos Aires. Perseo, 1940. 18 × 12.4 cm. Eugenio Espejo National Library, Quito

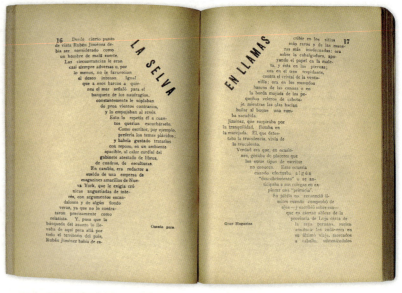

Cover by Leonardo Tejada and inner pages by José de la Cuadra (author) for *Guásinton: relatos y crónicas*, Quito. Talleres Gráficos de Educación, 1938. 21.3 x 15.5 cm. Archivo Lafuente

Cover by Emiliano Celery for *Áurea: revista mensual de todas las artes*, year I, no. 9, January 1928. Buenos Aires. Áurea. 37.5 x 27.2 cm. Private collection, Granada

Pre-Columbianism and Ancestralism

Rodrigo Gutiérrez Viñuales

A key element in the construction of artistic modernity in Europe and America was no doubt the reassessment and renewed appreciation of the past, its shapes and styles, and its usage in the making of new works. This process, initiated in the 19th century and very noticeable in the success of various forms of historicism and in eclectic practices, blossomed in the field of art in the first decades of the 20th century.

In Europe, a number of artists felt the need to renew a formal repertoire they considered limited and headed toward a cul-de-sac. At this time, one of the nerve centers of the avant-garde, Paris, was opening up to the artistic expressions of other latitudes and other times, thereby broadening the range of esthetic possibilities. If Van Gogh or Gauguin, among others, were inspired by Japanese prints, Vlaminck, Picasso and Braque would be influenced by African art. In 1909 the Russian Ballets under Serge Diaghilev began to perform in different countries; integrating painting, sculpture, set design, costume design, theater, music, and literature they created the *Gesamtkunsterk* or total work of art, characterized by a significant measure of popular art, one of the cornerstones of the Russian plastic avant-garde.

In this context, so-called primitive arts and archeology, over and above their esthetic connotations, were also used by artists as effective ways of distancing themselves from a present they felt was confusing. This was a time when those museums that had archeologic and popular collections, chiefly the Ethnographic Museum at the Trocadero, would capture the attention of numerous artists eager to find in such remnants of the past sources of inspiration that could project them toward the future. The Trocadero museum was founded in 1878 on occasion of the Exposition Universelle and in 1937 was transformed by Paul Rivet into the Museum of Man, housing a broad collection of

pre-Columbian art. It consequently became a site of pilgrimage for dozens of Latin American artists, either visitors to Paris or residents in the city, who began to explore its objects. Unlike their European counterparts, notwithstanding the insurmountable temporal distance from their original makers, these objects formed a part of the culture of their continent.

Events such as the numerous archeological expeditions that had succeeded one another since the 19th century, many of which had been organized by universities in the United States, the "discovery" of Machu Pichu following Hiram Bingham's journey to the region in 1911, the birth and consolidation of collections of pre-Hispanic art, and the recovery of literary works such as the Quechuan drama *Ollantay* meant that the interest in such repertoires increased steadily, as they came to be useful novelties that complemented artistic practice. *Ollantay*, specifically, would be staged frequently in theaters on both sides of the Atlantic; along with its music, wardrobe, set designs, posters, and literary texts, it became a sort of counterpart of the Russian Ballets *à la Américaine*.

This fascination would also make its way into the graphic design of the period. Its emergence in books and in magazines, both as regards illustration and diagrammation, was a gradual process, timid at first although by the mid-1920s characterized by an irrepressible freedom and fertile creativity. For Latin American artists it would develop into a true laboratory of avant-garde art, consolidating an idiosyncratic Modernism, as we shall be examining in the works selected.

Our journey begins with two early books published in Argentina in 1921, written by Jorge Carlos Servetti Reeves: *Scisi-Bacha (poema incaico)* and *Nina-Uilca. El fuego sagrado (poema incaico)*. Unfortunately, they contain no mention of the artists who designed their covers, although we believe that they must have been members

Cover by Alfredo Guido for Luis Barbé Pérez and Luis Gluzeau Mortet, *Languidece*, Buenos Aires. Eurindia, n.d. [c. 1923?]. 35.5 x 27 cm. Private collection, Granada

of the staff of the publishing house Editorial Porteña, or the printers Imprenta Mercatali. As regards their illustrations, both volumes reveal an incipient taste for archeology, that conformed to primitive formal references even when the compositions and even the lettering they explored strove to shake off their past.

Something similar could be said of the standardized editorial design, with variations in shades, that characterized La Novela Peruana (The Peruvian Novel) series that began to be published during these years in Lima. Among the covers worthy of mention are that of *El caballero Carmelo*, by the poet Abraham Valdelomar. Like that of the other books in the series, its design was presided over by a reinterpretation of the god Wiracocha taken from the Door of the Sun at the Tiahuanaco archeological site, which was not only beginning to be consolidated as a crucial reference in the recovery of pre-Hispanic Andean culture but also as the main symbol of what was actually known as the "Tiahuanaco style" that would soon influence both architecture and the plastic arts. The image would also feature in another series of books of the same period, this time in La Paz, Bolivia, published by the Library of the Playwrights Society (Biblioteca de la Sociedad de Autores Teatrales). Similarly to the titles in the previously mentioned series, the designs of these covers were repetitive although from one edition to the next there would be changes in color and, of course, in the inclusion of Tiahuanaco signs, in this case the heads of *kuntur* (condors) taken from the lower fringe of the Door of the Sum, shaping a design with an obviously more modern global conception.

Other more complex designs began to develop around the same time, in which the signs of pre-Columbian roots appeared in more storiated compositions, illustrations in every sense of the word. One of the first such meaningful designs was that of the cover for *Los hijos del sol* (1921), Incan stories by aforementioned Abraham Valdelomar, a rare and flimsy little book of which it is difficult to find copies in good condition. For this volume José Sabogal conceived a scene showing an indigenous figure decorating an *urpu* or aryballos with remarkable geometric designs, a characteristic feature of Incan ornamentation (as it is of other pre-Columbian cultures). These formal lines were perfectly in keeping with Art Deco, which blossomed at the Exposition Internationale des arts décoratifs et industrielles modernes, held in Paris in 1925.

Relevant examples also appeared in provincial cities, although today many of them are scattered around the world. Such is the case of the cover designed by a certain C. M. for *La ciudad de los incas* (1922), archeological studies published in Cusco by José Uriel García. In this composition, a pre-Hispanic motif shares importance with the colonial city, divided by an axis presided over by an offering *ñusta* (Incan princess) whose long dress ends in Symbolist waves. In the lower right-hand corner is an aryballos, subtly approached by the head of a Tiahuanaco condor. As regards the initials of the artist's name, to avoid speculation we should clarify that they do not correspond to César Moro, for esthetic reasons and also because, according to a letter to his brother Carlos discovered by Rosa Ostos Marño in 2015 (see Lefort-Villegas Torres, 2017, 35), Alfredo Quízpez Asín only adopted this name in September 1923.

In the case of Sabogal, it is important to note that his taste for graphic design was born during the years he spent in Argentina, where he came into contact with the work of artists like Alfredo Guido, Gregorio López Naguil and Rodolfo Franco, among many others, before returning to his native country around 1918. In Peru, he became chief representative of so-called Peruvian "Indigenism" (although it is now more common to speak of "Indianism", in esthetic rather than political terms) and went

Cover by J. P. L. for
La Información, year XIV, no. 131, August 1929. Santiago de Chile, Welfare Department of the Caja de Crédito Hipotecario and the Caja Nacional de Ahorros Savings Banks, 26.4 × 18.7 cm.
Private collection, Granada

on to consolidate his career in the field of book illustration, as seen in the chapter dedicated to Peru in this volume.

One of the features we've mentioned, the decorated aryballos, would become an iconic symbol for Latin American pre-Columbian artists, as proven by its appearance in all kinds of illustrations, paintings and even ceramics of indigenous tradition. In Argentina it is frequently found in the compositions by José Bonomi, an artist of Italian descent who created one of the most outstanding covers—that of *La Venus Calchaquí* (1924), a book by Bernardo González Arrili, remarkable for the very idea of transferring a symbol of European culture (the Venus) to the American telluric tradition of northeast Argentina (the Calchaquí). The central image, a hieratic female figure holding the ornamented vessel, is cut out against a precipitous landscape that includes another cliché of modernity, the cactus. The scene is framed by indigenous decorations, as is the title of the book. A couple of ceramic works complete the composition. Published by Nuestra América, few works could pay such a tribute to the company's name.

Despite not having irrefutable proof, we also attribute to Bonomi he cover of *Tierra de Huarpes* (1927), by Alfredo R. Bufano, a literary work with reminiscences of designs from Argentina's Cuyo region. The cover shows a typical Santa María funerary urn from the Calchaquí culture, characterized by geometric decorations and a face with slanted eyes and long eyebrows. In keeping with these features is the notable woodcut composition that Federico Lanau had previously made in Montevideo for the third edition of *Agua del tiempo* (1924), by Fernán Silva Valdés. Not only does it have a remarkable central vignette of a native firmly holding a vessel but, above all, a calligraphic game that evokes ancestral designs.

Perhaps by now readers will have noticed the absence of Mexican works influenced by this

Cover by Moacyr Campos
for *Seiva: Synthese do Pensamento Brasileiro*, year I, no. 6, December 1935. Editors: Amador Cysneros and Odilon Negrão, São Paulo. Novidades.
23.4 x 16.2 cm.
Private collection, Granada

pre-Columbian esthetic in our repertoire, chiefly because of the main role played by Aztecans and Mayans in the consistency of indigenous cultures on the continent and their referential relevance in contemporary reinterpretations, abundant in architecture, sculpture, painting, and the decorative arts. Nevertheless, if we count the illustrated books of pre-Columbian inspiration we see that there are fewer than in the Lima – Buenos Aires alignment during the first three decades of the 20th century. Perhaps, if we were to include the illustrations and decorative motifs produced for magazines, there would be a greater balance between the two areas.

One of the artists who would have a major influence on pre-Hispanic recreations in murals, paintings, drawings, and even architecture, having conceived the Anahuacalli (from the Nahuatl word for "house surrounded by water") was Diego Rivera. His role as an illustrator has been sufficiently reassessed in recent decades. Rivera made the illustrations for the tragedy titled *Cuahtémoc* (1925), by Joaquín Méndez Rivas, reproduced on paper of different colors, a practice that produced an attractive esthetic effect that also appears in other books reproduced here, such as *México Michoacán, 6 meses de acción artística popular* (Morelia, 1932), by Gabriel García Maroto (see pp. 488-489), or *Cuaderno de poesía negra* (Havana, 1934), by Emilio Ballagas (see pp. 390-391). In *Cuahtémoc*, published the same year that *Mexican Folkways* magazine was launched, Rivera chose to follow a highly recognizable style, characterized by sinuous lines (that announced the Surrealistic quality we will later see in his woodcut *Vasos comunicantes*, of 1938, conceived to illustrate the poster advertising a lecture to be delivered by André Breton in Mexico), a certain neo-popular taste and, in this specific case, the trace of codices.

By the mid-1920s the recovery of pre-Columbian traits had already appeared in a large number of illustrated books. The geometrized

frets, zigzags, masks, and invented calligraphy were used time and again by artists to provide their designs for poetry compilations, genre novels, history books, chronicles, tourist brochures, and all sorts of publications, especially those that needed to express an identity. We have chosen those we believe are most distinguished: among those made in Argentina, the panoramic cover that the critic, journalist, and storyteller José Gabriel made, in an exceptional foray into the field of illustration, for *Poemas de Cuyo* (1925), by Alfredo Bufano, in red and black inks; the cover designed by the sculptor Gonzalo Leguizamón Pondal for *Tierra fragosa* (1926), by Julio V. González; the one conceived by Lysandro Galtier—a follower of Martín Fierro's—for *Rumbo* (1926), by Elías Cárpena, resorting to the motif of the mask; one of the splendid covers, remarkable for their neo-pre-Hispanic calligraphy, for the rare editions of 1926 and 1927 of *Antología de poetas argentinos*; and the prominent handmade cover by José Speroni from the River Plate region for *La diplomacia de Yrigoyen* (1928), a political analysis of current affairs by Luis M. Moreno Quintana published by Editorial Inca, which was possibly a perfect excuse for its pre-Hispanic ornamentation.

Among similar books published in other countries we have included the cover of *Todo a América* (1926), by the Brazilian Modernist author Ronald de Carvalho, illustrated by Nicola de Garo, where the artist has chosen synthetic rather than archeological features. Later on we shall devote an entire sub-section exclusively to ancestral Brazilian productions. The aforementioned design is also strongly linked to the theme of the mask, as is the book *Máscaras mexicanas*, also published in 1926 by Roberto Montenegro in Mexico, characterized by at least two different covers with hard-cover binding: the most common is smooth, pale pink, and has a label attached to its upper right-hand corner (we know of three versions: red, blue, and yellow) containing the book's title. The less frequently found, which we include here for its pre-Hispanic design, conceived almost as a fabric, was used for special print runs. Last but not least, we must refer to three wonderful compositions for books published in Peru, all characterized by a disarray of pre-Columbian elements on the covers and harmonious calligraphic titles: *Huancayo* (1926), by Oscar O. Chávez, author of the book and also the designer of its cover, *El Perú descriptivo* (1926), by Fabio Camacho, and *La independencia del Perú y la colonia japonesa*, also published around the same time; the last two share the same shades, orange decoration, and black titles.

All these works we are examining were closely related to other pre-Columbian practices whose objective was the mass socialization of these designs and their inclusion in everyday life and in school teaching. In an essay we published almost two decades ago (Gutiérrez Viñuales, 2003) on the links between art and childhood in Latin America we alluded to the publication of decorative art manuals inspired by pre-Columbian shapes and styles. These included *Viracocha* (1923), six sketchbooks edited in Buenos Aires by Alberto Gelly y Cantilo and Gonzalo Leguizamón Pondal, *Método de dibujo*, by Adolfo Best Maugard, published in Mexico that same year, the two sketchbooks of *El arte peruano en la escuela* (Paris, 1925-1927), by Elene Izcue, and *Dibujos indígenas de Chile* (1928), by Abel Gutiérrez. The "book" format of the latter makes it worthy of mention here, as do its profuse indigenist illustrations made by Gutiérrez's pupils at the National Institute. This volume stands out because of its specific intention, destined as it was for "students, teachers, and architects who wished to distinguish their works with the stamp of Native American cultures."

Along the same lines, later on the book *Kuntur. Primer cuaderno de dibujo autóctono* (1936) was published in Arequipa by one of the "forgotten" Peruvian artists, Carlos Alberto Paz de Noboa,

whose work we discussed in the chapter dedicated to illustrated Peruvian books. Such manuals were truly exemplary and enabled many artists to discover designs they could conveniently reinterpret. Their influence can be recognized, in part, in one of the best indigenist and modern covers of those made in Latin America in the 1920s, by the genre painter Alfredo Gramajo Gutiérrez in Argentina: that of *Tejidos incaicos y criollos* (1927), by Fausto Burgos and María Elena Catullo. It is outstanding on account of its profuse coloring, and the ornamented figure of a native woman cut out against a ground of gold, a shade also used to define the pre-Hispanic title, its uneven letters inscribed in columns, adapting to the space destined for them, somehow framing the main scene.

Undeniably, as we advance along our visual and textual itinerary we are aware of the prevailing presence of elements related to indigenous cultures and Andean ancestralism, particularly of the Incan, effectively present in books in the aforementioned Lima – Buenos Aires axis. It would be tedious to stop and examine the complexity of all the works selected and their specific characteristics, so we shall simply provide a few historical and artistic references. We shall begin with one of the most colorful covers by José Sabogal, that of the book *Da la vida inkaica* (1926), by Luis E. Valcárcel, in which the artist already revealed the influence of the popular Peruvian arts that from then on would feature abundantly in his compositions. Also connected to the Cusco area, like Valcárcel, was José Uriel García, who published the transcendental essay *El nuevo indio* (1930). Its cover, featuring an illustration halfway between pre-Hispanic and neo-popular Sabogalesque references, is one of the most meaningful Peruvian works in the style, along with that of *Versiones incaicas*, by the Bolivian author Gregorio Reynolds, published that same year in Santiago de Chile. Neither of the two contain any reference to the illustrator.

In Argentina, and in connection with Andean and Incan influences, we must cite the Catalan illustrator Luis Macaya, and three literary authors: Ernesto Morales, Justo G. Dessein Merlo, and aforementioned Fausto Burgos. Macaya, one of the most prolific cover designers in the country, chiefly remembered for his vast legacy at Editorial Tor in the 1930s and 1940s, produced splendid pre-Hispanic designs as we see in the covers for *Leyendas de Indias* (1928) and *Las enseñanzas de Pacaric* (1929), both by Morales, and another of the same high standard and whose ornamentation is even more subtle and complex, that of *Andes del sol* (1929), by Dessein Merlo, harmoniously composed in red and blue inks. These covers included pre-Hispanic calligraphy, very much in keeping with their overall design.

A number of other artists followed the same paths during these years: Raúl Mario Rosarivo, who would become one of the most prominent figures in the fields of typography, diagrammation, and design applied to books in Argentina; Luis Perlotti, the most prolific Argentine sculptor to recreate indigenist Andean motifs his home country; and Mariano Fuentes Lira, the main representative of pre-Hispanic modernity in the Cusco – La Paz axis, himself from Cusco. Their works included Rosarivo's cover for *Pacha Mama* (1931), by Amadeo Rodolfo Sirolli, Perlotti's *Sabiduría de los incas* (1934), by Ernesto Morales, and Fuente Lira's cover and illustrations for *Huilka. Cuentos del Kosko* (1938), by Fausto Burgos, published in San Rafael (Mendoza) by the legendary Editorial Butti and printed on the unmistakable brown paper that characterized most of the literary works they released.

Brazil is a unique case when it comes to tracing pre-Columbian and ancestral influences. As we saw in the importance of Cusco and Incan elements in literature and graphic design, the same can be said of the promotion of the Amazonian region and its indigenous culture.

Having devoted a substantial chapter to the subject, we would now like to gather together a few scattered references. The first works that spring to mind are, of course, those by Vicente do Rego Monteiro made in Paris: his illustrations for *Légendes, croyances et talismans des indiens de l'Amazone* (1923) and *Quelques visages de Paris* (1925), that include a series of ideograms that, like the gaze of an Amazonian native, offer a unique and atypical vision of the French capital (see pp. 56-57).

Nevertheless, our research ended up revealing a comprehensive series, susceptible of being enlarged and of triggering an even more extensive repertoire. Some of these works are included in the Brazilian section of this volume, such as the poetry compilation titled *Muirakitans* (1928), by Carlos Marinho de Paula Barros, who would also create the illustrations (see p. 229). In the corresponding text, we elaborated on two paradigmatically "Amazonian" literary works, *Macunaíma* (1928), by Mário de Andrade, and *Cobra Norato* (1931), by Raúl Bopp, and on the decisive theme of the fortune of the *marajoara* style that derived from the reinterpretation of the indigenous designs on Marajó Island (in the state of Pará), cultivated in theory and in practice by Theodoro and María Braga, José Marianno Filho, Manoel Pastana, Fernando Correia Dias, Regina Gomide, and Flávio de Carvalho.

Several of the books included in our survey lack information concerning their designers, all the more when their quality is high, in which case strangely enough they are not even signed. Such is the case of the poetry volume *Alegría* (1927), by Guilherme de Castro e Silva, and of *Meu glorioso peccado* (1928), by the fondly remembered poetess Gilka Machado, presented with a striking bicolor cover in black and white, characterized by geometrized ornamentation that is further explored in the inner pages. The same can be said of the covers of *Amazonia. A terra e o homem* (1933), by Araújo Lima, and of *Letras da Amazônia* (published in Manaus in 1938), by Djalma Batista, no doubt one of the most accomplished in the series.

Among the designs that *were* signed, most of which are by artists unknown to us, is the cover of the interesting essay *A expressão artistica nos alienados (Contribução para o estudo dos symbolos na arte)* (1929), by Osório Cesar; signed by one "Orn" and also decorated in red and black ink, its composition combines indigenous influences and popular evocations. Another noteworthy design was signed by Elódio, the dark green cover of *Terra verde* (1929), by Eneida. Victoriano Gil Ruiz produced a similar illustration for the cover of *Paiz das pedras verdes* (1930), by Raymundo Moraes, featuring a splendid Amazonian mount that frames the green silhouette of a monumental city. Funnily enough, before his foray into Brazilian art Gil Ruiz, a Spaniard who by then was an established photographer in the Peruvian Amazonian region, had had a large graphic arts studio in Iquitos. Last but not least, Soliva designed the Amazonian cover of the first edition of the ballad titled *Terra de Icamiaba* (1934), a work in which Abguar Bastos condemned the lack of state interest in the Amazon and the plundering of the region by foreign adventurers who got rich at the expense of the poverty of the natives.

While the works examined in this chapter so far have been grouped according to their geographical origins, i.e. the axis of Argentina, Bolivia and Peru in connection with Andean influences, and Brazil in connection with Amazonian influences, we shall now allude to a series of works that encompasses a few from the above-mentioned countries besides others from around the continent. Mexico, up to this point only cited in relation to illustrations by Diego Rivera and Roberto Montenegro, deserves a mention for the cover that the Yucatecan architect Manuel Amábilis conceived for his book on *El Pabellón de México en la Exposición*

PRE-COLUMBIANISM AND ANCESTRALISM

Cover by unknown artist for *Bloque: revista de literatura, crítica y polémica*, year II, no. 4, March 1936. Editors: Alfonso Aguirre S. et al., Printing press of the Bernardo Valdivieso School, Loja.
Private collection, Granada

Ibero-Americana de Sevilla (1929), a building he designed in the Neo-Mayan style. On the cover of this edition, Amábilis depicted a general view of the main façade, and specifically a relief by the sculptor Leopoldo Tommasi featuring the figure of an eagle and a prickly pear flanked by two slender snakes, their zigzagging bodies quite characteristic of Art Deco.

The event staged in Seville in 1929, most of the American pavilions of which still stand and were characterized by both by neo-pre-Columbian and neo-colonial styles (and even by the combination of both), was a key setting for the dissemination of the ideals shared by Latin American countries outside the continent. We have already made enough references to these in this text, from the aforementioned axis between Peru and Argentina to the action of publishing houses like Nuestra América. In order to further emphasize this archetype we have included books with wonderful pre-Columbian designs, such as the cover an unknown artist made for *El*

hombre de América (1932), by Octavio N. Gallo, or the more synthetic cover of *América: novela sin novelistas* (1933), by Luis Alberto Sánchez. The latter was created by one of the most prolific artists in the field of indigenist graphic design, a renowned painter of the so-called Indigenist School, Alejandro González Trujillo, who at the time went by the artist's name Apu-Rimak ('Speaking God' in Quechua), a tribute to the Peruvian department where he had been born (Apurimac). During those years Apu-Rimak worked as a draftsman on archeologic expeditions commanded by the writer and anthropologist Luis E. Valcárcel, the author of *Cuentos y leyendas inkas* (1939).

Among this group of books is the only Paraguayan edition of the whole volume, that of the poetry compilation titled *El precio de los sueños* (1934), by Josefina Plá, a Canarian artist whose husband, Andrés Campos Cervera, better known by his artist's name Julián de la Herrería, made the woodcut design for the cover, the chief motif of which is ceramic vessel with triangular ornamentation, printed in red ink and set against a bluish shadow. Over the course of time, Josefina Plá would become the most important critic and historian of Paraguayan art and a tireless cultural promoter. Upon his early death, in Valencia in 1937, Julián de la Herrería left an important legacy of ceramics with indigenist designs, a result of his Americanist convictions applied to the techniques he had learned in the 1920s in the Manises factory, in the environs of Valencia. To a fair extent, the cover of *El precio de los sueños* was an emblematical work in the career of both.

Other covers with which we shall conclude this chapter confirm, once again, the variety of literary and essayistic themes adorned with pre-Columbian and ancestralist graphic designs. One is the archeology book dedicated to the Columbian massif *La vida en las tumbas* (1935), by Monsignor Federico Lunardi, written in Spanish despite being published in Rio de Janeiro. Another volume devoted to the theater and published in Havana that same year, *Ixquic. Tragedia mitológica quiché en un prólogo y tres actos*, by Carlos Girón Cerna, had a pre-Hispanic calligraphic cover and numerous inner illustrations signed by "Rosie". A new manual of ornamental art, *Aplicaciones industriales del diseño indígena de Puerto Rico* (1939), was jointly produced by Matilde Pérez de Silva (who made the wonderful series of illustrations) and the historian and archeologist Adolfo de Hostos. Two Mexican books also deserve a mention. *Roberto de la Selva* (1937), published in English by Carleton Beals y Rebecca Kaye, featured a sober indigenist illustration, the plainness of which was surpassed by *Morelos. Noviembre 20 de 1941*, an edition that paid tribute to the thirty-first anniversary of the outbreak of the Mexican Revolution, published in San José, Costa Rica.

Our journey comes to a close, deliberately and metaphorically, with the cover for *Metafísica de la prehistoria indoamericana* (1939), by the Uruguayan artist Joaquín Torres-García, one of those responsible for certain changes in paradigm regarding the assessment and reinterpretation of pre-Columbian past in modern art, given his desire to transcend the merely formal aspects of these representations, and explore more profoundly and spiritually the meaning of the signs and the Constructivist essence of former American settlers. The teachings of Torres-García opened up new paths of research that would crystallize in geometric and abstract reformulations throughout the continent, that shared protagonism with the colorful proposals inspired by ancestral models grouped within so-called Lyrical Abstraction. By then, pre-Columbian design applied to books was a consolidated reality that would persistently continue to yield fruits.

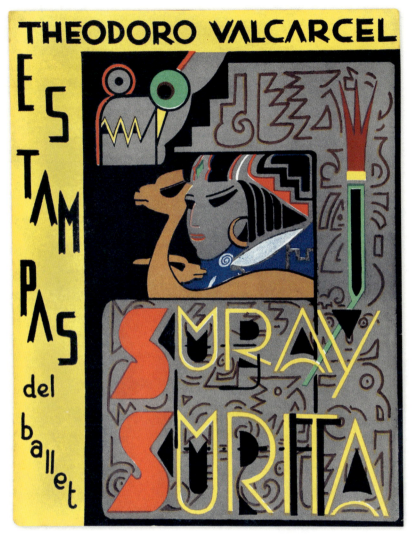

Cover by Manuel Domingo Pantigoso for Theodoro Valcárcel, *Estampas del ballet Suray Surita*, Paris. Self-edition, 1939. 31.7 x 24.6 cm. Private collection, Granada

Pre-Columbianism and Ancestralism

Cover by unknown artist for Jorge Carlos Servetti Reeves, *Scisi-Bacha: poema incaico*, Buenos Aires. Porteña, 1921. 18.6 x 13 cm. Mariano Moreno National Library of the Argentine Republic, Buenos Aires

Cover by unknown artist for Jorge Carlos Servetti Reeves, *Nina-Uilca [el fuego sagrado]: poema incaico*, Buenos Aires. Porteña, 1921. 18.6 x 13 cm. National Library of Spain, Madrid

Cover by unknown artist for E. W. Middendorf, *El Perú: estudio y observaciones sobre el Perú y sus habitantes* (vol. I), Arequipa. Biblioteca de El Deber, 1924. 21.6 x 15.5 cm. Latin American Architecture Documentation Center

Cover by unknown artist for Víctor Ruiz, *Los que pagan: drama de intenso realismo*, La Paz. Sociedad de Autores Teatrales, 1923. 16 x 12 cm. Latin American Architecture Documentation Center, Simón I. Patiño Space, La Paz

Cover by unknown artist for Saturnino Rodrigo, *En la pendiente: comedia de costumbres sucrenses*, La Paz. Sociedad de Autores Teatrales, 1926. 16 x 12 cm. Latin American Architecture Documentation Center, Simón I. Patiño Space, La Paz

Cover by José Bonomi for Bernardo González Arrili, *La Venus calchaquí: novela*, Buenos Aires. Nuestra América, 1924.
18.4 × 14.1 cm.
Private collection, Granada

Cover by Federico Lanau for Fernán Silva Valdés, *Agua del tiempo*, 3rd edition, Montevideo. Agencia General de Librerías y Publicaciones, 1924.
17.9 × 12.8 cm.
Private collection, Granada

Cover by José Sabogal for Abraham Valdelomar, *Los hijos del sol (cuentos incaicos)*, Lima. Euforion, 1921. 17.3 × 10.8 cm.
Private collection, Granada

Cover attributed to José Bonomi for Alfredo R. Bufano, *Tierra de Huarpes*, Buenos Aires. Tor, 1927.
18.2 × 12.7 cm.
Private collection, Granada

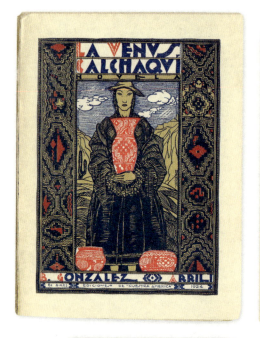
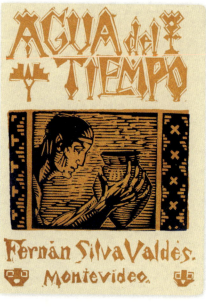
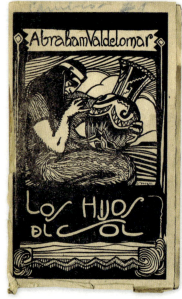
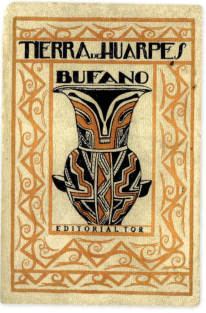

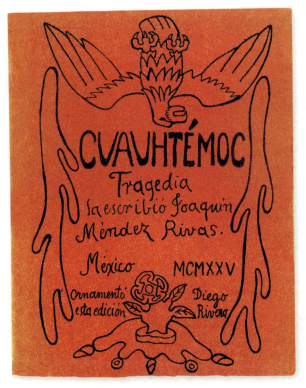

Covers by Diego Rivera for Joaquín Méndez Rivas, *Cuauhtémoc: tragedia,* Mexico City. n. p., 1925. 18.2 × 15 cm. Archivo Lafuente

Covers by José Gabriel [López] for Alfredo R. Bufano, *Poemas de Cuyo,* Buenos Aires. Tor, 1925. 18.6 x 13.5 cm. Private collection, Granada

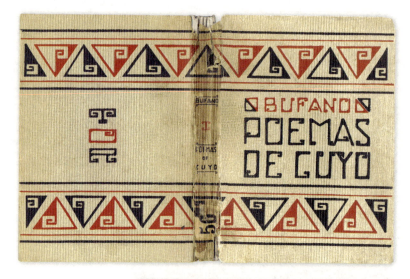

Cover by Roberto Montenegro (author) for *Máscaras mexicanas,* Mexico City. Talleres Gráficos de la Nación, 1926. 31 x 22.8 cm. Private collection, Granada

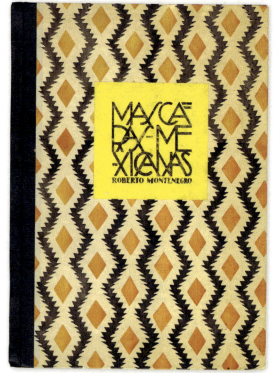

Cover by unknown artist for Fabio Camacho, *El Perú descriptivo*, Lima. Incazteca – Rotary Club de Lima, 1926. 21.2 × 16.2 cm. Private collection, Granada

Cover by unknown artist for *Antología de poetas argentinos: composiciones recitadas por sus autores en la Fiesta de la poesía*, Buenos Aires. Mercatali, 1926. 18.7 × 13.9 cm. Archivo Lafuente

Cover by unknown artist for *La independencia del Perú y la colonia japonesa*, Lima. Eduardo Ravago, 1926. 23.3 × 16.7 cm. Private collection, Granada

Cover by José Speroni for Luis M. Moreno Quintana, *La diplomacia de Yrigoyen*, La Plata. Inca, 1928. 18.7 × 14 cm. Private collection, Granada

Cover by Nicola de Garo (brush name of Nicolai Abracheff) for Ronald de Carvalho, *Todo a América*, Rio de Janeiro. Officina de Pimenta de Mello & Cía., 1926. 19 x 14 cm. Private collection, Granada

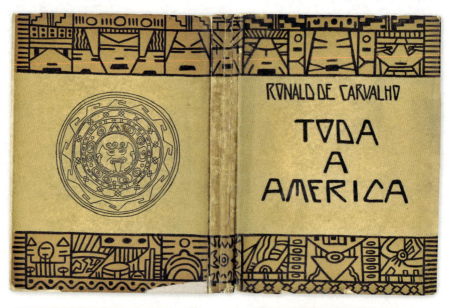

Cover by Lysandro Z. D. Galtier for Elías Cárpena, *Rumbo*, Buenos Aires. Sociedad de Publicaciones El Inca, 1926. 19 x 14.2 cm. Private collection, Granada

Cover by Gonzalo Leguizamón Pondal for Julio V. González, *Tierra fragosa: paisajes, tipos y costumbres del oeste riojano*, Buenos Aires. Juan Roldán & Cía., 1926. 18.3 x 12.7 cm. Private collection, Granada

PRE-COLUMBIANISM AND ANCESTRALISM

Cover and inner page by Carlos Alberto Paz de Noboa (author) for *Kuntur: primer cuaderno de dibujo autóctono*, Arequipa. Santiago Quiroz, 1936. 22 x 17 cm. Library of the Riva-Agüero Institute, Pontifical Catholic University of Peru, Lima

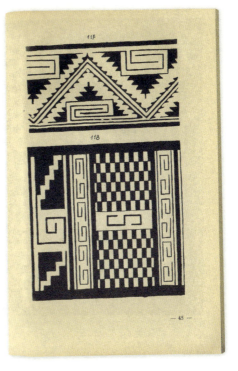

Cover and inner page by students at the National Institute (Chile) for Abel Gutiérrez A., *Dibujos indígenas de Chile*, Santiago de Chile. University Printing Press, 1928. 26 x 17.2 cm. Private collection, Granada

Cover by Alfredo Gramajo Gutiérrez for Fausto Burgos and María Elena Catullo, *Tejidos incaicos y criollos,* Buenos Aires. Talleres Gráficos de la Penitenciaría Nacional, 1927. 29 x 20.1 cm. Private collection, Granada

Cover by José Sabogal for Luis E. Valcárcel, *De la vida inkaika: algunas captaciones del espíritu que la animó,* Lima. Garcilaso, 1926. 18.7 x 13.2 cm. Private collection, Granada

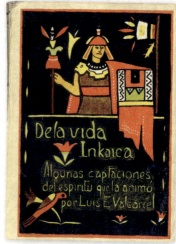

Cover by unknown artist for Gregorio Reynolds, *Versiones incaicas* (vol. I), Imprenta y Litografía Casa Amarilla, 1930. 27 x 19 cm. Latin American Architecture Documentation Center, Buenos Aires

Cover by unknown artist for José Uriel García Ochoa, *El nuevo indio: ensayos indianistas sobre la sierra surperuana,* Lima. H. G. Rozas, Sucesores, 1930. 23.5 x 16.1 cm. Private collection, Granada

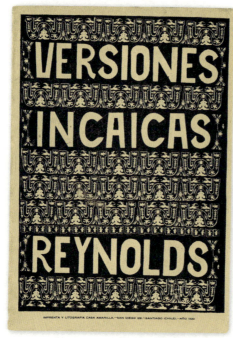

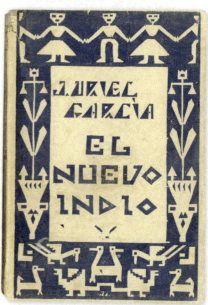

Cover by unknown artist for Luis A. Pardo, *Las tres fundaciones del Cuzco*, Lima. Talleres de la Prensa Mundial, 1939. 17.4 × 12 cm. Latin American Architecture Documentation Center, Buenos Aires

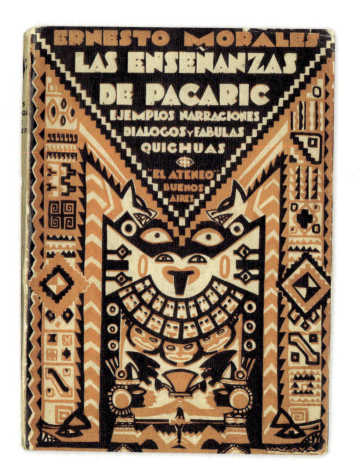

Cover by Luis Macaya for Ernesto Morales, *Las enseñanzas de Pacaric: ejemplos, narraciones, diálogos y fábulas quichuas*, Buenos Aires. El Ateneo, 1929. 19.9 x 14.7 cm. Private collection, Granada

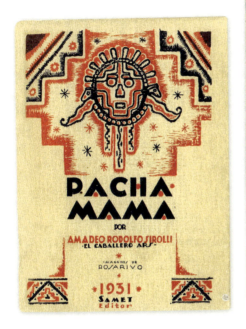

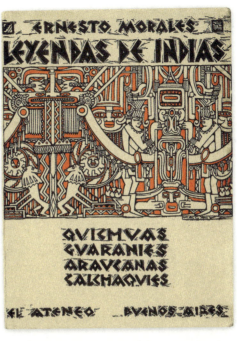

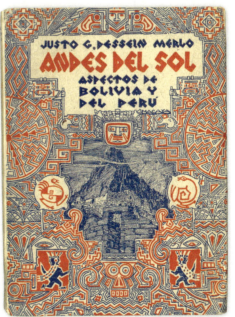

Cover by Raúl Mario Rosarivo for Amadeo Rodolfo Sirolli (el Caballero Ars), *Pacha Mama*, Buenos Aires. J. Samet, 1931.
18.6 x 13.8 cm.
Private collection, Granada

Cover by Luis Macaya for Ernesto Morales, *Leyendas de Indias: quichuas, guaraníes, araucanas, calchaquíes*, Buenos Aires. El Ateneo, 1928.
20.5 x 15.2 cm.
Private collection, Granada

Cover by Luis Macaya for Justo G. Dessein Merlo, *Andes del sol: aspectos de Bolivia y del Perú*, Buenos Aires. El Ateneo, 1929.
19.5 x 14 cm.
Private collection, Granada

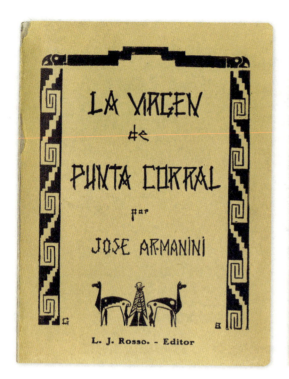

Cover and inner pages by Guillermo Buitrago for José Armanini, *La virgen de Punta Corral*, Buenos Aires. L. J. Rosso, 1929. 18.4 x 14 cm. Private collection, Granada

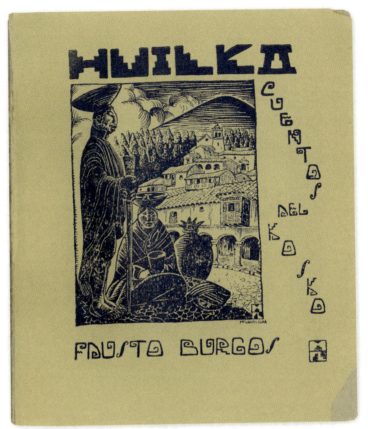

Cover by Mariano Fuentes Lira for Fausto Burgos, *Huilka: cuentos del Kosko*, San Rafael (Mendoza). Butti, 1938. 20.9 x 17.8 cm. Private collection, Granada

Cover by Soliva for Abguar Bastos, *Terra de Icamiaba (romance da Amazonia),* 2nd edition, Rio de Janeiro. Adersen, 1934. 19 x 13 cm.
Institute of Brazilian Studies, University of São Paulo, São Paulo

Cover by unknown artist for Gilka Machado, *Meu glorioso peccado,* Rio de Janeiro. Almeida Rorres & C., 1928. 16 x 11.5 cm.
The Guita and José Mindlin Brasiliana Library, University of São Paulo

Cover by unknown artist for José Francisco de Araújo Lima, *Amazonia: a terra e o homem,* Rio de Janeiro. Alba, 1933. 19.2 x 13.4 cm.
Archivo Lafuente

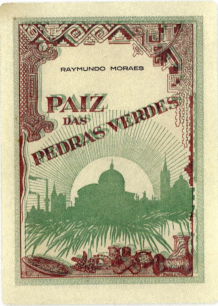

Cover by unknown artist for Guilherme de Castro e Silva, *Alegría: poemas*, Rio de Janeiro. Francisco Alvez, 1927. 19 x 14 cm. Ubiratan Machado Collection

First reproduced in the book *A capa do livro brasileiro, 1820-1950*, São Paulo. Ateliê Editorial, 2018

Cover by Victoriano Gil Ruiz for Raymundo Moraes, *Paiz das pedras verdes*, Manaos. Imprensa Pública, 1930. 19 x 14 cm. Private collection, Granada

Cover by Elódio for Eneida (Eneida de Vilas Boas Costa de Moraes), *Terra verde*, Belém (Pará). Livraria Globo, 1929. 19. 5 x 13.5 cm. Ubiratan Machado Collection

First reproduced in the book *A capa do livro brasileiro, 1820-1950*, São Paulo. Ateliê Editorial, 2018

Cover by Julián de la Herrería (brush name of Andrés Campos Cervera) for María Josefina Plá Guerra Galvany, *El precio de los sueños: versos*, Asunción. El Liberal, 1934. 18 x 13 cm.
IberoAmerican Institute – Prussian Cultural Heritage Foundation, Berlin

Cover by unknown artist for Octavio N. Gallo, *El hombre de América: transcripciones y síntesis etnográficas*, Buenos Aires. Alfredo Díaz 1932. 23 x 16 cm.
Private collection, Granada

Cover by Alejandro González Trujillo (Apu-Rimak) for Luis Alberto Sánchez, *América: novela sin novelistas*, Lima. Librería Peruana, 1933. 17.4 x 13 cm.
Private collection, Granada

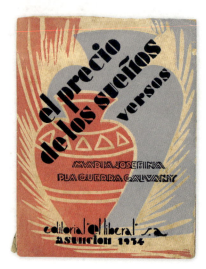
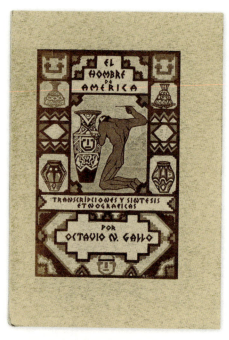
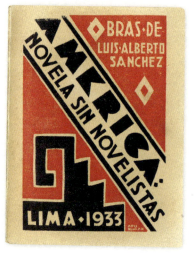

PRE-COLUMBIANISM AND ANCESTRALISM

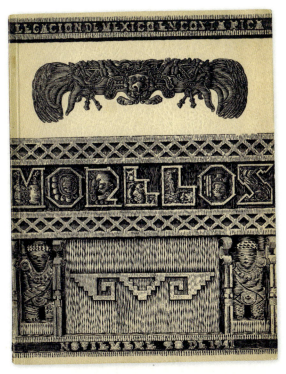

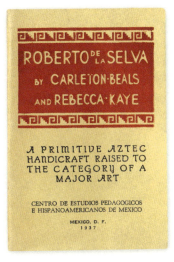

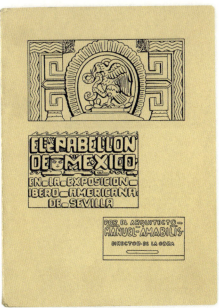

Cover by unknown artist for *Morelos: noviembre 20 de 1941*, San José (Costa Rica). Legación de México en Costa Rica – Junta Progresista del Barrio México, 1941. 27.7 x 21.4 cm. Private collection, Granada

Cover by unknown artist for Carleton Beals and Rebecca Kaye, *Roberto de la Selva*, Mexico City. Centro de Estudios Pedagógicos e Hispanoamericanos de México, 1937. 17.6 x 11.8 cm. Private collection, Granada

Cover attributed to Manuel Amábilis (author) for *El Pabellón de México en la Exposición Ibero-Americana de Sevilla*, Mexico City. Talleres Gráficos de la Nación, 1929. 22.5 x 16.6 cm. Private collection, Granada

Cover by Diego Rivera for Emily Edwards, *The Frescoes by Diego Rivera in Cuernavaca*, Mexico City. Cultura, 1932. 19.7 x 12.6 cm. Private collection, Granada

Cover by Matilde Pérez de Silva for Matilde Pérez de Silva and Adolfo de Hostos, *Aplicaciones industriales del diseño indígena de Puerto Rico / Industrial Applications of Indian Decorative Motifs of Puerto Rico*, Chicago / Philadelphia / Toronto. The John C. Winston Company, 1939. 25.9 x 21.5 cm. Private collection, Granada

Cover and inner page by Rosie for Carlos Girón Cerna, *Ixquic: tragedia mitológica quiché en un prólogo y tres actos*, Havana. Hermes, 1935. 16.8 x 12.5 cm. Private collection, Granada

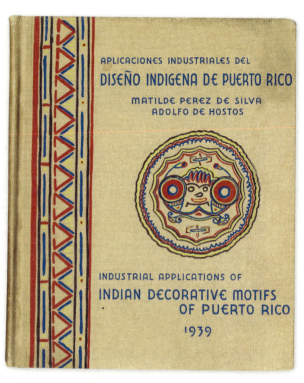

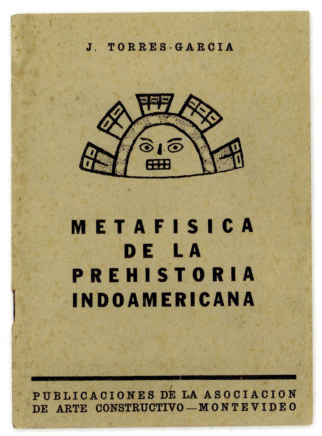

Cover by Joaquín Torres-García (author) for
Metafísica de la prehistoria indoamericana, Montevideo. Asociación de Arte Constructivo, n.d. [1939?].
19 x 14.3 cm.
Archivo Lafuente

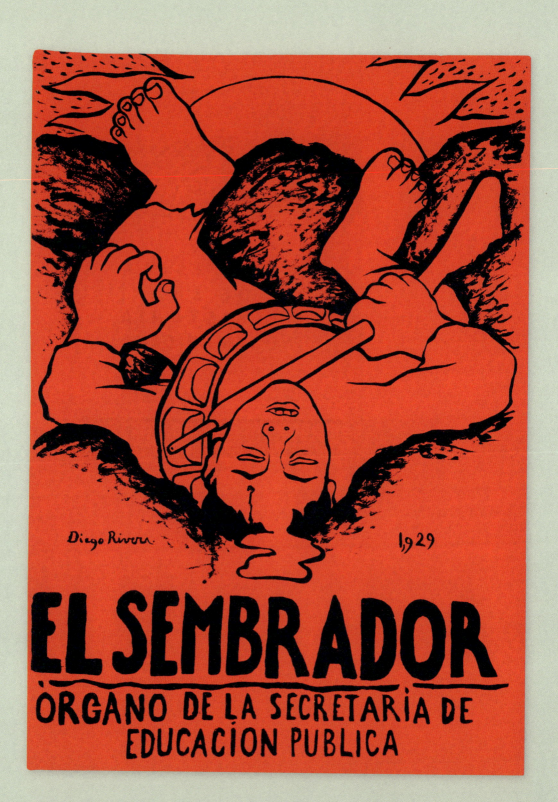

Political and Social Graphics

Dafne Cruz Porchini

America in search of America, from the north border to Cape Horn. A new continent predestined to contain a fifth race, the cosmic race, American mestizos before the challenge of linking the strong pride of the indigenous past with hopes for an egalitarian future.

E. YÉPEZ, "El maestro," *Revista de cultura nacional*, Mexico City, vol. I, 1921, p. 87

In 1921, in the only issue of *Vida Americana. Revista Norte, Centro y Sud-América*, printed in Barcelona (see p. 23), the Mexican artist David Alfaro Siqueiros published his manifesto titled "Tres llamamientos de orientación actual a los pintores y escultores de la nueva generación de América." In the text, Siqueiros called for the whole continent to embrace the avant-garde, the chief objective of which was to promote spiritual and commercial exchange between Europe and America, besides recovering "autochthonous" elements, in spite of the differences between Latin American countries.

Siquieros's manifesto conclusively declared "Let us reject theories anchored in the relativity of 'national art'. We must become universal! Our own racial and regional physiognomy will always show through in our work." (Spanish original in Tibol, 1966, 30).

In his proposal for this geographic and cultural context, Siqueiros also classified a series of

conceptual networks that paralleled the idea of the universalization of rational language, relating it to a model of modernization dependent on an industrial and commercial program (De la Rosa, 2014). That same year, 1921, the young poet and lawyer Manuel Maples Arce published his manifesto *Actual* in Mexico City, triggering the artistic and literary movement known as Stridentism. Besides the calls for "death to priest Hidalgo" or the slogan "Chopin deserves the electric chair," the movement was inspired by the ideas of Marinetti and by those of the promoters of Hispano-American Dadaism and Ultraism.

The force of the cultural and artistic solidarity, prompted in a great measure by the work titled *La raza cósmica* (1925), by the Mexican writer, politician, and civil servant José Vasconcelos, no doubt permeated the spirit of reconstruction characterizing post-revolutionary Mexico and Latin America as a whole.

One example of a Latin American reformation initiative was the idea of founding a Museum of American Art, discussed in 1927 in the Mexican magazine *Forma*, published by the Secretariat of Public Education. The objective was to assemble in one and the same place Mexican and Latin American artistic production. The museum—that unfortunately did not materialize—responded to a pressing "social need" and was supposed to establish a point of comparison between "the modern and the present modern": "We shall begin by welcoming Mexican works, in the hope that our museum may later have groups of works by artists from Central and South America. This ensemble of seemingly diverse forms of artistic expression will promote relations between the various collections, spur incentives, and clearly establish the plastic importance of each different country." ("El Museo de Arte Americano," 1927).

These attempts at cultural integration in the southern hemisphere enable us to try and draw up a map of political and social illustration in Latin America in the 1920s and 1930s, to

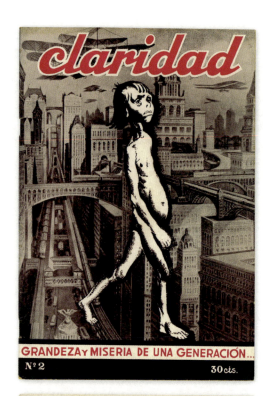

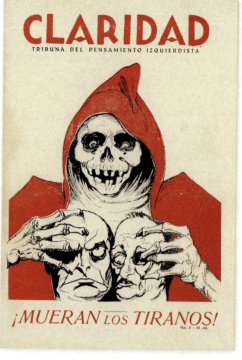

POLITICAL AND SOCIAL GRAPHICS

Claridad. Tribuna del pensamiento izquierdista, nos. 288, 338, 264, 247, 144 and 145, November 1926 – August 1939. Editor: Antonio Zamora, Buenos Aires. Claridad. Varying dimensions. Archivo Lafuente

«—
Cover by Diego Rivera for *El Sembrador: órgano de la Secretaría de Educación Pública*, no. 2, 5 May 1929, Mexico City. Secretaría de Educación Pública. Rafael Barajas Collection, Mexico City

Martillo: órgano del Departamento de Bellas Artes de la Secretaría de Educación Pública, n.d. [c. 1925?], Mexico City. Secretaría de Educación Pública.
Patricia Gamboa Collection, Mexico City

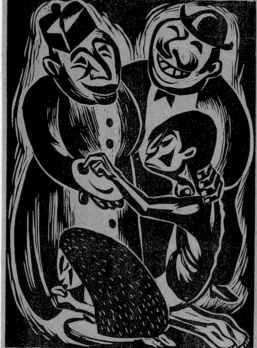

Camarada Trabajador:

antes de oír las opiniones contrarias a la educación socialista, mira cómo te explota el clero en alianza con el capitalismo.

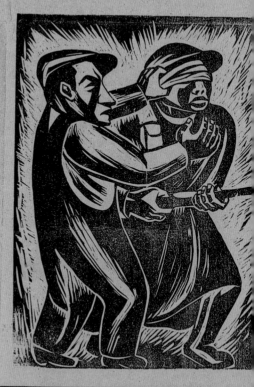

La educación socialista quiere hacer de la escuela la aliada de las cooperativas, del sindicato, de las comunidades agrarias. Trabajador, ¡defiéndela; es tu escuela!

• Colaboran: Federación de Escritores y Artistas P

de la Secretaría de Educación Pública

Las luchas entre obreros
perjudican a su clase
y favorecen los vicios
de los explotadores.

Maestra—
dijo el indio de cara pensativa,
rugosa por los vientos,
arada por el sol.
—Dime por qué nosotros somos pobres
y los dueños de la hacienda no lo son.

—No me digas que ha sido su trabajo,
que mi vida no puede rendir más.
Mi padre se ha muerto de cansancio,
y mis pequeños se fatigan ya,
mientras el patrón ocioso
acrecienta un capital.

No me digas, tampoco, que las letras.
Porque soy ignorante, pobre peón!
tú las sabes, maestra,
y sin embargo, eres tan pobre como yo.

El cura para mí no tiene crédito
cuando predica resignación
y venturas en un cielo lejano
y obediencia al patrón.

—Dime por qué nosotros somos pobres.
Por qué si siembra el trigo
se muere de hambre el peón!

maría luisa vera

arios, Alianza de Trabajadores de Artes Plásticas

Imprenta Mundial-Miravalle, 13

which we could certainly add the introduction of transnational intellectual networks, defined as "associative formations used by intellectuals at times when state institutions were weak and it was possible to act parallel to, or outside of, institutions through journals, following a logic of connections in groups of esthetic or political affinity" (Pita González, 2016, 11). Similarly, the continent wished to reassert its national identities and felt the obligation to set itself apart from the neighboring north, therefore the very artists and intellectuals added their critical voices to those raised against North American imperialism.

This map of transnational networks contains common elements that ran parallel to this search of identity—in all its rhetorical complexity—and a visual repertoire that was related to the political commitment derived from socialism, communism, and anarchism. Latin American books and reviews played a key role in disseminating the artistic proposals of Modernism, not only because of their contents but also because of the sort of images they used to illustrate the political events of the period.

Cover by David Alfaro Siqueiros for *Aportación*, year I, no. 1, June 1933. Montevideo, n. p.
34 x 24 cm.
Boglione Torello Collection

At this time, Argentina and Mexico were making substantial contributions to the imaginary of the modern Latin American left. These two countries conceived a collective identity that was reflected in the working classes and inspired different representations of the demonstrations organized and of their social situation.

Graphic modernity, particularly typography and images, succeeded in adapting other styles such as classicism, Art Deco, and *fin-de-siècle* Symbolism, the same styles that coexisted with several international codes and signs used repeatedly on book and magazine covers. The raised fist, for instance, belligerent gesture *par excellence*, was intended to express resistance, struggle, and solidarity; besides motivating workers' adhesion to the cause, it was used to enhance *rebellious* poetry, such as that of *Plebe* (1925), by Germán List Arzubide, illustrated by Ramón Alva de la Canal (see p. 500).

The publications launched by the united workers' fronts were extremely important. This type of printed matter responded to the collectivization of artistic practice and generated huge interest in political communicability and efficiency (Reyes Palma, 1994, 5). The connection between intellectuals and artists—who shared the same transnational networks—introduced "shared forms of creation" that coincided with a generalized feeling toward capitalism and its future, the latent economic crisis, and the rise of European totalitarianism and militarism (Reyes Palma, 1994, 5).

The visual resources in these illustrated books all sought to arouse the sympathy and adhesion of their recipients. Many books were clearly didactic, and endeavored to be direct, both in writing and in images, while others were intended as politically combative pamphlets and coexisted with novels, stories, and poems. The most prevalent style was Realism, although in some cases artists resorted to the techniques of collage and photomontage.

The urban working classes were the central feature of these publications. From Mexico City, Havana and Lima, to Montevideo, Rio de Janeiro, Santiago de Chile and Buenos Aires, organized work forces became the *masses* peopling cities. Neither chaotic nor irrational, most of the portrayals in these publications were orderly and more often than not followed a strong and charismatic political leader. The urban settings are paradoxical, as they are emblems of modernity and progress, yet they are also spaces rife with marginalization and poverty.

It is important to point out that several of these editions, however, weren't meant to be militant. Quite the contrary, many books and reviews were deliberately cosmopolitan; lacking a political stance, their purpose was purely esthetic. Artists and intellectuals strove to be avant-garde and original while opposing established canons, although they were never out of touch with the international political situation.

These Latin American publications of the 1920s and 1930s coincided in the widespread use of woodcuts on covers and in inner pages. Such prints had an inherent popular quality and denoted an intentional use of *naïveté* and primitivism. Xylography was the ideal technique for printed matter during this period, "as [artists] found its characteristics most suitable for the popular expression they sought: compositional synthesis, linear expressiveness, a small format, and the possibility of obtaining reproductions by the thousand" (Rodríguez Mortellaro, 2007).

* * * * *

The wide range of visual styles, themes, motifs, and symbols in Latin American periodical publications coincided with a phase of complete cultural and artistic renovation and modernization. It is therefore important to stress the fact that our countries learned to combine nationalist strains and interpretations

Cover by Julio de la Fuente for *Revolución (Poema)*, Xalapa. Integrales, 1934.
19.5 × 14.5 cm.
Ramón Reverté Collection, Mexico City

Cover by José Chávez Morado for José Muñoz Cota and María Luisa Vera, *Barricada. Poema*, 2nd edition, Mexico City. Federation of Proletarian Writers, 1934.
Ramón Reverté Collection, Mexico City

Cover by José Mendarozqueta for Carlos Gutiérrez Cruz, *Dice el pueblo. Versos revolucionarios*, Mexico City. Ediciones del Ateneo de México, 1936.
Ramón Reverté Collection, Mexico City

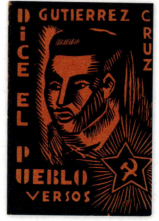

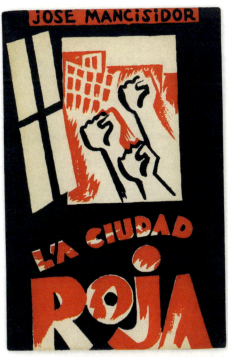
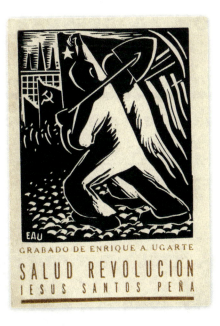
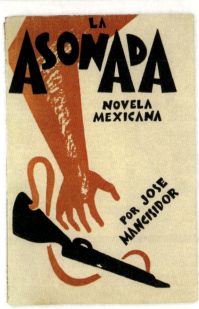

Cover attributed to Leopoldo Méndez for José Mancisidor, *La ciudad roja: novela proletraria*, Xalapa. Integrales, 1932. 19 x 13 cm. Archivo Lafuente

Cover by Enrique A. Ugarte for Jesús Santos Peña, *Salud. Revolución*, Mexico City. n. p., n. d. [c. 1939?]. Ramón Reverté Collection, Mexico City

Cover attributed to Leopoldo Méndez for José Mancisidor, *La asonada: novela mexicana*, Xalapa. Integrales, 1931. 1.7 x 12.8 cm. Archivo Lafuente

UNIDAD
POR LA DEFENSA DE LA CULTURA

ORGANO DE LA AGRUPACION DE INTELECTUALES, ARTISTAS, PERIODISTAS Y ESCRITORES (AIAPE)

La Enseñanza Religiosa en las Escuelas

Desde la penumbra y a través de caminos oblicuos, el Presidente del Consejo Nacional de Educación, ingeniero Pico, ha implantado la enseñanza religiosa en las escuelas.

El propósito maligno, acariciado desde hacía tanto tiempo por el sector más tenebroso de las derechas, se ha cumplido ahora subrepticiamente a propósito de una modificación en los programas que nada tiene que ver ni con los dogmas religiosos ni con los dogmas de moral.

En ausencia de uno de los miembros del Consejo, contra el voto terminante del vocal señor Rezzano, a espaldas del magisterio que no ha sido consultado, el señor Pico ha declarado en el lenguaje intruso de las sacristías — la urgencia de inculcar a los niños de los tres primeros grados, "narraciones y cuentos edificantes que pongan de manifiesto la existencia de un ser Supremo" y a los niños de los últimos tres grados, "la enseñanza con carácter preceptivo de los deberes para con los hombres, para con la familia y para con Dios".

Ex-Ministro de la Nación durante la dictadura del General Uriburu, colaborador y cómplice, por lo tanto, del más grave atropello reaccionario que se haya realizado en los últimos años contra la organización democrática y el pasado liberal de la Argentina, el ingeniero Pico no ha perdido oportunidad, desde su Presidencia del Consejo Nacional de Educación, para llevar a la práctica el vasto plan regresivo de enseñanza que la dictadura de Uriburu no tuvo tiempo de imponer más que en la universidad.

Está en la memoria de todos el sabotaje que el señor Pico organizó con motivo del cincuentenario de la enseñanza laica; nadie habrá olvidado tampoco la ingerencia desfachatada que permitió al clero católico en las escuelas del Estado a propósito, primero, del aniversario de Don Bosco; a propósito, después, de la realización en Buenos Aires del Congreso Eucarístico Internacional. Ingerencia católica tan auspiciada a todas luces por las altas autoridades de la enseñanza, que se le allanó el camino en cada caso, con amenazas a penas encubiertas para los indiferentes: con represión directa contra los disconformes. Mientras por un lado, el señor Pico hacía distribuir copiosas circulares prohibiendo en las escuelas la "propaganda comunista" — como se ha dado en llamar ahora a todas las formas del pensamiento libre — por el otro llegaba hasta la monstruosidad de prohibir en las escuelas la enseñanza de las doctrinas de Darwin y Ameghino.... Con fecha 30 de Junio de 1934, un inspector técnico notoriamente vinculado al Sr. Pico, consideró "conveniente resolver" que en el capítulo relativo a la zoología, de sexto grado, "sea suprimida la observación agregada al asunto cuatro vértebras, que dice así: 'en este asunto el maestro aprovechará para dar una ligera idea sobre el origen del hombre, y teorías de Darwin y Ameghino'".

Desde la interpretaciones en la Cámara y las denuncias en la prensa libre: el señor Pico ha seguido volteando uno por uno los pilares de la enseñanza laica, entre las plegarias y los aplausos de la misma oligarquía que en otros sectores de la vida argentina hipoteca al extranjero la riqueza nacional, viola las urnas de las elecciones, tortura y encarcela a los obreros, expulsa y persigue a los mejores estudiantes, asesina por la espalda a Bordabehere en el mismo recinto del Senado.

En el informe de la Inspección General se deja constancia de que "el propósito de someter a la consideración de un grupo de maestros los programas preparados, con el fin de que formularan las objeciones que estimaran convenientes, no será factible". El Consejo Nacional de Educación reconoce así, de manera indirecta, que no ignora la verdadera opinión del magisterio, y que precisamente por saber que vendría de allí el repudio más rotundo, se apresura a imponer por senderos tortuosos las "narraciones edificantes". Desautorizado en repetidas ocasiones por la totalidad de los maestros, cuyos últimos Congresos indican bien a las claras sus firmes decisiones, el señor Pico se ha propuesto sorprender a la opinión pública con el viejo sistema del "hecho consumado". Así también por sorpresa y en las sombras el señor Mantovani aderezó su "Ser Supremo" para introducirlo de rondón en la enseñanza secundaria. Bajo la forma de "Moyse y religiones", ya está incorporado en los estudios plásticos. Y fuerza es reconocer que desde las reformas de Pico y Mantovani — Arcades ambos — hasta el estatuto Nazar Cantex, se puede ir subiendo grado por grado en una continua y sistemática agresión a la cultura.

Los Maestros de las escuelas primarias, puestos de lado por el señor Presidente del Consejo, ofendidos hoy una vez más por una reforma que significa una inicua violación a lo más vivo de las tradiciones argentinas — desde Moreno y Rivadavia a Sarmiento y Mitre — deben hacer escuchar valientemente la opinión que no fué "factible" que expusieran por las vías oficiales. Estamos con ellos, los escritores y los artistas, los periodistas y los intelectuales — todos en fin los que sabemos que pasamos por horas de responsabilidad gravísima y que es necesario por lo mismo librar batalla a la reacción en todos los sectores, para desenmascararla primero, y aplastarla después.

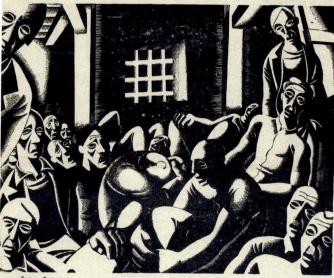

Cuatro x Cuatro — Dibujo de Guevara

Abril de 1936
Año I - Número 3
Moreno 1139
Buenos Aires

COLABORAN EN ESTE NUMERO PORTUGAL • SALCEDA • LACERDA • ORZABAL QUINTANA • CREYDT • PETER • ZORRILLA • CORDOVA ITURBURU • GONZALEZ CARBALHO • FAUSTINO JORGE • RODRIGUEZ ZELADA • VARELA • NYDIA LAMARQUE • HOJVAT • CUNEO • LONGUET • DEODORO ROCA • GONZALEZ TUÑON • LAS ILUSTRACIONES SON DE GUEVARA • CLEMENT MOREAU • REBUFFO • FALCINI • MARRE • BERNI • LAZANSKI • BARRAGAN • MARIA CARMEN • CASTAGNINO Y AIDA WAISMAN.

20 CENTAVOS

Illustration by Rosa Acle for *A. I. P. E. por la defensa de la cultura*, year II, no. 16, June 1938. Staff writer: Roberto Ibáñez, Montevideo, n. p. 39.3 x 29.8 cm.
Boglione Torello Collection

←
Illustration by Andrés Guevara for *Unidad por la defensa de la cultura*, year I, no. 3, April 1936. Buenos Aires, Agrupación de Intelectuales, Artistas, Periodistas y Escritores. 38 x 28 cm.
Private collection

of avant-garde isms with other elements, thus transforming them in keeping with their own ideological, cultural, and political contexts.

From their trenches, most artists and intellectuals were drawn to the revolutionary cause promoted by the Soviet Union at the time. Transferred to the American continent, to a certain extent Mexico conformed to this model given that a new culture was emerging from the country's own popular revolutionary movement. It is not surprising that, once the new post-revolutionary regime was established in the early 1920s, Mexico should have been an inspiration for other Latin American nations.

So, Mexican periodical publications were produced by official organizations as well as by independent agents. Books, magazines, brochures, and pamphlets chose typography in red and black inks, and prints. Official publications such as *El Sembrador* (Organ of the Secretariat of Public Education, 1929) resorted to the lay martyrology of peasants, not devoid of a certain violence, while other artists, like Fermín Revueltas, preferred monochrome vignettes in his portrayals of modern factory landscapes (*Crisol. Revista de crítica*, 1930). Both examples depict a dawn that appears to herald a new future.

In its early days, *El Machete*, that defined itself as a workers' and peasants' newspaper, was the mouthpiece of the Union of Workers, Technicians, Painters and Sculptors (SOTPE, for its initials in Spanish), although it would later become the voice of the Mexican Communist Party. Its images—woodcuts and caricatures—reveal an admiration for Soviet graphic design, in which urban subject matter coexisted with satirical representations against the Catholic church and the bourgeoisie. Anti-clericalism, that emerged around the same time as socialist education, became a leitmotif throughout Mexican graphic art, as to a certain extent it legitimized the power of the regime and destroyed previous forms of social organization. However, Jacobin and radical images would gradually be made official and would even be appropriated by the Mexican State.

El Machete inspired other collective actions that, in turn, developed into resistance groups that followed the guidelines of the Mexican left and the broad fronts that sought "the reconciliation of all potentially anti-Fascist sectors, including those derived from the bourgeoisie" (Reyes Palma, 1994, 9). Under this aegis, journals like *Noviembre*, *Martillo*, *Golpe* and *Ruta* were founded, the latter in Veracruz (see Garay Molina, 2013).

Like Mexico, Argentina and Brazil boasted a wide repertoire of political images that often resorted to religious iconography. The cover of *Cristo el anarquista* (c. 1936), by Aníbal Vaz de Mello, was illustrated by Abraham Vigo and features a figure of Christ with a red mantle blowing in the wind, observing the city of Buenos Aires in all its splendor. Lit up like a symbol of the modern age, the cover sums up very well the reversal of political identities.

The urban imaginary was all-pervasive in Argentine socialist publications. Among these, the long-standing magazine *Claridad* (1926-1941) and the books released by the publishing house of the same name established a frame of reference as notable as it was constant. Featuring once again the figure of the worker in the center, industrialization is paradoxical, for it becomes a job and a means of survival and yet it comes into conflict with individual rights. Books like *Los charcos rojos* (1927), by Bernardo González Arrili, illustrated by Rafael de Lamo (see p. 150), or *Mortalidad infantil y natalidad* (1935), by Jorge F. Nicolai, illustrated by José Planas Casas (see p. 156), directly address workers. The works by the artist Juan Antonio Ballester Peña (Ret Sellawaj) also reveal the dichotomy of individuals in cities. In the etching printed in the supplement titled *La protesta* (1928), the anonymous mass seems

Illustration by Carlos Hermosilla for *Sobre la marcha. Cartel mural de cultura para las masas*, July 1938. Editor: Blanca Luz Brum, Santiago de Chile, n. p. 76.8 x 50 cm. Santiago Vitureira Collection
Photo: Marcel Loustau

Illustration by Carlos Hermosilla for *Sobre la marcha. Cartel mural de cultura para las masas* (verso), July 1938.
Editor: Blanca Luz Brum, Santiago de Chile, n. p.
76.8 × 50 cm.
Santiago Vitureira Collection
Photo: Marcel Loustau

to march in step and in silence, amidst great architectural structures.

The theme of the global, utopian city was also frequently depicted on the covers of Brazilian books, as in *A fabrica do novo homem* (1937), by Alia Rachmanova, illustrated by Nelson Boeira Faedrich (see p. 245). In the image, a family contemplates huge smoking chimneys and functionalist architectural structures; both are international symbols of the future and progress. Metropoli like Rio de Janeiro, Buenos Aires or Mexico City were all similarly characterized by the transformation of the architectural landscape, thereby fostering the ideal conditions for the emergence of a new society with all its inequalities.

Some artists turned to modern photomechanical techniques such as photomontage, collage, and so-called "controlled accidents," while others preferred to continue to produce woodcuts. One constant factor is the use of red and black inks that are further emphasized by typography and its juxtaposition with images. The prints *Historia de arrabal* (1922) and *Los pobres. Cuentos* (1925) by Argentine artists Adolfo Bellocq and José Arato, respectively (see p. 112), are visual descriptions of the social situation, dramatically heightened by the lines engraved with a burin and gouge. Some publications adapted their translations for new readers. Such was the case of *Alemania atrasa el reloj* (1933) by Edgar Ansel Mowrer, translated by Jack Sarto and illustrated by an unknown artist (see p. 153), who depicted a worker hanging from a huge swastika, an obvious symbol of martyrology that condemned working conditions and endorsed the struggle against reactionary forces. In its turn, the cover of *Camisas negras. Estudio crítico histórico del origen y evolución del fascismo, sus hechos y sus ideas* (1934), by Luce Fabbri (see p. 152), with its peculiar perspective by Pompeyo Audivert, anticipated the fruitful exchange between the Argentine engraver and the Taller de Gráfica Popular (Workshop of Popular Graphics) founded in 1937 in Mexico (see Gené, 2006).

Other covers, such as *Reconstrucción social* (1933), by Ascanio Marzocchi Paz, or *El arte y las masas* (1935), by Abraham Vigo, are characterized by a profusion of red flags, working masses in an ideal city, the worker-martyr binomial, aspects of an imaginary that coexisted with those in the publications and posters about the Spanish Civil War. We should not forget that many of these works were financed by groups of intellectuals, journalists, and writers; solidarity and broad fronts in defense of the arts was a common motivation.

In the case of Peru, mention must be made of the review titled *Apra*, published in Lima. *Apra* was the organ of the Frente Único de Trabajadores Manuales e Intelectuales (Single Front of Manual Workers and Intellectuals) union of the 1930s, and its prints resembled those reproduced in *El Machete*, particularly the "global landscape" linked to Soviet propaganda and chiefly inspired by political and industrial utopias. The notion of world sovereignty formed a part of the ideological debate that was also present in these publications.

Along these lines, we must mention the great impulse that the Peruvian artist José Carlos Mariástegui gave to a special network of magazines and newspapers that became an important political, artistic, and literary catalyst in the 1920s and 1930s in Peru. Transnational connections were consolidated, as proven by the fact that Mexican artists like Gabriel Fernández Ledesma would contribute to *Apra* journal (November 1930). Fernández Ledesma produced an etching for a cover that bore the title "Latinoamericanos: conquistad vuestra paz" (Latin Americans: Conquer Your Peace), and portrayed a character halfway between a worker and a guerrilla fighter carrying a flag that featured the map of Latin America in the center, together with buildings, cannons, bags of money, and the word

Illustration by Ret Sellawaj (artist's name of Juan Antonio Ballester Peña) for *La Protesta: suplemento quincenal*, year IV, no. 287, 30 June 1928. Buenos Aires, La Protesta. 28.6 x 19.8 cm. Private collection, Granada

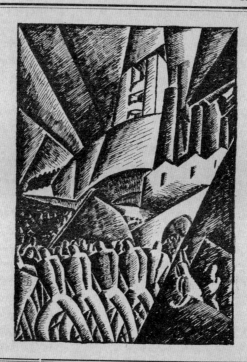

POLITICAL AND SOCIAL GRAPHICS 783

Cover by Diego Rivera for Sangre roja. Versos libertarios por Gutiérrez Cruz, Mexico City. Ediciones de la Liga de Escritores Revolucionarios, 1924.
16 x 12 cm.
Ramón Reverté Collection, Mexico City

Cover by Medo (brush name of Mariano Medina Febres) for Héctor Guillermo Villalobos, Afluencia, Caracas. Federation of Venezuelan Students, 1937.
23.3 x 16.5 cm.
Archivo Lafuente

Cover by Julio César Vergottini for Guarania, year I, no. 4, 20 February 1934. Editor: Juan Natalicio González, Buenos Aires.
n. p. 28.8 x 19.3 cm.
National Library of Paraguay, Asunción

Cover by Ramón Alva de la Canal for *Horizonte: revista mensual de actividad contemporánea*, year I, no. 2, May 1926. Xalapa, n. p.
29 × 21.5 cm.
Jesse Lerner Collection

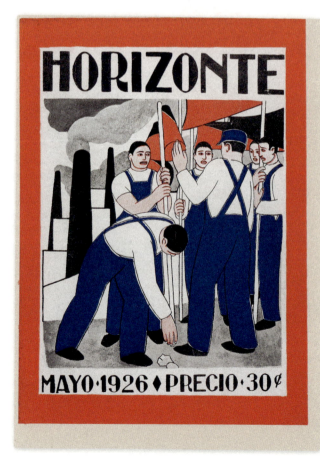

"imperialism", proving the work to be a call to defend sovereignty.

In another issue of the same publication, the typography—a combination of Art Deco and Neo-Indigenist—forms a frame around an Indian who is apparently letting out a cry of war (1932, an illustration by Alejandro González Trujillo, "Apu-Rimak"). Apu-Rimak's illustration in a subsequent book, *La vida sexual del indígena peruano* (1942), by Víctor L. Villavicencio, reveals the desire to integrate the Indian into the artistic and social reformist discourse.

The cover of the book *Defensa del Perú contra la Peruvian* (1932), by Raúl Vizcarra (see p. 553), is an obvious criticism of the economic and expansionist power of American companies. Resorting once again to the strength and the power of the image, the artist shows us a huge, even monumental arm that reads "imperialism" and takes control of a moving train. In one part of the drawing we discover electric cables and a llama contemplating the scene. The mountain range and vernacular architecture that can be made out in the distance testify to the violent

act of capturing the train. Once again, the iconographic resource evinces the defense of Latin American sovereignty.

It is a well-known fact that in the early 1930s, David Alfaro Siqueiros was in Montevideo and Buenos Aires, painting a mural and carrying out political work. Siqueiros's travels through the south were sponsored by left-wing militants, i.e. the Confederation of Intellectual Workers of Uruguay, and in the lectures, discourses, and meetings, he left his mark among his contemporaries regarding the role of artists as committee political actors. Precisely, the publication *Aportación* (1933) described murals and reproduced a number of prints related to prison life.

Other countries like Chile or Cuba also proved the existence of transnational relations of intellectuals and artists through their publications. The book by Ilya Ehrenburg titled *El pan nuestro* (1933), illustrated by the Chilean artist Arturo Adriasola, presents a rhetorical combination with Catholic tradition, and a vision of the globe as an utter bourgeois fantasy.

* * * * *

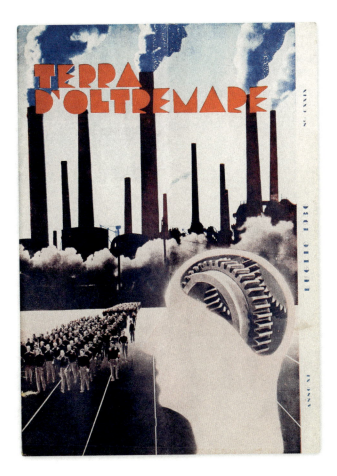

Cover by unknown artist for *Terra d'Oltremare*, year XI, no. cxxix, July 1936. Editor: Aldo Guido Gremigni, Buenos Aires. n. p. 31.5 x 23.2 cm. Private collection, Granada

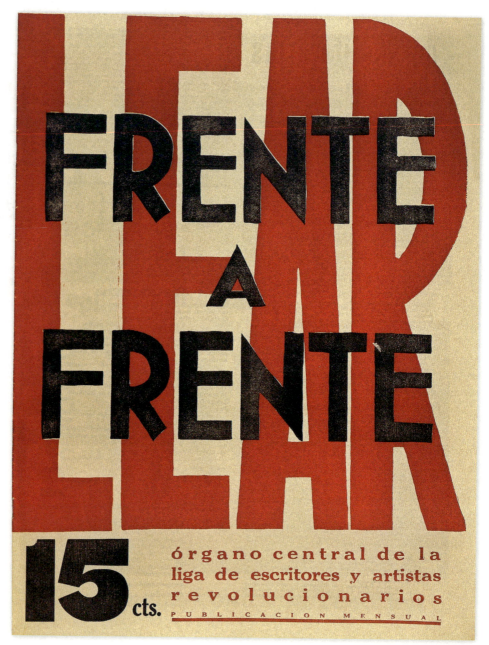

Frente a Frente: órgano central de la Liga de Escritores y Artistas Revolucionarios, no. 1, 2nd period, March 1936. Mexico City, n. p. 33 x 23 cm. Patricia Gamboa Collection, Mexico City.

The editorial design of these covers included a range of graphic resources: offset, photogravure, contrasting inks, vignettes, and a few ornamental features. The unfolded covers contained geometric elements that, furthermore, helped simplify certain visual devices to concentrate on the central topic, be it the struggle, labor, freedom, or dissidence. In short, the cardinal rule was that the illustration always had to serve the text. In the flyers, easy to reproduce, grounds were outlined in order to highlight contents, and staircases created visual games.

As regards the Latin American intellectual and artistic circles that to a great extent promoted these reviews, we see that they applauded the Bolshevik rhetoric that sought to establish a social order like "a game of references that, besides promoting the organization and mobilization of the masses, favored the unfolding of control mechanisms over popular groups" (Urías Horcasitas, 2005). Periodical publications and books made an important contribution to this political discourse in the service of society.

Printed matter endeavored to provide workers who were beginning their political activity with the means that would keep them informed and raise their class awareness. As a whole, these publications embraced political engagement, but also diligently sought artistic and cultural renewal. Simultaneously, events in Europe were prompting artists and members of the intelligentsia to establish new practices that would lead to a groundbreaking, politically-committed culture. Hence, the visual legacy of social and political graphics in Latin America has transcended to our days and, without a shadow of doubt, has acquired renewed relevance.

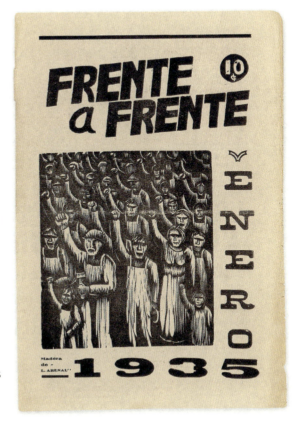

Illustration by Luis Arenal for *Frente a Frente*, no. 2, January 1935. Mexico City, n. p.
Patricia Gamboa Collection, Mexico City

→»
Illustration by Xavier Guerrero for *El Machete: periódico obrero y campesino*, no. 15, 2 - 9 October 1924. Mexico City. 57.5 x 37.5 cm.
Mercurio López Casillas Collection, Mexico City

El Machete: periódico obrero y campesino, no. 404, 1 May 1936. Editor: Hernán Laborde, Mexico City.
Mercurio López Casillas Collection, Mexico City

Aparece los Jueves — Periódico Semanario — Vale 5 centavos en la Capital y 10 en los Estados

Número 15 Responsable: XAVIER GUERRERO México, D. F., del 2 al 9 de Octubre de 1924 Registrado como artículo de 2a. clase el 12 de marzo de 1924. Redacción: Uruguay 100 Apartado 2703

El Machete sirve para cortar la caña,
para abrir las veredas en los bosques umbríos,
decapitar culebras, tronchar toda cizaña,
y humillar la soberbia de los ricos impíos.

LOS YANQUIS PRESTAN DINERO AL GOBIERNO PARA "COBRARSE A LO CHINO"

El Reciente Empréstito lo Concedieron los Financieros del Petróleo, a Cambio de la Anulación del Art. 27 Constitucional

Solamente un Gobierno Obrero y Campesino Nulificará las Deudas Contraídas por los Gobiernos Burgueses y Libertará a los Trabajadores de Toda Clase de Explotaciones

Los Explotadores de la Cía. de Luz, Fuerza y Tracción de Veracruz, Quieren Seguir Robando a sus Obreros

Estallará la huelga el día 3

Veracruz, septiembre 28.

En asamblea extraordinaria celebrada el 23 del pasado por el Sindicato Mexicano de Electricistas, División de Veracruz, acordóse declarar la huelga a la Compañía de Luz y Fuerza y Tracción de este puerto, en vista de que dicha negociación rehusó aceptar las peticiones de sus trabajadores, relativas al aumento de ocho horas de trabajo. Por lo pronto fracasaron las gestiones que se iniciaron hace días en la capital del Estado, ante el Gobernador y autoridades Municipales de la localidad, respecto al aumento de las horas de trabajo.

El día 22 fueron invitados por el Departamento del Trabajo, el señor Sedas Champión, Superintendente de Tráfico y apoderado de la Compañía de Electricistas, y los Secretarios del Sindicato de Electricistas, para tener un cambio de impresiones y buscar un medio de conciliación; pero los propósitos del jefe de dicho Departamento oficial fracasaron en virtud de que el señor Sedas Champión se presentó cuando ya los compañeros electricistas se habían retirado.

En vista de esto, los camaradas convocaron a una asamblea, en la cual se dió lectura a la contestación que la Compañía hizo a sus demandas, y que dice así:

SINDICATO DE ELECTRICISTAS — DIVISIÓN DE VERACRUZ

Recibimos al suscribir la nota de ustedes fecha 15 del actual, llamando grandemente la atención el sentido que ella contiene y más que todo, los términos y procedimientos usados, toda vez que consideran los mismos en pugna con preceptos legales de observancia y con la cortesía que debe usarse en todas ocasiones, principalmente cuando se dirige uno a la negociación a quien presta sus servicios. El perentorio plazo señalado por ustedes para recibir respuesta a su nota, por los motivos arriba expresados, no...

Pasa a la 2a. Plana

La Rusia de Hoy

artículos del delegado com...

LO QUE VERÍA CALLES EN RUSIA:

...ominio absoluto de la clase trabajadora sobre la improductiva clase de los explotadores, que desaparece rápidamente.
...greso efectivo, fraternidad, disciplina, ciencia, educación, trabajo.

¡¡Camaradas!! Preparáos a Recibir Triunfalmente al Embajador de los Obreros y Campesinos Rusos

Llegará en Noviembre

El heróico pueblo ruso nos envía un embajador. Llegará dentro de poco tiempo, probablemente antes del 7 de noviembre, fecha del 7o. aniversario de la Revolución Rusa; por lo tanto tenemos menos de un mes para prepararle al representante de los obreros y campesinos rusos, un agasajo capaz de demostrarles nuestro afecto, nuestra simpatía y gratitud por su Revolución.

La Revolución Rusa es una revolución mundial; esto es, los obreros y campesinos rusos se han sacrificado durante siete años y siguen sacrificándose aún por la clase obrera mundial. Han soportado los bloqueos, las intervenciones militares, las guerras, las contrarrevoluciones, el hambre y las privaciones más atroces durante siete años, para mantener viva la llama de la Revolución proletaria. Han dado su ayuda moral a todos los trabajadores del mundo. Cuando en octubre del año pasado se avecinaba una revolución en Alemania y se esperaba contra ella un ataque de los países capitalistas, especialmente del ejército francés de ocupación, el ejército ruso, cuyo himno nacional es "la Internacional" estaba listo para marchar en ayuda de los obreros alemanes contra los ejércitos de la burguesía. EL EJÉRCITO ROJO ES EL EJÉRCITO DEL PROLETARIADO MUNDIAL, Y LA REVOLUCIÓN RUSA ES EL PRINCIPIO DE LA REVOLUCIÓN MUNDIAL. LOS TRABAJADORES RUSOS SE HAN SACRIFICADO POR NOSOTROS Y POR TODA LA CLASE OBRERA DEL MUNDO. NOS HAN DADO Y NOS SEGUIRÁN DANDO SU AYUDA, SU SACRIFICIO, SU LUCHA Y SU TRIUNFO COMO UNA HERENCIA DE TODOS LOS EXPLOTADOS DE LA TIERRA.

¡MOSTREMOS NUESTRA GRATITUD! ¡MOSTREMOS NUESTRA SOLIDARIDAD! ¡MANIFESTÉMONOS EN PRO DE LA REVOLUCIÓN RUSA Y EN PRO DE LA REVOLUCIÓN MUNDIAL! HAGAMOS UNA MANIFESTACIÓN QUE NO TENGA PRECEDENTE EN LA HISTORIA DE LAS MANIFESTACIONES OBRERAS DE MÉXICO, SI VIENE POR VERACRUZ EL CAMARADA EMBAJADOR LOS OBREROS

(Pasa a la 2a. plana).

El Congreso Eucarístico

Reunidos en Congreso Eucarístico, los explotadores, del nombre de Cristo traman el modo de conservar los privilegios seculares de su clase, basados en la ignorancia y en la organización económica actual. ¿Cómo?

Pasa a la 4a. Plana

Bibliography

1927. *Revista de Avance*. "1927. Exposición de Arte Nuevo," year I, no. 5 (May 16, 1927): 114-115.

A Revista no Brasil. São Paulo: Editora Abril, 2000.

Adams, Beverly, and Majluf, Natalia. *The Avant-garde Networks of Amauta. Argentina, Mexico andf Peruin the 1920s*, (exh. cat.), Madrid: Museo Nacional Centro de Arte Reina Sofía, 2019.

Aguilera Álvarez, Claudio. *Antología visual del libro ilustrado en Chile*. Valparaíso: Quilombo Ediciones, 2014.

Alarcón Ibáñez, Verónica. *Cuando el libro se hace arte. Historia de un género artístico olvidado*. Valencia: Institució Alfons el Magnànim, 2009.

Albada-Jelgersma, Jill E. "La función del deseo por la mujer afroantillana en cuatro poemas de Luis Palés Matos," *Hispanic Journal*, vol. 18, no. 2 (1997): 357-372.

Alberdi Soto, Begoña. "La otra vanguardia: el expresionismo de Valparaíso en su revista *Litoral*," *Mapocho. Revista de Humanidades*, no. 71 (1st semester of 2012): 51-71.

Albiñana, Salvador, ed. *México ilustrado. Libros, revistas y carteles, 1920-1950*. 2nd edition. Mexico City: Editorial RM, 2014.

Alencar, Vera de, ed. *Castro Maya bibliófilo*. Rio de Janeiro: Nova Fronteira, 2002.

Alfaro Siqueiros, David. "Tres llamamientos de orientación actual a los pintores y escultores de la nueva generación americana," *Vida Americana. Revista Norte, Centro y Sud-América*, no. 1 (1921).

Aller, Ángel. *La pintura de Melchor Méndez Magariños*. Montevideo: Impresora Uruguaya, 1931.

Alsina Thevenet, Homero. "Del primer Onetti," *El País Cultural*, 177 (March 26, 1993): 5. http://letras-uruguay.espaciolatino.com/ (Accessed July 13, 2018)

Altolaguirre, Manuel. "Mario Carreño (1942)," *Litoral*, nos. 181-182 (1989): 215-217.

Álvarez, Lupe, ed. *Umbrales del arte en el Ecuador. Una mirada a los procesos de nuestra modernidad estética* (exh. cat.), Guayaquil: Museo Antropólogico y de Arte Contemporáneo and Banco Central del Ecuador, 2005.

Álvarez Caselli, Pedro. *Hdgch. Historia del diseño gráfico en Chile*. Santiago de Chile: Gobierno de Chile, Consejo Nacional del Libro y la Lectura, 2004.

Anales de la Escuela Nacional de Artes Gráficas. Mexico City: Escuela Nacional de Artes Gráficas, no. 1 (1966).

Andel, Jaroslav. *Avant-Garde Page Design*. New York: Delano Greenidge Editions, 2002.

Angelillo, Angelo, ed. *Historia y técnica de artes gráficas*. Rome: Centro Sociale Progetti, 1989.

Archivo Lafuente. *Vanguardia y propaganda. Libros y revistas rusos del Archivo Lafuente, 1913 – 1941* (exh. cat.), Heras and Madrid, La Bahía and La Fábrica, 2019.

Arellano, Jorge Eduardo. Preface to Pablo Antonio Cuadra, *Poesía selecta*. Caracas: Ayacucho, 1991: IX-XLIX.

Arias-Larreta, Abraham. "Realidad lírica peruana," *Revista Iberoamericana*, vol. IV, no. 7 (November 1941): 53-88.

Armas Alfonzo, Alfredo. *Diseño gráfico en Venezuela*. Caracas: Maraven, 1985.

Armstrong, Helen, ed. *Graphic Design Theory. Readings from the Field*. New York: Princeton Architectural Press, 2009.

Artundo, Patricia. *Norah Borges. Obra gráfica 1920-1930*. Buenos Aires: Fondo Nacional de las Artes, 1993.

— ed. *Arte en revista. Publicaciones culturales en la Argentina 1900-1950*. Rosario: Beatriz Viterbo Editora, 2008.

— "Modernidad y vanguardia en la década del veinte," *Pintura argentina. Panorama del periodo 1810-2000. Volumen dedicado a las primeras vanguardias*. Buenos Aires: Banco Vélox, 2011.

— *Emilio Pettoruti y Enrique E. García. Deriva de una amistad*. Buenos Aires: Fundación Pettoruti, 2018.

Aznar Soler, Manuel, ed. *Escritores, editoriales y revistas del exilio republicano de 1939*. Seville: Editorial Renacimiento, Universitat Autònoma de Barcelona, Grupo de Estudios del Exilio Literario, 4 vols., 2006-2017.

Baciu, Stefan. *Surrealismo latinoamericano. Preguntas y respuestas*. Valparaíso: Cruz del Sur, Ediciones Universitarias de Valparaíso, 1979.

Banham, Reyner. *Theory and Design in the First Machine Age*. 2nd edition. Cambridge: MIT Press, 1980.

Bardi, Pietro Maria. *O Modernismo no Brasil*. São Paulo: Sudameris, 1978.

— ed. *História da tipografia no Brasil* (exh. cat.), São Paulo: Museu de Arte de São Paulo, 1979.

Barón Biza, Raúl. *El derecho de matar*. Buenos Aires: Establecimiento Gráfico Argentino, 1933.

Barreto, Meykén; Sedano, Verónica. "El primer proyecto oficial de pintura mural en Cuba," *Crónicas*, no. 7 (2010): 19-30.

Barsante, Cássio Emmanuel. *Santa Rosa em cena*. Rio de Janeiro: Instituto Nacional de Artes Esénicas, 1982.

— *A vida ilustrada de Tomás Santa Rosa*. Rio de Janeiro: Fundação Banco do Brasil / Bookmakers, 1993.

Bartram, Alan. *Futurist Typography and the Liberated Text*. London: The British Library, 2005.

Battegazzore, Miguel. *Joaquín Torres-García: la trama y los signos*. Montevideo: Impresora Gordon, 1999.

Baur, Sergio, ed. *El periódico Martín Fierro en las artes y en las letras, 1924-1927* (exh. cat.), Buenos Aires: Museo Nacional de Bellas Artes, 2010.

— ed. *Vanguardias literarias argentinas. 1920-1940*. Buenos Aires: Ministerio de Relaciones Exteriores, Comercio Internacional y Culto, 2010.

— ed. *Claridad. La vanguardia en lucha* (exh. cat.). Buenos Aires: Museo Nacional de Bellas Artes, 2012.

— and Juan Manuel Bonet, eds. *Literatura argentina de vanguardia, 1920-1940*. Madrid: Casa de América, 2001.

Bedoya, María Elena. "Entre salones, agrupaciones y prensa: el desarrollo del humor gráfico en el Ecuador entre 1915-1940." In Bonilla, Xavier (Bonil). *Historia del humor gráfico en Ecuador*. Lleida: Editorial Milenio, 2007: 43-61.

— *Los espacios perturbadores del humor. Revistas, arte y caricatura 1918-1930* (exh. cat.). Quito: Banco Central del Ecuador, 2007b.: 20.

Beltrán Peña, José. *Poesía concreta del Perú. Vanguardia plena. Estudio y antología*. Lima: San Marcos, 1998.

Beretta Curi, Alcides and Ana García Etcheverry. *Los trazos de Mercurio. Afiches publicitarios en Uruguay (1875-1930)*. Montevideo: Santillana, 1998.

Berghaus, Günter, ed. *Handbook of International Futurism*. Berlin: De Gruyter, 2019.

Bermúdez, Jorge R. *Massaguer. República y vanguardia*. Havana: Ediciones La Memoria/Centro Cultural Pablo de la Torriente Brau, 2011.

Blackwell, Lewis. *20th-Century Type*. London: Laurence King Publishing, 1998.

Blaisten, Andrés. *Dr. Atl. Obras Maestras / Masterpieces*. Mexico City: Universidad Nacional Autónoma de México - Turner, 2012.

Blaisten, Renata. *Francisco Díaz de León*. Mexico City: Editorial RM / Museo Colección Blastein / Centro Cultural Universitario Tlatelolco Universidad Nacional Autónoma de México, 2011.

Blanco Ávila, Francisco Pascasio. "El negro que mejor pintó el solar cubano," *¡Ay, vecino!* (blog), 2010. ay-vecino.blogspot.com (Accessed April 15, 2018)

Boglione, Riccardo. "Poesía visual uruguaya, todavía: addenda," *La pupila*, no. 12 (2010): 10-13.

— "Apto para vanguardia: contexto, pretexto y texto de *Aliverti liquida*," *Troupe Ateniense. Aliverti liquida. Apto para señoritas*. Facsimile edition. Montevideo: Yaugurú-Irrupciones, 2012: 121-160.

— *Vibración gráfica. Tipografía de vanguardia en Uruguay (1923-1936)* (exh. cat.), Montevideo: Museo Nacional de Artes Visuales, 2013.

— "Figuras letradas. Lo verbovisual uruguayo en el siglo XIX," *La pupila*, no. 34 (2015): 19-23.

— "Reto al libro: las estrategias editoriales de Roberto de las Carreras," *La pupila*, no. 41 (February 2017a): 18-21.

— ed. *Vanguardia. Revista de avance*. Facsimile edition. Seville, Ulises, 2017.

— "Artistas de tapa. Gráfica de pintores y escultores uruguayos (1910-1932)," *Número*, 7 (December 2019a): 26-35.

— "Déco de acá: el arte gráfico de Luis Totasaus," *Almanaque del Banco de Seguro del Estado 2020*. Montevideo: Banco de Seguro del Estado (2019b): 148-153.

— and Georgina Torello, eds. *Poesie che sanno di nafta. Antologia della poesia futurista uruguaiana (1909-1932)*. Foggia: Sentieri Meridiani, 2014.

Bohn, Willard. *The Aesthetics of Visual Poetry, 1914-1928*. Cambridge: Cambridge University Press, 1986.

Bonet, Juan Manuel. *Diccionario de las vanguardias de España*. Madrid: Alianza Editorial, 2007.

— *Impresos de vanguardia en España, 1912-1936*. Valencia: Campgràfic, 2009. (Bonet, 2009a)

— "A 'Quest' for Tarsila," in *Tarsila do Amaral* (exh. cat.), Madrid: Fundación Juan March, 2009b, 67-91.

— *Impresos de vanguardia en España, 1912-1936*. Valencia: Campgràfic, 2010.

— "Papeles vanguardistas mexicanos: algunas pistas." In *México ilustrado. Libros, revistas y carteles, 1920-1950*, edited by Salvador Albiñana, 29-38. 1st edition. Mexico City: Editorial RM, 2010b.

— ed. *Las cosas se han roto. Antología de la poesía ultraísta*. Seville: Fundación Juan Manuel Lara, 2012.

— and Carlos Pérez. eds. *El ultraísmo y las artes plásticas* (exh. cat.). Valencia: Institut Valencià d'Art Modern, 1996.

— and Juan Bonilla. *Tierra negra con alas. Antología de la poesía vanguardista latinoamericana*. Seville: Fundación José Manuel Lara, 2019.

Bonilla, Juan. "Run-run chileno," *Unir* (May 9, 2013).

— *La novela del buscador de libros*. Seville: Fundación José Manuel Lara, 2018.

Bopp, Raúl. *Movimentos modernistas no Brasil, 1922-1928*. Rio de Janeiro: Livraria São José, 1966.

Boulton, Alfredo. "El Círculo de Bellas Artes." In Calzadilla, Juan and Esmeralda Niño Araque (eds.): El Círculo de Bellas Artes a cien años de su creación (1912-2012). Caracas: Galería de Arte Nacional, 2012: 41-48.

Bruna Pouchucq, Felipe Antonio. *Retrospectiva visual del Centenario de Chile. Tomo II. La editorial y las artes gráficas. Revistas y publicaciones*. Santiago de Chile: Pehuén Editores, 2010.

Brusiloff, Pedro et al. *Alberto de Villegas: estudios y antología*. La Paz: Universidad Mayor de San Andrés / Plural, 2013.

Bueno, Luís. *Capas de Santa Rosa*. Cotia and São Paulo: Ateliê Editorial and Edições SESC, 2015.

Bueno, Raúl. "La máquina como metáfora de modernización en la vanguardia latinoamericana," *Revista de Crítica Literaria Latinoamericana*, year XXIV, no. 48 (2nd semester 1998): 25-37.

Bury, Stephen. *Breaking the Rules. The Printed Face of the European Avant-Garde 1900-1937*. London: The British Library, 2007.

Cabrera Galán, Mireya. "Juan Manuel Acosta en *Social*," *Revolución y cultura*, no. 1 (2017): 46-57.

— *Juan Manuel Acosta y el arte moderno en Cuba*. Holguín: Editorial La Mezquita, 2019.

Caetano, Gerardo. Preface to Caetano, Gerardo, ed. *Los uruguayos del Centenario. Nación, ciudadanía y religión y educación (1910-1930)*. Montevideo: Taurus, 2001, 9-15.

Calzadilla, Juan. *Compendio visual de las artes plásticas en Venezuela*. Caracas: MICA Ediciones de Arte, 1982.

Camargo, Mário de, ed. *Gráfica. Arte e indústria no Brasil. 180 anos de história*. 2nd ed. São Paulo: Bandeirante Editora, 2003.

Canseco-Jerez, Alejandro. *La vanguardia chilena*. Santiago-París. Paris: Self-edition / ACJB Editions, 2001.

Cañas Dinarte, Carlos. "Un pintor llamado Salarrué," elsalvador.com (November 16, 2018) https://www.elsalvador.com (Accessed February 18, 2019)

Capote, María. *Agustín Acosta: el modernista y su isla*. Miami: Editorial Universal, 1990.

Cardoso, Rafael, ed. *O design brasileiro antes do design. Aspectos da história gráfica, 1870-1960*. São Paulo: Cosac Naify, 2005.

— ed. *Impresso no Brasil 1808-1930: destaques da história gráfica no acervo da Biblioteca Nacional*. Rio de Janeiro: Verso Brasil Editora, 2009.

Caricatura. Semanario humorístico de la vida nacional, vol. I (December 1918 - July 1919). Facsimile edition. Quito: Edición del Banco Central del Ecuador, 1989.

Carvalho, Bernardo. "'Mademoiselle Cinema' é best-seller moralista," *Folha de S. Paulo* (September 9, 1999).

Castedo, Leopoldo. *Historia del arte iberoamericano, 2. Siglo XIX, Siglo XX*. Madrid: Alianza Editorial, 1988.

Castillo Espinoza, Eduardo, ed. *Artesanos, artistas, artífices. La Escuela de Artes Aplicadas de la Universidad de Chile, 1928-1968*. Santiago de Chile: Ocho Libros Editores, 2010.

Castrillón-Vizcarra, Alfonso. *Tensiones generacionales*. Lima: Universidad Ricardo Palma, 2014.

Castro Riveros, Alan. "El regreso de Ramún Katari," *Página Siete* (October 31, 2015).

— "El trinar arcaico: escritura y grafía en Ramún Katari," *Ciencia y Cultura*, no. 43 (December 2019): 145-157.

Cavalcante, Sebastião Antunes. *O design de Manoel Bandeira: aspectos da memória gráfica de Pernambuco*. Master's Thesis, Universidade Federal de Pernambuco - CAC Design, 2012.

Cervantes, Freja I. and Pedro Valero, eds. *Colección Cvltvra. Selección de buenos autores antiguos y modernos*. Commemorative edition 1916-2016. Mexico City: Juan Pablos Editor and Secretaría de Cultura, 2016.

Chueca, Luis Fernando, ed. *Poesía vanguardista peruana*, vol. 1. Lima: Pontificia Universidad Católica del Perú, 2009.

Clara, Jaime. "Con Jorge Centurión (1916-2002). La pasión por perdurar," *Jaime Clara's Blog*, (April 5, 2010). http://arteycaricaturas.blogspot.com.uy/2010/04/con-jorge-centurion-1916-2002_05.html (Accessed April 16, 2018)

Cobas Amate, Roberto. *Arte cubano. La espiral ascendente*. Havana: Museo Nacional de Bellas Artes-Fundación Mariano Rodríguez, 2019.

Compton, Susan P. *The World Backwards. Russian Futurist Books, 1912-16*. London: The British Library, 1978.

Cortés Aliaga, Gloria. *Modernas. Historias de mujeres en el arte chileno, 1900-1950*. Santiago de Chile: Origo Ediciones, 2013.

Costa, María Eugenia, ed. *El arte de imprimir. Libros ilustrados y ediciones de bibliófilos*. Buenos Aires: Biblioteca Nacional Mariano Moreno, 2018.

Cruz Porchini, Dafne. "Estrellas, abrazos, auroras y puños en alto. Ilustración y política en los años treinta." In *México ilustrado. Libros revistas y carteles, 1920-1950*, edited by Salvador Albiñana. 1st edition. Mexico City: Editorial RM, 2010.

Damasem, Jacques. *Révolution typographique depuis Stéphane Mallarmé*. Geneva: Galerie Motte, 1966.

Dammert Elguera, Enrique. "Prólogo desglosable," *Biografía del joven que no vale nada*. Lima: Empresa Tipográfica Unión, 1931.

Daranyi, Georges, et al. *Lajos Kassák and the Hungarian Avant-garde* (exh. cat.), Valencia: Institut Valencià d'Art Modern, 1999.

El espíritu del motivo. Selección de obras del Museo Crespo Gastelú (exh. cat.). La Paz: Fundación Simón I. Patiño / Fundación Crespo Gastelú, 2015.

Délano, Luis Enrique. *Memorias. Sobre todo Madrid. Aprendiz de escritor*. Santiago de Chile: RIL Editores, 2004.

Díaz de León, Francisco. *Consejos para editar libros*. Mexico City: Secretaría de Educación Pública, 1960.

— "La supresión de la Escuela Nacional de Artes del Libro." In Candas Sobrino, María Covadonga. "Francisco Díaz de León, promotor de las artes gráficas." Bachelors Dissertation in Art History, Universidad Iberoamericana, 1981.

Díaz Navarrete, Wenceslao. *Bohemios en París. Epistolario de artistas chilenos en Europa, 1900-1940*. Santiago de Chile: RIL Editores, 2010.

Dieste, Eduardo. *Teseo. Los problemas del arte*. Buenos Aires: Editorial Losada S.A., 1940.

Dolinko, Silvia. "Grabados originales multiplicados en libros y revistas," Malosetti Costa, Laura and Marcela Gené, Marcela, ed. *Imagen y palabra en la historia cultural de Buenos Aires*. Buenos Aires: Edhasa, 2009.

Drucker, Johanna. *The Visible Word. Experimental Typography and Modern Art, 1909-1923*. Chicago: The University of Chicago Press, 1994.

— *The Century of Artists' Books*. New York: Granary Books, 2004.

Duis, Leonie ten, and Annelies Haase, eds. *De wereld moe(s)t anders. Grafisch ontwerpen en idealisme / The World Must Change. Graphic Design and Idealism*. Amsterdam and The Hague: Sandberg Instituut and Uitgeverij De Balie, 1999.

Duncan, Alastair. *Art Deco Complete. The Definitive Guide to the Decorative Arts of the 1920s and 1930s*. London: Thames & Hudson, 2014.

Duque López, Pedro José, ed. *Cartel ilustrado en Colombia: década 1930-1940*. Bogotá: Fundación Universidad de Bogotá Jorge Tadeo Lozano, 2009.

Echazú Conitzer, Alejandra and Rodrigo Gutiérrez Viñuales. "El manifiesto artístico de Alejandro González Trujillo *Apu-Rimak* en sus cartas a Yolanda Bedregal," *Illapa. Mana Tukukuq*, year 17, no. 17 (December 2020): 32-47.

EcuRed. "José Cecilio Hernández Cárdenas." Cubaliteraria, Instituto Cubano del Libro, n.d. www.ecured.cu, n.d. (Accessed April 15, 2018).

Eisenstein, Elizabeth L. *La révolution de l'imprimé. À l'aube de l'Europe moderne*. Paris: Hachette, 2003.

El arte del afiche (exh. cat.). Montevideo: Galería de la Matriz, 1992.

El Auto Uruguayo. "Falleció Orsini Bertani," no. 256 (1939): 11.

"El Museo de Arte Moderno Americano," *Forma. Revista de artes plásticas*. no. 3 (1927): 21-22.

Escobar, Ticio. "Postmodernismo/Precapitalismo," *Visión del arte latinoamericano en la década de 1980*. Lima: UNESCO, 1994, 51.

Escobar Calle, Miguel. "Aproximación a la obra de Pepe Mexía," Familia Mejía Arango, ed. *Pepe Mexía*, Bogotá: Banco de la República, 1987.

Escobar Mesa, Augusto. "Americanismo y modernidad en 'Mancha de aceite'," *Universitas Humanística*, no. 54 (2004): 31-41.

Escobar Vallarta, Claudia. "El libro y el pueblo: índice de artículos sobre bibliotecología y bibliografía (1922-1926, 1928-1935)." Bachelors dissertation, Library Science and Information Studies, Universidad Nacional Autónoma de México, 2007.

Espinoza O., Paula. *Editado en Chile (1889-2004)*. Valparaíso: Quilombo Ediciones, 2012.

Fabris, Annateresa, and Cacilda Teixeira da Costa, ed. *Tendências do livro de artista no Brasil* (exh. cat.). São Paulo: Centro Cultural São Paulo, 1985.

Fajardo, Juan Pablo. *Sergio Trujillo Magnenat artista gráfico, 1930-1940*. Bogotá: Banco de la República, 2013.

Fanelli, Giovanni. *Il disegno Liberty*. Bari: Laterza, 1981.

— and Ezio Grazioli. *Il futurismo e la grafica*. Milan: Edizioni di Comunità, 1988.

Fernández, Horacio. *El fotolibro latinoamericano*. Mexico City: Editorial RM, 2011.

Fernández, Jorge. *Agua: novela*. Quito: Élan, 1936.

Fernández, Justino. "Outline of Mexican Contemporary Typography," *Mexican Art & Life*, no. 7 (July 1939): n.p.

Fernández Ledesma, Enrique. *Historia crítica de la tipografía en la ciudad de México: impress del siglo XIX*. Mexico City: Universidad Nacional Autónoma de México, Instituto de Investigaciones Bibliográficas, 1991.

Fernández Retamar, Roberto. "La poesía vanguardista en Cuba." In *Los vanguardismos en América Latina*, Óscar Collazo, 211-224. Barcelona: Península, 1977.

Fernández Uribe, Carlos Arturo and Gustavo Adolfo Villegas Gómez. "En los umbrales del arte moderno colombiano: la exposición francesa de 1922 en Bogotá y Medellín," *HistoReLo. Revista de Historia Regional y Local*, vol. 9, no. 17 (2017): 86-119.

Férriz Roure, Teresa. *La edición catalana en México*. Mexico City: El Colegio de Jalisco, 1998.

Fontán del Junco, Manuel. "La vanguardia aplicada, 1890-1950 (instrucciones de uso)." In *La vanguardia aplicada, 1890-1950* (exh. cat.), Madrid: Fundación Juan March, 2012.

França, Patrícia de Souza. *"Livros para leitores": a atuação literária e editorial de Benjamim Costallat no Rio de Janeiro dos anos 1920*. Rio de Janeiro: Ministério da Cultura, Fundação Biblioteca Nacional, 2011.

Frassinelli, Carlo. *Tratado de arquitectura tipográfica*. Madrid: Aguilar, 1948.

Freeman, Judi et al. *The Dada and Surrealist Word-Image*. Cambridge and Los Angeles: MIT Press and Los Angeles County Museum of Art, 1989.

Freixes, Sergi and Jordi Garriga. *Libros Prohibidos. La vanguardia desde principios del siglo XX hasta la Guerra Civil*. Barcelona: Viena Ediciones, 2006.

Fuentes, Rodolfo. "El estructurador invisible," *Los veinte. El proyecto uruguayo. Arte y diseño de un imaginario 1910-1934* (exh. cat.), Montevideo: Museo Municipal de Bellas Artes Juan Manuel Blanes (1999): 26-29.

— *Del plomo al píxel. Una historia del diseño gráfico uruguayo*. Montevideo: La Nao Editorial, 2020.

Fuentes Pastor and André Hélard. *De artistas, dibujos y pinturas. Los apuntes publicados en el Diario Noticias de Arequipa, 1927-1964*. Arequipa: Universidad Nacional de San Agustín, 2014.

Gallo, Lylia. "Modernidad y arte en Colombia en la primera mitad del siglo XX," *Ensayos. Historia y teoría del arte*, no. 4, (1997): 10-31.

Gallo, Max. *The Poster in History*. New York: Times Mirror, 1974.

Gamoneda, Francisco. "Las artes gráficas en México; apuntes sobre su historia," *Boletín de la Biblioteca Nacional*, 2nd period, t. VI, no. 3 (July - September 1955): 3-15.

Gárate, Miriam V. *Entre a letra e a tela. Literatura, imprensa e cinema na América Latina (1896-1932)*. Rio de Janeiro: Papéis Selvagens Edições, 2017.

Garay Celeita, Alejandro. "La ciudad ilustrada. Rinaldo Scandroglio en Bogotá," *Ensayos. Historia y teoría del arte*, no. 21, (2010): 38-50.

Garay Molina, Claudia. "El grupo artístico y literario Noviembre y la revista Ruta, 1933-1938." Masters dissertation, Art History, Universidad Nacional Autónoma de México - Facultad de Filosofía y Letras, 2013.

García Montero, Carlos. *Reynaldo Luza 1893-1978*. Lima: Instituto Cultural Peruano Norteamericano, 2011.

García Rey, María del Rocío. "La presencia de Latinoamérica en las revistas *El Libro y el Pueblo* y *El Maestro*, 1921-1922." Bachelors dissertation, Latin American Studies, Universidad Nacional Autónoma de México, 2006.

García Rodríguez, Amaury A., ed. *Pasajero 21. El Japón de Tablada* (exh. cat.), Mexico City: Museo del Palacio de Bellas Artes, 2019.

Garone Gravier, Marina. "Las diferencias entre diseño como arte aplicado, como ciencia y como herramienta de comunicación."In *Antología de diseño 1*. Mexico City: Editorial Designio, 2001.

— "Breve resumen histórico y análisis de algunas definiciones de diseño," *Unidad y diversidad. Revista interdisciplinaria de divulgación*, vol. 3, no. 2 (July - December 2003). (Garone Gravier, 2003a).

— "La tipografía desde la interdisciplina. Tipografía y ergonomía (segunda parte)," *Unidad y diversidad. Revista interdisciplinaria de divulgación*, vol. 3, no. 2 (July - December 2003).

— "Cuando la portada se convirtió en escaparate: Ediciones Botas." In *México ilustrado. Libros, revistas y carteles, 1920-1950*, edited by Salvador Albiñana, 310-312. 1st edition. Mexico City: Editorial RM, 2010.

— "Diseño y tipografía que forjaron la patria." In *México ilustrado. Libros, revistas y carteles, 1920-1950*, edited by Salvador Albiñana, 55-64. 1st edition. Mexico City: RM, 2010.

— "Talleres Gráficos de la Nación: prensas para el estado y el pueblo." In *México ilustrado. Libros, revistas y carteles, 1920-1950*, edited by Salvador Albiñana, 304-305. 1st edition. Mexico City: RM, 2010.

— *Historia en cubierta. El Fondo de Cultura Económica a través de sus portadas (1934-2009)*. Mexico City: Fondo de Cultura Económica, 2011a.

— "Textos y contextos de una década de diseño gráfico en México (1990-2000)," *Ensayos. Historia y teoría del arte*, no. 21 (2011): 77-120.

— "La tipografía estridentista: diseño que huele a modernidad y a dinamismo." In *Nuevas vistas y visitas al estridentismo*, edited by Daniar Chávez and Vicente Quirarte. Toluca: Universidad Autónoma del Estado de México, 2014, 111-140.

— "Rojo: un camino del diseño a la edición." In *Vicente Rojo. Escrito Pintado* (exh. cat.), Mexico City: Museo Universitario de Arte Contemporáneo. El Colegio Nacional, 2015, 84-134.

Gené, Marcela. "Diálogos con buriles y gubias. Realismo y surrealismo en el grabado argentino." In *Territorios de diálogo. México, España y Argentina, entre los realismos y lo surreal (1930-1945)* (exh. cat.), Buenos Aires: Fundación Mundo Nuevo - Centro Cultural Recoleta, 2006, 137-143.

Gil Tovar, Francisco. *El arte colombiano*. Bogotá: Plaza & Janés, 2002.

Giroud, Vincent. *Parole in Libertà. Marinetti's Metal Book*. Berkeley: The Codex Foundation, 2012.

Godoli, Ezio (ed.). *Dizionario del Futurismo*. Florence: Valecchi, 2001.

Goic, Cedomil. *Vicente Huidobro, vida y obra. Las variedades del creacionismo*. Santiago de Chile: Lom Ediciones, 2012.

González Kreysa, Ana Mercedes. "La propuesta plástica de Max Jiménez." In *Max Jiménez: aproximaciones críticas*, edited by Álvaro Quesada Soto. San José: Editorial de la Universidad de Costa Rica, 1999, 59-107.

González Mello, Renato, and Anthony Stanton, eds. *Vanguardia en México 1915-1940* (exh. cat.), Mexico City: Museo Nacional de Arte, 2013.

González Molina, Óscar Javier. "Tradición y vanguardia en la revista *Hélice* (1926): perspectivas de un diálogo interoceánico," *Actas del II Congreso Internacional Cuestiones Críticas*, Rosario, 2013. http://www.celarg.org (Accessed July 12, 2017).

González de la Vara, Armida and Álvaro Matute. eds. *El exilio español y el mundo de los libros*. Mexico City: Universidad de Guadalajara, 2002.

Gordinho, Margarida Cintra, ed. *Gráfica: arte e indústria no Brasil, 180 anos de história*. São Paulo: Bandeirante, 1991.

Grinberg, Piedade Epstein: *Di Cavalcanti: um mestre além do cavalete*. São Paulo: Metalivros, 2005.

Grütter, Amedeo. *Origen del Graphic Design. Tradición y movimientos de vanguardia al principio del siglo xx*, 3 vols. Rome: Centro Analisi Sociale Progetti, 1989.

Guerrero, Diego. "Genio y figuras de Ricardo Rendón," *El Tiempo* (June 11, 1994).

Gutiérrez, Joaquín. Presentation by *Francisco Amighetti*. San José: Editorial de la Universidad de Costa Rica, 1989, 13-25.

Gutiérrez, Ramón and Rodrigo Gutiérrez Viñuales. "Fuentes prehispánicas para la conformación de un arte nuevo en América." In "Arte Prehispánico: creación, desarrollo y persistencia," *Temas de la Academia*, 2000.

Gutiérrez Viñuales, Rodrigo. "Presencia de España en la Argentina. Dibujo, caricatura y humorismo (1870-1930)," *Cuadernos de Arte de la Universidad de Granada*, no. 28, 1997.

— "El indigenismo y la integración de las artes en la Argentina (1910-1930)," *Actas del XIV Congreso Nacional del Comité Español de Historia del Arte*, Málaga, September 18 - 21, 2002.

— "La infancia, entre la educación y el arte. Algunas experiencias pioneras en Latinoamérica (1900-1930)," *Artigrama*, no. 17, (2003): 127-147.

— "Modernistas y simbolistas en la ilustración de libros en la Argentina (1900-1920)," *Temas de la Academia*, 2010.

— "La caricatura en la Argentina, anticipo de vanguardia," in Maradei, Hugo Oscar. coord. *Bicentenario. 200 años de humor gráfico. La Edad de Oro, 1910/1960*. Buenos Aires: Museo del Dibujo y la Ilustración, 2012.

— "Artistas gráficos en Correos y Telégrafos (1930-1956). Algunas notas." In *Arquitectura moderna y Estado en Argentina. Edificios para Correos y Telecomunicaciones (1947-1955)*, edited by Adriana Collado. Buenos Aires: Centro de Documentación de Arquitectura Latinoamericana, 2013, 117-120.

— "Bases para una comprensión del Simbolismo y Modernismo en el arte sudamericano." In *Alma Mía: Simbolismo y modernidad en Ecuador (1900-1930)*, edited by Alexandra Kennedy Troya and Rodrigo Gutiérrez Viñuales, 18-33. Quito: Museo de la Ciudad, 2013.

— "Modernidad expandida. Perú en el libro ilustrado argentino (1920-1930)," *Illapa Manu Tukukq. Revista del Instituto de Investigaciones Museológicas y Artísticas de la Universidad Ricardo Palma*, no. 10 (2013): 10-21.

— "Simbolismo y Modernismo en Sudamérica. Algunas historias reseñables (1895-1925)." In *Alma mía: Simbolismo y modernidad en Ecuador (1900-1930)*, edited by Alexandra Kennedy Troya and Rodrigo Gutiérrez Viñuales, 46-67. Quito: Museo de la Ciudad, 2013.

— *Libros argentinos. Ilustración y modernidad, 1910-1936*. Buenos Aires: Centro de Documentación de Arquitectura Latinoamericana, 2014a.

— "Modernidad rioplatense. Ilustradores de libros en Uruguay en una era de transformaciones artísticas (1920-1934)," *Temas de la Academia*, no. 11 (2014b): 72-84.

— "La vanguardia oculta. Trayectos del diseño gráfico rioplatense (1920-1935)." In *Modernidad y vanguardia: rutas de intercambio entre España y Latinoamérica (1920-1970)*, edited by Paula Barreiro López and Fabiola Martínez Rodríguez. Madrid: Museo Nacional Centro de Arte Reina Sofía (2015): 31-38.

— *Rómulo Rozo. Tallando la patria. Una colección de fotografía*. Bogotá: La Silueta, 2015b.

— *Ilustración latinoamericana (1915-1940). Libros y revistas para una modernidad propia*. Granada: Facultad de Filosofía y Letras, Universidad de Granada, 2018.

— "Del modernismo a las vanguardias. Italianos en las artes gráficas argentinas (1900-1940)." In *Studi di storia dell'arte in ricordo di Franco Sborgi*, directed by Leo Lecci and Paola Valenti. Genoa: Genova University Press (2019): 511-527.

— "Modernos y americanos. Las artes en la ruta Cuzco-Buenos Aires," *Ciencia y Cultura*, no. 43 (December 2019): 273-281.

Guzmán Vera, Ivonne Eulalia. "Alba Calderón, Germania Paz y Miño y Piedad Paredes: La pintura social como medio de acceso al campo artístico de tres mujeres en el Ecuador de la década de 1930." Masters dissertation, Universidad Andina Simón Bolívar, 2017.

Haedo, Óscar. "Adolfo Pastor," in XVIII *Plásticos Uruguayos (1920-1945)*. Buenos Aires: Talleres Gráficos Porter Hermanos (1947): 143-153.

Hallewell, Laurence. *O livro no Brasil (sua história)*. 1st ed. São Paulo: T. A. Queiroz-Edusp, 1985; 2nd ed. São Paulo: Universidade de São Paulo, 2005.

Haluch, Aline. *A Maçã. O design gráfico, as mudanças de comportamento e a representaçao femenina no inicio do século xx*. Rio de Janeiro: Editora Senac Río de Janeiro, 2016.

Handelsman, Michael. "Un estudio de la época modernista del Ecuador a través de sus revistas literarias publicadas entre 1895 y 1930," *Cultura. Revista del Banco Central del Ecuador*, no. 39 (January - April 1981): 196-211.

Haya de la Torre Castro, José Agustín. "La revista La Sierra y la trama del indigenismo." Unpublished Ph.D. thesis, Universidad de Salamanca, 2018.

Heller, Steven. *Merz to Emigre and Beyond: Magazine Design of the Twentieth Century*. London and New York: Phaidon, 2003.

— and Louise Fili. *Euro Deco*. London: Thames & Hudson, 2004.

Herrera, Bernal. "El caleidoscopio estético de Max Jiménez." In *Max Jiménez: aproximaciones críticas* edited by Álvaro Quesada Soto. San José: Editorial de la Universidad de Costa Rica, 1999, 86-107.

Hidalgo, Alberto. "Descripción del cielo." In *Poesía vanguardista peruana*, edited by Luis Fernando Chueca, vol. 1. Lima: Pontificia Universidad Católica del Perú, 2009.

Higgins, Dick. *Pattern Poetry: Guide to an Unknown Literature*. New York: State University of New York Press, 1987.

Hollis, Richard. *Graphic Design. A Concise History*. London: Thames & Hudson, 1994.

— "The Avant-garde and Graphic Design." In *The Avant-Garde Applied (1890-1950)* (exh. cat.), Madrid: Fundación Juan March, 2012.

Holstein, Jürgen, ed. *The Book Cover in the Weimar Republic*. Cologne: Taschen, 2015.

Huidobro, Vicente. *Obra poética*. Critical edition by Cedomil Goic. Madrid: Fondo de Cultura Económica / Archivos de la Literatura Latinoamericana, del Caribe y Africana del Siglo XX, 2003.

Hurlburt, Allen. *Layout: Design of the Printed Page*. New York: Watson – Guptill Publications, 1979.

Instituto Nacional de Bellas Artes, Consejo Nacional para la Cultura y las Artes: *Miguel Prieto, diseño gráfico*. Mexico City: CONACULTA, INBA, Universidad Autónoma Metropolitana, Universidad Nacional Autónoma de México, Universidad de las Américas, and Ediciones Era-Trama Visual-Matriz, 2000.

Italiano, Juan Ángel. *El rey de copas: caligramas y otras fruslerías de Francisco Acuña de Figueroa y su tiempo*. Maldonado: Ediciones del Cementerio Virtual, 2014.

Janecek, Gerald. *The Look of Russian Literature. Avant-Garde Visual Experiments, 1900-1930*. Princeton: Princeton University Press, 1984.

Jury, David. *Graphic Design before Graphic Designers. The Printer as Designer and Craftsman 1700-1914*. London: Thames & Hudson, 2012.

Kennedy Troya, Alexandra, and Rodrigo Gutiérrez Viñuales, eds. *Alma mía: Simbolismo y modernidad en Ecuador (1900-1930)*. Quito: Hominem Editores and Museo de la Ciudad - Centro Cultural Metropolitano, 2013.

Knychala, Catarina. *O livro de arte brasileiro*. 2 vols. Rio de Janeiro: Presença, Pró- memória / Instituto Nacional do Livro, 1983-1984.

Koshiyama, Alice Mitika. "Monteiro Lobato: empresário, trabalhador, intelectual e ideólo da indústria do livro no Brasil." Masters dissertation, Escola de Comunicações e Artes, Universidade de São Paulo, 1978.

Kuon Arce, Elizabeth, Rodrigo Gutiérrez, Ramón Gutiérrez, and Graciela Viñuales. *Cuzco-Buenos Aires. Ruta de intelectualidad americana (1900-1950)*. Lima: Universidad San Martín de Porres and Fondo Editorial, 2009.

Kurc-Maj, Paulina. ed. *Zmiana pola widzenia. Druk nowoczesny i awangarda / Changing the Field of View Modern Printing and the Avant-Garde* /exh. cat.), Łódź, Muzeum Sztuki, 2014.

La rivoluzione tipografica. Introduction by Claudia Salaris. Milan: Edizioni Sylvestre Bonnard, 2001.

Lafuente, José María, ed. *El arte de ver: tratados, revistas, manifiestos*. Santander: Ediciones La Bahía, 2016.

Lago, Pedro Corrêa do. *Brasiliana Itaú*. São Paulo: Capivara, 2009.

Las mil y una cosas. El arte de lo cotidiano 1900-1950 (exh. cat.). Montevideo: Galería Tejería Loppacher, 2001.

Lasarte Valcárcel, Javier. *Al filo de la lectura*. Caracas: Universidad Católica Cecilio Acosta, Universidad Simón Bolívar and Editorial Equinoccio, 2005.

Latchman, Ricardo A. "Diagnóstico de la nueva poesía chilena," *Sur*, year I, no. 3 (Winter 1931): 138-154.

Lefort, Daniel and Fernando Villegas Torres. eds. *César Moro. Obra plástica*. Lima: Academia Peruana de la Lengua, 2017.

Lemos, Antônio Agenor Briquet de. *Nicola de Garo no Brasil: un roteiro de pesquisa*. Brasilia: Briquet de Lemos Livros / Casa da Memória da Arte Brasileira, 2017.

Lima, Yone Soares de. *A ilustração na produção literaria (São Paulo-década de vinte)*. São Paulo: Instituto de Estudos Brasileiros, Universidade de São Paulo, 1985.

Liscano, Juan. "Mariano Medica Febres (Medo)." In *Medo. Caricatura de lucha. 1936-1939*. Caracas: Ediciones Centauro, 1991.

Lista, Giovanni. *Le livre futuriste. De la libération du mot au poéme tactile*. Modena: Editions Panini, 1984.

Lizama, Patricio and María Inés Zaldívar. *Las vanguardias literarias en Chile. Bibliografía y antología crítica*. Madrid and Frankfurt: Iberoamericana and Vervuert, 2009.

Llanes, Lilian. dir. *Cuba. Vanguardias 1920-1940*. Valencia and Milan: Institut Valencià d'Art Modern and Electa, 2006.

— "Cubismo en La Habana," *Art OnCuba* (June 2, 2015). www.artoncuba.com (Accessed April 15, 2018).

— "Imaginario ruso en La Habana en la década del 20," *Revolución y cultura*, no. 1 (2017): 2-6.

Llerena, José Alfredo and Alfredo Chaves. *La pintura ecuatoriana del siglo XX y Primer registro bibliográfico de artes plásticas en el Ecuador*. Quito: Sindicato de Escritores y Artistas, 1942.

Lobo Montalvo, María Luisa, and Zoila Lapique Becali. "The Years of *Social*," *The Journal of Decorative and Propaganda Arts*, no. 22 (October 1, 1996).

López Casillas, Mercurio. "Entre el taller del artista y la oficina del gobierno." In *México ilustrado, Libros, revistas y carteles, 1920-1950*, edited by Salvador Albiñana, 23-27. 1st edition. Mexico City: RM, 2010.

López Hernández, Alina Bárbara. "La revista *Social*, la generación del 25 y la experiencia soviética,"(January 24, 2021). www.fotosdlahabana.com/ (Accessed February 10, 2021).

López Lenci, Yazmín. *El laboratorio de la vanguardia en el Perú*. Lima: Editorial Horizonte, 1999.

López Rojas, José Evaristo, and Longino Becerra. *Honduras: visión panorámica de su pintura*, Tegucigalpa: Libélula Editores, 2014.

Lorenzo Alcalá, May. *La esquiva huella del futurismo en el Río de la Plata. A cien años del primer manifiesto de Marinetti*. Buenos Aires: Patricia Rizzo Editora, 2009.

Lucero, María Elena. "Modernismo cultural e historias locales. Intercambios estéticos y simbólicos en la gráfica de Vicente do Rego Monteiro," *Americania. Revista de Estudios Latinoamericanos*, New period, no. 4 (July - December 2016): 124-154.

Luis, William. *Las vanguardias literarias en el Caribe: Cuba, Puerto Rico y República Dominicana. Bibliografía y antología crítica*. Madrid and Frankfurt: Iberoamericana and Vervuert, 2010.

Luna Arroyo, Antonio. *El Dr. Atl paisajista puro*. Mexico City: Editorial Cultura, 1952.

Lupton, Ellen, and J. Abbott Miller, eds. *The ABCs of Bauhaus: The Bauhaus and Design Theory*. London: Thames & Hudson, 1993.

Lyons, Joan. *Artists' Books: A Critical Anthology and Sourcebook*. New York: Visual Studies Workshop Press, 1985.

Macías, Pablo G. ed. *Artes del Libro*. Mexico City: Escuela de Enseñanzas Especiales, 8 issues (1957-1959).

Machado, Ubiratan. *A capa de livro brasileiro, 1820-1950*. Cotia and São Paulo: Ateliê Editorial and SESI-SP Editora, 2017.

Madrid Letelier, Alberto, José de Nordenflycht Concha, and Paulina Varas Alarcón. *Revisión / Remisión de la historiografía de las artes visuales chilenas contemporáneas*. Santiago de Chile: Ocho Libros Editores, 2011.

Majluf, Natalia, and Luis Eduardo Wuffarden, eds. *Sabogal* (exh. cat.), Lima: Museo de Arte de Lima, 2013.

Malosetti Costa, Laura and Marcela Gené, eds. *Impresiones porteñas. Imagen y palabra en la historia cultural de Buenos Aires*. Buenos Aires: Edhasa, 2009.

Manzoni, Celina. *Un dilema cubano. Nacionalismo y vanguardia*. Havana: Casa de las Américas, 2001.

Margolin, Victor. *The Politics of the Artificial: Essays on Design and Design Studies*. Chicago: University of Chicago Press, 2002.

— "Diseño gráfico en Brasil en las décadas del 20 y el 30. Modernismo y modernidad," *Anales del Instituto Americano de Arte*, no. 43 (2013): 229-238.

Marinello, Juan. "Sobre el vanguardismo en Cuba y en América Latina." In *Los vanguardismos en América Latina*, Óscar Collazo, 211-224. Barcelona: Península, 1977.

Marinetti, Filippo Tommaso. "Destruction of Syntax - Imagination without Strings - Words in Freedom 1913." In *Futurist Manifestos*, edited by Umbro Apollonnio, 95-106. London: Thames & Hudson, 1973.

Maseda, Pilar. *Los inicios de la profesión del diseño en México. Genealogía de sus incidentes*. Mexico City: Consejo Nacional para la Cultura y las Artes, Instituto Nacional de Bellas Artes Centro Nacional de Investigación, Documentación e Información de Artes Plásticas, Instituto Tecnológico y de Estudios Superiores de Monterrey, 2006.

Massin, Robert. *La lettre et l'image. La figuration dans l'alphabet latin du VIIIe siècle à nos jours*. Paris: Gallimard, 1970.

Mato, Daniel. *Crítica de la modernidad, globalización y construcción de identidades*. Caracas: Universidad Central de Venezuela, 2003.

McGann, Jerome. *Black Riders: The Visible Language of Modernism*. Princeton: Princeton University Press, 1993.

Medina, Álvaro. *Procesos del arte en Colombia*. Bogotá: Instituto Colombiano de Cultura, 1978.

— *El arte colombiano de los años veinte y treinta*. Bogotá: Tercer Mundo, 1995.

— "El indio y el arte indigenista a principios del siglo xx," *Ensayos. Historia y teoría del arte*, no. 10 (2005): 143-177.

Medina, Cuauhtémoc, ed. *Diseño antes del diseño. Diseño grafico en México, 1920-1960* (exh. cat.) Mexico City: Museo de Arte Alvar y Carmen T. de Carrillo Gil México, 1991.

Melo, Chico Homem de, and Elaine Ramos, eds. *Linha do tempo do design grafico no Brasil*. São Paulo: Cosac Naify, 2012.

Mendelsund, Peter, and David J. Alworth. *The Look of the Book: Jackets, Covers, and Art at the Edges of Literature*. New York: Ten Speed Press, 2020.

Mendoza Guzmán, Justino A. *Mariano Fuentes Lira. 100 años de aporte al arte y la cultura andina* (exh. cat.). Cuzco: Escuela Superior Autónoma de Bellas Artes Diego Quispe Tito, 2006.

Merino, Luz. "Gráfica y cultura visual." In *Cuba. Arte e historia desde 1868 hasta nuestros días* (exh. cat.), 108-113. Montreal and Barcelona: The Montreal Museum of Fine Arts and Lunwerg Editores, 2008.

Mindlin, José E. "Illustrated Books and Periodicals in Brazil, 1875-1945," *The Journal of Decorative and Propaganda Arts*, no. 21 (1995).

— *Uma vida entre livros. Reencontros com o tempo*. São Paulo: EDUSP, 1997.

— "Não faço nada sem alegría". *A biblioteca indisciplinada de Guita e José Mindlin*. São Paulo: Museu Lasar Segall, 1999.

Moeglin-Delcroix, Anne. *Esthétique du livre d'artiste (1960-1980)*. Paris: Éditions de la Bibliothèque nationale de France, 2012.

Molina, Mary Carmen. "La ilustración en la literatura boliviana: Sombras de mujeres (Alberto de Villegas, 1929)," *Warszawa* (June 6, 2017). https://warszawasite.wordpress.com/2017/06/06/ilustraciones-de-sombras-de-mujeres-alberto-de-villegas-1929/ (Accessed April 12, 2018).

Montealegre, Jorge. *Historia del humor gráfico en Chile*. Lleida: Editorial Milenio, 2008.

Mora Guarnido, José. "Federico Lanau, grabador y ceramista," *Valoraciones*, no. 8 (November 1925): 127-141.

Morales Faedo, Mayuli. "'Poema en 20 surcos' desde la perspectiva de la vanguardia." In *Entre la tradición y el canon: Homenaje a Yvette Jiménez de Báez*, edited by Ana Rosa Domenella, Luzelena Gutiérrez de Velasco and Edith Negrín, 265-281. Mexico City: Colegio de México A. C., 2009, 265-281.

Moreno Aguilar, Andrea. *Eduardo Kingman Riofrío*. Quito: Banco Central del Ecuador, 2010.

Morgado, Benjamín. *Poetas de mi tiempo*. Santiago de Chile: Talleres Gráficos Periodística Chile Limitada, 1961.

Moyssén, Xavier. "Jorge Juan Crespo de la Serna (1887-1978)," *Anales del Instituto de Investigaciones Estéticas*, vol. xiii, no. 49 (1979): 161-163.

Müller-Bergh, Klaus, and Gilberto Mendonça Teles. *Vanguardia latinoamericana: historia, crítica y documentos. Tomo I. México y América Central*. Madrid and Frankfurt: Iberoamericana and Vervuert, 2007.

Muñoz Hauer, Mariana, and María Fernanda Villalobos Fauré. *Alejandro Fauré. Obra gráfica*. Santiago de Chile: Ocho Libros Editores, 2009.

Muñoz Reoyo, Amparo. "'El hombre que parecía un caballo:' la prefiguración de las técnicas de la vanguardia," *Anales de Literatura Hispanoamericana*, no. 26 (2) (1997): 325-332.

Navarrete, José Antonio. "Esperanza Durruthy: cuando el tiempo no alcanza. Sobre la ilustración de vanguardia en Cuba," *Deinós. Critical Journal*, no. 1, (January 20, 2020). https://deinospoesia.com/2020/01/20/esperanza-durruthy-cuando-el-tiempo-no-alcanza/

Noriega, Simón. *El realismo social en la pintura venezolana 1940-1950*. Mérida: Universidad de los Andes, Consejo de Publicaciones, 1989.

Núñez del Prado, Marina. *Eternidad en los Andes. Memorias de Marina Núñez del Prado*. Santiago de Chile: Álvaro Flaño / Editorial Lord Cochrane, 1973.

Ochoa Ochoa, Jorge Hernando. "Influencia de los movimientos artísticos en el diseño gráfico colombiano," *Dialéctica. Revista de investigación*, no. 26 (2010): 108-115.

Olivarez R., Fátima and Max Aruquipa Chambi. *El grabado en Bolivia* (exh. cat.), La Paz: Museo Nacional de Arte, 2012.

Ortega, Julio. "La constelación poética de Luis Cardoza y Aragón." in *La estafeta del viento*, Madrid: Casa de América, 2012.

Ortiz, Orietta. "La obra gráfica en El domador de pulgas de Max Jiménez," *Escena*, vol. 60, no. 1 (2007): 37-44.

Ortiz, Rodolfo, et al. *La mariposa mundial. Revista de literatura*, nos. 23-24 (2016-2017).

Ortiz Canseco, Marta, ed. *Poesía peruana, 1921-1931. Vanguardia + indigenismo + tradición*. Madrid and Lima: Iberoamericana and Vervuert-Librería Sur, 2013.

Osorio, Nelson. *El futurismo y la vanguardia literaria en América Latina*. Caracas: Centro de Estudios Latinoamericanos Rómulo Gallegos, 1982.

Otero Silva, Miguel. "Medo: pluma y corazón en el aire de España y del mundo." In *Medo. Caricatura de lucha. 1936-1939*. Caracas: Ediciones Centauro, 1991.

Paixão, Fernando, ed. *Momentos do livro no Brasil*. São Paulo: Ática, 1997.

Pallottino, Paola. *Storia dell'illustrazione italiana. Cinque secoli di immagini riprodotte*. Florence: Uscher, 2010.

Pantigoso Pecero, Manuel. *Pantigoso, fundador de los Independientes*. Lima: Ikono, 2007.

Pareja Díezcanseco, Alfredo. "El ensayo en la literatura ecuatoriana actual." In *Trece años de cultura nacional. Ensayos. Agosto 1944-1957*, 33-47. Quito: Casa de la Cultura Ecuatoriana, 1957.

Pasini, Leandro. "La poética de Losango cáqui, de Mário de Andrade: temporalidad y experimentación en el modernismo brasileño," *Literatura: teoría, historia, crítica*, vol. 22, no. 2 (2020): 211-240. https://revistas.unal.edu.co/index.php/lthc/article/view/86091

Paz Castillo, María Fernanda. *Una historia del libro ilustrado para niños en Colombia*. Bogotá: Biblioteca Nacional de Colombia, 2010.

Peluffo, Gabriel. "Las instituciones artísticas y la renovación simbólica en el Uruguay de los veinte." In *Los veinte. El proyecto uruguayo. Arte y diseño de un imaginario 1910-1934* (exh. cat.), 37-49. Montevideo: Museo Municipal de Bellas Artes Juan Manuel Blanes, 1999.

— *El grabado y la ilustración. Xilógrafos uruguayos entre 1920 y 1950* (exh. cat.), Montevideo: Museo Municipal de Bellas Artes Juan Manuel Blanes, 2003.

Pentimalli, Michela, ed. *Chaco trágico. Flora doliente y angustia de los hombres. Testimonios gráficos de la guerra*. La Paz: Fundación Simón I. Patiño, 2008.

— ed. *Bolivia. Lenguajes gráficos*. 3 vols. La Paz: Fundación Simón I. Patiño, 2016.

Pérez, Carlos, and Miguel Valle Inclán, eds. *Vicente Huidobro y las artes plásticas* (exh. cat.), Madrid: Museo Nacional Centro de Arte Reina Sofía, 2001.

Pérez, Omar Alberto. "Rivero Oramas, Rafael." In BiblioFEP. *Diccionario de Historia de Venezuela*. Caracas: Fundación Empresas Polar, n.d. http://bibliofep.fundacionempresaspolar.org (Accessed June 18, 2019).

Pérez Urbaneja, Elina. "Venezuela." In *Historia del diseño en América Latina y el Caribe*, edited by Silvia Fernández and Gui Bonsiepe. San Pablo: Editora Blücher, 2008.

Perloff, Marjorie. *The Futurist Moment: Avant-Garde, Avant Guerre, and the Language of Rupture*. Chicago: University of Chicago Press, 2003.

Peters, Victoria Eugenia. "Los carteles del periódico 'Tierra:' construcción de la identidad del obrero colombiano," *Hallazgos*, vol. 11, no. 21 (2014): 59-74.

Pettoruti, Emilio. "Fortunato Depero, el artista dinámico por excelencia." In *Emilio Pettoruti crítico en Crítica*, May Lorenzo Alcalá and Sergio Alberto Baur, 28-31. Buenos Aires: Patricia Rizzo Editora, 2010.

Pevsner, Nikolaus. *Pioneers of Modern Design. From William Morris to Walter Gropius*. New Haven: Yale University Press, 2005.

Pineda Botero, Álvaro. *Juicios de residencia: la novela colombiana 1934-1985*. Medellín: Editorial Universidad EAFIT, 2001.

Pini, Ivonne. *En busca de lo propio: inicios de la modernidad en el arte de Cuba, México, Uruguay y Colombia, 1920-1930*. Bogotá: Universidad Nacional de Colombia, 2000.

Pita González, Alejandra, ed. *Redes intelectuales transnacionales en América Latina durante la entreguerras*. Mexico City: Universidad de Colima and Miguel Ángel Porrúa, 2016.

Pivel Devoto, Juan. "Los orígenes de la imprenta en el Uruguay." In *Exposición Nacional de las Artes Gráficas* (exh. cat.), 23-25. Montevideo: Asociación de Impresores y Anexos del Uruguay, 1945.

Plath, Oreste. *Poetas y poesía de Chile*. Santiago de Chile: Talleres Gráficos La Nación, S. A., 1941.

Polano, Sergio, and Pierpaolo Vetta. *Abecedario. La grafica del Novecento*. Milan: Electa, 2010.

Pontus, Hulten, ed. *Futurism and Futurisms*. New York: Abbeville Press, 1986.

Portillo, Alicia. "Escuela de artes del libro. La más vieja escuela de diseño editorial en México," *El Corondel*, year 4, no. 47 (June 2011): 10-16.

Puñales-Alpízar, Damaris. "Espectáculo y compromiso: estrategias vanguardistas en César Vallejo y Carlos Oquendo de Amat," *Teatro: Revista de Estudios Culturales / A Journal of Cultural Studies*, vol. 24, no. 24 (2012): 91-109.

Querejazu Leyton, Pedro. *El dibujo en Bolivia*. La Paz: Fundación Banco Hipotecario Nacional, 1989.

— ed. *Pintura boliviana del siglo xx*. La Paz: Banco Hipotecario Nacional, 1997.

— *Arte contemporáneo en Bolivia, 1970-2013. Crítica, ensayos, estudios*. La Paz: Self-edition, 2013.

— "David Crespo Gastelú: el espíritu del motivo," *Arte, fotografía y Patrimonio en Bolivia*. Personal blog (October 1, 2015). https://pedroquerejazu.wordpress.com/2015/10/01/david-crespo-gastelu-el-espiritu-del-motivo/

— ed. *Pintura boliviana en el siglo xx*. La Paz: Vicepresidencia del Estado Plurinacional, 2018.

Ramírez, Mari Carmen, "A manera de introducción". En *De Oller a los Cuarenta: la pintura en Puerto Rico de 1898 a 1948*. San Juan: First Federal Savings Bank, 1989, pp. 12-15.

Ramos, Paula. *A modernidade impressa. Artistas ilustradores da Livraria do Globo - Porto Alegre*. Porto Alegre: Universidade Federal do Rio Grande do Sul Editora, 2016.

Raygada, Carlos. "Artistas de vanguardia. César Moro," *Variedades. Revista semanal ilustrada*, no. 918 (October 3, 1925).

Restrepo, Manuel. "'Revista de las Indias,' un proyecto de ampliación," *Boletín cultural y bibliográfico*, vol. 7, no. 23 (1990): 24-41.

Revista de Arte. Directed by Doming Santa Cruz. 1st period, 22 issues, 1934-1939.

Revista Válvula. Edición facsimilar. Presented by Roger Vilain and Diego Rojas Ajmad. Mérida: Ediciones Actuales, 2011.

Reyes Flores, Felipe. *Nascimento. El editor de los chilenos*. Santiago de Chile: Minimocomun Ediciones, 2013.

Reyes Palma, Francisco. "La LEAR y su revista de frente cultural." Estudio introductorio a la edición facsimilar de *Frente a Frente, 1934-1938*. Mexico City: Centro de Estudios del Movimiento Obrero y Socialista, A.C., 1994.

Riese Hubert, Renée. *Surrealism and the Book*. Berkeley, Los Angeles and London: University of California Press, 1988.

Rius Caso, Luis. *Las palabras del cómplice. José Juan Tablada en la construcción del arte moderno en México (1891-1927)*. Mexico City: Instituto Nacional de Bellas Artes y Literatura, 2013.

Rivera, Hugo, et al. *Carlos Hermosilla. Artista ciudadano, adelantado del arte de grabar*. Valparaíso: Editorial Puntángeles and Universidad de Playa Ancha, 2003.

Rivera Escobar, Raúl. *Caricatura en el Perú. El período clásico (1904-1931)*, Lima: Universidad de San Martín de Porres, 2006.

Robinson, Michael, and Rosalind Ormiston. *Art Deco. The Golden Age of Graphic Art and Illustration*. New York: Metro Books, 2008.

Robles, Humberto E. "La noción de vanguardia en Ecuador: Recepción y trayectoria (1918-1934)," *Revista Iberoamericana*, vol. LIV, nos. 144-145 (July - December 1988): 649-674.

Rocca, Pablo Thiago. "Ciudad, campo, letras, imágenes." In *Los veinte. El proyecto uruguayo. Arte y diseño de un imaginario 1910-1934* (exh. cat.), 103-106. Montevideo: Museo Municipal de Bellas Artes Juan Manuel Blanes, 1999.

— *Dos revistas culturales en la Guerra Civil Española. Literatura e imágenes en Boletín de A.I.A.P.E. y Ensayos de Montevideo (1936-1939)*. Montevideo: Centro Cultural de España, 2009.

— ed. *Poesía e ilustración uruguaya, 1920-1940* (exh. cat.), Montevideo: Museo Figari, 2013.

— "Federico Lanau. Apuntes para una retratística inconclusa," *La pupila*, no. 31 (June 2014): 28-32.

Rodríguez, Ana Mónica. "Publican *Un proyecto en marcha...*, libro conmemorativo de esa institución educativa. La Escuela Nacional de Artes Gráficas, cuna de grandes creadores, celebra 75 años," *La Jornada*, Cultura supplement (July 3, 2013).

Rodríguez, José Julio. *Francisco Díaz de León, como dibujante, pintor y artista gráfico*. Mexico City: Editorial ACASIM, 1961.

Rodríguez Castelo, Hernán. *Los de "Elán" y una voz grande: Augusto Sacotto Arias*. Guayaquil: Publicaciones Educativas Ariel, 1980.

— et al. *Eduardo Kingman*. Quito: La Manzana Verde, 1985.

— *Nuevo diccionario crítico de artistas plásticos del Ecuador del siglo xx*. Quito: Centro Cultural Benjamín Carrión, Municipio Metropolitano de Quito, 2006.

Rodríguez Mortellaro, Itzel. "Forma, revista de artes plásticas." In *Revistas culturales latinoamericanas 1920-1960*, edited by Lydia Elizalde, 83-103. Mexico City: Consejo Nacional para la Cultura y las Artes, Universidad Autónoma del Estado de Morelos and Universidad Iberoamericana, 2007.

Romero, Cira. "La ilustración en *Social*". Cubaliteraria, Instituto Cubano del Libro, n.d. www.ecured.cu. (Accessed April 15, 2018).

— "*Social* en su segunda etapa (1923-1928)". Cubaliteraria, Instituto Cubano del Libro, n.d. www.ecured.cu. (Accessed April 15, 2018).

Rosa, Natalia de la. "Vida americana, 1919-1921. Redes conceptuales en torno a un proyecto trans-continental de vanguardia," *Highways of the South: Latin American Art Networks*, special issue of *Artl@as Bulletin*, vol. 3, article 2 (2014): 21-35.

Roselló, A. A. "Enrique Riverón. Un caso de inquietud ambulante," *Carteles*, vol. XXI, no. 15 (1934): 28, 44, 49.

Rossi, Attilio. *Cómo se imprime un libro*. Buenos Aires: Imprenta López, 1942.

Rothschild, Deborah. "Dada Networking. How to Foment a Revolution in Graphic Design." In *Graphic Design in the Mechanical Age. Selection from the Merrill C. Berman Collection*, Deborah Rothschild, Ellen Lupton and Darra Goldstein, 9-49. New Haven and London: Yale University Press, 1998.

Rowell, Margit. "Constructivist Book Design: Shaping the Proletarian Conscience." In *The Russian Avant-Garde Book, 1910-1934* (exh. cat.), edited by Margit Rowell and Deborah Wye. New York: The Museum of Modern Art, 2002.

"Runrunismo," in Morgado, Benjamín. *Poetas de mi tiempo*. Santiago de Chile: Talleres Gráficos Periodística de Chile, 1961, 49-51.

Salaris, Claudia. *Marinetti editore*. Bologna: Il Mulino, 1990.

— *Il futurismo e la pubblicità: dalla pubblicità dell'arte all'arte della pubblicità*. Milan: Lupetti, 1996.

— *Riviste futuriste. Collezione Echaurren Salaris*. Pistoia: Gli Ori, 2013.

— *Futurismi nel mondo: collezione Echaurren Salaris*. Pistoia: Gli Ori, 2015.

Salas Zamudio, Salvador, and Julián López Huerta. "Evolución del término diseño gráfico." In *Reconstrucción del término diseño. Memorias del XI Congreso de Académicos de Escuelas de Diseño Gráfico*. Guadalajara: Universidad de Guadalajara, Centro Universitario de Arte, Arquitectura y Diseño, 2003.

Salazar Calle, Gustavo. "El arte en las cubiertas de nuestros libros," *El Comercio* (December 1, 2019): 7.

Salazar Mostajo, Carlos. *La pintura contemporánea de Bolivia. Ensayo histórico-crítico*. La Paz: Librería Editorial Juventud, 1989.

Salgado Ruelas, Silvia Mónica. "El Libro y el Pueblo. Revista de largo aliento." In *Revistas culturales latinoamericanas 1920-1960*. Mexico City: Consejo Nacional para la Cultura y las Artes, 2008.

Sánchez, Américo. *Miguel Covarrubias: Cuatro Miradas / Four Visions*. Mexico City: Editorial RM, 2005.

Santa Rosa, Tomás. *Roteiros de arte*. Rio de Janeiro: Serviço de Documentação, Ministerio da Educação e Saúde, 1952.

Satué, Enric. *El diseño gráfico. Desde los orígenes hasta nuestros días*. Madrid: Alianza Editorial, 1998.

— *Arte en la tipografía y tipografía en el arte: compendio de tipografía artística*. Madrid: Siruela, 2007.

Scarzolo Travieso, Luis. *Arte Moderno. Conferencia leída en el Club Vida Nueva*. Montevideo, Talleres de A. Barreiro y Ramos, n.d. [1902].

Schnapp, Jeffrey. "Las bombas de Bruno Munari." In *Revistas, modernidad y guerra*, edited by Jordana Mendelson. Madrid: Museo Nacional Centro de Arte Reina Sofía, 2008.

Scholz, László, ed. *Zsigmond Remenyik. El lamparero alucinado*. Madrid and Frankfurt: Iberoamericana and Vervuert, 2009.

Schwartz, Jorge, ed. *Da Antropofagia a Brasilia. Brasil 1920-1950* (exh. cat.), Valencia: Institut Valencià d'Art Modern, 2000.

Schwarz, Arturo, ed. *Almanacco Dada*. Milan: Feltrinelli, 1976.

Scudiero, Maurizio. "Vanguardia y tipografía: una lectura transversal." In *The Avant-Garde Applied (1890-1950)* (exh. cat.), 163-210. Madrid: Fundación Juan March, 2012.

Segura, Martha, ed. *Adolfo Samper*. Bogotá: Banco de la República, 1989.

Semprún Parra, Juan Ángel, and Luis Guillermo Hernández. *Diccionario general de Zulia*. Maracaibo: Sultana del Lago Editores, 2018.

Simioni, Ana Paula. *Di Cavalcanti ilustrador. Trajetória de um jovem artista gráfico na imprensa (1914-1922)*. São Paulo: Editora Sumaré, 2002.

Sobral, Julieta, and Cássio Loredano. *J. Carlos em revista*. Rio de Janeiro: Instituto Memória Gráfica Brasileira, 2014.

Soler, Jaime, coor. *Art Déco. Un país nacionalista. Un México cosmopolita*. Mexico City: Instituto Nacional de Bellas Artes and Secretaría de Salud, 1997.

Soto Morúa, Daniel, curador. *Lorem Ipsum. Breves anotaciones sobre la historia del diseño gráfico en Costa Rica* (exh. cat.), San José: Museo de Arte y Diseño Contemporáneo, 2018.

Spencer, Herbert. *Pioneers of Modern Typography*. Revised edition. Cambridge: MIT Press, 2004.

Sousa, Osvaldo Macedo de. *Fernando Correia Dias. Um poeta do traço*. Rio de Janeiro: Batel Editora, 2013.

Stols, Alexander. "La tipografía y el libro," part III of *Artes del Libro*, no. 4 (1958): 30.

Suárez, Sylvia Juliana. "'Arte serio': El arte colombiano frente a la vanguardia histórica europea en 1922," *Ensayos. Historia y teoría del arte*, no. 14 (2008): 64-91.

Szir, Sandra, ed. *Ilustrar e imprimir. Una historia de la cultura gráfica en Buenos Aires, 1830-1930*. Buenos Aires: Ampersand, 2016.

Tejeda, Juan Guillermo. *Amster*. Santiago de Chile: Ediciones Universidad Diego Portales, 2011.

Teles, Gilberto Mendonça and Klaus Müller-Bergh. "Puerto Rico." In *Vanguardia latinoamericana. Historia, textos y documentos. Tomo II: Caribe, Antillas mayores y menores*, 151-152. Madrid and Frankfurt: Iberoamericana and Vervuert.

Tibol, Raquel. *Palabras de Siqueiros*. Mexico City: Fondo de Cultura Económica, 1996.

— *Diego Rivera Gran ilustrador / Great Illustrator*. Mexico City: Editorial RM and Instituto Nacional de Bellas Artes, 2008.

Tonini, Bruno. "Avant-garde Typography (1900-1945). Theories and Characters." In *The Avant-Garde Aplied (1890-1950)* (exh. cat.). Madrid: Fundación Juan March, 2012.

Torello, Georgina. "La Troupe Ateniense, capítulo oriental." In *Aliverti Liquida*. Edición facsímil, Troupe Ateniense, 97-119. Montevideo: Yaugurú-Irrupciones, 2012.

— "Novela al nitrato. *Episodio (Film literario)* de R. Arturo Despouey." In *Nuevos mapas de las vanguardias. Reflexiones desde Montevideo*, edited by Emilio Irigoyen and Georgina Torello, 167-182. Montevideo: Linardi y Risso, 2015.

Torre Revello, José. *Los orígenes de la imprenta en la América Española*. Madrid: Francisco Beltrán, 1927.

Torre Villar, Ernesto de la. *Ilustradores de libros. Guión biobibliográfico*. Mexico City: Dirección General de Publicaciones y Fomento Editorial / Universidad Nacional Autónoma de México, 1999.

Torres, Ildemaro. *El humorismo gráfico en Venezuela*. Caracas: Armitano, 1988.

Torres Martinó, J. A. "Plástica y literatura en las primeras décadas del siglo veinte." In *De Oller a los Cuarenta: la pintura en Puerto Rico de 1898 a 1948*. San Juan: First Federal Savings Bank, 1989, 48-59.

Trapiello, Andrés. *Imprenta moderna. Tipografía y literatura en España*. Valencia: Campgràfic, 2006.

Travassos, Nélson Palma. *Livro sobre livros*. São Paulo: Hucitec, 1978.

Troconi, Giovanni, et al. *Diseño gráfico en México, 100 años: 1900-2000*. Mexico City: Artes de México and Universidad Autónoma Metropolitana, 2010.

Tschichold, Jan. *The New Typography*. Berkeley: University of California Press, 1995.

Universidad de Guadalajara: *Reconstrucción del término diseño. Memorias del XI Congreso de Académicos de Escuelas de Diseño Gráfico*. Mexico City: Encuadre and Centro Universitario de Arte, Arquitectura y Diseño, Universidad de Guadalajara. 2003.

Urías Horcasitas, Beatriz. "Retórica, ficción y espejismo: tres imágenes de un México bolchevique (1920-1940)," *Relaciones. Estudios de historia y sociedad en México*, no. 101, vol. XXVI (2005): 261-300.

Vaca, Marilú. "Chicas chic: representación del cuerpo femenino en las revistas modernistas ecuatorianas (1917-1930)," *Procesos. Revista Ecuatoriana de Historia*, no. 38 (July - December 2013): 73-93.

Valender, James, ed. *Los refugiados españoles y la cultura mexicana*. Mexico City: El Colegio de México A.C., 1996.

Vallejo, César. "Estética y maquinismo." in *El arte y la revolución. Obras completas. Tomo segundo*, 54-56. Lima: Mosca Azul Editores, 1973.

— *Trilce*. Edited by Julio Ortega, Madrid: Cátedra, 2003.

Vásquez Peralta, Marcia. "El arte plástico guatemalteco 1980-2000: Estudio de cuatro artistas," *Abrapalabra*, no. 44 (2011).

Vasyl. "Los juegos de Juan José Morosoli," *Albatros*, no. 2 (December 1928): 25-26.

Vázquez, María Ángeles. "La vanguardia en Ecuador a través de sus revistas," *Ómnibus. Revista Intercultural*, year IX, no. 43 (May 2013).

Velasco, Juan. "José Juan Tablada: los versos del precursor." In *Tres libros*, José Juan Tablada, 9-16. Madrid: Hiperón, 2000.

Velásquez Garcés, Norma, ed. *Alberto Arango*. Bogotá: Banco de la República, 1988.

Verdugo, Mario. "El veraneo psicoseado de Raúl Lara (1911-?). Alucinaciones en Playa Dadá," *Proyecto Patrimonio* (2016). http://letras.mysite.com/mver280116.html (Accessed October 19, 2018).

Videla de Rivero, Gloria. "El runrunismo chileno (1927-1934). El contexto literario," *Revista chilena de literatura*, no. 18 (1981): 73-87.

Vilac, Mario."Los dibujos." In *La casa sin ventanas*, Pasquale Casaula, 9-10. Santiago de Chile: Ediciones Cuadrante Ultra-Novecentista and Indoamérica.

Vilar, Mariela. *Diseño gráfico: evolución en Panamá 1900-1950*. Panama City: n.p., 2012.

Vilchis Esquivel, Luz del Carmen. *Historia del diseño gráfico en México: 1910-2010*. Mexico City: Consejo Nacional para la Cultura y las Artes, Instituto Nacional de Bellas Artes, 2010.

Villacís Molina, Rodrigo. *Palabras cruzadas*. Quito: Banco Central del Ecuador, 1988.

Villacrés, Yesenia. "Revista Caricatura: renovación del campo cultural quiteño por un 'Grupo de Intelectuales de Talento 1918-1924'." Bachelors dissertation, Pontificia Universidad Católica del Ecuador, 2007.

Villarroel Claure, Rigoberto. *Arte contemporáneo. Pintores, escultores y grabadores bolivianos*. La Paz: Self-edition, 1952.

Villegas Torres, Fernando. "El Instituto de Arte Peruano (1931-1973): José Sabogal y el mestizaje en arte," *Illapa Mana Tukukuq. Revista del Instituto de Investigaciones Museológicas y Artísticas de la Universidad Ricardo Palma*, no. 3 (December 2006): 21-34.

— *Vínculos artísticos entre España y el Perú (1892-1929). Elementos para la construcción del imaginario nacional peruano*. Lima: Fondo Editorial del Congreso del Perú, 2015.

Visca, Arturo Sergio. Preface to Visca, Arturo Sergio, ed. *Antología de poetas modernistas menores*. Montevideo: Ministerio de Educación y Cultura, Biblioteca Artigas, 1971, VII-LXVI.

Vitureira, Cipriano S. "El dibujo de Adolfo Pastor," *Apartado de la Revista Nacional*, no. 67 (1943).

Vlcková, Lucie, ed. *Letra y fotografía en la vanguardia checa*. Valencia: Campgràfic, 2006.

Zani, Giselda. "Indoamérica, órgano de la sección mexicana del APRA," *Vanguardia. Revista de Avance*, no. 2 (October 1928): 13-14.

Zárate, Freddy. "Tres artistas para Pérez Velasco," *La Razón* (October 4, 2015).

Zavaleta Ochoa, Eugenia. *Las exposiciones de artes plásticas en Costa Rica (1928-1937)*. San José: Editorial de la Universidad de Costa Rica, 2004.

Zurián, Carla. *Fermín Revueltas. Constructor de espacios*. Mexico City: Editorial RM and Instituto Nacional de Bellas Artes, 2002.

Index of names in catalogued works

A

Abadie Soriano, Roberto 685
Abascal, Valentín 266
Abela, Eduardo 366
Abracheff, Nicolai 218, 752
Abreu, Manoel de 223, 237, 238
Abril, Xavier 29, 655
Abril y de Vivero, Pablo 530
Acle, Rosa 777
Acosta, Agustín 384
Acosta, José Manuel 378, 382, 383, 384
Adriasola, Arturo 327, 329, 334
Aguilera Malta, Demetrio 398, 659
Aguirre, Manuel Agustín 417, 432
Agustini, Delmira 579
Alcán, Justino César 482
Alcobre, Manuel 138
Aldunate Philips, Arturo 328
Alexander, Francisco 673
Alfaro Siqueiros, David 23, 772
Almeida, Guilherme de 188, 191, 212, 217, 228, 229
Almeida, Paulo Mendes de 225, 709
Alva de la Canal, Ramón 452, 470, 472, 474, 475, 481, 500, 712, 784
Álvarez, Luis Fernando 660

Alvial, Aníbal 282, 309
Alvial Bensen, Lautaro 318
Amábilis, Manuel 682, 763
Amado, Jorge 235
Amador, Fernán Félix de 108
Amaral, Tarsila do 59, 196, 216, 237, 244, 708
Amiguetti, Francisco 270, 272
Amoretti Cassini, Emilio 176
Amorim, Enrique 684
Amster, Mauricio 435
Andrade, Flávio de 233
Andrade, Mário de 217, 710
Andrade, Oswald de 59, 196, 215, 216, 233, 237, 242, 708
Andrade (Filho), Oswald de 233, 242
Andrade Marchant, Clemente 292, 650
Andrade Moscoso, Carlos 412
Andrade y Cordero, César 413
Anjos, Augusto dos 657
Antolínez, Gilberto 619
Aóiz Vilaseca, Fausto 160, 187
Apu-Rimak: see *Alejandro González Trujillo*
Arancibia, Lupercio 320

Arango Uribe, Alberto 354, 355, 669
Arato, José 112
Araya, Juan Agustín 300
Arenal, Luis 787
Arévalo Martínez, Rafael 265
Arguedas, Alcides 176
Arias R., Augusto 412
Arias Trujillo, Bernardo 355
Ariza, Gonzalo 365
Arlt, Roberto 151
Armanini, José 758
Armaza, Emilio 657
Armaza, Juan de: see *Alfonso Bulnes*
Arp, Hans 333
Arquitecto poeta, El: see *Rafael Seijas Cook*
Arriagada Hermosilla, René 330
Arvelo Torrealba, Alberto 627
Arzúa, Jorge 609
Arzubiaga, Miguel de 147
Ascone, Vicente 685
Audivert, Pompeyo 124, 125, 152
Ávila, Julio Enrique 267
Ávila Jiménez, Antonio 719
Azuela, Mariano 78, 677

B

Ballagas, Emilio 390
Ballester Peña, Juan Antonio 91, 126, 127, 782
Baltra, Germán 308, 316, 512, 540
Bandeira, Manoel (or *Manuel*) 234, 651
Bandeira, Salvador 693
Barbé Pérez, Luis 734
Barbosa, Arnaldo 225, 709
Barletta, Leónidas 112
Barradas, Rafael 24, 26, 48, 49, 50, 51, 53, 602
Barrantes Castro, Pedro 552
Barreiro Tablada, Enrique 498
Barrera Parra, Jaime 358
Barriga Figueroa, Luis 321, 324
Barros, Carlos Marinho de Paula 229
Basaldúa, Héctor 68
Bascuñán, Ciro 319
Basile, Giambattista 60
Basso Maglio, Vicente 602, 675
Bastos Tigre: see *Manuel Bastos Tigre*
Bastos, Abguar 760
Bastos Barreto, Benedito Carneiro 228
Beals, Carleton 69, 80, 81, 763
Beaz, Nolo: see *Gustavo Adolfo Otero*
Beer, Max 502
Belausteguigoitia, Ramón de 505
Belleza, Newton 242
Bellocq, Adolfo 112
Bellolio, Antonio 412, 413, 415, 421
Belmonte: see *Benedito Carneiro Bastos Barreto*
Beloff, Angelina 462
Beraldo Fuentes, María Teresa 606
Bermúdez Franco, Antonio 108, 109
Bermúdez Franco, Fernando 108
Bernárdez, Francisco Luis 50
Bernárdez, Juan Carlos 624
Berninsone, Luis 668
Berríos, Gerardo 542
Besnard, Pierre 156
Best Maugard, Adolfo 439
Bianchi, Edmundo 597
Bianchi, Marco Aurelio 597
Blake, Pedro V. 117, 142
Blanco, Andrés Eloy 630
Blas, Camilo 552
Bohórquez, Carlos L. 622
Bojórquez, Juan de Dios
Bolaños, Federico 530
Bolaños, Reynaldo 540, 655
Bonilla del Valle, Ernesto 522

Bonomi, José 128, 715, 748
Booz, Mateo 148, 676
Bopp, Raul (or *Raúl*)
Borges, Jorge Luis 6, 86, 116, 118, 711
Borges, Norah 6, 24, 72, 86, 89, 116, 141, 308, 311, 584
Borja, Arturo 412
Bragaglia, Anton Giulio 145
Brandi Vera, Pascual 303, 321, 339
Bravo, Alfredo Guillermo 300
Brecheret, Victor (or *Víctor*) 215
Brescia Camagni, Ángel 549
Breton, André 396
Brannon Vega, Carmen 276
Brum, Blanca Luz 512, 534, 653, 779, 780
Bueno, Gonzalo E. 418, 421
Bueno, Luis 707
Bufano, Alfredo R. 748, 750
Buitrago, Guillermo 758
Burgos, Fausto 754, 759
Burgos, Julia de 264
Bulnes, Alfonso 63, 714
Bustamante, Abelardo 309
Bustamante y Ballivián, Enrique 550, 552, 554

C

Caballé, Ramón 144
Caballero Ars, El: see *Amadeo Rodolfo Sirolli*
Cabezón, Isaías 61, 282
Cabrera, Raimundo 352
Cáceres, Esther de 653, 677
Camacho, Fabio 751
Camargo Pérez, Gabriel 359
Cambours Ocampo, Arturo 676
Campoamor, Fernando G. 386
Campos, Moacyr 737
Campos Cervera, Andrés 762
Canal Feijóo, Bernardo 114, 115, 136, 664
Cané, Luis 658
Canel, Casto 602
Cardoza y Aragón, Luis 61, 724
Carlos Luis [NN] 671
Carnelli, María Luisa 129
Cárpena, Elías 752
Carrasco Délano, Gustavo 328
Carrasquilla, Tomás 358
Carreño, Mario 387, 393
Carrera Andrade, Jorge 412, 419
Carreras, Roberto de las 576
Carrión, Alejandro 425, 426
Carrión, Benjamín 417, 432, 648

Carvalho, Flávio de 208, 230, 231
Carvalho, Ronald de 218, 752
Casaula, Pasquale 319
Castagnino, Juan Carlos 155
Castañeda, Daniel 649
Castellanos Balparda, Leandro 587
Castellanos, Carlos Alberto 579
Castellanos, Julio 479
Castelnuovo, Elías 149
Castello, Enrico 215
Castro Fernández, H. Alfredo 276
Catullo, María Elena 754
Catunda [NN] 233
Caváco, Carlos 233
Cavalcanti, Emiliano Di 192, 195, 212, 214, 223, 226, 242, 710
Cavalcanti, Paulo 233
Celedón, Pedro 296
Celery, Emiliano 732
Cendrars, Blaise 42, 58
Césaire, Aimé 396
César, Guilhermino 246
César, Osório 244
Chapero, Ángel 678
Charlot, Jean 470, 473
Chas de Chruz, Israel 667
Chavarría Flores, Manuel 266
Chávez Morado, José 508, 774
Chin: see *Enrico Castello*
Cioppo, Atahualpa del: see *Américo Celestino del Cioppo Fogliacco*
Cioppo Fogliacco, Américo Celestino del 675
Codesido, Julia 545, 552
Coimbra Ojopi, Gil 175
Coke: see *Jorge Délano*
Colson, Jaime A. 64
Conde, Carmen 72
Coppola, Horacio 103, 159
Cordeiro, João 235
Cordero [NN] 460
Coronel, Rafael 337
Cossío del Pomar, Felipe 157
Costa, Eneida de Vilas Boas 761
Costallat, Benjamín 215, 242, 674
Couto Ribeiro, Rui 212, 239
Covarrubias, Miguel 73, 74
Crespo Báez, Nina 622
Crespo Gastelú, David 175, 180, 181, 185
Cruls, Gastão 214
Cruz, Horacio 146
Cruz de Caprile, Fifa 146
Cuadra, José de la 433, 434, 728, 729, 731

Cuadra, Pablo Antonio 269
Cuenca, Héctor 622
Cuesta, Jorge 481
Cunha, José Carlos de Brito e 240, 247
Curatella Manes, Pablo 66

D
D'Alvarez, (José) Martins 233
Dallegri, Santiago 595
Dávila, Ángel Eduardo 422
D'Elia, Miguel Alfredo 155
Delmar, Serafín: see *Reynaldo Bolaños*
Del Mar, Serafín: see *Reynaldo Bolaños*
Déjacque, Joseph 126
Délano, Jorge 324
Délano, Luis Enrique 308, 309
Delaunay, Robert 45
Delgado, Nicolás 412
Dell'Acqua, Juan Bautista 144
Descalzi, Ricardo 413
Dessein Merlo, Justo G. 144, 757
Devéscovi, Juan 29
Deza Méndez, Gonzalo 688
Dias, Fernando Correia 212
Díaz García, Olga 296
Díaz de León, Francisco 296
Díaz, Ramón M. 593
Díaz Casanueva, Humberto 311
Díaz Díaz, Oswaldo 363
Dieste, Eduardo 578
Djed Bórquez: see *Juan de Dios Bojórquez*
Doin, Jonny 243
D'Oliveira, Felippe 658
Dotti, Víctor M. 652
Dr. Atl: see *Gerardo Murillo*
Droguett, Carlos 339
Droguett, Luis O. 339
Dromundo, Baltasar 657, 684
Duarte, Benedito Junqueira 204
Duarte Moreno, Carlos 498
Duchartre, P. L. 56
Dueñas T., Ricardo 248

E
Edwards, Agustín 67
Edwards, Emily 764
Edwards Bello, Joaquín 301, 306, 323
Egas, Camilo 68, 402
Eguino Zaballa, Félix 187
Ehrenburg, Ilya: see *Ilya Grigoryevich Ehrenburg*
Eichelbaum, Samuel 667
Elódio [NN] 761

Eneida: see *Eneida de Vilas Boas Costa*
Enríquez, Plinio 321
Escala, Víctor H. 628
Escobar, Zoilo 316
Escudero, Gonzalo 435, 673
España, José de 128
Esquerre Montoya, Julio 542, 543
Esquerriloff: see *Julio Esquerre Montoya*
Estrada Gómez (Efraín) 283, 309
Estrada, Genaro 478
Estrella, Omar 718
Estudio Nuti (Pepe Mexía) 358
Etcheverts, Sara de 149

F
Fabbri, Luce 152
Fabrès, Oscar 61
Faedrich, Nelson Boeira 240, 245
Faig, Juan Carlos 598, 675
Favilla, Hyldeth 240
Fayol, Luis Alberto 675, 677
Fernández, Jorge 405, 418, 425
Fernández Díaz, Francisco Miguel 18
Fernández y González, Héctor 563, 590
Fernández Ledesma, Gabriel 462
Fernández Silva, Oscar 136
Ferreira, Ignácio da Costa 219, 227
Ferreiro, Alfredo Mario 588, 589, 717
Ferrer, Gilberto 372
Ferrignac: see *Ignácio da Costa Ferreira*
Figari, Pedro 62
Fijman, Jacobo 124
Filardi, Carmelo 262
Filartigas, Juan M. 601
Filloy, Juan 131
Fingerit, Marcos 122
Florit, Juan 282, 283, 711
Fontana, Lucio 111
Fontanals, Manuel 48
Fontes, José Martins 674
Fortuny, Manuel 147
Francisco Miguel: see *Francisco Miguel Fernández Díaz*
Franco, Luis 662
Frangella, Humberto 593, 594, 675
Frías, Carlos Eduardo 624
Friedric, José 690
Frontaura Argandoña, Manuel 175
Frontaura Argandoña, María 182, 183
Fuente, Julio de la 502, 774
Fuente, Nicanor A. de la 725
Fuente [NN], de la 78
Fuentes Lira, Manuel: see *Manuel Fuentes Lira*

Fuentes Lira, Mariano 184, 759
Fusco Sansone, Nicolás 586
Fusco, Rosário 246

G
Galaz, Alejandro 320
Galecio, Galo 417
Gallardo, Laurencio 325
Gallardo, Salvador 470
Gallegos Lara, Joaquín 659
Gallegos Sánz, Manuel 549
Gallo, Octavio N. 762
Galtier, Lisandro (or *Lysandro*) Z. D. 684, 752
Gálvez, Manuel 112
Gamboa Cantón, Raúl 499
Gandulfo, Juan 303
Garbi, Pedro Jorge 144
García, Enrique Eduardo 134
García, Luis: see *Luis Pardo*
García Benítez, Andrés 386
García Lorca, Federico 140
García Maroto, Gabriel 376, 443, 478, 481, 488
García (Ochoa), José Uriel 754
Garibaldi, Blanca 609
Garo, Nicola de: see *Nicolai Abracheff*
Gavela O., Humberto 434
Gehain, Adhemar 176
Gide, André 654
Giglio, Francisco Di 142, 143
Gil, Antonio Alejandro 684
Gil Gilbert, Enrique 684
Gil Ruiz, Victoriano 761
Gimeno, M. 667
Giordano, Luis 587
Girón Cerna, Carlos 764
Girondo, Oliverio 55, 91, 96, 128, 715
Gluzeau Mortet, Luis 734
Goeldi, Oswaldo 241
Gómez, Isola 277
Gómez Cornejo, Carlos 185
Gómez Robleda, José 483
Gómez de la Serna, Ramón 49, 142, 143
González, Carlos Alberto 653
González, Fernando 354
González, Juan Francisco 320, 321, 323
González, Julio V. 752
González Arrili, Bernardo 150, 748
González Barbé, Traslación Martín 677
González Camarena, Jorge 509
González Carballo, José 136, 139
González Gutiérrez, J. 348

González Lanuza, Eduardo 86, 654
González y Medina [NN] 176
González Puig, Ernesto 390
González Trillo, Enrique 670, 671
González Trujillo, Alejandro 527, 553, 762
González Tuñón, Enrique 128
González Tuñón, Raúl 129, 139, 155
Goyburu, Emilio 536, 713
Graiver, Bernardo 136
Gramajo Gutiérrez, Alfredo 754
Gravigny, Jean 56
Greiff, León de 364, 669
Grigoryevich Ehrenburg, Ilya 40, 41
Grullón, José Diego 395
Guarderas, Sergio 416, 421, 422
Guardia Mayorga, César A. 681
Guastini, Mario 219
Guayasamín Calero, Oswaldo 432
Guerra Solís, Lucas 544
Guerrero, Julio C. 187
Guerrero, Praxedis 498
Guerrero, Xavier 787
Guevara, Andrés 138, 139, 777
Guevara, Víctor J. 547, 553
Guido, Alfredo 174, 734
Guido, Ángel 137
Guijarro, Juan 684
Guillén, Alberto 531, 532
Guillén, Nicolás 394
Guillot Muñoz, Álvaro 581
Guillot Muñoz, Gervasio 581
Güiraldes, Ricardo 652
Guirao, Ramón 394
Gutiérrez, Alejandro 308, 309
Gutiérrez A., Abel 753
Gutiérrez Cruz, Carlos 774, 783
Gutiérrez Gutiérrez, Moisés Filadelfio 283, 287, 651
Gutmann, Enrique 506
Guzmán de Rojas, Cecilio 187

H
Harth-Terré, Émile (Emilio) 530
Hauteclocque, Xavier de 334
Henri, Ernst 156
Hermosilla, Carlos 336, 337, 668, 779, 780
Hernández Cárdenas, José Cecilio 369, 388, 389
Hernández de Alba, Gregorio 356
Hernández de Rosario (Fausto) 120
Hernández Franco, Tomás 64
Hernández, José 68

Herrera Frimont, Celestino 494
Herrería, Julián de la: see *Andrés Campos Cervera*
Herreros, Pedro 109
Hidalgo, Alberto 118, 132, 706
Himiob, Nelson 612, 615, 624
Hinojosa, Roberto 672
Hirka, Tristán 308
Hostos, Adolfo de 764
Huelén: see *Juan Francisco González*
Huidobro, Vicente 18, 23, 44, 45, 118, 332, 333, 701, 703, 711, 714
Humeres, Roberto 282

I
Ibáñez, Genaro 174, 178, 187
Ibáñez, Víctor M. 179
Icaza, Jorge 433, 434, 655, 726
Icaza, Xavier 491
Ignacios, Antonio de: see *Antonio Ignacio Pérez Giménez*
Ilin, M. 502
Ipuche, Pedro Leandro 583
Isajara: see *Isabel de Jaramillo*
Iturri Jurado, Pablo 179, 187
Izaguirre, Carlos 268
Izaguirre Rojo, Baltasar 268
Ízcua de Muñoz, María Carmen 601

J
J. Carlos: see *José Carlos de Brito e Cunha*
J. E. H. [NN] 149
J. P. L. [NN] 736
Jaimes Freyre, Raúl 174
Jaramillo, Isabel de 554
Jaramillo Medina, Francisco 352
Jiménez, Agustín 506, 509
Jiménez, Max 257, 271, 273, 274, 275
José Gabriel: see *José Gabriel López*
José Luis [NN] 609

K
KaiKu [NN] 357
Kanela: see *Carlos Andrade Moscoso*
Katari, Ramón (or Ramún): see *Pablo Iturri Jurado*
Kaye, Rebecca 763
Kingman, Eduardo 424, 425, 426, 427, 428, 430, 432, 433
Kirs, Manuel 137
Kyn Taniya: see *Luis Quintanilla*

L
Laborde, Guillermo 685
Lafuente, Mireya 328
Lagorio, Arturo 113
Laguardia, Adda 582
Lam, Wifredo 396
Lamar Schweyer, Alberto 383
Lamo, Rafael de 150
Lanau, Federico 566, 577, 579, 580, 748
Lars, Claudia: see *Carmen Brannon Vega*
Lara Valle, Raúl 288, 292, 314, 315
Lasarte, Juan 156
Lascano Tegui, Viscount 53
Lasso, Ignacio 405, 421
Latorre, Guillermo 414, 415, 422, 434
Lavín [NN] 152
Leal, Fernando 76
Léger, Fernand 603
Leguizamón Pondal, Gonzalo 752
Lema, Marcial 278
León, J. Iván de 152
León, Ricardo 433
Lery, Lila 609
Lessa, Orígenes 243
Lhevinne, Isadore 68
Lima, Hildebrando de 233
Lima, Jorge de 234
Lima, José Francisco de Araújo 760
Lira, Miguel N. 492
List Arzubide, Germán 452, 470, 471, 472, 474, 500, 501, 502
Llerena, José Alfredo 426, 686
López, José Gabriel 750
López Albújar, Enrique 530
López Dorticós, Pedro 386
López y Fuentes, Gregorio 82
López Gómez, Adel 360
López Naguil, Gregorio 108
López Pombo, María Clemencia 584, 585
López Rocha, Carlos 700
López Velarde, Ramón 477
Ludwig, Emil 82
Luza, Reynaldo 530

M
Macaya, Luis 144, 158, 756, 757
Machado, António de Alcântara 196, 220, 224, 708
Machado, Gilka 177, 760
Machado, Rodolpho 214
Mac-Lean y Estenós, Roberto 531, 535
Magariños, Renée 588

Magno, Paschoal Carlos 233
Mallea, Eduardo 159
Mancisidor, José 775
Manríquez y Zárate (Bishop of Huejutla), José de Jesús 674
Maples Arce, Manuel 76, 436, 440, 470, 473, 475, 688
Mar, Serafín del: see *Reynaldo Bolaños*
María del Mar [NN] 495
Mariani, Mario 223
Mariátegui, José Carlos 510, 519, 545, 635
Maribona, Armando 62
Marín, Juan 307, 326, 721
Marinetti, Filippo Tommaso 130
Marizancene: see *H. Alfredo Castro Fernández*
Martelli, Sixto C. 158
Martínez Sierra, Gregorio 48
Martínez Sotomayor, Gustavo 288
Martins, Maria 36
Masanés, Arturo Carlos 607
Mascarenhas, Manuel 137
Mata, Gonzalo Humberto 421, 433
Mate, Braulio 158
Matilde Eugenia NN] 460
Matos-Díaz, Eduardo 251
Matta Echaurren, Roberto 330
Maturana B., Ventura 676
Max [NN] 549
Maya, Alfredo 482
Medeiros e Albuquerque, José Joaquim de Campos da Costa 212
Medina, Gabriel de 312
Medina Febres, Mariano 626, 627, 783
Mediz Bolio, Antonio 83
Medo: see *Mariano Medina Febres*
Mejía Nieto, Arturo 272
Meléndez Ortiz, Luis 300, 301
Menasché, Marcelo 144
Mendarozqueta, José 774
Mendes, Murilo 238
Méndez, Francisco 267
Méndez, Leopoldo 452, 457, 494, 495, 498, 501, 775
Méndez Magariños, Melchor 71, 560, 582, 583, 589, 717
Méndez Rivas, Joaquín 749
Mendoza, Jaime 176
Mercado, Guillermo 544
Mérida, Carlos 80, 81, 265, 463
Mexía, Pepe 358
Middendorf, E. W. 746
Mideros, Víctor 423

Milliet, Sérge (or *Sérgio*) 212, 657
Mirabelli, Bartolomé 129
Miralles R., Enrique 289
Miranda Klix, José Guillermo 137
Moen, Arnoldo 646
Molina La Hitte, Alfredo 301
Molina Nuñez, Julio 300
Molinari, Ricardo E. 140, 141
Mondragón, Carmen 468, 469
Mongo Paneque: see *Manuel Navarro Luna*
Monsegur, Raúl 53
Montaine, Eliseo 158
Montaldo, Caupolicán 301
Monteiro, Vicente do Rego 56
Monteiro Filho [NN] 242
Montenegro, Carlos 388
Montenegro, Roberto 86, 460, 461, 471, 483, 484, 750
Monterrubio Sáenz, María Evelia 677
Moraes, Eneida de: see *Eneida de Vilas Boas Costa*
Moraes, Raymundo 761
Moraga Bustamante, J. 282, 283, 711
Morales, Delio 667
Morales, Ernesto 126, 756, 757
Morales Cuentas, Manuel 514
Morales Lara, Julio 626
Morales Nadler, Antonio 267
Moratorio de Torres, María Clotilde 594
Moreno y Oviedo, Antonio 482
Moreno Quintana, Luis M. 751
Morey Peña, Víctor 538, 717
Morgado, Benjamín 292, 316
Moro, César: see *Alfredo Quízpez Asín*
Morrón [NN] 369
Mowrer, Edgar Ansel 153
Mundy, Hilda 175
Munizaga Hozven, Maclovio 318
Muñoz, María Elena 583
Muñoz Cota, José 774
Murcia, Luis María 355
Murco, Staio 215
Murillo, Gerardo 67, 464, 465, 466, 467, 468, 469, 471, 712
Musetti, Francisco L. 595

N

Nahui Olin: see *Carmen Mondragón*
Nannetti, Cleonice 683
Narváez, Francisco 630, 631
Navarro Aceves, Salvador 422
Navarro Luna, Manuel 386, 387

Nazaré, Jacobo: see *Luis Barriga Figueroa*
Negri, Ada 596
Neli, Ecco: see *Cleonice Nannetti*
Neptalí Vaca, Telmo 412, 413, 415
Neruda, Pablo 303, 334, 655
Neves, Berilo 242, 243
Nicolai, Jorge F. 156
Ninón: see *Nina Crespo Báez*
Nixa: see *Nicanor A. de la Fuente*
Novo, Salvador 484
Núñez, Serafina 386
Núñez y Domínguez, José de Jesús 460
Núñez Regueiro, Manuel 111

O

Ocampo, Carlos 667
Ocampo, Isidoro 482
Odiozábal, Lucio T. 675
Oliva Nogueira, José 110
Olivari, Nicolás 139, 158, 658
Olmos, Pedro 326, 334
Onetti, Juan Carlos 602
Oquendo de Amat, Carlos 536, 713
Oribe, Emilio 580
Orozco, José Clemente 580
Ortiz, Fernando 382
Ortiz Behety, Luis 670, 671
Ortiz Hernán, Gustavo 506
Ortiz de Montellano, Bernardo 479, 658
Ortiz Saralegui, Juvenal 563, 590
Otero Reiche, Raúl 187
Otero, Gustavo Adolfo (Nolo Beaz) 187

P

Pacheco, Máximo 504
Pacheco U. [NN] 175
Padrón, Julián 631
Pagani, José María 591
Paim Vieira, Antônio 220, 229, 708
Pako [NN] 622
Palacio, Alfredo 406, 429, 432
Palacio, Pablo 414
Palacios, Arsenio 215
Palés Matos, Luis 262
Pantigoso, Manuel Domingo 512, 538, 743
Pardo, Luis 690
Pardo, Luis A. 527, 755
Paredes, Diógenes 413, 429
Paredes, Ricardo A. 424
Pareja y Díez-Canseco, Alfredo 413
Parra del Riego, Blanca Luz Brum de: see *Blanca Luz Brum*

Parra del Riego, Juan 577, 601, 665
Parra, Gonzalo de la 460
Paschin, Alberto: see *Abelardo Bustamante*
Pascual, Félix 110
Pastor, Adolfo 586
Pavletich, Esteban 674
Pavón Flores, Mario 485
Paz, J. A. 268
Paz y Miño, Germania 268
Paz de Noboa, Carlos Alberto 549, 753
Pazos Kanki, Vicente 176
Pedroso, Regino 389
Peixoto, Francisco Inácio 246
Pellicer, Carlos 461
Pena, Antonio 578
Penell [NN] 361
Peña, Eladio 601
Peralta, Alejandro 538
Pereda Valdés, Ildefonso 584, 585, 603
Pereyra, Emilia A. de 123
Pérez, Estefanía 663
Pérez Giménez, Antonio Ignacio 727
Pérez Morales [NN] 386
Pérez Petit, Víctor 675
Pérez Ruiz, Carlos 118, 711
Pérez Santana, Alfredo 292, 314, 315, 316, 721
Pérez de Silva, Matilde 764
Pérez Velasco, Daniel 178
Perotti, José 301
Pesce Castro, Carlos 601
Pettoruti, Emilio 98, 117, 134, 136, 145
Pineda, Roberto 354
Pinetta, Alberto 148
Pinto, Mercedes 661
Plá Guerra Galvany, María Josefina 762
Planas Casas, José 156
Plonka, Pedro: see *Pedro Valenzuela Páez*
Polillo, Raúl de 227
Ponferrada, Juan Óscar 129
Portal, Magda 543, 548, 651, 655
Portinari, Cândido 238
Portogalo, José 155
Portugal Zamora, Max 183
Posada, Guillermo 352
Prado, João Fernando de Almeida 228
Prado, Juvenal 212
Prado, Yan Almeida: see *João Fernando de Almeida Prado*
Prats, Lika 592
Preising and Vamp, Theodor: see *Benedito Junqueira Duarte*

Prieto, Julio 492
Pro, Raúl 531
Pruneda, Salvador 506
Puig Casauranc, J. M. 678

Q
Quijano Mantilla, Joaquín 362
Quintanilla, Luis 470, 712
Quirós, Teodorico 271
Quízpez Asín, Alfredo 530, 531, 534
Quízpez Asín, Carlos 531, 674

R
Rachmanova, Alia 245
Radaelli, Mario 604
Ramírez, José 622
Ramos, Graciliano 234
Ramponi, Jorge Enrique 144
Ramponi, Miguel Ángel 144
Ravenet, Domingo 390
Raygada, Carlos 534, 535
Recavarren de Zizold, Catalina 554
Rega Molina, Horacio 138
Rego, José Lins do 234
Reiss, Winold 291
Reissig, Luis 127
Remenyik, Zsigmond 304, 534
Renau, Josep 503
Rendón, Ricardo 352
Restrepo Jaramillo, José 361
Revueltas, Fermín 440, 449, 475, 476, 477
Reyes, Salvador 320
Reyes Gutiérrez, Carlos 359
Reyes Messa, Alfonso 721
Reynolds, Gregorio 174, 184, 754
Reza, Jorge de la 187
Ricaldoni, Hugo L. 599
Ricardo, Cassiano 204, 226, 228, 666
Ricci Sánchez (Federico) 309
Riccio, Gustavo 126
Rigol, Jorge 392
Rio, João do 214
Rivera, Diego 35, 40, 41, 82, 83, 447, 496, 497, 749, 764, 769, 783
Rivero Oramas, Rafael 612, 615, 616, 624, 628, 629
Roa, Raúl 392
Rocca, Víctor A. 605
Rocha, Dámaso 240
Rodig, Laura 325
Rodrigo, Saturnino 747
Rodríguez, Carlos 432
Rodríguez, Pedro Alejo 362

Rojas Giménez, Alberto 320
Rojas González, Francisco 475
Rojas, Rosa María 550
Rokha, Pablo de 286, 312, 336, 337, 650, 651, 656
Rokha, Winétt de 313
Romero Padilla, Emilio 552
Rosales, Justo Abel 552
Rosarivo, Raúl Mario 667, 757
Rosie [NN] 764
Rossato, Alex 674
Rossi, Attilio 103, 159
Rossi Delucchi, Elena 597
Rovira, José 168
Rozo, Rómulo 356
Ruiz, Víctor 747
Rumazo González, José 423
Ruschel, Nilo 240
Russo, Nicolás Antonio 87, 109
Ruzo, Daniel 532, 533
Ryan, Ricardo 149

S
Sabat Ercasty, Carlos 577, 579
Sábat Pebet, Juan Carlos 609
Sábat Pebet, María Matilde G. de 608
Sabogal, José 69, 510, 519, 535, 533, 541, 546, 551, 552, 635, 748, 754
Sacotto Arias, Augusto 427
Sáenz, Raquel 659
Salarrué: see *Salvador Efraín Salazar Arrué*
Salas, Hugo 187
Salazar, Rosendo 496
Salazar, Toño 61
Salazar Arrué, Salvador Efraín 259, 266, 267, 276
Salcedo C., Julio C. 311
Salmon, André 61
Salterain y Herrera, Eduardo de 591
Salvador, Humberto 416, 422, 432, 434
Salvat-Papasseit, Joan 46, 47
Samper, Adolfo 360
Samper, Darío 364
San Martín Ibarbourou, Carlos 641
Sánchez, Luis Alberto 546, 762
Sánchez de Andrade, Jaime 687
Sanjinés, Alfredo 187
Santa Rosa, Tomás 234, 235, 238
Santandreu Morales, Ema 596
Santos Peña, Jesús 775
Sarquis, Francisco 502
Scandroglio, Rinaldo 353, 355

Scarzolo Travieso, Luis 605
Schiavo, Horacio A. 128
Scotti, Ernesto 97, 155
Seguel, Gerardo 654
Seijas Cook, Rafael 629
Sellawaj, Ret: see *Juan Antonio Ballester Peña*
Seoane, Jorge 531
Seoane, Manuel 549
Sepúlveda, Luis C. 78
Serna, Roberto G. 684
Serrano, Gloria 180, 181
Serrano [NN] 397
Serrano Vernengo, Marisa 663
Servetti Reeves, Jorge Carlos 746
Setaro, Ricardo M. 139
Sgarbi, Héctor 598, 599
Silva, Guilherme de Castro e 761
Silva Román, Ernesto 323
Silva Valdés, Fernán 579, 601, 748
Silva y Aceves, Mariano 490
Silva, Julio 652
Sima, Joseph 332
Sirio, Alejandro 150, 667
Sirolli, Amadeo Rodolfo 757
Smith, Roberto 87, 120
Sofovich, Luisa 659
Soiza Reilly, Juan José de 446
Solari Ormachea, M.ª Teresa 174
Soldi, Raúl 142, 143
Soler Darás, José 119
Soliva [NN] 760
Sosa, Jesualdo 650
Sotomayor Febres Cordero, Adolfo 432
Souvirón, José María 327
Spatakis, Leónidas 597
Speroni, José 751
Spont Watteau, Andrés 670
Spotorno, Juan Antonio 654
Stevenson, Roberto L. 460
Students of the Instituto Nacional (Chile) 753
Suarée, Octavio de la: see *Octavio Suárez*
Suárez, Octavio 393
Suárez Vértiz, Germán 512

T

Tablada, José Juan 74, 623, 705
Tagle, María 328
Tallon, José Sebastián 109, 684
Tallon, Rodolfo 684
Tejada Zambrano, Leonardo 398, 429, 433, 731

Terán, Enrique A. 405
Tharsis, Gema de 328
Thibon de Libian, Valentín 112
Tigre, Manuel Bastos 247
Tirado Fuentes, René 476
Tobón Mejía, Marco 352
Toller, Ernst 152
Toro Moreno, Luis 174, 413
Toro, Jesús Carlos 304
Torre, Amadeo de la 547
Torre, Guillermo de 24, 51
Torres Bodet, Jaime 442, 443, 460, 463
Torres Donoso, J. 176
Torres Mariño, Rafael 357
Torres-García, Joaquín 46, 47, 556, 572, 610, 611, 765
Torres, Sagunto 108
Totasaus, Luis 677
Toussaint, Manuel 490
Travascio, Adolfo 122, 123
Troupe Ateniense 723
Trujillo, Federico 358
Trujillo Magnenat, Sergio 340, 345, 362, 363, 364

U

Ugarte, Enrique A. 775
Uribe Piedrahita, César 365
Urruchúa, Demetrio 152, 155

V

Vacas Gómez, Humberto 432
Valcárcel, Luis E. 754
Valcárcel, Theodoro 743
Valdelomar, Abraham 748
Valdivia, Víctor 638
Valencia, Guillermo 353
Valenzuela Páez, Pedro 311, 337
Valle Goycochea, Luis 552
Valle, Félix del 531
Valle, Rosamel del: see *Moisés Filadelfio Gutiérrez Gutiérrez*
Vallejo, Arístides 532
Vallejo, Carlos María de 52, 70, 71
Vallejo, César A. 538, 717
Vanzo, Julio 120, 148, 156, 157
Vargas [NN] 470
Vargas Fano, J. Américo 553
Vargas Rosas, Luis 67, 306
Vasconcelos, José 270, 534
Vásquez, Emilio 553
Vega, Daniel de la 301
Vela, Arqueles 474, 712

Vela, Pablo Hannibal 422
Velarde, Héctor 530
Velazco R., F. Leónidas 520
Vera, María Luisa 774
Vera, Pedro Jorge 427
Vergottini, Julio César 783
Vidales, Luis 650
Vigo, Abraham Regino 149
Villalobos, Héctor Guillermo 783
Villanueva, Marta 62
Villaurrutia, Xavier 480
Villegas, Alberto de 175
Villin, Jean Gabriel 199, 243
Vinatea Reinoso, Jorge 530
Vincenzi, Moisés 270
Viñole, Omar 138
Vizcarra, Raúl 553
Vizcarrondo, Carmelina 262

W

Welker, Juan Carlos 563, 601
Werneck, Paulo 674
Wiedner, (Carlos) 149
Wiesse, María 533, 541, 551
Wilde, Oscar 212
Wilms Montt, Thérèse 108

Y

Yela Günther, Rafael 267
Yllanes, Alejandro Mario 183
Yorio, Gerónimo 676
Yunque, Álvaro 126, 127, 684

Z

Zadán, Demetrio 138
Zani de Welker, Giselda 601
Zárate, P., Brother Rosario [Order of Preachers] 554
Zárraga, Ángel 42
Zarrilli, Humberto 566, 569, 659, 685
Zayas, Marius de 23, 32
Zevallos Menéndez, Carlos 420, 434, 728
Zorrilla de San Martín, José Luis 579
Zúccoli, Ofelia 328
Zúñiga, Horacio 486, 487, 647

Acknowledgements

José Ignacio Abeijón
Herenia Acosta
Rodrigo Agüero
Antonio Alonso
Carmen Alonso
Peter Altekrueger
Javier Álvarez
Pedro Álvarez Caselli
María Isabel Álvarez Plata
Gilvaldo Amaral Santos
Paola Amaya
Lucio Aquilanti
Alexis Argüello Sandoval
Libia Arteaga
Patricia M. Artundo
Silvia Badalotti
Federico Barea
Leonel de Barros
Malena Bedoya
María Isabel Bellido Gant
María Luisa Bellido Gant
Martín Bergel
Sara Bolaños
Juan Manuel Bonet
Juan Bonilla
Joana Bosak
Raquel Botubol Rivera
Susanne Brüning-Wehking
Alfonso Caballero Trenado
Pablo Cajas Vargas
Maristella Calil
María Luz Calisto Ponce
Rubén Capdevila Yampey
Doriana Capenti
Laura Carneiro
Carlos Carnero Figuerola
Alfredo Carril Tesauro
Mari Carmen Carrillo
Mabela Casal Reyes
Sarah Cash
Alan Castro
Macarena Cebrián
Mishel Cevallos Valencia
Antoine Chareyre
Pilar Chaves Castanedo
Leda Cintra Castellán
Dayse Conceição
Mariella Cosio
Iván Cruz Cevallos
Dafne Cruz Porchini
Kimberly Dumas

Luisa Durán Rocca
Ticio Escobar
Alberto Escovar Wilson-White
Daniel Expósito Sánchez
Alexis Fabry
Gabriel Fabry
Juan Pablo Fajardo
Junior Fernández
Varela Fernández Gumersindo
Maurício Vicente Ferreira Júnior
Bill Fisher
Ariel Fleischer
Katia Flor
Andrés Fresneda
Gabriela Gaona
Mara Garbuno
Araceli García
Migdalia García
Rodrigo M. García
Vicente García-Huidobro
Marina Garone Gravier
Margarita Lucila Gibbons
Héctor Gómez Estramil
Neto Gonçalves
Alejandro González Acosta
Andrea González Buj
Juan Antonio González Fuentes
José González Paredes
Renny José Granda
Eros Grau
Andrea Guañuna
Susana Gudalewicz
Ramón Gutiérrez
Alejo Gutiérrez Viñuales
Martín Gutiérrez Viñuales
Ignacio Gutiérrez Zaldívar
José Agustín Haya de la Torre
Ariane Herms
Magnolia Hernández L.
Ximena Hidalgo
Dylan Joy
Alexandra Kennedy-Troya
Elizabeth Kuon Arce
Krisztina Lakatos-Szrenkó
José Ignacio Lámbarri Orihuela
Clever Lara Echeverría
Andrés Linardi
Douglas Litts
Ramón López Quiroga
M. Leonor Lorente
Marcel Loustau

Eduardo Luciani
Osvaldo Macedo de Sousa
Ubiratan Machado
Cristina Machicado Murillo
Eduardo Machicado Saravia
Alberto Madrid Letelier
Vânia Mamede
Rómulo Martí Cuesta
Tomás Martín Grondona
Plinio Martins Filho
Autumn Lorraine Mather
Carolina Mc Namara
Alfonso Meléndez
Eugenia I. Mendoza
Sandra Meneses Jorquera
Marisa Midori Deaecto
María Antonia Miguel Escolano
Marcio Miquelino
Pablo Montini
Amanda Moreno
Marília Moschkovich
Julio Moses (†)
Martín Murcia
Anna Naldi
José Antonio Navarrete
Sandra Negro
Francisca Noguerol Jiménez
José de Nordenflycht
Kristen Nyitray
Noelia Ordóñez
Alfonso Ortiz Crespo
Inés Palomar
Iván Panduro Sáez
Manuel Pantigoso
Massimo Pastorelli
Peter Paulik
Valeria María Paz Moscoso
Gabriel Peluffo Linari
Eliana Pena Córdova
Wilfredo Penco
Michela Pentimalli
Juan Pérez Hernández
Terrence Phillips
Victoria Pilato
Humberto Pimentel
Pedro Querejazu Leyton
José E. Ramírez Carvajal
Paula Ramos
Fábio del Re
Luis E. Repetto Málaga (†)
Ramón Reverté

INSTITUTIONAL ACKNOWLEDGEMENTS

Maria das Graças Ribeiro dos Santos
Renata Ribeiro dos Santos
Erminio Risso
Polyanna Rizzoli
Pablo Thiago Rocca
Omar Rocha
Arie Rosenthal
Salomón Rosenthal
Pablo Rosero Rivadeneira
María Angélica Rozas
Mario Sagradini
Eduardo Salas
Gustavo Salazar Calle
Jacinto Salcedo
Silvia Salgadº
Marcelo Salom
Walter Sanseviero
Javier Santos
Eileen Schroeder
Daniela Eugenia Schutte González
José Luis Sepúlveda Carvajal
Ligia Siles Crespo
Daniel Soldi
Miguel Ángel Sorroche Cuerva
Carlos Stein
Winston Sterling
Teresa Suárez Molina
Stefania Tavella
Daniel Tawricky
Fernando Tesón
Percival Tirapeli
Marcela Tomé
Georgina Torello
Javier Torres Seoane
Ana Torres Terrones
Hugo Vallenas
Rodolfo Vallín Magaña (†)
Gumersindo Varela Fernández
Eloísa Vargas
Martín Vecino
José Vera
Arturo Vilchis Cedillo
Fernando Villegas Torres
Graciela M. Viñuales
Santiago Vitureira
Angela Waarala
Valeria Alexandra Yajamín Vasco
Beatriz Yunes Guarita
Freddy Zárate
María Paz Zegers Correa

Academia Argentina de Letras, Buenos Aires
Archivo José Carlos Mariátegui, Lima
Biblioteca América, Universidad de Santiago de Compostela
Biblioteca de Andalucía, Granada
Biblioteca Brasiliana Guita e José Mindlin, Universidade de São Paulo
Biblioteca Ecuatoriana Aurelio Espinosa Pólit, Quito
Biblioteca de la Fundación Guayasamín, Quito
Biblioteca del Instituto Riva-Agüero, Pontificia Universidad Católica del Perú, Lima
Biblioteca Jacinto Jijón y Caamaño, Ministerio de Cultura y Patrimonio, Quito
Biblioteca Luis Ángel Arango, Bogotá
Biblioteca Municipal Federico González Suárez, Quito
Biblioteca Nacional de Chile, Santiago de Chile
Biblioteca Nacional de Cuba, La Havana
Biblioteca Nacional de España, Madrid
Biblioteca Nacional «Eugenio Espejo», Quito
Biblioteca Nacional Mariano Moreno, Buenos Aires
Biblioteca Nacional de México, Mexico City
Biblioteca Nacional del Perú, Lima
Biblioteca Nacional de Venezuela, Caracas
Centro Cultural Benjamín Carrión, Quito
Centro de Documentación de Arquitectura Latinoamericana, Buenos Aires
Centro de Documentación en Artes y Literaturas Latinoamericanas, Espacio Simón I. Patiño, La Paz
Cuban Heritage Collection, University of Miami Libraries, Coral Gables, Florida
Fondazione Echaurren Salaris, Rome
Fundação Biblioteca Nacional, Rio de Janeiro
Fundación Flavio Machicado Viscarra, La Paz

Fundación Vicente Huidobro, Santiago de Chile
Galería López Quiroga, Mexico City
Hispanic Library, Spanish Agency for International Development and Cooperation, Madrid
IberoAmerican Institute - Prussian Cultural Heritage Foundation, Berlin
Ibero-Amerikanisches Institut, Berlin
Instituto de Estudos Brasileiros, Universidade de São Paulo
Latin American and Caribbean Collections, George A. Smathers Libraries, University of Florida
Librería L'Argine, Madrid
Manuscripts Reading Room, National Széchényi Library, Budapest
Morton Subastas, Mexico City
Museo Claudio Jiménez Vizcarra, Guadalajara, Jalisco
Museu Amazônico da Universidade Federal do Amazonas, Manaos
Museu Imperial, Petropolis
Nettie Lee Benson Latin American Collection, The University of Texas at Austin
Ryerson and Burnham Libraries at the Art Institute of Chicago
Universidad de Cuenca, Ecuador
Universidad de Granada, Spain
Universidad de Vigo
University of Illinois at Urbana-Champaign
University of Texas at Austin
Vera Nunes Leilões, São Paulo

March 2023

CO-PUBLISHERS
Ediciones La Bahía
Editorial RM

EDITOR
José María Lafuente Llano

AUTHORS
Rodrigo Gutiérrez Viñuales
Riccardo Boglione

ESSAYS
Juan Manuel Bonet
Rodrigo Gutiérrez Viñuales
Riccardo Boglione
Marina Garone Gravier
Dafne Cruz Porchini

ARCHIVO LAFUENTE DIRECTOR
José María Lafuente

ARCHIVO LAFUENTE COORDINATION
Sonia López Lafuente
Noelia Ordóñez Vélez

RM CREATIVE DIRECTION
Ramón Reverté

RM EDITORIAL COORDINATION
Eneka Fernández
Lea Tyrallová

DESIGN
José Luis Lugo

ESSAY EDITING
María del Carmen Pedraja Ibarguren

ENGLISH TRANSLATION
Josephine Watson

PROOFREADING
María del Carmen Pedraja Ibarguren
Josephine Watson

PHOTOTYPESETTING
La Troupe

PRINTERS
Brizzolis, Madrid, Spain

© to the edition: Ediciones La Bahía & Editorial RM, 2023
© to the essays: the authors
© to the works: the artists
© to the photographs: the photographers

Ediciones La Bahía
(Archivo Lafuente, S. L. U.)
Pol. Industrial de Heras, Parcela 304
39792 Heras (Cantabria), Spain
www.edicioneslabahia.com

Editorial RM
RM Verlag, S. L.
Loreto 13-15, Local B
08029 Barcelona, Spain

Editorial RM, S. A. de C. V.
Mexico City, Mexico

www.editorialrm.com
@editorial_rm
info@editorialrm.com

RM #422

ISBN Ediciones La Bahía: 978-84-123723-4-2
ISBN Editorial RM: 978-84-17975-79-1

Legal deposit: B 2743-2023

In some cases, the technical specifications (size or other bibliographic details) concerning the works reproduced are incomplete.

All rights reserved.
No part of this book may be reproduced or transmitted in any form or by any means without express written permission by the authors.

Every reasonable effort has been made to supply complete and correct credits. If there are errors or omissions, please contact the publishers so that corrections can be addressed in any subsequent edition.

Printed in Spain
Paper: Munken Pure 90 grams
Typography: Brandon Text